Heritage, Museums and Galleries

This volume provides a comprehensive introduction to the key issues that have faced heritage, museums and galleries in recent years. It presents a clear overview of the heritage sector and encourages a blurring of the artificial boundaries between heritage, museum and gallery studies.

Comprising twenty-eight thought-provoking articles, *Heritage, Museums and Galleries* introduces and discusses a range of important topics in detail. These include:

- Human remains, repatriation and illicit trade in antiquities
- Indigenous peoples, heritage management and museum action
- Representation, multiculturalism and globalization
- Memories and meaning-making
- Contestation and controversy
- Communication, interpretation and education
- Heritage tourism
- Public participation and working with different communities.

The book provides an ideal starting point for those coming to the study of museums and galleries for the first time, and brings the reader the very best of modern scholarship from the heritage community.

Gerard Corsane is a Lecturer in Heritage, Museum and Gallery Studies with the International Centre for Cultural and Heritage Studies at the University of Newcastle.

Heritage, Museums and Galleries

An introductory reader

Edited by Gerard Corsane

Routledge
Taylor & Francis Group

LONDON AND NEW YORK

First published 2005
by Routledge
2 Park Square, Milton Park, Abingdon, Oxon, OX14 4RN

Simultaneously published in the USA and Canada
by Routledge
270 Madison Ave, New York, NY 10016

Reprinted 2006

Routledge is an imprint of the Taylor & Francis Group

Typeset in Garamond 3 by Bookcraft Ltd, Stroud, Gloucestershire
Printed and bound in Great Britain by TJ International Ltd, Padstow, Cornwall

British Library Cataloguing in Publication Data
A catalogue record for this book is available from the British Library

Library of Congress Cataloging in Publication Data
Heritage, museums and galleries: an introductory reader / edited by Gerard Corsane.
 p. cm.
Includes bibliographical references and index.
 1. Museums. 2. Heritage tourism. 3. Art museums. 4. Museums–Management. 5.
Museum techniques. 6. Culture and tourism. 7. Cultural property–Protection. 8. Theft
from museums. 9. Archaeological thefts. 10. Art thefts. I. Corsane, Gerard, 1962–

 AM7.H465 2005
 069–dc22
 2004012159

ISBN 0-415-28945-9 (hbk: alk. paper)
ISBN 0-415-28946-7 (pbk: alk. paper)

Contents

Figures

Tables

Acknowledgements

I owe much to many people for making this book possible. First, thanks must go to all my ex-colleagues, both practitioners and academics, from whom I have learned so much. I am grateful to my current colleagues – Peter Davis, Rhiannon Mason, Andrew Newman, Peter Stone and Chris Whitehead – in the International Centre for Cultural and Heritage Studies at the University of Newcastle for their input and comments. A special note of thanks needs to go to all the students that I have worked with. I would also like to thank Catherine Bousfield and her colleagues at Routledge for their patience. Last, but far from least, I am indebted to my wife, Michelle, and my children, Jonathan and Danielle, for their unfailing encouragement and support.

Much of the material in this book has previously been published elsewhere, and the editor and publishers would like to thank the following for permission to reprint these important contributions.

Chapter 1 was written specially for this volume.

Chapter 2 was originally published in Roger Miles and Laura Zavala (eds), *Towards the Museum of the Future: New European Perspectives*, Routledge, 1994, pp. 57–69. Reproduced with the permission of the publisher.

Chapter 3 was originally published in Brian Graham, Gregory J. Ashworth and John E. Tunbridge (eds), *A Geography of Heritage: Power, Culture and Economy*, Edward Arnold, 2000, pp. 11–26. Reproduced with the permission of Hodder Headline.

Chapter 4 was originally published in *Museum Management and Curatorship*, Vol. 13, 1993, pp. 160–76. Reproduced with the permission of Elsevier Journals.

Chapter 5 was originally published in *Museum Management and Curatorship*, Vol. 12, 1993, pp. 267–83. Reproduced with the permission of Elsevier Journals.

Chapter 6 was originally published in *Curator* Vol. 38, 1995, pp. 31–7. Reproduced with the permission of Rowman & Littlefield Publishers.

Chapter 7 was originally published in Carol Duncan, *Civilizing Rituals: Inside Public Art Museums*, Routledge, 1995, pp. 7–20. Reproduced with the permission of the publisher.

Chapter 8 was written specially for this volume.

Chapter 9 was originally published in Cressida Fforde, Jane Hubert and Paul Turnbull (eds), *The Dead and Their Possessions: Repatriation in Principle, Policy and Practice*, Routledge, 2002, pp. 1–16. Reproduced with the permission of the publisher.

Chapter 10 was originally published in Neil Brodie and Kathryn W. Tubbs (eds), *Illicit Antiquities: The Theft of Culture and the Extinction of Archaeology*, Routledge, 2002, pp. 1–22. Reproduced with the permission of the publisher.

Chapter 11 was originally published in *Public Archaeology*, Vol. 2, 2001, pp. 21–34. Reproduced with the permission of James & James (Science Publishers) Ltd.

Chapter 12 was originally published in *Proceedings of the International Conference on Anthropology and the Museum*, Taiwan Museum, Taipei, 1995, pp. 285–94.

Chapter 13 was originally published in *Theory, Culture and Society*, Vol. 4, 1997, pp. 123–46. Reproduced with the permission of Sage Publications Ltd.

Chapter 14 was originally published in Sarah Nuttall and Carli Coetzee (eds), *Negotiating the Past: The Making of Memory in South Africa*, Oxford University Press, 1998, pp. 143–60. Reproduced with the permission of the publisher.

Chapter 15 was originally published in *Museum News*, Vol. 79, 2000, pp. 47–53. Reproduced with the permission of the American Association of Museums.

Chapter 16 was written specially for this volume.

Chapter 17 was originally published in Peter Stone and Brian Molyneaux (eds), *The Presented Past: Heritage, Museums and Education*, Routledge, 1994, pp. 14–28. Reproduced with the permission of the publisher.

Chapter 18 was written specially for this volume.

Chapter 19 was originally published in *Progress in Tourism, Recreation and Hospitality Management*, Vol. 5, 1994, pp. 309–24. Reproduced with the permission of John Wiley & Sons Ltd.

Chapter 20 was originally published in Douglas G. Pearce and Richard W. Butler (eds), *Contemporary Issues in Tourism Development*, Routledge, 1999, pp. 108–26. Reproduced with the permission of the publisher.

Chapter 21 was originally published in Chris Rojek and John Urry, *Touring Cultures: Transformations of Travel and Theory*, Routledge, 1997, pp. 155–75. Reproduced with the permission of the publisher.

Chapter 22 was originally published in S. Abram, D. Macleod and J. Waldern (eds), *Tourists and Tourism: Constructing and Deconstructing Identity*, Berg, 1997, pp. 197–221. Reproduced with the permission of the publisher.

Chapter 23 was originally published in *Daedalus*, Vol. 130, 2001, pp. 277–96. Reproduced with the permission of the American Academy of Arts and Sciences.

Chapter 24 was originally published in *Museums Journal*, Vol. 101, 2001, pp. 34–6. Reproduced with the permission of the Museums Association.

Chapter 25 was originally published in *Museum News*, Vol. 80, 2001, pp. 29–31. Reproduced with the permission of the American Association of Museums.

Chapter 26 was originally published in *Curator*, Vol. 39, 1996, pp. 19–44. Reproduced with the permission of Rowman & Littlefield Publishers.

Chapter 27 was originally published in *Community Museums in Asia: Report on the Training Workshop, February 26–March 10, 1997*, Japan Foundation Asia Center, 1998. Reproduced with the permission of the publisher.

Chapter 28 was written specially for this volume.

Preface

In my current and last two teaching positions I have been an admissions officer for applicants wishing to register for postgraduate qualifications in heritage, museum or gallery studies. During the six years in these posts, the most frequently asked question I have heard has been: 'Is there a book that I can start reading before beginning my programme?' This reader has been developed in response to that question.

The principal aim of this reader is to provide a starting point and introductory resource for anyone wishing to begin an engagement with certain key issues relating to the heritage, museums and galleries sector. This includes graduate students who have completed a first degree from a range of different disciplines and who are looking for a pre-sessional text to start their preparations to go into a postgraduate programme in the interdisciplinary – or postdisciplinary – fields of heritage, museum and gallery studies. However, as a reader, it will also be useful as a text for undergraduate students who, within a single discipline or combined first degree, are given the opportunity to begin to explore links between what they are studying and current issues in heritage, museums and galleries.

Apart from students participating in taught programmes, the selection in the reader will be of interest to research students and academics. In the main, the articles in the book have appeared elsewhere, yet there are four new ones (by Whitehead, Chapter 8; Mason, Chapter 16; Newman, Chapter 18; and Davis, Chapter 28) that have been especially commissioned for this volume. In addition, although the reprinted articles selected for the more general first part of the book may be fairly easily accessible in their original published forms, an attempt has been made in the rest of the book to source and bring together a collection of lesser known and/or more difficult items to access. For example, certain articles may originally have been included in volumes where heritage, museums or galleries were not the primary focus. Others may have first appeared in a volume that has been difficult to acquire because of a limited print run, or in a publication with high production costs and, consequently, a purchase price that placed them beyond the reach of many.

Another group of users that will find value in the book are heritage, museums and gallery professionals who face these issues on a day-to-day basis and who may like to use the volume as a platform for continuing professional development. Finally, general members of the public are increasingly being called on to be active participants in heritage, museum and gallery processes. If they are to be informed participants, they will find it useful to acquaint themselves with some of the current issues, challenges and ideas that are impacting on heritage, museums and galleries.

There are an increasing number of readers, anthologies and edited volumes relating to heritage, museums and galleries available in bookshops and on library shelves. With its stated prin-

cipal aim, this reader is not intended to be in competition with them. Rather, it could be seen as a first primer and introduction that can provide a foundation and an entry point that the user can then build upon. The choice of articles in this volume will provide tasters that will draw readers in and stimulate them to begin an intellectual journey on which they can critically engage with the full range of available material. Users of this reader are encouraged to make note of the references and bibliographic entries and to follow up and develop their understanding on areas that attract their interest.

Regarding its content, this volume is a selection of articles on certain issues. The selection has mainly been influenced by the teaching and research approaches and interests of the International Centre for Cultural and Heritage Studies at the University of Newcastle upon Tyne. In the Centre an integrated vision is followed, which encourages thinking across the artificial boundaries often set up between heritage, museum and gallery studies. This has informed the framework of the book, and the choice and grouping of the articles. However, to some degree the selection has also been influenced by my personal experiences, both as a heritage practitioner and as an educator/trainer in South Africa, during the exciting period around that country's first democratic elections.

On a final note, for everyone who reads this volume, I am sure that we share the belief that heritage, museums and galleries are vital cultural, social and economic resources within society. They are immensely useful in lifelong learning and they can have the capacity to empower. They are important as sites for the construction and exchange of ideas, memories and identities, and for public engagement with issues. They have a place in society and, as long as they are prepared to change when the need arises, they will survive in one form or another. We need to look at the issues and challenges facing heritage, museums and galleries and decide whether or not they need to transform and reconfigure themselves as public institutions. This reader does not wish to impose answers, as there are no absolutes: rather it provides material that can be used by readers to stimulate questions and critical engagement. I hope that you find the particular selection of material in this volume different, useful and worthwhile.

1

Issues in heritage, museums and galleries
A brief introduction

Gerard Corsane

Introduction

Where does one start to introduce the myriad of issues that have been identified and brought to the fore in relation to heritage, museums and galleries over the past couple of decades? In a postmodern and postcolonial world, the range of issues has proliferated and spread, especially with the increased information flow and possibilities for exchange of ideas that have accompanied the development of new communication technologies and new media. Discourses on heritage, museums and galleries have become a massive, complex and organic network of often loosely articulated understandings, ideas, issues and ways of perceiving things; a network that is fluid, dynamic and constantly reconfiguring itself as individuals critically reflect on and engage with it. In addition, the way in which individuals reflect on the issues will depend on their starting points. Practitioners, academics, government officials, along with users and non-users of cultural and heritage institutions, will each have different approaches. However, although it is now accepted that no two people will share exactly the same list of perceived issues in the same order of priority, there are a number that appear to have currency in recent and present debates and discourses in heritage, museum and gallery studies. Many of these issues are associated with challenges to modernist Western principles and practices, along with calls for greater transparency and democratization. The selection of material in this volume has been informed by this, and by the range of material included in the suggested further reading list.

To assist in providing a framework for the reader to engage with some of the issues, this volume has been divided into four parts. Part 1 contains a selection of chapters relating to heritage, museums and galleries that present overviews and useful starting points for critical reflection. The items included in this part offer broad contributions that introduce the terminology and concepts relating to recent and current issues. The intention of Part 1 is to provide the reader with a general platform before certain key issues are introduced in more depth in the remaining three parts of the book. Lumley (Chapter 2) and Graham, Ashworth and Turnbridge (Chapter 3) provide a valuable background for understanding many of the issues relating to heritage more generally. Harrison (Chapter 4) and Stam (Chapter 5) identify and chart a number of the key challenges and trends in recent museological thinking that have influenced museum development over the past couple of decades, whilst Duncan (Chapter 7) and Whitehead (Chapter 8) bring useful perspectives on the relationships between people and art museums and galleries. Gurian (Chapter 6) makes an important contribution in showing how the boundaries between museums and other sites and media that store and shape memories are blurring, potentially leading to the reconfiguration of the heritage and cultural sector. The relationships

between these sites and individuals or social groups, in terms of memory-making and the sharing of memory, are covered in Crane (2000) and Kavanagh (2000), and relate to Davison (Chapter 14).

Part 2, which has the largest number of articles, aims to draw the reader's focus more specifically to a number of selected issues of significance. Parts 3 and 4 then go into further depth on issues in two particular areas: Part 3 concentrates on issues related to cultural heritage and tourism and Part 4 is dedicated to public participation in heritage, museum and gallery processes and activities.

In Part 3, the contribution from Prentice (Chapter 19) shows the range of attractions that can be considered in terms of heritage tourism. He makes some useful observations about the profile of visitors and suggests interpretative strategies that could be used to widen the visitor base. Richter (Chapter 20) follows with a discussion on issues surrounding the political dimensions currently associated with heritage tourism. Each of the final three chapters by Macdonald (Chapter 21), Hitchcock, Chung and Stanley (Chapter 22) and Witz, Rassool and Minkley (Chapter 23), discusses the construction and presentation of heritage products within different political, economic, social and cultural contexts. With each of these it is interesting to consider who drives the processes of construction and presentation and how the different types of visitors and users – with varying expectations – consume the heritage tourism products described.

Finally, the reason for placing the articles in Part 4 at the end of the volume is that issues relating to social exclusion (Newman, Chapter 24), the co-creation of the civic museum (Thelen, Chapter 25), the approaches of the neighbourhood museum (James, Chapter 26), the negotiated community-based museum (Gordon, Chapter 27) and the principles of ecomuseum models (Davis, Chapter 28) are concerned with democratization. These chapters complete a circle that will bring the reader back to a model, to be proposed below, as a way of developing an ideal democratic overall process for heritage, museum and gallery work.

Overall process of heritage/museum/gallery work: a proposed model

The proposed model (Figure 1.1) emphasizes the importance of public participation in all stages and activities of the overall process of heritage/museum/gallery work, from involvement in the activities themselves to the decision-making processes that both lie behind these activities and connect them. This model provides a framework that can be used to bring together many of the key issues that are raised in the chapters included in Part 2 and, after the model has been discussed, these issues will be considered in turn.

Although the process may appear very linear and rigid in the diagram, this is not the case in reality. The process should be viewed as being circulatory and dynamic in character. At any point during the process, one must be aware of the importance of allowing for feedback loops, which can further help to expand areas of the process already worked through.

The model takes as its starting point the notion that heritage, museum and gallery work is performed to provide vehicles for learning, inspiration and entertainment. Taking note that there would have been processes behind the original formation of cultural practices, material and expressions, the overall process in the model works from the *heritage resources* at one end through to the *heritage outputs* that are communicated at the other. This central line of activities performed in the model, and the acts of interpretation that follow, denote the *processes* of meaning-making in heritage, museums and galleries.

Ideally, throughout the process, practitioners work with representatives from different stakeholder groups and 'communities' in consultation and negotiation (see arrows down left-hand

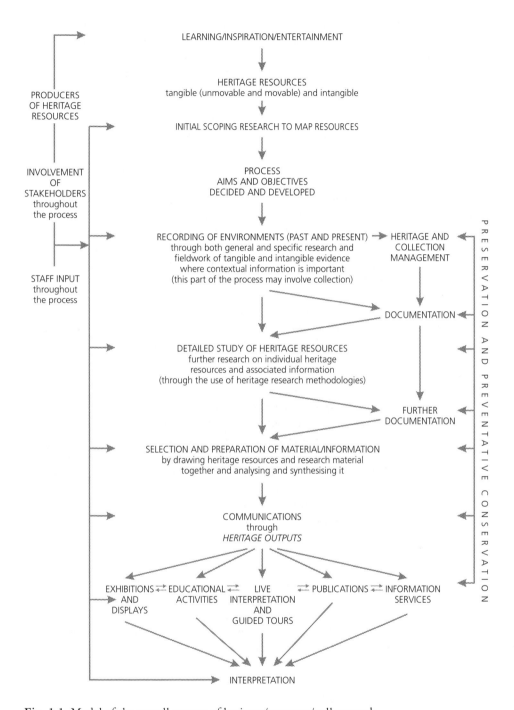

Fig. 1.1 Model of the overall process of heritage/museum/gallery work

side of model in Figure 1.1). Together, they identify appropriate heritage resources through initial scoping research. This initial research provides the basis for developing aims and objectives that guide the ongoing process, starting with activities where 'environments' are recorded and documented (see e.g. Kavanagh, 1990). The word 'environment' is used here in its broadest meaning and includes natural, social, cultural, creative and political contexts, and the relationships between them. This level of recording will require the use of a range of different research methodologies and techniques in order to gain both general and specific information. It will involve 'fieldwork', which again is used in its broadest sense to mean recording heritage resources wherever they may be found. This may involve documenting and studying anything from natural habitats and ecosystems, urban and rural landscapes, archaeological and heritage sites, the built environment, suites of material objects, archival material and artistic forms of expression – through to different knowledge systems, belief patterns, oral traditions, oral testimonies, song, dance, ritual, craft skills and everyday ways of doing things. The activities of recording and documentation at this level may involve the active collection of movable objects, as is the case with most museums, or it may require the relocation of larger items, such as buildings, for open-air museums. Wherever this takes place, the documentation activities are of even more importance, as associated contextual information is needed for material that is moved from its original location.

Following these first-level recording and documentation activities, the research can become more focused on the individual aspects and sources of evidence. For example, in museum research, material culture and artefact study approaches are employed to read meanings out of (and into) the material (see e.g. Pearce, 1992, 1994; Schlereth, 1982, 1990; Lubar and Kingery, 1993). In all of this documentation and research, information is produced and is fed into the second-level (or archival) documentation that becomes part of the heritage and collection management line of documentation, denoted by the arrows down the right side of Figure 1.1.

The results of all of this documentation and more detailed research then goes through a process of selection and preparation and become the communication outputs, which are communicated through a range of different, but interlinking, media. This final part of the meaning-making process involves a certain amount of mediation as decisions are made about:

- the selection of material and information;
- the construction of the messages to be communicated;
- the media to be used in the communication.

It is at this stage that the input from stakeholder groups (being all those that could have an invested interest) and communities may be most crucial, although they *must* be included throughout the overall process.

Traditionally, these last stages of the processes have been viewed as the activity of interpretation. However, as will be seen later, the acts of interpretation of the heritage, museum and gallery outputs involve the users of these products – the 'visitor' (see also Mason, Chapter 16).

Parallel to the central process of meaning-making runs the process of heritage and collections management, which involves taking care of the heritage resources through documentation, preservation and conservation of the material and associated information. What is undertaken in this parallel process should also be negotiated with stakeholders. In addition, it should be noted that whatever is done in this process will have some form of impact on meaning-making.

Finally, when considering the model, two further points need to be made. The first and most direct is that, ideally, the process should allow for feedback and evaluation loops. Second, it

needs to be understood that there are a range of external factors that will influence the process. These factors could be set by political, economic, social and cultural conditions and agendas.

Placing current concepts and issues against the overall process

Many of the concepts and issues that relate to current discussions in heritage, museums and galleries – and which are raised throughout the chapters in this volume – may appear to be more specifically connected to a particular component of this overall process. For example:

- some concepts and issues relate more clearly to the actual cultural property and *heritage resources* themselves;
- others are linked more closely to the *heritage outputs* as communicated through different media, products, public programmes and commodities, along with how they are used and consumed in a variety of ways;
- finally, there are those concepts and issues that are associated with the range of *sub-processes* associated with the overall process outlined above.

It should be noted here, however, that the sub-processes in the third component can be located at different points within the overall process. Certain sub-processes are more closely allied to the actual production of heritage resources, which can never really be seen as 'raw', as they have been invested with meanings during their original formation. In terms of heritage resources, there are also a wide range of issues associated with the sub-processes of selection of what is deemed worthy of preservation and conservation, along with the sub-processes allied to collecting activities and the documentation of associated information. These revolve around the questions of: who makes the decisions; how are they informed and what criteria are used when making the selection?

Other sub-processes can be positioned further along the system on either side of the heritage outputs. There are those that are part of the final mediation, construction and packaging of the outputs (e.g. label-writing processes, scripting of re-enactment live interpretations, or the design of educational activities) and others that relate more to how heritage outputs are consumed and utilized by the heritage visitor, or user. In addition, there are those that can lie in the overall process somewhere in between the resources and outputs, and are linked more to the methodologies used in recording, research, and heritage and collection care in different contexts. Although many of the concepts and issues relating to these aspects of the system are contingent and in actuality cannot be easily separated out, the three components of the overall process can be used for convenience as a basic framework for introducing the different concepts and issues explored in the chapters in this volume.

At this point, it can be noted that many of the concepts and issues, wherever they are placed within this system, share a common feature in that they relate to notions of 'ownership' – ownership of the cultural and heritage resources, ownership of the heritage outputs and ownership of the activities and sub-processes in between. With these notions of ownership come legal and ethical issues.

Intangible cultural heritage

Before going on to look at the more specific issues that relate to the ownership of heritage resources and cultural property covered in this volume, it may be useful to alert readers to a more general issue of current significance. Traditionally in Western models, heritage, museums and

galleries have tended to concentrate their collection and preservation activities on material culture. Heritage has focused on the preservation and conservation of immovable tangible heritage, and museums and galleries on movable tangible heritage. However, more recently the heritage, museum and gallery sector is being encouraged to expand its notion of what heritage is, in order to take account of intangible cultural heritage. At an international level, the Section for Intangible Heritage within the Division of Cultural Heritage of the United Nations Educational, Scientific and Cultural Organisation (UNESCO) has been active in this area, with several key projects documented on the UNESCO web site. The most recent of these has been the adoption of the *Convention for the Safeguarding of the Intangible Cultural Heritage* at the thirty-second session of the UNESCO General Conference on 17 October 2003. The definition of intangible culture heritage used in the convention states that:

> The 'intangible cultural heritage' means the practices, representations, expressions, knowledge, skills – as well as the instruments, objects, artefacts and cultural spaces associated therewith – that communities, groups and, in some cases, individuals recognize as part of their cultural heritage. This intangible cultural heritage, transmitted from generation to generation, is constantly recreated by communities and groups in response to their environment, their interaction with nature and their history, and provides them with a sense of identity and continuity, thus promoting respect for cultural diversity and human creativity. For the purposes of this Convention, consideration will be given solely to such intangible cultural heritage as is compatible with existing international human rights instruments, as well as with the requirements of mutual respect among communities, groups and individuals, and of sustainable development.

> The 'intangible cultural heritage', as defined above, is manifested *inter alia* in the following domains: oral traditions and expressions, including language as a vehicle of the intangible cultural heritage; performing arts; social practices, rituals and festive events; knowledge and practices concerning nature and the universe; and traditional craftsmanship
>
> (UNESCO, 2003:2)

The value of intangible cultural heritage has already been engaged with in a number of countries that have a culturally diverse population and indigenous peoples. However, it will be interesting to see what longer term effects these UNESCO initiatives will have at a national and more local level. Hopefully, heritage will become more inclusive. By expanding the understanding of what constitutes heritage, there is far more scope for reflecting on cultural diversity and recognizing and incorporating other knowledge systems and models of museum action and heritage management (e.g. Ndoro and Pwiti, Chapter 11; Hakiwai, Chapter 12; Stone, Chapter 17; and Davis, Chapter 28).

Current issues related to heritage resources

Turning now to the concepts connected to the legal and ethical issues of ownership of cultural property, an obvious starting point is the set of issues that revolve around the notions of repatriation and restitution, and the arguments for and against the return of cultural property. Certain tangible cultural heritage resources may have been acquired through one of a variety of means, whereby the fairness and/or legality of the original transfer of ownership can now be called into

question. This often includes items that were obtained during periods of altered or newly imposed power relationships, with prime examples being during times of conquest, occupation and colonization. In these periods, (re)movable heritage resources may have been appropriated from the original owners without their express permission, through unfair trading, through the exploitation of power relations between dominant and subservient groups, or, as the spoils of war. In certain cases, the legality of the transfer of ownership may appear to lie with the current owner. Yet, arguments for repatriation need to move beyond the legality of the current ownership and consider ethical issues related to what is best for the material, the claimant(s), the current custodians and society at large. The call for the return of the Parthenon/Elgin Marbles from the British Museum to Greece, along with the debates surrounding this, is a well-known example of the types of arguments for and against repatriation. Most would now argue that each claim should be considered individually, as each will have its own set of contexts and complexities. A useful entry point into the debates is provided by Greenfield (1996), who considers the issues related to the return of cultural property in the light of certain cases, including the case of the Parthenon Marbles.

Another dimension to the repatriation debate concerns appeals, often by indigenous peoples, for the return of human remains and associated grave goods and sacred objects. Where these remains and goods have been uncovered at heritage sites, or are located within museum collections, the requests for their return are predicated on concerns that the remains and objects need to be treated with the correct respect and buried, or reburied, in a responsible and proper manner. This has led to tensions developing between scientists, curators, heritage managers and representatives from indigenous groups. Hubert and Fforde (Chapter 9) introduce and explore issues relating to the different views of those concerned.

Linked to the concept of restitution, art museums and galleries also have to engage with a particular set of issues of ownership in terms of artworks that may have been acquired during times of conflict, as spoils of war. Indeed, 'spoliation', especially artworks looted by the Nazis during the Second World War and particularly the Holocaust, has become a key issue (see e.g. Palmer, 2000; American Association of Museums, 2001). Provenance research that looks into the history and legitimacy of ownership and how – and from whom – institutions acquired works of art is now common standard practice, with well-established guidelines and mechanisms for the dissemination of information about art collections and individual works. In the USA, the endeavours undertaken by the Association of Art Museum Directors (n.d.) provides an important example, as does the ongoing work of the National Museum Directors' Conference (2000–2003) in the UK.

The looting of artefacts and artworks by the victors is only one issue associated with what happens to cultural property during times of conflict. Others relate to the damage and destruction caused to cultural property during military action (see e.g. Layton *et al.*, 2001). At times, this damage and destruction may be accidental and unintended. However, as cultural property has deep significance and meaning, it may be deliberately targeted as part of a process aimed to break the spirit of a people. Returning to the issue of theft, periods of conflict lead to destabilization and a breakdown of normal social and economic structures. With priorities placed elsewhere, the security of cultural property is often reduced, leaving it more open to theft by people desperate – or unscrupulous – enough to see it as a form of economic capital.

The issues of destruction and theft during conflict form part of the piece by Brodie (Chapter 10). However, the main focus of his chapter relates to a fuller range of issues centred on the illicit trade in cultural property, which is a major concern internationally. The theft of cultural material from institutions open to the public, or its unlicensed removal from sites, means that many significant items leave the public domain and enter private collections. Furthermore, material

that is removed from sites without being documented correctly loses its context, and its value as a source of evidence is greatly diminished. There are a number of ethical issues that heritage, museum and gallery professionals in market countries need to consider, especially when they are approached with offers of donations with dubious provenance, or when bidding to purchase material on the open market.

Issues relating to heritage resources go beyond those associated with the movable tangible heritage. Earlier, issues of repatriation and restitution were introduced in terms of movable heritage resources; however, there are issues that also relate to immovable heritage resources. Ndoro and Pwiti (Chapter 11) raise a number of these issues in their article. With colonialism, sites significant to indigenous peoples may have been appropriated and drawn into the developing Western models of heritage management by the colonial authorities. This was often accompanied by the beginning of a legacy wherein local indigenous people have been alienated from sites that were important to their ancestors. Where heritage sites or conservation areas have been designated at a national or international level for protection, the access of local people to the sites and resources becomes curtailed and strictly controlled. Their sense of ownership of and participation in the decision-making processes concerning the sites or areas is reduced, especially when Western models of heritage management are imposed over the more traditional approaches to conservation and sustainable usage. Indigenous knowledge and belief systems are ignored, or even suppressed, with the spirit of place and space being lost.

This theme is again picked up in the article by Hakiwai (Chapter 12), which looks at similar issues in relation to movable material culture. The article also provides a useful link between issues relating to heritage resources and those connected to heritage outputs. Starting with the issues concerning ownership of *taonga*, or Maori treasures in New Zealand museums, Hakiwai goes on to challenge Western Eurocentric approaches to research, interpretation and presentation of Maori cultural heritage. For him, these approaches remove the life and spirit from objects. In order to legitimize the work done in museums, indigenous peoples need to be involved in how their cultures are researched, interpreted and presented. They wish to have control and ownership over their material culture and the production of heritage outputs, which are so important in terms of how their culture is represented and how these representations affirm their sense of identity.

Issues relating to heritage outputs

The introduction of notions of representation and identity opens up the issues more closely connected to heritage outputs. Here the key issues are indeed clustered around shifting understandings concerning notions of representation. These shifts are epistemological in basis in that they have been associated with perceptions of how knowledge is acquired, produced and communicated. The main shift has been from the modern world-view of knowledge to an understanding of knowledge that has been influenced by postmodernist thinking. In the modernist world-view, with its Western dominance, there was a strong belief that there is a fixed body of absolute knowledge with 'certainties' and 'facts' that can be tapped into through 'objective' research. Once acquired, it was believed that these certainties and facts could be disseminated and transmitted as the 'truth'. However, today, people are far more sceptical about this and question the ideals of 'positivist' approaches. Rather, knowledge is seen as being constructed by humans as they process available information, and that the processes of knowledge construction are coloured by the interplay between different factors including economic, social, cultural and political contexts. This has had a significant impact on how heritage outputs, and the way they

are used, are perceived. Heritage, museums and galleries cannot present and transmit absolute knowledge and are no longer viewed to hold the same authority that they once had. They can only provide representations and interpretations of the world. There is no one fixed message to be transmitted and no single voice. Consequently, two questions can be asked:

• Whose voices should be heard?
• How can the outputs allow for different voices to come through?

Rather than being monovocal, outputs should allow for a polyvocality with representation being focused on all, no matter what their age, gender, class, ethnic background, religious persuasion or political allegiance.

Linked to representation and the multiplicity of potential voices are issues concerning the construction of identities. The representations in heritage, museums and galleries are often discussed as being about the presentation of images of 'self' and 'other'. All of this is significant in terms of the construction of individual, community, national and transnational identities. However, the construction of identities is complex, as each individual does not have a single identity or belong to a single community. In many ways the notion of 'community' is also problematic, as it too is an intellectual construct. A person may belong to and move between a range of different communities and identify with each differently. For example, she or he may belong to a geographical community defined by locality, or an ethnic community, or a community centred on a particular industry. Added to this are the issues related to globalization and its relationship to the construction of national and local identities. This makes the use of notions of 'self', 'other' and 'community' difficult, and Nederveen Pieterse (Chapter 13) provides a useful engagement with a number of the issues related to representation and the construction of identities, especially as they have been played out in ethnographic museums. This is followed by an article by Davison (Chapter 14), which considers many of the issues in relation to the particular situation of South Africa. This article was included as South Africa is a prime example of the impact that the dynamics of power relationships can have on issues of representation, the construction of identities, and the shaping and re-shaping of official public memories.

When heritage, museums and galleries become sites and spaces where a multiplicity of voices can be heard and different representations found, they open up as places where dialogue can take place. They can challenge, inspire and act as resources for life-long learning. This is all positive. However, they can also become arenas of contestation that at times stimulate controversy. In recent years, a number of exhibitions that have caused this type of controversy have been documented. The article by Macdonald (Chapter 15) looks at the controversy caused by the art exhibition, *Sensation: Young British Artists from the Saatchi Collection*, after it opened at the Brooklyn Museum of Art in late 1999. Other well-documented examples of recent exhibitions that have been centres of heated controversy include: the original exhibition planned for the National Air and Space Museum of the Smithsonian Institution in the early 1990s that included the Enola Gay (the aeroplane that dropped the first atomic bomb on Hiroshima), which proved so controversial with war veterans that the plane ended up not being displayed as originally intended (Harwit, 1996; Zolberg, 1996; Gieryn, 1998; Dubin, 1999); and the *Into the Heart of Africa* exhibition that was on display in the Royal Ontario Museum, Canada, during 1989 and 1990 (Mackay, 1995; Riegel, 1996; Butler, 1998).

Heritage, museum and gallery outputs need to be prepared to engage with topical and sometimes difficult issues. Where risks are taken in order to produce outputs and public programmes

that will be challenging and stimulating, there is always the potential for controversy. Yet when carefully negotiated in responsible and sensitive ways, this potential for outputs to attract controversy may be reduced, whilst at the same time the possibilities of encouraging challenging engagement and opportunities for learning can be enhanced.

The role of heritage, museums and galleries in providing opportunities for life-long learning is seen to be an important priority. Stone (Chapter 17) provides a focus on issues related to archaeological heritage and education in a post-colonial world at the intersection between academic archaeology, indigenous knowledge systems, school curricula and interpretations offered through public programmes at museums and heritage sites. Here formal and informal learning opportunities are considered, and attention is drawn to where archaeological heritage and indigenous views are excluded from what is presented.

Further issues related to learning are also picked up by Mason (Chapter 16), as part of a wider discussion on museums, galleries and heritage, and theories of meaning-making and communication. The processes of communication in the sector are now seen as being more complex than in older linear transmission models. Rather than passive receivers of fixed messages, visitors and users should be seen as active participants in interpretation, meaning-making and learning (Hooper-Greenhill, 1994, 1999). In these processes, visitors and users bring their own experiences and prior understandings into play as they engage with public programmes. This personal context is one of the three intersecting contexts identified by Falk and Dierking (1992, 2000), with the other two being the sociocultural and the physical contexts. These contexts all influence how a user engages with the outputs and takes ownership of the processes of learning and interpretation, which involves free choice (Falk and Dierking, 2002). With an understanding that knowledge itself is socially constructed, the constructivist model within learning theory can be applied to heritage, museums and galleries (Hein, 1998). Heritage, museums and galleries can facilitate learning by making available heritage resources and information through exhibitions, educational material and activities, along with other public programmes. If the visitors and users have been empowered through well-thought-through orientation, then they can become active interpreters.

Concepts related to meaning-making, communication, interpretation and learning are taken a step further by Newman (Chapter 18), who considers the social impact of museums, galleries and heritage in terms of the benefits that people can accrue in different forms of capital that may be acquired from visits. This is a useful approach, as visitors bring different forms of capital to the visit and these will have a bearing on how accessible each visitor finds the material communicated and the overall experience. An understanding of how these forms of capital work will help us better to understand what visitors are likely to take away from the experience.

Other issues linked to heritage, museum and gallery outputs relate to the ideals of access. These ideals include physical and sensory access for people with disabilities. However, they should go further and look to breaking down barriers to intellectual, cultural and economic access (Dodd and Sandell, 1998). Finally, in the development of outputs, practitioners in the heritage, museum and gallery sector are now looking more and more at the development of new audiences and users from those groups of people who previously may have felt alienated, or marginalized and unseen. Many institutions and organizations very successfully run outreach programmes with the aim of encouraging new audiences. However, somehow, the very notion of 'outreach' appears to place these institutions and organizations somewhere outside, beyond and above, society. It suggests that they have to reach out across some sort of divide, or gap. Consequently, it may be more appropriate to look to a notion of 'inreach', where institutions and organizations can be seen as being placed centrally within society (see Davies, Chapter 28, Figure

28.4, p. 373). When this is done, the institutions may be more willing for people to reach into and take part in the overall process introduced earlier. Likewise, people may be more interested in becoming involved, thereby allowing the institutions to reach into more corners of society. In many ways, this is what the co-created civic museum (Thelen, Chapter 25), the neighbourhood museum (James, Chapter 26) and, most especially, the ecomuseum (Davis, Chapter 28) have attempted to do.

There are a wide range of issues that heritage, museums and galleries face today. When a process model is used, a number of the issues can be viewed as being linked to the heritage resources, while others are more closely associated to the heritage outputs. Many of the issues have a connection with ownership – either ownership of resources, ownership of processes, or ownership of the outputs. These issues need to be addressed by establishing working partnerships in a way that is democratic and which will benefit as many stakeholders as possible.

References

American Association of Museums (2001) *Museum Policy and Procedure for Holocaust Era Issues: Resource Report*, Washington: AAM.

Association of Art Museum Directors (n.d.) 'Art museums and the identification and restitution of works stolen by the Nazis', available at www.aamd.org/documents/Nazi%20Looted%20Art.pdf (accessed July 2004).

Butler, S.R. (1998) *Contested Representation: Revisiting Into the Heart of Africa*, Amsterdam: Gordon & Breach.

Crane, S.A. (ed.) (2000) *Museums and Memory*, Stanford: Stanford University Press.

Dodd, J. and Sandell, R. (1998) *Building Bridges: Guidance for Museums and Galleries on Developing New Audiences*, London: Museums and Galleries Commission.

Dubin, S.C. (1999) *Displays of Power: Controversy in the American Museum from the Enola Gay to Sensation*, New York: New York University Press.

Falk, J. and Dierking, L. (1992) *The Museum Experience*, Washington: Whalesback.

—— (2000) *Learning from Museums: Visitors' Experiences and the Making of Meaning*, Walnut Creek: AltaMira.

—— (eds) (2002) *Lessons without Limits: How Free-choice Learning is Transforming Education*, Walnut Creek: AltaMira.

Gieryn, T.F. (1998) 'Balancing acts: science, Enola Gay and history wars at the Smithsonian', in Macdonald, S. (ed.), *The Politics of Display: Museums, Science, Culture*, London and New York: Routledge.

Greenfield, J. (1996) *The Return of Cultural Treasures* (2nd edn), Cambridge: Cambridge University Press.

Harwit, M. (1996) *An Exhibit Denied: Lobbying the History of Enola Gay*, New York: Copernicus.

Hein, G.E. (ed.) (1998) 'The constructivist museum', in *Learning in the Museum*, London and New York: Routledge.

Hooper-Greenhill, E. (ed.) (1994) *The Educational Role of the Museum*, London and New York: Routledge.

—— (ed.) (1999) *The Educational Role of the Museum* (2nd edn), London: Routledge.

Kavanagh, G. (1990) *History Curatorship*, London: Leicester University Press.

—— (2000) *Dream Spaces: Memory and the Museum*, London: Leicester University Press.

Layton, R., Stone, P. and Thomas, J. (eds) (2001) *Destruction and Conservation of Cultural Property*, London: Routledge.

Lubar, S. and Kingery, W.D. (eds) (1993) *History from Things: Essays on Material Culture*, Washington: Smithsonian Institution.

Mackay, E. (1995) 'Postmodernism and cultural politics in the multicultural nation: contests over truth in the "Into the Heart of Africa" controversy', *Public Culture*, 7, 403–31.

National Museum Directors' Conference (2000–3) 'Spoliation of works of art during the holocaust and world war II period: progress report on UK museums' provenance research for the period 1933–1945', available at www.nationalmuseums.org.uk/spoliation.htm (accessed July 2004).

Palmer, M. (2000) *Museums and the Holocaust*, Washington: AAM.

Pearce, S.M. (1992) *Museums, Objects and Collections: A Cultural Study*, London: Leicester University Press.

—— (ed.) (1994) *Interpreting Objects and Collections*, London: Routledge.

Riegel, H. (1996) 'Into the heart of irony: ethnographic exhibitions and the politics of difference', in Macdonald, S. and Fyfe, G. (eds), *Theorizing Museums: Representing Identity and Diversity in a Changing World*, Oxford: Blackwell/The Sociological Review.

Schlereth, T.J. (1990) *Cultural History and Material Culture: Everyday Life, Landscapes, Museums*, Charlottesville: University Press of Virginia.

—— (ed.) (1982) *Material Culture Studies in America*, Nashville: AASLH.

United Nations Educational, Scientific and Cultural Organisation (n.d.) 'Intangible heritage, cultural diversity and preventing intentional destruction of heritage', available online at www.portal.unesco.org/en/ev.php-URL_ID=16454&URL_DO=DO_TOPIC&URL_SECTION= 201.htm (accessed July 2004).

—— (2003) 'Convention for the safeguarding of the intangible cultural heritage', available at www.portal.unesco.org/en/ev.php-URL_ID=17716&URL_DO=DO_TOPIC&URL_SECTION= 201.htm (accessed July 2004).

Zolberg, V.L. (1996) 'Museums as contested sites of remembrance: the Enola Gay affair', in Macdonald, S. and Fyfe, G. (eds), *Theorizing Museums: Representing Identity and Diversity in a Changing World*, Oxford: Blackwell/The Sociological Review.

Heritage/museums/galleries

Background and overview

The debate on heritage reviewed

Robert Lumley

In England, the 'heritage debate' that began to come to the fore from the mid-1980s has left a legacy in Anglo-American literature that has influenced how heritage has been defined and perceived over the past two decades. Although the discourse on academic literature centred on heritage has become more complex, this chapter provides a useful historical context and platform for exploring current issues in heritage studies. It is relevant in that it raises questions about how heritage is defined.

Understanding that the heritage debate in England 'had strong political connotations', the chapter looks at features of the debate under three broad headings. The first of these relates to the origins of the debate at a time of economic and industrial decline, which was accompanied in certain quarters by perceptions of heritage preservation as being primarily an attempt to avoid change by recalling nostalgic and romanticized presentations of the past. As a counter point, the second focuses on heritage as enterprise and a catalyst for change, where it has provided a way forward in economic and regenerative terms. Finally, issues related to heritage as a medium for interpreting, representing and communicating history are considered.

> To be is to have been.
> David Lowenthal

For over a decade now there has been a lively and sometimes bitter debate in England over the question of 'heritage'. It is not an entirely new discussion in that an anxious preoccupation with the nation's past and its material (and spiritual) legacy has acquired a particular salience since the 1960s. A 'transplanted' North American academic noted then a people deeply imbued with historicity:

> English attitudes towards locale seem permeated with antiquarianism – a settled bent in favour of the old or the traditional, even if less useful or beautiful than the new ... all arts and the whole built environment reflect this bias. Delight in continuity and cumulation is integral to English appreciation of *genius loci*, the enduring idiosyncrasies that lend places their precious identity.
>
> (Lowenthal, 1985:xviii)

In the 1970s and 1980s, 'heritage' became a key word in a wider debate about the nation's identity. It stood as a metaphor for the English condition, with some commentators referring to the 'national necropolis' or 'museum society'.

To non-English readers, the very framework of the debate might confirm their image of the 'insularity' of what Winston Churchill called 'this island people'. The imagery used, as well as

the neuroses of a nation coming painfully to terms with its European future after an imperial past, suggests peculiarity. Hopefully, all this will not appear irrelevant. After all, it is but one example of the difficulties of living in an 'old country' in a period of dramatic historical transition. And, as will be shown, concern with 'heritage' is increasingly international in scope and reveals the impact on local cultures of the forces of globalization. The search for authenticity and roots gets more intense the more cultures become placeless.

Heritage undefined

What is 'heritage'? Look it up in the *Shorter Oxford English Dictionary* and you will find the following entry:

1 That which has been or may be inherited.
2 The fact of inheriting; hereditary succession.
3 Anything given or received to be a proper possession.
4 An inherited lot or portion.

It does little to help analyse the phenomenon which this chapter will examine.

A better starting point is a passage from Patrick Cormack's (1976) *Heritage in Danger*. One particular extract is cited by at least four of the main books involved in the heritage debate. I propose, therefore, to quote Cormack first, and then various comments on him.

> When I am asked to define our heritage I do not think in dictionary terms, but instead I reflect on certain sights and sounds. I think of a morning mist on the Tweed at Dryburgh where the magic of Turner and the romance of Scott both come fleetingly to life; a celebration of the Eucharist in a quiet Norfolk Church with the medieval glass filtering the colours, and the noise of the harvesting coming through the open door; or of standing at any time before the Wilton Diptych. Each scene recalls aspects of an indivisible heritage, and is part of the fabric and expression of our civilization.
>
> (Cormack, 1976:14)

> The interpretative stress on the senses, on the experience of meanings which are vitally incommunicable and undefinable may only seem clear as an example of what Hermann Glaser once described as the 'deadening of thought through mysticising vagueness'... a kind of sacrament encountered only in fleeting if well remembered experiences which go without saying to exactly the extent that they are taken for granted by initiates, by true members of the ancestral nation.
>
> (Wright, 1985:81)

> Equally ineffable is the concept of national heritage, normally evoked with sublyrical vagueness ... Those who drafted the National Heritage Act confess they 'could no more define the national heritage than we could define, say, beauty or art ... So we let the national heritage define itself.' That heritage 'includes not only the Tower of London but agricultural vestiges visible only by the aid of aerial photography'.
>
> (Lowenthal, 1985:36–7)

This pastoral, romantic and religiose evocation, not far from a Hovis bread commercial, in fact defines a very specific view of heritage – but we can expect quite different sights and sounds at the Beamish Open Air Museum Geordies' Heritage Day.

(Hewison, 1987:32)

This is heritage at its most pretentiously reverential, drawing on art, religion and rurality in ways unlikely to connect fully with a broad popular response, despite their continuing potency within the codes of narrower (though influential) versions of national identity. Such versions often have strong imperialist assumptions, giving their rhetoric a white racial character which either ignores, or openly rejects, the nature of Britain as a multiracial society.

(Corner and Harvey, 1991:51)

It should be evident from these quotations that the debate about heritage in England has had strong political connotations. The past has been, and continues to be, a vital source of legitimation for both Left and Right. However, the struggle to define heritage has involved a range of actors from museum professionals and academics and critics to amateur collectors, with lobbies and voluntary organizations playing central parts. Political parties have been relatively marginal to the defining process. Moreover, the steady broadening of the concept of heritage to include natural as well as human phenomena, and the increasingly anthropological (as opposed to art historical) definition of culture are long-term developments not reducible to political explanation. In the face of such fundamental cultural changes, it was perhaps wise (tautologically) to 'let the national heritage define itself'.

The 'heritage debate' has had many aspects and a full account would need, above all, to examine its consequences for what has or has not been conserved and preserved. My aim is the more modest one of introducing some of the main features of the debate under three headings: its recent origins in the context of economic decline; the connection between heritage and enterprise; and, lastly, the problem of interpreting history through the idea of heritage.

Heritage and decline

The coupling of the two terms 'heritage' and 'decline' is most explicit in the subtitle of a book which did a great deal to popularize the debate, Robert Hewison's *Heritage Industry*; it reads 'Britain in a Climate of Decline'. For Hewison, heritage entailed the promotion of a culture that is backward-looking rather than future-oriented, fearful of the present and therefore escapist, and incapable of innovation. It focuses on a Britain that is post-imperial and steadily losing out to other countries in the struggle for industrial and commercial competitiveness.

Hewison cites Neil Cossons, then newly appointed Director of the Science Museum and formerly of the pioneering Ironbridge Open Air Museum, as saying: 'There is an anti-industrial, anti-technological feeling which has grown up enormously in the last 20 to 25 years ... We're an industrial nation desperately pretending not to be one' (Hewison, 1987:104). Hewison goes on to refer to the vogue for historical re-enactment as 'evidence of the persistent fantasy that it is possible to step back into the past. Museums and fashion exploit the same nostalgic drive; the most contemporary attitude is a disdain for the present day' (ibid.:83). The tremendous growth in museums and museum visiting, the development of open air museums concentrating on industrial archaeology, the fortunes of the country house conservation lobby, the popularity of Civil War re-enactments, the marketing of Victoriana in modern dress by Laura Ashley – all

these are symptoms of a life-forsaking nostalgia for the 'glorious' past. Because the British (it would be more accurate to say 'English' as all Hewison's examples are drawn from England) are unable to face the present, they turn for consolation to the past.

A commentator, Patrick Wright, whose book, *On Living in an Old Country*, first initiated the wider debate (Wright, 1985), has a more subtle approach, but finds an overarching connection between decline and the contemporary obsession with heritage: 'This sense of history as entropic decline gathers momentum in the sharpening of the British crisis. National heritage is the backward glance which is taken from the edge of a vividly imagined abyss, and it accompanies a sense that history is foreclosed' (Wright, 1985:70). If decline, and anxiety about decline, can be traced to the late nineteenth century (coincidentally, the National Trust was founded in 1895), it grows in strength in the decades following the Second World War. The supremacy of science; the attendant disqualification of everyday forms of knowledge; the rise of bureaucracy and the economics of scale – these are all developments common to industrialized countries. Disenchantment is not, argues Wright, peculiar to Britain, but it has taken a particular form in which historical consciousness has been dominant:

> History becomes, more urgently, the object of ceremonies of resonance and continuity when it seems actively to be threatened and opposed by an inferior present epoch – when, to put this differently, society is developing (or 'receding') in a way that cuts across the grain of traditional forms of security and self-understanding. More strongly still, we turn to the past when the future seems unattainable ... We have in the modern period conceived the future through progressivism philosophies of history. In terms of these philosophies, history is less and less intelligible ... In the [postwar] British experience, the idea of 'progress', linked as it has been to the development of liberal market forces, or, under Labour, to a statist social democracy, has failed to deliver the promised land.
>
> (Wright, 1985:166)

The seminal texts in the debate belong to the mid-1980s, but the theme of heritage as an aspect of a society pathologically obsessed with tradition recurs subsequently (Samuel, 1989). Drawing on psychoanalytic terminology, Kevin Robins uses the concept of 'protective illusion' to analyse the 'prevailing concern with the comforts and continuities of historical tradition and identity' that 'reflects an insular and narcissistic response to the breakdown of Britain' (Robins, 1991:22). The British problem is seen to be about 'recognising the overwhelming anxieties and catastrophic fears that have been born out of empire and the imperial encounter', and coming to terms with 'other cultures, other states, other histories, other peoples'. The alternative is a 'retreat into cultural autism and of a rearguard reinforcement of imperial illusions' (Robins, 1991:22–3). The whole national response to the Falklands/Malvinas war, brilliantly explored by Wright through the media coverage of the raising of one of Henry VIII's warships from the bottom of the Channel (Wright, 1985:161–83), revealed the power of such illusions.

The linking of heritage and decline is seen, therefore, as fundamental to the English case – the result of epochal and structural factors given a sharp twist in the conjuncture of the late 1970s/ early 1980s. A phenomenon that is quintessentially cultural, but simultaneously a matter of economic and psychic health. However, during the debate, the nature of the connections has frequently been asserted rather than closely examined within a framework of causality. Hewison's approach of juxtaposing information on economic decline with facts about the growth of heritage tends to *assume* connections and not demonstrate them. Wright's use of micro case studies provides greater insights into the *experience* of protagonists, but the economic dimension remains nebulous.

Heritage as enterprise: imagineering

The fact that something new was happening provoked the debate on heritage. Even if that 'new' was dressed in old clothing, its novelty was striking. Suddenly, it seemed, England, was being covered with heritage sites. This paradox (and paradox is the rhetorical figure most often employed in the language of commentators) is contained in the very title *Heritage Industry*, two words which, Hewison argues, are in conflict with one another. However, in the early stages of the debate, Hewison and Wright both stressed the heritage-decline couplet, leaving other aspects in the margins.

The idea that the heritage boom was a sign of change and innovation rather than of decline was noted by Peter York as early as 1984. He writes of the Covent Garden development:

> Everybody in Covent Garden, consciously or not, is doing their bit in the *grand tableau* – their contribution to what Walt Disney called 'imagineering' – the professional dreaming up and execution of three-dimensional fantasies. The new Convent Garden is one vast designers' world … It is clearly the newest of a series of new urban theme parks: areas planned, reconstructed, laid on, for total experience.
>
> (York, 1984:47)

Heritage, in this perspective, comes to be seen less an inability to come to terms with change (escapism, nostalgia, etc.) and more as a strategy for enabling change. Heritage also gets reinterpreted as a sign of modernity, rather than as the downside of modernity with its failures and disappointments (Lumley, 1987, 1988).

It is not that industrial decline has not taken place. John Urry refers to the profound sense of loss that accompanied the 'remarkably rapid deindustrialisation' of the early 1980s, especially in Northern England, Scotland and Wales. However, he goes on to show how conditions were created for an economic restructuring in which heritage often played a key role. Local authorities, taking advantage of vacant inner-city premises and the rise of small businesses, tended to lead initiatives in regeneration. A city like Bradford was exemplary in investing in museums and historic sites in an attempt to change its image and attract tourism together with new investment. Similar local ventures have had a knock-on effect, whereas Britain 'within a global division of tourism' has come to 'specialise in holidays that emphasise the historical and the quaint' (Urry, 1991:108).

Note that we are no longer dealing with a phenomenon that is seen as exclusively or pathologically 'British', but with one in which the British case represents a variant of a general development. Tourism, the motor force, is a global industry growing at a vertiginous pace. By 1984, international tourism was the second largest item of world trade. In addition, its internationalization, especially in Europe, means that every tourist site can be compared with those located abroad (Urry, 1991:48). Note also the pioneering role played by the USA with the mall and waterfront development, with ever more frequent references to Disneyland as the model for Europeans and others (ibid.:119–20).

The radical implications of the globalization of the economy for notions of cultural identity is interestingly examined by Kevin Robins. The language of heritage ('heritage-speak') is, of course, shot through with essentialism, with the idea of roots suggesting a deeply physical belonging to a place. Although this can have exclusivist and racial connotations, it does not follow automatically. As Wright insists, a sense of place can also be understood as an attachment to everyday historical consciousness in the face of dislocation and the experience of modernity

(Wright, 1985:86–7). However, heritage is increasingly a construct in a world of rootlessness; as 'the old order of prescription and exclusive places and meaning endowed durations is dissolving', we are faced with 'the challenge of new self-interpretation'. For people living in a region, this can often mean reconstructing a sense of place within a context in which giant corporations, such as Sony, transform a previous situation. Regional identity can grow, while national identity becomes less encompassing: 'in order to position itself in the new global context, the region must re-image and, ultimately, re-imagine itself' (Robins, 1991:39). The North East of England is a case in point. The region's history has had to be reassessed to stress the 'special relationship with Japan' now that over forty Japanese companies are located there. New open-air museums, such as Beamish and Ironbridge, have been important in attempting to re-create identities for whole areas, promoting a local or regional form of patriotism and aiming in the process to make them more attractive to investors. The degree to which the image produced by the image-makers corresponds to the self-image of the inhabitants is more difficult to assess (West, 1988; Bennett, 1988). However, for Robins, this capacity to reinterpret the self is not seen negatively as 'fabrication' or 'false history', but as a form of adaptation. Potentially it entails freeing the (national) self from the burden of a past formed in defence of an essentialist identity designed to exclude 'the other'.

Heritage versus history: a case study

A recent book on tourism has suggested that the very term 'museum' has ceased to be useful in describing the new phenomenon of heritage, even if the label continues to be used:

> It is clear that museums cannot be created about anything anywhere. But a museum on almost any topic can be created somewhere. A lot more museums will emerge in the next few years although whether we should still refer to them as 'museums' stems from a period of high art and auratic culture well before 'heritage' had been invented.
>
> (Urry, 1991:164)

One of the features of postmodernity is said to be the collapse of older cultural hierarchies and the replacement of canons of taste by a spirit of relativity (Perniola, 1990). In this perspective, differences between museums, heritage centres and theme parks cease to be very significant. Ironically perhaps, the insistence of certain populist Marxists that culture should be seen in terms of 'industry' rather than of the authors and artists so central to auratic notions of culture converged with the ideas promoted by the *laissez-faire* school of thinking. Attacked from all sides, the so-called paternalist, elitist model of culture lost its ascendancy.

So far, I have presented a sort of overview of the heritage debate in order to identify its main contours. I want now to look at the heritage phenomenon by examining its manifestation in a particular instance, an example small in itself, but revealing in miniature of attempts to redraw the cultural map. The micro study will open the way for some more general observations. The example in question is a real one and all the documents quoted are genuine, but I shall invent names and alter some details to disguise the identity of the place and people involved.

Oldholm is a small country house in northern England which includes some original medieval parts, but which is largely early nineteenth-century neoclassical. Architecturally it is interesting, but not a landmark. Rather, the fame of the house is due chiefly to the celebrated playwright who lived there and whose name attracts visitors. Oldholm now belongs to the local authority who took it over in 1980. My story begins in 1988 when two members of senior

management from the local authority Arts Department visited the house and wrote a report. That report and the reply to it by the curatorial staff form the basis of this account.

The report contained a number of criticisms and recommendations. The criticisms concerned 'legibility' – the lack of signs and consequent difficulty for visitors to get an overall idea of the house; poor labelling; an excess of objects on display – and the problem that 'the house has an exceptional collection of furniture but lacks the sense of people. The danger is that it may acquire the air of an expensive antique shop'. The uniforms of the attendants, it was said, created a 'barrier'. The major thrust of the criticism, however, was that the presentation as a whole lacked the theatrical touch of the playwright himself.

As for the recommendations, these started with the call for a 'clear concept', and went on to suggest a relevant visitor survey. The stress was very much on dividing the house into different areas, in some of which visitors could sit on replica furniture, giving the house that 'elusive quality of being "lived in"', and on including an 'interpretation centre'. The report also proposed the use of details of everyday life, such as unmade beds, which would draw attention to the famous playwright himself, and the production of audio tapes with sound effects, including 'replicated dialogues and correspondence, plainsong, the roar of boars and howl of wolf-dogs, the sound of unearthly footfalls following the listener'. Whereas the National Trust property of Erdigg (a country house entered by the servants' hall) provided the report with a model for paying greater attention to the humble and daily aspects of history, the Warwick Castle *tableaux*, using wax figures, represented a more accessible approach to the past. In order to help implement such changes, an Education, Interpretation and Events Officer was said to be required.

The curators responded to the assessment report by noting first of all that the assessors had at no point consulted them about their current plans and work-in-progress; i.e. they had parachuted in, making a brief visit based on little knowledge of the house and its history. They claimed that many of the proposals (e.g. concerning labelling) were already under way. Moreover, they rejected the suggestion that there was lack of 'concept': 'a clear concept does exist in the sense that we have a clear idea of why Oldholm is important and of what we are doing, why we are doing it and how it should be done'.

It is evident from the reply that fundamental differences divided the curators from the assessors. Some of these can be grouped under the heading of 'work-place knowledge' and professionalism, and primarily concern the practicability of the report's recommendations. But more is at stake. There is a conflict over their very desirability. At one level there is know-how: 'Do the assessors know what they mean by replica furniture and what it would cost?' 'Do they realise the difficulties in supervising differentiated areas of access?' 'Do they have any ideas of the costs of *tableaux* which Warwick Castle can afford to use because of its ownership by Madame Tussaud's?' Again and again, the assessors reveal their ignorance of crucial technicalities. They come, moreover, with preconceptions derived from the latest fashion for market research, multimedia events or displays and for showing the social history of under-or un-represented groups (such as domestic servants). These interests are, of course, entirely valid. The problem in this instance is that the assessors start by ignoring or failing to value, and hence fail to connect with, the very considerable experience, knowledge and commitment of curators who are in daily contact with the house and its visitors.

The difference in terms of presentational strategies is dramatic. Take the proposals for *tableaux* and for sound effects: 'The introduction of *tableaux* would be obtrusive and most inappropriate. Oldholm is a reality and its effective presentation demands only the most subtle forms of illusion'. 'A theatrical approach does have a place, especially given the playwright's

eccentric use of the house and work habits … these can be suggested using props in his study for example, but the theatrical approach must be backed up by sound research. It should entertain but never mislead or misinform'. 'We are sceptical about the use of sound effects and if incorporated they would need to be very carefully selected and well researched.' It is tartly pointed out, for instance, that a recording of singing in the plunge-bath might be rather anachronistic as there would only have been cold water in it! The curators observe twice that the intelligence of the public should not be underestimated and they note the interest in the restoration of the library: 'Visitors are fascinated by the detective work.' The report's conclusion is unqualified: 'If Oldholm were to be developed along certain of the lines suggested by the assessors, its character would not only be trivialised but destroyed.'

The 'concept' (or should one say 'theme') of the assessors is clearly not shared by the curators. The clash between them can be explained in a number of ways. There is a difference of work culture; the assessors are an Exhibitions Officer and an Education Officer who are not tied to any particular historical site and who work from the offices who are not tied to any particular historical site and who work from the offices of the local authority; the fact that the exchange took place in 1998 is important to bear in mind. Local authorities, under pressure from central government, were then showing a new interest in the management and exploitation of their resources, including cultural ones, and a new breed of professionals (notable in marketing, advertising, public relations and design) was emerging in the public as well as the private sector. The language of reports, such as the one referred to here (and the sheer number of them) reflects the impact of economic and management terminology, with its 'concepts' and 'corporate planned approach'. Furthermore, the idea of heritage as enterprise and as the means of regenerating areas, of attracting tourism and putting places on the map, was being actively promoted by local authorities.

However, the clash has a wider cultural dimension. On the one hand, there are the assessors who adopt a new brand of heritage centre approach. They stress the importance of entertainment, accessibility and the use of *mise en scène* designed to make history visible and audible. They want to play on the public's fascination with the private life of great men, simultaneously provoking awe and deconsecrating the act of worship. For them, it does not matter so much whether reconstructions are historically accurate in every detail: the problem of immediate visitor enjoyment and identification is paramount. On the other hand, the curators belong to an older tradition associated with the work of the National Trust, in which the organic unity of the house and its preservation for future generations are cardinal concerns. They insist on the 'appropriateness' of the relationships between object, context and display – an appropriateness guaranteed by the historical truth provided by scholarly research. The authenticity of the house and its contents furnish the unique experience to which visitors accede through guidance, but also through intellectual effort.

Many of these issues of interpretation will be familiar to readers who work in the museum sector. They have been at the centre of debate for some time. In Britain, at least one director of a national museum has provoked controversy by speaking of the need to learn from Disneyland. In this context, I want just to conclude by linking the issues more closely with the whole heritage debate. In this sense, the Oldholm example is useful in illustrating a number of key points: the multifaceted and internally divided features of the heritage phenomenon; the increasingly conscious orientation towards the public; and, lastly, the intellectual questions posed by how to represent 'history'.

History and myth

Robert Hewison's *The Heritage Industry* (Hewison, 1987) had presented heritage as a mono-lithic phenomenon in which diverse manifestations from museums and the National Trust to fashion revivalism were said to be engaged equally in producing 'bogus history'. Likewise, Hewison seemed to assume that the public was a credulous mass, easily seduced by the sirens of nostalgia. However, this analysis, even though of polemical value, reproduced a Frankfurt School conception of mass culture incapable of grasping the complexities of the situation. Critics of Hewison have drawn attention to the differences within the so-called 'heritage industry' and to the need to make assessments and judgements accordingly. Patrick Wright, for instance, contrasts the work of the National Trust with the historical speculation of prop-erty developers engaged in 'imagineering' and underlines the democratic impulses in the museum world:

> If you look at the open air museums, you are looking at people whose intention is extremely worthy. It is democratic, connected with adult education, about reaching new constituencies, giving people a way of thinking about what had been the domain of exclusive professions.
>
> (Wright, 1989:52)

He also provides an appreciation of latterday antiquarians, such as the much maligned metal detectorists, busy reinventing cabinets of curiosities at a time when museums have been banishing aura and magic from their collections in the name of science and education (Wright, 1991:139–51). Clearly, heritage cannot be adequately understood as the product of museum professionals and businessmen when it is defined and redefined 'from below' as well as 'from above'. It is better analysed as a field in which competing groups and interests seek to establish or undermine orthodoxies (Bourdieu, 1980).

The second question – the relationship between visitors and heritage – has witnessed an equivalent critique of Hewison's earlier formulations. Whereas he identified the new promo-tional strategies at work, he failed to allow visitors the independence of perception and judge-ment, which he evidently found in himself. More recent contributions to the heritage debate have suggested that audience research should be the starting point for proper enquiry. How else, it is asked, can one know what effect is being achieved? As Adrian Mellor observes of the Albert Dock in Liverpool, some of the questions that might be asked concern the social groups who visit and their relationship to their localities:

> Why are there so few black people, or people by themselves? Is dock visiting more of a middle class or working class pursuit? Is it perhaps that people now have to seek through communal visiting the neighborliness they feel they have lost from their real communities?
>
> (Mellor, 1991:114–15)

Museum curators themselves have shown a much greater interest in how visitors perceive displays in the wake of the concern with the 'consumer' generated by the new heritage sites. A particularly insightful comment comes from an assistant keeper at the Victoria and Albert Museum in London who notes the importance of ambience as opposed to individual displays:

> Since all the surveys of the patterns of museum visiting demonstrate that visitors spend extremely little time inspecting any of the contents, except in the museum shop, it is arguable that the overall environment is of greater importance than what is actually displayed. This is not as straightforward an issue as curators are likely to think. I certainly do not visit botanical gardens, which I like and enjoy, for the plants on display, in which I have little interest.
>
> (Saumarez-Smith, 1989:18)

In this perspective, the public ceases to be divided into the discerning few and the ignorant many, and is seen as complex and differentiated, requiring subtle and carefully calibrated strategies in order to have its attention engaged.

Finally, the heritage phenomenon has put questions of historical representation firmly on the agenda. The desire to 'show' history by making the past into an experience was the key ingredient in the new generation of museums, such as the Jorvik Viking Centre in York and the Beamish Open Air Museum. History had to be brought to life in 3-D and to include the everyday life of people, whether ordinary or great. The desire to create this illusion has had remarkable influence, gaining ground outside the new museums and penetrating places such as our Oldholm. The visitor-centred approach has reinforced this tendency, while the discrediting of a positivist conception of history has opened the door to a relativism, according to which, fact, like beauty, is in the eye of the beholder.

This experiential notion of history comes in for some fierce criticism from those few academic historians who have engaged with the issue. An excellent critique of museum practice, referring especially to the Jorvik Viking Centre in York and the London Museum of Childhood, is worth quoting:

> There is a theory of history implicit in such claims [to provide a simulacrum of the past], and it hinges on our ability to use objects as means of entering into and living vicariously in a past time. Visitors are required to assent to the historical authenticity and reality of what they have seen, while they simultaneously recognize its artificial, fabricated nature … an exact facsimile is technically impossible, and many aspects of life cannot be conveyed through looking, smelling and listening – work, hunger, disease, war, death are obvious examples. We understand the past, not by spuriously re-experiencing it, but by turning over many different kinds of evidence relating to it and by generating from this an understanding which inevitably has a strong intellectual, that is, abstract component. What is present, like that which is omitted, is not accidental, even if the selection processes are largely unconscious. It is precisely in this way that historical myths are constructed – myths that express powerful, if silent needs.
>
> (Jordanova, 1989:25–6)

Visit an English country house and you are unlikely to be confronted with previous ravages of hunger, work and war. Rather, the past is liable to be a 'place of rest, certainty, reconciliation, a place of tranquillized sleep' (Bennett, 1988:70). Visit a museum of rural life and you are most likely to learn about the workings of a plough than about those of the laws that governed life in the country. Jordanova's critique can be illustrated with innumerable examples. However, the hold that myths exercise on the imagination is such that they are frequently resistant to rationalist critique. The 'invention of tradition' has been related to the demise of liberal rationalist ideologies in the nineteenth century (Hobsbawm and Ranger, 1984:8), and we should by now

have acquired a considerable respect for the power of myths. The problem for those who pit themselves against the facile forms assumed by history in the guise of heritage is not just to expose falsehoods, but to find a way to present a different history that is communicable to a wider public. Historical truths left in abstract form remain within the limited domain of the profession. The possibilities in the English case for reinventing heritage present particularly severe difficulties, as should now be apparent. A sense of national identity is at stake. However, there are many who work in museums and other cultural institutions associated with heritage for whom a less narrow and insular conception of the constructed rather than natural character of heritage can help to loosen the grip of myth. For all its inadequacies, the heritage debate may have contributed to this process.

References

Bennett, T. (1988) 'Museums and "the people"' in Lumley, R. (ed.), *The Museum Time Machine*, London: Comedia/Routledge.

Bourdieu, P. (1980) 'The symbolic production of belief: a contribution to an economy of symbolic goods', *Media, Culture and Society*, 2, 225–54.

Cormack, P. (1976) *Heritage in Danger*, London: New English Library.

Corner, J. and Harvey, S. (1987) *Enterprise and Heritage*, London: Routledge.

Hewison, R. (1987) *The Heritage Industry*, London: Methuen.

Hobsbawm, E. and Ranger, T. (eds) (1984) *The Invention of Tradition*, Cambridge: Cambridge University Press.

Jordanova, L. (1989) 'Objects of knowledge: a historical perspective on museums', in Vergo, P. (ed.), *The New Museology*, London: Reaktion.

Lowenthal, D. (1985) *The Past is a Foreign Country*, Cambridge: Cambridge University Press.

Lumley, R. (1987) 'Museums in a postmodern world', *Museums Journal*, 87(2), 81–3.

—— (ed.) (1988) *The Museum Time-Machine*, London: Comedia/Routledge.

Mellor, A. (1991) 'Enterprise and heritage in the dock', in Corner, J. and Harvey, S. (eds), *Enterprise and Heritage*, London: Routledge.

Perniola, M. (1990) *Enigmi*, Genoa: Costa e Nolan.

Robins, K. (1991) 'Tradition and translation: national culture in its global context', in Corner, J. and Harvey, S. (eds), *Enterprise and Heritage*, London: Routledge.

Samuel, R. (ed.) (1989) *Patriotism: The Making and Unmaking of British National Identity*, London: Routledge.

Samaurez-Smith, C. (1989) 'Museums, artifacts and meanings', in Vergo, P. (ed.), *The New Museology*, London: Reaktion.

Urry, J. (1991) *The Tourist Gaze*, London, Sage.

West, B. (1988) 'The making of the national working past', in Lumley, R. (ed.), *The Museum Time-Machine*, London: Comedia/Routledge.

Wright, P. (1985) *On Living in an Old Country*, London: Verso.

—— (1989) 'Sneering at the theme parks', *Block*, Spring, 48–53.

—— (1991) *A Journey through Ruins*, London: Radius.

York, P. (1984) *Modern Times*, London: Heinemann.

3

The uses and abuses of heritage

Brian Graham, Gregory John Ashworth and John E. Tunbridge

> Heritage is a resource as well as a product. This chapter considers the origins of heritage as defined by using the past as a resource for the present. It shows how this way of thinking about the past emerged at the same time as the codification of nationalism into the nation-state. Second, it begins an explanation of the functions and uses of heritage, which can be subdivided between the cultural – or socio-political – and the economic. Finally, in examining the issue of 'whose heritage?', it begins to consider the reasons for the contested nature of heritage.

The origins of heritage

Heritage, or a concern for the past, emerged from the raft of ideas and ideologies, which loosely constitute what we have come to know as modernity. The 'modern' is usually divided into the early modern of the sixteenth and seventeenth centuries, the modern eighteenth and nineteenth centuries, and the (post)modern twentieth century. The modern era, as traditionally defined, often necessarily reflects a Eurocentric perspective on the world. The European eighteenth and nineteenth centuries are seen as being the apogee of modernism as the secular culture conceived in the Renaissance ultimately evolved into the eighteenth-century Enlightenment, the Age of Reason with its belief in an individual's ability to think and act for himself. The concept of the European territorial state was shaped within such a mindset, the French Revolution being a defining catalyst in this process. Like the Renaissance before it, we can see the Enlightenment being framed by its particular rendition of the past, one in which the values and traditions of European Christianity were depicted as the principal reactionary forces in European society. In turn, the modern era is defined by the emergence of the 'one-out-of-many' meta-narrative of nationalism as 'the ideology of belongingness' (Hall, 1995:185) and principal force of legitimation in the processes of state formation. For Woolf (1996:25–6):

> National identity is an abstract concept that sums up the collective expression of a subjective, individual sense of belonging to a sociopolitical unit: the nation state. Nationalist rhetoric assumes not only that individuals form part of a nation (through language, blood, choice, residence, or some other criterion), but that they identify with the territorial unit of the nation state.

Hobsbawm (1990), for example, regards nationalism as pre-eminently the product of triumphant bourgeois liberalism in the period *c.* 1830–80, although other commentators place its origins rather earlier. Colley (1992) locates the making of a Britishness vested in recurrent Protestant wars, commercial success and imperial conquest to the eighteenth century, while Hastings (1997) argues for an even earlier medieval origin of both nationalism and nations. Although it is often argued that nationalism received its biggest boost from the French Revolution, its crystallization as the driving social and political force of nineteenth- and early

twentieth-century Europe stems from a succession of previous 'revolutions' that transformed societies in Europe – and North America – between the sixteenth and eighteenth centuries. In parts of Europe, the cumulative effect was to replace the medieval power structures of church and nobility with a recognizably capitalist and secular élite. Nevertheless, as Davies (1996:821) argues, irrespective of the precise relationship between nationalism and modernization, 'it is indisputable that the modernizing process expanded the role of nationalism beyond all previous limits'.

In this conceptualization of a political state that is also the homeland of a single, homogeneous people, heritage is a primary instrument in the 'discovery' or creation and subsequent nurturing of a national identity. Nationalism, and a representation of the past designated as 'national heritage', developed synchronously as the 'nation' was asserted over communities defined by other spatial scales or social relationships. The nation-state required national heritage for a variety of reasons. It supported the consolidation of this national identification, while absorbing or neutralizing potentially competing heritages of social-cultural groups or regions. Again, a national heritage helped combat the claims of other nations upon the nation's territory or people, while furthering claims upon nationals in territories elsewhere. Small wonder then that the fostering of national heritage has long been a major responsibility of governments and that the provision of many aspects of heritage has become in most countries a near-monopoly of national governments (Graham *et al.*, 2000a; Graham *et al.*, 2000b).

In turn, the Age of Reason spawned its antithesis in a nineteenth-century Romanticism, that emphasized the irrational and the deification of nature. Familiar in literature from the works of a panoply of writers and poets, including Goethe, Shelley and Wordsworth, these ideas informed the work of the 'prophets of wilderness' as Schama (1995:7) calls the nineteenth-century founding fathers of modern environmentalism. Among others, Henry David Thoreau, George Perkins Marsh and John Muir were responsible for the representation of the American West as a 'wilderness ... awaiting discovery ... an antidote for the poisons of industrial society'. Schama (1995:61) argues, however, that:

> [l]andscapes are culture before they are nature; constructs of the imagination projected onto wood and water and rock ... But it should also be acknowledged that once a certain idea of landscape, a myth, a vision, establishes itself in an actual place, it has a peculiar way of muddling categories, of making metaphors more real than their referents; of becoming, in fact, part of the scenery.

Indeed, that idea of landscape became institutionalized in the later nineteenth century through the creation of the US national parks. The first, the 'strange unearthly topography' of the Yosemite Valley, was established by an Act of Congress in 1864, testimony, as Schama (1995:7) observes, that the 'wilderness ... does not locate itself, does not name itself'. National parks were originally identified with natural environmental heritage and commonly promoted or paralleled the development of a system of national historic parks or sites to conserve places of cultural significance. It became apparent early on, however, that the two realms could not be separated satisfactorily. Thus national park agencies in the wider world of European settlement have been instrumental in the creation of cultural heritage, not least through establishing the hegemony of Eurocentric imagings of place at the expense, for example, of the landscape representations particular to the cultures of the indigenous peoples.

Equally, it is salutary to remember that the desire to preserve large parts of the existing built environment is both recent and historically aberrant. While it is possible to cite odd cases from

settlement history of the deliberate preservation of particular buildings – usually for symbolic reasons – these remain exceptions to the general trend that what we now possess has survived through chance, neglect and lack of motive to redevelop, rather than the deliberate act of preservation, an idea that dates only to the late eighteenth and nineteenth centuries. Religious buildings are something of an exception to this generalization as they were commonly continuously maintained, if not actually self-consciously preserved, as we would understand that term. In terms of the cultural past, the Romantic concomitant to wilderness was a renewed fascination with the medieval world, which had been marginalized both by Renaissance and Enlightenment thinkers. Although 'Gothic' was used in the eighteenth century to denote the barbarous and uncouth, it has since become synonymous with the architecture of Northern Europe's great medieval cathedrals, which were one of the cardinal enthusiasms of the Romantics who conflated a hatred of industrial civilization with a vision of a rationalist and even ideal Middle Ages. John Ruskin's minutely detailed descriptions of the cathedrals at Rouen, Amiens and Bourges were among the principal inspirations of Marcel Proust's rendering of the past, recreated through memory in *A la Recherche du Temps Perdue*. Besides Ruskin, the key figures – largely anti-modernist Romantics – included A. W. N. Pugin and William Morris in Britain, together with the Frenchmen, Eugène Viollet-le-Duc and Prosper Mérimée.

Thus the will to conserve was the obsession of a passionate, educated and generally influential minority and the social, educational and political characteristics of heritage producers have changed little since the nineteenth century. The initiative for the identification and conservation of heritage was by no means always governmental, but was frequently triggered by the concerns of private citizens for the protection of a past legacy perceived to be disappearing under the weight of nineteenth-century urbanization and industrialization. In some major cases the initiative began and remained with voluntary organizations, which succeeded in winning governmental favour and the necessary legislative protection for their activities. Among these, by far the most successful and best known are the British National Trusts, founded in 1895 (England, Wales and Northern Ireland) and 1931 (Scotland), which in conserving natural and cultural heritage have become the biggest private landowners, pillars of national culture in their own right and increasingly potent agents of geographical change (Tunbridge, 1981).

In the nineteenth century, the idea that some buildings and even cityscapes should not be replaced when physical or functional obsolescence dictated was thus a novel one. Rather, because they contained transferable values, whether architectural/aesthetic, social or moral, particular buildings and townscapes should be preserved (and even 'restored') back to some previous condition (Ashworth, 1998). Then as now, the extent of restoration permitted and the definition of 'true' values was the subject of bitter debate and controversy. Hewison (1987) defines preservation as the maintenance of an object, building or landscape in a condition defined by its historic context and in such a way that it can be studied with a view to revealing its original meaning. In so far as it is possible to achieve such an aim, which invokes notions of an objective and value-free history, the careful preservation of archeological sites or monuments provides the best example. The only rebuilding done is that necessary to preserve the stability of the structure – which may well be a ruin. In contrast, conservation may involve preservation but also restoration of the physical fabric. Much European heritage of apparently medieval origin owes its present appearance to nineteenth-century tastes in restoration.

To paraphrase Ruskin, however, every instance of restoration must lie in the sense that authenticity is unattainable, all heritage being created in and by the present. Extensively restored during the nineteenth century, the contemporary appearance of the *cité* of Carcassonne in south-west France, often described as among Europe's finest medieval towns, owes more to

the energetic Viollet-le-Duc's imaging of the Middle Ages than to any 'reality' grounded in academic study of medieval urbanization. As Henry James somewhat pretentiously observed of the *cité*, while entirely missing the point:

> One vivid challenge, at any rate, it flings down before you; it calls upon you to make up your mind on the subject of restoration. For myself, I have no hesitation; I prefer in every case the ruined, however ruined, to the reconstructed, however splendid. What is left is more precious than what is added: the one is history, the other is fiction; and I like the former the better of the two – it is so much more romantic.
>
> (James, 1884:144)

None the less, the search for authenticity and spirituality took the artist, Paul Gaugin, for example, first to the margins of Europe at Pont-Aven in Brittany, and then to Tahiti. In his evocation of the West of Ireland, the poet, W.B. Yeats, is perhaps, 'the supreme example of an artist setting out to construct a deliberate, symbolic landscape allegory of identity, impressing himself on a landscape like a "phase of history"' (cited in Duffy, 1997:66). The celebration of the romantic was paralleled by the processes through which cultures of non-European people were appropriated:

> So called 'pre-modern' non-European cultures were both desired and denigrated as 'primitive'. European discourses of gender and the 'primitive' were intermeshed in complex ways, gender on the one hand, structuring these asymmetrical power relations and imaginative geographies of primitivism, and on the other deployed to reinforce European superiority. European discourses of modern and gendered domesticity were central to the ways in which Europeans defined themselves as 'modern' in contrast to the 'primitivism' of non-European people, and set the privatized, patriarchal, bourgeois nuclear family and culturally specific concepts of reason, individual freedom, citizenship and the nation state as global registers of modernity, and narratives of 'progress' as a universal target of development.
>
> (Nash, 1999:22)

In sum, nineteenth-century conceptualizations of heritage emerged in the ethos of a singular and totalized modernity, in which it was assumed that to be modern was to be European, and that to be European or to espouse European values (even in the USA) was to be at the pinnacle of cultural achievement and social evolution. The acquisition of the adjective, 'modern', for itself by Europe was an integral part of imperialism and the pinnacle of heritage was to become the European metropolitan core of the imperial empires.

The functions and uses of heritage

If its origins lie in the tastes and values of a nineteenth-century educated élite, the wider conceptualization of heritage raises many of the same issues that attend the debate on the role of the past and the meaning of place. To reiterate, heritage is that part of the past which we select in the present of contemporary purposes, be they economic, cultural, political or social. The worth attributed to these artefacts rests less in their intrinsic merit than in a complex array of contemporary values, demands and even moralities. As such, heritage can be visualized as a resource but simultaneously, several times so. Clearly, it is an economic resource, one exploited everywhere as a primary component of strategies to promote tourism, economic development and rural and

urban regeneration. But heritage also helps define the meanings of culture and power and is a political resource; and it thus possesses a crucial socio-political function. Consequently, it is accompanied by an often bewildering array of identifications and potential conflicts, not least when heritage places and objects are involved in issues of legitimization of power structures.

The social and political uses of heritage

Heritage is a knowledge, a cultural product and a political resource. In Livingstone's terms (1992), the nature of such knowledge is always negotiated, set as it is within specific social and intellectual circumstances. Thus our concern is partly with questions such as why a particular interpretation of heritage is promoted, whose interests are advanced or retarded, and in what kind of *milieu* was it conceived and communicated. If heritage knowledge is situated in partic-ular social and intellectual circumstances, it is time-specific and thus its meaning(s) can be altered as texts are re-read in changing times, circumstances and constructs of place and scale. Consequently, it is inevitable that such knowledges are also fields of contestation.

As Lowenthal (1985, 1996) has argued, this suggests that the past in general, and its inter-pretation as history or heritage in particular, confers social benefits as well as costs. He notes four traits of the past (which can be taken as synonymous with heritage in this respect) as helping make it beneficial to a people. First, its antiquity conveys the respect and status of antecedence, but, more important perhaps, underpins the idea of continuity and its essentially modernist ethos of progressive, evolutionary social development. Second, societies create emblematic land-scapes in which certain artefacts acquire cultural status, because they fulfill the need to connect the present to the past in an unbroken trajectory. Third, the past provides a sense of termination in the sense that what happened in it has ended, while, finally, it offers a sequence, allowing us to locate our lives in what we see as a continuity of events.

Although Lowenthal's analysis is couched largely in social terms and pays little attention to the past as an economic resource, it is helpful in identifying the cultural – or more specifically socio-political – functions and uses of heritage. Building on these traits, which can help make the past beneficial to people, Lowenthal sees it as providing familiarity and guidance, enrich-ment and escape, but, more potently perhaps in the context of this book's discussion, we can concentrate on the functions of validation (or legitimation) and identity. The latter can be visu-alized as a multi-faceted phenomenon that embraces a range of human attributes, including language, religion, ethnicity, nationalism and shared interpretations of the past (Guibernau, 1996), and constructs these into discourses of inclusion and exclusion – who qualifies and who does not. This form of definition refers therefore to the processes, categories and knowledges through which communities are defined as such, and the ways in which they are rendered specific and differentiated (Donald and Rattansi, 1992). Central to the entire concept of identity is the idea of the Other, groups – both internal and external to a state – with competing, and often conflicting, beliefs, values and aspirations. The attributes of Otherness are thus funda-mental to representations of identity, which are constructed in counter-distinction to them. As Douglas (1997:151–2) argues:

> The function of identity lies in providing the basis for making choices and facilitating rela-tionships with others while positively reinforcing these choices ... In emphasizing same-ness, group membership provides the basis for supportive social interaction, coherence and consensus. As identity is expressed and experienced through communal membership, awareness will develop of the Other ... Recognition of Otherness will help reinforce self-

identity, but may also lead to distrust, avoidance, exclusion and distancing from groups so-defined.

According to Lowenthal, the past validates the present by conveying an idea of timeless values and unbroken lineages and through restoring lost or subverted values. Thus, for example, there are archetypal national landscapes, which draw heavily on geographical imagery, memory and myth (Gruffudd, 1995). Continuously being transformed, these encapsulate distinct home places of 'imagined communities' (Anderson, 1991; see Chapter 2), comprising people who are bound by cultural – and more explicitly political – networks, all set within a territorial frame-work that is defined through whichever traditions are currently acceptable, as much as by its geographical boundary. Such national traditions are narratives that are invented and imposed on space, their legitimacy couched in terms of their relationship to particular representations of the past.

Implicit within such ideas is the sense of belonging to place that is fundamental to identity, itself a heavily contested concept and a theme pursued here in subsequent chapters. Lowenthal sees the past as being integral both to individual and communal representations of identity and its connotations of providing human existence with meaning, purpose and value. Such is the importance of this process that a people cut off from their past through migration or even by its destruction – deliberate or accidental – in war, often recreate it, or even 'recreate' what could or should have been there but never actually was. European cities, for instance, contain numerous examples of painstakingly reconstructed buildings that replace earlier urban fabric destroyed in the Second World War (Ashworth, 1991a).

Inevitably, therefore, the past as rendered through heritage also promotes the burdens of history, the atrocities, errors and crimes of the past, which are called upon to legitimate the atrocities of the present. Indeed, as we explore later in the book, atrocity can become heritage. Lowenthal also comments that the past can be a burden in the sense that it often involves a dispiriting and negative rejection of the present. Thus the past can constrain the present, one of the persistent themes of the heritage debate being the role of the degenerative representations of nostalgic pastiche, and their intimations of a bucolic and somehow better past that so often characterize the commercial heritage industry.

The economic uses of heritage

As Sack (1992) states, heritage places are places of consumption and are arranged and managed to encourage consumption; such consumption can create places, but is also place altering. 'Landscapes of consumption ... tend to consume their own contexts', not least because of the 'homogenizing effect on places and cultures', of tourism (Sack, 1992: 158–9). Moreover, preservation and restoration freezes artefacts in time whereas previously they had been constantly changing. Heritage – variously defined – is the most important single resource for international tourism. That market is highly segmented, but although heritage will be consumed at different levels by different types of tourist, that consumption is generally superficial for culture is rapidly consumed. Tourism is an industry with substantial externalities in that its costs are visited upon those who are not involved in tourism consumption. The same also applies to the transport industries upon which tourism depends. Thus tourism is parasitic upon culture, to which it may contribute nothing. If taken to the extreme, the economic commodification of the past will so trivialize it that arguably it can result in the destruction of the heritage resource which is its *raison d'être*. Thus major European heritage sites such as the Norman monastery of Mont St

Michel or Carcassonne may be seen simultaneously by different observers as either successful and profitable providers of satisfying heritage experiences, or little more than stage-sets for mock medieval displays and inappropriate economic exchange, infested with tawdry souvenir shops and cafés. Around them are arrayed the car parks that compound their trivialization.

Tourism producers operate both in the public and private sectors. They may be development agencies charged with regional regeneration and employment creation, or they can be private sector firms concerned almost entirely with their own profit margins. Whichever, tourism producers impose what may well be relatively unconstrained costs on heritage resources. In turn, the relationship between costs and benefits is very indirect. It may well be that the capital from tourism flows back to heritage resources only indirectly (if at all). It follows, therefore, that heritage tourism planning and management has enthusiastically embraced the idea of sustainable development. Notoriously difficult to define, this concept is usually operationalized through concepts such as parsimony and reuse of resource inputs, output equities, intergenerational equities, environmental or perceptual carrying capacity, and the internalizing of negative externalities (Graham *et al.*, 2000a, b). In sum, sustainability requires that contemporary development must address the demands of the present without compromising the ability of future generations to meet their own requirements.

If heritage is regarded as a resource, sustainability in this context has three basic conditions. First the rates of use of renewable heritage resources must not exceed their rates of generation: in one sense, all heritage resources are renewable because they can be continuously reinterpreted. Their physical fabric, however, is a finite resource, one factor promoting the immense widening of what might be called the heritage portfolio. Second, the rates of use of non-renewable physical heritage resources should not exceed the rate at which sustainable renewable substitutes are developed (for example, the substitution of irreplaceable sites or artefacts with replicas). Finally, the rates of pollution emission associated with heritage tourism should not exceed the assimilative capacity of the environment. Heritage management is thus implicated in the belated recognition that the growth in personal mobility in the western world cannot be sustained indefinitely. Nevertheless, sustainability remains an exceptionally difficult issue, and not only because of the inherent vagueness of the concept. It is about values and rights over resources, the primacy of the economic over the cultural (and vice-versa), public and private and, finally, about individual profit and communal rights.

The duality of heritage

To summarize, heritage can be visualized as a duality – a resource of economic and cultural capital. This is less a dialectic than a continuous tension, these broad domains generally being in conflict with each other. To put it succinctly, heritage can be visualized as a commodity, moreover one that is simultaneously multi-sold in many segmented market places. The relics and events of the past are thus raw materials which are commodified for contemporary consumption (Ashworth, 1991b). The two heritage domains are linked by their shared dependence on the conservation of past artefacts and the meanings with which these are endowed; it is the latter which generally constitute the broad arena of contestation. Within both domains, however, we can detect both 'high' and 'low' constructions of heritage, a dichotomy which enriches and complicates the extent of contestation. The economic commodification of heritage embraces, on one hand, the consumption of culture through art and museums and the largely élitist landscapes protected by agencies such as the United Kingdom's several National Trusts – theatres for the re-enactment of the past in Hewison's terms (1987) – and, on the other, commercial

theme-park heritage, largely a pastiche with no higher purpose than popular entertainment. 'High' heritage, in contrast, is generally accorded an educational role in addition to its function as superior entertainment. The cultural commodification of heritage embraces state-sponsored allegories of identity expressed through an iconography that is congruent with processes of legitimation of structures of power, but also more localized renditions of identity, which in their appeal to the popular and resistance to the centre, may be subversive of state power. Tension and conflict are thus inherent qualities of heritage, whatever its form.

Contestation: whose heritage?

The axes of contestation

It is quite inevitable given this range of different uses of heritage, and its importance to so many people for such different reasons, that it has emerged as a major arena of conflict and contestation. In the first instance, the primary contestation lies within heritage itself because of these distinct and often incompatible uses. Heritage is multi-sold and multi-consumed. Urry (1990, 1995) points to the exceptional levels of contestation that result when socially or politically invoked memories, embedded in place, are consumed as tourism commodities. Brett (1996) concurs, regarding heritage as part of the entire cultural logic of late capitalism (post-Fordism), which demands the commodification of everything. Drawing on Baudrillard, he argues that the subsequent piling of representation upon representation could preclude the rediscovery of any absolute level of the real, which, in turn, also renders illusion impossible. Culture disintegrates into pure image without referent, content, or effects, creating a mental landscape in which everything is pastiche (Urry, 1995), and combined with its resonances of nostalgia, one that is inimical to the modernist belief in the future. In essence, however, there are élitist connotations to this argument, which depends on the assumption that people are unthinking dupes when interacting with tourism commodities. Consequently, Brett argues that trivialization of heritage is not necessarily the issue. Instead, we must view some heritage, at least, as a contemporary form of popular culture, which should offer representations that are 'based on a sense of self and community that is neither contrived or shallow' (Brett, 1996:35). (Much heritage, of course, is distinctly unpopular.) Whatever, the point here concerns the tourism commodification of heritage, and the wide range of potential conflicts that emanate from the commercialization of what can be sacred objects. The tensions arising from the multi-selling and multi-consumption of heritage form a recurring theme that emerges at almost every stage of the arguments in this book. As discussed below, it has been conceptualized largely through the notion of dissonance, the discordance or lack of agreement and consistency as to the meaning of heritage (Tunbridge and Ashworth, 1996).

Second, as Cosgrove (1993) argues, the cultural realm involves all those conscious and unconscious processes whereby people dwell in nature, give meaning to their lives and communicate that meaning to themselves, each other and to outsiders. Thus culture is signification and Cosgrove believes that there is no way out of the hermeneutic circle of signification and interpretation; consequently, 'cultures cannot be seen as uniform but rather are constantly reproduced and contested' (1993:6), not least in the realm of social power. Control of the media of representation – of which heritage is one – is vital in determining the trajectory of such contestation in which cultural hegemony is the goal. Albeit historically transient, this can be defined as the attempt by a powerful social group to determine the limits of meaning for everyone else by universalizing its own cultural truths. Reality is rarely so simple, however, as

one dominant élite imposing its values on a subordinate group through heritage. There are usually many ideas communicated with varying success to others who may, or equally may not, receive the messages as intended.

Heritage dissonance

The most sustained attempt to conceptualize this contestation of heritage and its repercussions is to be found in Tunbridge and Ashworth's examination of what they term dissonance (1996). To reiterate, this condition refers to the discordance or lack of agreement and consistency as to the meaning of heritage. For two sets of reasons, this appears to be intrinsic to the very nature of heritage and should not be regarded as an unforeseen or unfortunate by-product. First, dissonance is implicit in the market segmentation attending heritage – essentially place products which are multi-sold and multi-interpreted by tourist and 'domestic' consumers alike; that landscapes of tourism consumption are simultaneously people's scared places is one of the principal causes of heritage contestation on a global scale. Second, dissonance arises because of the zero-sum characteristics of heritage, all of which belongs to someone and logically, therefore, not to someone else. The creation of any heritage actively or potentially disinherits or excludes those who do not subscribe to, or are embraced within, the terms of meaning defining that heritage. This quality of heritage is exacerbated because it is often implicated in the same zero-sum definitions of power and territoriality that attend the nation-state and its allegories of exclusivity. In this sense, dissonance can be regarded as destructive, but, paradoxically, it is also a condition of the construction of pluralist, multicultural societies based on inclusiveness and variable-sum conceptualizations of power. Whether through indifferences, acceptance of difference or, preferably, mutuality (or parity) of esteem, dissonance can be turned round in constructive imaginings of identity that depend on the very lack of consistency embodied in the term.

The intrinsic dissonance of heritage, accentuated by its expanding meanings and uses and by the fundamentally more complex constructions of identity in the modern world, is the primary cause of its contestation. Because of its ubiquity, heritage cannot be examined without addressing the implied questions – who decides what is heritage, and whose heritage is it? More simply put, can the past be 'owned' and, if so, who 'owns' it, what do we mean by 'own', and who reconciles conflicting claims to such ownership? These issues constitute yet another theme that permeates the entire content of this book and, at this stage, it is sufficient to frame a general response in terms of the myriad axes of differentiation that characterize contemporary society – notably ideology, class, gender and ethnicity (see Chapter 2).

In terms of ideology, a useful distinction can be found in Hardy's distinction (1988) between heritage as a conservative force that supports and reinforces dominant patterns of power, and a radical force that challenges and attempts to subvert existing structures of power. It follows that once a subversive heritage succeeds to power, it quickly loses its revolutionary intent and becomes a conservative force in itself. A Marxist critique would explain this in terms of popular consciousness being moulded to suit the needs of the dominant class and its ideology. Ideas such as Bourdieu's concept of dominant ideology (1977) have been adapted to the heritage debate. This assumes that a ruling élite upon assuming power must capture 'cultural capital' – the 'accumulated cultural productivity of society and also the criteria of taste for the selection and valuation of such products' (Ashworth, 1994:20) – if it is to legitimate its exercise of power. It has to be remembered, however, that because the medium is the message, the same heritage artefacts support different ideologies; the object remains but its messages change. Again, constructions of heritage are commonly framed within conventional stereotypes of gender.

There is little critical literature referring to this dimension, but national heritages, for example, are commonly rendered in terms of war and its ethos of (masculine) glory and sacrifice, while women are relegated to a domestic role – the keepers of the hearth.

Despite the development of multicultural societies, the content of heritage is also likely to reflect dominant ethnicities. The prevailing themes of English heritage, for example, whether exemplified in the pastoral nostalgia largely created in the early nineteenth century, or in the late twentieth-century exploitation of the country's decayed industrial fabric (mines, canals, warehouses etc.), have little space for the heritage of the many European and non-European minority groups who live in the country. Again, no European heritage – still heavily informed by the fabric of Christianity, despite the avowedly secular nature of contemporary European society – has yet found a way to accommodate the traditional enemy, Islam, although there has been substantial immigration of Islamic peoples into most Western European states. Even Spain and Portugal, historically the part of Western Europe most heavily influenced by Islamic culture, evolved an iconography of Christian victory and Arab subjugation. Moreover, most European societies are loathe to acknowledge the cultural identities of their former colonial subjects. Indeed the heritage of the former colonies themselves may largely remain that of the metropolitan powers; it can often not be torn down or even reinterpreted, the key factor in the former colonial world being that 'ideology is manifestly constrained by practicality' (Western, 1985:356).

Conclusion

These issues of contestation are addressed at every point throughout the remainder of the book, because they are intrinsic to the uses and abuses of heritage. This forms part of the socialization process, one mechanism of social reproduction, with all the tensions implied in such a role. It is notable in this regard that heritage is widely held to have an educative role and that the young are among its most commonplace consumers. Heritage is implicated in all society's divisions, carrying its multiple and conflicting messages at a variety of scales. And yet, simultaneously, it is a crucial product in the world's largest service industry, international tourism.

We are all too aware that we have created a complex matrix of potential interaction. To state that the past is contested and that heritage is the instrument of that contest is simple. To trace the nature, consequences and management of such conflicts within the socio-political and economic domains, and within and between spatial entities at various scales, is inevitably complex. It is perhaps worth stating before we commence the detailed discussion of the long inventory of difficulties, issues and conflicts addressed in the subsequent chapters, that most heritage, most of the time, and for most people is harmoniously experienced, non-dissonant and an essential enrichment of their lives. It is the minority of cases that raise the very serious issues upon which we now embark.

References

Anderson, B. (1991) *Imagined Communities: Reflections on the Origins and Speed of Nationalism* (2nd edn), London: Verso.

Ashworth, G.J. (1991a) *War and the City*. London: Routledge.

—— (1991b) *Heritage Planning: The Management of Urban Change*. Groningen: Geopers.

—— (1994) 'From history to heritage – from heritage to history: in search of concepts and models'. In Ashworth, G.J. and Larkham, J. (eds), *Building a New Heritage: Tourism, Culture and Identity in the New Europe*, London: Routledge.

—— (1998) 'The conserved European city as cultural symbol: the meaning of the text', in Graham, B. (ed.), *Modern Europe: Place, Culture, Identity*, London: Arnold.

Bourdieu, P. (1977) *Outline of a Theory of Practice*, Cambridge: Cambridge University Press.

Brett, D. (1996) *The Construction of Heritage*, Cork: Cork University Press.

Colley, L. (1992) *Britons: Forging the Nation*, London: Yale University Press.

Cosgrove, D.E. (1993) *The Palladian Landscape: Geographical Change and its Cultural Representations in Sixteenth-century Italy*, Leicester: Leicester University Press.

Davies, N. (1996) *Europe: A History*, Oxford: Oxford University Press.

Donald, J. and Rattansi, A. (eds) (1992) *'Race', Culture and Difference*, London: Sage/Open University.

Douglas, N. (1997) 'Political structures, social interaction and identity changes in Northern Ireland', in Graham, B. (ed.), *In Search of Ireland: A Cultural Geography*, London: Routledge.

Duffy, J. (1997) 'Writing Ireland: literature and art in the representation of Irish place', in Graham, B. (ed.), *In Search of Ireland: A Cultural Geography*. London: Routledge.

Graham, B., Ashworth, G.J. and Tunbridge, J.E. (2000a) 'Heritage and national identity', in Graham, B., Ashworth, G.J. and Tunbridge, J.E. (eds), *A Geography of Heritage: Power, Culture and Economy*, London: Arnold.

—— (2000b) 'Heritage and scale: the national', in Graham, B., Ashworth, G.J. and Tunbridge, J.E. (eds), *A Geography of Heritage: Power, Culture and Economy*, London: Arnold.

—— (2000c) 'Heritage, power and identity', in Graham, B., Ashworth, G.J. and Tunbridge, J.E. (eds), *A Geography of Heritage: Power, Culture and Economy*, London: Arnold.

—— (2000d) 'Heritage and economics: an ambiguous relationship', in Graham, B., Ashworth, G.J. and Tunbridge, J.E. (eds), *A Geography of Heritage: Power, Culture and Economy*, London: Arnold.

—— (2000e) 'Heritage in economic development strategies', in Graham, B., Ashworth, G.J. and Tunbridge, J.E. (eds), *A Geography of Heritage: Power, Culture and Economy*, London: Arnold.

Gruffudd, P. (1995) 'Remaking Wales: nation-building and the geographical imagination, 1925–50', *Political Geography*, 14.

Guibernau, M. (1996) *Nationalisms: The Nation State and Nationalism in the Twentieth Century*, Oxford: Polity.

Hall, S. (1995) 'New cultures for the old', in Massey, D. and Jess, P. (eds), *A Place in the World? Place, Cultures and Globalization*, Oxford: Open University/Oxford University Press.

Hastings, A. (1997) *The Construction of Nationhood: Ethnicity, Religion and Nationalism*, Cambridge: Cambridge University Press.

Hewison, R. (1987) *The Heritage Industry: Britain in a Climate of Decline*, London: Methuen.

Hobsbawm, E. (1990) *Nations and Nationalism since 1780: Programme, Myth, Reality*, Cambridge: Cambridge University Press.

James, H. (1983; orig. pub. 1884) *A Little Tour in France*, Harmondsworth: Penguin.

Livingstone, D.N. (1992) *The Geographical Tradition*, Oxford: Blackwell.

Lowenthal, D. (1985) *The Past is a Foreign Country*, Cambridge: Cambridge University Press.

—— (1996) *The Heritage Crusade and the Spoils of History*, Cambridge: Cambridge University Press.

Nash, C. (1999) 'Historical geographies of modernity', in Graham, B. and Nash, C. (eds), *Modern Historical Geographies*, Harlow: Prentice Hall.

Sack, R.D. (1992) *Place, Modernity and the Consumer's World*, Baltimore: Johns Hopkins University Press.

Schama, S. (1995) *Landscape and Memory*, London: Harper Collins.

Tunbridge, J.E. (1981) 'Conservation trusts as geographic agents: their impact upon landscape, townscape and land use', *Transactions, Institute of British Geographers*, NS6, 103–25.

——and Ashworth, G.J. (1996) *Dissonant Heritage: The Management of the Past as a Resource in Conflict*, Chichester: Wiley.

Urry, J. (1990) *The Tourist Gaze: Leisure and Travel in Contemporary Societies*, London: Sage.

—— (1995) *Consuming Places*, London: Routledge.

Western, J. (1985) 'Undoing the colonial city', *Geographical Review*, 75, 335–57.

Woolf, S. (ed.) (1996) *Nationalism in Europe, 1815 to the Present*, London: Routledge.

4

Ideas of museums in the 1990s

Julia D. Harrison

Drawing on examples from Canada, the USA and Great Britain, and with particular reference to museums which hold anthropological collections, this chapter reviews the framework of much of the thinking that has gone on in museums in recent decades. Most closely, it examines the argument put forward by several writers that a much greater critical and socially substantive role was an exciting direction for museums.

This chapter is useful in the way it charts the challenges faced by museums in the 1980s and 1990s that stimulated new ways of thinking and new practices. Traditionally seen as authorities and centres for scholarship, museums were being called upon to become more democratic, with the public educational role and purpose being brought to the fore. Museums were being challenged in terms of their economic future, power relationships and traditional identities. The chapter provides an introduction to two 'new museologies' that played a part in informing new ideas, along with the impact of new concepts of business management and the voices of minority groups, indigenous peoples and others.

An intellectual crisis and a crisis of anti-intellectualism

What is a museum? This question is currently being asked by a surprisingly wide range of people, including members of the museum profession itself, those whose cultural objects are held by museums, politicians and members of the business community who are being asked in ever increasing numbers to support museums through sponsorships. The traditional understanding of what constitutes a museum was couched in functional terms. Thus the purposes of museums were perceived as concrete and tangible, paralleling the essence of the 'material evidence' (Weil, 1990:46), which historically has been the focal point of museums. Collection, preservation, study, interpretation and exhibition of this 'material evidence' have been the components which lie at the root of all definitions of what a museum is. Stephen Weil, an important critic of museums, has suggested several reasons why museums have chosen such a focus:

> It has proven comfortable. To focus museum rhetoric on the socially beneficial aspects of a museum would ultimately be to invite discussion on a wide range of political and moral issues that could well pit trustees against staff members and staff members against one another. By contrast, to focus on function – on the good, seemingly value-free work of collecting, preserving and displaying – projects with a sense of ideological neutrality ... in which people of diverse social views are able to work more amiably together.
>
> (Weil, 1990:46)

Weil maintains that this focus aids and abets museum workers' aspirations towards professionalism as it defines something unique in the mission of the museum. In pursuit of professionalism museum workers have focused on what they see as 'most distinctive' rather than what is 'most important'

(ibid.:46–7). They have become driven by 'good collections management … [which] can no more make a museum excellent than good bookkeeping can make a business flourish' (ibid.:56).

But what is a museum at a more abstract level? The self-determined mission statements of most museums suggest that the institutions are involved in such culturally valued practices as the pursuit of science, scholarly study and publication. The separation of these activities into spaces removed from the routine of daily life, the fact that these spaces are architecturally reminiscent of churches or the mansions of those who rule, impresses upon the visitor the idea that museum visits are a privilege and an educational, if not morally uplifting, experience. Thus the public understanding of the museum is as a purveyor of truth and a venerated 'cultural authority'. Moreover, the collections are often the former property of the wealthy and the powerful, and they relate to historical events and times – either those of the Western world or of 'exotic' peoples of the world. Thus they carry with them the authority of 'tradition' and this further validates the authority of the institution.

Several authors (Karp and Kratz, 1991; Haraway, 1984; Duncan and Wallach, 1978) argue that museums are institutions of *'overpowering* cultural authority … [expressing] ambitious and encyclopedic claims to knowledge' (Karp and Kratz, 1991:23, 25; emphasis added). In natural history museums, according to Haraway (1984:21), behind 'every mounted animal, bronze sculpture, or photograph lies a profusion of objects and social interactions among people and other animals, which in the end can be recomposed to tell a biography embracing major themes for 20th century United States'. She proves her point by an analysis of what she calls 'Teddy Bear Patriarchy' (the name ironically derived from the Theodore Roosevelt monument which graces the entrance to the Natural History Museum, New York), which embodied 'the commerce of power and knowledge [of] white and male supremacist monopoly capitalism' (ibid.:21). Duncan and Wallach (1978:28), looking at the Museum of Modern Art, New York, came to similar conclusions. Museums are 'ceremonial monuments … dedicated exclusively to ideology', specifically that of late capitalism.

In recent times, those who work in museums are exploring and questioning these underlying attitudes. This process leads to a state of uncertainty, which is further compounded by the anti-intellectualism that currently pervades much of the Western world and which is reflected in an intellectual crisis in museums. Intellectual crises for museums are not new. The modern museum is a public democratic institution, and this does not flow smoothly from its conflicting nineteenth-century scholarly and entertainment roots. Thus museums must have passed through some challenging times in search of firm foundations for their current mode of existence and its perpetuation. In the period up to the Second World War, museums in the USA struggled to emphasize their educational role. But in a more fundamental sense they wrestled with questions as to what their primary function was, and asked: if they did not exist, would someone invent them (Wittlin, 1970:157)? In the period after the war, in the fervour of rebuilding the Western world, there was a great growth in the number of museums (seen potentially as monuments to the ideology that had proved itself invincible in the recent global battle). But at the same time the effectiveness of the work of museums was questioned, and as the definition of what could be a museum diversified, it was suggested that there was a need for clarity of purpose. Academic research was increasingly challenged by the more public educational role of museums. Most dramatic was the development of the idea of the museum 'profession', with all of its attendant role specialization, leading to a more precise definition of museum work.[1] The issue of 'if museums did not exist, would somebody invent them?', was essentially abandoned. Museum 'work' focused on such functionally motivated issues as cataloguing and registration procedures, conservation techniques and improved facilities for museum visitors. For some, this professionalization was simply an avoidance strategy to hide

from the real issues confronting the modern museum. The staff of the post-modern museum or at least the museum that exists in the post-modern world, can no longer avoid confronting questions about the reasons for its existence – although many are assiduously, or possibly blindly, assuming that they can. To some, the challenges that are being thrown at the museum are interesting, so long as they do not detract from 'our knitting, the fundamentals' (Cameron, 1992b:7).[2] To others, they represent potentially the most critical intellectual crisis that the museum has faced. The 'why' of the existence of the museum is not a new issue, but placed in the context of the new historicism, post-modernism and deconstructionism, it takes on a new urgency as these paradigms expose new understandings of museums.

Anti-intellectualism, the other force presently challenging the museum as an institution, encompasses two rather different traditions of thought. On the one hand, it is potentially not so much a state of anti-intellectualism, as one of anti-empiricism, espoused by feminists, and a range of ethnic, racial, religious and other minority groups. In the minds of the dominant group, it is the voice of the Other. It is a stand against the dominant ideology of the Western world – an ideology grounded in the empiricist sense of truth articulated in the Western world by male, Christian, capitalist thought. Simply, these oppositional voices promote an anti-Western intellectualism, more inclusive than Western intellectualism, and reflective of the multiple realities of the world.

The other component of 'anti-intellectualism' is the voice of the Philistines, exemplified in the controversy over the Robert Mapplethorpe show, which was exhibited in 1989 in several galleries in the USA. Its photographic images were deemed pornographic, or at least homocerotic by some, and this led to the efforts of Senator Jesse Helms to deny access to funds from the National Endowment for the Arts. His case was based on a highly subjective interpretation of what did, and did not, constitute 'art' (Orsekes, 1989; Kimmelman, 1989; Russell, 1989). These voices, essentially conservative, also oppose any institutional efforts to re-interpret history. An example of such an attempt was the exhibition *The West As America: Reinterpreting Images of the Frontier*, 1820–1920, which opened at the National Museum of American Art in 1991 (Kimmelman, 1991; Masters, 1991).[3] These conservative voices clamour for what some critics of this posture would call 'populist pap'. They want nothing to be seen in museums that challenges the dominant ideology; they affirm traditional Eurocentric myths and understandings.

The voice of the Philistine, or the voice of the Other, both provide a challenge to museums: one challenges the intellectual (or curator) who is setting up new frames of thinking about basic assumptions of the Western worldview; the Other wants to determine what those new frames of thinking should be, and frequently rejects the dominant empiricist paradigm validated by the institution. As Michael Ames (1991:7) has said of this dilemma: 'a contest arises between those asserting the equality, commonality or universalism – the right to be equal while remaining different – versus the expectation that to become equal one should assimilate'. Identity, tradition, history and individual expression are all part of the processes of invention, construction and structural reproduction, which place aspects of the past in the present. Understandings of these phenomena in any representation are negotiated, particularly in the work of museums. The extent of this challenge is part of the contemporary reality of museums.

Money, power and identity

Museums today exist in an environment which should be encouraging them to consider what their future is. At one level the issues have been explored superficially. A review of the major journals published by the museums associations and other interested bodies in the USA, Canada and the

UK for the last five years reveals what the museum professionals consider to be the critical issues for museums in the future. These include the incorporation of peoples from diverse ethnic and cultural backgrounds in all aspects of the museum from boards to audience; the role of the museum in the national education; the need for museums to manage and conserve their collections, especially those which include vital information for our environmental well-being; ethical questions about cultural patrimony and collecting policies; the need for better training and selection of museum professionals; the critical financial situation of many museums and the dwindling sources of potential support; and the need for superlative leaders in the museum field who have the necessary vision and creativity to guide the institutions through these times (see e.g. J.P. Greene 1989). In these publications, museum collections are normally championed as the main object of concern, although some charge the museum profession to put people first. In addition, to some critics the profession has to demonstrate a 'passion' for people to truly do justice to the role of museums in contemporary society (Davies, 1989).

In the 1980s, Stephen Weil (1983[4]) identified three parallel crises which faced museums: money, power and identity. Money issues are obvious and predictable, as public and private sponsorships rise and fall with boom and recession cycles, and political agendas determine priorities in the support of the arts and culture. Power issues, as Weil identified them, focused on staff-trustee relationships, and the voices of outside groups clamouring to have a say in the activities of museums (at this time he was specifically referring to artists). The identity crisis concerned whether museums were to be object- or people-oriented, and whether they were research institutions, or whether they were there to serve the public through educational programmes. The identity crisis was also discussed by Duncan Cameron (1971) in the same year in his classic article 'The Museum: A Temple or the Forum?' To him, some museums at the beginning of the 1970s evidenced an 'identity crisis ... while others are in an advanced state of schizophrenia' (ibid.:11). The museum can be both temple and forum, he argued, but above all else museums must be socially responsive in both arenas. He charged that the museum 'must institute reform and create an equality of cultural opportunity'. Society he felt 'would no longer tolerate institutions that [only] serve a minority audience of the elite' (ibid.:23). (Society has proved to be more tolerant than Cameron predicted, as much of the contemporary critique will show.) By 1977, another writer felt that museums had begun to realize that they must present ideas and not just collections. He suggested that in order to achieve this there was a need for a museum profession filled with the 'right people' – those who exhibit dedication to their job – to achieve this (Finlay, 1977:175).

In the late 1970s, Kenneth Hudson tried to gain some sense of where museums would go in the 1980s. Using ICOM data banks and questionnaires which allowed a global perspective, he noted two developments: 'a growing feeling that the past and the present shade off into one another and that a sensitivity to the achievements of the past can be a great help towards understanding the present ... [and] ... a willingness to accept the fact that museums can be appreciated emotionally and sensually as well as intellectually' (Hudson, 1977:6). Hudson considered that the influence of museums in former colonies and other parts of the Third World offered a glimmer of hope for challenging the dominant models of museums by bringing in 'the present', and in broadening the notion of 'understanding' in the museum. He wanted museums to become more human places (ibid.:91), to tackle risky subjects (ibid.:90), but primarily insisted that 'the nature of museum work must be continually questioned' (ibid.:151). The full implications of this radical proposition were not understood for many years. It is the challenge that faces museums still.

The American Association of Museums commissioned a report in the mid 1980s entitled *Museums for a New Century* (Bloom *et al.*, 1984). The commission set out 'to study and clarify the role of museums in American society, their obligations to preserve and interpret [the] cultural

and natural heritage, and their responsibilities to an ever-broadening audience' (ibid., 1984:11). It determined that four forces would direct museums in the future: a proliferation of voices, cultural pluralism, the impact of the information age and challenges in education (ibid.:24). The commission singled out seven aspects of museums that 'need to be approached with fresh insight' to respond to these forces. These included collection management, the educational potential of museums, internal organizational structures, the value of museums to the human experience, representation of cultural diversity through all aspects of the museum, the visibility of American museums within the nation at large and the economic future of museums (ibid.:28–9). The commission then set out a series of 16 recommendations which affirmed the basic roles of museums and suggested ways to carry them out more efficiently and forcefully. In the context of promoting the idea that museums must respond to the external forces around them, the commission made reference to 'the strong sense of internal identity that museums (have) as a community' (ibid.:28). The report continued that museums have only just 'begun to clarify' their sense of community and their sense of internal identity. I will argue that the concepts of 'community' and their influence on the 'internal identity' of museums have not yet been either fully explored or properly understood.

The 1980s saw the effects of the post-industrial era, as the Western world struggled to adjust to a new economic future. Severe financial constraints forced museums to adopt new concepts of management. In the USA, the business model was forced on museums not only by potential funders, but also by new legislation, which demanded greater accountability for use of federal funds. The recognition of the need to improve museum management developed throughout the decade. In 1985, Neil Cossons edited a collection of essays on the management of change in museums. By the late 1980s, there was a proliferation of journal articles on managing change and conflict in museums, the relevance of matrix management, the nature of the museum as an organization and other managerial topics. These developments heralded an era in which processes and procedures in museums achieved a high profile, along with issues of the profit-ability of some museum activities. There were moves towards partnering with business; perfor-mance measures would be introduced and the commodification of museum 'products' – exhibitions, research, public programmes, spaces – into objects with a definable dollar value which could be marketed as a discrete entity, was brought about (see M. Greene, 1989; Yaeger and Brown, 1992; Prescott, 1983; Griffin, 1987, 1988; Walden, 1991, Hewison, 1991; Emery, 1990a, b; Kovach, 1989). Museums began to see themselves as part of the tourist industry and the heritage experience (Cannon-Brookes, 1991:351). Public relations and marketing offices subsequently became an integral part of all major museums. Museum visitors were surveyed regularly for information on their educational and economic background, and attendance figures were kept in order to prove the social worth of the museum. The emphasis on quantity in these surveys would lead to claims in the 1990s that there was also a need to determine the qual-itative thoughts of museum visitors – why they came, what they learned, what they expected of museums (Merriman, 1989, 1991; Harris, 1990). These developments resulted from attempts to apply to museums new management structures and analyses, drawn largely from the corpo-rate sector. The concept that museums had to be 'managed', as opposed to being allowed simply to evolve, was possibly the most revolutionary development.

Concomitant with the efforts to adopt corporate management models were moves to define further the museum profession. There have always been those who have questioned whether a museum profession exists at all, whether there is such a thing as museology (or museography as some would say), defined as the body of specialized information essential for the definition of a profession. The move, at least in the USA, to the 'professionalization of everyone' has been the

subject of intellectual debate since at least the 1960s (see Wilensky, 1964). In 19
Washburn raised twelve points which argued against the existence of a museun
Yet by the early 1970s, there were Masters degrees in museum studies springin
sides of the Atlantic. Museology as a recognized phenomenon has always been mc
in Europe and England than in the USA and Canada. In 1988, Stephen Weil, ；
asked of his museum community if it was 'possible that, in our intensity to be considered a
profession, we have simply assumed the existence of a body of theoretical knowledge that is not
really there' (Weil, 1988:33). He acknowledges that the pursuit of professionalization has
certainly improved what museums do, and it has brought to the attention of the larger public
the value of museums, even if a 'profession' *per se* remains elusive. To others, professionalization
represented even greater specialization within the museum, with the creation of more rigid divi-
sions and inner sanctums of 'knowledge'.

The 'new museologies'

In Europe and England, museology as a corpus of thought had become so well established that,
by the 1970s, there was talk of a 'new museology'. This paradigm replaced the 'old museology',
which had focused on the activities of trained professionals in collecting, documenting,
preserving, exhibiting and interpreting objects. In this context, the large museums were held
up to be the models for what constituted the 'old museology'. The rationale for the 'new
museology' was that it was driven by the local community; social subjects and concerns replaced
objects as its focus; community needs drove the museological development and the museum was
not necessarily confined to a building (Stevenson, 1987; 31; see also Weil, 1990:55–6). This
paradigm is best exemplified by the ecomuseum movement which originated in France.[5] The
ecomuseum is 'primarily a way of thinking, a holistic, open systems view of the world' (Heron,
1991:8). Planning hinges on sensitivity to the environmental setting, and quality of life issues
are seminal in any museological programming. Some felt that the movement had failed by the
1990s and its ideals had slowly been watered down to confirm the establishment (see Hudson,
1992). To others, ecomuseums are still a viable expression of the 'new museology', defined in
terms of museums being proactive rather than reactive, and sensitive to the 'social, political and
economic conditions not only of the past, but also of the present and future' (Heron, 1991:8;
Šola, 1987a).

Another type of 'new museology' in the 1990s, if it can be called that, involves the reaffirma-
tion of the free-enterprise, business management model for museums (see Prud'homme, 1991).[6]
Linked to this style of museology is the adoption of the 'Disney' model of display and presenta-
tion to the public. Some see this as the most extreme, and somewhat contentious, interpretation
of the American Association of Museums' Code of Ethics, which stresses that museums exist to
serve the public (Boyd, 1991:176).

Following the lead of P.T. Barnum, many American museums learned in the nineteenth
century 'that for economic reasons ... it was necessary to submerge the scientist in the showman
and the result was a curious mix of education and entertainment' (Flint, 1990:65). Many of these
lessons were lost as museums, especially large monolithic ones, became symbols of higher
learning and elitism, where curators functioned as gatekeepers, carefully screening those who
entered (Jenkinson, 1989; see also Hooper-Greenhill, 1992). Curators and scientists who
worked in museums adopted the attitude that if visitors to a natural history museum left with
'nothing but sore feet, a bad headache and a general idea that the animal kingdom is a mighty
maze', it was not the fault of those who prepared the exhibits (Hamilton, 1991:3). But the ghost

of Barnum is rattling its chains in the latter decades of the twentieth century as museums struggle financially in an intellectual climate which challenges the ivory towers of museums and academe as a whole, and demands that the masses be let in, and that scientific work be made accessible and relevant to the daily life of the ordinary person. By the end of the 1980s, the clamour could no longer be ignored, and headlines in British museum journals such as 'Director gone Disney' and 'Swings and roundabouts', suggesting images of fun, play, entertainment and fantasy, foretold of fundamental changes in major institutions (and internal near-revolts against such changes at the same time).

These two particular articles detail the dramatic shift in focus and direction of two of Britain's major museums – The Victoria and Albert Museum and the London Natural History Museum. Both museums underwent dramatic restructuring at this time. There were major staff cuts, largely among the research staff – in some cases research departments were closed – and there was a total change in the philosophy underlying the display of exhibits. At the London Natural History Museum, exhibits such as 'Creepy Crawlies', 'Human Biology', and 'Ecology' replaced the classic, more pedagogic, galleries such as the 'Bird Gallery' and 'Marine Invertebrates'. The corporate plane for the London Natural History Museum, which was written, as one critic said, in the 'business-speak that the Treasury finds to sexy', laid out that the museum had 'taken the opportunity to reappraise and redefine its role in the market-place'. The plan went on to say that it promised a reduction in recurrent costs by reducing permanent staff and 'increasing self-generated income to 30 per cent of the total budget by 1994–1995' (quoted in Hamilton, 1991:3). In a nation which held a traditional and almost sacred assumption that government should fully support museums and other cultural agencies, such 'free-enterprise' thinking amounted to heresy. The cutting of staff could be achieved, albeit with much pain, in one brutal act. But the generation of income through entrance fees and other means depended on museums making themselves more appealing to the public. It meant removing the dour and serious image of the museum. The new administration of the London Natural History Museum, which was the driving force behind such changes, turned to the 'guru' of knowing how to bring in the crowds – Disney.[7]

The London Natural History Museum was by no means alone in taking these steps. In 1983, the Canadian government launched the building of a new National Museum of Man, which changed its name during the course of construction to the presumably more 'politically correct' Canadian Museum of Civilization. The senior administration of the museum incorporated the Disney model into their design and conceptualization of the new museum. They analysed which factors attracted the large number of visitors, ensured their satisfaction and generated revenue for the Disney corporation. These tactics range from 'welcoming guests' rather than 'admitting visitors', to using an integrated planning team to ensure that everyone understood what was intended and expected of a particular project or programme (MacDonald and Alsford, 1989:55).[8] The administrators also looked at the Epcot Center (Experimental Planned Communities of Tomorrow) as a model that successfully delivers an authentic experience of artefacts, foods, arts and crafts and entertainment in a manner far more successful than any museum. The new Canadian Museum of Civilization emulated the Epcot model (see MacDonald, 1988).

By 1992, it seemed that it was time to 'say good-bye to the stuffed elephants' (Honan, 1990), and to ask if the 'era of the curator driven exhibition [was] dead' (Terrell, 1991). The uproar caused by the new *Travelling the Pacific* exhibition at the Field Museum in Chicago (see Honan, 1990; Terrell, 1991), which led to the resignation of the head of the anthropology department, and confirmed the supremacy of the newly-defined rôle of 'exhibit developer', who champions the experiential and participatory aspects of the museum exhibits over dense artefactual presen-

tation and curatorially-determined content, ushered in a new era for museum exhibitions. To some, this simply reflects current populist trends, which advocate a more responsive attitude to the public's wants and needs. The consumer demand is now for variation and a distinctive experience. This is threatening the future of the predictable shopping mall in many parts of the Western world, and certainly in the USA; and is a demand to which the museum world is responding (see Honan, 1990:35; Popcorn, 1991). These trends feed into the model of fun, fantasy and 'the visualization and sculpting of shared [knowledge] as played out in the American mind' (Kind, 1990:62) typified by the Disney theme park model. Exhibits designed according to these principles reinforce stereotypes and validate certain mythologies as truth. However, there is an inherent tension in this approach because of the new challenges that minority groups are presenting to museums. It would appear that these new trends in exhibit development are still only listening to some voices and not to others.

This whole development deeply worries many museum curators. Most of their concerns are rooted in a basic fear for job security, along with their more noble concerns about the 'academic soundness' of the information and knowledge that is being transmitted in this new style of exhibit, and about the dismissal of the value and worth of the collections in exhibits (many of these 'new' exhibits use only a limited number of objects in their presentation, opting rather for technological and other participatory devices to get their message across; see Honan, 1990). Curators generally fear that their work, specifically their research, is no longer valued. Major museum journals in recent years have dedicated entire issues to the dilemma of the modern curator. These issues includes articles entitled 'Research and Education in Natural History Museums – The Need for Commitment' (Novacek); 'Scholarship or Self-Indulgence'; 'Museums Research: Axiom or Oxymoron?' (McGillivary); 'The Contemporary Curator – Endangered Species or Brave New Profession?' (Mayer).[9] These articles, mainly written by curators, reflect a certain degree of self-appraisal, but concentrate more on claims about the misunderstanding and misrepresentation of their motivations and their commitment to public understanding, and on the value of their work to the quality of the human experience. These articles and others (see Terrell, 1991; Strong, 1988) reflect a feeling emphasized by one author that it is the 'moral obligation [of curators] to speak out' (Cannon-Brookes, 1989:6) to ensure that the appropriate parties know of the value of their work.

It is in some ways surprising that anthropology curators seem unused to defending themselves against attacks on the value of their work. The relevance of museum anthropology, even to the broader discipline of anthropology, has been a topic of debate ever since university departments blossomed in the early twentieth century, particularly in American institutions. Recent developments in material culture studies may help to rescue museum anthropology from the obscurity in which it has languished for the past several decades. Objects are now the focus of intense theorizing in ways unknown since the late nineteenth century. This new work takes it as axiomatic that objects are to be understood in their contemporary social and political context so that the study of objects is linked, once again, to mainstream theoretical concerns. It affirms that objects are ideas.

Renewed interest in material culture has come from two directions. A result of renewed academic (that is, university-based as opposed to museum-based) interest in objects has been publications such as *The Social Life of Things* (Appadurai, 1986); *Reading Material Culture* (Tilley, 1991); *Material Culture and Mass Consumption* (Miller, 1991); *Culture and Consumption* (McCracken, 1988); *Entangled Objects* (Thomas, 1991); *Captured Heritage: The Scramble for Northwest Coast Artifacts* (Cole, 1985); *Objects and Others* (Stocking, 1988). All of these came out in the 1980s and early 1990s, and while generally grounded in anthropology, drew on other disci-

plines such as archaeology, the new art history, economic theory and social history. These publications apply a wide variety of theoretical frames – structuralism, hermeneutics, post-structuralism, phenomenology and deconstructionism – to the study of objects and their social relations. While not drawing exclusively (or in some cases at all) on objects in museum collections, these studies provide frames for thinking about objects in museums, as well as tools for thinking about the context of the museum and its relation to its collections and communities.[10]

A second, more powerful (and public) interest in material culture and museums was spawned by the public debates which arose around some museum exhibitions: the *Hidden Peoples of the Amazon* exhibition at the Museum of Mankind in London (1986); *The Spirit Sings: Artistic Traditions of Canada's First Peoples* in Calgary and Ottawa (1988); *Into the Heart of Africa* in Toronto (1990) and *Hispanic Art in the United States: Thirty Contemporary Painters and Sculptors* (1984–87), which traveled in the USA; all provoked controversies into which the staff of the museums, the academic community and the general public were drawn. The controversies revolved around the issue of museum authority and the right of curators to determine and interpret information in exhibitions. These were issues which challenged the entire discipline of anthropology, but often the 'poor sister' of anthropology – museum anthropology – because of its public profile, bore the brunt of the criticism from both the community at large and the academic world (see Ames, 1989; Harrison, 1988, 1993; Harrison *et al.*, 1988; Trigger, 1989; Schildkrout, 1991; Livingston and Beardsley, 1990). Some museum professionals rose to the challenge and launched into co-operative and productive discussions with minority peoples (see Ames, 1986, 1987, 1991, 1992; Anderson, 1990; Assembly of First Nations and Canadian Museums Association, 1992). Others preferred to defend the solid foundations of museums and museum anthropology, and, while acknowledging that change is necessary, set fairly rigid parameters for the change that they would be willing to accept (Freed, 1991).

Exhibitions like *The Spirit Sings* were on the cusp of a change which revolutionized the agenda for museum work. All types of museums, not only those with ethnographic collections, had to face these issues, and all aspects of the museum were affected: collection, preservation, exhibition, interpretation and management. In the USA, the passage of the *Native American Grave Protection and Repatriation Act* in 1990, which established a policy for the repatriation of certain museum collections to Native American groups, and required that the process of returning these pieces began within five years, gave a sense of urgency. Museum collections were no longer sacrosanct. Legislation had determined that certain parts of them (skeletal material and related items of cultural patrimony) could be returned to descendants to dispose of as they wished. Only three museums testified in favour of this legislation at the Senate hearings – two from the Southwest and the Bishop Museum in Hawaii. Those who spoke against it felt that it would force them to abandon their fiduciary responsibilities, act against the law of their state, deprive the nation of its cultural patrimony and adversely affect relationships with some Native American groups (see Tatar, 1990). Despite this hard-line stand, the legislation was passed. As the Hawaiian senator who introduced the bill said, it addressed 'a basic issue of human rights' (ibid.:5).

During the time that the American legislation was being developed and debated, the Canadian Museums Association and the Assembly of First Nations were sponsoring a Task Force on Museums and First Peoples in Canada. The Task Force released its final report in early 1992 and recommended co-operative and proactive projects in interpretation, access, repatriation and training. To date there is little indication that any of these recommendations will become legislation, but there have been efforts by Canadian museums to comply with the Task Force's recommendations. Nevertheless, in North America, the group most predomi-

nantly concerned about museum control over the holding, handling and display of, and access to, their material heritage are its native peoples. But they are only one of many groups – women, Blacks, Asians, Hispanics, Quebecois and other ethnic peoples – who want to regain control of their individual histories (and future), who seek equal representation of their creative works in museums and galleries and who are demanding full participation in any representation of the history of which they are a part. These are the voices challenging the dominance of the hegemonic Western intellectual and empiricist traditions.

From the concerns of these groups, there has emerged an interesting body of literature in parallel to the contemporary critique of anthropology which examines the 'poetics and politics' of museums as institutions, their exhibitions, their collections and their relationship with communities (see Karp and Lavine, 1990; Karp *et al.*, 1992; Clifford, 1988). Some museum professionals have been influenced by the view of museology represented in this work, and in their thinking it is combined with the 'other' museologies. Much of this new thinking is prompted, at least in part, by the need to respond to issues of minority representation, and by the desire to capture the potential represented by the ecomuseum. In its preliminary articulations (see Šola, 1987a), this new paradigm applies more easily to the larger, monolithic institutions than did earlier paradigms. It is these large institutions which, even today, despite the plethora of institutions that call themselves 'museums', are the models upon which ideas, understandings and criticisms of museums are essentially based. The rather late emergence of this most recent 'new museology', which draws on the 'peripheral' ideas exemplified by the ecomuseum (which first emerged in the late 1960s), is in some ways unsurprising. The centre by its very nature tends to be more 'self-absorbed, monopolistic, cautious, and involuted' (Ames, 1988b:41) and thus is unlikely to be the birth-place of revolutionary change.[11] The historians Raymond Williams and Max Weber both argued that such change is initiated in the periphery (either social or spatial) (Ames, 1988b:41; see also Weil, 1990; Clifford, 1990; Gaither, 1992). Gómez-Peña points out that it is those on the margins or borders who 'are actually the centre ... bring[ing] out the hybrid and dynamic realities of ... fractured realities' (as interpreted in Karp, 1992:25). One could ask of museums whether they can shift from the centre to the periphery, and play the kind of role described by Gómez-Peña. The new thinking in museums draws on the theme park model, but ideally more constructively than by just borrowing its methodology. The representation of popular culture is a vital part of this new thinking; the present is an integral part of any story the 'new' museum will tell. But in contrast to the theme park, it would endeavour to stretch and inform its visitors rather than appeal to the lowest common denominator.

Words and phrases such as 'resonance', 'wonder', 'commitment', 'liberation', 'islands of hope', 'dialogue', 'platform for ideas', 'social re-definition', 'cultural empowerment', 'emotional' and 'redefinition of our consciousness' appeared in museum writings in the late 1980s and 1990s. 'Ambiguity', 'vulnerability', 'self-reflection', 'critical thinking', 'accountability' and 'social responsibility' were highly evident: a redefinition of the museum experience and the museum mission was advocated (see e.g. Šola, 1987a, b; *Context and Commitment*, 1990; Postman, 1990; Raven, 1989; Hoepfner, 1987; Greenblatt, 1990; Shelton, 1990; Cameron, 1990, 1992a; Heron, 1991; van Mensch, 1988; Pearce, 1992; Weil, 1990; Vogel, 1990). Harris called this a period of 'existential scrutiny' in which the museum experience was 'constant[ly] renegotiate[ed]' in terms of 'meaning and value', which he (optimistically) felt would lead the profession 'to admit the need for a *phenomenological reconstruction* ... of every aspect of museum learning and experience' (Harris, 1990:51, 53; emphasis added). This is a long way from the ideas of the museum as venerated authority, as purveyor of truth, as centre

of scientific research, as another form of school where knowledge is doled out in digestible amounts. It is even further from the museum as collector of 'material evidence', or as a caretaker of heritage. The 'new museum' is not to be an institution where 'knowledge' is transmitted; but where '[g]enuine communication ... inspire[s] a form of poetic experience' (Šola) 1987a:49; see also Tchen, 1992). In this paradigm, communication in the museum has magical, spiritual, social and creative elements. The museum is a place driven by 'ideas, viewpoint and insight' (Weil, 1990:56).

Advocates of the 'new thinking' about museums suggest the abandonment of any idea that interpretation of the museum object is objective, and suggest that 'the challenging [and] adaptive nature [of the object] make it a creative and basically subjective medium' (Šola, 1987a). Museums fundamentally (and finally) are to be about ideas and not objects (Weil, 1990). As such, the role of the museum is to be an institution from which 'the public can form a reliable intuition' (Šola, 1987b:9). This intuitive understanding will be derived from the museum's standing in a posture of argument, dialogue or at the very least in conversation with society (see Postman, 1990:58; *Context and Commitment*, 1990:66; Perin, 1992).

Some argue further that museums of natural history, art, anthropology and history can promote 'a sense of internationalism in a world whose very future depends on such a perspective' (Raven, 1990:60–1; Julien, 1987). This would lead to the incorporation of political and economic issues in museum discourse, so that museums would be entering the forum discussed by Cameron in 1971. However this 'liberated museology' (Ames, 1988a:19) will not come about simply through the discussion of new topics in museum exhibitions, public programmes and publications. It will require more fundamental changes within the museum. At one level it means opening all aspects of museum work to 'cultural empowerment [and] multi-vocal interpretations' (Ames, 1992:161). This does not mean inviting a particular cultural group into the museum to see if they approve of what the museum is doing in handling and interpreting the group's story. It means handing to that group the authority to tell their own story, letting them determine how, or even if the story is to be told. It means making museums at least, bicultural (Ames, 1991). It implies acceptance of the idea that there is more than one 'science', more than one 'truth', more than one set of 'facts'. In thinking about museums, proponents of critical theory, assume acceptance of the idea that all 'knowledge is an artifact of society' (Hoepfner, 1987:27), thus asserting that one can admit that there are many versions of 'truth' without devolving into solipsism.

It has been argued that systems of power and authority, and validated forms of artistic and cultural expression traditionally affirm the dominant ideology. (As I suggested earlier, this has been argued to be the case for museums – see Duncan and Wallach, 1978, 1980s; Haraway, 1984–5; Karp and Kratz, 1991.) The globalization and, in some interpretations, the 'mongrelization' (see Ames, 1991) of world culture, creates the conditions for questioning the assumed right of any one ideological structure to overall dominance in the Western world. Is there a role that museums can play in this process? I firmly believe that there is.

Notes

1 A majority of the writing about museums in this post-war period includes texts such as Wittlin's, which in 1970 proposed a 'twelve point program for museum renewal' without fundamentally questioning what was being renewed.

2 The original inspiration for this reference may come from Peters and Waterman's book, *In Search of Excellence* (1991), which lists 'sticking to one's knitting' (that is, to what one knows) as one way of making a company successful.

3 The exhibition was a very direct attempt at a revisionist history of the encounter of Americans and North American Native Peoples. To its critics (on both sides) it lacked any kind of ambiguity. To those who welcome new understandings of the events of history, it merely swapped one dogma for another, while to the establishment it was anti-American and leftist.

4 This article was originally written in 1971.

5 The first ecomuseum development in France (where the movement was born) at Le Creusot, Montceau-les-Mines, had political underpinnings: it was an effort on the part of the community to retain its local identity in the face of industrial development and to apply a new understanding developed among a group of radical thinkers of what a museum could be (Duncan Cameron, personal communication).

6 To some, this is merely a retrenchment and a reaffirmation of the establishment which launched museums in the first place. It is simply a retreat to the far-right capitalist model, affirming economic value as the highest value, which was a driving force of the colonialist, capitalist expansion of the nineteenth century and which in turn was the impetus behind the founding of many museums.

7 Senior staff from the museum were sent to Disney seminars to learn the corporation's philosophy and strategies. That the Disney corporation is an American organization was even more offensive to those who protested these moves – it was one more painful blow in the much hated 'Americanization' of Britain, which many British felt they had been subjected to, particularly during the Thatcher years.

8 The full impact of these strategies at the Canadian Museum of Civilization was not apparent three years after its opening. There was a lack of funds for completing the exhibits and fully developing the programming. Some critics charged that the substantial funds allocated to the futuristic design of the building, were inappropriately spent, and that the true substance of the museum was ignored.

9 See *International Journal of Museum Management and Curatorship*, Vol 9, No 4, December 1990; *MUSE*, Vol IX, No 2, Summer/Fall 1991.

10 Other studies (see Cantwell *The Research Potential of Anthropological Museum Collections* 1981), which came from within the museum world sought to demonstrate the contemporary potential of material culture studies and indicated a growing receptiveness among academics to the idea of working seriously with museum collections. Another body of literature emerging from England was also rethinking the study and interpretation of objects. Representative books are *The New Museology* (P. Vergo, ed.), *The Museum Time Machine* (R. Lumley, ed.), *Museums and Material Culture Studies* and *Objects of Knowledge* (S. Pearce, ed.). These books were closely focused on museums and objects in museums, and on the 'intellectual crisis' in which museums found themselves. Some looked to other disciplines such as linguistics and semiology to provide new insight into the methods, processes and understandings of museum work.

11 This is demonstrated by the *Excellence and Equity: Education and the Public Dimension of the Museums*, a report by the Task Force of Museum Education of the American Association of Museums produced in 1991. It acknowledged many of the contentious issues that museums faced in the 1990s, but it offered very predictable solutions.

References

Ames, M. (1986) *Museums, The Public and Anthropology*, New Delhi: Concept/Vancouver: University of British Columbia Press.

—— (1987) 'Free Indians from their ethnological fate', *MUSE*, 4(2), 14–25.

—— (1988a) 'Proposals for improving relations between museums and the indigenous peoples of Canada', *Museum Anthropology*, 12(3), 15–19.

—— (1988b) 'Daring to be different', *MUSE*, 6(1), 38–42.

—— (1989) 'The liberation of anthropology: a rejoinder to Professor Trigger's "A present of their past"?' *Culture*, 8(1), 81–5.

—— (1991) 'Biculturalism in exhibitions', *Museum Anthropology*, 15(2), 7–15.

—— (1992). 'Cultural empowerment and museums: opening up anthropology through collaboration', in Pearce, S. (ed.), *Objects of Knowledge*, London: Athlone.

Anderson, C. (1990) 'Australia Aborigines and museums – a new relationship', *Curator*, 33(3), 165–79.

Appadurai, A. (ed.) (1986) *The Social Life of Things*, Cambridge: Cambridge University Press.

Assembly of First Nations and the Canadian Museums Association (1992) *Turning the Page: Forging New Partnerships between Museums and First Peoples*. Ottawa: AFN/CMA.

Bloom, J. *et al*. (1984) *Museums for a New Century*, Washington: AMA.

Boyd, W. (1991) 'Museum accountability: laws, rules, ethics and accreditation', *Curator*, 34(3), 165–77.

Cameron, D. (1971) 'The museum, a temple or the forum?' *Curator*, 14(1), 11–24.

—— (1990) 'Values in conflict and social re-definition', *MUSE*, 8(3), 14–16.

—— (1992a) *A Change of Heart*, unpublished manuscript.

—— (1992b) 'Getting out of our skin: museums and a new identity', *MUSE*, 10(2–3), 7–10.

Cannon-Brookes, P. (1991) 'Museums, theme parks and heritage experiences', *Journal of Museum Management* and *Curatorship*, 10, 351–8.

Cantwell, A.-M., Griffin, J. and Rothschild, N. (1981) 'The research potential of anthropological museum collections', *Annals of New York Academy of Science*, 376, 1–595

Clifford, J. (1988) *Predicament of Culture*, Cambridge MA: Harvard University Press.

—— (1990), 'Four northwest coast museums: travel reflections', in Karp, I. and Lavine, S. (eds), *Exhibiting Cultures: The Poetics and Politics of Museum Display,* Washington: Smithsonian Institution.

Cole, D. (1985) *Captured Heritage: The Scramble for Northwest Coast Artifacts*, Vancouver: Douglas and McIntyre.

'Context and commitment' (1990) *Museum News*, 69(5), 66–9.

Cossons, N. (ed.) (1985) *The Management of Change in Museums*. Greenwich: National Maritime Museum.

Davies, M. (1989) 'Towards the millennium', *Museums Journal*, 89(3), 18–20.

Duncan, C. and Wallach, A. (1978) 'The museum of modern art as late capitalist ritual: an iconographic analysis', *Marxist Perspectives*, Winter, 28–51.

—— (1980) 'The universal survey museum', *Art History*, 4, 448–69.

Emery, A. (1990a) 'The management of change: the case of the Canadian Museum of Nature', *MUSE*, 8(3), 76–9.

—— (1990b) 'Museum staff: defining expectations', *Journal of Museum Management and Curatorship* 9(3), 265–72.

Finlay, I. (1977) *Priceless Heritage: The Future of Museums*, London: Faber and Faber.

Flint, R. (1990) 'Living the legacy', *Museum News*, 69(5), 63–5.

Freed, S. (1991) 'Everyone is breathing on our vitrines: problems and prospects of museum anthropology', *Curator*, 34(1), 58–79.

Gaither, E.B. (1992) '"Hey, that's mine": thoughts on pluralism and American museums', in Karp, I., Kreamer, C. and Lavine, S. (eds), *Museums and Communities: The Politics of Public Culture*, Washington: Smithsonian Institution.

Greenblatt, Stephen (1990) 'Resonance and wonder', in Karp, I. and Lavine, S. (eds), *Exhibiting Culture: Poetics and Politics of Museum Display*, Washington: Smithsonian Institution.

Greene, J.P. (1989) 'Museums for the year 2000 – a case for continuous revolution', *Museums Journal*, 88(4), 179–80.

Greene, M. (1989) 'Doing the business', *Museums Journal*, 89(6), 26–9.

Griffin, D. (1987) 'Managing in the museum organization: leadership and communication', *International Journal of Museum Management and Curatorship*, 6(4), 387–98.

—— (1988) 'Managing in the museum organization: conflict, tasks, responsibilities', *International Journal of Museum Management and Curatorship*, 7(1), 1–23.

Hamilton, J. (1991) 'Pay and display', *Spectator*, 11 May, 3–4.

Haraway, D. (1984) 'Teddy bear patriarchy: taxidermy in the Garden of Eden, New York City 1908–36', *Social Text*, 2, 19–64.

Harris, N. (1990) 'Polling for opinions', *Museums News*, 69(5), 48–53.

Harrison, J. (1988) '"The Spirit Sings" and the future of anthropology', *Anthropology Today*, 4(6), 6–9.

—— (1993) *An Institution in Transition: An Ethnography of the Bernice Pauabi Bishop Museum*, DPhil thesis, Oxford University.

——, Trigger, B. and Ames, M. (1988) 'Point? Counterpoint: "The Spirit Sings" and the Lubicon boycott', *MUSE*, 6(3), 12–25.

Heron, P. (1991) 'Ecomuseums – a new museology', *Alberta Museums Review*, 17(2), 8–11.

Hewison, R. (1991) 'The heritage industry revisited', *Museums Journal*, 91(4), 23–6.

Hoepfner, C. (1987) 'Local history and critical theories', *History News*, Sept./Oct., 27–9.

Honan, W. (1990) 'Say goodbye to the stuffed elephants', *The New York Times Magazine*, 14 January, 35–8.

Hooper-Greenhill, E. (1992) *Museums and the Shaping of Knowledge*, London: Routledge.

Hudson, K. (1977) *Museums for the 1980s: A Survey of World Trends*, Paris and London: UNESCO/Macmillan.

—— (1992) 'The dream and the reality', *Museums Journal*, 92(4), 27–31.

Jenkinson, P. (1989) 'Material culture, people's history and populism in museum studies', in Pearce, S. (ed.), *Museums Studies and Material Culture*, Leicester: Leicester University Press.

Julien, R. (1987) *ICOM News*, 40(1), 5–12.

Karp, I. (1992) 'Civil society and social identity', in Karp, I., Kreamer, C. and Lavine, S. (eds), *Museums and Communities: The Politics of Public Culture*, Washington: Smithsonian Institution.

—— and Kratz, C. (1991) *The Fate of Tippoo's Tiger: A Critical Account of Ethnographic Display*, Los Angeles: Getty Center.

—— and Lavine, S. (eds) (1990) *Exhibiting Cultures: The Poetics and Politics of Museum Display*, Washington: Smithsonian Institution.

——, Kreamer, C. and Lavine, S. (eds) (1992) *Museums and Communities: The Politics of Public Culture*, Washington: Smithsonian Institution.

Kimmelman, M. (1989) 'Helms Bill, whatever its outcome, could leave mark on arts grants', *New York Times*, 30 July, A1, A26.

—— (1991) 'Old West, new twist at the Smithsonian', *New York Times*, 26 May, 11, 1, 27.

King, M. (1990) 'Theme park thesis', *Museum News*, 69(5), 60–2.

Kovach, C. (1989) 'Strategic management for museums', *The International Journal of Museum Management and Curatorship*, 8, 137–48.

Livingston, J. and Beardsley, J. (1990) 'The poetics and politics of Hispanic art: a new perspective', in Karp, I. and Lavine, S. (eds), *Exhibiting Cultures: The Poetics and Politics of Museum Display*, Washington: Smithsonian Institution.

Lumley, R. (ed.) (1988) *The Museum Time-Machine: Putting Culture on Display*, London: Routledge.

McCraken, G. (1988) *Culture and Consumption: New Approaches to the Symbolic Character of Consumer Goods and Activities*, Bloomington: Indiana University Press.

MacDonald, G. (1988) 'Epcot Centre in museological perspective', *MUST*, 6(1), 27–37.

—— and Alsford, S. (1989) *A Museum for the Global Village*, Hull: Canadian Museum of Civilization.

Masters, K. (1991) 'Westward, no: a frontier showdown', *The Washington Post National Weekly Edition*, 17–23 July, 10–11.

Merriman, N. (1989) 'The social basis of museum and heritage visiting', in Pearce, S. (ed.), *Museum Studies and Material Culture*, Leicester: Leicester University Press.

—— (1991) *Beyond the Glass Case: The Past, the Heritage and the Public in Britain*, Leicester: Leicester University Press.

Miller, D. (1991) *Material Culture and Mass Consumption*, Oxford: Blackwell.

Orsekes, M. (1989) 'Senate votes to bar "obscene or indecent" art', *New York Times*, 27 July, A1, C18.

Pearce, S. (1992) *Objects of Knowledge*, London: Athlone Press.

Perin, C. (1992) 'The communicative circle: museums as communities', in Karp, I., Kreamer, C. and Lavine, S. (eds), *Museums and Communities: The Politics of Public Culture*, Washington: Smithsonian Institution.

Peters, T. and Waterman, R. (1991) *In Search of Excellence*, New York: Harper Collins.

Popcorn, F. (1991) *The Popcorn Report*, New York: Doubleday.

Postman, N. (1990) 'Museum as dialogue', *Museum News*, 69(5), 55–8.

Prescott, D. (1983) 'Matrix management: an alternative for museums?' *MUST*, 1(1), 30, 32.

Prud'homme, A. (1991) 'The CEO of Culture Inc.', *Time*, 38(121), 40–2.

Raven, P. (1990) 'Platform for ideas', *Museum News*, 68(6), 58, 60–1.

Russell, J. (1989) 'Getting high on moral indignation', *New York Times*, 6 August, C31.

Schildkrout, E. (1991) 'Ambiguous messages and ironic twists: "Into the Heart of Africa" and the Other Museum', *Museum Anthropology*, 15(2), 16–23.

Shelton, A.A. (1990) 'In the lair of the monkey: notes towards a post-modernist museography', in Pearce, S. (ed.), *Objects of Knowledge*, London: Athlone.

Šola, T. (1987a) 'The concept and nature of museology', *Museum*, 153(39,1), 45–9.

—— (1987b) 'From education to communication', *ICOM News*, 40(3/4), 5–10.

Stevenson, S. (1987) 'Balancing the scales: old views and a new muse', *MUSE*, 5(1), 30–3.

Stocking, G. (ed.) (1985) *Objects and Others: Essays on Museums and Material Culture*, London: University of Wisconsin Press.

Strong, R. (1988) 'Scholar or salesman: the curator of the future', *MUSE*, 6(2), 16–20.

Tatar, E. (1990) *The Politics of Cultural Heritage: Recent Developments at the Bishop Museum*, Honolulu: East West Center.

Tchen, J.K.W. (1992) 'Creating a dialogic museum: the Chinatown History Museum experiment', in Karp, I., Kreamer, C. and Lavine, S. (eds), *Museums and Communities: The Politics of Public Culture*, Washington: Smithsonian Institution.

Terrell, J. (1991) 'Disneyland: the future of museum anthropology', *American Anthropologist*, 93(1), 149–51.

Thomas, N. (1991) *Entangled Objects: Exchange, Materials Culture, and Colonialism in the Pacific*, Cambridge, MA: Harvard University Press.

Tilley, C. (ed.) (1991) *Reading Material Culture*, Oxford: Blackwell.

Trigger, B. (1989) 'A present of their past? Anthropologists, native people, and their heritage', *Culture*, 8(1), 71–81.

Van Mensch, P. (1988) 'Museology and museums', *ICOM News*, 41(3), 5–10.

Vergo, P. (ed.) (1990) *The New Museology*, London: Reaktion.

Vogel, S. (1990) 'Always true to the object, in our fashion', in Karp, I. and Lavine, S. (eds), *Exhibiting Cultures: The Poetics and Politics of Museum Display*, Washington: Smithsonian Institution.

Walden, I. (1991) 'Qualities and quantities', *Museums Journal*, 91(1), 27–8.

Washburn, W. (1985) 'Professionalizing the muses', *Museum News*, 64(2), 18–25, 70–71.

Weil, S. (ed.) (1983) 'The multiple crises in our museums', in *Beauty and the Beasts: On Museums, Art and the Law, and the Market*. Washington: Smithsonian Institution.

—— (1988) 'The ongoing pursuit of professional status', *Museum News*, 67(2), 30–4.

—— (1990) *Rethinking the Museum*, Washington: Smithsonian Institution.

Wilensky, H.L. (1964) 'The professionalization of everyone', *The American Journal of Sociology*, 70(2), 137–58.

Wittlin, A. (1970) *Museums: In Search of a Usable Future*, Cambridge, MA: MIT Press.

Yaeger, D. and Brown, C. (1992) 'The art of partnering', *Museum News*, 71(2), 28–33.

The informed muse
The implications of 'The New Museology' for museum practice
Deirdre C. Stam

This chapter looks in more detail at the influences of certain aspects of 'The New Museology'. Theorists of The New Museology, who regard museums as social institutions with political agendas because of inherent shared biases and assumptions, advocate integrating museums more closely with the multicultural social groups which these critics believe they should represent and serve. The New Museology specifically questions traditional museum approaches to issues of value, meaning, control, interpretation, authority and authenticity. These challenges have implications for both internal operations and external relations of museums. They point to the importance of the 'information base' underlying museum missions and functions, and its potential for supporting more cohesive and integrated institutions.

Regarding the implications for internal operations and external relations of museums in the 1990s, the chapter identified key areas for changed thinking and practice and provides useful insight into these. Areas identified in internal operations were organizational structures, staffing, museum education, exhibition theory, display techniques, classification, labelling, media and management/business practices; those linked to external relations were strategic planning, establishment of consortia and electronic networks.

Introduction

> The museum of the past must be set aside, reconstructed, transformed from a century of bric-a-brac into a nursery of living thought.
>
> George Brown Goode, Smithsonian Institution, 1889 [1]

Criticism of museum practice has been a popular intellectual sport among museum players and spectators since the inception of museums. Typically, the criticism decries the old as irrelevant to 'today's' world, and calls for adopting 'the new', or for 'change', or 'reform', or even for a full-fledged revolution in the name of better service to 'the populace', museum-going or otherwise. This rhetorical form usually includes a few snide remarks about the self-serving, possessive and neurotic tendencies of curators, and the mendacious and wily natures of administrators and trustees. The call for reform typically ends with the recommendation that power to govern museums be granted henceforth to the disenfranchised constituency most passionately committed to the future of the institution, that is to say, the writers themselves.

The rhetoric of The New Museology, though rather more self-righteous in tone than has been characteristic of the genre, is basically true to form, calling as it does for change, relevance,

curatorial reorientation and redistribution of power. These time-honored sentiments are cast here largely in the language of Structuralism and Deconstruction, and include rather more code words drawn from disciplines outside the traditional museum world than has been the case in earlier polemics.

Apart from its contemporary jargon, the novelty of New Museological rhetoric lies in the high proportion of attention given to the relationships of the museum to its social, economic and political environment as part of the analysis of pertinence, relevance and meaning. Given its faithful, if unwitting, adherence to the tradition of museum criticism, the proclamations of The New Museology would evoke nothing more than a weary yawn – except among its more youthful and hopeful proponents – were it not the case that museums are in fact experiencing radical and perplexing changes in their societal environment. These changes involve changes in economic conditions, patterns of support, visitor profiles, competition from other institutions and organizations, public expectation, communication modes, reputation and political roles.[2] 'Crisis' is a world commonly used to describe the conditions of museums today.

Significant changes in social environment, almost all of which threaten the stability of museums, are causing a major rethinking of all aspects of these institutions. Reactions from the museum community to these changes have been widely varied. In the intellectual sphere, attempts made to broaden the social base of the museum have included exhibitions that explore and exemplify cultural diversity, such as *Hispanic Art of the United States* at the Museum of Fine Arts in Houston, and *Te Maori* at the Fine Arts Museums of San Francisco. In the economic sphere, there is developing a growing commitment to sales activities, such as has occurred for some years at the Metropolitan Museum of Art, together with a move toward the development of 'international cultural franchises', as is being undertaken by the Guggenheim Museum.[3] There is also the forging of links to museums in other and arguably more prosperous nations such as that occurring between the Museum of Fine Arts in Boston and a 'sister' museum in Japan. While some of these non-traditional responses to changing conditions might represent imaginative, well-considered and theoretically-grounded moves, many are suspiciously *ad hoc* in character, desperate in tone and curiously at odds with the basic educational purposes of the sponsoring institutions. Is there a better way to respond?

It would be reasonable for museums at this time to look for a theoretical framework to guide them in improving their relationships to their social milieu. The New Museology, which regards museums primarily as social institutions with political roles, offers exactly this conceptual structure. One should understand, however, that The New Museology has not so far explained exactly how this theoretical framework should be translated into practice. Its spokespersons, such as Peter Vergo, editor of the important collection of essays entitled *The New Museology*, deliberately refrain from carrying their arguments into the practical realm. Vergo specifically criticizes museums for having concentrated in the past too closely on museum practice at the expense of larger 'humanistic' issues of purpose and meaning.[4]

While the New Museological rhetoric, then, does not itself offer ready-made answers to practical problems of running museums, its growing literature does contain implications for museum managers. It is the purpose of the following review to extract from New Museological theory some lessons pertaining to museum management.

This review begins with a discussion of the individual basic concepts of The New Museology. These concepts are then treated as an integral unit under the umbrella of 'information-based' concerns. Following that analysis are three sections that deal with applications of the New Museological theory to issues of museum management: defining the institutional mission, managing internal operations and relating to the outside world. The review ends with observa-

tions on the utility of the New Museological theory for museum management; the focus of this section is on the reorientation of museums on issues and conditions of the 'Information Age'.

To place these New Museological ideas in an historical context, one can benefit from a backward glance at some *old* museological theory, particularly that of the 1930s, when not dissimilar sentiments were expressed in different words by museum theorists and leaders. To cite one example, consider T.R. Adam's 1939 comment on museum work and its relationship to social justice: the control of museums 'is no routine or honorary matter, but a front-line job in the continuous struggle to preserve social freedom'.[5]

Though the parallel between the rhetoric of the 1930s and that of the 1990s is striking, one should not assume a direct and clear influence of the earlier period on the later. In the first place, few New Museologists seem particularly conscious of the history of this discipline. And in the second, one can find the foundations of the New Museological thought in much historical theory of the past decades. Examples of a particularly pertinent movement is the 'Annales' school of historians, active in the 1950s and later, who focused attention on material culture, everyday life and the political and economic interpretation of commonplace objects. These approaches were carried into the museum sphere in the 1970s and 1980s by American historians such as Thomas J. Schlereth in *Artifacts and the American Past* (1980).[6] Many others might be mentioned as significant sources in the development of New Museological principles: examples are Fernand Braudel, Philippe Arias, Emmanual LeRoy Ladurie, E.A. Wrigley, Keith V. Thomas and Peter Gay. Suffice it to say that The New Museology can be seen to have roots in theoretical developments in order fields, most notably the social sciences. Its implications and future should be understood to exist within a broad intellectual tradition.

Basic concepts of 'The New Museology'

As noted above, the term 'The New Museology' was used as the title of a collection of papers edited by Peter Vergo in 1989, and in his introduction, Vergo defines this concept as: 'a state of widespread dissatisfaction with the "old" museology ... what is wrong with the "old" museology is that it is too much about museum *methods,* and too little about the purposes of museusm'.[7] Vergo continues: 'Unless a radical re-examination of the role of museums within society – by which I do not mean measuring their "success" merely in terms of criteria such as more money and more visitors – takes place, museums may well find themselves dubbed only "living fossils".'

Although the term 'The New Museology' has not yet been widely adopted in American museum theory, the concepts explored in Vergo's volume have been treated extensively in a number of publications on both sides of the Atlantic in recent years. Particularly important for this review, in addition to the previously mentioned Vergo volume, were two collections of essays with an anthropological emphasis published by the Smithsonian Institution: *Exhibiting Cultures; The Poetics and Politics of Museum Display* (1991)[8] and *Museums and Communities: The Politics of Public Culture* (1992).[9] The art museum is addressed in *Different Voices: A Social, Cultural, and Historical Framework for Change in the American Art Museum* (1992).[10] Also significant was the serial published in the UK entitled *New Research in Museum Studies,* Vol. 1 (1990). More popular treatments of these ideas began to appear in such mainstream museum journals as *Museum News,* with the publication of *The Epistemic Museum* by David Chapin and Stephen Klein in the summer of 1992.[11] Some of the writers who are here labeled New Museologists might have been surprised to be included under this title. Some did not use the term, and some may never have heard of it, or of the (then) recently formed organization that bore this name.[12] The label is applied here to those writers whose ideas

seem consonant with those authors who have published under the *New Museology* title, and most specifically with Vergo's pioneering circle of contributors.

A review of New Museological ideas may with reason begin with a definition, proffered in 1988 by Stephen Weil, of the concepts underlying the Smithsonian Institution's international conference of that year. The meeting addressed *The Poetics and Politics of Representation,* topics meant to deal with how one culture should present another in the museum setting. Underlying the Washington conference were two concepts central to The New Museology, the 'poetics' of presentation and the political agenda of museums as social institutions. According to Weil:[13]

> Poetics, in this case, may be understood as identifying the underlying narrative/aesthetic patterns within exhibitions. The politics of representation refers to the social circumstances in which exhibitions are organized, presented, and understood ... Clearly these are intersecting domains which draw on a common pool of historical memory and shared (often unconscious) assumption.

From the seemingly neutral and familiar ideas of communication and context, here called 'poetics' and 'politics', have sprung several sub-topics that have received impassioned treatment in the museum press. Chief among them are value, meaning, access, politics and economics. New Museologists challenge the authority of museums to make decisions in all these matters *in vacuo.* The New Museological view of these topics, as defined by major thinkers in this area, are here reviewed briefly.

Value, according to Harold K. Skramstad, Jr., is not an inherent property of objects, but rather an attribute bestowed upon objects by their inclusion in the museum. The 'aura' giving rise to the impression of value comes from the traditional cultural role of the museum as embodiment of established social values.[14]

Meaning, like value, is altered by museums through the recontextualization of objects in the museum setting. Beyond the problematic dimensions of time and space, George W. Stocking, Jr, notes distortions in meaning entailed by relations of power implied in the ownership by museums of objects wrested from disadvantaged individuals or peoples. Even more significant for the meaning of objects than ownership, according to Stocking, is the question of who controls the 'representation of meaning'.[15] This issue is particularly pertinent to what the West calls the material culture of non-Western societies. Frequently, an assumption of romantic exoticism has affected interpretation of such largely anthropological materials.

Meaning, declares Edwina Taborsky, resides not in the object itself, but is 'socially; determined and assigned', determined by 'our own "fore-knowledge" about our society. A meaning is arbitrarily assigned, which makes it changeable and, therefore, a potential lie'.[16] Borrowing from Michel Foucault, Taborsky claims that meaning is assigned through social discourse, an interaction that assigned meaning to an object, and allows some interpretation of that meaning through intellectual negotiation. The 'bundle of relations' associated with that object, to use a concept proposed by Levy-Strauss, ultimately determines its meaning.[17] Its truth is thus socially rather that materially determined.

Access. The museums, according to Anthony Alan Shelton's interpretation of the guru Pierre Bourdieu, should be seen as part of the world of the educational establishment which acts 'not only as the mode of transmission of official culture, but as an institutionalization of that culture which prescribes competence in its attainment, regulates access to ownership of knowledge, and encourages the constant renewal of its central core by their teleological referral to a series of object phenomena which it claims are constituted outside, and are independent of it',[18]

According to Bourdieu: 'A work of art has meaning and interest only for someone who possesses the cultural competence, that is, the code, into which it is encoded ... A beholder who lacks the specific code feels lost in a chaos of sounds and rhythms, colours and lines, without rhyme or reason ... Thus, the encounter with a work of art is not "love at first sight" as is generally supposed'.[19]

Politics. 'Ultimately, what museums are, what they become, boils down to a question of power: who controls their research and their collections', claim David Chapin and Stephan Klein.[20] Ignored by the museum, according to Chapin and Klein, are marginalized societal groups, such as 'lesbian mommies' or sufferers of black lung disease in museums that purport to deal respectively with children or with the mining industry.[21]

Also dealing with the politics of museums are the 'critical theorists', such as Michael M. Ames who advocates 'applying more critical perspectives to both the management of museums and their curatorial and interpretative enterprises' for the purpose of identifying those 'social situations which can be altered in order to eliminate certain injustices, frustrations and mystifications people experience'.[22]

Economics. Noting that museums have traditionally disavowed economic interest, Shelton takes them to task for misrepresenting their participation in the 'bourgeois political economy'.[23] Museums are accused of building a 'practice of consecration' that enables them to accumulate economic capital in the form of their collections. Drawing from Bourdieu, Shelton castigates museums for acting as 'symbolic bankers' in a 'bad faith economy'.

Information as fundamental to The New Museology

While the tenets of The New Museology seem at first reading to make up a disparate list, one can find a common thread among them. Almost all New Museological concepts deal with the museum's information base, and this information base is the full complex of data supporting institutional activities, ranking from the pragmatics of acquisition to the abstractions of interpretive display. Pertinent data are housed variously, in registration files, curatorial records, public relations files, institutional archives, administrative data, correspondence, financial records, personnel files and more.

These categories of museum information are usually considered to be quite separate from one another, because their technology – paper cards and metal filing cabinets – are scattered through the typical museum structure, and they have traditionally been departmentally focused. The records from different functional areas are, however, conceptually related, as New Museologists imply, because all of the activities documented and supported by these records are complementary, and part of the museum's total mission. Conservation records interact with curatorial files. Classification schemes of the registrar relate to exhibition patterns. Library and archival sources affect interpretation. Personnel records can indicate the cultural make-up of the staff and thus imply power relationships. And administrative information relates to the larger social community surrounding the museum.

Consider the role played by such 'museum information' in the concerns of New Museologists: value, meaning, power, control, interaction with visitors, interpretation, understanding, authenticity and authority. These concerns are largely cognitive. They center on processing of knowledge: creating information, interpreting information, receiving information and understanding information. The changes sought by New Museologists lie in this cognitive realm, involving new kinds of understanding and conceptions of the self in relation to society and its institutions. It could be argued that the redefinition of self in relation to social institutions has economic and

political implications, as well as psychological aspects, but it would be extending the New Museological doctrines beyond their stated goals to see in this movement a clear call for more full-scale social and economic revolution. However, the common informational thread has been all but invisible to the New Museologists themselves, since each of them has been able to see mainly his or her concern in the context of a single setting or limited set of circumstances. Information is generally ignored as a basic resource of the museum, though the adoption of new information technologies in museums is forcing staff to become somewhat more aware of its existence and its properties.[24]

George F. MacDonald and Stephen Alsford are almost alone in articulating the importance of museum information for the development of the institution. Their concept of information is narrower than that assumed here, consisting largely of information imparted to the visitor through museum activities and installations. Such information in their view is useful for decision-making and for causing change in the state of knowledge in its recipient. They recognize that the societal change from an industrial past to an information age is one of the forces that is causing museums to re-evaluate their social role. They see also implications of this shift of emphasis to information for internal operations: an 'advantage of a shift in orientation away from objects towards information is that it should make it easier (when formulating a museum's mission, for instance) to balance the traditional functions of collection, preservation, research and display, with the newer rallying-flags of education and communication'.[25] On the other hand, taking a narrower and more pessimistic view of museum information, Barry Gaither notes that however sensitive museums like his own Museum of the National Center of Afro-American Artists in Boston might be to social issues, 'the dissemination of information is not controlled by the museum community, but by the media. The consensus of what's in and what's out is really what determines what gets attention and how the information is communicated on a mass basis'.[26]

While it is so that museums are not fully in control of the use made of their information, they can become more sophisticated in handling this resource and creating a more beneficial interface between their own information and that picked up by the media. The improvements must begin at home. The implications of The New Museology for museum management might be seen at the most general level as a call for an improved understanding and handling of the full information base – including internal and external information – affecting museum attitudes and practices.

However true the general observation about the pervasiveness of the information base might be, it is far too abstract an idea to serve as a plan for moving the museum in a New Museological direction. A more concrete and detailed discussion is needed. Yet a totally concrete interpretation of New Museological concerns, with emphasis on things and procedures, would violate the spirit of this primarily intellectual and ideological movement. A middle ground will be sought here, consisting of an exploration of concepts and the implications of these concepts, each considered in turn, for application to museum activities. This review should point to a new way of thinking about the familiar practices surrounding the basic museum functions of exhibition, display, labeling and so forth. An outline only, this treatment does not include actual, detailed solutions to the 'nitty-gritty' of museum practice. It begins with the fundamental question of New Museology: what is the purpose of the museum?

The New Museology and museum missions

Many traditional mission statements are similar to the well-known statement of director John Cotton Dana articulated for the Newark Museum in 1923. The museum was to be 'a first reader in visual instructions; something that would please, instruct and provoke to thought and action those who used it'.[27] The desired 'action' was improved social behavior. It was hoped, according

to Nicholas Pearson, that 'raising taste might result in a reduction in undesirable behaviour ... Nobody expects that the whole of the working classes will at once take to drawing and entirely renounce strong liquor, but many may be rescued from temptation to excess'.[28]

Similar operational definitions of museum missions also occur in New Museological theory. Just a few examples are given here. James T. Evans, for one, notes that populists (read 'New Museologists') 'emphasize the role of the museum as an educational and cultural resource facility, whose programs and exhibitions should be oriented to serve the needs of the museum's visitors'. Evans speaks further of social conscience, social change and moral enrichment for 'various publics'.[29] Also assuming the possibility of progress in social affairs, MacDonald and Alsford urge the museum 'to help their audiences exploit effectively the information resources in their self-directed quest for knowledge'.[30] Taking a pragmatic stance, they further claim that museums can, by providing useful information, nicely position themselves 'to play a central role in the new age, in which information-based services are expected to be a key to economic prosperity and to social status – two things necessary in the real world, to museums to ensure their effectiveness, if not their survival'.[31]

Dealing more abstractly with the idea of progress, Andrew West contends the museum purpose must be reaffirmed in terms of the 'spiritual and educational needs' of the community at large. West is particularly contemptuous of an oversimplified emphasis on popularity that does not really promote access to the broadest spectrum of society, but rather favors those of a particular, business-oriented ideology.[32] Rejecting the traditional images of museum as palace or treasure-house, New Museologists offer less tangible metaphors to suggest purpose: the museum can be a forum,[33] or a dialogue between curators and the public,[34] or even 'a public access system' where visitors assemble their own experience.[35] The visitors' experience becomes, paradoxically, the more tangible entity, to wit, the product of the museum.[36] This view implies that the primary product of the museum is then not the preservation and display of the artefact, but rather the information to be derived by the public from the museum. The wisdom developed from that information – and it can be intellectual, aesthetic, sensory, spiritual or emotional – is to be used for subsequent decision-making in everyday life.[37]

A discordance between what the museum intends to communicate by way of information and what the public takes from its experience can of course occur. The receiver's understanding of an experience, the Deconstructionists in particular would avow, is inevitably affected by his/her previous experience of the world. This is not a new idea in arts circles. More than a decade ago, for example, discussing photography as a medium of communication, Estelle Jussim noted that: 'it is probably one of the most widespread and unfortunately naive notions that communication is "neutral" – that it is just a matter of taking information from over here, putting it on a physical channel in some way, and conveying it over there ... we are not just passive receivers of messages, but are actively selecting out of our message environment only those things which we find interesting, amusing, or necessary to survival'.[38] While interest in these communication issues among New Museologists leads in some instances to a lessening of attention to the physical properties of the museum objects, most seem to agree with the traditional museum tenet that the object plays a central role in the museum concept. Many, however, depart from tradition in rejecting the time-honored and automatic reverence among museologists for the 'authenticity' of the object. They question the very concept of authenticity as it relates to the museum objects, exploring such complexities of the concept as genuineness, authority, intent and artistic nature.

When New Museologists speak of the 'authentic' qualities of the museum object – what Jussim calls its 'itness'[39] – they frequently begin their discussion with reference to Walter Benjamin's 1936 pronouncement on authenticity and politics:

The unique value of the 'authentic' work of art has its basis in ritual, the location of its original use value. This ritualistic basis, however remote, is still recognizable as secularized ritual even in the most profane forms of the cult of beauty ... the instant the criterion of authenticity ceases to be applicable to artistic production, the total function of art is reversed. Instead of being based on ritual, it begins to be based on another practice – politics.[40]

The observations of Benjamin cast doubt not only on the very nature of authenticity, but also on the societal commitment to demand any meaningful degree of authenticity from its museums, the designated keepers of its collectively-owned objects. New Museologists Spencer R. Crew and James E. Sims state flatly that: 'Authenticity is not about factuality or reality. It is about authority. Objects have no authority; people do ... Authenticity (authority) enforces the social contract between he audience and the museum, a socially agreed-upon reality that exists only as long as confidence in the voice of the exhibition holds'.[41]

So far, the elements of museum mission considered here have had a generally positive tone, with the possible exception of skepticism relating to authenticity. Some New Museologists, however, are frankly cynical about high-minded statements of purpose. One such critic is Carol Duncan, who observes that: 'every major state, monarchical or republican, understood the usefulness of having a public art museum. Such public institutions made (and still make) the State look good: progressive, concerned about the spiritual life of its citizens, a preserver of past achievements and a provider for the common good ... the art museum gives citizenship and civic virtue a content without having to redistribute real power'.[42]

In sum, when looking then for a theoretical basis for the mission of museums, New Museologists draw upon ideas and persons who have been only loosely connected to the traditional mainstream disciplines of museologists. Rather than citing art historians, American historians or natural scientists, for example, they draw upon psychologists, political scientists, communication theorists and philosophers. Traditional mission statements, prior to The New Museology, tended to emphasize the *personal* experience of museum visitors, and the ameliorating effect of personal development most immediately on private behavior, and eventually; on social or collective behavior. The New Museology stresses, rather, the group identity of museum constituents, usually defined in terms of ethnicity or gender. While adopting social betterment as a goal, they believe that it will come about when the 'disadvantaged' groups share in the power and authority of those who make decisions about cultural and other institutions.[43] The museum, as an interpretative instrument for a society, is an important source of understanding and self-knowledge for that society, and is therefore worth reorienting to allow greater exploration of social diversity than has traditionally been the case.

In the political sense, the potential mission of museums according to The New Museology is enlarged, even glorified, to include the fostering of social justice. But at the same time, the potential social role of museums seems diminished by the negative tone of New Museological rhetoric. Attempts to define new missions seem riddled by doubts about the possibility of knowing in any meaningful sense, or of communicating effectively, or of presenting a message that is untainted by class or personal interests. The New Museologists present a pessimistic view of the current missions of museums as self-serving for the relevant professionals, sympathetic only to the interests of the established social and political order, and indifferent to the interests of the broader public. They advocate a more positive and integrated social role for museums, but seem to offer little hope that fundamental progress in human nature will make their vision a reality.

Implications for internal operations

So critical is The New Museology about present-day museums that anyone serious about responding to its charges would have to consider a wholesale re-examination of the institution, including its organizational structure. Manfred Eisenbeis, who in 1972 advocated just this kind of analysis, might be considered a forerunner of this movement:

> Any attempt to clarify the institutional problems of the museum is incomplete without an analysis of the organizational aspects. The museum as an organization [has] ... its own traditions as regards administration, its relationship with the public and the selection of staff ... It is, moreover, the case that concrete changes in the museum as an institution will nearly always be expressed through organizational changes – the creation of new 'roles'.[44]

Taking a cue from Eisenbeis, this review examines the implications of The New Museology for internal museum operations by looking at these aspects of its functions: staffing, organizational structures, educational practices, exhibition theory, display techniques, classification structures, labelling, media use and management/business practices. How might these elements be altered to suit new institutional purposes and conditions?

Organizational structures

Among the structural changes advocated by the New Museologists is the destruction of communication barriers between traditional departmental units. Just as the activities of curators and educators, for example, are seen by many New Museologists as entwined,[45] so should museum operations and structures be integrated, in the words of Phillip M. Kadis, 'with no one activity in an airtight compartment'.[46] Exhibitions have long been recognized as collaborative ventures,[47] and could serve as models for other types of intramural cooperation. Criticism of the traditional departmental structure of museums – which separates curatorship, conservation, education, administration and exhibition – is not a new phenomenon. As early as 1942, in the American Association of Museums/Metropolitan Museum of Art report, *The Museum as Social Instrument,* it was recognized that the departmental structure in museums needed adjustment, the usual structural pattern having been developed long before people recognized, for example, that public education had any part to play in museum missions.[48]

Staffing

'Everyone knows', claims Kadis, 'that museums are institutions for the advancement of the careers of curators ... The public interest is secondary'. According to Kadis, curators of the new order should be encouraged to do more curatorial editing aimed at social relevance, shift their focus from objects to the relationship of people to objects, and get out of their offices to learn about their audience.[49]

Museums have often neglected the training of 'non-professional' staff such as docents, security attendants and maintenance workers. Increased attention to these 'front-line' workers could greatly improve the quality of the visitors' experience, and, according to Eisenbeis, 'could provide needed insights into the habits and wishes of the museum's visitors, thereby improving the quality of feedback necessary for program evaluation by top administrators'.[50] (Such feedback is now sought of course through professionally designed questionnaires and comment

books; these innovations do not address the large issue of the education of non-professions.) Such attention to support workers in the museum is not entirely novel, having occurred in rhetoric of the early 1940s, to cite only one example, in the AAM/MMA joint report. Here, it is pointed out that while guards form the largest group with which this public comes in contact, it is the 'sales girls' who actually inform visitors about museum activities. Their 'propaganda powers' must not be underestimated.[51]

Museum education

As for education of the museum's public, it is not just *more*, but quite a different kind, that is being called for. Chapin and Klein claim that museums have very effectively taught the values of the dominant culture, prevailing systems of loyalties, behavior in sacred places and social myths. They consider museums as creators of the frames of observation through which the world is seen, and these frames have usually been built by the dominant culture, one they see as repressive, racist and distorting. They call for a diversity that 'requires an attack on privilege, an assault on the bastions of knowledge that are the provinces and supports of the plutocracy ... museums (should) stop helping to maintain the order of things and start teaching different, more liberating values'.[52]

Exhibition theory

New Museologists reject the directive, overly interpreted presentation, especially if that interpretation reflects the values only of the dominant culture. This position is engagingly presented by Gerald George:

> On the one hand, I felt happy; I had just had a fascinatingly informative two hours in an admirably well-planned museum. On the other I felt demeaned, as if I had been led by the nose through a canned presentation of slickly packaged pap. I felt I had been made to read a history textbook, illustrated with objects as well as photographs, all of which had been subordinated to a thin story line and selected for their conformity to it.[53]

George recommends that a history museum ask itself, not 'What story do we want to tell?', but rather 'What questions do we want to raise?'

Display techniques

Cultural museums in particular, traditionally identified as history and anthropological museums, are urged to undertake three initiatives: allow populations to exert control over the way they are represented in museums, expand understanding of non-Western and minority domestic populations, and devise ways of exhibiting multiple perspectives (or make clear the tendentiousness of the chosen approach).[54] Exhibits ought further to acknowledge that there are three sets of actors related to any exhibition: makers of objects, exhibitors of those objects and viewers. These players come into contact somewhere between the object and the label. The active relationships of these parties in an exhibition should be exploited, with the final integration left to the viewers.[55]

Classification

Classification of objects is a particularly vexing topic for New Museologists. Structuralism has informed this discussion; one finds constant reference to the classification structures developed by a society to 'signify', but not mirror, objects. These structures might emphasize use, as is typical in a society built upon empirical tests, but might equally stress natural elements – as is characteristic, for example of Navaho society – or spiritual factors. Almost all Anglo-American classification systems, at least for natural and cultural history museums, are biased toward a 'theology of use',[56] and ignore the values and/or the original complex from which the objects were plucked.[57]

More discreditable than this simple misinterpretation of the objects is the development of a classification system which gives 'value' to objects reflecting its own social order. This 'value' has very little to do with the object, its original society, or its meaning for non-dominant cultures in present society. The ascribing of relative value among objects – turning everything displayed into a work of art – that is based on dominant values, is part of the 'museum effect'[58] that an object enjoys upon inclusion in a collection, and classification within it. Classification reflects power; the political implications of that viewpoint are particularly problematical for conscientious new ethnographic museums.[59]

Classification, according to Duncan, is a method for reinvesting the meaning of objects, and art in particular, for political purposes. Made possible by art history, classification in the art museum, for example, recontextualizes art into statements of national and individual genius.[60] Among other uses, this kind of classification could be employed to bolster nationalism and to legitimize princely wealth by making collections of objects obtained through war and plunder seem to be a kind of shared public wealth. Such rationalization occurred, for example, in nineteenth-century French national museums. Classification of this kind, based on national affiliation and origin, has implications for the ranking of persons within the state, 'to declare some as having a greater share than others in the community's common heritage'.[61]

And finally, and most colorfully, Timothy W. Luke, in pointing out how cultural mythologies and political power are expressed in the showing of artworks in museums, castigates art history for its traditional classification structures:

> Trapped in the muc(k) of inappropriate categories, very few art writers escape with useful insights from the discursive ooze of genre, style, or school that bogs down their search for the political dimensions in art. Rather, they tend to chase both real politics and serious aesthetics farther back into the swamps of formal analysis until both of these subjects simply slip under the surface of deadly metaphorical quicksand. Consequently, we need a new, more critical approach to understanding how power, politics and ideology operate in art exhibitions.[62]

Labelling

Here, defined broadly as 'all identifying data', labelling too comes in for criticism. Some New Museologists observe that labels usually omit information about the *particular* history of artefacts, in favor of information that presents objects as examples of general principles. This impoverishment of data and decontextualization serves to enhance the clarity of the presentation and the authority of the museum, but it oversimplifies the object, implying that it can serve adequately as representative of a class. In fact, it is often the unusual that is collected, and not the

average example of the type of object.[63] An additional problem with labels is their assumption of one-way communication from staff to visitor. A variation proposed by Elaine Heumann Gurian provides for comment-boards to which visitors can add their reactions and interpretations. Other interactive strategies are encouraged.[64]

Media

Noting the wide range of high-tech communication media appearing in museums, New Museologists advocate imaginative mixtures and applications of these devices. They caution against reacting negatively to media traditionally associated with 'plebeian' activities. Contending that a museum's product is both its collection and information about it, Nick Baker notes that:

> Within its own walls a museum will use a variety of techniques to present its collection to the visiting public. The 'media' used typically include permanent displays, special exhibitions, guides, lectures, videos, catalogues and other printed material. A balance will be sought between information, education, persuasion and entertainment, so as to maximize the benefit which visitors derive from the collection.[65]

While the names of the media are new, one should be aware that the use in museums of those media associated with entertainment is a time-honored practice. The late eighteenth/early nineteenth-century museum innovator Charles Willson Peale was particularly venturesome in this regard, scheduling lectures with music and poetry among his public events, and even adding an organ to his natural history museum.[66] (It is no doubt significant that his techniques and his museum were both taken over by P.T. Barnum.[67]) The modern equivalent of such a device must, according to George F. MacDonald, take into account the audience's familiarity with modern media, such as television. The significance of such media is that the public has become more comfortable with visual than with traditional textual information.[68]

Management/business practices

As for adopting prevailing business practices for fiscal accountability and other objectives, there is both skepticism and support in The New Museology. Andrew West, for example, finds it regrettable that museums, 'now that the business-oriented community ... has such access'[69] to them, 'are encouraged to follow the same lines of organisation, funding and market response as the businesses'. Others, however, look more favorably on business and the help it can provide beleaguered museums. Val Bott, for example, calls for a corporate business plan in written form.[70] Reflecting recent trends in management theory, and indicating their own concern with visitors' experiences, New Museological theorists advocate making museums 'client-centered' in order to deliver improved 'product quality'. A favorable reference to Disney ventures inevitably occurs in this context.[71] (This enthusiasm is particularly ironic for a Marxist-oriented movement in that the client-centered approach derived clearly from the corporate world, manifested there in Japanese management theory, and in the all-pervasive Total Quality Management [TQM] management doctrine.)

Summary

To sum up the many implications of The New Museology for internal museum operations is an extremely difficult task. There are too many voices and too many topics to accommodate in a simple re-statement that could guide museum practice. More useful than a simple summary is a look at the few meta-topics that occur over and over again in individual statements. The first of these meta-topics, identified earlier, is information. Information is here considered a fundamental resource of the museum; its value, meaning and management are debated and questioned throughout this body of literature. The second meta-topic is communication with the public. Here too the museums' traditionally narrow and authoritarian approach is challenged. And the last is integration of functions. Traditional partitioning of activities is questioned by New Museological critics who call for integrated approaches to accomplishing museum missions.

Implications for external relations

Even though the relationship of museums to their social environments is central to New Museological thought, the literature of this movement contains relatively little by way of recommendations in this sphere. Just a few scattered ideas are indicated here.

Strategic planning

To make good use of its insights, museums would benefit from management techniques such as strategic planning. Although the term 'strategic planning' somewhat predates The New Museology movement, the sentiments of its proponents are very much in keeping with the approach. Strategic planning, explains James T. Evans, 'concentrates on the museum's external environment and the way in which the organization interacts with it'.[72]

Consortia

The isolation of museums from one another, predicts Val Bott, will be less common in the future, due primarily to economic pressures. Larger museums may well take over smaller and compatible institutions in order to help smaller institutions deal with increased competition for visitors and support.[73] While some consolidation may be desirable from the economic point of view, New Museologists value the distinctive character of museums that respond to particular communities and needs. Foreseeing networks of museums rather than conglomerations, Gaither comments:

> It's almost as if there is no place longer for the 19th century notion of 'the' museum being the all-encompassing definitive statement on the cultural contributions of humankind. There is, instead, a need for a network of complementary institutions to play their particular roles.[74]

Electronic links

Connections of the electronic variety are very likely to draw museums and their constituencies closer together in the future. As described by Patrick Cardon, The European Museum Network is already experimenting with ways of allowing audiences to 'create and follow associations

connected to an object and associative connection between different objects or artefacts stored in the electronic archives of the participating museums'.[75] Furthermore, focusing on the potential of information technology, MacDonald and Alsford state with obvious enthusiasm that museums will not reach their full potential until they find a way of sharing their information through 'joint venturing', notably by forming networks.[76] Research on the technical means for achieving this end is well underway, and currently receiving considerable attention in the museum press.[77]

Conclusion

Implications of The New Museology for both internal and external aspects of museum operations involve the integration of things formerly seen as separate: internally, compartmentalization is challenged; and external isolation from the larger society is criticized. Some degree of physical separation is, of course, necessary in both internal and external realms. One cannot reasonably or practically house all staff in one room; nor can one tear down security devices that separate the public from collections. It is not, however, physical alteration that is called for, but rather attitudinal change. Central to this change is the recognition of information as a basic and shared museum resource. The peculiar qualities of information allow it to penetrate physical walls and thus to foster closer links among parts of the museum, and closer contact with the outside world.

Museums are exhorted to take a holistic approach to the information with which they deal, and to the enterprise in which they are engaged, the museum itself. This approach involves integrating internal information (such as coordinating curatorial and conservation files), providing wider access for staff and public to newly coordinated institutional data, drawing more deeply from sources that reveal the context of objects (through more assiduous use of published material and original archival resources), and preparing more sensitively for relating to the community at large (by conducting research on and with visitor constituencies). While seeming to turn attention at least temporarily from the object itself, this approach would, imply New Museologists, lead ultimately to a richer encounter with the object for all concerned.

What is the utility of The New Museology for museum practice? Admittedly, it offers no blueprint for change. Nor does it provide a manual for survival. Its benefits are less specific than either, but none the less useful for their abstractness. Most useful are the suggestions embodied in its reflective literature on the subject of the future directions of museums. The New Museology:

- upholds the traditional emphasis upon the collection, preservation and use of objects for ultimate social benefit;
- encourages improved understanding of the complex social environment in which museums operate;
- points out the need to recognize sophistication in the demands of its audiences;
- encourages flexibility in interpretation of museum objects;
- calls for the use of modes of communication familiar to modern audiences;
- advocates increased communication of information among all interested parties, including staff, object-makers and museum visitors;
- specifies increased coordination of functions, especially in collecting, displaying and interpreting museum objects;
- calls for increased understanding of the implicit economic and political biases of museums.

While providing at least loosely articulated answers to theoretical questions about desired future directions of museums, The New Museology is less helpful on praxis. Remaining for the museum field to answer for itself are a set of significant questions about how to get 'there' from here. These questions, raised by New Museological concerns, form an agenda for museums. To function as New Museologists would have them, museums must develop these techniques:

- new methods for attempting understanding of society and audience;
- new ways of testing visitors' needs and responses;
- new organizational structures and management approaches to deal with new and dynamic functional relationships;
- new ways to evaluate 'productivity';
- new communication patterns;
- new approaches to information management and utilization.

The importance of information in achieving the objectives of the New Museologists cannot be overstated. The society in which museums now find themselves is itself well into the Information Age, and museums must follow if they are to speak to their constituencies. Their very survival depends on the effectiveness of their management of their information base and the communication of their peculiar kind of information to their potential publics.

Notes

1 George Brown Goode, 'The museums of the future', quoted in Edward P. Alexander, *Museum Masters: Their Museums and Their Influence* (Nashville: American Association for State and Local History, 1983), p. 296.
2 Ivan Karp, 'Introduction: museums and communities: the politics of public culture', in Ivan Karp, Christine Mullen Kreamer and Steven D. Lavine (eds), *Museums and Communities: The Politics of Public Culture* (Washington and London: Smithsonian Institution, 1992), p. 12.
3 John Richardson, 'Go go Guggenheim', *The New York Review of Books*, 39(13), 16 July 1992; pp. 18–22.
4 Peter Vergo (ed.), *The New Museology* (London: Reaktion, 1989), p. 3.
5 T.R. Adam, *The Museum and Popular Culture* (New York: American Association for Adult Education, 1939), p. 28.
6 Thomas J. Schlereth, *Artifacts and the American Past* (Nashville: American Association for State and Local History, *c* 1980).
7 Vergo, op. cit., p. 3.
8 Ivan Karp and Steven D. Lavine (eds), *Exhibiting Cultures: The Poetics and Politics of Museum Display* (Washington and London: Smithsonian Institution, 1991).
9 Ivan Karp, Christine Mullen Kreamer and Steven D. Lavine (eds), *Museums and Communities: The Politics of Public Culture* (Washington and London: Smithsonian Institution, 1992).
10 *Different Voices: A Social, Cultural, and Historical Framework for Change in the American Art Museum* (New York: Association of Art Museum Directors, 1992).
11 David Chapin and Stephen Klein, 'Forum: the epistemic museum', *Museum News*, 71(4), July/Aug. 1992, pp. 60–1, 76.
12 The International Movement for a New Museology (MINOM), an organization affiliated with the International Council of Museums (ICOM).
13 Stephen E. Weil, 'Rethinking the museum; an emerging new paradigm of essential museum functions reduces the number to three: preserve, study, and communicate', *Museum News,* 69(2), March/April 1990, p. 59.
14 Harold K. Skramstad, Jr., 'Interpreting material culture: a view from the other side of the glass', in Ian M.G. Quimby (ed.), *Material Culture and the Study of American Life* (New York and London: Norton, 1975), p. 180.

15 George W. Stocking, Jr. (ed.), *Objects and Other; Essays in Museums and Material Culture* (Madison: University of Wisconsin Press, 1985), pp. 11–12.

16 Edwina Taborsky, 'The discursive object', in Susan Pearce (ed.), *Objects of Knowledge* (London and Atlantic Highlands: Athlone Press, 1990), p. 52.

17 Ibid., p. 64.

18 Anthony Alan Shelton, 'In the lair of the monkey: notes towards a post-modernist museography', in Susan Pearce (ed.), *Objects of Knowledge* (London and Atlantic Highlands: Athlone Press, 1990), pp. 80ff.

19 Pierre Bourdieu, *Distinction: A Social Critique of the Judgement of Taste* (Cambridge MA: Harvard University Press, 1984), pp. 2–3.

20 Chapin and Klein, op. cit., p. 76.

21 Ibid., p. 61.

22 Michael M. Ames, 'Cultural empowerment and museums: opening up anthropology through collaboration', in Susan Pearce (ed.), *Objects of Knowledge* (London and Atlantic Highlands: Athlone Press, 1990), pp. 161–2.

23 Shelton, op. cit.

24 Deirdre C. Stam, 'Taming the beast; guidance for administrators on managing museum computerization', *Museum Management and Curatorship*, 11, 1992, p. 46; see also 'The high tech museum', *Museum News*, July/August 1992, passim.

25 George F. MacDonald and Stephen Alsford, 'The museum as information utility', *Museum Management and Curatorship*, 10, 1991, pp. 306–7.

26 Barry Gaither, 'Voicing varied opinions', *Museum News*, 68(2), March/April 1989, p. 50.

27 John Cotton Dana, 'A museum of service', *Survey Graphic*, February 1923; reprinted in April 1929, p. 1.

28 Nicholas Pearson, *The State of the Visual Arts* (Milton Keynes: Open University Press, 1982), p. 18, quoted by Ghislaine Lawrence, 'Object lessons in the museum medium', in Susan Pearce (ed.), *Objects of Knowledge* (London and Atlantic Highlands: Athlone Press, 1990), p. 108.

29 James T. Evans, 'Third sector management: the museum in an age of introspection-survival and redefinition for the 1980s', *Public Administration Review*, Sept./Oct. 1982, p. 460.

30 MacDonald and Alsford, op. cit., pp. 306–7.

31 Ibid., p. 307.

32 Andrew West, 'Museums and the real world', *Museums Journal*, 90, Feb. 1990, pp. 24–6.

33 Steven D. Lavine and Ivan Karp, 'Introduction: museums and multiculturalism', in Karp and Lavine, op. cit., p. 3.

34 Val Bott, 'Beyond the museum', *Museums Journal*, 90, Feb. 1990, p. 28.

35 Frederick Schmid, 'Can museums predict their future?', *Museum News*, 52, Nov. 1973, p. 49.

36 Bott, op. cit., pp. 33–4.

37 McDonald and Alsford, op. cit., pp. 306–9.

38 Estelle Jussim, 'The real thing: museums and communications', address given at the Museum of Photography at the George Eastman House, Rochester, New York, 25 April 1979.

39 Ibid., p. 25.

40 Walter Benjamin, *Illuminations* (New York: Schocken, 1936), p. 224.

41 Spencer R. Crew and James E. Sims, 'Locating authenticity: fragments of a dialogue', in Karp and Lavine, op. cit., p. 163.

42 Carol Duncan, 'Art museums and the ritual of citizenship', in Karp and Lavine, op. cit., pp. 93–4.

43 Donald Garfield, 'Dimensions of diversity: if museums are to respond to the challenges of cultural diversity, everything from exhibits to staffing to board composition must be scrutinized', *Museum News*, 68(2), March/Apr. 1989, pp. 43–8.

44 Manfred Eisenbeis, 'Elements for a sociology of museums', *Museum*, 24(2), 1972, pp. 117–19.

45 Weil, op. cit., p. 59.

46 Phillip M. Kadis, 'Who should manage museums?', *Art News*, 76, Oct. 1977, p. 48.

47 Skramstad, op. cit., p. 184.

48 American Association of Museums and The Metropolitan Museum of Art, *The Museum as Social Instrument* (Washington and New York: AAM/MMA, 1942), p. 48.

49 Gaynor Kavanaugh, *History Curatorship* (Washington: Smithsonian Institution, 1990).

50 Evans, op. cit., p. 463.

51 AAM/MMA, op. cit., p. 76.

52 Chapin and Klein, op. cit., p. 76.
53 Gerald George, *Visiting History* (Washington: AAM, 1990), p. 15.
54 Lavine and Karp, op. cit., p. 6.
55 Michael Baxandall, 'Exhibiting intention: some preconditions of the visual display of culturally purposeful objects', in Karp and Lavine, op. cit., pp. 36–7, 41.
56 Shelton, op. cit., p. 99.
57 Taborsky, op. cit., pp. 51–2; Lawrence, op. cit., p. 113.
58 Svetlana Alpers, 'A way of seeing', in Karp and Lavine, op. cit., pp. 26–7.
59 Shelton op. cit., p. 92.
60 Duncan, op. cit., p. 95.
61 Ibid., p. 102.
62 Timothy W. Luke, *Shows of Force: Power, Politics and Ideology in Art Exhibitions* (Durham and London: Duke University Press, 1992), p. 1.
63 Lawrence, op. cit., pp. 110–11.
64 Elaine Heumann Gurian, 'Noodling around with exhibition opportunities', in Karp and Lavine, op. cit., p. 178.
65 Nick Baker, 'Worlds apart?', *Museums Journal*, 90, Feb. 1990, p. 27.
66 Alexander, op. cit., p. 62.
67 Richard W. Flint, 'Living the legacy; today's emphasis on enticing the public has its roots in the old practice of mixing scientific arrangement with a "Theater of Marvels"', *Museums News*, 69(5) Sept./Oct. 1990, pp. 63–5.
68 George F. MacDonald, 'Change and challenge', in Karp, Kreamer and Lavine, op. cit., p. 175.
69 Andrew West, 'Museums and the real world', *Museums Journal*, 90, Feb. 1990, pp. 24ff.
70 Bott, op. cit., p. 33.
71 Ibid.
72 Evans, op. cit., pp. 463ff.; see also Alice McHugh, 'Strategic planning for museums', *Museum News*, 59, July 1980, pp. 23–5.
73 Bott, op. cit., p. 34.
74 Gaither, op. cit., p. 50.
75 Patrick Cardon, 'Museums and telecommunications', *ICOM News*, Summer 1989, p. 1.
76 MacDonald and Alsford, op. cit., p. 309.
77 John Perkins, 'CIMI's data movement'. *Museum News*, 71(4), July/Aug. 1992, pp. 24–6.

6

A blurring of the boundaries

Elaine Heumann Gurian

This chapter makes the important point that the boundaries between museums and other public institutions, sites, spaces and even technology-based storage systems are blurring. This has significant implications, especially for those involved in memory construction, sharing and communication. Our certainty about the definition of museums is disappearing and with it goes our assurance about where we are and what we are becoming. Observing visitors' use of the United States Holocaust Memorial Museum could cause us to change our understanding about how people use and act in museums. Further boundaries are blurring as the native communities worldwide ask museum personnel to change their methods of care of collections and alter rules of accessioned objects' use. Without acknowledging it, museum personnel are becoming more comfortable with reproductions and purpose-built material. Technology is making us a 'paperless' society. Our need for and understanding of 'authenticity' is changing, and we no longer rely purely on our objects to define our work. Are we destroying museums, changing with the times, or creating some new and potentially more vibrant and useful institutions? Can a new realignment and new definition of our institutions help us to create a more civil society? Do we wish to continue on this road?

Introduction

In twenty-five years, museums will no longer be recognizable as they are now known. Many will have incorporated attributes associated with organizations that now are quite distinct from museums; hence, the 'blurred boundaries' of the title. The process has been and will continue and seem gradual and inevitable.

The change will come slowly and maybe not overtly, though a new expanded definition of museums and these emerging hybrids will be embraced by the museum community. These many new museums are to be welcomed; there is the opportunity for the changed museum to make a more relevant contribution to our society.

The museum's relationship to its collections and to the ownership and care thereof will change, and in some instances already have changed. The distinct edges of differing function among libraries, memorials, social services centers, schools, shopping malls, zoos, performance halls, archives, theaters, public parks, cafes, and museums will (and in many cases, have already begun to) blur. On the content side, museums will become more comfortable with presentations that contain a multiplicity of viewpoints and with the interweaving of scientific fact and what is considered by some, but not by others, to be 'myth'. On the interpretive side, museums will rely less on collections to carry the story, and more on other forms of expression, such as stories, song and speech and the affective, dramatic and psychological power that their presentations can contain; and they will be less apologetic about including emotional and evocative messages. These changes will help museums become more effective storehouses of cultural information.

Rather than the collecting of objects defining museums, museums will be seen as aligned with other entities in new classifications. One important grouping – the one concentrated on here – is those institutions of memory that store and transmit our collective human and earthly past. Not surprisingly, this group of institutions will include libraries, archives and schools, but will also contain technologically-based storehouses such as databases, distance-learning sites and film, video and recording storage facilities. Institutions of memory will include, for example, religious centers and language classes.

While some will collect three-dimensional material, others will house songs, ritual, music, dance and stories. The defining element for this classification will be the storing and passing on of evident markers of culture and cultural transmission.

The United States Holocaust Memorial Museum

Significant trends in museums today lead to the conclusion that museums will become more closely aligned with other such institutions of memory. Let us start with the United States Holocaust Memorial Museum and the visitor behavior that can be observed there. The team that produced that place hoped to create a quality museum. They had no idea that they were creating an artistic masterpiece or that they were creating more than a museum. The United States Holocaust Memorial Museum has become an icon, a symbol, for the contemplation of personal responsibility, and a place to reflect on the excesses of government (even as it sits in the shadow of the US federal buildings).

The architecture and the permanent exhibition work so well together, they seem to be a single unified environment. The permanent exhibition is large and occupies space on three different floors. The linear route the viewer has to traverse includes an elevator ride; four glass bridges, each of which overlooks a four-story atrium; two towers (one of which holds the 'Tower of Faces' photographs from the town of Ejszyszki); two 'pause' spaces (one designed by Ellsworth Kelly and one by Sol Lewitt); and many galleries. The exhibition contains three films; nearly seventy different video programs; over five thousand individual items, which range in size from a railcar to a toothbrush; a few large castings of *in situ* historic monuments; lots of text; and thousands of photographs.

The museological implications are interesting and puzzling. Visitor behavior contradicts what is normally to be expected. Is this the exhibition that proves the rule? Or is it the exhibition that opens all rules to re-evaluation?

Rather than the usual one- and one-and-a-half-hour visit that people usually engage in, regardless of the size of the museum, visitors here stay much longer. Rather than conversational interactions with each other, they are quiet and almost reverential. Rather than ignoring their fellow visitors who are strangers, they show concern for each other's well-being. In the absence of research, one can only surmise that the visitor believes that this sojourn is more like a pilgrimage to a church, a gravesite, or a memorial than a museum visit and is therefore not to be entered into lightly. Could it be that the visitors' kindness stems from their desire to distance themselves from the behavior of the Nazi perpetrators they see depicted?

The exhibition is linear. Visitors must either follow the route offered or jettison the whole experience; they cannot alter their path. Everything previously understood about exhibitions produced for a democratic society suggests that successful exhibitions must offer visitor freedom of choice, so that they can decide the order in which they will experience exhibition elements and choose to skip some altogether. At the Holocaust Museum, that is certainly not the case. There is a fixed order. Does the willingness of the crowd to participate in this directed march

suggest that whenever one produces what the creator of the experience, Jeshajahu Weinberg, calls a 'narrative exhibition', visitors will not feel oppressed by being led? Alternatively, is this exhibition successful because the forced march that was part of the actual Nazi history is emotionally echoed by the viewers' optionless route?

The exhibition artefacts were chosen for their narrative illustrative value, quite like pictures in a children's book, even though some of them are extremely noteworthy. They are rarely there for their unique quality, but to add credence to the overall story. Likewise, the photos and the collections of photos grouped together in video presentations are there as evidence rather than as singular images. From the moment you enter the elevator to the time you exit two stories below the starting point, you are inescapably surrounded by the story. Is it this atmospheric surround that brings such power to the experience? Has the museum become a three-dimensional theater with a play containing crescendos, respites, and resolution?

There is seemingly endless text. We all know that visitors do not read. Yet, at the Holocaust Museum, many visitors read everything, even though the typeface is small, the text is long, and the reader needs a sophisticated vocabulary. Why does the audience read this lengthy group of texts? Is it the nature of the topic, the embedding within the environment, or a style of writing that is stark and without judgmental modifiers? Has the text become a novel and, like a good mystery, too engaging to put down?

The exhibition engages adolescents, the hardest age group for any museum to reach, especially when they come in groups of peers. Why is this so?

Museum professionals quizzed immediately after their visit say that they cannot integrate what they have just seen and need some time to reflect. Most people cannot immediately reengage with their normal lives. During the next week or so, they say that the images and ideas invade their thinking at odd moments. Is this because of the power of the story? Or because this narrative is presented in an encompassing multi-sensory environment that takes time for people to integrate? Or because, according to Howard Gardner, the different modes of intelligence needed to experience the exhibition do not have easy integrative pathways one to another?

People revisit this exhibition, contrary to expectations that this would be a single, though indelible, experience. They say that they return so that they can read more about areas that they did not fully explore in their previous visit. Are we to believe that if you fill an exhibition with too much information, rather than defeating visitor interest, it serves as an impetus to return?

And what about the subject matter! This is an exhibition about horrific news. Yet we do not see the voyeuristic behavior or hear sounds of titillation that, prior to the opening, was feared. Visitors emotionally prepare themselves to come and take on the visit as a journey of personal introspection. They, in their internal dialogue, decide not only how they would have behaved in the past, but also how they wish to behave in the future when confronted with issues of racism or government excess. This is not to suggest that this exhibition by itself is a change agent, creating a more concerned public out of its visitors. However, if museum professionals are interested in the role exhibitions can play within a civil society, visitors to this exhibition are worthy of long-range study to ascertain if exhibitions can be contributing factors in attitudinal change.

Further, the museum is used as metaphor in public debate by national and world leaders who assume in their discourse that their listeners have seen the museum. Members of the Museum's Council are asked to comment publicly on national policy and to appear at historic occasions at the side of the President of the USA. It is interesting that visiting heads of state visit the museum if they have not already done so.

Taking these elements together, the United States Holocaust Memorial Museum has blurred the boundaries between museum and theater, between museum and religious memorial, and has

become a national icon and public metaphor. Visitor experience in this museum should cause the museum community to rethink audience behavior, stay length, and exhibition technique.

Indigenous peoples

Recently, the George Gustav Heye Center of the National Museum of the American Indian opened in the Alexander Hamilton Custom House in New York. It is the first branch of the National Museum of the American Indian to do so; two additional sites are planned. Native Americans (and, by extension, other indigenous peoples) wish to have a profound effect on the shaping of museums in the future. In the USA, Canada, Australia, and New Zealand, many museum professionals now concede that native people are the legitimate spokespersons for the use and display of 'their' artefacts within the museum. New laws and museum policies state that material such as human remains, associated grave goods, and secret/sacred objects are subject to repatriation, regardless of the clarity of the provenance, if the acknowledged spokespersons of the applicable tribes so request. Thus, the exclusive right of museum personnel to decide what shall be included or excluded in their public exhibitions will, and in some cases already has, ended. The display of any objects without consultation with the native group and, by extension, any group importantly affected, will become obsolete.

At the three Custom House exhibitions, all label text includes native first-person narrative, sometimes alone and sometimes with anthropological and curatorial voices as well. Who can or should speak for the object are questions that have now been broadened. Upon reflection, the resolution of the Enola Gay exhibition controversy relies on the same premise. That is, it is the users of the object in question who have the primary right to control the narrative voice used.

The involvement of native peoples in the business of museums goes much deeper than mere presentation. They propose to change many of the most basic tenets of our profession regarding care of the collections made by their ancestors. Museums that hold native material are increasingly allowing those objects to be used during ceremonies to which the object is related. Using objects, of course, may affect their condition and is anathema to those who feel they are charged with preservation at all costs. This sending out of objects for use and subsequent return makes museums more like lending libraries than storage vaults. In some museums, the analogy to a process in America called 'self storage' is more apt. The native family or tribe need not cede ownership at all and withdraws the object whenever it is needed; the museum houses and preserves (and even displays) the object at other times, with the permission of the owners. The example of the Queen of England's access to her jewels held in the Tower of London is no different.

Additionally, because for some American Indians, the boundary between animate and inanimate things is translucent, how an object is to be housed and preserved interests them. Some objects need to be 'fed', some need to be separated from their neighbors, and some cannot be visited by women or by the uninitiated. Objects of one tribe should not sit next to objects of their traditional enemies, and most objects cannot be wrapped in such a way as to prevent them from 'breathing'. The demand to treat objects in storage in accordance with native wishes supersedes the increasingly technological methods of collection care that have been taught as good practice. This insistence by the peoples has caused conservators to reappraise more traditional conservation methods, and interest in the benefits of these older, less costly, methods is growing.

The case of the Zuni War Gods is perhaps the most dramatic example in which the preservation of objects is not seen as the ultimate good. Zuni War Gods were funerary figures of the Zuni tribe that were supposed to remain with the above-the-ground corpse until both had disinte-

grated. The Zuni tribe argued successfully in the courts that their graves had been desecrated and the War Gods stolen. Therefore, the objects should be returned and should be allowed to disintegrate as originally intended. The Zuni position was sustained and museums that held these objects have, by and large, returned them. The War Gods were placed in a secure vault open to the elements, where they are now disintegrating. Museums, through their care of collections, have had a key role in conserving the artifacts of many cultures, but preservation can no longer be seen as an absolute good, and the dimensions on what to preserve are no longer ours alone to make.

Museums that hold ethnological collections most commonly face these questions, but these issues do not relate only to natural history and history museums. When faced with requests to balance information arrived at by the scientific method and by the differing explanations of natural phenomena arising from alternate world views, what stand should museums take? How, for example, does one reconcile the current scientific explanation of the arrival of the American Indian in North America via the Bering Strait land bridge with the emergence from the Fourth World seen by some tribes as the creation explanation? Is one to be referred to as 'science' and one as 'myth'? Should both be presented in the same exhibitions as explanations of equal value? Does displaying both with equal weight open the door to the Flat Earth Society and the Creationists? Do we care? This is not a theoretical discussion, but one that gets wrestled with in all museums dealing with this material now. There are many museum people of good will struggling with these issues – some with frustration and some in a spirit of optimism, but all feeling that they are wandering in an unconventional and uncharted environment.

Native colleagues are not very interested in object display as the principal method of cultural transmission. They feel their culture is more aptly transmitted and understood through association with environments, language, dance, song, music, smell, and storytelling; and they, therefore, wish the public display of Indian material to include those methods. They do not seem alone in that position. There are other sections of our society, African-American people, for example, who wish to have their history publicly told, but find there are few readily available preserved artefacts, and so must look to other methods of presentation. They feel that much of their culture has been preserved in the form of stories, songs, food, and forms of speech and are interested in creating forms of presentation that will include them. It may be that the notion of a museum as primarily a display of objects fits best within a very few cultures. As the world's population continues to migrate and intermingle, institutions called museums that include more active methods of cultural transfer will be created. Sound, smell, and environmental setting will gain an ascendancy as methods of interpretation; and objects will become, not the *raison d'être,* but rather just one element in a complex presentation. In this regard, the multiple exhibition strategies of the Holocaust Memorial Museum and the preferences of indigenous people coincide.

The changing view of authenticity

Jeshajahu Weinberg, Director of the Holocaust Museum, was previously the founding director of the Museum of the Diaspora in Tel Aviv. When faced with no available collection and the desire to tell the more-than-five-thousand-year history of the migration of Jews, he made a decision to create a 'museum' that used all the most interesting technological presentational methods available at the time and reproductions of all the three-dimensional objects needed. There was not a single 'authentic' object in the entire presentation. That institution is now considered a museum, but whether it qualified as one was debated at its inception.

Science museums have had a long tradition of creating purpose-built tactile stations to illustrate scientific phenomena and, at least in the USA, many science museums have few or even no collections. Yet science centers are called 'museums', even though we continue to talk about museums as the place where the authentic object can be found. But this was hotly debated and at first they were denied AAM accreditation.

As we move to a time in which we are increasingly reliant on the most modern means of communications, the impact these methods will have on presentations within the institutions we currently call museums will be great. While the central tenet of museums has until now been the holding of material evidence, the major modern means by which we communicate with each other (telephone, Internet) either leave no material trace of that event – or, like computer printouts, faxes, photos, movies, CDs, tapes, and computer discs, the 'original' evidence can come in large runs of multiples. Except for the production of the visual and craft artists and the occasional handwritten letter, we are creating a plethora of evidence for which there is no unique object and, in many cases, no object at all.

Now, as we no longer produce much of the unique thing, we may be becoming much more comfortable with the idea and use of reproductions and copies. Uniqueness is losing its importance, and the definition of authenticity is broadening. Except in rare instances, we believe that all copies made from a photo negative are real enough, and it is the image that becomes the object. We will all have to struggle with what in the future constitutes the real object and what environments or parts thereof can be honorably replicated. Though not a new struggle (many of the dinosaur bones on display have long been castings), it becomes more complicated with the advent of easy digital manipulation of images.

Next steps

So what can be made of these examples? This is not a recitation intended to deconstruct museums. Rather, the desire is to review and then recombine. Out of these and other new threads may come the likelihood of producing institutions that use a multiplicity of 'meaning-making' process that fit better with people's natural learning and cultural-transference styles.

The Holocaust Museum has demonstrated that out of the fixed narrative can come enough points of empathy so that each visitor can find compelling relevance. The visitor has become engaged not only in information gathering, but also in an attitudinally and emotionally provocative process. The American Indians have helped redefine the place of collections within a rich complex of cultural transmission methods. Boundaries have been blurred, and a different way of focusing begins to emerge.

In the past, museums have been defined as belonging to a number of institutional categories; for example, as one of a number of cultural organizations that contribute to our 'quality of life'. Additionally, they have been placed in a category with other 'informal education' institutions. They have been further identified as part of a small group that acts as protectors of the original object. The suggestion here is that we create new categories and in doing so acknowledge the more central role these institutions play in our collective well-being. One of these groups in which museums can claim membership could be called 'institutions of memory'.

As we begin to dissect the elements that make up civil behavior, we discover that organized consensual rules of interaction help us humans, who tend to be violent and aggressive, live relatively peaceably within our own groups. These rules of behavior are transmitted in many forms by a wide variety of affiliative associations – family, religious, cultural, ethnic, class, etc. – each of which helps to define us. These groups need methods and structures for collecting their past

in order to study, alter current understandings accordingly, and pass accumulated wisdom on to the future. It is institutions of memory that store the collected past. Some of these institutions are individuals (storytellers, for example), some collect ephemeral material (song, for example), and some collect tangible material (museums, libraries, archive, for example). The boundaries between these institutions are blurring as we discover that we need, in some cases, to replace older and no-longer-functioning forms of cultural transmission and, in others, to take on the task of storing new kinds of material. Museums with their broadened definition can become important, and even central, institutions of memory.

Violence and acrimony seem to be increasing worldwide. While some of this violence is caused by the breakdown of community, in other cases, group coherence is maintained by hate of and violence toward others. Institutions of memory have been used both to foster a healthy and positive group recognition and to justify aggression toward others.

Thus museums and their kindred institutions can be used for either peaceable or aggressive ends and are not *a priori* institutions of good or evil. Citizens must, therefore, pay remedial attention to the fostering of those institutions that are seen to serve as agents of civilizing behavior and more peaceful coexistence. New and important research is helping to explain the importance of family, neighborhood, church, and other institutions that, when combined, could help us become individually safer, more disciplined and productive, and more communally responsible. Our collective opportunity is to ascertain how to create, restore, or re-create systems and organizations that can bring us a greater measure of nonviolent human interaction. As boundaries blur, museums can and should be counted among them.

The art museum as ritual

Carol Duncan

The special nature of art museum and gallery space has been, for some decades now, a significant preoccupation both in academia and in the academic sector. What is it that differentiates this public space from others? What forms of behavior does it demand from visitors and by what means does it do this?

This chapter seeks to answer these questions by examining art museum architecture, practices of display and behavioral conventions in visiting, with the help of the notion of 'ritual' drawn from the discipline of anthropology. Art museum and gallery space is viewed here as the carefully constructed stage and setting for a specific kind of secular ritual. This ritual is both personal and social. It is personal because of the visitor's individual choice to enter a 'liminal' zone in which a state of exaltation can be reached through contemplation of, and engagement – perhaps even a sense of communion – with, works of art presented as paragons of aesthetic beauty (and not, for example, as material elements of social histories). This relates to the Western model of aesthetic appreciation as a transforming, spiritual process. The art museum/gallery and the ritual it involves is also social in that it defines groups: those who are best equipped to enact the ritual find a confirmation of their personal and group identities in their learned and shared responses to the prompts of art museum and gallery space. This view of the conventional nature, philosophy and behavior of the visit is similar to Bourdieu's notion of 'cultural capital', and his account of the ability of some groups to use and accumulate the capital needed to interpret the 'codes' of the art museum and gallery.

Art museums have always been compared to older ceremonial monuments such as palaces or temples. Indeed, from the eighteenth through the mid-twentieth centuries, they were deliberately designed to resemble them. One might object that this borrowing from the architectural past can have only metaphoric meaning and should not be taken for more, since ours is a secular society and museums are secular inventions. If museum facades have imitated temples or palaces, is it not simply that modern taste has tried to emulate the formal balance and dignity of those structures, or that it has wished to associate the power of bygone faiths with the present cult of art? Whatever the motives of their builders (so the objection goes), in the context of our society, the Greek temples and Renaissance palaces that house public art collections can signify only secular values, not sacred rites. We are, after all, a post-Enlightenment culture, one in which the secular and the religious are opposing categories.

It is certainly the case that our culture classifies religious buildings such as churches, temples and mosques as different in kind from secular sites such as museums, court houses, or state capitals. Each kind of site is associated with an opposite kind of truth and assigned to one or the other side of the religious/secular dichotomy. That dichotomy, which structures so much of the modern public world and now seems so natural, has its own history. It provided the ideological foundation for the Enlightenment's project of breaking the power and influence of the church. By the late eighteenth century, that undertaking had successfully undermined the authority of

religious doctrine – at least in western political and philosophical theory, if not always in practice. Eventually, the separation of church and state would become law. Everyone knows the outcome: secular truth became authoritative truth; religion, although guaranteed as a matter of personal freedom and choice, kept its authority only for voluntary believers. It is secular truth – truth that is rational and verifiable – that has the status of 'objective' knowledge. It is this truest of truths that helps bind a community into a civic body by providing it a universal base of knowledge and validating its highest values and most cherished memories. Art museums belong decisively to this realm of secular knowledge, not only because of the scientific and humanistic disciplines practiced in them – conservation, art history, archaeology – but also because of their status as preservers of the community's official cultural memory.

Again, in the secular/religious terms of our culture, 'ritual' and 'museums' are antithetical. Ritual is associated with religious practices – with the realm of belief, magic, real or symbolic sacrifices, miraculous transformations, or overpowering changes of consciousness. Such goings-on bear little resemblance to the contemplation and learning that art museums are supposed to foster. But in fact, in traditional societies, rituals may be quite unspectacular and informal-looking moments of contemplation or recognition. At the same time, as anthropologists argue, our supposedly secular, even anti-ritual, culture is full of ritual situations and events – very few of which (as Mary Douglas has noted) take place in religious contexts.[1] That is, like other cultures, we, too, build sites that publicly represent beliefs about the order of the world, its past and present, and the individual's place within it.[2] Museums of all kinds are excellent examples of such microcosms; art museums in particular – the most prestigious and costly of these sites[3] – are especially rich in this kind of symbolism and, almost always, even equip visitors with maps to guide them through the universe they construct. Once we question our Enlightenment assumptions about the sharp separation between religious and secular experience – that the one is rooted in belief, while the other is based in lucid and objective rationality – we may begin to glimpse the hidden – perhaps the better word is 'disguised' – ritual content of secular ceremonies.

We can also appreciate the ideological force of a cultural experience that claims for its truths the status of objective knowledge. To control a museum means precisely to control the representation of a community and its highest values and truths. It is also the power to define the relative standing of individuals within that community. Those who are best prepared to perform its ritual – those who are most able to respond to its various cues – are also those whose identities (social, sexual, racial, etc.) the museum ritual most fully confirms. It is precisely for this reason that museums and museum practices can become objects of fierce struggle and impassioned debate. What we see and do not see in art museums – and on what terms and by whose authority we do or do not see it – is closely linked to larger questions about who constitutes the community and who defines its identity.

I have already referred to the long-standing practice of museums borrowing architectural forms from monumental ceremonial structures of the past. Certainly, when Munich, Berlin, London, Washington, and other western capitals built museums whose facades looked like Greek or Roman temples, no one mistook them for their ancient prototypes. On the contrary, temple facades – for 200 years the most popular source for public art museums[4] – were completely assimilated to a secular discourse about architectural beauty, decorum and rational form. Moreover, as coded reminders of a pre-Christian civic realm, classical porticos, rotundas, and other features of Greco-Roman architecture could signal a firm adherence to Enlightenment values. These same monumental forms, however, also brought with them the spaces of public rituals – corridors scaled for processions, halls implying large, communal gatherings, and interior sanctuaries designed for awesome and potent effigies.

Museums resemble older ritual sites, not so much because of their specific architectural references, but because they, too, are settings for rituals. (I make no argument here for historical continuity, only for the existence of comparable ritual functions.) Like most ritual space, museum space is carefully marked off and culturally designated as reserved for a special quality of attention – in this case, for contemplation and learning. One is also expected to behave with a certain decorum. Museums are normally set apart from other structures by their monumental architecture and clearly defined precincts. They are approached by impressive flights of stairs, guarded by pairs of monumental marble lions, entered through grand doorways. They are frequently set back from the street and occupy parkland – ground consecrated to public use. (Modern museums are equally imposing architecturally and similarly set apart by sculptural markers. In the USA, Rodin's *Balzac* is one of the more popular signifiers of museum precincts, its priapic character making it especially appropriate for modern collections.[5])

By the nineteenth century, such features were seen as necessary prologues to the space of the art museum itself:

> Do you not think that in a splendid gallery … all the adjacent and circumjacent parts of that building should … have a regard for the arts, … with fountains, statues, and other objects of interest calculated to prepare [visitors'] minds before entering the building, and lead them the better to appreciate the works of art which they would afterwards see?

The nineteenth-century British politician asking this question[6] clearly understood the ceremonial nature of museum space and the need to differentiate it (and the time one spends in it) from day-to-day time and space outside. Again, such framing is common in ritual practices everywhere. Mary Douglas writes:

> A ritual provides a frame. The marked off time or place alerts a special kind of expectancy, just as the oft-repeated 'Once upon a time' creates a mood receptive to fantastic tales.[7]

'Liminality', a term associated with ritual, can also be applied to the kind of attention we bring to art museums. Used by the Belgian folklorist Arnold van Gennep,[8] the term was taken up and developed in the anthropological writings of Victor Turner to indicate a mode of consciousness outside of or 'betwixt-and-between the normal, day-to-day cultural and social states and processes of getting and spending'.[9] As Turner himself realized, his category of liminal experience had strong affinities to modern western notions of the aesthetic experience – that mode of receptivity thought to be most appropriate before works of art. Turner recognized aspects of liminality in such modern activities as attending the theater, seeing a film, or visiting an art exhibition. Like folk rituals that temporarily suspend the constraining rules of normal social behavior (in that sense, they 'turn the world upside-down'), so these cultural situations, Turner argued, could open a space in which individuals can step back from the practical concerns and social relations of everyday life and look at themselves and their world – or at some aspect of it – with different thoughts and feelings. Turner's idea of liminality, developed as it is out of anthropological categories and based on data gathered mostly in non-western cultures, probably cannot be neatly superimposed onto western concepts of art experience. Nevertheless, his work remains useful in that it offers a sophisticated general concept of ritual that enables us to think about art museums and what is supposed to happen in them from a fresh perspective.[10]

It should also be said, however, that Turner's insight about art museums is not singular. Without benefit of the term, observers have long recognized the 'liminality' of their space. The Louvre curator Germain Bazin, for example, wrote that an art museum is 'a temple where Time seems suspended'; the visitor enters it in the hope of finding one of 'those momentary cultural epiphanies' that give him 'the illusion of knowing intuitively his essence and his strengths'.[11] Likewise, the Swedish writer Goran Schildt has noted that museums are settings in which we seek a state of 'detached, timeless and exalted' contemplation that 'grants us a kind of release from life's struggle and ... captivity in our own ego'. Referring to nineteenth-century attitudes to art, Schildt observes 'a religious element, a substitute for religion'.[12] As we shall see, others, too, have described art museums as sites which enable individuals to achieve liminal experience – to move beyond the psychic constraints of mundane existence, step out of time, and attain new, larger perspectives.

Thus far, I have argued the ritual character of the museum experience in terms of the kind of attention one brings to it and the special quality of its time and space. Ritual also involves an element of performance. A ritual site of any kind is a place programed for the enactment of something. It is a place designed for some kind of performance. It has this structure whether or not visitors can read its cues. In traditional rituals, participants often perform or witness a drama – enacting a real or symbolic sacrifice. But a ritual performance need not be a formal spectacle. It may be something an individual enacts alone by following a prescribed route, by repeating a prayer, by recalling a narrative, or by engaging in some other *structured* experience that relates to the history or meaning of the site (or to some object or objects on the site). Some individuals may use a ritual site more knowledgeably than others – they may be more educationally prepared to respond to its symbolic cues. The term 'ritual' can also mean habitual or routinized behavior that lacks meaningful subjective context. This sense of ritual as an 'empty' routine or performance is not the sense in which I use the term.

In art museums, it is the visitors who enact the ritual.[13] The museum's sequenced spaces and arrangements of objects, its lighting and architectural details provide both the stage set and the script – although not all museums do this with equal effectiveness. The situation resembles in some respects certain medieval cathedrals where pilgrims followed a structured narrative route through the interior, stopping at prescribed points for prayer or contemplation. An ambulatory adorned with representations of the life of Christ could thus prompt pilgrims to imaginatively re-live the sacred story. Similarly, museums offer well-developed ritual scenarios, most often in the form of art-historical narratives that unfold through a sequence of spaces. Even when visitors enter museums to see only selected works, the museum's larger narrative structure stands as a frame and gives meaning to individual works.

Like the concept of liminality, this notion of the art museum as a performance field has also been discovered independently by museum professionals. Philip Rhys Adams, for example, once director of the Cincinnati Art Museum, compared art museums to theater sets (although in his formulation, objects rather than people are the main performers):

> The museum is really an impresario, or more strictly a *régisseur,* neither actor nor audience, but the controlling intermediary who sets the scene, induces a receptive mood in the spectator, then bids the actors take the stage and be their best artistic selves. And the art objects do have their exits and their entrances; motion – the movement of the visitor as he enters a museum and as he goes or is led from object to object – is a present element in any installation.[14]

The museum setting is not only itself a structure; it also constructs its *dramatis personae.* These are, ideally, individuals who are perfectly predisposed socially, psychologically, and culturally to enact the museum ritual. Of course, no real visitor ever perfectly corresponds to these ideals. In reality, people continually 'misread' or scramble or resist the museum's cues to some extent; or they actively invent, consciously or unconsciously, their own programs according to all the historical and psychological accidents of who they are. But then, the same is true of any situation in which a cultural product is performed or interpreted.[15]

Finally, a ritual experience is thought to have a purpose, an end. It is seen as transformative: it confers or renews identity or purifies or restores order in the self or to the world through sacrifice, ordeal, or enlightenment. The beneficial outcome that museum rituals are supposed to produce can sound very like claims made for traditional, religious rituals. According to their advocates, museum visitors come away with a sense of enlightenment, or a feeling of having been spiritually nourished or restored. In the words of one well-known expert:

> The only reason for bringing together works of art in a public place is that ... they produce in us a kind of exalted happiness. For a moment there is a clearing in the jungle: we pass on refreshed, with our capacity for life increased and with some memory of the sky.[16]

One cannot ask for a more ritual-like description of the museum experience. Nor can one ask it from a more renowned authority. The author of this statement is the British art historian Sir Kenneth Clark, a distinguished scholar and famous as the host of a popular BBC television series of the 1970s, 'Civilization'. Clark's concept of the art museum as a place for spiritual transformation and restoration is hardly unique. Although by no means uncontested, it is widely shared by art historians, curators, and critics everywhere. Nor as we shall see below, is it uniquely modern.

We come, at last, to the question of art museum objects. Today, it is a commonplace to regard museums as the most appropriate places in which to view and keep works of art. The existence of such objects – things that are most properly used when contemplated as art – is taken as a given that is both prior to and the cause of art museums. These commonplaces, however, rest on relatively new ideas and practices. The European practice of placing objects in settings designed for contemplation emerged as part of a new and, historically speaking, relatively modern way of thinking. In the course of the eighteenth century, critics and philosophers, increasingly interested in visual experience, began to attribute to works of art the power to transform their viewers spiritually, morally, and emotionally. This newly discovered aspect of visual experience was extensively explored in a developing body of art criticism and philosophy. These investigations were not always directly concerned with the experience of art as such, but the importance they gave to questions of taste, the perception of beauty, and the cognitive roles of the senses and imagination helped open new philosophical ground on which art criticism would flourish. Significantly, the same era in which aesthetic theory burgeoned also saw a growing interest in galleries and public art museums. Indeed, the rise of the art museum is a corollary to the philosophical invention of the aesthetic and moral powers of art objects: if art objects are most properly used when contemplated as art, then the museum is the most proper setting for them, since it makes them useless for any other purpose.

In philosophy, Immanuel Kant's *Critique of Judgment* is one of the most monumental expressions of this new preoccupation with aesthetics. In it, Kant definitively isolated and defined the human capacity for aesthetic judgment and distinguished it from other faculties of the mind (practical reason and scientific understanding).[17] But before Kant, other European writers, for

example, Hume, Burke, and Rousseau, also struggled to define taste as a special kind of psychological encounter with distinctive moral and philosophical import.[18] The eighteenth century's designation of art and aesthetic experience as major topics for critical and philosophical inquiry is itself part of a broad and general tendency to furnish the secular with a new value. In this sense, the invention of aesthetics can be understood as a transference of spiritual values from the sacred realm into secular time and space. Put in other terms, aestheticians gave philosophical formulations to the condition of liminality, recognizing it as a state of withdrawal from the day-to-day world, a passage into a time or space in which the normal business of life is suspended. In philosophy, liminality became specified as the aesthetic experience, a moment of moral and rational disengagement that leads to or produces some kind of revelation or transformation. Meanwhile, the appearance of art galleries and museums gave the aesthetic cult its own ritual precinct.

Goethe was one of the earliest witnesses of this development. Like others who visited the newly created art museums of the eighteenth century, he was highly responsive to museum space and to the sacral feelings it aroused. In 1768, after his first visit to the Dresden Gallery, which housed a magnificent royal art collection,[19] he wrote about his impressions, emphasizing the powerful ritual effect of the total environment:

> The impatiently awaited hour of opening arrived and my admiration exceeded all my expectations. That *salon* turning in on itself, magnificent and so well-kept, the freshly gilded frames, the well-waxed parquetry, the profound silence that reigned, created a solemn and unique impression, akin to the emotion experienced upon entering a House of God, and it deepened as one looked at the ornaments on exhibition which, as much as the temple that housed them, were objects of adoration in that place consecrated to the holy ends of art.[20]

The historian of museums Niels von Holst has collected similar testimony from the writings of other eighteenth-century museum-goers. Wilhelm Wackenroder, for example, visiting an art gallery in 1797, declared that gazing at art removed one from the 'vulgar flux of life' and produced an effect that was comparable to, but better than, religious ecstasy.[21] And here, in 1816, still within the age when art museums were novelties, is the English critic William Hazlitt, aglow over the Louvre:

> Art lifted up her head and was seated on her throne, and said, All eyes shall see me, and all knees shall bow to me ... There she had gathered together all her pomp, there was her shrine, and there her votaries came and worshipped as in a temple.[22]

A few years later, in 1824, Hazlitt visited the newly opened National Gallery in London, then installed in a house in Pall Mall. His description of his experience there and its ritual nature – his insistence on the difference between the quality of time and space in the gallery and the bustling world outside, and on the power of that place to feed the soul, to fulfill its highest purpose, to reveal, to uplift, to transform and to cure – all of this is stated with exceptional vividness. A visit to this 'sanctuary', this 'holy of holies', he wrote, 'is like going on a pilgrimage – it is an act of devotion performed at the shrine of Art!'

> It is a cure (for the time at least) for low-thoughted cares and uneasy passions. We are abstracted to another sphere: we breathe empyrean air; we enter into the minds of Raphael, of Titian, of Poussin, of the Caracci, and look at nature with their eyes; we live in time past,

and seem identified with the permanent forms of things. The business of the world at large, and even its pleasures, appear like a vanity and an impertinence. What signify the hubbub, the shifting scenery, the fantoccini figures, the folly, the idle fashions without, when compared with the solitude, the silence, the speaking looks, the unfading forms within? Here is the mind's true home. The contemplation of truth and beauty is the proper object for which we were created, which calls forth the most intense desires of the soul, and of which it never tires.[23]

This is not to suggest that the eighteenth century was unanimous about art museums. Right from the start, some observers were already concerned that the museum ambience could change the meanings of the objects it held, redefining them as works of art and narrowing their import simply by removing them from their original settings and obscuring their former uses. Although some, like Hazlitt and the artist Philip Otto Runge, welcomed this as a triumph of human genius, others were – or became – less sure. Goethe, for example, thirty years after his enthusiastic description of the art gallery at Dresden, was disturbed by Napoleon's systematic gathering of art treasures from other countries and their display in the Louvre as trophies of conquest. Goethe saw that the creation of this huge museum collection depended on the destruction of something else, and that it forcibly altered the conditions under which, until then, art had been made and understood. Along with others, he realized that the very capacity of the museum to frame objects as art and claim them for a new kind of ritual attention could entail the negation or obscuring of other, older meanings.[24]

In the late eighteenth and early nineteenth centuries, those who were most interested in art museums, whether they were for or against them, were but a minority of the educated – mostly poets and artists. In the course of the nineteenth century, the serious museum audience grew enormously; it also adopted an almost unconditional faith in the value of art museums. By the late nineteenth century, the idea of art galleries as sites of wondrous and transforming experience became commonplace among those with any pretensions to 'culture' in both Europe and America.

Through most of the nineteenth century, an international museum culture remained firmly committed to the idea that the first responsibility of a public art museum is to enlighten and improve its visitors morally, socially, and politically. In the twentieth century, the principal rival to this ideal, the aesthetic museum, would come to dominate. In the USA, this new ideal was advocated most forcefully in the opening years of the century. Its main proponents, all wealthy, educated gentlemen, were connected to the Boston Museum of Fine Arts and would make the doctrine of the aesthetic museum the official creed of their institution.[25] The fullest and most influential statement of this doctrine is Benjamin Ives Gilman's *Museum Ideals of Purpose and Method*, published by the museum in 1918, but drawing on ideas developed in previous years. According to Gilman, works of art, once they are put in museums, exist for one purpose only: to be looked at as things of beauty. The first obligation of an art museum is to present works of art as just that, as objects of aesthetic contemplation and not as illustrative of historical or archaeological information. As he expounded it (sounding much like Hazlitt almost a century earlier), aesthetic contemplation is a profoundly transforming experience, an imaginative act of identification between viewer and artist. To achieve it, the viewer 'must make himself over in the image of the artist, penetrate his intention, think with his thoughts, feel with his feelings'.[26] The end result of this is an intense and joyous emotion, an overwhelming and 'absolutely serious' pleasure that contains a profound spiritual revelation. Gilman compares it to the 'sacred conversations' depicted in Italian Renaissance altarpieces – images in which saints who lived in different centuries miraculously gather in a single imaginary space and

together contemplate the Madonna. With this metaphor, Gilman casts the modern aesthete as a devotee who achieves a kind of secular grace through communion with artistic geniuses of the past – spirits that offer a life-redeeming sustenance. 'Art is the Gracious Message pure and simple,' he wrote, 'integral to the perfect life', its contemplation 'one of the ends of existence.'[27]

The museum ideal that so fascinated Gilman would have a compelling appeal to the twentieth century. Most of today's art museums are designed to induce in viewers precisely the kind of intense absorption that he saw as the museum's mission, and art museums of all kinds, both modern and historical, continue to affirm the goal of communion with immortal spirits of the past. Indeed, the longing for contact with an idealized past, or with things imbued by immortal spirits, is probably pervasive as a sustaining impetus not only of art museums, but many other kinds of rituals as well. The anthropologist Edmund Leach noticed that every culture mounts some symbolic effort to contradict the irreversibility of time and its end result of death. He argued that themes of rebirth, rejuvenation, and the spiritual recycling or perpetuation of the past deny the fact of death by substituting for it symbolic structures in which past time returns.[28] As ritual sites in which visitors seek to re-live spiritually significant moments of the past, art museums make splendid examples of the kind of symbolic strategy Leach described.[29]

Nowhere does the triumph of the aesthetic museum reveal itself more dramatically than in the history of art gallery design. Although fashions in wall colors, ceiling heights, lighting, and other details have over the years varied with changing museological trends, installation design has consistently and increasingly sought to isolate objects for the concentrated gaze of the aesthetic adept and to suppress as irrelevant other meanings the objects might have. The wish for ever closer encounters with art have gradually made galleries more intimate, increased the amount of empty wall space between works, brought works nearer to eye level, and caused each work to be lit individually.[30] Most art museums today keep their galleries uncluttered and, as much as possible, dispense educational information in anterooms or special kiosks at a tasteful remove from the art itself. Clearly, the more 'aesthetic' the installations – the fewer the objects and the emptier the surrounding walls – the more sacralized the museum space. The sparse installations of the National Gallery in Washington, DC, take the aesthetic ideal to an extreme, as do installations of modern art in many institutions. As the sociologist César Graña once suggested, modern installation practices have brought the museum-as-temple metaphor close to the fact. Even in art museums that attempt education, the practice of isolating important originals in 'aesthetic chapels' or niches – but never hanging them to make an historical point – undercuts any educational effort.[31]

The isolation of objects for visual contemplation, something that Gilman and his colleagues in Boston ardently preached, has remained one of the outstanding features of the aesthetic museum and continues to inspire eloquent advocates. Here, for example, is the art historian Svetlana Alpers in 1988:

> Romanesque capitals or Renaissance altarpieces are appropriately looked at in museums (*pace* Malraux) even if not made for them. When objects like these are severed from the ritual site, the invitation to look attentively remains and in certain respects may even be enhanced.[32]

Of course, in Alpers' statement, only the original site has ritual meaning. In my terms, the attentive gazing she describes belongs to another, if different, ritual field, one which requires from the performer intense, undistracted visual contemplation.

In *The Museum Age*, Germain Bazin described with penetrating insight how modern installations help structure the museum as a ritual site. In his analysis, the isolation and illumination of objects induces visitors to fix their attention onto things that exist seemingly in some other realm. The installations thus take visitors on a kind of mental journey, a stepping out of the present into a universe of timeless values:

> Statues must be isolated in space, paintings hung far apart, a glittering jewel placed against a field of black velvet and spot-lighted; in principle, only one object at a time should appear in the field of vision. Iconographic meaning, overall harmony, aspects that attracted the nineteenth-century amateur, no longer interest the contemporary museum goer, who is obsessed with form and workmanship; the eye must be able to scan slowly the entire surface of a painting. The act of looking becomes a sort of trance uniting spectator and masterpiece.[33]

One could take the argument even further: in the liminal space of the museum, everything – and sometimes anything – may become art, including fire-extinguishers, thermostats, and humidity gauges, which, when isolated on a wall and looked at through the aesthetizing lens of museum space, can appear, if only for a mistaken moment, every bit as interesting as some of the intended-as-artworks on display, which, in any case, do not always look very different.

In this chapter, I have been concerned mainly with arguing the general ritual features of art museums. These are: first, the achievement of a marked-off, 'liminal' zone of time and space in which visitors, removed from the concerns of their daily, practical lives, open themselves to a different quality of experience; and second, the organization of the museum setting as a kind of script or scenario which visitors perform. I also have argued that western concepts of the aesthetic experience, generally taken as the art museum's *raison d' être*, match up rather closely to the kind of rationales often given for traditional rituals (enlightenment, revelation, spiritual equilibrium or rejuvenation). In the chapters that follow, liminality will be assumed as a condition of art museum rituals, and attention will shift to the specific scenarios that structure the various museums discussed. As for the purposes of art museums – what they do and to whom or for whom they do it – this question, too, will be addressed, directly or indirectly, throughout much of what follows. Indeed, it is hardly possible to separate the purposes of art museums from their specific scenario structures. Each implies the other, and both imply a set of surrounding historical contingencies.

Notes

1 Mary Douglas, *Purity and Danger,* London, Boston, and Henley, Routledge & Kegan Paul, 1966, p. 68. On the subject of ritual in modern life, see Abner Cohen, *Two-Dimensional Man: An Essay on the Anthropology of Power and Symbolism in Complex Society,* Berkeley, University of California Press, 1974; Steven Lukes, 'Political ritual and social integration', in *Essays in Social Theory,* New York and London, Columbia University Press, 1977, pp. 52–73; Sally F. Moore and Barbara Myerhoff, 'Secular ritual: forms and meanings', in Moore and Myerhoff (eds), *Secular Ritual,* Assen/Amsterdam, Van Gorcum, 1977, pp. 3–24; Victor Turner, 'Frame, flow, and reflection: ritual and drama as public liminality', in *Performance in Postmodern Culture,* Michel Benamou and Charles Caramello (eds), Center for Twentieth Century Studies, University of Wisconsin-Milwaukee, 1977, pp. 33–55; and Turner, 'Variations on a theme of liminality', in Moore and Myerhoff, op. cit., pp. 36–52. See also Masao Yamaguchi, 'The poetics of exhibition in Japanese culture', in I. Karp and S. Levine (eds), *Exhibiting Cultures: The Poetics and Politics of Museum Display,* Washington and London, Smithsonian Institution, 1991, pp. 57–67. Yamaguchi discusses secular rituals and ritual sites in both Japanese and western culture, including modern exhibition space. The reference to our culture being anti-ritual comes from Mary Douglas, *Natural Symbols* (1973), New York, Pantheon Books, 1982, pp. 1–4, in a discussion of modern negative views of ritualism as the performance of empty gestures.

2 This is not to imply the kind of culturally or ideologically unified society that, according to many anthropological accounts, gives rituals a socially integrative function. This integrative function is much disputed, especially in modern society (see, for example, works cited in the preceding notes by Cohen, Lukes, and Moore and Myerhoff, and Edmond Leach, 'Ritual', *International Encyclopedia of the Social Sciences,* vol. 13, David Sills (ed.), Macmillan Co. and The Free Press, 1968, pp. 521–6.

3 As Mary Douglas and Baron Isherwood have written, 'the more costly the ritual trappings, the stronger we can assume the intention to fix the meanings to be' (*The World of Goods: Towards an Anthropology of Consumption* (1979), New York and London, W. W. Norton, 1982, p. 65).

4 See Nikolaus Pevsner, *A History of Building Types,* Princeton, NJ, Princeton University Press, 1976, pp. 118 ff.; Neils von Holst, *Creators, Collectors and Connoisseurs,* trans. B. Battershaw, New York, G. P. Putnam's Sons, 1967, pp. 228 ff.; Germain Bazin, *The Museum Age,* trans. J. van Nuis Cahill, New York, Universe Books, 1967, pp. 197–202; and William L. MacDonald, *The Parthenon: Design, Meaning, and Progeny,* Cambridge, Mass, Harvard University Press, 1976, pp. 125–32.

5 The phallic form of the *Balzac* often stands at or near the entrances to American museums, for example, the Los Angeles County Museum of Art or the Norton Simon Museum; or it presides over museum sculpture gardens, for example, the Museum of Modern Art in New York or the Hirshhorn Museum in Washington, DC.

6 William Ewart, MP, in *Report from the Select Committee on the National Gallery,* in House of Commons, *Reports,* vol. xxxv, 1853, p. 505.

7 *Purity and Danger,* op. cit., p. 63.

8 Arnold van Gennep, *The Rites of Passage (1908),* trans. M. B. Vizedom and G. L. Caffee, Chicago, University of Chicago Press, 1960.

9 Turner, 'Frame, flow, and reflection', op. cit., p. 33. See also Turner's *Dramas, Fields, and Metaphors: Symbolic Action in Human Society,* Ithaca and London: Cornell University Press, 1974, especially pp. 13–15 and 231–2.

10 See Mary Jo Deegan, *American Ritual Dramas: Social Rules and Cultural Meanings,* New York, Westport, Conn., and London, Greenwood Press, 1988, pp. 7–12, for a thoughtful discussion of Turner's ideas and the limits of their applicability to modern art. For an opposing view of rituals and of the difference between traditional rituals and the modern experience of art, see Margaret Mead, 'Art and reality from the standpoint of cultural anthropology', *College Art Journal,* 1943, vol. 2, no. 4, pp. 119–21. Mead argues that modern visitors in an art gallery can never achieve what primitive rituals provide, 'the symbolic expression of the meaning of life'.

11 Bazin, *The Museum Age,* op. cit., p. 7.

12 Goran Schildt, 'The idea of the museum', in L. Aagaard-Mogensen (ed.), *The Idea of the Museum: Philosophical, Artistic, and Political Questions, Problems in Contemporary Philosophy,* vol. 6, Lewiston, NY, and Quenstron, Ontario, Edwin Mellen Press, 1988, p. 89.

13 I would argue that this is the case even when they watch 'performance artists' at work.

14 Philip Rhys Adams, 'Towards a strategy of presentation', *Museum,* 1954, vol. 7, no. 1, p. 4.

15 For an unusual attempt to understand what museum visitors make of their experience, see Mary Beard, 'Souvenirs of culture: deciphering (in) the museum', *Art History,* 1992, vol. 15, pp. 505–32. Beard examines the purchase and use of postcards as evidence of how visitors interpret the museum ritual.

16 Kenneth Clark, 'The ideal museum', *ArtNews,* January, 1954, vol. 52, p. 29.

17 Kant, *Critique of Judgment* (1790), trans. J. H. Bernard, New York, Hafner Publishing, 1951.

18 Two classics in this area are: M. H. Abrams, *The Mirror and the Lamp,* New York, W. W. Norton, 1958, and Walter Jackson Bate, *From Classic to Romantic: Premises of Taste in Eighteenth-Century England,* New York, Harper & Bros., 1946. For a substantive summary of these developments, see Monroe C. Beardsley, *Aesthetics from Classical Greece to the Present: A Short History,* University, Alabama, University of Alabama Press, 1975, chs. 8 and 9.

19 For the Dresden Gallery, see von Holst, op. cit., pp. 121–3.

20 From Goethe's *Dichtung und Wahrheit,* quoted in Bazin, op. cit., p. 160.

21 Von Holst, op. cit., p. 216.

22 William Hazlitt, 'The Elgin Marbles' (1816), in P.P. Howe (ed.), *The Complete Works,* New York. AMS Press, 1967, vol. 18, p. 101. Thanks to Andrew Hemingway for the reference.

23 William Hazlitt, *Sketches of the Principal Picture-Galleries in England,* London, Taylor & Hessey, 1824, pp. 2–6.

24 See Goethe, cited in Elizabeth Gilmore Holt. *The Triumph of Art for the Public,* Garden City, New York, Anchor Press/Doubleday, 1979, p.76. The Frenchman Quatremère de Quincy also saw art museums as destroyers of the historical meanings that gave value to art. See Daniel Sherman, 'Quatremère/Benjamin/Marx: Museums, aura, and commodity fetishism', in D. Sherman and I. Rogoff (eds), *Museum Culture: Histories, Discourses, Spectacles, Media and Society,* vol. 6, Minneapolis and London, University of Minnesota Press, 1994, pp. 123–43. Thanks to the author for an advance copy of his paper.

25 See especially Paul Dimaggio, 'Cultural entrepreneurship in nineteenth-century Boston: The creation of an organized base for high culture in America', *Media, Culture and Society,* 1982, vol. 4, pp. 33–50 and 303–22; and Walter Muir Whitehill, *Museum of Fine Arts, Boston: A Centennial History,* 2 vols., Cambridge, Mass., Harvard University Press, 1970. In this chapter, I have quoted more from advocates of the aesthetic than the educational museum, because, by and large, they have valued and articulated more the liminal quality of museum space, while advocates of the educational museum tend to be suspicious of that quality and associate it with social elitism (see, for example, Dimaggio, op. cit.). But, the educational museum is no less a ceremonial structure than the aesthetic museum.

26 Benjamin Ives Gilman, *Museum Ideals of Purpose and Method,* Cambridge, Boston Museum of Fine Arts, 1918, p. 56.

27 Ibid., p. 108.

28 Leach, 'Two essays concerning the symbolic representation of time', in *Rethinking Anthropology,* London, Athlone Press, and New York, Humanities Press, Inc., 1961, pp. 124–36. Thanks to Michael Ames for the reference.

29 The art critic Donald Kuspit suggested that a quest for immortality is central to the meaning of art museums. The sacralized space of the art museum, he argues, by promoting an intense and intimate identification of visitor and artist, imparts to the visitor a feeling of contact with something immortal and, consequently, a sense of renewal. For Kuspit, the success of this transaction depends on whether or not the viewer's narcissistic needs are addressed by the art she or he is viewing ('The magic kingdom of the museum', *Artforum,* April, 1992, pp. 58–63). Werner Muensterberger, in *Collecting: An Unruly Passion: Psychological Perspectives,* Princeton, NJ, Princeton University Press, 1994, brings to the subject of collecting the experience of a practicing psychoanalyst and explores in depth a variety of narcissistic motives for collecting, including a longing for immortality.

30 See, for example, Charles G. Loring, a Gilman follower, noting a current trend for 'small rooms where the attention may be focused on two or three masterpieces' (in 'A trend in museum design', *Architectural Forum,* December 1927, vol. 47, p. 579).

31 César Graña, 'The private lives of public museums', *Trans-Action,* 1967, vol. 4, no. 5, pp. 20–5.

32 Alpers, 'The museum as a way of seeing', in Karp and Levine, op. cit., p. 27.

33 Bazin, op. cit., p. 265.

Visiting with suspicion
Recent perspectives on art museums and art museums

Chris Whitehead

Increasingly over the past couple of decades, the roles of art museums and galleries and the justification for their funding have been questioned and a number of tensions, issues and themes have come to the fore. In the past, art museums and galleries were seen as being agents of moral improvement. More recently, their roles have been expanded, with a number of significant new art museum and gallery initiatives playing a central position within economic regeneration projects. In addition, there have been the calls that these institutions should be more accessible, socially inclusive and working towards developing new audiences.

This chapter provides a useful overview and introduction to a range of the key themes that art museums and galleries face today. After reflecting on the issues related to culture-led economic and social regeneration, the chapter continues by considering reasons for visiting and visitor responses in terms of types of 'fruition', including the accumulation of 'cultural capital'. It engages with tensions between public perceptions and the institutionalized definition and legitimization of what contemporary art is accepted into the 'official' canon and what form art historical narratives take. It shows how, on the one hand, this institutionalization can shape, delimit or determine the forms that artistic creativity takes; whilst on the other, stimulating 'extramuseological' solutions for those artists who do not want to be contained (in all of the word's senses) by the four walls of the gallery.

Importantly, the chapter makes a case for the development of interpretative strategies capable of opening dialogue and debate on theoretical and intellectual concerns that normally remain unacknowledged in gallery space. This takes the emphasis of textual interpretation away from the authoritative and disembodied voice of the expert curator, and the passive reception of the visitor.

This chapter is intended as a general introduction to many of the most pressing themes which have surrounded art museums and galleries over the last fifteen years or so. How are the existence and funding of art museums and galleries justified? What might the rationales of visitors be, and what are the conventions of visiting? What are the stories of art told in gallery space and how contestable are they? Fundamental to all of these questions is the instability of art as a philosophical concept and as a category of material or activity, and the corollary ambiguity and perhaps even fraught nature of the relationships between us and what we think of as art (or what is presented to us as such). One aim of this chapter is to suggest that it may be opportune to explore these tensions in the display and interpretation of art (both historical

and contemporary), even though this may undermine many of the conventions of art curatorship and visiting.

In a recent essay, the critic and curator Raymund Ryan posed the following question:

> Is there any real need for art museums in the twenty-first century? Any actual need beyond some loose combination of browsing for the exquisite and often ludicrous object, a desire for acquaintance with curatorial fashion (epistemologies easily accessed on the Internet) and a feeling of superiority of Doing the Right Thing, among certain largely urban tribes? (2000:90)

As it stands, this question cannot yet be answered empirically. At its heart is disillusionment at the old claim that going to a gallery and looking at art has beneficial personal and social effects. In the nineteenth century, the art gallery was seen by policy makers as an agent of 'moral improvement' (Taylor, 1999:29–67), and, although few people would now use such a term, in recent years a substantial amount of research has attempted (with very questionable methods and results) to make similar claims, suggesting, for example, that the incidence of crime can be reduced through engagement with the arts (DCMS, 2001: point 6.22; Matarasso, 1997:35; cf. Merli, 2002). The key rationale of such research is to demonstrate unequivocally that art museums and galleries have just as much right to public funding as more obviously beneficial projects, such as building hospitals or providing council housing. However, no reliable causal link between looking at art in a museum or gallery (or any) context and what might be termed the range of socially optimum behaviours has yet been shown. Ryan's question presupposes an individual visitor – probably middle-class and of an appropriate milieu – who browses, desires and feels superior, gaining and consolidating cultural capital in doing so, according to a Bourdieuan paradigm [Bourdieu and Darbel, 1969 (1991); see also Mason in this volume]. For Ryan, the value of this exercise for the visitor seems to relate to egotism and perhaps also to snobbery, which, it seems to be implied, are inherently negative, or at least unsavoury foundations for visiting.

Let us dispense for a moment with the 'moral improvement' argument (and even the twenty-first century 'social inclusion' argument) as justification for the continued existence of art museums and galleries, and turn instead to economics. To pick the most conspicuous example, it is generally perceived that the Basque city of Bilbao has benefited from the presence of the Guggenheim Museum (Plaza, 2000); that the museum has transformed (through what has become known as the 'Bilbao effect') the city from an industrial backwater into a thriving, tourist hot-spot (perfect for weekend city breaks) with all of the associated economic benefits. This assumption underpins much art museum building at the moment (e.g. the Tate Modern on London's South Bank, the New Art Gallery Walsall, the Baltic Centre for Contemporary Art in Gateshead etc.), the theory being that a very visible new art museum will provoke more generalized economic regeneration (thus perhaps laying the foundations for social regeneration) in a given locality. The assumption is as hard to prove as it is to argue with, although it is worth voicing concern about exactly who benefits from economic regeneration projects (see Belfiore, 2002:95). But why is it that the art museum has become the conventional emblem of such projects instead of, say, the theatre, the cinema or the music venue (which seems to follow a close second after the art museum, for example, at Bilbao and Gateshead)? Perhaps the modernist (or postmodernist) public spaces of the art museum or gallery refer suggestively to the future qualities and attractiveness of the loft apartments that will be developed in nearby warehouses or developments, so that building a gallery is always a good first step in terms of economic returns!

(In this context, the rapid development of residential apartment buildings on the 'Baltic Quay' in Gateshead, near the Baltic Centre for Contemporary Art – which used, as a building, to be iconically isolated – is a clear example of a marriage between cultural and economic strategies.) Perhaps the art museum imposes a kind of cultural capital onto a place (though not necessarily onto its inhabitants), ensuring its economic potential for development targeted essentially at the middle classes. Perhaps it is related to philanthropist policy, with its roots in the nineteenth century, and the desire on the part of property developers and buyers to show charitable support for this philanthropy, which endeavours to throw open to the (potentially 'disadvantaged') masses a site normally associated with middle-class leisure, and all, most of the time, for free.

However, recently it has become fashionable to question the value of 'culture-led regeneration' as a universal panacea (Minton, quoted in Beckett, 2003), and even as a money spinner (Khan, 2003; Weaver, 2003). Here, for example, is one journalist's picturesque description of what he encountered after climbing the 'steep hillside and banks of fresh, green landscaping [which] separate the [Baltic] from the rest of the city [of Gateshead]':

> There are bits of cars and the remains of fires, and mattresses for homeless people improvised under railway arches. There is an abandoned pub and a long, blocked-up warehouse, its interior wallpapered with graffiti like an illicit rival to the Baltic. There are suddenly no pedestrians. An isolated roadside billboard promises 'a new £250m World Class Business Park', yet there is not much sign of its construction, due to start in 'early 2003'. Then the city centre comes into view. Like the old industrial zone, it is scheduled for redevelopment, but there are enough empty premises and charity shops to dent your optimism. A chipped and echoing concrete shopping centre with a multi-storey car park on top, Gateshead's best-known building before the Baltic, looms above. The car park's upper floors have been closed off. Down below, an old man in a leather coat and pressed grey trousers picks grapefruit out of a skip, as if it were the most natural thing in the world.
>
> (Beckett, 2003)

Hand in hand with this kind of pessimism (and stereotyping) go concerns that the philanthropic ideal of universal access to art is naive. Andrew McClellan (2003:33) notes that new museums and galleries *have* succeeded in attracting more people, but worries, along with Alan Wallach (2000), that the class profile of these increased audiences has remained identical and that they are still composed of the kind of egotistical visitor whom Raymund Ryan disparages in the quotation at the beginning of this essay (cf. Prior, 2003:58). Meanwhile, commentators such as James Cuno, an ex-director of the Fogg Art Museum and until recently of the Courtauld Institute, uphold the view that art museums are, and cannot be other than, elitist by definition, and that to stage shows with 'mass' appeal such as the Guggenheim's exhibitions of Armani clothes and Harley-Davidson motorbikes, is a travesty (McClellan, 2003:36). In this line of thinking, the quality of the art is more important than the numbers of people who visit in order to engage with it; but decisions as to quality in artworks, or even whole genres and bodies of material culture, are still apparently made by an art world intelligentsia not dissimilar from the educated gentlemen who, for David Hume in 1757, agreed upon a 'standard of taste'.

To respond briefly to Ryan's question, there are needs for art museums and galleries (whether they are *real* needs is another matter), but these needs are not necessarily 'noble' in the Victorian sense that regulated the early development of these institutions. As a conventional element in collective notions of enlightened western civilization, art museums and galleries become – whether we visit or not – players within our identities and egos, and within the economics of our

urban spaces and our lives. In this sense they seem practically indispensable. However, to be good postmodernists, we who visit (and perhaps even enjoy visiting) should be suspicious of ourselves and our motives.

In a recent television documentary, the art critic Brian Sewell stated that his normal response to a 'real' work of art (as opposed to something like Anthony Gormley's *Angel of the North*, which he was in the process of denigrating) was 'a wallop in the stomach' (BBC, 2003). Although this sounds painful, Sewell was in fact upholding a certain traditional view in art appreciation, which is that we have a special emotional response to art that is powerful enough to be, or seem to be, physical and perhaps even visceral. It raises the question of how we benefit from looking at art objects and therefore, to some extent, why we bother with art galleries. Is there some kind of special quality (or aura) which prompts in us a special emotional response, which, to use Stephen Greenblatt's definition of *wonder*, stops us in our tracks, 'to convey an arresting sense of unique-ness, to evoke an exalted attention'? (1991:42). In some ways the modernist 'white cube' and 'black box' displays are vehicles and celebrations of this idea that there is, after all, something profoundly affecting and transcendental about art objects, through their attempt to create (impossibly) distraction-free or 'neutral' conditions of engagement whereby our aesthetic responses can be purer. But to dip back into postmodern suspicion, we may question whether the assumption about emotional response has any foundation, and whether our so-called aesthetic appreciation of art is simply a learned response, a social construct which we buy into in order to construct personal and social images of ourselves, to perform our cultural duty, to clas-sify ourselves as 'gallery-goers' or intelligentsia of whatever variety. In other words: do we really have some form of 'aesthetic' encounter with art? Can this be identified and studied? What is the balance of nature and nurture in its determination? (See Csikszentmihalyi and Robinson, 1990, for some initial research into these and similar questions.)

Of course, there are numerous other possible reasons for visiting art museums and galleries. The visit may perhaps be a vehicle for escapism, for catharsis, for learning about art history (exactly *which* art history is a different matter, to which we will return), for learning about narra-tives (for example those represented in history painting) and it may constitute a formal opportu-nity – and perhaps in some way a pleasurable one – to look, examine and scrutinize things and to decode signs with greater energy and dedication than is necessary in other circumstances. We may engage with art objects creatively, using them to reminisce or imagine (see Hooper-Greenhill *et al.,* 2001a,b, for examples). Gavin Jantjes, the director of the Henie Onstad Kunstsenter in Oslo, recently termed the gallery a 'realm of enlightenment' from which you exit feeling 'slightly more aware of the world and yourself than you were when you entered' (Baltic *Producers* discussion, 2003). Perhaps we can pick and choose from all of these reasons and ratio-nales, and more. Nevertheless, art museums and galleries have tended to formalize our relation-ships with art and our expectations about processes of viewing and apprehending it (since Duchamp's submission of a porcelain urinal entitled *Fountain* to an open exhibition in New York in 1917, this is something with which artists and curators have sometimes played subver-sively). But these relationships, and these expectations, have uncertain foundations: just as there is no accepted definition of art, so our criteria for fruition are also vague and shifting. [A recent piece of research into fruition (Solima, 2000:18) flatly and confidently defined fruition by way of a graph, whose axes were 'the aesthetic dimension' and 'the cognitive dimension', respec-tively. 'Fruition', it was posited, exactly bisected the two axes. The assumptions inherent in this or any other such scheme appear to me to be completely untenable.]

The uncertain definitions of art and of fruition distinguish the display of art in museums from less unstable categories. For example, how often do we encounter the complaint that this or

that is not art? Conversely, we rarely hear it said, that 'this is not social history', or 'this is not archaeology'. Many museum visitors (or rather, people who engage with art in the museum/ gallery context in whatever way) clearly often believe that art *can* be defined, and that the museum should ensure that whatever goes into it *is definable* as *art*. Many early public museums developed in the Enlightenment, and were designed to some extent to define and classify natural and man-made objects, and eighteenth-century aesthetics reflect a view that art can be defined objectively. Arguably, something of this notion has survived and the museum is still popularly seen as a defining, legitimizing agent. This leads to indignation when its contents do not correspond to a certain popular definition of art. For example, commentators like the TV presenter David Frost were upset that the Tate had legitimized Tracey Emin's *Bed* by shortlisting it for the 1999 Turner Prize and including it in display: during a televised interview he asked her why it should be considered art; before long he answered his own question – because the Tate *thinks* it is. This is a kind of intuitive version of the institutional theory of art (for an overview of which see Carroll, 1999:224–40). Meanwhile, Rolf Harris (whose views are absorbed by a large public) defined the bed as not being art:

> I've always imagined that something to do with art should be artistic. [Art should be done by] somebody who's studied and learnt how to be extra special with whatever medium they're doing.
>
> (BBC, 2001)

Judging from opinions voiced in the media, a large proportion of the public has found that much of the art produced over the past decade neither corresponds to their concept of art nor to their standards of taste. The frequent complaint that 'a three-year-old could do that' reveals a concept of art which involves unusual technical ability and effort in accordance with traditional notions of 'making' and/or 'representing'. Ivan Massow, until early 2002 the Chairman of the Institute of Contemporary Arts, expressed something similar when he noted that contemporary conceptual art was 'pretentious, self-indulgent, craftless tat' (Massow, 2002). New art has also frequently shocked by offending moral standards, from Serrano's *Piss Christ* to Ofili's *Madonna* and Marcus Harvey's *Myra* (Dubin, 2000). Other art has shocked not so much through content as through presumption – the idea that the artist is taking the public for a ride, laughing at us, as in the case of Martin Creed's *The Lights Going On and Off.* There are a few reasons for accepting this piece of work (if such it can be termed) as a viable winner of the 2001 Turner Prize, but it did mark an important shift in terms of the relationship between an art world *au fait* with such conceits and a public no longer willing to admit the value or interest of it, as the head of the Tate empire Nicolas Serota's comment on the matter shows:

> We give them [i.e. the public] the purest, most dematerialized installation, and they still complain.
>
> (2001 press conference)

Here, Serota's very language is schismatic, and Roy Harris (2003:198–200) has recently explored similar instances of what he terms 'Serotaspeak'.

Interestingly, all of these works can be accounted for by various established theories of purpose in art, from anthropological perspectives through to the modernist notion of the artwork as a means of social criticism. I will not attempt to show how they can be boxed into theories here – I wish only to emphasize that none of these works so revolutionize the possibilities of what art

might be as to fall beyond existent, and actually rather old, theories of art and frameworks for understanding.

The problem is that these theories and frameworks are relatively inaccessible beyond the realms of specialist literature. The tendency in displays of contemporary art is not to provide written interpretation. There are interesting exceptions, such as the Irish Museum of Modern Art in Dublin and the Baltic in Gateshead (where written interpretation was provided for the 2003 Pedro Cabrita Reis exhibition only after some weeks and upon public demand). The employment of gallery attendants as *ad hoc* interpreters to whom visitors can turn if they require illumination is also fashionable, but is fraught with problems, not least the unwillingness of some visitors to exploit this resource. Art objects may well be seen, in some curatorial circles, to 'speak for themselves' and text interpretation may appear to impose a specific understanding of an art object on visitors where many are possible, and it is probably true that artists today expect to be able to show their work with little or no written interpretation. But the abnegation of responsibility which this implies can be far from ideal. What do curators think about artworks which might be problematic? What do the artists themselves think? In what histories of art are difficult works located? (For example, what are the links between Emin's bed, Duchamp's fountain and Van Gogh's chair?) In what ways are some contemporary artworks intentionally ambiguous, playful or humorous? Explaining this might kill the joke, but it might also mean that more people get it. The critic Matthew Collings recently noted that contemporary art *is* difficult, that the public *should* make an effort (2002). But maybe audiences should be met half way, by rendering the theories, judgements and uncertainties of artists, curators, critics and perhaps even visitors open to scrutiny and discussion. In short, it is time for galleries of contemporary art to experiment creatively and responsibly with written interpretation, to develop uses of language which are relevant and simple yet not 'dumbed down' and to produce text which does not shy away from theoretical uncertainties, and which is open-ended enough to allow visitors to engage with more than one interpretation of works of art.

A fascinating example of courageous (but flawed) experimentation can be found in Patricia Ellis' labels at the Saatchi Gallery in London, in which a conscious effort has been made to avoid academic language and to incorporate slang terms and references to popular culture. Here, for example, is the label for Tracey Emin's *I've Got It All*, an ink-jet print dating from 2000 (the photograph shows Emin sitting, legs apart, on the floor; she looks downwards intently at coins and banknotes which are scattered between her legs, some of which she clutches to her abdomen and crotch):

> Emin is almost always portrayed as a Diana-esque *femme tragique*. It's rare to get a glimpse of the happy, successful, confident person she's become. *I've Got It All* is a transient, crowning glory: a shameless, two fingers up to her critics. Emin's triumphed all over all, and has money up the wazoo to boot!
>
> (Ellis, 2003:209)

This is a powerful piece of interpretation, breaking many of the conventions and rules of gallery interpretation (also, the label's graphics and miniscule font size are at fault here). It is humorous, irreverent, engaging and fun to read and there is an attempt to speak a vernacular language less rarefied and more vibrant and relevant than the 'artspeak' usually associated with contemporary art. Measures of intellectual access such as reading age were probably not involved in the creation of the written interpretation at the Saatchi Gallery, but in another way it embodies a drive for wider access in using (ostensibly) more popular terms, figures of speech and references. Whether it succeeds is another matter. The fundamental flaw of this new kind of

interpretation, however, is that it presents a single interpretation (which in the case of Emin's *I've Got It All* is actually questionable as the image may not be at all celebratory) and thereby goes a long way to eradicating the possibility of others. This subjective and opinionated quality has led to criticism: Adrian Searle, for example, called the labels 'misinformative nonsense' (Searle, 2003), while Simon Ford laments the exclusion of traditional data within them ['where did these artists come from? How did they become so famous? Why is their work so important?' (2003:267)]. However, it is good to see some boundaries being transgressed, whether the results please or not.

Another concern with the institutionalization of difficult art in the art gallery is that it is seen to exclude some artistic potentials. This fear was voiced recently by Ivan Massow, who described conceptual art as a totalitarian 'official art' (Massow, 2002), and by Stuart Pearson Wright, who won the 2001 BP portrait award (with a figurative portrait) and used his success as a platform to criticize Serota for excluding all figurative art from the contemporary canon by not collecting it for the Tate. The shock factor is another area of unsettlement; the UK's key collector of contemporary art, Charles Saatchi, is thought to prefer provocative art, which artists therefore produce in the hope of a sale. One can respond that artists throughout history (with very rare exceptions) have always played to market forces, suppressing or modifying their 'creativity' in some way. However, in our postmodern but still rather romantic age some artists find this problematic and seek to bypass the patron and the museum so that their productions are not conditioned by someone else's desires or by the expectations of curators waiting to fit them into the canon. Examples of this include the shop opened by Sarah Lucas and Tracey Emin in 1993, the impermanent, unsponsored 'happenings' which have been common for almost half a century and the activities of landscape and net artists. These artists have sought what can be called 'extramuseological' solutions to the problem of compromised creativity, although it must be said that their avoidance of the gallery still implies, necessarily, a kind of dependency upon it: by their (often self-imposed) exclusion from gallery space, artists are able to present their work as the dangerous, subversive, avant-garde other. Meanwhile, when such 'extramuseological' work meets with success it is invariably incorporated into and appropriated by the art museum or gallery: happenings and performances are increasingly staged in or by the gallery, the drawings, photographs and maps of landscape artists such as Andy Goldsworthy, Richard Long and Christo and Jeanne-Claude make their way into the gallery, and even net art, potentially the *non plus ultra* of extramuseological strategy, is subsumed into the gallery (for example at Kiasma, or at the Whitney Biennial in 2000) with debateable results (see Cook *et al.*, 2001).

However, some works of art do manage to avoid display in gallery space (or being defined as 'public art', with all of its associations of worthy civic work) without sacrificing their visibility. Some notable, recent, sponsored events of this kind include Michael Landy's systematic destruction of everything he owned in his Artangel sponsored 'Breakdown' show at the old Oxford Street C&A in London, or the *Parklight* event held at Clissold Park in Stoke Newington in 2000, where the artist Tomoko Takahashi organized team games at night in which participants wore fluorescent headbands – and the games were such that visually this was a stunning thing to behold, never mind to participate in. Both of these events involved impermanence in some way: the game ended, or the possessions were destroyed – the antithesis of the museum's rationale to collect and preserve objects for perpetuity. Again, museological paradigms are conspicuous by their absence and even exclusion from such artistic processes. Nevertheless, such efforts to escape the dictatorship of gallery space have been frequent in recent decades, leading to the development of organizations like Artangel, which aim to develop new ways of engaging with artists and audiences for art. The profile and visibility of commissions such as Rachel Whiteread's

House is a testimony to the fact that the art museum or gallery is no longer the only driver in the art world, nor its only valid or most appropriate locus.

But what of historical art in the gallery? (I define this as: anything which is interpreted historically, and as art; but in practice 'historical' seems mainly to mean pre-1970s, if not pre-war.) The National Gallery in London, for example, is unlikely to be seen to quash artistic potentials today, because the artists represented in its collection are all dead. But it can promote historical artists to pre-eminent status (with an exhibition, or a key place in a permanent display) and relegate others, either to the oblivion of the storage facility or to the seclusion of the 'lower floor' galleries (where the hessian-covered walls and the functional, unassuming display make for an extraordinarily free viewing experience). In this way, its curators create hierarchies of value and tweak the canon, just as curators of contemporary art do when they programme exhibitions. Arguably, however, we tend not to be overly suspicious of this, because the historical canon is not as undefined or as publicly contested as the contemporary one. As to the 'is it art?' debate, it is unlikely that any of the works in the National Gallery collection will ever be seriously or hotly debated in such terms. This is because there is practically a complete agreement that it contains art, notwithstanding the gulf between modern views of art and those from the past (Shiner, 2003) and though it too contains works (e.g. by Van Gogh and Monet, to name but two) which were considered difficult to accommodate as art in the past. However, our historical distance from all of the works in the National Gallery has disabled us from thoroughly understanding controversies of this type. Written interpretation in the form of labels functions here like a final, incontrovertible verdict, saying that what we are looking at is indeed art and is beyond the sphere of controversial discussion.

Nevertheless, the National Gallery and other museums of non-contemporary art have special problems of their own, primarily concerning their representations of meta-narratives of art history. Over the past few decades, the 'New Art History' has challenged the bases of the kind of conventional historiographical display, which is concerned above all with connoisseurial classification of material culture in terms of chronology, 'school'/movement, style and authorship. It has also challenged, though to a lesser degree, the distinctions which isolate different bodies of material culture from one another. For example, why are 'fine' and 'decorative' arts so frequently segregated into different spaces or even different buildings? Should we still have to adhere to seventeenth- and eighteenth-century academic hierarchies of media? Some of these problems of representation are consequences of the histories of the museums and their collections themselves. For example, the National Gallery focuses on painting alone, and has what might, from a revisionist perspective, be considered disproportionate strengths in specific areas of the collection, such as fifteenth-century Florentine painting. This relates to nineteenth-century museological policies and preoccupations and practices of connoisseurship (which, for example, saw fifteenth-century Florence as the well spring of the Renaissance), and it would be difficult and perhaps undesirable to controvert the Gallery's historical nature in the pursuit of new art histories.

However, there are other questions that we can ask about the display of fine art. For example, why is it that in an art gallery paintings and sculptures are generally interpreted in terms of style and representational or formal content and not as social documents and as objects with historical social agency? Stephen Greenblatt touches on this in his discussion of *resonance* – 'the power of the displayed object to reach out beyond its formal boundaries to a larger world, to evoke in the viewer the complex, dynamic cultural forces from which it has emerged …' (1991:42) – which is a counterweight to his definition of *wonder*, discussed earlier. Broadly speaking, these two models of display have been seen to be in conflict with one another [although Greenblatt himself attempts to suggest that a satisfactory compromise is possible (1991:54)] and have

characterized a schism between, on the one hand, the art histories (or even the 'visual cultures') researched and taught in universities, which look at artistic processes and art objects and their consumption in a socio-historical context and, on the other, those presented in museums, which involve rather separate discourses – on creative genius (even if the word is nowhere used), on rarity and economic value, on workmanship, materials and technique, on style and on artists' biographies. This schism has become the subject of recent fora (Wallach, 1998:125; Haxthausen, 2002). Compromises have been attempted, such as the National Gallery's 1997–8 exhibition *Making and Meaning: Holbein's Ambassadors*, which diligently laid bare the myriad meanings and roles of this celebrated painting in sixteenth-century Europe, or the Musée d'Orsay's display of nineteenth-century French academic painting alongside more familiar avant-garde works, as well as furniture and decorative arts. About this display the art historian Svetlana Alpers noted:

> Works of lesser visual interest (e.g. Couture) are better placed for looking than those of greater visual interest (e.g. Courbet), and the paintings of lesser visual interest are not improved by this exposure. One critic [Linda Nochlin] has defended the Orsay by saying that the social history of art is not about what is visible but about what is invisible. All well and good, but then one might ask: how, or why, exhibit it in a museum?
>
> (1991:29)

This is also the kind of response we would probably witness if the National Gallery integrated its 'lower floor' collection into the main floor displays. Its philosophy is that art museum display should not seek to transgress the boundaries of the established canon. There is evidently some distance to be travelled before the 'two art histories' become one, or before a common desire for this to take place emerges. It is worth presenting comments from either side of the fence here. One British curator noted:

> Unfortunately so much art history in universities seems to me quite divorced from the real subject of art and has become an unsatisfactory ersatz vehicle for sociology, history, psychology and God knows what else. Fewer and fewer people coming out of university seem to know what a work of art is. A response needs above all to be based on a genuine love and pleasure of art.
>
> (Haxthausen, 2002:x)

Meanwhile Alan Wallach laments what he perceives as a conservative 'opposition to the historical understanding of art', but also notes that audiences too have conservative expectations which may prove obstructive:

> It will take years of patient labor by curators, as well as zealous support from museum administrators, to win over a public long accustomed to believing that art is the work of transcendent genius and thus 'speaks for itself'. The public will have to get used to the idea that, whatever else they may be, works of art are historical artefacts – an idea that flies in the face of all that art museums have stood for.
>
> (Wallach, 1998:127)

It may be, however, that while alienating some audiences, producing revisionist art histories in museum displays will attract new ones. This is ostensibly the case with 'Art on Tyneside' at the Laing art gallery in Newcastle, which may have been the catalyst for dramatically increasing

visitor numbers after its opening in 1992. The then director of Tyne and Wear Museums, David Fleming, wrote that this was where the 'revolution' of the 'humanisation' of art museums had begun. 'Notwithstanding some predictably adverse comments from the more reactionary end of the art historical profession', he noted, this was 'the shape of the future' (Fleming, 1992). This permanent display was conceived as 'a trip into the past' during which one learns 'about the rich history of art and craft on Tyneside, including paintings, silver, ceramic, glass and textiles'. The display uses 'sound, interactive games and open exhibits' and includes various tableaux, such as a noisy eighteenth-century coffee shop decorated by prints and populated with mannequins reading the *Newcastle Courant*. The display concludes with a video in which the north-eastern actor Tim Healey, of *Auf Wiedersehen Pet* fame, incites us to be proud of the achievements of our region (it is assumed that all visitors are local).

The risk here is that the local and very celebratory art history which it presents may bolster regionalism (not necessarily a bad thing), while being rather saccharine in its attempt to endear the gallery primarily to local audiences, with those from elsewhere unable to share in the communal pride-fest. Is the appeal to regionalism the only, or the best way to encourage communities to engage with histories of art? Whatever the answer, 'Art on Tyneside' was and is a fascinating attempt to reconcile populism, museum display and social histories of art, and forms an important precedent for later ventures elsewhere, such as the critically acclaimed British Galleries at the Victoria and Albert Museum in London, which manage with greater success to combine resonance and wonder. A very small number of fascinating comparable ventures elsewhere have involved borrowing techniques from social history curatorship. Live, first-person historical interpretation is an example of this, which by its nature dissolves the modernist aesthetic of the art work as a timeless, ahistorically hermetic masterpiece, and engagement with it as a silent, private and transcendental experience. The live interpretation company Past Pleasures, for example, recently staged a debate between Hogarth and Canaletto at Birmingham City Art Gallery, while Time Travellers have used live interpretation to explore the social histories represented in paintings such as George de la Tour's *The Dice Players* at the Preston Hall Museum (Whitehead, 2003). Elsewhere, for example at the Victoria and Albert Museum's excellent Photography Gallery, oral history techniques are used and incorporated into discreet audiovisual units, as well as into web resources available remotely (www.vam.ac.uk/vastatic/microsites/photography/). In this time of burgeoning and exciting interpretive techniques and technologies, it is important that art museums explore new potentials in curatorship, in order to be able to explore new forms of narrative and, on a more cynical note, in order to compete effectively with other types of museum for visitor interest and approval.

Another, perhaps more creative aspect of art historical revisionism is the Tate's negation of the modernist primacy of chronology and notions of 'progress' in displays of art (Sylvester 2000), through the careful and imaginative juxtaposition of works from quite different historical eras and contexts. At Tate Modern, for example, alternative taxonomies are created by the themes of 'History/Memory/Society'; 'Nude/Action/Body'; 'Landscape/Matter/Environment' and 'Still Life/Object/Real Life'. These themes are translated into environments in which Serota hopes to 'promote different modes and levels of 'interpretation' by subtle juxtapositions of 'experience'' (Serota, 2000:55). By 'interpretation', Serota means the arrangement and juxtaposition of artworks 'to give selected readings, both of art and the history of art' (2000:8–9), while 'experience' is a state of visual contemplation and concentration and perhaps (although Serota never states this explicitly) something like an epiphany, be it emotional, spiritual, or both. The dismantling of conventional chronology at the Tate galleries is a reaction against survey-like 'stories of art' (see Elkins, 2002) and Alfred Barr's 1936 'flowchart' of modern art, which was

enacted in early displays at the Museum of Modern Art in New York. Serota's intention to combine interpretation and experience also recognises the visitors' prerogative to explore 'according to their particular interests and sensibilities' (Serota, 2000:55; cf. Prior, 2003:65).

Seeing works by Monet and Richard Long in the same room is a shock to the system, encouraging us to dispense with our interiorized chronological frameworks of art history (assuming we have any) and to savour the communications and continuities between the works, as if 'art', 'artistry' and 'the artist' were universal constants whose meanings always remain the same. In discussing a similar thematic display at Tate Britain, the late critic David Sylvester noted that he had enjoyed many of the juxtapositions in that they had given him new insights into familiar works (though he wondered whether those insights were intended by the curators or merely happy accidents). As to the death of chronology, he noted:

> It is all very well for curators to want to ignore chronology. But chronology is not a tool of art-historical interpretation which can be used at one moment, discarded at another. It's an objective reality, built into the fabric of the work. And into the artist's awareness. An artist can paint a nude in the morning, a tea party in the afternoon; what he's conscious of all the time is his location in history.
>
> (Sylvester, 2000)

Sylvester concluded by bemoaning the egotism of the curators, concerned only with their 'territorial rights' and the primacy and sophistication of their creative insight into the artworks they had chosen to juxtapose. It may be that this show of curatorial cleverness [or 'courage', as Serota would have it (2000:50)] makes those visitors already possessed of the appropriate cultural capital think (or feel) again about art and its histories, but it is worth questioning whether less urbane audiences will be anything other than nonplussed at the subtle connections, tensions and ironies which bind the artworks in (literally) artificial synchronicity. However, it would be churlish to attack the Tate for having expunged the old regime of art historical meta-narratives only to replace it with a new, equally tyrannical one.

There are other museological tyrannies in existence at the moment: the tyrannical 'signature' building to whose space and grandeur the commissioned artist must respond; the policy makers' mantra of 'participation by all', which is leading artists (for better or for worse) to seek ways of involving communities in the processes of art; the sponsor and often the donor too, whose needs may very well relate to commerce; and ultimately the local authority, which frequently demands indicators of success only in terms of visitor numbers, and not in qualitative terms. This essay has attempted to make a few simple points: that art museums and galleries play complex roles in constructing geographical, social and personal identities, and in constructing narratives about art and its histories; and that these narratives can and perhaps should be contested by curators and visitors alike. But it is rewarding, occasionally, to let go of postmodern suspicion, allow oneself to be gullible, and enjoy the ride.

References

Alpers, S. (1991) 'The museum as a way of seeing', in Karp, I. and Lavine, S.D. (eds), *Exhibiting Cultures: The Poetics and Politics of Museum Display*, Washington: Smithsonian Institution.

BBC (2001) 'Modern art is a con, says Harris', available online at www.news.bbc.co.uk/1/hi/entertainment/arts/1492967.stm (accessed 19 August 2004).

BBC (2003) 'Art connoisseur faces his critics in the north', available online at www.bbc.co.uk/pressoffice/pressreleases/stories/2003/06_june/02/inside_out_brian_sewell.shtml (accessed 19 August 2004).

Beckett, A. (2003) 'Can culture save us?', *The Guardian*, 2 June.

Belfiore, E. (2002) 'Art as a means of alleviating social exclusion: does it really work? A critique of instrumental cultural policies and social impact studies in the UK', *International Journal of Cultural Policy*, 8(1), 91–106.

Bourdieu, P. and Darbel, A. with Schnapper, D. (1991) *The Love of Art: European Art Museums and Their Public*, Cambridge: Polity Press.

Carroll, N. (1999) *Philosophy of Art: A Contemporary Introduction*, London: Routledge.

Collings, M. (2002) *Is Britart Any Use?* available online at www.bbc.co.uk/arts/britart/collings4.shtml (accessed 19 August 2004).

Cook, S., Graham, B. and Martin, S. (2001) *Curating New Media: Third Baltic International Seminar, 10–12 May 2001*, Newcastle: Baltic.

Csikszentmihalyi, M. and Robinson, R.E. (1990) *The Art of Seeing: An Interpretation of the Aesthetic Encounter*, Los Angeles: Paul Getty Museum/Getty Education Institute for the Arts.

Department for Culture, Media and Sport (2000) *Culture and Creativity: The Next Ten Years*, London: DCMS.

Dubin, S. (2000) *Displays of Power: Controversy in the American Museum from Enola Gay to Sensation*, New York: New York University Press.

Elkins, J. (2002) *Stories of Art*, London: Routledge.

Ellis, P. (2003) *100: The Work that Changed British Art*, London: Jonathan Cape/Saatchi Gallery.

Fleming, D. (1992) 'Letter from Newcastle upon Tyne', *Museums Journal*, February, 56.

Ford, S. (2003) 'Saatchiworld: roll up, roll up', *Art Monthly*, June.

Greenblatt, S. (1991) 'Resonance and wonder' in Karp, I. and Lavine, S.D. (eds), *Exhibiting Cultures: The Poetics and Politics of Museum Display*, Washington: Smithsonian Institution.

Harris, R. (2003) *The Necessity of Artspeak: The Language of the Arts in the Western Tradition*, London: Continuum.

Haxthausen, C.W. (2002) *The Two Art Histories: The Museum and the University*, Cambridge, MA: Yale University Press.

Hooper-Greenhill, E., Moussouri, T., Hawthorne, E. and Riley, R. (2001a) *Making Meaning in Art Museums 1: Visitors' Interpretive Strategies at Wolverhampton Art Gallery*, Leicester: RCMG/University of Leicester.

—— (2001b) *Making Meaning in Art Museums 2: Visitors' Interpretive Strategies at Nottingham Castle Museum and Art Gallery*, Leicester: RCMG/University of Leicester.

Khan, S. (2003) 'What did culture ever do for us?', *The Observer*, 8 June.

McClellan, A. (2003) 'A brief history of the art museum's public era', in McClellan, A. (ed.), *Art and its Publics: Museum Studies at the Millennium*, Oxford: Blackwell.

Massow, I. (2002) 'It's all hype: conceptual art endangers real talent', *Resurgence*, May/June 2002 (reprinted from *New Statesman*, 21 January 2001), available online at www.resurgence.gn.apc.org/issues/massow212.htm (accessed 19 August 2004).

Matarasso, F. (1997) *Use or Ornament? The Social Impact of Participation in the Arts*, Stroud: Comedia.

Merli, P. (2002) 'Evaluating the social impact of participation in arts activities: a critical review of François Matarasso's *Use or Ornament?*', *International Journal of Cultural Policy*, 8(1), 107–18.

Plaza, B. (2000) 'Evaluating the influence of a large cultural artifact in the attraction of tourism: the Guggenheim Museum Bilbao case study', *Urban Affairs Review*, 36(2), 264–74.

Prior, N. (2003) 'Having one's Tate and eating it: transformations of the museum in a hypermodern era', in McClellan, A. (ed.), *Art and its Publics: Museum Studies at the Millennium*, Oxford: Blackwell.

Ryan, R. (2000) 'New frontiers', *Tate Magazine*, special issue, 90–9.

Searle, A. (2003) 'The trophy room', *The Guardian*, 15 April.

Serota, N. (2000) *Experience or Interpretation: The Dilemma of Museums of Modern Art*, London: Thames & Hudson.

Shiner, L. (2003) *The Invention of Art: A Cultural History*, Chicago: University of Chicago Press.

Solima, L. (2000) *Il pubblico dei musei: indagine sulla comunicazione nei musei statali italiani*, Rome: Gangemi.

Sylvester, D. (2000) 'Mayhem at Milbank', *London Review of Books,* 22(10).

Taylor, B. (1999) *Art for the Nation: Exhibitions and the London Public, 1747–2001*, Manchester: Manchester University Press.

Wallach, A. (1998) *Exhibiting Contradiction: Essays on the Art Museum in the United States*, Cambridge, MA: University of Massachusetts Press.

—— (2000) 'Class rites in the age of the blockbuster', *Harvard Design Magazine*, 11, 48–54.

Weaver, M. (2003) 'Benefits of Liverpool's culture crown "overestimated"', *The Guardian*, 4 June.

Whitehead, C. (2003) 'Live interpretation and art in museum, gallery and heritage studies', *Insights* (IMTAL newsletter).

Suggested further reading for Part 1

Arnold, J., Davies, K. and Ditchfield, S. (eds) (1998) *History and Heritage: Consuming the Past in Contemporary Culture*, Shaftesbury: Donhead.

Barker, E. (ed.) (1999) *Contemporary Cultures of Display*, New Haven: Yale University Press.

Blockley, M. (ed.) (2003) *Heritage Interpretation*, London: Routledge.

Boswell, D. and Evans, J. (eds) (1999) *Representing the Nation: A Reader – Histories, Heritage and Museums*, London: Routledge.

Brett, D. (1996) *The Construction of Heritage*, Cork: Cork University Press.

Carbonell, B.M. (ed.) (2003) *Museum Studies: An Anthology of Contexts*, Oxford: Blackwell.

Chitty, G. and Baker, D. (eds) (1999) *Managing Historic Sites and Buildings: Reconciling Presentation and Preservation*, London: Routledge/English Heritage.

Duncan, C. (1995) *Civilising Rituals: Inside Public Art Museums*, London: Routledge.

Graham, B., Ashworth, G.J. and Tunbridge, J.E. (2000) *A Geography of Heritage: Power, Culture and Economy*, London: Arnold.

Graubard, S.R. *et al.* (1999) 'America's Museums', *Dædalus, Journal of the American Academy of Arts and Sciences*, 128(3).

Greenberg, R., Ferguson, B. and Nairne, S. (eds) (1995) *Thinking about Exhibitions*, London: Routledge.

Grenville, J. (ed.) (1999) *Managing the Historical Rural Landscape*, London: Routledge/English Heritage.

Ham, S. (1992) *Environmental Interpretation: A Practical Guide for People with Big Ideas and Small Budgets*, Golden, CO: North American Press.

Harrison, R. (ed.) (1994) *Manual of Heritage Management*, Oxford: Butterworth/Association of Independent Museums.

Haskell, F. (2002) *The Ephemeral Museum: Old Master Paintings and the Rise of the Art Exhibition*, London: Yale University Press.

Hewison, R. (1987) *The Heritage Industry: Britain in a Climate of Decline*, London: Methuen.

Howard, P. (2003) *Heritage: Management, Interpretation, Identity*, London: Continuum.

Larkham, P. (1996) *Conservation and the City*, London: Routledge.

Lowenthal, D. (1985) *The Past is a Foreign Country*, Cambridge: Cambridge University Press.

—— (1996) *The Heritage Crusade and the Spoils of History*, London: Viking.

Lumley, R. (ed.) (1988) *The Museum Time-machine: Putting Cultures on Display*, London: Comedia/Routledge.

Macdonald, S. and Fyfe, G. (1996) *Theorizing Museums: Representing Identity and Diversity in a Changing World*, Cambridge, MA: Blackwell.

Merriman, N. (1991) *Beyond the Glass Case: The Past, Heritage and the Public in Britain*, Leicester: Leicester University Press.

O'Doherty, B. (1999) *Inside the White Cube: The Ideology of the Gallery Space*, Berkeley: University of California Press.

Perry, G. and Cunningham, C. (1999) *Academies, Museums and Canons of Art*, London: Open University.

Pickard, R. (ed.) (2000) *Management of Historic Centres*, London: Spon.

Pointon, M. (ed.) (1994) *Art Apart: Artefacts, Institutions and Ideology in America from 1800 to the Present*, Manchester: Manchester University Press.

Preziosi, D. and Farago, C. (eds) (2004) *Grasping the Word: The Idea of the Museum*, Aldershot: Ashgate.

Prior, N. (2002) *Museums and Modernity: Art Galleries and the Making of Modern Culture*, New York: Berg.

Samuel, R. (1995) *Theatres of Memory: the Past and Present in Contemporary Society*, London: Verso.

—— (1998) *Island Stories: Unravelling Britain*, London: Verso.

Serota, N. (2000) *Experience or Interpretation: Dilemma of Museums of Modern Art*, London: Thames & Hudson.

Taylor, B. (1999) *Art for the Nation: Exhibitions and the London Public, 1742–2001*, Manchester: Manchester University Press.

Tilden, F. (1977) *Interpreting our Heritage* (3rd edn), Chapel Hill: University of North Carolina Press.

Uzzell, D. (ed.) (1989) *Heritage Interpretation: The Natural and Built Environment*, London: Belhaven.

—— (ed.) (1989) *Heritage Interpretation: The Visitor Experience*, London: Belhaven.

—— and Ballantyne, R. (eds) (1998) *Contemporary Issues in Heritage and Environmental Interpretation*, London: HMSO.

Vergo, P. (ed.) (1989) *The New Museology*, London: Reaktion.

Wallach, A. (1998) *Exhibiting Contradiction: Essays on the Art Museum in the United States*, Amherst: University of Massachusetts Press.

Weil, S.E. (1990) *Rethinking the Museum and Other Meditations*, Washington: Smithsonian Institution Press.

—— (1995) *A Cabinet of Curiosities: Inquiries into Museums and Their Prospects*, Washington: Smithsonian Institution Press.

—— (2002) *Makings Museums Matter*, Washington: Smithsonian Institution Press.

Witcomb, A. (2002) *Re-imaging the Museum: Beyond the Mausoleum*, London: Routledge.

Wright, P. (1985) *On Living in an Old Country: The National Past in Contemporary Britain*, London: Verso.

Highlighting key issues

9

The reburial issue in the twenty-first century

Jane Hubert and Cressida Fforde

Contestation over ownership of human remains, grave goods, sacred objects and other culturally significant items is a current issue in heritage and museum studies. Claims on these remains and objects, and calls for their return and/or reburial have led to often well-publicized campaigns for and against their return. Although internationally there is a larger context regarding how human remains are treated and calls for the finding of bodies and the return of human remains in other situations, the issue in relation to archaeology, heritage and museums has been particularly focused by increasing demands from indigenous peoples for the return of remains and materials removed during periods of coloniszation.

This chapter provides an overview of the arguments for and against the return of human remains and material – and the tensions between them. On the one hand, there are the indigenous claimant's spiritual and cultural beliefs and motivations, as well as political agendas linked to self-determination, whilst on the other hand assertions have been made that the remains have scientific value and should be retained in institutional collections. This chapter considers attitudes and perceptions concerning the issue and introduces a wide range of experiences from different parts of the world. It refers to structures that have been set up in certain countries to engage with the issue, including the promulgation of the Native American Graves Protection and Repatriation Act (NAGPRA) into legislation in 1990 and its impact in the USA and in its influences beyond.

The past thirty years have witnessed the emergence of what has been widely, and loosely, referred to a the 'reburial' issue.[1] Australian Aborigines, Native Americans and, increasingly, indigenous peoples from other parts of the world, have campaigned for the right to determine the future of the human remains of their ancestors. In many cases, they are also claiming grave goods, sacred objects and other culturally significant items. In particular, this campaign has contested the ownership of human remains housed in museums and other institutions, and has commonly demanded that such material be returned to the cultural group in the area from which the human remains originated for final disposal. In addition, indigenous groups have sought to ensure that human remains found today, whether through archaeological excavation, construction work or other chance discovery, are returned to them. In the past, it was often standard procedure for indigenous remains to be automatically assigned to museum collections, whereas 'white' bones would be taken away to be buried immediately (Zimmerman, 1989).

The reburial issue has been widely represented as an indigenous issue, but it is not only indigenous people who wish for the return of their dead. People all over the world are concerned about the fate of the bodies of their kin and those of significant members of their cultural group. When wars end, the families of those who were killed often want their bodies brought back to

them so that they can be buried at home and properly mourned. In 2000, during the first visit of an American president to Vietnam since the Vietnam war, Bill Clinton collected the partial skeletal remains of one of the American troops killed during the conflict and previously deemed 'Missing in Action' so that they could be buried at home. Currently, forensic archaeologists are finding, excavating and trying to identify the remains of the 'disappeared' in many countries (for example, in Africa, South America and Eastern Europe), so that they can be returned to their families, and thus, to some degree, heal the wounds of the trauma of history (Thornton, 2001).

Indigenous groups request the return of the human remains of their ancestors for a number of reasons, but primarily on the grounds that their ancestors must be accorded funerary rituals appropriate to their cultural beliefs. Some consider the retention of remains in museums as spiritually dangerous. As is well known, all societies have some kind of death rituals, though they vary in form and function, and funerary activities have been of great interest to social anthropologists for many years. Such rituals have various functions. Some of these are for the spirit of the dead – to disentangle the soul from the body, to enable the spirit to be free, to help it reach another destination, or to enable resurrection, and so on. For the living, the rituals serve to formalize the death, to make the break between life and death visible and help people come to terms with the death, and enable them to mourn their dead. Death rituals may serve to reaffirm cultural beliefs, but they may also be, or form part of, a display by the living of their own standing and aspirations in society.

People in different cultures perceive and manage the boundary between life and death in different ways (Hockey, 1990). In many societies, death is not believed to occur at a single point in time, but is a process from one world to another, a journey over time, and enveloped in a body of rituals to bring this about. Thus without funerary rituals the process of death is considered incomplete. In some societies, if appropriate rituals are not carried out, a person's spirit is believed to be doomed to wander in limbo for eternity, or will return to the community bringing sickness or death (see Hubert, 1989).

The need to mourn and dispose of the dead with appropriate rituals is one of the reasons why people want the bodies of their dead returned to them, but the demand for return of human remains has other dimensions. It is also a means by which people – especially those who have been dispossessed – can assert their pre-eminent right to make their own decisions regarding what should happen to their ancestors' remains. In this way, they can lay claim to their own pasts and determine what should or should not be part of their cultural heritage.

This can also work in the opposite direction. In Zimbabwe, for example, there is a group who are demanding the disinterment, and exile from the country, of the human remains of an erstwhile national hero, Cecil Rhodes (Muringaniza, 2002). To some contemporary Zimbabweans, Rhodes' grave – which draws thousands of tourists every year – represents the colonial past and should not be considered part of Zimbabwe's national heritage. The current debate is about perceptions of Zimbabwe's cultural heritage, and how it is to be managed in the aftermath of colonial occupation. It is also about the wishes of the living, not the dead – Rhodes had specifically requested that he be buried in the Matopos hills.

It is in countries that have been colonized that the issue of the remains of the dead has acquired an added significance of its own. This is party because the beliefs and practices of colonized people are known to have been ignored and denied over many generations. The colonizers have not only taken over their lands, but have often deliberately tried to destroy their cultures and religious beliefs, as well as physically removing the human remains of their dead. What is now called the 'cultural heritage' of colonized peoples was plundered, and among the many things that were taken back to Europe were skeletons (especially skulls), mummified bodies, limbs, shrunken heads and various other anatomical specimens.

There are also other contexts in which human remains are removed from their resting place: for example, in the building of roads, bridges, railways, housing and commercial developments. Human remains have also been removed by archaeological excavation, to be studied by archaeologists and physical anthropologists, and to be stored and displayed in museums and university departments.

Many accounts of the colonists' treatment of the bodies of indigenous people from the late eighteenth through to the early twentieth centuries are shocking, but it should be remembered that in Britain, for example, as recently as the early nineteenth century, surgeons and anatomists were employing people to dig up the graves of the British poor to provide bodies for dissection by medical students. Although the Anatomy Act of 1832 made the practice of grave-robbing illegal, over 50,000 bodies of poor people who died in institutions are said to have been used for dissection up until the 1930s (Richardson, 1987). Clearly, those sections of the British population who were too poor to pay for proper burials, and as a result were interred in shallow graves, were considered sufficiently 'other' (by those who had higher status, power and authority) to be treated with what would normally be considered disrespect and inhumanity.

The reburial issue emerged from what was seen as a fundamental clash of interests, and by the 1980s it had been become the subject of intense debate, which has continued into the twenty-first century. There is no need to reiterate in detail here the well-known arguments on different sides (see e.g. Hammil and Cruz, 1989; Hubert, 1989, 1992; Mulvaney, 1991; Swidler *et al.*, 1997). Briefly, various indigenous groups have put pressure on museums and other institutions to disclose their holdings of human remains and funerary objects, to remove them from display and to return them to the communities concerned. Many museums have done so, sometimes being forced to do so by legislation (Anyon and Thornton, 2002), but some are still unwilling to disclose their holdings, let alone return human remains, in spite of repeated representations to them.[2]

It is worth nothing that as long ago as 1990, *The Times* wrote in an editorial devoted to the subject of the return of Australian Aboriginal skeletal remains: 'No curator can rest easy in his mind about holding on to such items.' Yet in spite of this support, as Fforde (2002a) observes, museums refuse to return human remains, and the implications of one cultural group assuming the right to carry out scientific research on the bodies of another group are profound. The scientific analysis of the 'Aboriginal body', comparative anatomy and physical anthropology 'fashioned an identity for Aborigines, the effects of which reached far beyond the boundaries of the laboratory' (ibid.). Fforde looks in detail at the way in which collecting and repatriation are intricately linked with identity, a connection also clearly expressed by Palm Island (2002), Martinez Barbosa (2002) and Engelbrecht (2002).

Although some suggested arrangements such as Keeping Places (Aird, 2002; Hanchant, 2002) allow for the possibility of future access to human remains, cremation or reburial mark the loss to science of a unique source of information about the past. Indigenous claims for the return of their ancestors' remains have thus been opposed by many who study and curate such items. With present techniques, human remains can provide archaeologists and biological anthropologists with data about such things as past diseases, diet, social practices, population movement and human evolution (see, for example, *World Archaeological Bulletin* 6, 1992). With the development of such techniques as DNA analysis, scientists are now able to elicit even more information from human remains, even perhaps from the most ancient ones.

Although the potential of future research has been, and still is, a common argument put forward by scientists who wish to retain skeletal material, this argument has sometimes been undermined. For example, evidence from the analysis of a large number of bodies from the crypt

of Christ Church cemetery in Spitalfields, London, in the 1980s, whose age and date of death were known, raises significant questions about the reliability of standard – and hitherto presumed to be accurate – osteological techniques. Estimations of age at death using these techniques, for example, were found to be inaccurate when matched with the written records. This led some of the researchers on the project to conclude (Molleson *et al.*, 1993:213) that: 'The lesson from Christ Church must surely be that it is extremely dangerous to make assumptions about populations from skeletal samples.' Another example is the controversy (*Sydney Morning Herald* 05.05.01) among archaeologists and physical anthropologists regarding the date of Australia's 'most ancient skeleton', Mungo Man, resulting from differing interpretations of DNA samples taken from the remains.

The history of the study of skeletal remains has produced many 'truths', which have been subsequently disproved, rejected or qualified. Yet what is held to be the primary reason for the retention of remains – their potential importance for future scientific research – is asserted without question. Those requesting the return of remains say that, in any case, scientists have had long enough to study them, and if they have not done so already – and in many cases collections have lain unused for decades – these remains should not suddenly be deemed crucial because of their possible use for future research.

Another argument frequently voiced against the return of human remains is that the study and curation of such items was not an issue among indigenous populations until their political organizations campaigning for reburial began to gain international publicity. This is refuted by Turnbull (2002), who considers that the scientists' claim to moral ownership is at best tenuous. He presents documentation of a long history of concern and care for human remains among Australia's indigenous people, which not only demonstrates their determination to prevent the desecration of burial sites and the removal of human remains and funerary objects, but also that this was widely recognized by the Europeans involved. Indeed, Turnbull (ibid.) reveals that in mid-nineteenth-century colonial Australia, the British government legally recognized the right of indigenous people to own and control land when it was used for mortuary ceremonies. The British law of the land drew no distinction between the protection it gave to indigenous and settler dead. Turnbull discusses the profound implications of the colonial British recognition of Aboriginal burial sites and also draws attention to the central, and frequent, accounts about mortuary rites and ceremonies that have been ignored by the wider community, and which could be invaluable to those making decisions about repatriation today. So far, these have been very largely ignored.

The confrontation between indigenous people and scientists in the context of the reburial issue has frequently appeared in the media. Joyce (2002) suggests that 'much discussion of the impact of repatriation has centred on a false polarity pitting native people against scientists, as if either category were a real unity'. Although the polarized views of many archaeologists and indigenous people have emerged strongly in the 'reburial' issue (see Zimmerman, 2002), neither group is an homogenized, undifferentiated whole, in which all share the same views.

The recent ongoing disputes between Australian Aborigines, Hawaiians and other indigenous peoples, and institutions such as the Natural History Museum in London, demonstrate that 'ownership' of human remains continues to be claimed by scientific institutions. However, Simpson (2002) is optimistic that many museum curators in Britain (though by no means all) are beginning to change their attitudes. Whether or not this is so, in 2000 the issue of the return of indigenous human remains entered the national political agenda in Britain. A joint Australian/UK prime ministerial statement was issued, agreeing 'to increase efforts to repatriate human remains to Australian indigenous communities'.[3] A Parliamentary Select Committee

was set up later that year (see Simpson, 2000), followed by a working group on human remains in March 2001. This movement of the reburial issue into national politics echoed a similar shift that occurred in Australia and the USA ten to fifteen years before.

It is clear that it was not a change in the attitudes of academics which brought about widespread repatriation, but the intervention of politicians and the development of legislation, perhaps also aided by exposure in the media. It will be interesting to see whether a similar development occurs in the UK. As Anyon and Thornton (2002) note in their analysis of what can be learned from repatriation legislation in the USA: 'to guarantee that repatriation will occur, and occur in a structured manner, it is essential that repatriation legislation be enacted. Relying purely on the goodwill of institutions or individuals to implement repatriation often promotes ineffective, inadequate, and arbitrary efforts'.

The development of legislation does not mean that the attitudes of specialists necessarily change. Nagar (2002), for example, records his own lack of agreement, as an archaeologist, with the recent (1994) reinterpretation of Israel's Antiquities Law by the orthodox Jewish leadership in Israel. This law demands that *all* human remains that are uncovered, whatever their faith, must be immediately reburied. Thus in Israel *every* human remain is reburied, no matter what its cultural affiliation, to ensure that all bones that might possibly be of Jewish ancestry are reinterred. In this example, the identification of past cultural affiliation is not a pre-eminent criterion in deciding what to do with excavated remains. In other examples, identifying the origin of human remains is of crucial importance, and the question of how to deal with unprovenanced remains, or those whose cultural affiliation is unclear or contested, has emerged as one of the most difficult aspects of decisions about what to do with repatriated items.

The symbolic power of the return of human remains to a formerly oppressed people is vividly described by Thornton (2002), both in personal and historical terms. It is claimed that the return of human remains and important cultural objects from traumatic events of the past can begin to heal the wounds of the people as a group, and help them to come to terms with the past. The ability for repatriation to heal past wrongs is echoed by Sellevold (2002) (and see also Martinez Barbosa, 2002), who describes the first Saami reburial ceremony of two skulls as a 'symbolic rectification of past and present oppression, both against the families of the deceased and against the Saami people by the Norwegian authorities'. Schanche (2002) describes the history of the exploitation of the Saami people, both dead and alive, who were perceived as static, doomed and 'primitive', and even as an 'alien inland people' who had moved westward, rather than as the indigenous inhabitants of Norway. Currently Saami representatives are negotiating the return of a large collection of skulls from the Institute of Anatomy in the University of Oslo (and see Ucko, 2001, for further details of the factors involved in Saami claims).

The retention of human remains in museums, against the wishes of claimants, is frequently seen as a continuance of the attitudes and perceptions which oppressed indigenous groups throughout colonialism. Those in control of collections deny this accusation, and assert that they are not responsible for the actions of early collectors, even through they now curate items collected during the colonial period.

The reburial issue was brought into international archaeological focus at the first World Archaeological Congress (WAC) in 1986, where archaeologists were drawn into debate with indigenous participants – Native Americans, First Nation people from Canada, Indians from South America, Australian Aborigines, Inuit, and Saami people – about their claims for the return of the remains of their ancestors. This led WAC, in 1989, to draw up a position statement, the Vermillion Accord, which called for respect for the mortal remains of the dead, irrespective of origin, race, religion, nationality, custom and tradition, and for the wishes of the

local community and relatives of the dead, as well as respect for the scientific research value of human remains. It also stipulated that agreement on the disposition of human remains should be reached by negotiation on the basis of mutual respect for the 'legitimate concerns of communities, as well as the legitimate concerns of science and education'. (See Zimmerman, 2002, for the full text of the Accord.) Zimmerman (ibid.) discusses the impact of the Accord and suggests that it may even have been one of the factors that influenced the US Congress to finally make decisions about how the federal government should treat human remains and funerary goods.

The Native American Graves Protection and Repatriation Act (NAGPRA) and the National Museum of the American Indian Act (NMAI Act) are by far the most significant pieces of legislation developed so far regarding human remains and funerary goods, and their enactment in the early 1990s has proved a powerful influence far beyond the USA. McManamon (2002) reports that in spite of concerns about adequate financial and staff resources and other various problems encountered, 'thousands of government, museum and academic professionals in hundreds of museums and agency offices have been able to arrive at acceptable resolutions to hundreds of NAGPRA cases with thousands of Native Americans'. Anyon and Thornton (2002) discuss NAGPRA's ramifications, while Joyce (2002) examines the relationships which emerge from it regarding concepts of academic freedom.

Isaac (2002) presents a case study of the problems encountered, as a result of NAGPRA, by museums that contain very large collections. Thus the Peabody Museum of Archaeology and Ethnography (PMAE), because of a lack of financial resources, has found it difficult to meet the imposed deadlines for summaries and inventories. Only recently has the museum found the money to improve the situation. The process of repatriation is considerably slowed by the fact that there are vast quantities of previously uninventoried human remains and funerary objects in the PMAE. This unprofessional state of affairs is evident in other museums as well. For example, the Natural History Museum in London is only now beginning to catalogue its large and very long-standing collection of indigenous material. This situation severely undermines claims that the material is held by museums because it is a source of important information for use by researchers.

The process of repatriation from the PMAE is also delayed because disagreements may arise between Native American groups about which of them are more closely affiliated to specific human remains or objects. As noted above, there is also controversy regarding the disposition of *unaffiliated* human remains and associated funerary goods. Some Native American groups consider that unprovenanced or poorly provenanced material should be reburied in the general area of origin, whereas others would prefer that the remains are retained by the museum. This situation is also found in other countries. In Australia, for example, Hanchant (2002) persuaded her family to keep (what was assumed to be) their relative's skull in the South Australian Museum until she had conducted further archival research to try and locate the related post-cranial material. The skull proved not to be that of her relative, and was therefore no longer claimed by her family.

This highlights a number of important points: first, museum records cannot always be relied on for their accuracy; second, the repatriation process requires detailed archival research to determine or validate provenance; third, relatives may, in some instances, choose to keep remains (temporarily or permanently) in museums; and fourth, the return of human remains may not always result in harmony within the group receiving them, but dissension.

Hanchant recommends that remains whose cultural affiliation is unknown be kept in a National Keeping Place until decisions about their disposition are made – by Aborigines. She suggests that wide consultation would be required to establish agreement among groups who may in fact have very different ideas about what should happen to the remains. As McKeown

(2002) describes, in the USA the NAGPRA Review Committee considers matters regarding items with little or no associated cultural affiliation information. Their role is potentially highly important since, as Watkins (2002) suggests, in instances where cultural affiliation is unclear or contested, museums may play one tribe against another, and in this way retain control over grave goods and cultural artefacts.

When cultural affiliation is unclear, the question of who should have authority to determine what should happen to returned material – and the decision making process which takes place to make such a determination – is of vital concern. It is not only lack of provenance information which can lead to uncertainty as to cultural affiliation of remains, but this also may occur when remains are uncovered in an area where the modern community has no apparent biological or cultural connection to them. For example, in South Africa, Fish (2002) describes a fifteenth-century archaeological site which, from archaeological evidence, appears to relate to pre-Venda, Sotho-speaking peoples, whereas the contemporary community is almost entirely Venda. This community did not wish to claim the remains, and this, as well as the fear that traditional healers might dig up the remains in order to extract medicinal substances from them, contributed to a decision to take the remains to the Anatomy Department of the University of Pretoria.

Another excavation in South Africa, at Thulamela, led to initial disagreement between two different local groups because of the alleged lack of clear cultural continuity of the site to modern communities (Nemaheni, 2002). Because of this uncertainty, when the remains of two bodies were found at the site, problems arose about who should rebury them. Neither group wanted to be 'associated with the dead', and also no one wanted to be seen to be associated with 'other people's ancestors'. After debate, the reburial went ahead, although those who undertook the ceremony were later criticized for erecting Christian crosses on the graves. As Nemaheni describes, the challenges made explicit by the Thulamela reburial have informed more recent projects which have, consequently, been less problematic.

The first reburial, in any cultural group, is by definition a totally new experience. Decisions have to be made about what rituals are the appropriate ones to carry out. Thus new traditions are developed. For some, being given the responsibility to carry out a reburial involves intense training in traditional values. Ayau and Tengan (2002) describe the difficulties that young Native Hawaiians had learning the necessary cultural protocols from the Elders for carrying out their first reburial 'due to our weakness in speaking our native language and understanding traditional values and practices as a result of our Western upbringing', and, for some, there was the added difficulty of reconciling this training with their Christian values.

Even if the provenance of remains is known, there may be other problems when the remains are returned. As Fforde describes (2002b), the reburial of Yagan's skull has been delayed while archaeologists, on behalf of Aborigines, try to locate the exact position of his post-cranial remains, buried in an unmarked grave following his murder in 1833.

Decisions about what should be done with repatriated human remains and grave-goods when they are returned may not be straightforward. Failure to immediately rebury remains may evoke criticism – and the suggestion that such delays reflect indifference to ancestors – and demonstrates an overwhelming political agenda. However, as Ucko (2001:231) points out: 'It is too easy for those opposing the repatriation of human remains to ignore the need for lengthy considerations of the appropriate way to handle the new situation which has created unprovenanced mixtures of ancestral remains'.

Whatever the political contexts of repatriation demands may be, and however complex the issues involved, there can be no doubt about the depth of feeling involved in such demands. The repatriation issue often centres on a heartfelt appeal for the return of the remains of a significant

leader of the past. One of these comes from Engelbrecht (2002), who writes from the perspective of those people in South Africa descended from the Khoisan and Griqua people, who were classified as 'Coloureds' by the apartheid regime. They have claimed the remains of a Griqua chief, Cornelis Kok II, who is seen as part of a heritage denied to them by apartheid policies – 'we want to return to our roots'. The repatriation of Kok's remains must, he states, be under Griqua control, and the necessary funding supplied, as the group demands that they should no longer be 'neglected and excluded in major decisions and budgets that will heal our people'. Thus in this case there are two linked, but different, agenda. The demand for the return of human remains is one component of a demand for recognition, and a degree of autonomy. It also represents the re-emergence of an 'ethnic group', which had been submerged by group ethnicities prescribed by the apartheid regime.

Martinez Barbosa (2002) also describes a claim for the return of a named individual, a Uruguayan Charruas leader, who died while being exhibited in a circus in France, and whose remains are held by the Musée de l'Homme in Paris. Like Engelbrecht, he sees the return of this former leader as 'an historic expression of justice for a dispossessed people ... [which would recognize] the identity of indigenous descendants as part of their own heritage, despite their minority status'.

Walter Palm Island (2002) reports on the return of the remains of his great-great-uncle Tambo, a Manbarra man from Palm Island, Australia, who had been taken to the USA, also to be exhibited in a circus. He describes how this repatriation gave the young people on Palm Island a sense of identity: Tambo 'has become an ancestor for all the Palm Island people, not only the Manbarra'. In this case, Tambo's return appears to have established a new cultural identity and cohesion for a heterogeneous people who had not all originated from Palm Island – the island had been a penal settlement in which 'Aborigines of different tribal cultures and customs ... were thrown together' (Rosser, 1994). The cultural cohesion brought about by Tambo's return, at least temporarily, was even more poignant because those who had been sent to Palm Island had been forbidden by law to carry out any of their own cultural practices or ceremonies (ibid.; see also Fforde 1997).

For Parsons and Segobye (2002), the struggle to repatriate the body of a stuffed 'bushman' (popularly known as 'El Negro') exhibited in a Spanish museum also raises many issues (and see Jaume *et al.*, 1992), such as how peoples are represented, how human remains are perceived and how the identity of individuals can be appropriated (and these issues are clearly interwined). Identified simply as 'El Negro', his body appears to have been displayed, without any explanatory label, in order to represent the 'African race'. The display also conveyed multiple implicit messages about how Africans were viewed by the society that made his body an exhibit, not least perceptions of 'primitiveness', 'savagery' and 'inferiority'.

In the days prior to his return, the Spanish authorities reduced the body of El Negro to skeletal remains. This act of desecration removed the final vestiges of his human form, and may have been intended to confirm his status as 'object'. Arriving in Botswana as bare bones in a small box, his identity as El Negro was then in doubt. Despite criticism that he should have been re-interred in his place of origin, the Botswana government buried him in the Tsholofelo Park, Gaborone. His burial place has become a national monument, his identity now appropriated by Botswana as a national symbol.

Ayau and Tengan (2002) narrate the struggle, or 'journey', to repatriate Native Hawaiian human remains and grave goods under the auspices of the NAGPRA process. They describe the repercussions of this struggle in terms of the strengthening of cultural values and the heightening of awareness of the damage wreaked by colonization: 'The disturbance of our burials is

intimately tied to colonization – the complicated processes by which Euro-Americans appropri-ated our lands, exploited our resources, disenfranchised our people and transformed the very way we think about who we are'. For Ayau and Tengan, repatriation and reburial are the means to re-establish harmony between the living and the dead, and the land, and to restore mana to Native Hawaiians.

From these accounts, there is no doubt of the immense spiritual and material significance of these remains and objects. Repatriation from this perspective is not only a question of regaining ownership of property, though possession and control are fundamental requirements, it is also seen as a process towards the re-creation of the wholeness of the people receiving the remains of their ancestors.

Although members of a community may be united in their desire to have the human remains and grave goods of their ancestors returned, there may be disagreement among them about what happens when they are. Among the Native Hawaiian people who have struggled to get their human remains returned (Ayau and Tengan, 2002), there are serious ongoing disagreements over the disposition of some grave goods (though not the human remains, which all are agreed should be buried). Some groups opposed the burial of these funerary objects, arguing that they should be preserved for future generations. Those who rebury them consider that the wishes of the ancestors and traditional values necessitated this action. It seems that those who oppose the reburial of grave goods are concerned more with the preservation of cultural markers for the future and less with conforming to traditional ways of managing these objects.

The Hawaiian example serves to demonstrate that communities may differ in what they feel should be done with significant items of cultural property. Similarly, Watkins (2002) describes an example where two separate groups could lay claim to funerary objects from the Spiro Mounds in Oklahoma, USA, one considering that repatriated grave goods, although sacred, should be 'proudly displayed', and the other that grave goods should be buried 'away from the sight of individuals who had no right to view them'.

In New Zealand, claims of ownership of cultural objects have resulted in successful partner-ships between Maori groups and museums. Some traditionally oriented Maoris working with museums are rejecting 'repatriation' in favour of the establishment of Maori museum advisory groups, which are involved in the decision-making process regarding the trusteeship and resource management of Maori cultural objects (Kawharu, 2002; Tapsell, 2002). Tapsell suggests that such claimants may be attempting to 'redefine [ancestral treasures] and human remains as pan-Maori identity markers' in order to gain 'wider access to Crown controlled resources'.

Aird (2002) describes the loan (not return) of cultural objects by the Museum of Queensland to Australian Aboriginal groups who can demonstrate that they are culturally affiliated to the objects. He sees this loan as a form of repatriation, an example of 'cultural knowledge' being returned to the community. As a museum curator, he also sees it as an opportunity to build a relationship between Aboriginal groups and the museum. It also illustrates that the reburial issue is at times one process through which the 'divide' between indigenous people and museums can be bridged to the mutual benefit of all those involved.

Endere (2002) raises important issues regarding the disposition of repatriated remains in relation to concepts of identity, in particular the nature of ethnicity and indigeneity within the nation-state. In 1990, the remains of a Ranquel chief, Mariano Rosas, were released for repatria-tion by the La Plata Museum, Argentina. The Secretary of Culture of La Pampa decided to build a monument in the capital city of La Pampas, to house Rosas' remains, as well as the remains of chiefs from other indigenous groups. This was to ensure that the nation's history would appear

more pluralist: 'we are trying to rescue the Pampean identity and the indigenous peoples are part of this identity' (Endere, 2002). However, the Ranquel people contested this attempt to appropriate the identity of their chief, saying that his resting-place should not be a monument for tourists: 'our ancestors should lie in peace in their own land'. In contrast, a small sign outside the mausoleum containing the returned remains of another Argentinian chief, Inakayal, 'welcomes' visitors, although it is not known whether it attracts tourists (see Endere, 2002, Fig. 23.6). Significantly, the mausoleum is not located in a capital city, but in the open country, close to the area where Inakayal lived.

Issues of identity permeate the whole concept of repatriation. Individual cultural groups may oppose the merging of their identity with other cultural groups whom they regard as distinct from themselves, but where there has been comparatively recent oppression and destruction of a nation's indigenous population, there will, perhaps inevitably, be a perceived need to create a pan-indigenous identity within a national population. As Fforde (2002a) writes, 'the perception and construction of Aboriginal identity play a significant role in both repatriation requests and argument put forward by those who have opposed them'. Repatriation can 'not only articulate, strengthen and construct local Aboriginal identity but Aboriginality as a pan-Australian commonality'. Thus repatriation can create a 'commonality' between cultural groups that did not exist in pre-colonial times, but has become relevant and necessary in the face of the legacy of colonialism. The process can change the cultural identity of a group, and the way that members of the group see themselves (and see Ucko, 2000).

Although repatriation of human remains has become policy in many places, there continues to be a great divide, at least in some parts of the world, between those who excavate them, curate them in museums, and draw up legislation about them, and those whose ancestors they are believed to be, to whom they are being repatriated. This is demonstrated by the way that different interest groups talk about human remains; thus, for example, Walter Palm Island (2002), when his ancestor, Tambo, came home, said that a Nyawaygi speaker was needed 'because it was crucial to be able to address Tambo's spirit in a language he would understand – to identify us as people from his own region, to tell him that he was being brought home'. All the indigenous accounts of repatriation and reburial reflect the perception of the remains of their ancestors as 'living' people – even if only a skull or other scant remains have come back to them. This contrasts with the language of scientists and museum curators, which articulates the perception that remains are objects, labelled and classified components of a collection, and of the lawyers, who write about them as objects of negotiation.

However, the contrast in language and approach between cultural groups and those who study and curate human remains is not impermeable, and the scientific approach to remains is not always consistent with the view that human remains are primarily data. Named individuals, or those who have known descendants, are frequently the first 'types' of remains to be returned by institutions (in countries where repatriation legislation for all human remains does not exist). There is no scientific basis for this distinction (and see Pardoe, 1991). It may be that those in charge of museums in fact agree with the indigenous perception of named remains as 'dead people', and thus believe that burial is an appropriate course of action. On the other hand, refusal to return 'anonymous' bones implies that unnamed remains are not similarly considered, despite cultural beliefs that state otherwise. It may be that the anonymity of remains-as-data is central to their positioning as 'objects'.

Significantly, modern DNA analysis now appears to have the capacity to identify the modern relatives of ancient remains. When DNA analysis of the 5,000-year-old 'Iceman', a frozen body recovered from the Italian Alps in 1991, identified a living relative, Marie Moseley, the scientist

responsible for this discovery Professor Bryan Sykes (Institute of Molecular Medicine, Oxford University) noted that:

> Marie began to feel something for the Iceman. She had seen pictures of him being shunted around from glacier to freezer to post-mortem room, poked and prodded, opened up, bits cut off. To her, he was no longer the anonymous curiosity whose picture had appeared in the papers and on television. She had started to think of him as a real person and as a relative, which is exactly what he was.
>
> *The Sunday Times*, 20 May 2001

The Iceman's anonymity was eroded, for Moseley, by the authority of science, which 'proved' that he was her distant ancestor. For indigenous groups claiming ancient remains as their ancestors, the authority lies in cultural beliefs.

The decisions that are taken by museums about which human remains should be returned appear to be determined more by how the dominant society defines what (or who) constitutes 'the dead' than by the needs of science. The wishes of indigenous groups are certainly not of primary concern, as many requests make no distinction between named or unknown individuals, post-colonial remains or fossils.

In fact, not all museums distinguish between named and unnamed individuals. The University of Edinburgh, UK has agreed to return all the remains in its collection 'when so requested, to appropriate representatives of cultures in which such remains had particular significance'. On the other hand, the Musée de l'Homme in Paris does not allow the return of named individuals, such as Sara Baartman to South Africa, (Skotnes 1996) or Vaimaca Pirú to Uruguay (Martinez Barbosa, 2002).

Perhaps it is the nature of the study of human remains itself that requires something similar to 'medical detachment', which produces an attitude towards the human body, whether alive or dead, that appears to differ from that held by society at large. Judging by the public support for repatriation (see Simpson, 2002), and the outrage that follows desecration of the bodies of their own dead (see below) and of graveyards (Hubert, 1989), the wider society generally appears to have respect for the dead, and acknowledges the right of relatives to accord them appropriate treatment.

Such 'medical detachment' would perhaps explain why early scientists with close indigenous friends felt able to deflesh their bones as soon as they died, and incorporate them into museum collections (Endere, 2002) or take their organs for research purposes (Miklouho-Maclay, 1982: 127–31). In such cases, the interests of science appear to have been paramount, overriding any feeling of affection, or fulfilment of the responsibility to carry out funerary rituals and dispose of the body according to cultural expectations.

The complexity and inconsistencies of perceptions and attitudes in this area have recently exploded into the consciousness of the British public. A scandal has erupted about the treatment of the bodies of their own dead, and the removal and retention of human organs in British hospitals without the knowledge and permission of relatives. A government inquiry (Department of Health 2000) reports that over 54,000 organs, body parts, still-births or fetuses had been retained from post-mortems by NHS pathology services, many without fully informed consent.

Until this scandal arose, it was generally assumed that the bodies of the dead were treated with respect by doctors and those staff whose responsibility it was to care for them between the moment of death and their return to relatives for disposal through burial or cremation. Furthermore, central to this assumption is the belief that it is the relatives who should make decisions

about what happens to the dead. Now it appears that, without consent, many bodies, including those of babies, have been stripped of their organs, which have then been kept in jars, stored in cupboards or in some cases sold. In Alder Hey hospital, in Liverpool, for example, some 3,000 organs of dead babies were alleged to be stored without parents' knowledge. In cases such as these, the 'body' that parents had buried and mourned was, to all intents and purposes, simply an 'empty shell'. Since this was discovered, some parents have felt the need to carry out two or three subsequent burials of body parts which were later returned to them, such as the hearts, lungs and brain of their child, in the original grave, with funerary rituals. On the face of it, this desire to bury the remains of a relative appears to echo the responses of indigenous people, who have for many years been trying to take home the various human remains of their own dead to dispose of them with due rituals. Until now, it was not envisaged that parents in Britain would find themselves in a position of having to bury different body parts on separate occasions. Just as for colonized peoples, who are successful in securing the return of human remains, this is a new situation that has arisen, necessitating the creation of new ceremonies and rituals, to encompass these subsequent burials of body parts.

Another example in Britain concerns the families bereaved by the sinking of the *Marchioness* pleasure boat in the Thames in 1989. Relatives have recently learned that, in addition to the hands of many of the victims having been chopped off 'for identification', all the bodies were stripped of their organs – lungs, brains, livers, kidneys, hearts, spleens, tonsils and others – without the relatives' consent. Some bodies were returned to their families in sealed body-bags (*Independent on Sunday* 11.03.01).

These recent events in Britain demonstrate that the contrast between the treatment of the human remains of 'others' – kept for possible future evolutionary and other research purposes – and the supposedly humane treatments of the bodies of the dead in British contemporary culture, is less clear-cut than was thought before. In some cases, doctors and hospitals appear to have been paying only lip service to what the public believes to be appropriate respect for the dead, their wishes and the wishes of their relatives. These practices, accepted as normal among at least some doctors and scientists, may reveal that some look upon patients and their relatives as 'other' – that there is an established culture of 'us' and 'them' that permits such disregard for what is considered ethical practice.

Whether or not the circumstances and contexts of attitudes to the disposal of the dead are similar, the same or different, it is to be hoped that the horror and disgust of the British public at the revelation that parts of bodies were separated, without permission, from the whole dead person, will lead to a greater understanding of attempts by indigenous people to repatriate the human remains of their relatives.

Social meanings are inextricable from perceptions of the human body, in life and in death. Those who curate and study human remains, against the wishes of those who seek their repatriation, may seek to deny, ignore or devalue these social meanings. A perceived duty to retain collections inherited from the past – by definition 'objects' to be curated – has often overridden social and cultural meanings. The reburial issue, however, has demanded that social and cultural values *are* acknowledged and responded to. During the past two decades this has gained sufficient strength to change the very nature of museums and what they were originally created to do.

In some countries, the acceptance of cultural beliefs and values, and a desire to right the wrongs of the past, has resulted in repatriation legislation. In other countries, this is only now being developed, and in yet others the repatriation debate is still in its early stages. It is now critically important that we listen to the voices of indigenous peoples, archaeologists, museum curators and others concerned with the principles, policies and practice of the reburial issue throughout the world.

Acknowledgement

We are very grateful to Peter Ucko for his comprehensive and constructive comments on the various drafts of this chapter.

Notes

1 The term 'reburial' is commonly used in the debate regarding the return of human remains to countries or cultures of origin. However, it should be noted that cultural practices relating to disposal of the dead often do not include burial at all (Turnbull, 2002), and human remains may have been initially collected before they underwent any funerary rites (Fforde, 2002a; Palm Island, 2002).
2 Memorandum submitted by the Foundation for Aboriginal and Islander Research Action (FAIRA) to the House of Commons Culture, Media and Sport Committee: Cultural Property: Return and Illicit Trade 2000. www.publications.parliament.uk/pa/cm199900/cmselect/cmcumeds/371/0051002.htm.
3 10 Downing Street Press Notice, July 2000.

References

Anyon, R. and Thornton, R. (2002) 'Implementing repatriation in the United States: issues raised and lessons learned', in Fforde, C., Hubert, J. and Turnbull, P. (eds), op. cit.
Arid, M. (2002) 'Developments in the repatriation of human remains and other cultural items in Queensland, Australia', in Fforde, C., Hubert, J. and Turnbull, P. (eds), op. cit.
Ayau, E.H. and Tengan, T.K. (2002) 'Ka huaka 'i o na 'oiwi: the journey home', in Fforde, C., Hubert, J. and Turnbull, P. (eds), op. cit.
Culture, Media and Sport Select Committee (2000) *Culture, Media and Sport: Seventh Report*, available at www.publications.parliament.uk/pa/cm199900/cmselect/cmcumeds/371/37107.htm (accessed 19 August 2004).
Department of Health (2000) *Report of a Census of Organs and Tissues Retained by Pathology Services in England*, London: HMSO.
Endere, M.L. (2002) 'The reburial issue in Argentina: a growing conflict', in Fforde, C., Hubert, J. and Turnbull, P. (eds), op. cit.
Engelbrecht, M.L. (2002) 'The connection between archaeological treasures and the Khoisan people', in Fforde, C., Hubert, J. and Turnbull, P. (eds), op. cit.
Fforde, C. (1992) 'The Williamson Collection', *World Archaeological Bulletin*, 6, 20–1.
—— (1997) *Controlling the Dead: An Analysis of the Collecting and Repatriation of Aboriginal Human Remains*, unpublished PhD thesis, University of Southampton.
—— (2002a) 'Collection, repatriation and identity', in Fforde, C., Hubert, J. and Turnbull, P. (eds), op. cit.
—— (2002b) 'Yagan', in Fforde, C., Hubert, J. and Turnbull, P. (eds), op. cit.
——, Hubert, J. and Turnbull, P. (eds) (2002) *The Dead and Their Possessions: Repatriation in Principle, Policy and Practice*, London and New York: Routledge.
Fish, W.S. (2002) '"Ndi nnyi ane a do dzhia marambo?" ("Who will take the bones"): excavations at Matoks, Northern Province, South Africa', in Fforde, C., Hubert, J. and Turnbull, P. (eds), op. cit.
Hammil, J. and Cruz, R. (1989) 'Statement of American Indians against desecration before the World Archaeological Congress', in Layton, R. (ed.), *Conflict in the Archaeology of Living Traditions*, London: Routledge.

Hanchant, D. (2002) 'Practicalities in the return of remains: the importance of provenance and the question of unprovenanced remains', in Fforde, C., Hubert, J. and Turnbull, P. (eds), op. cit.

Hockey, J. (1990) *Experiences of Death: An Anthropological Account.* Edinburgh: Edinburgh University Press.

Hubert, J. (1989) 'A proper place for the dead: A critical review of the "reburial issue"', in Layton, R. (ed.), *Conflict in the Archaeology of Living Traditions*, London: Routledge.

—— (1992) 'Dry bones or living ancestors? Conflicting perceptions of life, death and the universe', *International Journal of Cultural Property*, 1, 105–27.

Isaac, B. (2002) 'Implementation of NAGPRA: the Peabody Museum of Archaeology and Ethnology, Harvard', in Fforde, C., Hubert, J. and Turnbull, P. (eds), op. cit.

Jaume, D., Pons, G., Palmer, M., McMinn, M., Alcover, J.A. and Politis, G. (1992) 'Racism, archaeology and museums: the strange case of the stuffed African male in the Darder Museum, Banyoles (Catalonia), Spain', *World Archeological Bulletin*, 6, 113–18.

Joyce, R.A. (2002) 'Academic freedom, stewardship and cultural heritage: weighing the interests of stakeholders in crafting repatriation approaches', in Fforde, C., Hubert, J. and Turnbull, P. (eds), op. cit.

Kawharu, M. (2002) 'Indigenous governance in museums: a case study, the Auckland War Memorial Museum', in Fforde, C., Hubert, J. and Turnbull, P. (eds), op. cit.

McKeown, C.T. (2002) 'Implementing a "true comprimise": the Native American Graves Protection and Repatriation Act after ten years', in Fforde, C., Hubert, J. and Turnbull, P. (eds), op. cit.

McManamon, F.P. (2002) 'Repatriation in the USA: a decade of federal agency activities under NAGPRA', in Fforde, C., Hubert, J. and Turnbull, P. (eds), op. cit.

Martinez Barbosa, R. (2002) 'One hundred and sixty years of exile: Vaimaca Pirú and the campaign to repatriate his remains to Uruguay', in Fforde, C., Hubert, J. and Turnbull, P. (eds), op. cit.

Miklouho-Maclay, N. (1982) *Travels to New Guinea: Diaries, Letters, Documents*, Moscow: Progress Publishers.

Molleson, T., Cox, M. and Waldron, T. (1993) *Spitalfields Project Vol. 2, The Anthropology: The Middling Sort*, London: Council for British Archaeology/Whitaker.

Mulvaney, J. (1991) 'Past regained, future lost: The Kow Swamp pleistocene burials', *Antiquity*, 65, 12–21.

Muringaniza, S.J. (2002) 'Heritage that hurts: the case of the grave of Cecil John Rhodes in the Matopos National Park, Zimbabwe', in Fforde, C., Hubert, J. and Turnbull, P. (eds), op. cit.

Nagar, Y. (2002) 'Bone reburial in Israel: legal restrictions and methodological implications', in C. Fforde, J. Hubert and P. Turnbull (eds), op. cit.

Nemaheni, T.I. (2002) 'The reburial of human remains at Thulamela, Kruger National Park, South Africa', in C. Fforde, J. Hubert and P. Turnbull (eds), op. cit.

Palm Island, W. (2002) 'Tambo', in Fforde, C., Hubert, J. and Turnbull, P. (eds), op. cit.

Pardoe, C. (1991) 'Eye of the storm', *Journal of Indigenous Studies*, 2(1), 16–23.

Parsons, N and Segobye, A.K. (2002) 'Missing persons and stolen bodies: the repatriation of "El Negro" to Botswana', in Fforde, C., Hubert, J. and Turnbull, P. (eds), op. cit.

Richardson, L. (1989) 'The acquisition, storage and handling of aboriginal skeletal remains in museums: an indigenous perspective', in Layton, R. (ed.), *Conflict in the Archaeology of Living Traditions*, London: Routledge.

Richardson, R. (1987) *Death, Dissection and the Destitute*, London: Routledge and Kegan Paul.

Rosser, B. (1994) *Return to Palm Island*, Canberra: Aboriginal Studies Press.

Ryan, L. (1981) *The Aboriginal Tasmanians*, St Lucia: University of Queensland Press.

Sellevold, B.J. (2002) 'Skeletal remains of the Norwegian Saami', in Fforde, C., Hubert, J. and Turnbull, P. (eds), op. cit.

Simpson, M. 'The plundered past: Britain's challenge for the future', in Fforde, C., Hubert, J. and Turnbull, P. (eds), op. cit.

Skotnes, P. (ed.) (1996) *Miscast: Negotiating the Presence of the Bushmen*, Cape Town: University of Cape Town.

Swidler, N., Dongoske, K.E., Anyon, R. and Downer, A.S. (eds) (1997) *Native Americans and Archaeologists: Stepping Stones to Common Ground*, Walnut Creek: AltaMira.

Tapsell, P. (2002) 'Partnership in museums: a tribal Maori response to repatriation', in Fforde, C., Hubert, J. and Turnbull, P. (eds), op. cit.

Thornton, R. (2002) 'Repatriation as healing the wounds of the trauma of history: cases of Native Americans in the United States of America', in Fforde, C., Hubert, J. and Turnbull, P. (eds), op. cit.

Turnbull, P. (2002) 'Indigenous Australian people, their defence of the dead and native title', in Fforde, C., Hubert, J. and Turnbull, P. (eds), op. cit.

Turner, E. (1989) 'The souls of my dead brothers', in Layton, R. (ed.), *Conflict in the Archaeology of Living Traditions*, London: Routledge.

Ucko, P.J. (2000) 'Enlivening a dead past', *Conservation and Management of Archaeological Sites*, 4(2), 67–92.

—— (2001) '"Heritage" and "indigenous peoples" in the 21st century', *Public Archaeology*, 1(4), 227–38.

Watkins, J. (2002) 'Artefactual awareness: Spiro Mounds, grave goods and politics', in Fforde, C., Hubert, J. and Turnbull, P. (eds), op. cit.

Weatherall, R. (1989) *Aborigines, Archaeologists and the Rights of the Dead*, unpublished paper presented at WAC Inter-Congress, Vermillion, South Dakota.

Zimmerman, L. (1989) 'Made radical by my own: an archaeologist learns to accept reburial', in Layton, R. (ed.), *Conflict in the Archaeology of Living Traditions*, London: Routledge.

—— (2002) 'A decade after the Vermillion Accord: what has changed and what has not?', in Fforde, C., Hubert, J. and Turnbull, P. (eds), op. cit.

10

Illicit antiquities
The theft of culture

Neil Brodie

Trade in illicit antiquities is an established problem that has continued to increase internationally, with the movement of archaeological and heritage material viewed as commodities from 'source' countries (usually in the developing world) to 'demand' countries (usually in the developed world). This chapter highlights issues related to this trade. It introduces: legal contexts; ethical issues in terms of tracking the movement of material and its provenance; and different perspectives on ownership of cultural property, as set against academic concerns with the construction of knowledge and the breakdown between material and its original contexts when it is illicitly removed. Linked to the latter, it considers how in many source countries, archaeology and heritage material is seen in terms of capital and how in areas of poverty it is viewed as an economic resource – albeit a finite resource with illicit removal being an unsustainable activity that will lead to the extinction of archaeology. There are also issues here concerning who benefits from the market in terms of the appreciation of profits from the first transaction to the last. This chapter also covers issues related to shipwrecks, especially those not in territorial waters protected by law, and looting during wartime.

In terms of working towards solutions to help lessen the problems, the chapter outlines how public programmes that make archaeological material more accessible, and public participation and partnerships in fieldwork, could help with raising awareness of the importance of the resource and provide an advocacy for archaeological activity. It also looks at the role that responsible cultural tourism based on sound heritage management could play in income generation for the benefit of local communities.

The chapter also provides a useful introduction to international conventions and professional ethics related to the topic.

Introduction

This chapter is about the recent plunder of archaeological sites and cultural institutions, much of which is thought to be commercially motivated. Concerns raised by this plunder during the late 1960s led to the drafting of the Convention on the Means of Prohibiting and Preventing the Illicit Import, Export and Transfer of Ownership of Cultural Property, which was adopted by UNESCO in 1970 (Coggins, 1969; Meyer, 1973), but since then the situation has grown out of all control (Leyten, 1995; Tubb, 1995; Schmidt and McIntosh, 1996; Vitelli, 1996a; O'Keefe, 1997; Messenger, 1999; Brodie *et al.*, 2000; Renfrew, 2000). This seems to be for two reasons. First, the means of destruction have become much more powerful. For millennia, the tools of the tomb robbing trade consisted of little more than simple digging implements and probing rods, but they have been joined over the past couple of decades by bulldozers and mechanical diggers,

dynamite, metal detectors, power saws and drills and, underwater, propwash deflectors. Second, improving technology has also opened up areas which had until recently been out of reach, as all-terrain vehicles probe deep into the desert, helicopters hover over the jungle and, on the deep seabed, remotely operated submersibles nose out long-lost wrecks. Access to sites has also been made easier by the falling cost of international travel and the erosion of political barriers. This new combination of destructive power and easy communication has proved disastrous for the world's archaeological and cultural heritage, and it seems that no site or museum around the world is now safe from the attentions of archaeological bandits – the nighthawks, *tombaroli or huaqueros* – who have been joined by treasure salvors, militiamen and common thieves.

But this calamity is not purely a technological phenomenon, detached from any socio-cultural matrix. Stolen material needs a market, and in this instance it is provided by private and institutional collectors who regard archaeological or ethnographic objects as works of art, investment opportunities, or even as fashionable decorations. There is a global aspect to the problem too, an imbalance, as the market – museums, collectors and salerooms – is concentrated in the countries of Europe and North America, which have been called the 'demand' countries. Those countries whose cultural heritage is under serious threat of plunder – the so-called 'source' countries – are found largely in the developing world, although as writers like Addyman and Brodie (Addyman and Brodie, 2002; Brodie, 2002), Schávelzon (2002) and Davis (2002) make clear, the archaeology and culture of demand countries themselves are not immune.

Illicit antiquities

Archaeological objects which have been torn from monuments, stolen from museums or illegally excavated and/or exported have been christened 'illicit antiquities'. This is not a legal term, but has been coined by archaeologists to highlight a unique characteristic of the trade in such material, which is that although in most countries of the world (with important exceptions such as the USA and the UK) archaeological heritage has been taken into public ownership, so that its unlicensed excavation or export is illegal, its ultimate sale in a country other than that of its origin may not be. Thus the antiquities are illicit inasmuch as the method of their original acquisition was; it says nothing of the legality or otherwise of their subsequent trade.

An illicit antiquity may change hands several times before being bought by an institutional or private collector and details of its illicit origin are lost or erased in the process. Ultimately it is sold without provenance – without indication of ownership history or 'find spot'. However, once published in an academic paper or exhibition catalogue, or even sale catalogue, it acquires a new, respectable pedigree as an object of scholarly interest or of esteem (Gill and Chippindale, 1993), and its illicit origin is quietly forgotten. Illicit material is, in effect, 'laundered' by sale or publication in Europe or North America. This was the case in 1997, for example, when two Attic kylikes stolen from the Corinth Museum in 1990 were offered for sale in a major New York auction house described as the property of an American private collector.

Although stolen, most illicit antiquities, particularly those which have been clandestinely excavated, evade detection because they were not registered on any museum or excavation inventory prior to their theft and disposal. The Corinth kylikes had been inventoried and were identifiable, and were, in consequence, recovered. Most material is not. Even when a piece is recognized to be from a country which claims ownership, it will not be treated as stolen unless the country in question can prove that it was exported after the date of the relevant national patrimony law. Obviously, if an antiquity has been secretly excavated and smuggled, the date of its export is unlikely to be revealed. For example, there is the case of the Roman statue of the

'Weary Herakles'. The upper half of this statue surfaced in the USA in the early 1980s and is currently in the joint ownership of the Boston Museum of Fine Arts and an American private collector. The lower half was excavated near the Turkish town of Antalya in 1980. However, despite this fact, the American owners of the top half insist that there is no evidence to show that it was stolen, as it may have been removed from Turkey many years – centuries even – before the relevant 1906 patrimony law. Without evidence to prove otherwise, the Turkish government has not pressed its case.

The situation is further clouded by what has been called a 'loophole' in international law (Ellis, 1995:223). Many antiquities and other cultural objects are sold in civil law countries of continental Europe, whose property law differs from that of US and UK common law in that title to a stolen object can be obtained by means of a 'good faith' purchase. Thus, even if it can be demonstrated unequivocally that an antiquity was taken illegally from its country of origin, if it was subsequently bought in good faith in a country such as Switzerland, it will no longer be regarded in law as stolen.

Illicit antiquities move erratically across many national borders and jurisdictions. This allows them to be easily laundered, but it also facilitates the entry onto the market of fakes. Without a verifiable provenance, objects that are faked – completely or in part – can easily be passed off as genuine, and it is left to the connoisseur or scientific test to determine their authenticity, and both have in the past been proved fallible. There are now many fakes in private and institutional collections around the world (Muscarella, 2000); their true number will probably never be known, although it has been estimated that nearly 80 per cent of the terracotta statuettes which have left Mali since the 1980s may be forgeries (Brent, 2001:27). While the fakes remain undetected, perhaps even unsuspected, the effect on scholarship can hardly be guessed at.

Not all antiquities appearing on the market are illicit, however. Dealers are keen to stress that large quantities of antiquities moved out of their countries of origin during the 'grand tour', or in colonial times, and that documentary proof of original provenance is long lost. They are right and this is the crux: in the absence of provenance, how can licit material be distinguished from illicit? 'From an old European collection' is a common enough auction appellation, but one that might hide an old family heirloom or a recently looted (or fake) piece. Who is to know? The only cautious response is to regard all unprovenanced material as looted.

The extinction of archaeology

Archaeological extinction may seem an incongruous concept. After all, how can something already dead become extinct? But if archaeology is viewed as a resource, at a time when both natural and cultural resources have become commodities to be bought and sold, the relevance of the association becomes clear. For many people in the developing world, the sale of looted archaeological or cultural material can help supplement a meagre income, so much so that looting in these areas has been termed subsistence digging (Matsuda, 1998:91); it is the same spectre of poverty that is seen behind illegal timber extraction and animal poaching. But these depredations share more than a cause – left unchecked they are unsustainable. The resource is exhausted or becomes extinct. Even government-sponsored – albeit environmentally unsuited – development can be detrimental to the archaeological record (Nalda, 2002).

Thus there are very real links between economic underdevelopment and the degradation of natural and archaeological environments, and the fundamental problem is that of rural poverty. It is estimated that 65 per cent of the developing world's population live in rural areas and depend upon immediately available resources to meet their daily needs (Elliot, 2000:102).

While, presumably, most easily accessible archaeological sites are in rural areas, this is an economic and demographic reality that cannot be ignored. Since the failure of 1960s' modernization policies, it has become clear that underdevelopment is a global problem, caused as much by unrestrained market forces as by poorly developed economic infrastructures. As such, a global response is necessary, with more ethical investment and trade practices put in place to support economic developments of a type which are sustainable in local environments and of benefit to local populations. If, in the developed world, deforestation and species – and even archaeological – extinction are high on the agenda, in developing countries improved standards of living are higher still, and any equitable resolution of the trade in illicit antiquities and of the plunder of archaeological sites must take this into account. Matsuda's point about subsistence digging was well made and, until rural poverty is eradicated, it will no doubt continue.

Shipwrecks

Looting on land is well documented, but it is also important to emphasize the problems caused by treasure salving of deep-water wrecks, which is a relatively recent phenomenon. The development of scuba gear during the 1950s first allowed the exploration and excavation of wrecks lying in shallow coastal waters, perhaps down to a depth of about 50 m, but it also allowed their plunder. Although treasure hunting in these waters is a lottery [most wrecks do not contain treasure and many archaeologically significant examples can be damaged or destroyed during a futile search (Conlin and Lubkemann, 1999:64)], damage has been widespread in some areas and most wrecks lying in territorial waters now enjoy some degree of legal protection.

Those in deeper water remained safe from human interference until the 1980s when, in 1985, the recovery of gold and porcelain from the wreck of the Dutch East Indiaman *Geldermalson* and gold and silver bullion from the Spanish galleon *Nuestra Señora de Atocha*, both lying just outside territorial waters, showed that there were fortunes waiting to be made on the international seabed. In the same year, the *Titanic* was discovered in 3600 m of water, and a new prospect of deep-water recovery opened up. By 1987, a remotely operated submersible had been instrumental in the removal of over $1 million worth of gold bars from the wreck of the *Central America*, which had sunk in 1857 in 2,400 m of water 420 km off the coast of South Carolina. The deepest wreck currently known is that of the Japanese submarine *1–52*, sunk in 1944 while carrying a load of gold bullion to Germany, and presently 5,400 m down (Delgado, 1996; Johnston, 1997). The sudden 'appearance' of deep-water wrecks grabbed the attention of governments, archaeologists and treasure hunters, and Dromgoole (2002) and O'Keefe (2002) discuss the competing claims to access, jurisdiction and ownership, and their possible resolution by means of the UNESCO Draft Convention on the Protection of the Underwater Cultural Heritage.

Archaeological participation in treasure salving expeditions can be in contravention of professional ethics, which hold that archaeological sites should be preserved *in situ*, excavated material should be carefully conserved for future study, and that recovered artefacts should not be sold, even if the sale is intended to fund further research (Elia, 1992). Thus, future collaborations between salvors and archaeologists seem unlikely unless an excavation is properly conducted and recorded, the material recovered is properly conserved, and, crucially, the excavated assemblage is preserved intact (Johnston, 1993:59; Delgado, 1996:43). Salvage operations are now typically investor-funded and the returns have not to date been reliable – they are high-risk investments. Salvors themselves may make more money from investors than treasure. A more secure, albeit longer-term, strategy would be to conserve excavated ships for public presentation, a strategy that would not require the break up and sale of any recovered assem-

blage (Throckmorton, 1990: 183; Johnston, 1993: 59). Only under these circumstances might it be possible to envisage future cooperation between salvors and archaeologists.

The anaerobic conditions of deep-water wrecks have favoured good preservation and Sutherland (2002) discusses the technical and ethical issues that conservators face when confronted with recovered material. It is in everybody's interest to avoid disasters such as that of the *De Braak*, a British warship that sank off the coast of Delaware in 1798. It was raised by cranes in 1986, artefacts spilling out as it rose, but ownership – and the responsibility for conservation – has now reverted to Delaware, and to the public purse (Johnston, 1993:57; *US News,* 1999). It is clear that for any collaboration between salvors and archaeologists to succeed, a budget must make good allowance for the proper conservation and curation of the ship, its fittings and all its accoutrements, which is not a primary concern for a treasure hunter interested only in a valuable cargo.

Looting during wartime

In the past, war has perhaps been the greatest enemy of cultural heritage, and this is recognized in Boylan's (2002) account of the long series of international agreements and conventions which have been drafted in consequence. There are three ways in which war might have a damaging impact. First, there is what the military would call collateral damage – accidental damage caused to a cultural monument or institution, or archaeological site, during an attack on a legitimate military target. Second, there is the age-old practice of taking booty – the forcible removal of cultural material for profit of purposes of aggrandizement. Finally, there is the deliberate destruction of religious or other culturally important structures or artefacts for the purpose of erasing the material symbols of an ethnic or religious group – what would today be referred to as 'cultural cleansing'. Perhaps all destruction during wartime comes out of a confluence of all three causes, but in some recent conflicts, looting for saleable material has certainly been to the fore and has exacerbated an already disastrous situation. Two in particular are well documented: Afghanistan and Cambodia.

After the Soviet withdrawal from Kabul, Afghanistan in 1992, the various mujahideen factions began fighting among themselves for control of the city. The National Museum was repeatedly hit by rocket or artillery fire and it was also badly looted. By 1996, more than 70 per cent of the museum's collections were missing, with only the less valuable pieces left behind, a sure sign that the plunder was commercially motivated and not carried out for reasons of cultural cleansing (Dupree, 1996). Once aware of the commercial potential of Afghanistan's archaeological remains, local militia commanders also began to sponsor illegal excavations of archaeological sites and used the money gained from the sale of artefacts to pay soldiers or buy munitions (Lee, 2000a).

However, not all of the damage in Afghanistan can be attributed to the search for saleable material. In 1996, the fundamentalist Taliban took over in Kabul and issued an edict banning all forms of figurative representation, but also decreed that ancient cultural objects were exempt and to be protected. Nevertheless, in 1997, a Taliban commander besieging Bamiyan threatened to destroy the two monumental Buddhas for which the town is famous (Dupree, 1998). The central government again warned against such vandalism, but in 1998 the head of the smaller of the two Buddhas was blown off in a deliberate act of iconoclasm (Lee, 2000a). This prompted the issue of a new law decree in July 1999, which outlawed the excavation of historic sites (Lee, 2000b), but in March 2001 the Taliban leader ordered that all religious 'idols' were to be destroyed, and the larger of the two Bamiyan Buddhas was subsequently blown up with high explosive.

In Cambodia, military factions have engaged in the plunder of Khmer temples and monuments. It is reported that Angkor Wat alone used to have 1,000 Buddha statues but that only eighteen now survive (Rooney, 2001:45). Many were vandalized during the Khmer Rouge regime (1975–79), but since then they have been looted and sold. In 1999, more than twenty tons of archaeological material were found hidden in the headquarters of the last Khmer Rouge commander, and not long afterwards the temple of Banteay Chmar was attacked and stripped of its famous bas-reliefs by renegade units of the regular army. Material from Cambodia is smuggled into Thailand and sold in the River City area of Bangkok for export abroad (Rooney, 2001:48), although the Banteay Chmar reliefs were intercepted on the Thai side of the border and in March 2000 were displayed at the National Museum of Thailand, prior to their return to Cambodia (Bahn, 2000:753).

It is clear from these two conflicts that when central authority breaks down, the existence of an international market intensifies the looting as material is sought out and sold, with the proceeds helping to keep soldiers in the field. In May 1999, Pakistani customs seized six boxes of archaeological material at Peshawar Airport. Much of it had been smuggled out of Afghanistan. The boxes were bound for London, Dubai and Frankfurt, and two were addressed to a London art-shipping agency [which denied any knowledge of the consignment (Levy and Scott-Clark, 1999)]. Nevertheless, in January 2000, material from Afghanistan was openly on sale in central London at an outlet only a few hundred metres away from the British Museum. The publication by ICOM in 1993 of their first edition of *Looting in Angkor* led to the recovery of six Cambodian pieces, two of which had been sold at Sotheby's London and one at Sotheby's New York (ICOM, 1993:10–11). One of the pieces sold in London was found in the Honolulu Academy of Arts, while a further piece was in the possession of the Metropolitan Museum of Art, New York. Both have now been returned to Cambodia. However, the occasional recovery or return cannot disguise the fact that in wartime the money pumped into the market by Western collectors not only fuels archaeological destruction, but also helps underwrite and thus prolong the conflict.

But not all wilful cultural destruction during times of civil disturbance or war is commercially driven. The fighting in former Yugoslavia has seen massive destruction of religious and other buildings and monuments. It is estimated that in Bosnia more than 12,000 mosques, together with 300 Catholic and 100 Orthodox churches, were destroyed during the fighting (Chapman, 1994; Dodds, 1998), and since the NATO bombing of Serbia in 1999, mosques and Orthodox churches in Kosovo have also been damaged or destroyed (*Art Newspaper*, 2000:6). In 1993, the sixteenth-century bridge over the River Neretva at Mostar, a long-time symbol of a multi-ethnic state, was deliberately blown apart by a Bosnian-Croat tank. It is a measure of the importance that might be attached to such architectural symbols that the Muslim community of Mostar is hoping to restore the bridge at a cost of $5 million, using the original stones (Dodds, 1998:53).

The 1954 Hague Convention was drafted with World Wars I and II in mind, but most recent conflicts have taken the form of civil wars or guerrilla actions. With this in mind, the 1999 Second Protocol to the Convention was adopted for what Boylan (2002) terms 'dirty' armed conflicts. Yet although the former Yugoslav states are all parties to the 1954 Hague Convention, the destruction proceeded nevertheless (Clement, 1996:159). During the Serbian bombing of Dubrovnik in 1991–2, houses protected under the terms of the Hague Convention seem to have been deliberately targeted (Burnham, 1998:153). In conflicts such as this, when cultural obliteration is a primary war aim, it is difficult to see how international protective legislation can be effective.

The terminologies of culture

From a legal perspective, Merryman (1996) has identified three competing images of the international debate over cultural, including archaeological, material. First, there is his nationalist image, the discourse of source nations which stresses the relationship between cultural objects and a national heritage, and which expects such objects to remain in their country of origin. Second, there is his internationalist image, which maintains that cultural heritage is international and that objects should be free to circulate. Finally, there is his object/context image of archaeologists and ethnographers, which places primary emphasis on the information or meaning held trapped in the relationship between an object and its context.

Through an archaeological lens, however, these images refract into alternative discourses, with different concepts requiring different terminologies. Merryman's nationalist and internationalist images are in fact manifestations of an object-centred discourse of ownership, while archaeologists and ethnographers are but part of a larger (perhaps Western) academic discourse which values knowledge over property.

Collectors, dealers, politicians and lawyers are largely (though not exclusively) focused on issues of ownership (as is Merryman). This is quite clearly seen in the use of the term 'cultural property' to describe the material under consideration. The concept of private property as enshrined in the common law of the UK and USA is very much a European (ultimately English) one, and implies rights of uninterrupted ownership – rights of an owner to exploit, alienate and exclude (Prott and O'Keefe, 1992:310), unencumbered by any greater, public, interest. Conceptions of property in other cultural traditions differ and might recognize rights in an object other than those of the owner, or deny alienability. Differences between common law and civil law are discussed by Dromgoole (2002). Nevertheless, in common law the concept of exclusive, private ownership is a powerful one, as, since the end of the seventeenth century at least, it has been thought fundamental to the constitution of liberal society (Macfarlane, 1998:104), and appeals made to the rights of a private owner are guaranteed a sympathetic ear. It might be argued against this that the public interest vested in academic enquiry is sufficient to outweigh the right of an individual to exclusive ownership, a sentiment that has been expressed by Sax (1999) in his wider analysis of cultural material.

In contrast to dealers and politicians, as Merryman correctly points out, many (though not all) archaeologists subscribe to an ideal of knowledge, and the information-rich relationship between object and context. A forthright statement of this position has been made by Vitelli:

> Frankly, my major concern has never been with who owns or possesses an archaeological object, where the object resides, or, for that matter, whether an object was traded licitly or illicitly. My real concern is with information, which, for archaeological objects derives from their original context.
>
> (Vitelli, 1996b:109)

Vitelli is making two points. First, she is expressing dissatisfaction with current object-centred concepts of property, as they are applied to archaeology, and to debates over ownership that pervade the non-archaeological literature. But Vitelli is also questioning the very nature of the enquiry, she is stressing the importance of intangible relationships, the archaeological context where information resides, and downplaying the role of artefacts, of the material objects themselves.

The archaeological ideal is based on the concept of an archaeological site as an entity with emergent properties, an entity whose whole (artefacts in context) is greater than the sum of its

parts (artefacts out of context). But although it is usual for archaeologists to talk about an arte-fact and its context, as fields of study multiply, it is becoming increasingly difficult to choose what is context and what is object. For example, to an archaeologist interested in identifying ancient foodstuffs, a pot might become context and its contents the object. Similarly, for a student of ancient textiles, the fragment preserved in copper salts on the surface of a corroded bronze blade might be the object and the blade its context. An ancient coin might provide the context which dates the soil showing traces of human alteration. Thus the terms 'object' and 'context' are relative and are decided within the frame of a particular research project. It makes no sense to talk of objects as a single category of entities with distinctive properties that set them apart from another entity, the context. An archaeological site is composed of a web of relation-ships which are destroyed when antiquities – the so-called objects – are removed.

Thus the debate over archaeological material appears often to be a polemical one, fought between two extreme camps, and neutral observers – sometimes self-styled moderators – despair of the zealots with whom they are forced to deal. But the extremism is more apparent than real, as arguments which are developed within incompatible frames of reference can easily be misun-derstood, and what seems sometimes to be an uncompromising rebuttal is due simply to a different understanding of the issues involved.

It has been proposed that the less ideologically loaded term 'cultural heritage' should be substituted for 'cultural property', the word 'heritage' being chosen to express better the idea of a cultural object as something to be shared and conserved, not something to be bought and sold, used in exclusion and, even, possibly, consumed (Prott and O'Keefe, 1992:311). This change in terminology has already occurred in some areas. The term 'cultural property' was first used in the 1954 Hague Convention and next in the 1970 UNESCO Convention, but by 1972 it had been replaced in the UNESCO Convention on the Protection of the World's Cultural and Natural Heritage (ibid.:318–19), and now also in the UNESCO Draft Convention on the Protection of Underwater Cultural Heritage. The 1995 UNIDROIT Convention on Stolen and Illegally Exported Objects avoids the use of either term. The shift in terminology is also clearly demonstrated in the edited volume. *The Ethics of Collecting Cultural Property* (Messenger, 1999). The first edition of this book was published in 1989 when the term 'cultural property' was included in its title, but by the time of the epilogue to the second, 1999, edition, the editor preferred to use the term 'cultural heritage', noting that even this might be objectionable to some (presumably those who partake of Merryman's internationalist image), but that it had the advantage of not ascribing symbolic qualities of cultural or political dominance to material remains (ibid.:254).

Nevertheless, the discourse of ownership is the dominant one, and archaeologists are forced to enter the debate over cultural material on, quite literally, disadvantageous terms. There are huge quantities of decontextualized antiquities in circulation that can only be talked of as objects, as they are in this chapter, and which are categorized on the basis of monetary value. Political solutions and legal arguments are also framed using such terms, despite the suggested alternative of 'heritage'. The reasons for this are political and historical. Political because national governments and rich institutions and individuals – Merryman's nationalist and inter-nationalist images – together form a powerful constituency, but also historical because in the past archaeologists too have subscribed (some still do) to the ideals of object and ownership. The development of an archaeological methodology with its associated terminology is an ongoing process, and will continue to be so, but outside the discipline this is not generally understood.

Thus, sometimes it is suggested that the sale of duplicate objects – small pots perhaps – from an archaeological site might go some way towards satisfying the demand of the market, and so

reduce looting. To a neutral observer, this sounds a perfectly reasonable suggestion. A representative sample can be kept back for the purposes of archaeological research, while the remainder can enter circulation. Archaeologists appear extreme and unreasonable when they oppose such a scheme, but their opposition is rational within their own understanding of the material in question. At the end of the day, who is to decide which pot is the duplicate? Is each one to be scientifically characterized by all available techniques? If a representative sample is to be kept back 'just in case', how many? In fact, the truth is that there is no such thing as a duplicate pot. Indices of diversity and standardization can throw light upon the organization of ceramic manufacture, and such indices cannot be derived from a single pot.

For example, at Myrtos, on the south coast of Crete, a small site which had been destroyed some time during the Early Minoan period (early Bronze Age) was excavated in 1967–68, and some 700 pottery vessels were recovered, some only partially preserved, but including 350 vessels which were complete and had been in use at the time of the site's destruction (Warren, 1972). This material recently formed the basis of a large-scale project of stylistic and scientific analysis which, according to the investigators, provided them with '… a unique opportunity to begin to investigate the significance of ceramic variation within and between Early Minoan communities, and to broaden the range of issues concerning Early Minoan society which ceramics can be used to address' (Whitelaw *et al.*, 1997:267). This would not have been possible if all 'duplicates' had been released onto the market once the excavation had been published. Thus, archaeologists are not being extreme or unreasonable when they oppose proposals which advocate the break-up of excavation assemblages, but they are merely being realistic. A large set of ostensibly similar pots is a valuable resource to be carefully curated, not one to be thoughtlessly scattered on the winds of a contrary market.

The misunderstandings that arise out of this clash of terminologies can only be addressed by archaeologists adopting a more positive or proactive stance towards public education, and better explaining what archaeology is and what archaeologists do.

What is archaeology?

If the discourse of ownership is currently dominant, it is due in part to the failure of archaeologists to make their own voices heard through active engagement with the public that provides the ultimate sanction for their activities. Lazrus (2002) and Nalda (2002) discuss this failure in some depth and it is clear that it is to some degree institutional. University departments continue to privilege exploration over conservation or presentation: '… it is … sexier to hire a specialist in Oldowan technology or Inka urbanism than in the impact of tourism on the archaeological record' says Fagan (1996:240) and this is also true of research funds which are channelled into fieldwork (termed 'primary research'), rather than what are considered to be secondary activities of archaeological resource management and public education. The result is a surfeit of (unemployable) specialists in ancient cultures, while the needs of the general public for an accessible archaeology are not met (ibid.:241); and if the success of television programmes devoted to archaeology – whether fringe or mainstream – is anything to go by, the public is certainly hungry for such fare.

Public enthusiasm for archaeology in demand countries is often sparked by the perceived romance of treasure hunting, and the challenge for archaeologists is to redirect this enthusiasm, without dimming it, towards a more nuanced understanding of the past (Dromgoole, 2002; McManamon, 1994:63; see papers in Stone and Molyneux, 1994). In the USA, the challenge is being met by the Society for American Archaeology, which established a Public Education

Committee in 1990 to offer consultation on media projects and travelling displays of archaeological education resources, while the American Institute of Archaeology continues publication of its popular – and successful – magazine *Archaeology*. In the UK, the CBA publishes *British Archaeology* and there is the long-running independent *Current Archaeology,* and though public education seems to be more a concern of museum archaeologists than of fieldworkers (Schadla-Hall, 1999:150), this is not to overlook the success of model sites constructed for purposes of experimentation, education and public presentation (Stone and Plane,l 1999a:4; see also papers in Stone and Planel, 1999b). Although subject to commercial constraints, it seems desirable that museums and sites should seek to engage rather than entertain the public, and to challenge their preconceptions rather than pander to their stereotypes and prejudices, otherwise the damaging stereotype of archaeology as treasure hunting will only be reinforced.

Public participation

Although many modern archaeological techniques require specialist skills or instrumentation, there is still a role for active public participation and employment in fieldwork, particularly in the so-called source countries. This has been shown on several occasions to be an effective strategy for dealing with looting. In Agua Blanca, Ecuador, local *huaqueros* were trained in archaeological techniques (Howell, 1996:50) and at Sipán, Peru, *huaqueros* were also employed on the excavation. In the UK, the technical expertise of metal detectorists is increasingly called upon. There are two reasons for the success of these experiments. First, the perception often held by locals that (outsider) archaeologists are interested only in stealing their patrimony is exploded, and the true nature of archaeological concerns are revealed and accepted as valid. The archaeology is seen as something to be understood and curated rather than consumed. Second, the work is legal, probably less hazardous than tomb robbing at night and remuneration is guaranteed (Seeden, 1994:96). Interpretations, too, can benefit from the multiple perspectives which are engendered through such cooperations.

An ideal scenario seems to have been realized by the inhabitants of La Conga, a Peruvian village close to the archaeological site of Kuntur Wasi in the northern Andes (Onuki, 1999). The villagers first organized themselves in 1972 to guard Kuntur Wasi and received the support of the National Cultural Institute (NCI) at Lima. In 1988, the NCI invited an archaeological team from Tokyo University to begin excavating the site, and in 1989, three tombs were discovered and found to contain gold, which normally should have been removed to Lima. However, in this case, the NCI gave special dispensation for the finds to remain in the village, but in 1990, more tombs were discovered and it became clear that a museum would have to be built. In 1991, a travelling exhibition of the excavation finds visited Japan to raise funds and in 1994, the museum was opened – the first Peruvian museum built with the explicit participation of the local community. In 1996, a small library was added and the museum has now become a cultural centre where villagers can meet to watch videos and television, or give and attend lectures. The excavations at Kuntur Wasi continue and the site itself has remained free of damage.

Kuntur Wasi is an exemplary case, but the development and maintenance of such a centre is not without pitfalls. It may be politically untenable if the 'version' of the past presented differs radically from that of the dominant group, and any tourist attraction is irresistible for commercial interests wishing to 'develop' it further. The vicissitudes that such centres may face are discussed by Ucko (1994). The Kuntur Wasi museum seems to be successful as it is situated at the conjunction of a proactive local community, a sympathetic government and a foreign archaeological mission sensitive to local opinion. Crucially, perhaps, the initiative was indige-

nous and not imposed. The villagers now appear on television and visit towns and cities in northern Peru to talk about their experience, so that their innovative strategy might be copied.

Matsuda (1998:93) has recently pointed to an apparent hypocrisy whereby subsistence diggers are treated as criminals and denigrated by archaeologists who profit culturally and financially from the same resource base. While it is clear that many archaeologists would not regard subsistence diggers as the real looters, collectors are the real looters says Elia (Elia, 1996:61); it is also true that archaeologists working in developing countries have an intellectual and economic obligation to the people who host their research. How this obligation can be met within current institutional and financial structures is problematical, but suggests that the war against archaeological looting must be fought in the committee room as much as in the field or the marketplace.

Cultural tourism

It is well established that archaeological sites and museums can act as the mainspring of tourist developments, with the economic benefits that accrue. In Turkey, an archaeological museum was founded in Bodrum in 1959 at a time when the town received almost no tourists, but by 1990 it was the second most popular museum in Turkey and the population of the town had tripled. In the Cypriot town of Kyrenia the number of visitors doubled in the three years following the opening of a museum to display a fourth-century BC shipwreck (Throckmorton, 1990:180). The several museums and monuments along the Kenyan coast in 1989 attracted 167,000 foreign visitors, and continue to have a beneficial effect on the entire regional economy (Wilson and Omar, 1996:241). At Chiclayo, Peru, the nearest big town to the archaeological site of Sipán, a spectacularly rich (and partly looted) Moche site in Peru, in the ten years following the plunder and then excavation of the site, the number of tourists grew from 'a handful' to between 40,000 and 70,000 a year (Watson, 1999:16).

The long-term benefits to a depressed economy of cultural tourism have rarely been quantified, although it has been estimated that at Sipán, after careful excavation, the subsequent display of both artefacts and site now generates something in the region of $14 million a year in tourist revenue, a far cry from $250,000 the looters are thought to have earned for their initial finds (ibid.:16). The Swedish Tourist Board has estimated that every year the salvaged seventeenth-century AD battleship *Vasa* attracts several hundred million dollars into the Swedish economy (Throckmorton, 1990:181). This is the economic reality that underlies the observation that the curation and imaginative display of archaeological material in local museums, and the development of archaeological sites for public presentation, can create a resource which will help to attract tourists, and that sustainable employment will then follow.

It is essential that the income derived from tourist support be used for the benefit of communities in the immediate vicinity of sites, and not be siphoned off by a central, and perhaps distant, government or by outside commercial concerns. Where possible, local people should be employed and the development of the necessary infrastructure should be under local guidance and meet local needs or aspirations. As shown in the case of Kuntur Wasi, excavated material needs to be curated and displayed in museums close by and not removed to a 'national' museum in a far-off capital city.

But tourism of course brings along its own set of problems. Too many tourists can cause the physical erosion of a site and even the deterioration of museum exhibits if environmental control systems are overloaded (Nalda, 2002; Périer-D'Ieteren, 1998; Merhav and Killebrew, 1998:15). The list of the world's 100 most endangered sites published in 1996 included such famous sites

as Angkor Wat, Teotihuacan, Petra, Mesa Verde and Pompeii (Burnham, 1998:150), all physically decaying despite the huge numbers of tourists they attract. Until recently at Pompeii, with two million visitors per year, only 40 per cent of the site was open to the public because of its poor state of repair. In 1997, the Italian government moved to rectify the situation by declaring the site an autonomous area, so that in future any tourist revenue will be retained for conservation and further research at the site (ibid.:151). Again, this illustrates the point that money from entrance fees must be used directly to maintain the fabric of the site or monument, and not to support a centralized bureaucracy.

Commercial development can also trivialize the local or traditional significance of a site and even the experience of curation in a museum can be viewed as foreign or alienating for material which is considered to be still sacred or otherwise important for the social well-being of a community (Ucko, 1994:260; Jegede, 1996:129–30). For this reason alone, the primary audience for any display should be considered to be the local population, and all parts of this population (including minority groups) should be consulted about possible presentations.

In 1999, ICOMOS adopted a new Cultural Tourism Charter to replace the earlier, 1976, version, and which was thought necessary on account of the growth of international tourism in the intervening period, as well as changing attitudes to site conservation. While the original, 1976, Charter emphasized the negative effects of tourism, the 1999 Charter stresses the need to make heritage sites (broadly interpreted) more accessible to the visitor. In its introduction it states:

> Tourism should bring benefits to host communities and provide an important means and motivation for them to care for and maintain their heritage and cultural practices. The involvement and co-operation of local and/or indigenous community representatives, conservationists, tourism operators, property owners, policy makers, those preparing national development plans and site managers is necessary to achieve a sustainable tourist industry and enhance the protection of heritage resources for future generations.
>
> (ICOMOS, 1999:2)

This might often require imaginative legislation, but again there is a need for reorientation of archaeological concerns, as already discussed, away from the academic ethic of research and peer-reviewed publication and instead towards one of conservation and presentation. Again, it might be a mistake to consider archaeology in isolation, something tourists are not prone to do. The original definition of ecotourism included 'cultural manifestations (both past and present)' and if this has since been played down (Weaver, 1998:18) it is probably due more to the interests of (non-archaeological) academics whose studies have focused upon destinations which are popular on account of their wildlife and scenery. In other countries, archaeology might be the primary attraction, and even when it is not, in many areas of the developing world a sustainable strategy of ecotourism might include an archaeological component.

A free trade?

Dealers and collectors, who adhere to the liberal ideology of Merryman's internationalist image, demand a free trade in archaeological and other cultural material (Bordkey, 1996; Marks, 1998; Ortiz, 1998; White, 1998). Suggestions that the trade has a damaging effect on the world's archaeological and cultural heritage are dismissed, and instead it is claimed that free trade acts in the common interest: it puts money into the pockets of the poor, it preserves valuable material for posterity and it promotes a universal appreciation of a diverse range of

artistic forms. This claim can be opposed from the theoretical position that there are social inequalities which are deeply rooted and not so easily overcome, and that the concept of a common interest has no grounding in reality. But, as more case studies are reported and quantifiable data are made available, each of the individual propositions has become more amenable to empirical examination.

First, there is the proposition that the trade is justified on economic grounds. Often, particularly in developing countries, the money derived from illicit digging can supplement a small and uncertain income. Politis (2002) tells how the cemetery at an-Naq' in Jordan has for years been looted by impoverished locals and this is not unusual, but those who dig are swindled out of the true value of their finds by the middlemen who organize the trade and the dealers who make the final sale. This point is made by Schávelzon (2002) and Togola (2002), and other studies suggest that diggers routinely receive less than one per cent of the final sale price of an object (Boylan, 1995:103; Brodie, 1998).

Nevertheless, what, in western terms, is a small sum of money might represent a substantial amount to a poor subsistence farmer. But it is a short-term gain. Once removed from their original contexts, archaeological and other cultural objects become commodities on the art market, and presumably continue to increase in monetary value, or at least are thought to have done so in recent times. But again, this appreciation, or profit, is lost to the original finder, and to the economy of the country of origin. And again, it is to the long-term benefit of western economies as jobs and income are generated on the back of this expropriated material. Thus, in reality, the original diggers are swindled twice over: first out of the initial monetary value of their find, and then out of its long-term economic potential. Governments who are prepared to allow treasure salvors to operate in their territorial waters in return for a share of any treasure found are cheated in similar fashion, out of a long-term economic resource in return for a one-off, undervalued payment.

The second proposition used to justify free trade is that the market 'rescues' what are euphemistically termed 'chance finds' which are thrown up during the course of industrial or agricultural development projects, or through urban expansion or renewal. Without the market, these pieces would simply be discarded and destroyed, but their monetary value guarantees their recovery and their ultimate sale and collection ensures their survival.

Quantitative studies – such as they are – suggest that as a cause of damage to archaeological sites, sometimes commercially motivated looting does indeed rank below agricultural or urban development. A study of 12,725 sites in Andalusia, Spain, showed that the greatest cause of damage was surface ploughing, which had affected 24 per cent of sites, while looting was second at 14 per cent (Fernández Cacho and Sanjuán, 2000:18). In the Aegean area of Turkey, a survey of 180 palaeolithic – early bronze age sites showed looting to rank third (at thirteen per cent) behind agricultural and urban development. In the Marmara area of the same country, looting again ranked third (at six per cent) behind the same two causes (Tay Project, 2001). However, caution is needed here, as surveys such as these probably underestimate the true scale of looting. This is for two reasons. First, looting may be sporadic and the results not observable at the time of site inspection. Second, not all sites will be targeted by looters. Prehistoric sites of the type registered in the Turkish surveys, for instance, are probably less attractive than the country's many iron age, classical or Roman sites. This latter point was confirmed by a study of Mayan sites in Belize, known by looters to be a good source of saleable material, which showed that 58.6 per cent of 181 sites had been damaged by looting, while only 34.2 per cent had been touched by agricultural, urban or industrial development (Gutchen, 1983).

Thus, although development projects are sometimes a major cause of archaeological destruction, it is not always so. Even when it is the case, it is not clear to what extent the destruction is

exacerbated or ameliorated by the market and, if the latter, whether, on balance, local episodes of amelioration can justify the greater global mischief caused by the market. In his discussion of the Jordanian site of Zoar, Politis (2002) provides a rare case study of how the development-led destruction of an archaeological site articulated with the global antiquities market. Clearly, in this particular instance there was a destructive synergy between the market and development that proved disastrous for the local archaeology, but more studies of this type are urgently needed.

The final proposition is that a free trade in archaeological and other cultural material can help to promote a universal appreciation of human creativity and engender mutual respect. For this to be true, however, there would need to be a *fair* exchange of material, while at the present time the exchange is manifestly unfair. Material flows from source countries to demand countries and there is no countervailing flow, no fair exchange. Thus, free trade does not promote international harmony, it merely sustains economic inequality and causes resentment among those whose culture is traded.

Collectors and dealers claim that, although in the first instance they may be acting out of self-interest, their actions ultimately have beneficial consequences, but it is difficult to muster empirical support for this position. A free trade in archaeological and cultural material seems to bestow few, if any, long-term benefits on those who, in the source countries, are its ultimate victims.

Conventions and ethics

No country has the resources necessary to protect its archaeology. Even rich nations such as the USA and the UK suffer from looting (Addyman and Brodie, 2002; Davis, 2002). It is futile to demand that large countries such as Mali or India should protect their own heritage from depredations fuelled by rich collectors and institutions abroad. Countries such as these are dependent upon the international community to ensure that their own domestic laws are not broken, which in practice means enforcement of instruments such as the 1970 UNESCO Convention on the Means of Prohibiting and Preventing the Illicit Import, Export and Transfer of Ownership of Cultural Property (McIntosh, 2002; Pachaur,i 2002).

McIntosh describes the US implementation of the 1970 UNESCO Convention, with special reference to the bilateral agreement reached between the USA and Mali within its framework. However, she also emphasizes that at the time of writing only two of the major market nations (USA and France) had ratified the Convention, although Switzerland is currently drafting implementing legislation and in March 2001 the UK government announced its intention to accede. Implementation of the Convention by these latter countries will allow their participation with the USA in future multilateral agreements, an eventuality envisaged by the USA at the time of its ratification (Kouroupas, 1995).

It could be argued that the main effect of the UNESCO Convention has been moral rather than material. For a long time, museums acted to underwrite the trade, buying material on the open market and accepting as bequests privately accumulated collections. Norskov (2002) demonstrates how the research interests of individual curators in the past have influenced the composition of museum collections, but also suggests that attitudes are now changing. In no small part, this is due to the introduction of ethical codes which call for acquisition policies to be adopted in accordance with the principles laid down in the UNESCO Convention. Section 3.2 of the 1986 ICOM Code of Professional Ethics, for instance, states that:

> A museum should not acquire, whether by purchase, gift, bequest or exchange, any object unless the governing body and responsible officer are satisfied that the museum can acquire

a valid title to the specimen or object in question and that in particular it has not been acquired in, or exported from, its country of origin and/or any intermediate country in which it may have been legally owned (including the museum's own country), in violation of that country's laws ...

So far as excavated material is concerned, in addition to the safeguards set out above, the museum should not acquire by purchase objects in any case where the governing body or responsible officer has reasonable cause to believe that their recovery involved the recent unscientific or intentional destruction or damage of ancient monuments or archaeological sites, or involved a failure to disclose the finds to the owner or occupier of the land, or to the proper legal or governmental authorities.

Archaeologists too are responding. In 1988, the International Congress for Classical Archaeology recommended in the Berlin Declaration that archaeologists should not provide expertise or advice to dealers or private collectors. Principle no. 3 of the 1996 Society for American Archaeology's Principles of Archaeological Ethics warns that archaeologists should be aware that the commercialization of archaeological objects results in the destruction of archaeological sites and of contextual information, and recommends that archaeologists should discourage and avoid activities that enhance the commercial value of an object. The Archaeological Institute of America's 1990 (amended 1997) Code of Ethics also requires that its members do not encourage or participate in the trade in unprovenanced antiquities. In the UK, the British Academy passed a resolution in 1998 affirming its adherence to the principles laid down in the 1970 Convention, and in 1999, the Institute of Archaeology in London became the first university department to adopt an ethical policy based on similar principles (Tubb 2002). These principles are also guiding the editorial policies of some academic journals such as the *American Journal of Archaeology*.

The 1995 UNIDROIT Convention on Stolen and Illegally Exported Cultural Objects, designed to augment the 1970 UNESCO Convention looks set to be equally influential on the development of codes of due diligence, which are intended to help prevent the inadvertent purchase of illicit cultural material.

Nevertheless, many museums continue to collect or display unprovenanced material in complete contravention of ethical codes, although in so doing they risk public embarrassment and financial loss (Brodie *et al.*, 2000:43–58; McIntosh, 2002).

Conclusion

Gill and Chippindale (1993) have written of the material and intellectual consequences of collecting. By 'intellectual consequences', they mean the 'corruption of reliable knowledge' (ibid.:269), which is caused by the revaluation and reinterpretation of decontextualized objects in a modern setting. This chapter focuses more on the material consequences, the damage caused to the material record by irresponsible collecting, and for good reason: it seems that those who benefit from the illicit trade – the dealers and collectors – are in a state of denial. The scale of the trade is often played down and the damage it causes is discounted. For this reason, eye-witness testimony and factual, preferably quantitative, data are invaluable in what is an ongoing debate. While this chapter was being prepared, the US implementation of the UNESCO Convention was challenged in the US Senate, and in the UK both parliament and government carried out enquiries into the trade in illicit material. The Second Protocol to the Hague Convention was adopted and negotiations continued over the UNESCO Draft Convention on the Protection of the Underwater Cultural Heritage. This is not an exercise in academic obscurity, a faint polemic

from a distant ivory tower; academics and museum personnel the world over are actively engaged in the political process, and their work is instrumental in changing the present reality of archaeological plunder – in stopping the theft before extinction.

References

Addyman, P.V. and Brodie, N. (2002) 'Metal detecting in Britain: catastrophe or compromise?', in Brodie, N. and Tubb, K.W. (eds), op. cit.

Art Newspaper (2000) 'Systematic destruction', *Art Newspaper*, 105 (July–Aug.), 6.

Bahn, P.G. (2000) 'Khmer artefacts return to Cambodia', *Antiquity*, 74, 753–4.

Bordkey, A.K. (1996) 'The failure of the nationalization of cultural patrimonies', in Briat, M. and Freedberg, J.A. (eds), *Legal Aspects of International Trade in Art*, The Hague: Kluwer.

Boylan, P.J. (1995) 'Illicit trafficking in antiquities and museum ethics', in Tubb, K.W. (ed.), *Antiquities Trade or Betrayed: Legal, Ethical and Conservation Issues*, London: Archetype/UKIC.

—— (2002) 'The concept of cultural protection in times of cultural conflict: from the crusades to the new millennium', in Brodie, N. and Tubb, K.W. (eds), op. cit.

Brent, M. (2001) 'Faking African art', *Archaeology* 54, 27–32.

Brodie, N. (1998) 'Pity the poor middlemen', *Culture Without Context*, 3, 7–9.

—— (2002) 'Britannia waives the rules? The licensing of archaeological material for export from the UK', in Brodie, N. and Tubb, K.W. (eds), op. cit.

——, Doole, J. and Watson, P. (2000) *Stealing History: The Illicit Trade in Cultural Material* Cambridge: McDonald Institute.

—— and Tubb, K.W. (eds) (2000) *Illicit Antiquities: The Theft of Culture and the Extinction of Archaeology*, London and New York: Routledge.

Burnham, B. (1998) 'Architectural heritage: the paradox of its current state of risk', *International Journal of Cultural Property*, 7, 149–65.

Chapman, J. (1994) 'Destruction of a common heritage: the archaeology of war in Croatia, Bosnia and Hercegovina', *Antiquity*, 68, 120–6.

Clément, E. (1996) 'UNESCO: some specific cases of recovery of cultural property after an armed conflict', in Briat, M. and Freedberg, J.A. (eds), *Legal Aspects of International Trade in Art*, The Hague: Kluwer.

Coggins, C. (1969) 'Illicit traffic in Pre-Columbian antiquities', *Art Journal*, 29(1), 94–8.

Conlin, D.L. and S.C. Lubkemann (1999) 'What's relevant about underwater archaeology … and not about treasure hunting', *Archaeology Newsletter*, 64, 62.

Davis, H.A. (2002) 'Looting graves / buying and selling artefacts: facing reality in the US', in Brodie, N. and Tubb, K.W. (eds), op. cit.

Delgado, J.P. (1996) 'Lure of the deep', *Archaeology*, 49(3), 41–7.

Dodds, J.D. (1998) 'Bridge over the Neretva', *Archaeology*, 51(1), 48–53.

Dromgoole, S. (2002) 'Law and the underwater cultural heritage: a question of balancing interests', in Brodie, N. and Tubb, K.W. (eds), op. cit.

Dupree, N.H. (1996) 'Museum under siege', *Archaeology* 49(2), 42–51.

—— (1998) 'The plunder continues', *Archaeology Online*, available at www.archaeology.org/online/features/afghan/update.html (accessed 22 August 2004).

Elia, R.J. (1992) 'The ethics of collaboration: archaeologists and the Whydah project', *Historical Archaeology*, 22, 105–17; reprinted in Prott, L.V. and Srong, I. (eds) (1999) *Background Materials on the Protection of the Underwater Cultural Heritage*, Paris and Portsmouth: UNESCO/Nautical Archaeology Society.

—— (1996) 'A seductive and troubling work', in K. Vitelli (ed.), op. cit.

Elliot, J.A. (2000) *An Introduction to Sustainable Development*, London: Routledge.

Ellis, R. (1995) 'The antiquities trade: a police perspective', in Tubb, K.W. (ed.), op. cit.

Fagan, B. (1996) 'The arrogant archaeologist', in Vitelli, K. (ed.), op. cit.

Fernández Cacho, S. and L.G. Sanjuán (2000) 'Site looting and illicit trade of archaeological objects in Andalusia, Spain', *Culture Without Context*, 7, 17–24.

Gill, D. and C. Chippindale (1993) 'Material and intellectual consequences of esteem for Cycladic figures', *American Journal of Archaeology*, 97, 601–59.

Gutchen, M. (1983) 'The destruction of archaeological resources in Belize, Central America', *Journal of Field Archaeology*, 10, 217–28.

Howell, C.L. (1996) 'Daring to deal with huaqueros', in Vitelli, K. (ed.), op. cit.

ICOM (1993) *Looting in Angkor*, Paris: ICOM.

ICOMOS (1999) *International Cultural Tourism Charter*, available at www.icomos.org/tourism/sugaya.html (accessed 22 August 2004).

Jegede, D. (1996) 'Nigerian art as endangered species', in Schmidt, P.R. and McIntosh, R.J. (eds), op. cit.

Johnston, P.F. (1993) 'Treasure salvage, archaeological ethics and maritime museums', *International Journal of Nautical Archaeology*, 22, 53–60.

—— (1997) 'Treasure hunting', in Delgado, J.P. (ed.), *British Museum Encyclopaedia of Underwater and Maritime Archaeology*, London: British Museum.

Kouroupas, M.P. (1995) 'US efforts to protect cultural property: implementation of the 1970 UNESCO Convention', in Tubb, K.W. (ed.), op. cit.

Lazrus, P. (2002) 'Walking a fine line: promoting the past without selling it', in Brodie, N. and Tubb, K.W. (eds), op. cit.

Lee, D. (2000a) 'History and art are being wiped out', *Art Newspaper*, 101, 31.

—— (2000b) 'A small step forward', *Art Newspaper*, 107, 6.

Levy, A. and C. Scott-Clark (1999) 'Looters take millions in Afghan treasures', *Sunday Times*, 11 July.

Leyten, H. (ed.) (1995) *Illicit Traffic in Cultural Property: Museums Against Pillage.* Amsterdam: Royal Tropical Institute.

McIntosh, S.K. (2002) 'Reducing incentives for illicit trade in antiquities: the US implementation of the 1970 UNESCO Convention', in Brodie, N. and Tubb, K.W. (eds), op. cit.

McManamon, F.P. (1994) 'Presenting archaeology to the public in the USA', in Stone, P.G. and Molyneux, B.L. (eds), op. cit.

Macfarlane, A. (1998) 'The mystery of property: inheritance and industrialization in England and Japan', in Hann, C.M. (ed.), *Property Relations: Renewing the Anthropological Tradition*, Cambridge: Cambridge University Press.

Marks, P. (1998) 'The ethics of dealing', *International Journal of Cultural Property*, 7, 116–27.

Matsuda, D.J. (1998) 'The ethics of archaeology, subsistence digging, and artefact looting in Latin America: point, muted counterpoint', *International Journal of Cultural Property*, 7, 82–97.

Merhav, R. and A. Killebrew (1998) 'Public exposure: for better and for worse', *Museum International*, 50(4), 5–14.

Merryman, J.H. (1996) 'A licit international trade in cultural objects', in Briat, M. and Freedberg, J.A. (eds), *Legal Aspects of International Trade in Art*, The Hague: Kluwer.

Messenger, P.M. (1999) *The Ethics of Collecting Cultural Property*, Albuquerque: University of New Mexico Press.

Meyer, K.E. (1973) *The Plundered Past*, London: Readers Union.

Muscarella, O. (2000) *The Lie Became Great: The Forgery of Ancient Near Eastern Cultures*, Groningen: Styx.

Nalda, E. (2002) 'Mexico's archaeological heritage: a convergence and confrontation of interests', in Brodie, N. and Tubb, K.W. (eds), op. cit.

Nørskov, V. (2002) 'Archaeology and education in Kenya: the present and the future', in Brodie, N. and Tubb, K.W. (eds), op. cit.

O'Keefe, P.J. (1997) *Trade in Antiquities: Reducing Destruction and Theft*, London: Archetype/ UNESCO.

—— (2002) 'Negotiating the future of the underwater cultural heritage', in Brodie, N. and Tubb, K.W. (eds), op. cit.

Onuki, Y. (1999) 'Kuntur Wasi: temple, gold, museum ... and an experiment in community development', *Museum International*, 51(4), 42–6.

Ortiz, G. (1998) 'The cross-border movement of art: can it and should it be stemmed?' *Art, Antiquity and Law*, 3, 53–60.

Pachauri, S.K. (2002) 'Plunder of cultural and art treasures – the Indian experience', in Brodie, N. and Tubb, K.W. (eds), op. cit.

Périer-d'Ieteren, C. (1998) 'Tourism and conservation: striking a balance', *Museum International*, 50(4), 5–14.

Prott, L.V. and P.J. O'Keefe (1992) '"Cultural heritage" or "cultural property"?' *International Journal of Cultural Property*, 1, 307–20.

Politis, K.D. (2002) 'Dealing with the dealers and the tomb robbers: the realities of the archaeology of the Ghor es-Safi in Jordan', in Brodie, N. and Tubb, K.W. (eds), op. cit.

Renfrew, C. (2000) *Loot, Legitimacy and Ownership: The Ethical Crisis in Archaeology*, London: Duckworth.

Rooney, S. (2001) 'Tomb raiders', *Times Magazine*, 6 January, 44–8.

Sax, J.L. (1999) *Playing Darts with a Rembrandt*, Ann Arbor: University of Michigan Press.

Schadla-Hall, T. (1999) 'Public archaeology', *European Journal of Archaeology*, 2, 147–58.

Schmidt, P.R. and R.J. McIntosh (1996) *Plundering Africa's Past*, London: James Currey.

Schávelzon, D. (2002) 'What's going on around the corner? Illegal trade of art and antiquities in Argentina', in Brodie, N. and Tubb, K.W. (eds), op. cit.

Seeden, H. (1994) 'Archaeology and the public in Lebanon: developments since 1986' in Stone, P.G. and Molyneux, B.L. (eds), op cit.

Stone, P.G. and Molyneux, B.L. (eds) (1994) *The Presented Past: Heritage, Museums and Education*, London: Routledge.

Stone, P.G. and P.G. Planel (1999) *The Constructed Past: Experimental Archaeology, Education and the Public.* London: Routledge.

Sutherland, A. (2002) 'Perceptions of marine artefact conservation and their relationship to destruction and theft', in Brodie, N. and Tubb, |K.W. (eds), op. cit.

TAY Project (2001) *Destruction Report*, available online at www.tayproject.org/raporeng.html (accessed 22 August 2004).

Throckmorton, P. (1990) 'The world's worst investment: the economics of treasure hunting with real life comparisons', *Underwater Archaeology Proceedings from the Society for Historical Archaeology*, 6–10; reprinted in Prott, L.V. and Srong, I. (eds) (1999) *Background Materials on the Protection of the Underwater Cultural Heritage*, Paris and Portsmouth: UNESCO/Nautical Archaeology Society.

Togola, T. (2002) 'The rape of Mali's only resource', in Brodie, N. and Tubb, K.W. (eds), op. cit.

Tubb, K.W. (1995) *Antiquities Trade or Betrayed: Legal, Ethical and Conservation Issues*, London: Archetype/UKIC.

—— (2002) 'Point, counterpoint', in Brodie, N. and Tubb, K.W. (eds), op. cit.

Ucko, P.J. (1994) 'Museums and sites: cultures of the past within education – Zimbabwe, some ten years on', in Stone, P.G. and Molyneux, B.L. (eds), op. cit.

US News (1999) 'The race for riches', *US News*, 10 April.

Vitelli, K.D. (ed.) (1996a) *Archaeological Ethics*, Walnut Creek: AltaMira.

—— (1996b) 'An archaeologist's response to the draft principles to govern a licit international traffic in cultural property', in Briat, M. and Freedberg, J.A. (eds), op. cit.

Warren, P. (1972) *Myrtos: An Early Bronze Age Settlement in Crete*, London: Thames and Hudson.

Watson, P. (1999) 'The lessons of Sipán: archaeologists and huaqeros', *Culture Without Context*, 4, 15–20.

Weaver, D.B. (1998) *Ecotourism in the Less Developed World*, New York: CAB International.

White, S. (1998) 'A collector's odyssey', *International Journal of Cultural Property*, 7, 170–6.

Whitelaw, T., P.M. Day, E. Kiriatzi, V. Kilikoglou and D.E. Wilson (1997) 'Ceramic traditions at EM IIB Myrtos, Fournou Korifi', in Laffineur, R. and Betancourt, P.P. (eds), *Craftsmen, Craftswomen and Craftsmanship in the Aegean Bronze Age* (Aegaeum 16: Proceedings of the 6th International Aegean Conference, Temple University, 18–21 April 1996).

Wilson, T.H. and Omar, A.L. (1996) 'Preservation of cultural heritage on the East African coast', in Schmidt, P.R. and McIntosh, R.J. (eds), op. cit.

11

Heritage management in southern Africa

Local, national and international discourse

Webber Ndoro and Gilbert Pwiti

Heritage management in southern Africa has been the by-product of colonialism. During the colonial period, therefore, much of the practice reflected the interests of the colonial masters and hardly considered the aspirations of the local communities. Heritage was largely considered to be of scientific interest and protection was also viewed in this light. As far as its protection was concerned, the general thinking was that proper scientific procedures needed to be followed. In this chapter, however, it is argued that, traditionally, there did exist ways and means of protecting cultural heritage that were just as effective as scientific procedures. However, with the insistence on science as well as the political process in southern Africa and indeed elsewhere on the continent, part of the legacy of colonialism has been the alienation of local communities from their cultural heritage. Regrettably, it would seem that, despite political independence, heritage management in the region has continued to reflect the colonial discourse within which it was scientifically established. It is argued in this chapter that successful heritage management should involve local communities and should integrate both traditional and scientific procedures.

Introduction

Heritage management is about the care and continuing development of a place such that its significance is retained and revealed and its future secured. Archaeology in the context of heritage management should add to its primary aim, of reconstructing the past, the protection and presentation of sites and monuments. Archaeological heritage management is not only technical prescription but also the creation of a dialogue between archaeology and the general public. Heritage management therefore bestows on archaeology the additional responsibility of being sensitive to public aspirations and at the same time protecting archaeological resources. Both as a theoretical concept and in practice, archaeological heritage management is central to defining archaeology's role in society. This chapter explores the development of archaeological heritage management in southern Africa in general and Zimbabwe in particular. The main objective is to outline the main influences which shaped the development of heritage management in Zimbabwe and explore how the present situation has arisen.

According to Kristiansen (1998), heritage management in Europe developed in three phases. The first phase was the period before the nineteenth century when the main emphasis was on archaeological objects. The main focus was on research and the protection of artefacts. It also focused on museum collections, classification and cemetery excavation. Artefacts were removed from their original context and presented to the public in urban areas through museums. The

second phase was after the nineteenth century, with the major thrust being on the protection of archaeological monuments. This was mainly a response to the destruction of monuments by developments in the process of industrialization and field clearance for agriculture. During this period, the middle classes in Europe started to visit monuments and this led to the preservation and restoration of some ruined monuments. The last phase began in the 1970s, when efforts were concentrated on enlarging the area of protection with emphasis on the landscape surrounding the monuments. This was due to the increasing understanding of the relationship between monuments and their surroundings. The landscape provided an important dimension for understanding and experiencing the larger context. What is important to note here is the fact that the changes in heritage management in Europe were linked to changes in the new popular interests and behaviour of its citizens. In part, it was an ideological change that developed with changes in archaeological research and in popular perceptions of both the landscape and monuments. Heritage management was part of wider changes in society. What the heritage managers and archaeological researchers were doing was to satisfy a public need. This was not the case in southern Africa.

Heritage management as we know it was introduced into southern Africa during the colonial period and, even after independence, has continued to be through international agents like UNESCO. The result has been that western ideas and international demands, rather than local values, have been driving the course of heritage management in southern Africa. A new heritage management élite whose values are rather different from those of the population at large administers new models of managing the heritage. Indigenous views and feelings about the past held by the wider community thus have been disregarded (Ucko, 1994; Pwiti and Ndoro, 1999).

Western models impose on bodies of cultural material the analytical rigour of categorization, division and quantification in place of the synthetic interpretative modes of integration and association. The approaches to heritage management in Europe, at least in part, could be described as holistic to landscape interpretation, an attempt to understand the landscape as a cultural construction, with changing uses and meaning over time. Landscape is seen as part of the cosmology of a people. This way, heritage management is used to promote or reinforce social strategies.

Heritage management practice in southern Africa

In southern Africa, the tendency has been to think that heritage management started with the European colonization of the subcontinent. However, the fact that the Europeans found so many archaeological sites intact means that these sites could survive because of some form of management. Obviously places associated with religious practice and those in everyday use received more attention than those abandoned. In Zimbabwe it is no mere coincidence that so many of the national monuments are also rainmaking shrines, for example Khami, Great Zimbabwe, Domboshava and Silozwane. Such places were sacred and protected by a series of taboos and restrictions. King Lobengula, the last ruler of the Ndebele state, for example, preserved Khami as a place for rainmaking and had soldiers stationed at the monument most of the time (Summers, 1967). During Lobengula's reign the Shona religious leaders who resided in the Matopo area were allowed to conduct rituals at most of the caves. King Mzilikazi (first ruler of the Ndebele state) and Lobengula are said to have sponsored some of the religious ceremonies conducted in the Matopo. However, once the area was designated a National Park and the sites declared national monuments, these activities were prohibited (Ranger, 1999). For example, at Thulamela in South Africa, until recently, the local communities could not visit the place (Miller, 1996). At Domboshava, the rituals still continue today, but are deemed illegal by the National Monuments Act (Pwiti and Mvenge, 1996). In fact, the area designated for protection

is less than a square kilometre, but the whole hill and the nearby forest are supposed to be a sacred cultural landscape. The same situation prevailed at Silozwane in the Matopo and Makwe in Wedza. In Mozambique, the site of Manyikeni was under Shona traditional custodianship until 1975 when it was handed over to the University of Eduardo Mondlane. In Botswana, the Kharni type site of Majojo is used today for ritual purposes (authors' personal observations). During the pre-colonial era most places of cultural significance enjoyed protection in the sense that no one was allowed to go to them except with the sanction of the religious leaders. However, with the advent of colonization these places became important scientific sites. Scientific research makes the sites accessible to a wider and larger audience, which leads to its desecration and hence its cultural debasing.

In southern Africa, the mandate to preserve and present the archaeological heritage is entrusted to national museums. In South Africa, some universities also are responsible for sites, for example the Universities of Witswatersrand and Pretoria. In countries such as Uganda, Ethiopia, Malawi and Tanzania, the responsibility for archaeological resources is shared between government departments of antiquities and museums. At times, this has led to conflict over responsibilities for specific resources, for example, the ownership of artefacts and their subsequent presentation to the public. Sometimes collections are even shared between countries. For example, the Omo early Stone Age material from Ethiopia is shared by the University of California (Berkeley), France and Ethiopia. A similar situation exists with the Olduvai Gorge material fragmented between Kenya and Tanzania (Mzalendo, 1996). In Botswana, part of the cultural material from the site of Domboshaba is now at the University of Texas. The dual or multiple ownership of archaeological resources at times militates against a uniform and more holistically effective management system.

In countries such as Zimbabwe, South Africa and Kenya, where there was a large European settler population, heritage management developed as a preserve of the few and as a result it was seen as a highly academic subject and never meant for popular consumption. The museum organizations and at times universities were responsible for this, and their main function was research and the application of scientific principles. Studies usually focused on the establishment of categories, typologies and chronology. Very little was done in the form of linking the studies with the local communities, who were also themselves seen as objects of study (for example, hunter–gatherer communities of the Kalahari desert in Botswana). During the colonial times, the local communities and their cultures were also to be discovered, analysed and taxonomized as cultural and geographical entities (Kifle, 1994). It can be argued that the so-called lack of interest that most indigenous communities seem to show in cultural resources is deeply rooted in the social and political fabric of the subcontinent. Many people, particularly in countries that had a large European settler community, were excluded from the use and management of their cultural resources. In schools and churches, they were taught for decades to despise their cultures. There was an assumption that only Europeans would be interested in these things as objects of study. While the communities did not abandon their culture wholesale, it is now difficult for them to express themselves confidently.

Protective legislation

A central element in heritage management is appropriate protective legislation. All countries in southern Africa have laws that govern the way heritage resources are to be protected and used. The protective legislation of the archaeological and cultural heritage throughout the world is usually governed by three basic purposes, namely:

- to protect the existence of the resource for present and future generations;
- to develop understanding and experience of the cultural heritage as a precondition for the quality of human life;
- to protect and extract the scientific information inherent in the cultural environment as a precondition for describing and interpreting its history.

National legislation in southern Africa is similar in many ways in its objectives, definitions, forms of ownership, actions or practices permitted or prohibited and sanctions. The focus is on the protection of the structures and objects. One universal requirement in the subcontinent is that it should be location specific and have historical, artistic or scientific value. It must also have existed before a certain date: in the case of Zimbabwe before 1890; in Botswana 1902 and in South Africa, until the recent legislation (2000), it had to be at least fifty years old. Thus the sites of recent liberation struggle in Zimbabwe, for example, cannot qualify as national monuments. In South Africa, places like Robben Island are protected, not because of the famous or infamous prison, but in part because of the colonial history represented on the island dating back to the occupation of the Cape by the Dutch East India Company.

Most protective legislation ranks heritage resources into two categories: national monuments and ancient monuments/ relics. At national level, the main protective designation established by various protective legislation in southern Africa is a 'national monument'. This is the highest designation and its purpose is to provide a means of recognizing in law those monuments deemed to be of national importance. This is the case in Botswana, Malawi, South Africa, Zambia and Zimbabwe. A close look at the designated sites indicates that even so many years after the attainment of independence, colonial sites dominate in all the countries and these are the ones afforded the highest protection. Thus the legal instruments seem to continue to undervalue and misrepresent the cultural and archaeological heritage of southern Africa. Of the nearly 12,000 sites registered in Zimbabwe, approximately 200 are of colonial ancestry. This means that almost every colonial site is a national monument (Table 11.1).

In Zimbabwe, just as in other southern African countries, legislation is silent on issues of intangible aspects of the heritage. (In South Africa new legislation introduced in 2000 has now changed this.) The definition of an 'ancient monument', the lower form of protection, is any building, ruin, relic or area of land of historical, archaeological palaeontological or other scientific value. Nowhere in the whole Act does the term 'culture' or 'cultural landscapes' appear.

In all southern African countries except South Africa, the government or the state agency owns designated ancient and national monuments. In South Africa, national monuments can belong to individuals or institutions. Thus the legislation gives guidelines on how to look after nationally valued property. This means that the designation of a place as a national monument

Table 11.1 Ranking and distribution of designated national monuments in some southern African countries

	Botswana	South Africa	Zambia	Zimbabwe
Stone Age	0	14	18	3
rock art	8	10	15	14
Iron Age	8	14	9	13
colonial	22	4400	22	142
post colonial	1	4	11	0

does not in any way impinge on the individual or group's rights to land ownership. In most of the countries, therefore, the enactment of protective legislation makes cultural property government property; interest of government equals adherence to national and international regulations whose formulation had no input from the local communities. The transfer to state ownership of much of the cultural or archaeological resource through designation also resulted in the displacement of local people, and disempowerment with regard to control and access to cultural resource use and management. Even in South Africa, the property laws, which allow individuals to own land and therefore cultural sites, also led to the disempowerment of the traditional custodians of the land and therefore the cultural heritage.

Generally the protective legislation in southern African countries is very strong in what it is intended to protect. For example, the Zimbabwean National Museums and Monuments Act (25:11) requires members of the public to notify National Museums and Monuments of Zimbabwe (NMMZ) of any archaeological sites or relics that they find. It also makes it an offence to destroy, alter, damage or remove any archaeological sites or relics without written approval from the Director. The penalty for the latter offence is a fine of up to Z$2000 or five years' imprisonment, or both. The legislation implies that the public is responsible for ensuring that archaeological resources are not destroyed without prior approval. The unfortunate problem is that in most of southern Africa, the majority of the general public is not aware of this legislation. The reality in a number of southern African countries is that existing laws are not being effectively used and promulgating of new ones will not change matters. Despite many inadequacies, the existing laws could still protect the heritage, particularly the physical structures. Although most countries have laws that specifically prohibit damaging, excavation or removal of antiquities without permits, the penalties are paltry and, as a result, many groups violate them (Pwiti, 1996).

International conventions

The other designation which applies to southern African countries which is higher than 'national monument' is the 'world heritage' status. The World Heritage Convention (1972) was ratified by three countries in southern Africa by 1998. It provides for the identification, protection, conservation and presentation of cultural and natural sites of outstanding universal value. Seven cultural sites from southern Africa are on the list, two in Zimbabwe, two in Mozambique, one in Tanzania and two in South Africa. Several other sites are currently being processed for nomination. The 1972 convention was born out of the encounter of two concepts of thought: one, emerging directly from the Athens Conference organized in 1931 under the aegis of the League of Nations, concerned the preservation of the cultural heritage, relying largely on the classic concept of 'master-piece' or 'wonder of the world'; the other was concerned with transmitting to future generations a certain number of outstanding natural sites in an unspoiled state (Pressouyre, 1996). While enjoining states to undertake the inventory and assure the preservation of the natural and cultural heritage, the 1972 Convention has formulated criteria of excellence permitting recognition of the most outstanding properties in each category and placing them under the protection of the international community.

At present, the balance weighs heavily in favour of developed countries possessing great monuments, primarily located in Europe. At the same time, the heritage of humankind as defined by the convention is modelled upon a restrictive concept of cultural heritage. Cultural properties on the World Heritage List, whether they be monuments, groups of buildings or archaeological sites, should have a spatial dimension. The intangible aspect is not considered. Africa's heritage, though of infinite richness, does not always coincide with the sphere of appli-

Table 11.2 Distribution of cultural World Heritage sites

Continent	Number
Asia and the Pacific	81
Africa (excluding southern Africa)	44
southern Africa	7
Europe	224
North America	31
South America	39
Middle East	21

cation of the 1972 Convention. In Africa, more than anywhere else, the simplistic classification, long challenged by anthropologists, which opposes the immaterial heritage to the physical heritage, is meaningless. Culture is perceived in its totality and in its complexity as an ensemble of behaviours, of a person's connection to the social group, to nature and to the divine. Artistic creations are rarely separate from practical, social or religious motivations. Thus there is a conceptual difficulty in applying conventions such as that of 1972, as it appears to mutilate the idea of culture by introducing inappropriate categories. In most cases, the idea of cultural heritage to a large extent has been embodied in and confined to architectural monuments (Table 11.2).

The study of art and architecture, archaeology, anthropology and ethnology no longer concentrates on single monuments in isolation, but rather on considering cultural groups that were complex and multi-dimensional. These demonstrate social structures, ways of life, beliefs, systems of knowledge and representations of different past and present cultures. In fact, the search for monuments, groups of buildings or sites in keeping with European definitions implied in the Convention has for a long time done Africa a disservice by ignoring some of its most authentic and most precious heritage. This is the idea of cultural landscapes which does not separate the cultural and natural heritage. Given the fact that adherence to the convention brings in financial incentives in the form of grants; it can be argued that organizations such as the International Council on Monuments and Sites (ICOMOS) and the International Union for the Conservation of Nature (IUCN) usurp quasi rights of governance. Thus, fulfilling these conventions becomes the main objective of the heritage managers, rather than the interests of the owners of the heritage.

In 1990, the General Assembly of ICOMOS adopted the Charter for the Protection and Management of Archaeological Heritage. The charter calls on nations to make archaeological resources part of their overall land planning in order to ensure that development does not result in the destruction of the archaeological sites. It calls for the adoption of adequate protective legislation and funding for archaeological investigations. However, most heritage managers and agencies in southern Africa are not aware of these professional charters, which are intended for a better legal and physical protection of the heritage. Because of the above problems, there are no regional or country chapters adapted for the protection of the archaeological heritage. There is a need to make heritage managers in southern Africa, even the several foreign field schools, and the rest of the continent aware of the charter.

Risk management

There is now an increasing recognition in the world that all heritage resources are at risk, in the sense that there is always a chance or possibility of loss, injury, damage or some other adverse consequence as a result of nature or the intentional actions of individuals. This concept of risk

management is largely lacking in southern Africa, although countries like Bostwana and South Africa have begun implementing steps towards such a policy. Four stages have been identified in the development of risk management for heritage resources (Darvill and Fulton, 1998). The stages start with the identification and perception of risk in terms of the kinds of hazards that might impact on archaeological monuments. Subsequent stages deal with the examination of risk, the evaluation of incidence and the development of risk reduction strategies. The basis of this model is that heritage resources like archaeological sites or monuments exist as integral components of working landscapes and are thus also very fragile in being subjected to the erosive effects of whatever is happening, on the land itself and in the surrounding areas. Land use practices and natural decay are the main elements which determine the survival and condition of the heritage resource. This then means that careful planning is required for all intended actions which impact on the landscape, be it negatively or positively.

In many European countries, risk management of the heritage was included in the physical planning process during the 1960s and 1970s, for example in Denmark and the UK. Integration of heritage management and physical planning and protection led to the incorporation of archaeology and nature conservation (Kristiansen, 1998). In Europe, the main objectives of the new perception of the cultural environment was the adoption and reinforcement of the protection and management of the cultural environment within other relevant legislation and planning. Part of this wider international planning was reflected in the habitat conference in 1998 and the Rio conference of 1992.

In southern Africa, archaeological resources do not enjoy adequate protection partly because of the inadequacy of other national legislation. It is also very striking that all protective legislation in southern Africa is overridden by mines or mineral rights. Thus, where mineral rights exist, the heritage protection is weak. In South Africa, the engineering and agricultural regulations override the National Monuments Act (1969). However, the Environment Conservation Act (1989) and the new Mines Act (1993) does allow for the protection of the man-made environment. The new environmental regulations seem to harmonize this by allowing impact assessments before any development. This will also become the case in Zimbabwe and Botswana once their environmental legislation comes into operation. In the face of mining operations, heritage agencies in the region will have to rely on protective instruments other than their own.

The other weakness in the implementation of risk management in southern Africa is the lack of any meaningful integration of the heritage laws and the general urban and regional planning systems. Large urban projects do not recognize the existence of heritage legislation. It also means that planners do not design schemes with the needs of heritage in mind. The fragmented nature of these pieces of legislation militates against a systematic adoption of risk management. In most European countries, an environmental legal instrument caters for risk management.

The threats to the well-being of the cultural heritage are not limited to material damage. Displacement of the cultural heritage against the will of the owner causes what may be called spiritual damage. Separation of cultural items from their natural environment under coercive circumstances such as colonial occupation may inflict spiritual damage upon the people and cause great emotional stress. In southern Africa, colonization resulted in the seizure of territories of indigenous populations. In Zimbabwe, laws like the 1931 Land Apportionment Act and the 1969 Land Tenure Act led to the uprooting of people and in some instances the distance moved meant that the people lost touch with their cultural heritage. The new settler communities did not respect the religious and cultural monuments of the local people (Pwiti and Ndoro, 1999). This is the reason why there was an upsurge of ritual activities, at such places as Ntabazikamambo and Great Zimbabwe, after 1980 when the country became independent.

The existing legislation in all southern African countries does not explicitly state that pre-development impact studies should be undertaken. It does, however, imply that the public is responsible for ensuring that archaeological resources are not destroyed without prior approval. Unfortunately, both the general public and developers are largely unaware of this legislation. Any attempt at implementation should therefore be preceded by a general awareness campaign. Undertaking pre-development impact assessments and ensuring that mitigation occurs would ensure that a representative selection of sites is preserved for posterity. However, the integration of the protection of the archaeological heritage with development or planning policy is a very difficult business in Africa. We have to think here of Maslow's (1954) hierarchical needs, the food and shelter dilemma. He postulated that there is a hierarchy of needs which tends to motivate human behaviour. The hierarchy is from basic biological needs to more complex psychological motivations and these only become important after basic needs have been satisfied. When food and safety are difficult to obtain, the satisfaction of those needs will dominate a person's action and higher motives are of little significance. Only when basic needs can be satisfied easily will the individual have time to devote to aesthetic and intellectual interests. Artistic and scientific endeavours do not flourish in a society in which people must struggle for food, shelter and safety. What is important to a village, a new dam providing water or Stone Age sites whose origins the local people may not even know? The local community does not even see the results of the research and does not benefit from the protection of the sites. Thus, the benefits of protecting the archaeological heritage need to be demonstrated to the local community.

Developments in Zimbabwe

The development of heritage management in Zimbabwe can be linked to changes occurring in the early settler society. The pioneer column that entered Zimbabwe in 1890 did reflect British and South African settler society of that time. Carl Mauch's 'discovery' of Great Zimbabwe and, more importantly, the discovery of gold objects at some sites reinforced the notion of Zimbabwe as the source of gold for the biblical King Solomon. It was these images of a country filled with untapped wealth that attracted people to join the pioneer column and many of these people were prospectors who had been working in South Africa. The arrival of the pioneer column at Fort Salisbury was followed by its disbanding. William Harvey Brown, in his book *On the South African Frontier* (1899), describes how the camp was rapidly depopulated as people went in search of gold. The search was not directionless, but was rather guided by the myth of the gold of the Queen of Sheba. Prospectors went round the countryside swapping blankets, beads, brass cartridge cases and sometimes the shirts from their backs for information on the location of 'ancient gold workings'. Although references are less numerous, it is also clear that these prospectors focused on stone-walled sites of the Zimbabwe tradition and found some gold.

The link between these sites, ancient workings and gold was therefore confirmed by people's experiences. The disappointing results of early prospecting in northern and southern Mashonaland were not immediately apparent, partly because they were masked by the armed take-over of Matabeleland by the British South Africa Company (BSACo) in 1893. It was this incorporation of this area into the BSA company that provided the next scene for the commercial exploitation of archaeological sites.

In June 1894, Hans Saner (one of the newly arrived settlers) and a number of fellow travellers visited the Zinjanja (Regina) ruins. They noted bottle-shaped, stone-lined holes on the surface of the platform and, thinking that they might contain treasure, they drove a trench from the outside wall to one of the holes. The results were disappointing, but they were made up for at the

next site visited, Danamombe. Here the party found silver, pottery and chains and over fifteen ounces of alluvial gold in the burnt and decayed houses' remains. Saner recounts how he kept the source of gold secret, but he eventually told two Americans, Burham and Ingram.

All remained quiet on the ruins front until September 1894 when it was announced that 208 ounces of gold had been recovered from a ruin in Mberengwa (Belingwe), in the south-eastern part of the country. This announcement came at an opportune moment for the BSACo, because by this stage the South African press was casting doubt on the existence of vast mineral resources in Rhodesia. The *Bulawayo Chronicle* played the story for all it was worth as a counter to the South African claims. They were further assisted by the belated announcement that Burham and Ingram had found 607 ounces of gold at Danamombe. This late announcement seems to confirm Saner's story that Burham and Ingram had followed his lead to Danamombe, collected gold and taken it to London and surreptitiously sold it to Rhodes.

The announcement of these two finds was followed by the formation of Rhodesia Ancient Ruins Ltd, a company formed to search for gold in the stone ruins. The setting up of the company was, however, not problem-free, because Burham and Ingram already had a concession for Danamombe. After some negotiations, they were given shares in the new company. The initial launch of the company was preceded by advertisements in the *Bulawayo Chronicle* pointing out that it was the only body licensed to work and explore for treasure (Summers, 1967). Two special conditions were attached: that they were forbidden to damage the ruins, and, on Rhodes' instructions, Great Zimbabwe was to be excluded. The BSACo was also to receive 20 per cent of all finds and had the first option to purchase the rest.

It is clear that the development of heritage management in Zimbabwe was linked to the potential economic value of the ruined structures. Soon after the BSACo had been granted a charter to occupy the land, they sought help from the British Royal Geographical Society and the Association for the Advancement of Science to conduct research on the origins of Great Zimbabwe. This was to be led by Theodore Bent, who was also linked to the treasure-hunting company, Rhodesia Ancient Ruins Ltd. In order to cover up the mounting criticism from the academic world on the activities of the company, an ordinance to protect the ancient monuments was passed by the Legislative Council and it become law in 1902 as the Ancient Monuments Protection Ordinance. In this ordinance, ancient monuments and relics were defined as any material predating 1800. The colonial administrator was to implement the ordinance. However, the ordinance exempted ancient workings from protection. These were to be exploited under the 1895 Mines and Minerals Ordinance. This exemption on mines and mineral claims still stands.

The importance of the 1902 ordinance was that it laid the foundation of the present heritage management system in Zimbabwe. However, this ordinance did not cover rock art sites in its definition of ancient monuments. This anomaly was amended in 1912, with the proclamation of the Bushmen Relics Ordinance, which was influenced by large-scale exploitation of rock art sites in South Africa (Murambiwa, 1991). 1902 was also very important in the development of heritage management in that this was when the Natural History Museum in Bulawayo was established. Its mandate was research and public presentation of the natural heritage, with specific reference to geology. Again, the influence of gold mining was very much in the minds of the people who established this museum to protect the nation's heritage.

The developments in South Africa continued to have a profound impact on heritage legislation in Rhodesia, with the repeal of both the 1902 and 1912 ordinances by the 1936 Monuments and Relics Act. The previous ordinance had not differentiated the status of ancient monuments. The 1936 act brought in the new concept of ranking sites by affording some the status of national monuments. The 1936 Monuments and Relics Act also brought into existence

the Commission for the Preservation of Natural and Historical Monuments and Relics, better known as the Monuments Commission. For the first time, an administrative organization was being proposed. Thus it was felt at this early stage that protective legislation was not enough and that there was need for some effective physical protection in the form of regular inspection of the sites. Apart from undertaking maintenance and excavation, the commission was also tasked with documenting and keeping a register of all ancient monuments and relics in southern Rhodesia. From this national register, the Commission could recommend some to the Minister of Internal Affairs for proclamation as national monuments. Although this was the thinking, it took ten years before the Commission could make its first appointment.

By 1954, the Commission had designated seventy-nine sites as national monuments. The Commission also carried out publicity campaigns in the form of public lectures by its members. Generally, by this time the number of visits by the public to national monuments like Great Zimbabwe, Victoria Falls, Rhodes Matopos and Inyanga was on the increase. The Commission also out several publications aimed at both the academic and general public. They even had a schools programme aimed at popularizing archaeology.

However, during this time the general public was defined as 'white'. Even the major archaeological surveys, which led to the creation of a comprehensive database, only concentrated on the settler commercial farms. Thus in the African reserves, awareness of heritage management issues as articulated in the protective legislation remained unknown. This was made more complicated by large-scale population movements, which resulted from the 1931 Land Apportionment and 1969 Land Tenure Acts. A number of places of cultural significance like Great Zimbabwe, Matopo, Mhakwe, Ntabazikamambo, Khami and Tsindi were placed under commercial or National Parks lands. The Africans in the reserves no longer had official access to them. For example, the people of Mangwende in Murewa used to occupy the area around Tsindi and used to conduct rituals there. After they were moved, they could not continue using the site without being prosecuted for trespassing or practising witchcraft. Movement to new areas like Gokwe and Sipolilo (Guruve), areas sparsely populated, meant that the places they moved to had little cultural meaning for them. The superimposition of the site distribution maps compiled from the databank in the National Archaeological Survey and that of the Land Apportionment does indicate that most archaeological places are now located in the areas designated European Land.

The Christian churches, too, were also denouncing the importance of such sites and linking them with paganism. For example, after many years of unsuccessful mission work in the Matopo area, the Christian church at Hope Fountain Mission decided to conduct its services at these sacred sites like Silozwane in an attempt to discredit their use by local communities (Ranger, 1999). Above all, by the late 1970s, the African reserves were over-populated and this led to deforestation and general land degradation. As a result, archaeological sites were destroyed and cultural landscapes altered. The effects of the land appropriation can be seen today by the perceived lack of appreciation and care for archaeological sites in areas to which people were moved (Pwiti and Ndoro, 1999). Thus it can be argued that although the creation of the Monuments Commission was a positive move in terms of protecting the archaeological heritage, some of the colonial laws on land impacted negatively on the cultural landscape.

The 1972 National Museums and Monuments Act repealed the 1936 Act. The main contribution of the new act was to bring about the amalgamation of the Monuments Commission and the various city museums in the country. Although this move has been viewed negatively by some (Murambiwa, 1991; Collett, 1992), it helped in spreading heritage management to all the major cities. It can also be argued that the city museums expanded the presentation of the archaeological heritage to the general public. It also meant that for the first time all archaeolog-

ical property (finds and sites) were under a single curatorial administration. The 1972 Act led to the creation of five administrative regions and at present all the regions have the capacity to protect and present the archaeological heritage. It is, however, at Great Zimbabwe that a lot of experimentation in terms of preservation and presentation has been made. The heritage management system at Great Zimbabwe in part reflects the general thrust of the system in Zimbabwe.

Conclusion

Since the advent of colonization in southern Africa, local communities have become increasingly alienated from their cultural heritage. Most of the legislation and administrative structures were set up during the colonial period and as a result they seem to have been aimed at limited interests. With the introduction of protective legislation, archaeological sites became government property. The interests of government equal modernization and this means that the heritage agents will not permit cultural or ritual ceremonies to take place on the sites. In many instances, local communities were moved hundreds of kilometres away from their original homes, thereby creating physical and spiritual distance between them and their ancestral homes (cultural landscapes and monuments). It appears that the pioneering protective legislation was not founded on an objective approach to preserve the diverse African cultural landscape, but rather on protecting a few sites which served the interests of the early white settlers. The transfer of ownership of cultural property to government and the displacement of people in these areas meant that the local communities no longer had legal access to the sites. The promulgation of the Witchcraft Suppression Act and the condemnation of ancestral worship by Christian churches suppressed African cultural activities.

It is no coincidence that the main Christian churches were located near major cultural sites. For example, the London Missionary Society at Hope Fountain Mission was near the Matopo sites, a Dutch Reformed Church was at the foot of Great Zimbabwe, the Anglican churches in Manicaland were near several important sites and one of the Roman Catholic churches was located near the Domboshava sites. The Christian church was particularly strong in its influence, since it had control of the education system. The problems faced by southern African countries in heritage management are numerous, but the main ones include:

- mass destruction of sites by development projects;
- looting and illegal exportation of antiquities;
- the quality of management of archaeological resources;
- limited efforts in making the heritage relevant to the local situation.

Most heritage agents in southern Africa lack meaningful heritage management policies. There is lack of capacity and research methods on the presentation of cultural resources and lack of capacity to diagnose the deterioration mechanisms and the prescription of curative measures. There is also almost total absence of any presentation or interpretative work aimed at reaching the local general public. Whatever exists is usually aimed at the foreign tourist or the academic public.

The empowering of local communities and the restoration of pride in the local heritage is a contentious issue in most parts of southern Africa. Communities around heritage places need to be involved in the management of sites in their locality. The involvement in such endeavours makes them feel proud and they would see the need for the continued survival of the heritage

places. While heritage management offers a chance for community involvement, this is usually not done. The excuse is that this is a highly technical subject, which is better left to technocrats who know better. One example of local involvement in heritage management was at the Zimbabwe-type site of Manyikeni located in Mozambique's south central region. By 1978 some 400 local people had participated voluntarily in the field work at the site, and in the following year a site museum was opened in an attempt to make the archaeological site accessible to the local communities (Sinclair *et al.*, 1993:429).

Another example is the restoration of the stone Zimbabwe-type monument at Thulamela in South Africa, occupied between AD 1400 and 1700. The Shona dialect-speaking people who make up the modern Venda community are directly linked to Thulamela. The Venda who were moved from this area when the park was created claim traditional ownership of this site (although this ownership has been contested (Nehemani, pers. comm.). Apart from the Venda, the Tsonga, Shangaan and Sotho also lived in the same area. However, it appears that the last people to stay in the area were the Makuleke Tsonga who were evicted in 1969 to make way for the expansion of the Kruger National Park (they too claim that their ancestors built the site). A restoration and excavation project to rehabilitate the stone ruins began its preliminary work in 1994 (Miller, 1996). However, the discovery of burials during the excavation led to the need to involve the Venda people in the way the project was being implemented. It was also meant to provide ethnographic depth to the interpretation of the remains. Thus the project endeavoured to set up negotiated decision-making processes that involved local communities in the long-term management of the site.

The attraction of Thulamela was not just in the stone walls similar to those of Great Zimbabwe, but also the gold-adorned skeletons discovered during the excavations in 1996. The cooperation between academic archaeologists and Venda chiefs in resolving sensitive issues relating to the excavation and reburial of remains at Thulamela has been hailed as a model of successful negotiations. The Venda people have taken immense pride in the excavations and restoration project. The opening of the site to the public affirms the complexity of African culture in southern African and reclaims a significant chapter in Venda history (Davison, 1998). Yet the site is in the Kruger National Park and the Venda community lives outside the park. Thus the community cannot have easy and ready access to the cultural place. This leads to the critical questions of access and local community participation. Is participation only appearing at the official opening? What role does Thulamela play today for the Venda or nearby communities? What questions of ownership can arise from this exercise?

In southern Africa, more than anywhere else, heritage management has a great potential for the re-building of cultural identity among communities that have lost their roots, and archaeology can play a significant role in enhancing pride in self-determination. Generally, current heritage management in southern Africa is conducted under a patchwork of legal and regulatory mandates promulgated by governments linked to a middle class with strong links to western cultural milieu. These legal mandates are never designed in consultation with the local communities. Global charters emanating from such organizations like UNESCO nowadays support these local legal statutes. For many heritage managers in southern Africa, heritage sites are valued for their potential to inform about bygone days. However, to the indigenous communities, heritage places are essentially links to the land, their ancestors, their culture and traditions; sites embody life forces (Kifle, 1994; Pressouyre, 1996). Religious rituals conducted in the past are still important and significant even if the group has been moved to a new place. The place is important because ancestral spirits continue to reside in these places. Thus to them, heritage management is not restricted to the physical archaeological remains. Cultural resources have

tangible and intangible meaning, regardless of when it was last accepted. The protective legislation in most countries needs to reflect these ideas common to their people. It appears therefore that the protective legislation and regulatory mechanism in Southern Africa is not founded on the objective approach to preserve the diverse African cultural landscape, but on rather narrow definitions of what constitutes a cultural landscape. In most cases, the local communities could not care less for the global charters or the local legal instruments from central government.

References

Collett, D. (1992) *The Master Plan for the Conservation and Resource Development of the Archaeological Heritage*, Harare: National Museums and Monuments of Zimbabwe.

Darvill, D and Fulton A. (1998) *The Monuments at Risk Survey of England 1995*, Bournemouth: English Heritage/University of Bournemouth.

Davison. P. (1998) 'Negotiating the past', in Nuttall, S. and Coetzee, C. (eds), *Making of Memory in South Africa*, Oxford: Oxford University Press.

Harvey Brown, W. (1899) *On the South African Frontier: The Adventures and Observation of an American in Mashonaland and Matebeleland*, London: Sampson, Low, Marston & Co.

Kifle, J. (1994) *International Legal Protection of Cultural Heritage*, Stockholm: Juristforlaget.

Kristiansen, K. (1998) 'Between, rationalism and romanticism', *Current Swedish Archaeology*, 6 7–21.

Maslow, A. (1954) *Motivation and Personality*, New York: Harper & Row.

Miller, S. (1996) 'Rebuilding of the walls of sixteenth-century Thulamela', in Pwiti, G. and Soper, R. (eds), *Aspects of African Archaeology*, Harare: University of Zimbabwe.

Murambiwa. I. (1991) *Archaeological Heritage Management in England and Zimbabwe*, unpublished MPhil thesis, University of Cambridge.

Mzalendo, K. (1996) 'The status of archaeological collections and resources in Africa', in Pwiti, G. and Soper, R. (eds), *Aspects of African Archaeology*, Harare: University of Zimbabwe.

Pressouyre, L. (1996) 'Cultural heritage and the 1972 Convention', in Ndoro, W., Mnujeri, W., Sibanda, C., Levi-Strauss, L. and Mbuyamba, L. (eds), *African Cultural Heritage and The World Heritage Convention*, Harare: UNESCO.

Pwiti, G. and Ndoro, W. (1999) 'The colonial legacy: heritage management in southern Africa', *African Archaeological Review*, 143–53.

Pwiti, G. (1996) 'Let the ancestors rest in peace? New challenges for heritage management in Zimbabwe', *Conservation and Management of Archaeological Sites*, 1(3), 150–60.

Pwiti, G. and G. Mvenge (1996) 'Archaeologists, tourists and rainmakers: problems in the management of rock art sites in Zimbabwe; a case study of Domboshava national monument', in Pwiti, G. and Soper, R. (eds), *Aspects of African Archaeology*, Harare: University of Zimbabwe.

Sinclair, P., Morais, L., Adamoweiz, L. and Duarte, L. (1993) 'A perspective on archaeological research in Mozambique', in Shaw, E., Sinclair, P., Andah, B. and Okpoko, A. (eds), *The Archaeology of Africa: Food, Metals and Towns*, London: Routledge.

Ranger, T. (1999) *Voices From the Rocks*, Harare: Baobab.

Summers, R. (1967) *Khami Ruins*, Oxford: Oxford University Press.

Ucko, P. (1994) 'Museums and sites: cultures of the past within education – Zimbabwe, some ten years on', in Stone, P. and Molyneaux, B. (eds), *The Presented Past*, London: Routledge.

The search for legitimacy
Museums in Aotearoa, New Zealand – a Maori viewpoint

Arapata T. Hakiwai

For many indigenous peoples, museums have been alienating and lifeless places that have appropriated and controlled their material culture and arts, particularly during colonial periods. From a Maori viewpoint expressed in the mid-1990s, this chapter considers the legacy left by traditional museum activity in New Zealand and explores how the legitimacy of museums among Maori people can be placed on a firmer footing and what needs to be considered if their future is to be justified. Central to all of this is a critical reflection on the relationship between the museums and the Maori people, both in terms of historical precedents and future visions. Here, the traditional function and role of the museum are challenged in terms of the power dynamics of who has been, and who should be, involved in knowledge production and meaning-making.

The relationship between museums and the Maori people revolves around the *taonga* – the Maori cultural and artistic treasures – and issues related to notions of ownership and control. Maoris want to have more control of how their treasures are taken care of and presented, especially as these treasures, along with Maori culture and identity, need to be seen as living and dynamic, rather than frozen in time. They need to be released, liberated and freed, and future ways to do this have been expressed.

He pukepuke maunga ka pikingia e le tanguta
He pukepuke moana ka ekengia a le waka
He tihi tangata, he mana tangata a kore e pikingia e le tangata
He tapu, he tapu he tapu.

A rocky mountain peak can be scaled by man
Rough seas can be traversed by a canoe
But the dignity and majesty of man cannot be scaled by man
for he is Sacred.
 A Maori proverbial saying illustrating the importance of people.

Introduction

As we move into the latter part of the twentieth century and view the position of museums in New Zealand, several points of view appear to be prevalent. First, there seems to be a sense of

apathy, regret and frustration, among many, for what appears to be a lack of cultural understanding for Maori material culture – those who view with nostalgia the classical museum traditions of the past and have a sense of foreboding for what the future might hold.

Second, there is a view that recognizing the changes that need to take place creates uncertainly and a sense of extreme trepidation for these cultural institutions. Third, there are those who, conscious of the infinite possibilities that can be imagined, view the future with a certain sense of anticipation and hope.

Many questions are being asked of museums. To what extent are museums recognizing and acknowledging the peoples and cultures of origin as represented by their material culture? Who owns the past and who has the right or responsibility to preserve it, look after it, interpret it and make decisions about it?

Can any specific group claim ownership of cultural heritage or does it belong to a common humanity? To what extent have museums changed and modified to meet these challenges and responsibilities? What are the positions of museums in New Zealand society and how might the Maori people retain or recover some degree of control over their heritage? Are museums the most appropriate place to look after and speak about the Maori idonga (prized possessions, artefacts) and, by implication, the culture and life they represent? What are the influences and issues that often frustrate and impede the relationship between the Maori people and New Zealand museums?

This chapter will examine various issues concerning the legitimacy of New Zealand museums with reference to their historical precedents and future visions in their relationship with the indigenous people of New Zealand – the Maori. This is a personal viewpoint based on my own Maori upbringing and tempered with a degree of museum experience as the Curator of Maori Collections at The Museum of New Zealand – Te Papa Tongarewa.

To begin with, let us consider the *Oxford English Dictionary* definition of 'legitimate' as establishing a frame of reference for this chapter:

> to affirm or show to be legitimate; to authorize or justify by word or example; to serve as justification for.

Adopting this general definition, I have looked at the relationship of New Zealand museums towards the Maori people and the Maori people towards museums. In my opinion, the search for legitimacy centres around this dynamic relationship, a relationship built on trust, respect and understanding.

The legacy of the past

The origins of museums in New Zealand have not been unlike that experienced overseas, with their early beginnings and associations with the wealthy, the scholarly and the early literary and scientific societies. The motivations for collecting so-called curios and mementos were varied. In New Zealand, a prime motivation was to acquire the unique objects from what many Europeans believed was a dying race. Many believed that the Maori race would suffer dramatically as a result of 'colonisation' and thus vigorously collected, recorded and documented this 'noble and savage' race before its inevitable fate. Some collected these 'curios' to further personal interest and personal definitions of value and social reality, while others looted, ransacked and pillaged burial grounds and other sacred places (King, 1981).

There are many areas of concern regarding museums: access to the treasures, lack of participation and involvement in the decision-making process, cultural insensitivity and monoculturalism. Museums are seen by many as a sad legacy of the past imbued with a continuing sense of paternalistic colonialism and monoculturalism. Although many Maori treasures in New Zealand museums are owed to the endeavours of the Pakeha people who acquired them during the aftermath of the meeting of the settler culture, there now appears to be an issue of extreme importance. What is the role of the museum in relation to the living culture and people of today?

Today, many Maori people are actively seeking ways of repossessing their cultural inheritance and of re-imposing their right to control the treasures handed down by their ancestors. Notwithstanding how and why museums have collected these treasures, the question that is now being asked is what should be done in relation to them.

Many of the problems facing New Zealand museums stem directly from the way museums have viewed Maori society and culture, how they have interpreted the Maori *taonga*, how they have presented and communicated it, how they have studied it and ultimately how they have 'controlled' and 'owned' the cultural heritage and associated information and knowledge systems that form such an important part of Maori identity and ethnicity.

Museums have often been seen as the keepers of culture by the dominant society and a place where the heritage can be preserved for future generations. The question that needs to he asked is preserved for whom? Hill says that:

> Indians are often seen as a people caught between the cultural void of the romance of the good old days (pre-1492) and the realities of the modern, 'civilized' world. We hardly ever think of Indians as a significant constituency of museums, we see Indians as suppliers of artifacts, crafts, paintings and an occasional dance or two.
>
> (Hill, 1988:32)

New Zealand's experience has many parallels.

The romanticized 'noble-savage' often became the norm in the nineteenth century and still persists, among many, at the present time. This 'twilight zone' of arrested time appears to be intensely compelling for many New Zealand museums and can be clearly seen in their ethnographic exhibitions and in their collection and acquisition policies. The lack of any modern or contemporary Maori treasure after the beginning of this century is very noticeable. In the New Zealand museum environment there was, and perhaps still is, the view that the 'real' Maori is gone.

To this attitude the Maori people are saying to museums: We are not dead. We did not die out before the turn of the century and are not a diluted form of the supposed 'real' and 'authentic' Maori. We still speak the language, we still have our traditions, our stories, our myths – our culture. The Maori people are saying our present and future is inseparable from our past and our past is our present and future.

Museums – what is their function and role?

Museums are presently entering what is called 'the age of information', an age where we see many societies dependent on the flow and transmission of information. Information to many people is often associated with knowledge and, by implication, power. For the Maori people, there has been a great degree of ambivalence towards museums. They are important and respected places because of the cultural wealth they possess, but concurrently many Maori people feel anger and resentment

in the way that museums have acted as 'experts' and managers of cultural heritage and knowledge systems. Most New Zealand museums are run by non-Maori people, staffed mostly by non-Maori people and organized according to Western academic practice. The Maori people are the passive observers in the play, while the dominant group writes the script and dictates how it should be acted out. In this respect can museums be confident in being legitimate in the eyes of the Maori people? To assess this, let us first examine the oft-quoted definition of a museum:

> A museum is a non-profit making, permanent institution, in the service of society and of its development, and open to the public, which acquires, conserves, researches, communicates and exhibits for the purposes of study, education and enjoyment, material evidence of man and his environment (ICOM definition).

I believe that there is something critically wrong with this definition if museums fail to acknowledge, respect and actively pursue appropriate relationships with the cultures whose cultural heritage museums possess. How can this worldwide definition be reconciled with New Zealand's own experience?

Issues of acquisition, research, exhibitions, communication and education in the service of society are specifically museum-related, but should not the real questions be directed to the criteria, methods and processes for deciding such foci and on the inherent and underlying assumptions, perceptions and attitudes that people carry with them? Many museums throughout the world are products of their own establishment and represent the assumptions, philosophies and definitions of their institution. New Zealand is certainly no exception.

Museums, as McDonald and Alsford have stated, have always been one of the principal memory-banks of culture, contributing to 'defining culture by selecting what elements of heritage they collect, preserve, and make accessible to human experience; that selection not only reflects the past, it expresses the attitudes and interests of the present' (McDonald and Alsford, 1988:1). The New Zealand museums fit into this category as it is often the museums who define, research, and indeed, communicate their ethnic cultures to the general public. New Zealand's experience could also be described as extreme paternalism, where the Maori's material culture is often regarded as 'theirs'. Many Maori people find this paternalistic attitude culturally arrogant and one that continues to fuel attempts to regain some degree of control over what is rightfully an integral part of their cultural heritage and identity. Should museums have this right to control and dictate the terms of indigenous peoples and cultures? Is this truly legitimate in the eyes of the people whose cultural heritage is at issue? I think not.

Two worlds

Many Maori people are disenchanted with museums over their attitudes regarding cultural treasures and want some degree of control over their artistic heritage and to explain, define and communicate their view to themselves and to the world around them. Museums are seen by many people as monocultural, eurocentric and places totally detached from the social, cultural and spiritual realities of the people. The relations between museums and Maoris centre largely around the *taonga* or treasures and the question of ownership and control of these *taonga*. Since the early navigators like Abel Tasman in 1642 and Captain Cook in 1769, the Maori society and life has never been the same.

Colonialism shattered the reefs of an enclosed, slowly changing traditional world, bringing with it a bewildering array of new values, attitudes, ideas, conventions, impressions, images and symbols, other interpretations of reality and the universe, new technologies, doctrines and

dogmas, and ever-changing art styles, fads and fashions. The colonizers, especially the mission-aries, condemned and banned much of the Maori art as being pagan, evil and licentious.

The relations between museums and the Maori people centre around the *taonga* – the cultural treasures. Many New Zealand museums still have a paternalistic attitude over these treasures viewing them as 'their' property,which upsets the Maori people whose attitude towards artefacts and treasures is deeply personal and meaningful. Like the land many *taonga* are treasured and have been passed down from generation to generation. We are caretakers and guardians of these treasures in our lifetime and we pass these down to future generations. Should museums have the right to control and dictate the terms pertaining to these priceless cultural jewels? Is this truly legitimate in the eyes and hearts of the people whose cultural heritage is at the heart of their identity and social universe? The problem is that our museums are in two worlds. One world demands the inalienable right to their cultural heritage as forming an important part of their universe both past, present and future. The other world appears to spend a lot of time ratio-nalizing, justifying, analyzing and exploiting the items that make it a museum.

> *He Toi Whakairo* *Where there is artistic excellence*
> *He Mana Tangata* *There is human dignity*

New Zealand has a population of 3.8 million people of which the Maori people make up twelve per cent and occupy the lowest socio-economic sector of New Zealand society. The Maori people lead the statistics in crime and have a disproportionately low level of educational achievement and poor health. The social, economic and political climate makes life extremely difficult for many Maori people. Museums, through the cultural treasures they possess, thus become more important as places where self-worth, identity and self-determination can be regained and act as catalysts for growth.

The alienation of the Maori land in New Zealand is presently being addressed with renewed vigour by the present government using the *Treaty of Waitangi,* a treaty signed by many Maori tribes and the Crown in 1840. This treaty, although at the centre of intense legal debate, guaranteed the Maori the same rights and privileges of British citizens and exclusive possession of the forests, fisheries, lakes and other prized possessions. The call for the return of land and the many initiatives that the Maori people and the New Zealand government are making in regards to the Maori language and culture bring museums to the fore.

The Maori people are increasingly calling for the return of their artistic and cultural heri-tage, because it is still an essential part of their identity and culture. Although the indigenous people of New Zealand, Maoris are a minority and the struggle to regain these treasures is often difficult and frustrating. Museums, many people would argue, have done very little in terms of our essential humanity as *tangata whenua* (first people of the land) in terms of human dignity, of equality and of freedom to live according to our own cultural needs. Have museums through their displays, researchers, publications, education programmes and activi-ties given justice and 'real' credence and meaning to the Maori people and culture?

Commenting after the highly successful Maori art exhibition 'Te Maori' that toured the USA in 1986, Professor Sid Mead, the co-curator and himself a Maori, poignantly stated that this exhibition contrasted with the general trend in the past, where plainly it was the Pakeha (European; non-Maori) who drove the bus, while the Maori rode as passengers (Mead, 1986:103). What was plainly obvious at that time was a move towards repossessing one's own cultural heritage and by owning it to make a move towards controlling it (Mead, 1990:168).

The Te Maori exhibition that toured the USA in 1985–86 highlighted a number of inade-quacies and problems with New Zealand museums. Given the metaphor of *waka* (canoe) it was

described as a 'voyage of rediscovery' and a vision for tomorrow. It focused attention on all New Zealand museums and the relationship between them and the people whose material culture they possessed. Some interesting comments were:

> Te Maori has proved to us that a museum's interpretation of the 'culture' of a country needs to be something more than a lifeless collection of dusty artifacts (P. Tapsell, Minister of Internal Affairs and himself a Maori).

Maori art was transformed and in a sense 'released' and 'freed' from the history and intellectual context in which our artworks had been 'imprisoned' (Mead, 1985c:3–5).

After the Te Maori exhibition, New Zealand museums were not quite the same. They appeared to be inadequate, unsatisfactory and totally detached from the reality of the Maori people and culture. Their legitimacy for many Maori people was fiercely debated and severely criticized, as they were seen as empty shells without any heart and *wairua* (spirit). Koro Wetere, the Minister of Maori Affairs at that time quite rightly said that:

> Te Maori showed the world of art and museum presentation that treasures like these are still part of our present and living culture. To the unknowing, the pieces by themselves are merely made of wood and stone, but when the elders with the young come together to chant the rituals of yesteryear, and to sing the songs that recount the history, the hopes, the hurts, and the aspirations of the people – the exhibition lives. The people are the living culture, and they breathe life into the taonga – and when the two come together the exhibition becomes a living and new experience for the uninitiated
>
> (Wetere, 1986)

Sid Mead aptly described the relationship of the people to their treasures. Art is for people, is about people, and is people. It is living art in the sense that there is a very close bond between the artworks and the Maori people (after Mead, 1985a:13).

Te Maori was a journey of rediscovery, where the powerful processes of contextualization and traditions within museums were subverted. It was a time of 'ethnic realism' and 'cultural integrity' where the Maori people had control of their artistic heritage, if only for a limited time, defining, explaining, communicating and heralding the awakening of a new age. For many Maori people it said 'no turning back'. No longer was it acceptable that museums chip away at our identity, robbing us of our stories, and perpetuating a construction of reality which by all accounts is not shared by us. The message was clear. For museums to be legitimate in the eyes of the Maori people, they had to break with Western traditions of so-called sound museological practice and make Maoris the players in the script which informs, educates and communicates, not only to the museum profession, but also to the world at large.

'Release', 'liberate' and 'free' are all terms expressed by many Maori people with regard to the stifling atmosphere of New Zealand museums' practice and operation. Some museums have taken heed of the Te Maori experience and adapted and modified like the noted anthropologist, Franz Boaz, did in his work with different and diverse cultures. Some have employed Maori staff and established tribal networks and organizations to work in partnership with the Maori people. Others are exploring ways of developing and fostering positive and mutual relationships with the Maori people.

On the return of the exhibition to New Zealand, many *hui* (meetings) were arranged for tribes to discuss issues concerning museums and the Maori people. Many tribes felt that there

should be Maori people, representatives from their tribal areas, working in museums to act as *kaitiahi* (cultural guardians and caretakers) for the *taonga* and for their people. At this seminar, there was general agreement on the necessity for regional and tribal development. Some tribes had thought very seriously about their vision for the future and wanted to establish their own tribal museums, while others said that the Maori people should occupy all levels of the museum organization, especially in positions of authority. Many tribes said that it was necessary that museums consult, liaise and communicate with the Maori people concerning their cultural heritage at the earliest possible time. The Maori people find it extremely arrogant to be called in to give a 'cultural blessing' after the event without having any real input and participation before the event. Some tribes made the point that the past *was* the future.

By and large, many tribes unconsciously felt that museums could be legitimate if they respected and honoured the cultural processes that needed to happen. Many tribes supported the view that bilingual tribal representatives be selected by their tribe for training at various New Zealand museums and that these trainees be funded by the government. Many tribal groups felt the necessity to be informed, to participate and to see museums working for the people rather than for their own selfish interests. The Kai Tahu tribe of the South Island supported the plea for regional-tribal development and wanted more work done on cataloguing and identification of artefacts. Their vision of the future centred around training more Maori people to work in museums and for museums to record oral traditions and histories now. Finally it was suggested at this seminar that an important part of the dream for the future was to think about a political structure which could help tribal groups achieve cultural ends more easily. No recipe was suggested, but it was noted that it would be far easier for the Maori people to look after their heritage and determine their future than was the case during the last 100 years.

Meanwhile, there are some Maori tribes that want to fully regain and control their artworks, histories and stories and advocate the setting up of 'tribal museums', where their own descendants can see, experience and learn about their past and future accomplishments. Some tribes are formally requesting the repatriation of all their artefacts and information associated with them, so that they can decide how and what to do with them. Others leave *taonga* on deposit at museums, which add to the custodial role that museums are often associated with. Some museums and art galleries have empowered their 'spaces' within their institutions and given the decision-making process to the people and this has created positive dimensions as the Maori people have been involved at the earliest possible time and not called in after exhibitions have been curatored by museum curators.

On the international scene, there have been various examples to date that show that positive partnerships can work in the search for legitimacy. First, the highly successful Te Maori exhibition which, in large part, was given to the Maori people to orchestrate and dictate the terms. This showed to the museum world and public at large that the Maori people could be the key players and tell their own stories in the way they thought appropriate. Rather than adopt and duplicate the colonial concept of museology, which portrays indigenous cultures as 'dead' and 'gone' or worse, primitive and dysfunctional, this must be a legacy which has to change. It showed that museums can empower people to control the presentation of their material, culture, information and knowledge. For museums, it helped to legitimize these often cold, impersonal memorials to European domination and colonization.

Second, I suggest that the working partnership being realized with the Field Museum of Natural History, Chicago and the Maori people of Tokomaru Bay is becoming a model for other museums to follow. The project concerns the restoration and renovation of an historically important carved Wharenui (meeting house) that the Field Museum acquired in 1905. The staff

at the Field Museum greeted the Maori people during the Te Maori exhibition in 1986 and were deeply affected with the emotions and attachments the Maori people had towards this meeting house. In their determination to do something with the meeting house, a delegation visited Tokomaru Bay and talked with the people whose ancestors built and used the house. Since that time, the Maori people have visited Chicago and have talked through how best to work this process. Many of the decisions on the house, its conservation, its reassembly and its protocols, which help to guide the many educational-type activities, have been given back to the Maori people of Tokomaru Bay. This I believe to be an extremely new and enlightened approach to museology, where the indigenous people are empowered in a very 'real' way to make decisions. In this particular project, the power and control, to a large extent, can only contribute to the legitimating of museums for native people.

The 'indigenisation of modernity' (after Sahlins, 1992), or rather the realization that cultures are dynamic and change and adapt over time, is extremely important for New Zealand museums to acknowledge and understand. For many museums, there has been an extreme reluctance to accept this in preference for the romanticized version of how the Maori was and should be – the authentic or 'real' Maori. Museum anthropologists and intellectuals find it very disturbing and confusing that the 'traditional' view of the Maori culture is being shattered by rapidly changing definitions. Recent statements by anthropologists in terms of the 'invention of traditions' with the notion of dilution of culture purity is absolutely ludicrous and shows a gross misunderstanding of the dynamism and emerging consciousness that the Maori people and culture have. The Maori people are saying: 'We are not a culture of the past, lifeless and frozen in time, defying the continuity, development and dynamism of our culture'. The Maori people are saying: 'We are "alive", we are "here" and we are the past, present and future'. The question I often wonder is, has the *mana* of the Maori people been raised by our museums or is it that the Maori people are raising the *mana* of our museums? I suspect the answer is affirmative for the second question. In terms of legitimacy, I believe museums must be more proactive in their commitment and understanding for the continuing of the Maori identity and ethnicity.

Back to the future

The search for legitimacy from a Maori perspective has been a very challenging topic for discussion. For museums to become more legitimate in the eyes of the Maori people, New Zealand museums, as James Mack suggests, must look at the culture 'from inside out' (Mack, 1990:113). Museums must acknowledge and recognize that the *taonga* or prized treasures are not merely objects that are interesting, fascinating and providers of research, primarily for museum professionals. *Taonga* to the Maori people are living and real. To reiterate the feelings of Sid Mead:

> We treat our artwork as people because many of them represent our ancestors who for us are real persons. Though they died generations ago they live in our memories and we live with them for they are an essential part of our identity as the Maori individuals. They are anchor points in our genealogies and in our history. Without them we have no position in society and we have no social reality. We form with them the social universe of Maoridom. We are the past and the present and together we face the future
>
> (Mead, 1985a:13)

The search for legitimacy is the search for cultural integrity and ethnic realism, it is a search that challenges the museum orthodoxy and raises questions about how we define what a

museum is and perhaps what it should be. There are a number of positive initiatives that New Zealand museums are adopting that can only engender hope and encouragement for a better future. From a Maori point of view, the search for legitimacy is the search 'back to the future'.

References

Ames, M.M. (1987) 'Free Indians from their ethnological fate', *MUSE*, Summer, 14–9.

Hakiwai, A.T. (1990) 'Taonga Maori: protocol, exhibitions and conservation', in *Taonga Maori Conference Publication*, Wellington, Department of Internal Affairs.

Hill, R. (1988) 'Sacred trust: cultural obligation of museums to native people, *MUSE*, Autumn, ###

King, M. (1981) *The Collector: A Bibliography of Andreas Reischek*, Auckland: Hodder and Stoughton.

Kinkaid, J.R. (1992) 'Who gets to tell their stories?' *The New York Times*, 3 May, 23–9.

Mack, J. (1990) 'Cultural awareness in exhibitions', in *Taonga Maori Conference Publication*, Wellington, Department of Internal Affairs.

Mead, S.M. (1985a) 'Te Maori: a journey of rediscovery for the Maori people of New Zealand, *Triptych Magazine*, June–July, ###.

—— (1985b) 'Taonga Maori Mana Maori', *Art Gallery and Museums Association of New Zealand Journal*, 14(4), 15–7.

—— (1985c) 'Concepts and models for Maori museums and culture centres', *Art Gallery and Museums Association of New Zealand Journal*, 16(3), 3–5.

—— (1986) *Magnificent Te Maori: Te Maori Whakahirahira*, Auckland: Heinemann.

—— (1990) 'The nature of taonga', in *Taonga Maori Conference Publication*, Wellington, Department of Internal Affairs.

McDonald, G.F. and S. Alsford (1988) 'The museum as hypermedium', paper presented at the UNESCO conference *Que devient la culture dans une societe mediatheque?*

McManus, G.W. (1988) *Museums and the Maori People*, MA thesis, University of Leicester.

Novitz, D. (1989) 'On culture and cultural identity', in Novitz, D. and Willmott, B. (eds), *Culture and Identity in New Zealand*, Wellington, G.P. Rooks.

Sahlins, M. (1992) 'Goodbye to *tristes tropes*: ethnography in the context of modern world history', *Journal of Modern History*, 65, 1–25.

Te Maori Report (1986) *Te Hokings mai o nga Taonga Whakairo: The Return of the Art Treasures*, report of a seminar held at the National Museum of New Zealand. Wellington, National Museum.

Warren, K.J. (1988) 'A philosophical perspective on the ethics and resolution of cultural property issues', in Mauch, P. (ed.), *The Ethics of Collecting: Whose Culture? Cultural Property: Whose Property?*, Albuquerque: University of New Mexico Press.

Wetere, K. (1986) 'Comments on the Te Maori exhibition', *Art Gallery and Museums Association of New Zealand Journal*, 77(3), 6.

13

Multiculturalism and museums
Discourse about others in the age of globalization

Jan Nederveen Pieterse

Discourses on globalization, postmodernism, postcolonialism, and perceptions of cultural pluralism, multiculturalism and cultural diversity have raised many new challenges for heritage, museums and galleries.

This chapter looks at how globalization, postmodernity, postcoloniality and forms of multiculturalism have opened up issues in terms of representations in museums – especially with regard to ethnographic museums. Conventional understandings of representation have tended to concentrate on the perceived dichotomy between 'self' and 'other', with exhibition strategies being identified as those that are exoticizing and focus more on difference, those that are assimilating and focus more on similarities, and those that are more cross-cultural and encyclopaedic in nature. The chapter outlines the traditionally more prominent strategy approaches of 'art-culture' (mainly assimilating), '*in situ*' (mainly exoticizing), 'in context' and 'encyclopaedic' exhibitions. It then charts different views on culture and multiculturalism that have informed exhibition strategies, before going on to discuss how globalization has led to the destabilization of the dichotomy between self and other. This has led to more complex understandings of self and otherness, linked to the notion of multiplicity of identities, and to the emergence of alternative agendas for display. These alternative approaches, based on 'pluralism', 'dialogue', 'self-representation', 'intercultural hybridity' or 'reflexive representation', are critiqued. Finally, the chapter engages with issues concerning the power of representation. Where this is overtly recognized and explored through reflexive representation, museums and exhibitions can be transformative.

If it is true that knowledge is power, and that therefore, as Umberto Eco argued, the library is the central institution of Western culture, this also applies to the museum, for the museum is the library on display, turned inside out. The key to the museum is 'its role in making visible the foundational and originary narrative structures of western knowledge about the nature of the world' (Marcus, 1991:11).

Exhibitions are 'privileged arenas for presenting images of self and 'other'' (Karp, 1991a:15) and ethnological museums, more than any others, are concerned with narratives about 'others'. That might be why ethnographic museums have never been in the limelight of prestige. Prestige went to national history museums and art galleries and then shifted to the modern art museum, as the central sites of the museums' 'rituals of citizenship' (Duncan, 1991; Kaplan, 1994). Ethnographic museums have never been museums of influence, models to other museums (Hudson, 1991). Often they have been scenes of neglect and rather shabby, under-funded institutions, standing in relation to other museums like the Third World to the First (Karp, 1991a). Occupying a derivative status as a scientific, moral and political annex of

the majority museums, excluded from the leading museums' rituals of citizenship, ethnological museums serve as a counterpoint to them, politically marginal, while symbolically central.

In the words of American president William McKinley, 'Exhibitions are the timekeepers of progress'. The colonial exhibitions of the late nineteenth century, which were the origins of many ethnographic museums, offered panoramas of power in which imperial hierarchies were on display. The ethnological museum, the public storehouse of the legacy of empire, is as Julie Marcus (1991) observes, a monument of imperial tropes: the acquisition of objects – trophies of empire, taken by armies, as if decapitating the natives by taking their sacred objects; the collector as hero – salvaging the object from the decay of oriental melt-down; the charisma of the object – and the claim to 'undisputed origin as the mark of authenticity; the intersection of taxonomy and chronology – situating the object while structuring the institutional world of museums itself.

In recent times, the entire field has radically changed for all museums. In the age of accelerated globalization (Prösler, 1996), national museums are losing their function and becoming shrines of nostalgia. Citizenship is in the process of becoming global, civilizational, regional, local. Thus the German Historical Museum in Berlin, founded in 1987, takes as its approach a 'post-nationalist' view of German history as part of European history (Stölzl, 1988). Earlier, the modern art museum initiated the principle of the transnational aesthetic. Postmodernity further undermines conventional exhibiting strategies – although it is argued that 'postmodernist art practice is even more dependent on the museum than was modernism. For postmodernism, even more so than modernism, is an art about art' (Negrin, 1993:123).

Ethnographic museums are deeply affected by these wider trends, to the point that they now seem quaint in the wider context. They 'exhibit ideas about the 'other' in the earlier, cruder forms left over from the time in which the ideas came into being, and not in the glossier disguised forms into which they have developed and in which they are found in many art and history museums' (Karp, 1991b:379). They are directly affected by two further epochal shifts, postcoloniality and multiculturalism. The function of offering vivid evidence of the West's triumphal evolutionary attainment has shrunk since decolonization. Ethnographic museums can no longer afford to be colonial museums, display windows of empire, indirect testimonies of national grandeur. (Although several museums quietly linger on in this mode, such as the Museum for Central Africa in Tervuren, Belgium, probably more on the grounds of inertia than principle.) Postcoloniality unsettles ethnographic museums, as it does ethnography and anthropology itself. The time of ethnographic museums might be past altogether: 'the collections and displays are overwhelmingly of the shield, spear, boomerang, and war-canoe type'; they emphasize 'traditional culture' and thus 'encourage a patronizing and escapist attitude toward the people involved' (Hudson, 1991:460, 464).[1]

Multiculturalism has brought the natives home in the post-imperial countries, occasioning a need for the redefinition of citizenship. Multiculturalism unhinges the old citizenship rituals of the national museums and museums of modernism. It opens up a new field of cultural flux and opportunity – of 'insurgence of subjugated knowledges', of cross-cultural translation, hybridization. Museums, along with other media, are in the forefront of this new arena. In this time of transition, several exhibiting strategies have come into prominence in a curious mélange of newness and nostalgia.

The first part of this article lays out the conventional thesis that representations of others are either exoticizing (emphasizing difference) or assimilating (emphasizing similarities). Thus, displaying ethnographic objects as art follows an assimilative approach, while *in situ*

exhibitions (reconstructing habitats) tend to be exoticizing and encyclopaedic exhibitions follow mixed strategies. Section two considers perspectives on culture that inform display strategies. Cultural relativism and evolutionism in anthropology reproduce different gazes of the Enlightenment: modernist and universalist, viewing roadmaps to modernity, or Romantic and differentialist. Actual politics of representation are further affected by the *rapport de forces* in different settings, such as light or strong multiculturalism, cultures with a stable centre or canon and those in flux. Section three is about changing notions of self and others. The dichotomy of self and other is destabilized by accelerated globalization. The conventional Enlightenment subjectivities (national, imperial, modern) are refracted in multiple identities (local, regional, transnational, global, sexual, urban and so forth) and 'the other' becomes 'others' (differentiated by 'race', class, gender, national origin, lifestyle and so forth). The earlier idea that representation of others must either be exoticizing or assimilating ignores other options – such as recognizing difference without exoticism, others as counterparts in dialogue, or oneself as an other. Section four concerns the alternative display agenda reflecting and producing these changes, each posing different questions. Pluralism – but is there still a centre? Dialogue – but who is in control? Self-representation – but who speaks for indigenous and other communities? Intercultural hybridity – but what are the terms of mixture? And reflexive representation – zeroing in on the dilemmas of representation itself. The closing section addresses the core dilemma of exhibiting power. Representation tends to keep out of view the power of representation. Thus, colonialism frames ethnographic exhibitions, but is rarely addressed by it. The charisma of power is fetishized (or sometimes neutralized) rather than examined in exhibitions. This follows from exhibiting as a gesture of power and museums as sites of power. Reflexive representation can transform exhibitions into laboratories of collective understanding. From sites of power, links in the chain of reproduction of desire, museums can become laboratories of reflexivity and transformation.

Exhibiting strategies

> The Museum of the Indian in Manaus, the capital of the state of Amazonas, is run by the Silesian Mission. Upon entering the museum, one sees a Neanderthal-looking figure made out of some sort of plastic depicting a 'Typical Amazonian Indian' fishing in a pond made of broken pieces of tile set in concrete. The caption reads, 'Typical Uaupés River Landscape'.
>
> (Durham and Alves, 1993:133)

In a recent work on *Exhibiting Cultures* – a 'trailblazing collection' according to Rydell (1992:243) – Ivan Karp, one of the editors, observes that 'Discourse about the 'other' requires similarity as well as difference' and 'exhibiting strategies in which differences predominate I call *exoticizing,* and one that highlights similarities I call *assimilating*' (1991:375).

The most prominent contemporary exhibiting strategy is to display ethnographic objects as art: 'Treatment of artifacts as fine art is currently one of the most effective ways to communicate cross-culturally a sense of quality, meaning, and importance' (Clifford, 1991:225). The art-culture approach tends to follow an assimilationist exhibiting strategy, seeking to emphasize similarities between the aesthetic of the viewers and of the makers of the objects. This is generally done on the basis of purely formal criteria and structural considerations – not to mention the commodification of ethnographic objects. The stage was set by the Museum of Modern Art exhibition '"Primitivism" in Twentieth Century Art'. 'I want to understand the Primitive

sculptures', writes William Rubin in the catalogue, 'in terms of the western context in which modern artists "discovered" them' (1984, 1:1; cf. Nicodemus, 1993). A classic instance of an assimilationist approach, Rubin desired to:

> place 'primitive' aesthetics on a par with modernist aesthetics. In the end, however, he only assimilates the aesthetics of other cultural traditions to a particular moment within his own tradition ... he ends up constructing cultural 'others' whose beliefs, values, institutions, and histories are significant only as a resource used in the making of modern art.
>
> (Karp, 1991:377)

The art-culture system prevails wherever we see ethnographic objects set apart in glass vitrines under boutique lighting. The 'Magiciens de la terre' exhibition in Paris 1989 was another step from the ethnographic into the modern art museum. At the same time, the category art was avoided for the category magic, which brings us back to the witchcraft routine, the oldest cliché of ethnography: the other as magical mystery other. In the process, exoticism was reinvented in the curatorial preference for self-taught artists or 'people who have no training' (Picton, 1993).

Another prominent exhibiting strategy is the *in situ* exhibition. Kirshenblatt-Gimblett (1991) distinguishes between *in situ* and *in context* strategies. *In situ* exhibitions practice the art of mimesis, recreating native habitats and re-enacting rituals. Such environmental and recreative displays may include live persons, preferably representatives of the cultures on display. The hyperrealism of in situ exhibitions highlights difference and tends to be exoticizing. It builds on the tradition of colonial exhibitions with native villages rebuilt on the fairground along with live specimens of natives doing what natives do, under the ethnographic gaze. There are several problems with this approach. '"Wholes" are not given but constituted' and often hotly contested (Kirshenblatt-Gimblett, 1991:389). There is a further question of 'social pornography' – as in slumming and tourism generally. In the process, 'A neighborhood, village or region becomes ... a living museum in situ' (1991:413). This can lead to the conversion of living spaces into 'historical' sites and museums, as in the following newspaper announcement:

> UNESCO is about to launch next year an international appeal for the restoration of the old imperial city of Fès, in Morocco. A blueprint, elaborated by international experts ... provides that the historic buildings should be restored and their inhabitants rehoused elsewhere, in order to create centres dedicated to Islamic arts and thought.
>
> (*Le Monde,* 1977 quoted in Gilsenan, 1982:211)

In this case, it is an élite 'view of how Islam is to be practised, studied, taught, and authorized' that prevails. In other situations, the dilemma can be summed up 'Import the tourist? Or export the village and festival?' (Kirshenblatt-Gimblett, 1991:419). *In situ* exhibitions are substitute tourism, feeding the hunger for difference, recreating the travel experience at one remove. Visitors can imagine themselves in a street in Cairo, Yemen, Mexico, India. The *festival* ('Festival of India', etc.) is a related exhibiting formula. This is hegemony in action, treating 'the life world of others as our playground' (1991:419). In Australia in the early 1980s, grandiose plans for life-size Aboriginal villages recreated on museum grounds were quite popular. To show what an ethnic group *really* does, a recent proposal to display the lifeworld of Italian immigrants was to set up a Tibaldi salami factory on the museum grounds (Marcus, 1991:10).

In context strategies pose different problems, in particular the problem of the interpretive frame of reference. In context approaches 'exert strong cognitive control over the objects, asserting the power of classification and arrangement to order large numbers of artifacts'. 'Viewers need principles for looking', but of course 'There are as many strategies for an object as there interpretive strategies' (Kirshenblatt-Gimblett, 1991:390). The context of Western ethnography, the gaze of modernity, is now itself under scrutiny and no longer serves as an unproblematical guide.

A different strategy is illustrated by encyclopaedic exhibitions, such as 'Japan und Europa 1543–1929' in Berlin 1993, 'Europa und die Orient' in Berlin, 'Al-Andalus: The Art of Islamic Spain' (see Dodds, 1992), 'The Art of Pre-Columbian America', 'Art of the Aztecs', etc. In one sense, these are harbingers of global consciousness, milestones on the road of globalization. In displaying civilizational aesthetics and trajectories they evoke cross-civilizational sensibilities. As their titles indicate, these exhibitions display what Clifford (1991:240) calls 'the sweep, the non-oppositional completeness characteristic of majority History'. They seek to be authoritative, encompassing, definitive. They nourish the panoramic urge of the panoptic gaze. Through blockbuster exhibitions, Julie Marcus (1991:12) suggests, 'museums confront and resolve the lost unities (and certainties) of modernism, by offering an expanded consuming public the opportunity to experience the awe generated by the control of time, space and object which is inherent within them'.

Allowing for occasional oppositional views is part of their non-oppositional, pluralist, encyclopaedic intent. They take us out of ethnographic curiosity into the state of awe for Great Civilizations; they follow the tracks of, in Redfield's (1956) terms, great traditions rather than little traditions. They tend to be reverential, showing relics of humanity's great forward march. The global consciousness articulated in these exhibitions is partial, restricted to Great Civilizations, typically situated in the past and viewed from the point of view of the centre of power. The imperial era was obsessed with great civilizations – Rome, Greece, China, Egypt, India, Persia – and there was no contradiction between this reverence and Victorian evolutionism, Eurocentrism and racism: they display the same hierarchical view of civilization.

Multiculturalisms

We can distinguish between static and closed, or fluid and open views of culture and hence of multiculturalism. Static perspectives on culture come in various guises, for instance notions of national identity. Static views of multiculturalism are based on essentialist and territorial understandings of culture, as in the colonial concept of 'plural society' and the contemporary views of multiculturalism which treat the coexistence of cultures as a form of 'pillarization', a series of cohabiting ghettoes, in fact, a form of neo-apartheid.

Different perspectives on multiculturalism overlap with leading perspectives in anthropology. Roseberry (1992) points to three episodes in the development of American anthropology: the period when *cultural relativism* dominated from the 1890s to 1940 – a time when the USA faced a great influx of new immigrants and many anthropologists themselves were immigrants, often Jewish, like Franz Boas; the period from 1940 to 1980, when *systems-anthropology* predominated, concerned with large-scale evolutionary dynamics and structures of global inequality – the time of the US rise to globalism when the overriding problematic was that of public power; and the period from the 1980s, marked by the crisis of categories and assumptions – again a period when multiculturalism ranks high on the US agenda and resembling the pluralism of the early twentieth century.

Cultural relativism in anthropology took shape at a time when nation/race/Volk/ Gemeinschaft were near synonyms. Herder's romantic view of language/nation/culture was passed on to cultural relativism. It results in a similar outlook of cultural determinism and 'national character'. Culture, reified and homogenized, is manipulated in the same way as 'history'. Roseberry refers to cultural relativism's 'image of neatly bounded, discrete cultures with clearly defined traditions, imparting a singular set of values', and goes on to say:

> On its own, the assumption of cultural boundedness and essentialism may seem harmless enough, but it also serves as an ingredient to a dangerous variety of claims to cultural authenticity and the uniqueness of particular cultural visions … The distance between academic claims of epistemological privilege along racial, cultural, or gendered lines and ideologies of 'ethnic cleansing' is not that great.
>
> (Roseberry, 1992:849)

Disseminated through the media, static notions of culture may operate as an acceptable form of 'intellectual racism' and thus serve as the infrastructure of the racism of the street, of the skinheads.

Fluid views of culture, identity and multiculturalism treat culture as a constructed identity, which is perennially in motion, continually under reconstruction. The underlying epistemology is not essentialist but constructivist: cultural identities are not given but produced. Multiculturalism is viewed not simply as the cohabitation of neatly bounded cultural communities, but as a field of interspersion and crossover culture and the formation of new, mixed identities (Hall, 1992; Hannerz, 1992; Nederveen Pieterse, 1995a).

Evolutionism, another stream in anthropology, along with diffusionism and functionalism, has also put its mark on ethnological exhibiting strategies – witness the Pitt Rivers Museum in Oxford as the greatest example of the evolutionist inspired kind of display.[2]

A different kind of distinction runs between strong or deep multiculturalism as in multinational states such as India, the USA, the Commonwealth of Independent States; and the light multiculturalism of societies that have recently become immigrant countries (as in much of Europe), or where nationalities other than the dominant majority are weak and few in number (as in Canada outside Québec). The difference lies in the general *rapport de forces*. Strong multiculturalism offers the stage for developed power struggles in the arena of cultural politics. Here 'The struggle is not only over what is to be represented, but over who will control the means of representing' (Karp, 1991a:15). Power struggles may be taken to the point that the canon is dethroned and recoded by emerging social forces. A further difference runs between societies with a stable cultural centre and those which are culturally in flux. In the former, multiculturalism refers to majority/minority relations, or peripheral differences arranged around a stable hegemony, while the latter has been termed 'polycentric multiculturalism' (Shohat and Stam, 1994) or, better still, interculturalism.

Marked shifts in the balance of forces among groups tend to make for realignments in cultural politics – witness the struggles over the university curriculum in the USA. Other instances are the shift from Rhodesia to Zimbabwe (Munjeri, 1991) and the transition to postapartheid South Africa. In South Africa, this has generated a National Symbols debate on the question of what to do about the monuments of the period of white supremacy and Apartheid – museums representing history as white settler history, monuments and statues commemorating colonial wars, such as the Voortrekkers Monument, or claims to cultural domination, such as the Taal Monument (Tomaselli, 1994; Wright and Mazel, 1991).

Upon closer consideration, the two exhibiting strategies outlined by Ivan Karp, the assimilating and exoticizing strategies, are *both* hegemonic strategies, both defined from the point of the view of the centre: both are instances of 'discourse about the other'. The exoticizing strategy insists on difference, while the assimilating strategy eliminates difference or reworks it in a wider modernizing perspective. The exoticizing approach, premised on essentializing difference, parallels cultural relativism and static notions of multiculturalism with their insistence on the purity of cultural 'wholes' or configurations. The assimilating strategy subsumes difference and reinscribes it as a substructure of modernity.

These discourses about others, then, represent twin faces of the Enlightenment: the Romantic gaze and the modern gaze. The Romantic gaze highlights the diversity of cultures and infuses it with meaning – as in reverence for the *bon sauvage*, the noble savage, discourses of authenticity and 'roots'. The modernist gaze views different cultures as multiple paths leading towards the citadel of modernity. These twin gazes produce the familiar tension between *Lebenswelt* and system, *Gemeinschaft* and *Gesellschaft,* thematized in phenomenology (Brentano, Husserl, Heidegger, Merleau-Ponty) and poststructuralism. It produces the dialectics of Enlightenment addressed in critical theory.

Ethnological museums have been strongly influenced by the perception and interpretation of cultures as distinct configurations which could be represented through 'typical' specimens. Cultural relativism and the notion of cultures as separate wholes echoes into the present and is being revived in the age of multiculturalism. Thus, in a conference of European ethno-logical museums in Paris, 1993, a call was made for European solidarity in pushing back xenophobia and in 'conserving the cultural identity of minorities'. It was also argued that 'The cultural wealth of the peoples of the world must be conserved, to avoid a worldwide standardization ...'[3] This is a familiar refrain in contemporary criticisms of globalization. Is there no middle ground then between cultural apartheid and global standardization?

Selves and others

Fundamental to the question of representation is the dichotomy between self and other. This underlies both exoticizing and assimilating strategies. The dichotomy of self and other overlaps with the worn-out dichotomies of colonizer/colonized, centre/periphery, Occident/Orient, North/South. The dichotomy of self/other has been enshrined in structuralist anthropology, mined in hermeneutics, problematized in poststructuralism and unpacked in deconstruction as another binarism. In a conversation with Michel Foucault, Gilles Deleuze remarks: 'You were the first to teach us something absolutely fundamental: the indignity of speaking for others.' Deleuze concludes in appreciating the 'fact that only those directly concerned can speak in a practical was on their own behalf' (in Sheridan, 1980:114). As Maurice Berger (1987:10) observes, 'every representation – every painting, photograph, film, video or advertisement – is a function of "someone's investment in sending a message"'.

This critical awareness parallels several trends in anthropology: the crisis of ethnographic representation (Clifford and Marcus, 1986; Marcus and Fischer, 1986; Sangren, 1988) and experimentation with new methods of representation in anthropology. Anthropology in the postcolonial era shows affinities with postmodernism and the techniques of collage, montage and dialogue. Self-representation, such as Yanomamo filming themselves, is part of the reorientation away from the *National Geographic* tradition.

The relationship between self and others, which entered into the foundations of museum display has been undergoing profound transformations. The museum is a product of the

Enlightenment. The identities that framed the age of the museum, from about 1840 to 1930 (Phillips, 1995), were national, imperial and modern. National identity was constructed in history museums and national art galleries (and military and war museums); imperial identities were produced in colonial and ethnographic museums and displays; while modern identities have been staged in world exhibitions (Rydell, 1993), science and modern art museums. These Enlightenment subjectivities were in turn enframed by race, class and gender.

Globalization in the twentieth century gradually opened up these identity frames. Major phases of accelerated globalization have been the turn of the century (new imperialism, transport revolution, new technologies, industrial war, international treaties) and the postwar period (US hegemony, Bretton Woods, communications revolution, informatization). The high modern or postmodern turn de-centred the universalist Enlightenment subject and introduced the multiplicity of identity. In widening the range of organizational framework, accelerated globalization widens the range of identity repertoires.

> Multiple identities and the decentring of the social subject are grounded in the ability of individuals to avail themselves of several organizational options at the same time. Thus globalization is the framework for the amplification and diversification of 'sources of the self'.
>
> (Nederveen Pieterse, 1995a:52)

Gradually, different identities come to the foreground. Community identities are constructed in local community museums. Migration histories are presented in displays of diasporic journeys. Intercultural art exhibitions produce multicultural identities. Transnational identities are articulated in 'festivals' and encyclopaedic civilizational displays. Exhibitions such as 'Africa: The Art of a Continent' or 'Asian Modernism' produce macro-regional, continental identities. The first was staged in London (see Archer-Straw *et al.*, 1995) and the other in Tokyo (Furuchi and Nakamoto, 1995). Beyond the old town and municipal museums, urban identities are reconstructed in displays of urban space and architecture. Gender awareness contributes different inflections in modern art as well, witness Manhattan's 'Guerilla Girls'. Sexual preferences inform exhibitions devoted to, for instance, gay history. Age awareness becomes a factor in display strategies geared toward children (play and touch museums, theme parks). These different identities do not replace the old ones, but coexist and interact with them in novel combinations.

Just as 'the self' is not what it used to be, 'the other' is no longer a stable or even meaningful category. The time of structuralist pontificating on 'the question of the other', for instance by Tzvetan Todorov (1988), is past. 'The other' now seems a hopelessly static notion (e.g. Spivak, 1993). The current terminology is 'others', reflecting the awareness that of course there are many different kinds of others. 'Others' in the plural, because of the Big Three – race, class, gender – and because of national origin, religion, lifestyle, sexual preference, age. That self and others necessarily stand to one another in a polarized relationship is also in question. Martin Buber in *I and Thou* and Emmanuel Levinas in several works develop alterity as a relational concept, a framework for dialogue. Freud spoke of the unconscious as the ego's other. And according to Foucault, 'modern thought is advancing to that region where man's Other must become the Same as himself' (in Sheridan, 1980:80). In feminism, the theme of otherness makes place for *difference*, a more neutral and subtle category in which the question of alterity reconnects with fundamental philosophical queries of what constitutes identity. Notions of otherness originated there in the first place (Gasché, 1994). Surely there are many

different kinds of difference and cultural differences are but one dimension amid the wider spectrum of differences (ontological, metaphysical, transcendental).

Museums are institutions of modernity. Their concern with conservation reflects the modern *esprit* of control and appropriation through classification and taxonomy; as such, museum displays are triumphal processions of modernity. The history of museums parallels the career of modernity; this also means that museums take part in reflexive modernity and thus become sites of reflexivity, both with respect to multicultural takes on modernity (or, modernities) and to modernity's evolution.

Alternative agendas

If there is a general principle for exhibiting strategies in the age of globalization, it is abandoning the premise of discourse about the other. First, because the very dichotomy of self/other is being refigured in the process of globalization, which involves the interpenetration of cultures world-wide, the merging of histories over time, and the growing awareness and recognition of this happening. And, second, because of the epistemological and political arrogance of representing others.

The division of labour among History, Art, Ethnography museums reflects the nineteenth-century order and is increasingly being abandoned: ethnographic objects are now also on display in art museums; colonialism can also be addressed in history museums. Generally, the principle of a separation between 'their' history and 'our' history is no longer tenable. There-fore whether there are grounds for a separate agenda for ethnographic museums is increasingly in doubt.

It might be argued, on the other hand, that because of their institutional history ethnographic museums have a particular responsibility in addressing the so-called North/South gap. While the notion Third World is no longer adequate, implying a territorialization of poverty which is not tenable since rich/poor divisions crosscut geographical markers, still for the majority of humanity poverty and deprivation are a glaring reality. Displays inspired by soli-darity, however, are double-edged, for in the process they construct a moral high ground: while showing that it is 'them' not 'us' who suffer, the viewing gaze remains outside the frame (Edwards, 1991; Back and Quaade, 1993). How then can a reorientation be implemented? The

Table 13.1 Selves, others and exhibitions before/after accelerated globalization

Selves	*Others*	*Exhibitions, museums*
Before		
National	(Foreign)	History, art
Imperial/colonial	Savage/colonized	Ethnography
Modern	(Traditional)	Art, science
After		
Local		Community
Regional		Folklore
Macro-regional	Continental	Civilizational
Transnational		Diaspora
Hybrid	Hybrid	Cross-cultural
Global	Global	Common concerns

general reorientation of cohabitation in the context of globalization may be summed up, to borrow a phrase of James Clifford (1991:224), as a shift from a 'colonial' to a 'cooperative' museology.

An obvious question is, 'How can museums make space for the voices of indigenous experts, members of communities represented in exhibitions, and artists?' (Lavine, 1991b:151). The postmodern answer is to 'turn the conflict of interpretations into an exhibition tool' (1991b:155). Thus, the imperial voice – the voice of classic ethnography – can be contrasted to the indigenous voice of resistance, recuperation. The question is, usually, under what terms are these voices combined?

Pluralism as a political and aesthetic strategy for incorporating alternative representations is contested: 'Pluralism as an ideology makes a peripheral place for new possibilities without allowing them to challenge the central idioms of "Euro-centered art"' (Ybarro-Frausto quoted in Lavine, 1991:83). Thus, 'other' cultural and aesthetic expressions in the West have often been categorized as 'ethnic art' (Araeen, 1989). Pluralism as such does not address the underlying question of cultural centre and periphery.

A *dialogical* approach can take the form of joint exhibitions organized by museums North and South or mainstream and periphery institutions. A transnational cooperative museology can address matters of global common concern such as human ancestry and ecological development. Joint exhibitions are an increasingly common practice, although usually the format is decided by sponsors, foundations or museums, in Europe, North America or Japan.

It may be argued that a general guiding principle should be *self-representation,* i.e. representations produced, staged, developed by 'others' in question. In photography a relevant example is a title such as *Picturing Us: African-American Identity in Photography* (Willis-Braithwaite, 1993). Self-representation requires resources which may be available to post-colonial societies or in conditions of strong multiculturalism. Besides, under certain conditions, such as repression and danger, self-representation may be the only option. John Berger introduces a collection of drawings by Palestinian children from the Occupied Territories thus: 'Where the TV cameras were banned and journalists forbidden, schoolchildren painted for the world in watercolors' (in Boullata, 1990:10).[4]

Tribal and African-American museums in North America reflect community perspectives and local or alternative history and genealogy rather than majority history.[5] The Field Museum in Chicago and the Schomburg Center in Harlem, New York, belong in this category. This option is open only to multicultural societies with substantive minorities with local historical memory of sufficient depth, a situation which is not the case in most of northwest Europe.

At some point, however, the logic of self-representation wears thin. For if there is no other, who is self? The twin terms of the dichotomy are interdependent and if one goes, so does the other. There is a comparable dilemma in the indigenization of knowledge – the repudiation of Eurocentric knowledge and the affirmation of indigenous knowledge. What is indigenous and who decides? What are its boundaries, its circumference? Who belongs and who does not, what is essential and what is not? Who speaks for the 'others'? Once we repudiate the representation of others across cultural boundaries, this naturally leads to questioning them across boundaries of gender, class, age, status, region, language *within* cultures and groups. The problem of representation extends infinitesimally: in the process of representation as a manifestation of power, *all* others represented are 'others'.

Museums which exhibit community histories – such as the histories of immigrant groups in the USA or Britain – are not beyond contestation. Even though they may reflect community

values more adequately than any outsider view, no community is homogeneous. Different generation cohorts, for instance, hold different perspectives. Self-representations staged by museums in postcolonial countries, by Arab Cultural Centres in Manhattan or London, or the Institut du Monde Arabe in Paris tend to be constrained by élite constructions of Arabic culture. Cultural self-representation as a principle, then, does not settle the question of representation and power, but shifts it from the intercultural to the intracultural sphere. More precisely, cultural insiders can contest the ways in which culture is constructed and represented interculturally.

Thus, the African-American critic Greg Tate (1992:245, 251) criticizes an exhibition on 'Black Art, Ancestral Legacy' (Dallas Museum of Art, 1991) for its cultural nationalism and ghettoization of black art, 'as if Western art history never happened', collapsing 'all Black art into an ethnically pure African reclamation project'. To avoid ghettoization and modes of self-representation that freeze identities rather than opening up to identities in the making, a radically different option is *hybridity* as an approach. This means breaking with inward-looking cultural nationalism and opening the windows. In cultural studies, hybridity is the pivotal point where analysis and positioning in the anticolonial and national liberation mode end and analysis in the postcolonial and pre-imperial mode begins. Hybridity foregrounds the openness and fluidity of identities, the cut'n'mix zone of selves and others. In cultural studies, this outlook has taken shape in Stuart Hall's 'new ethnicity' (rather than freezing existing ethnic identities), Homi Bhabha's cultural translation and Houston Baker Jr's style of criticism (cf. Bhabha, 1993, 1994; Nederveen Pieterse and Parekh, 1995). In British arts, it has inspired the 'long march from "Ethnic Arts" to "New Internationalism"' (Papastergiadis, 1994:42; see also Gupta, 1993).

Cross-cultural mixing is not merely a subject matter of exhibitions, but also an exhibiting strategy. As a strategy, instead of highlighting the alleged separateness and distinct character of cultures, it is concerned with showing the mélange of cultures over time, the emergence of crossover cultural forms. A point of reference is the Silk Roads project of UNESCO. Several terrains of cultural mixing, historical and contemporary, come to mind: migration, trade, technology, knowledge, language, medicines, foods, arts and crafts; and in contemporary culture, consumption, popular music, world music, fashion (Nederveen Pieterse, 1994). It undermines the Romantic view, by pointing to the differences within, and unsettles the modernist thesis, by relativizing the rupture of modernity. On the other hand, hybridity should not be allowed to become a new mask. 'Deterritorialization, hybridization and multiculturality should not turn into new totalizations hiding new structures of power' (Mosquera, 1993:91). Hence hybridity also refers us to an examination of the terms under which mixing occurs as the recoding of relations of power.

A further option is what we might term, in analogy with reflexive anthropology, *reflexive representation* – reflexive in the sense of self-questioning, problematizing the politics of representation itself. In the context of exhibiting strategies, this refers to exhibitions not about others, but about the relationship between selves and others, about the process and the logics of *othering*. In an ethnological context, this involves self-examination of the ethnographic gaze. It involves questioning the colonial matrix of anthropology and the relationship between ethnography and 'national history'. For instance, in white settler colonies such as Australia and South Africa, ethnography has been traditionally subsumed under natural history and native peoples have been shown as part of Natural History museums, while 'white' ('our') history has been displayed in art and history museums (Marcus, 1991:15). Thus the National Museum in Cape Town displays dioramas with life-size models of San people in situ next to exhibits of dinosaur skeleton models.

Presently, if this is considered an age of ethnicity, the distinction between nation or *ethnos* and 'others' or *ethnikos* (i.e. ethnicity) is also being unsettled (Nederveen Pieterse, 1995b). From a generalized 'ethnic' point of view, national history may be regarded as a monocultural regime, a form of ethnocracy, and national museums as ceremonial sites of ethnocratic citizenship. In that sense, oppositional exhibiting strategies are forms of ethnocriticism.

One of the options for reflexive representation is practising anthropology-in-reverse: looking at the West with the same gaze and cognitive instruments as were directed at the other. Since the late eighteenth century, the ethnographic gaze fashioned overseas also influenced the perception of rural and folk cultures within Europe: 'From the study of manners and customs in Tahiti or among the Iroquois it was only a step for French intellectuals to look at their own peasants, scarcely less distant from them (they thought) in beliefs and style of life' (Burke, 1978:14). Ethnography practised in the West, also in urban anthropology, has long been influenced by anthropology 'overseas'. A step further is looking at the West through the eyes of others, turning the tables of power. There are enough examples of such a perspective (e.g. Fohrbeck and Wiesand, 1983; Theye, 1985). This involves examining the power embodied in the ethnographic gaze, in the creation of the ethnographic object, the classification of the object as ethnographic document. It is an exercise in the decolonization of imagination, engaging the history of colonialism and the culture of empire, of which ethnography is a part.

'Race and Representation' at Hunter College Art Gallery in New York, 1987, is an example of a reflexive exhibition. The 'White on Black' exhibition in the Tropenmuseum, Amsterdam, 1990, is another. Based on an extensive collection of images of Africa and blacks in Western popular culture over the past 200 years, it was effective as an act of self-reflection (Nederveen Pieterse, 1992). Effective also in terms of deconditioning viewers' stereotypes (Abel and Duwell, 1990). On the other hand, due to limitations imposed by the collection, what was not represented was the oppositional voice – e.g. black on white or, more precisely, black on white on black.

Several exhibitions have dealt with the 'gaze of others' directed at Europeans. 'Colon' in Munich, 1983, exhibited African images of Europeans (Jahn, 1983). 'Exotic Europeans' were on display in London in 1991 featuring Nigerian, Japanese, Chinese, Indian and Native American images of Europeans. Black analyses of the 'white eye' and critiques of white stereotyping of blacks are amply represented in the literature, but not as well represented in exhibitions. Several that have been organized – such as 'Ethnic Notions' in the Berkeley Art Center, 1982, and 'Distorted Images' in 1984 in The Muse, a Brooklyn community museum – typically took place in African-American community settings. The setting is significant if we consider the importance of exhibitions as occasions of public display and presencing. These exhibitions did not take place in museums. Accordingly, there remain definite *boundaries* to collective remembering and reflexivity, and limits to what can be shared, where it can be shared, and to what degree it can be shared at all. An exhibition that did gain access to museum grounds was 'The Black Image in American Art' (McElroy, 1990) – note the framing title – in the Corcoran Gallery of Art.

Juxtaposing contrasting exhibiting strategies is another mode of reflexive representation. Fred Wilson (1993), an artist of African-American descent, created an installation in the Contemporary Museum in Baltimore in which discarded slave shackles are displayed next to a silver tea set, or handcrafted armchairs side by side with a handmade whipping post. Thus museum resources are used as tools to reflect on the role of museums and their exhibiting strategies.

James Clifford (in Lavine, 1991b:157) has noted 'how differences in power and perspective radically affect exhibiting voices': 'even museums with opposed cultural policies can be united in the style of their discourse, universalizing in the case of majority museums and oppositional in the case of alternative kinds of museums'. Perhaps this is why some exhibitions, while based on interesting ideas, have been inconsistent in conceptualization and implementation. The 'Exotische Welten/Europäische Phantasien' exhibition in Stuttgart 1987 was premised on a challenging notion: that exotic worlds are European fantasies; but the actual exhibition and the extensive catalogues were quite uneven. The idea was not consistently followed through in its consequences and many items were displayed in conventional terms, such as 'treasures of the Orient'.

One of the issues that present themselves is the repatriation of trophies of colonialism – sacred objects of indigenous peoples, antiquities and artworks taken without proper authorization. A cooperative museology must address these questions in the knowledge that accountability is no longer national, but global. At times, the interests of conservation may clash with indigenous interests; the construction of both positions may be problematic.[6] What is at issue is the wider question of indigenous intellectual property rights and traditional rights.

The alternative agendas discussed so far – pluralist, dialogical, hybrid, reflexive – refer primarily to Western, metropolitan countries. In postcolonial countries the situation tends to be different. In many cases nation-building is an ongoing process, national identity is privileged and marginalization – of minorities, tribals, ethnic groups out of favour – is often a harsh reality. Public culture is defined narrowly, often in statist terms – particularly in many African. Asian and Middle Eastern countries. National identities are more secure in Latin America, but peripherality (economic, cultural) is a lingering preoccupation and the preoccupation with peripherality internationally may be compensated for by centralism in national contexts. Thus, the Latin American ideology of inter-ethnic mixing, *mestizaje*, implicitly refers to a cultural centre of gravity of whitening/Europeanization/modernization, despite recurrent rendezvous with *indigenismo, tiempos mixtos* or hybridity. This reminds us that exhibitions and museums are situated in landscapes of power of which the parameters are as wide as the public culture and ethos allow.

Exhibiting power

> Following turn of the century European aesthetic trends – Orientalism and Japonisme – Australian artists and institutions embraced *Asia* as style: homogeneous, traditional and static, exotic and serene. On the one hand, the people were viewed with derision, on the other, the culture was framed in desire.
>
> (McAlear, 1994:6)

Brian Wallis recounts how cultural festivals staged in the USA devoted to 'Turkey: The Continuing Magnificence' (1987–88), 'Indonesia' (1990–92) and 'Mexico: Splendor of Thirty Centuries' (1990) have been 'intricate, multilayered engines of global diplomacy' that 'function as huge public relations gambits, designed to "sell" the nation's image in the United States' (Wallis, 1994:267, 266). Directed at the USA, these 'festivals mark a specific moment in the realignment of international political and economic power relations' (1994:227).[7] They involve the government's hiring major US public relations firms, the sponsorship of multinational corporations and are 'symptomatic of the trend toward using the aura of culture to attract capital' (1994:227). 'Yet

national cultural festivals mask the contemporary situations in the countries, especially the factionalism, by papering it over with catch-phrases like the Indonesian national motto, Unity in Diversity' (1994:274).

The role of art and culture in international diplomacy is familiar enough. There have been recent disclosures of the role of the CIA in promoting abstract expressionism as a counter to Soviet realism during the Cold War. Australia in its recent interest to embrace 'Asian values' and to snuggle up to the economic dynamism in Asia, has been sponsoring artists and cultural events in Asian countries to change its image in Asia, away from koalas and the White Australia policy (McAlear, 1994:5). This is the tip of the iceberg of wider and more or less subtle correlations of aesthetics and power (see e.g. Duncan, 1993; Nederveen Pieterse, 1993; Zolberg, 1995).

Indeed, with a slight shift of angle, power itself appears as a charm operation, a theatrical performance in the production of charisma.[8] Museums are regarded as educators of the gaze (Katz, 1991), reformatories of manners (Bennett, 1995). But when it comes to power, museums and exhibitions tend to reproduce the charms of power. 'Treasures of', 'Gold of', 'Splendour of' exhibitions invite the public to luxuriate in the aura of power, moonstruck by the accumulated glitter of palaces turned inside out. Under the heading of education, museums provide gratification.[9]

'In some dim but important way we expect museums to be decorous rather than challenging' (Fulford, 1991:28), but this is only a faint expression of the role of museums. With schools and media, museums and libraries are links in the chain of cultural reproduction. Museums are sites of power, 'ceremonial monuments'. Tucked in amid national monuments, statues of statesmen, mausoleums of nation-builders, triumphal arches and obelisks commemorating national achievements, museums themselves are part of the landscape of power, assigned to documenting the giant steps taken by the nation's history. 'Museums do not simply resemble temples architecturally; they work like temples, shrines, and other such monuments.' They induce a 'willingness to shift into a state of receptivity' (Duncan, 1991:90, 91).

The point of reflexive representation is to zero in on representation as power. But representations tend to keep out of view the power of representation. First, power itself has rarely been the object of display. It frames the context of display, rather than being addressed by it. Power is more often fetishized in exhibitions than interrogated by them. In the present context, the fetishism of power involves, first, the culture of empire as a culture of power. Arguably this is insufficiently covered in anthropology. As Roseberry (1992:850) notes, power and colonialism are often referred to in recent poststructuralist anthropology and yet: 'One is often struck, however, by how little the authors actually have to *say* about colonialism and the state.' It is certainly insufficiently addressed in ethnographic museums. In line with the museum culture of conventionality, it is the decorous, edifying side of empire that is on exhibit rather than its bloodstained record. Indeed, colonialism as a subject is excluded from ethnological museums: it enframes the ethnological museum, but is not addressed by it. In cultural, festival-type exhibitions the postcolonial state is diplomatically kept out of view, is the sponsor and beneficiary of the exhibition, 'self-orientalizing' the nation in the process for the sake of tourism glamour.

An obstacle that runs deeper is the sentimentality about empire and the discreet affection for colonialism, because, even though this is an unfashionable sentiment in the postcolonial age, it is viewed as part of modernization led from the West. Besides, it is a matter of national pride. Why in Belgium has there not been a major exhibition devoted to Belgian colonialism, to the colonialism of King Leopold II and the 'Congo atrocities' juxtaposed to the national rhetoric of civilizing mercy? The same applies to England, France, the Netherlands,

Germany, Portugal, Spain and their colonial past. In the Netherlands an exhibition could be devoted to the colonization of the East Indies – not about *tempo doeloe*, not about the cultural treasures of Indonesia, not about the exotic cultures of the island peoples, not about Javanese gamelan or Balinese dancing, but about the bloody conquests of Bali and Lombok, about the Acheh wars, about the plantation system, about the frontier society of Deli in Sumatra, about colonial divide and rule, and about the military effort to forestall Indonesian independence.[10]

Colonialism is behind us, but repressed rather than assimilated. The critical assimilation of empire has not taken place in museums nor, by and large, in other public media such as film or theatre. To an extent, it has taken place in literature (Said, 1993) and scholarship. In the public and popular sphere, up to the present, a docile view of colonialism prevails, particularly of one's own nation's colonialism. The empire nostalgia industry serves as an annex of the heritage industry and thrives on a saccharine view of empire, as in TV productions such as the English series, *Jewel in the Crown*.

A partial exception to this pattern is the USA. The exhibition 'The West as America' (Truettner, 1991) in the National Museum of American Art challenged the decorous clichés of 'how the West was won', unpacked the ideological messages and techniques in the cherished art depicting the frontier, and in the process reaped a storm of protest from the media to Congress. What contributes to the capacity to stage reflexive exhibitions is the populist American tradition of aversion to Big Government. In the USA, it has been possible to produce critical films and access mass media about the Vietnam war and the US role in Central and Latin America. Equally important is that the USA is a country of strong multiculturalism in which minorities have been playing a profound role from the outset: as an immigrant society from the start, the USA, in a profound sense (but not a complete sense), is a culture with an open imaginary.

'From Totem to Life Style' in Amsterdam 1987 was an exhibition based on the provocative idea of juxtaposing the 'totems' of non-Western cultures to totems of the West. The latter were concretized in the consumer lifestyles promoted in marketing (Fohrbeck and Kuijpers, 1987). In the process, however, the actual totems of the West – the church, the Pope, the state, the nation, the monarchy, science, technology, the media – remained completely outside the picture. Thus a glaring asymmetry ensued in which sacred objects of non-Western cultures were placed side by side with contemporary icons of consumerism in the West. A steep asymmetry in time (traditional/modern) and the status of symbolism was intrinsic in the exhibition concept, making a trite point that 'our' worship is the market.

The main obstacle in getting a focus on power may be people's desire to be hypnotized by power. Even while contesting its gestures, public media reproduce the cult of leadership, indulge the obsession with the official public realm of politics – even if it is no longer the centre of actual political decision-making. Part of this cult are the aesthetics of power and the methodologies of the manufacture of charisma. 'Fascism is theatre', according to Jean Genet. Why, for instance, has there not been a major exhibition devoted to the Nazi era – not to 'Entartete Kunst' (degenerate art) or music (which both have been the theme of recent exhibitions in Germany), but to probing the methodologies of 'Entartete Politik'? One of the reasons is the wish to avoid erecting shrines to Nazism. What exhibitions have been organized have produced 'feminized', domesticated renderings of the Nazi era such that viewers identify with the victims of Nazi politics (see Rogoff, 1994).

These considerations refer to an unresolved question: what is the model for the museum, the university or the theatre? It reminds us of the affinity between the museum and the theatre. It has been observed that 'the production of an exhibition is more akin to the production of a

theater piece than any other form' (Gurian, 1991:188), while others insist that the museum emulates the university rather than the theatre (Harris, 1990). Museums may be sites where the university and the theatre meet. Better still, they may be intermediaries and laboratories for experimenting with new cultural combinations and encounters.

This brings us to the status of museums as sites of power. A strategy that problematizes the relationship between the museum and the public is what Nick Merriman refers to as the 'active, transactional museum'. 'In recognition of the subjectivity and plurality of interpretation we should challenge', according to Merriman (1992:138), 'the notion of the curator as the sole interpreter, handing down wisdom to a passive public. Instead, we should now aim for interpretation to be a transaction between the public and the curator, a shared task.' Various forms of public participation – sorting archaeological finds, examining reserve collections, involving communities in the production of their own past – are being developed to address the fluidity of interpretation.[11] This also extends to ethnological exhibitions, as in the Ethnography Gallery at Birmingham Museum.

> One section of the gallery displays objects from Papua New Guinea, which the visitor can then find out about through using an interactive video programme. In this, the objects are interpreted in four different ways, by a nineteenth-century collector, by a Christian missionary, by a museum curator, and by a present-day New Guinean.
>
> (Merriman, 1992:138)

Discourse about others is a function of difference and uneven development. The power of representation is anchored in discursive practices and taxonomic conventions which correlate with forms of 'hard' power, economic and political power included – political power because influence counts and economic power because representation is for sale. On the one hand, discourse about others is old-fashioned and, on the other, it will remain with us for as long as there is uneven development. A growing degree of reflexivity about this condition itself may be what has been gained in the shift from colonial to postcolonial times, and this implies a shift from discourse about others to discourse about *othering*. There are numerous ways in which difference is conceived and experienced, such as polarized and dialogical, static and fluid, deep and shallow.

Notes

This is the revised version of a lecture to the Museum Arbeitsgruppe of the Deutsche Gesellschaft fur Völkerkunde, Leipzig, October 1993 and at Yokohama National University, October 1994. I am indebted to comments by Ineke van Hamersveld of the Boekmanstichting and referees of *Theory, Culture & Society*.

1 '… it is quite possible that the day of the ethnographical museum has already gone, and that, in the years ahead, the habits of man will be presented in a total environmental context…' (Hudson, 1991:458).
2 For a setting and sequence of development of anthropological thought different from American anthropology see Kuklick (1992) on the social history of British anthropology and its phases of evolutionism, diffusionism and functionalism.
3 European Conference of Ethnological and Social History Museums: Museums and Societies in a Europe of Different Cultures, Paris, February 1993. The statement quoted first is attributed to the opening speech by the French president; the second is attributed to the president of the International Committee of Museums of Ethnography, in a conference report by Lothar Stein (1993).
4 Cf. the methods of self-representation of black South African workers used by Sandra Kriel in Williamson (1989:70–1).
5 See Clifford (1991:225–6) on the difference between majority museums and alternative/tribal museums.

6 See Posey (1994) for a framework and covenant for traditional resource rights and the ensuing discussion on intellectual, cultural and scientific property rights.

7 All of the countries that have had festivals in the USA have shared an economic profile. They all have huge international debts (mainly to the USA); cheap, docile labour markets (attractive to US businesses); and valuable exports managed by US multinational corporations (principally oil). All of them have recently privatized state industries (with encouragement from the USA and the International Monetary Fund (Wallis, 1994:277).

8 Anthony Appiah (1992:145): the beginning of postmodern wisdom is to ask whether Weberian rationalization is in fact what has occurred historically. For Weber, charismatic authority – the authority of Stalin, Hitler, Mao, Che Guevara, Kwame Nkrumah – is antirational, yet modernity has been dominated by just such charisma.

9 In *Landscapes of Power: From Detroit to Disney World* Sharon Zukin describes how in Disney World 'the fantasies of the powerless are magically projected onto landscape developed by the powerful' (1991:218). This could also apply to 'Splendour of' and festival exhibitions which cater to middle-class fantasies by staging fairy-tales of cultural utopias.

10 An example is an exhibition in the Ethnological Museum in Leiden, Netherlands titled 'Tegenbeelden van Tempo Doeloe' (Counterimages of Tempo Doeloe). Unlike the title's promise, the exhibition missed the point and in the manner of display made the counter-images peripheral to the standard nostalgic images of decorous Tempo Doeloe, which were represented centre stage (see Vanvugt, 1993).

11 Interactive, experiential museum strategies are also part of the Museum of Tolerance of the Simon Wiesenthal Center in Los Angeles, with exhibits on racism and prejudice in America and on the history of the Holocaust.

Bibliography

Abel, J.P. and Duwell, B. (1990) *Het Effect van de Tentoonstelling 'Wit over Zwart'*, Amsterdam: Universiteit van Amsterdam.

Ames, M. (1986) *Museums, The Public and Anthropology: A Study of the Anthropology*, Vancouver: University of British Columbia Press.

Appiah, K.A. (1992) *In My Father's House: Africa in the Philosophy of Culture*, Oxford: Oxford University Press.

Araeen, R. (1989) 'From primitivism to ethnic arts', *Third Text*, 1.

Archer-Straw, P., Phillips, T. and Mack, J. (eds) (1995) *Africa: The Art of a Continent*, London: Royal Academy of Arts.

Back, L. and Quaade, V. (1993) 'Dream utopias, nightmare realities: imaging race and culture within the world of Benetton advertising', *Third Text*, 22, 65–80.

Bennett, T. (1995) *The Birth of the Museum*, London: Routledge.

Berger, M. (1987) *Race and Representation*, New York: Hunter College Art Gallery.

Bhabha, H.K. (1993) 'Beyond the pale: art in the age of multicultural translation', in Lavrijsen, R. (ed.), *Cultural Diversity in the Arts*, Amsterdam: Royal Tropical Institute.

—— (1994) *The Location of Culture*, London: Routledge.

Boullata, K. (1990) *Faithful Witnesses: Palestinian Children Recreate their World*, Brooklyn: Interlink.

Buber, M. (1970) *I and Thou*, New York: Scribner.

Burgin, V. (ed.) (1982) *Thinking Photography*, London: Macmillan.

Burke, P. (1978) *Popular Culture in Early Modern Europe*, New York: Harper & Row.

Clifford, J. (1988) *The Predicament of Culture*. Cambridge, MA: Harvard University Press.

—— (1991) 'Four northwest coast museums: travel reflections', in Karp, I. and Lavine, S. (eds), op. cit.

—— and Marcus, G. (eds) (1986) *Writing Culture: The Poetics and Politics of Ethnography*, Los Angeles: University of California Press.

Crimp, D. (1985) 'On the museum's ruins', in Foster, H. (ed.), *Postmodern Culture*, London: Pluto.

Dodds, J.D. (ed.) (1992) *Al-Andalus: The Art of Islamic Spain*, New York: Metropolitan Museum of Art.

Duncan, C. (1991) 'Art museums and the ritual of citizenship', in Karp, I. and Lavine, S. (eds), op. cit.

—— (1993) *The Aesthetics of Power: Essays in Critical Art History*. Cambridge: Cambridge University Press.

Durham, J. and Alves, M.T. (1993) 'Complaints and discoveries', *Lusitania*, 5, 130–8.

Edwards, S.E. (1991) 'Photography and the representation of the other', *Third Text*, 16/17, 157–72.

Ethnic Notions: Black Images in the White Mind (1982) Berkeley: Berkeley Art Center.

Exotic Europeans (1991) London: The South Bank Centre.

Festival of India in the United States 1985–1986 (1985), Frankel, L. (ed.), New York: Abrams.

Fohrbeck, K. and Kuijpers, H. (eds) (1987) *Van Totem Tot Lifestyle*, Amsterdam: Koninklijk Institut voor de Tropen.

Fohrbeck, K. and Wiesand, A.J. (1983) *'Wir Eingeborenen': Zivilisierte Wilde und Exotische Europäer/Magie und Aufklarung im Kulturvergleich* (2nd edn), Hamburg: Rowohlt.

Fulford, R. (1991) 'Into the heart of the matter', *Rotunda*, 24(1), 19–29.

Furuchi, Y. and Nakamoto, G. (eds) (1995) *Asian Modernism: Diverse Developments in Indonesia, the Philippines, and Thailand*, Tokyo: Japan Foundation Asia Center.

Gasché, R. (1994) *Inventions of Difference: On Jacques Derrida*, Cambridge, MA: Harvard University Press.

Gidley, M. (ed.) (1992) *Representing Others: White Views of Indigenous Peoples*, Exeter: University of Exeter Press.

Gilsenan, M. (1982) *Recognizing Islam: Religion and Society in the Modern Arab World*, New York: Pantheon.

Gupta, S. (ed.) (1993) *Disrupted Borders*, London: Rivers Oram.

Gurian, E.H. (1991) 'Noodling around with exhibition opportunities', in Karp, I. and Lavine, S. (eds), op. cit.

Hall, S. (1992) 'New ethnicities', in Donald, J. and Rattansi, A. (eds), *Race', Culture and Difference*, London: Sage.

Hannerz, U. (1992) *Cultural Complexity*, New York: Columbia University Press.

Harris, N. (1990) *Cultural Excursions: Marketing Appetites and Cultural Tastes in Modern America*, Chicago: Chicago University Press.

Hudson, K. (1991) 'How misleading does an ethnographical museum have to be?', in Karp, I. and Lavine, S. (eds), op. cit.

Jahn, J. (1983) *Colon: Das schwarze Bild vom weissen Mann*, Munchen: Rogner und Bernhard.

Kaplan, F.E.S. (ed.) (1994) *Museums and the Making of 'Ourselves': The Role of Objects in National Identity*, London: Leicester University Press.

Karp, I. (1991a) 'Culture and representation', in Karp, I. and Lavine, S. (eds), op. cit.

—— (1991b) 'Other cultures in museum perspective', in Karp, I. and Lavine, S. (eds), op. cit.

—— and Lavine, S. (eds) (1991) *Exhibiting Cultures: The Poetics and Politics of Museum Display*, Washington: Smithsonian Institution Press.

Katz, A. (1991) 'Le musée d'anthropologie, des deux côtés du miroir', in *Le futur antérieur des musées*, Paris: Editions du Renard.

Kirshenblatt-Gimbeltt, B. (1991) 'Objects of ethnography', in Karp, I. and Lavine, S. (eds), op. cit.

Kuklick, H. (1992) *The Savage Within: The Social History of British Anthropology, 1885–1945*, Cambridge: Cambridge University Press.

Lavine, S. (1991a) 'Art museums, national identity, and the status of minority cultures: the case of hispanic art in the United States', in Karp, I. and Lavine, S. (eds), op. cit.

—— (1991b) 'Museum practices', in Karp, I. and Lavine, S. (eds), op. cit.

—— and I. Karp (1991) 'Introduction: museums and multiculturalism', in Karp, I. and Lavine, S. (eds), op. cit.

Lumley, R. (ed.) (1988) *The Museum Time Machine: Putting Cultures on Display*, London: Routledge.

Marcus, G.E. and Fischer, M.M.J. (1986) *Anthropology as Cultural Critique*, Chicago: University of Chicago Press.

Marcus, J. (1991) 'Postmodernity and the museum', *Postmodern Critical Theorizing*, 30, 10–19.

McAlear, D. (1994) *High Performance*, London: Organisation for Visual Arts.

McElroy, G.C. (1990) *Facing History: The Black Image in American Art 1710–1940*, San Francisco: Bedford Arts.

Merriman, N. (1992) 'The dilemma of representation', in *La Nouvelle Alexandrie*, Paris: Direction des Musées de France/Collège International de Philosophie.

Mosquera, G. (1993) 'Encounters/displacements: conceptual art and politics', *Third Text*, 24, 87–91.

Munjeri, D. (1991) 'Refocusing or reorientation? The exhibit or the populace: Zimbabwe on the threshold', in Karp, I. and Lavine, S. (eds), op. cit.

Nederveen Pieterse, J.P. (1992) *White on Black: Images of Africa and Blacks in Western Popular Culture*, New Haven and London: Yale University Press.

—— (1993) 'Aesthetics of power: time and body politics', *Third Text*, 22, 33–43.

—— (1994) 'Unpacking the West: How European is Europe?', in Rattansi, A. and Westwood, S. (eds), *Racism, Modernity and Identity: On the Western Front*, Cambridge: Polity.

—— (1995a) 'Globalization as hybridization', in Featherstone, M., Lash, S. and Robertson, R. (eds), *Global Modernities*, London: Sage.

—— (1995b) 'Varieties of ethnic experience and ethnicity discourse', in Wilmsen. E.N. and McAllister, P. (eds), *The Politics of Difference: Ethnic Premises in a World of Power*, Chicago: University of Chicago Press.

—— and Parekh, B. (1995) 'Shifting imaginaries: decolonization, internal decolonization, postcoloniality', in Nederveen Pieterse, J.P. and Parekh, B. (eds), *The Decolonization of Imagination*, London: Zed.

Negrin, L. (1993) 'On the museum's ruins: a critical appraisal', *Theory, Culture and Society*, 10(1), 97–126.

Nicodemus, E. (1993) 'Meeting Carl Einstein', *Third Text*, 23, 31–8.

Oguibe, O. (1993) 'In the "Heart of Darkness"', *Third Text*, 23, 3–8.

Papastergiadis, N. (1994) *The Complicities of Culture: Hybridity and 'New Internationalism'*, Manchester: Cornerhouse.

Phillips, R.B. (1995) 'Why not tourist art? Significant silences in Native American museum representation', in Prakash, G. (ed.), *After Colonialism*, Princeton: Princeton University Press.

Picton, J. (1993) 'In vogue, or the flavour of the month: the new way to wear black', *Third Text*, 23, 89–98.

Posey, D.A. (1994) 'Traditional resource rights', in van der Vlist, L. (ed.), *Voices of the Earth: Indigenous Peoples, New Partners and the Right to Self-determination in Practice*, Amsterdam: Netherlands Centre for Indigenous Peoples.

Prösler, M. (1996) 'Museums and globalization', *Sociological Review Monograph 4*, New York: Hunter College Art Gallery.

Redfield, R. (1956) *Peasant Society and Culture*, Chicago: University of Chicago Press.

Rogoff, I. (1994) 'From ruins to debris: the feminization of fascism in German history museums', in Sherman, D.J. and Rogoff, I. (eds), *Museum Culture: Histories, Discourses, Spectacles*, London: Routledge.

Roseberry, W. (1992) 'Multiculturalism and the challenge of anthropology', *Social Research*, 59(4), 841–58.

Rubin, W. (1984) *'Primitivism' in Twentieth-Century Art: Affinity of the Tribal and the Modern* (2 vols), New York: Museum of Modern Art.

Rydell, R.W. (1992) 'Museums and cultural history', *Comparative Studies of Society and History*, 242–7.

—— (1993) *World of Fairs: The Century-of-Progress Expositions*, Chicago: University of Chicago Press.

Said, E.W. (1993) *Culture and Imperialism*, New York: Alfred Knopf.

Sangren, P.S. (1988) 'Rhetoric and the authority of ethnography: "postmodernism" and the social reproduction of texts', *Current Anthropology*, 29(3), 405–35.

Seeck, A. (ed.) (1991) *'Rohe Barbaren' oder 'Edle Wilde'? Der Europäische Blick auf die 'Andere Welt'*, Göttingen: Institut fur Angewandte Kulturforschung.

Sheridan, A. (1980) *Michel Foucault: The Will to Truth*, London: Tavistock.

Sherman, D.J. (1989) *Worthy Monuments: Art Museums and the Politics of Culture in Nineteenth-century France*, Cambridge, MA: Harvard University Press.

—— and Rogoff, I. (eds) (1994) *Museum Culture: Histories, Discourses, Spectacles*, London: Routledge.

Shohat, E. and Stam, R. (1994) *Unthinking Eurocentrism*, London: Routledge.

The Significance of the Silk Roads in the History of Human Civilizations (1992) Osaka: National Museum of Ethnology.

Spivak, G.C. (1993) *Outside in the Teaching Machine*, London: Routledge.

Stein, L. (1993) 'Erste Konferenz der europäischen Ethnographie-Museen', *Mitteilungen aus dem Museum fur Völkerkunde Leipzig*, 55, 60–1.

Stölzl, C. (ed.) (1988) *Deutsches Historisches Museum: Ideen, Kontroversen, Perspektiven*, Frankfurt and Berlin: Ullstein and Propyläen.

Tate, G. (1992) *Flyboy in the Buttermilk*, New York: Fireside.

Theye, T. (ed.) (1985) *Wir und die Wilden: Einblicke in einer kannibalische Beziehung*, Reinbek.

Todorov, T. (1988) *La Conquête de l'Amérique: la question de l'autre.* Paris: Seuil.

Tomaselli, K. (1994) *The Rearticulation of Meaning of National Monuments*, Durban: Centre for Cultural and Media Studies, University of Natal.

Truettner, W. (ed.) (1991) *The West as America: Reinterpreting Images of the Frontier, 1820–1920*, Washington: Smithsonian Institution Press.

Vanvugt, E. (1993) *Een Propagandist van het Zuiverste Water: H.F. Tillema en de Fotografie van Tempor Doeloe*, Amsterdam: Mets.

Wallis, B. (1994) 'Selling nations: international exhibitions and cultural diplomacy', in Sherman, D.J. and Rogoff, I. (eds), op. cit.

Williamson, S. (1989) *Resistance Art in South Africa*, Cape Town: David Philip.

Willis-Braithwaite, D. (1993) *Picturing Us: African-American Identity in Photography*, New York: New Press.

Wilson, F. (1993) *Mining the Museum: Rethinking the Institution*, New York: New Press.

Wright, J. and A. Mazel (1991) 'Controlling the past in the museums in Natal and KwaZulu', *Critical Arts*, 5(3), 59–78.

Zolberg, V. (1995) 'The collection despite Barnes: from private preserve to blockbuster', in Pearce, S.M. (ed.), *Art in Museums*, London: Athlone.

Zukin, S. (1991) *Landscapes of Power: From Detroit to Disney World*, Berkeley: University of California Press.

Museums and the re-shaping of memory

Patricia Davison

All heritage resources, places and spaces are associated with memory. Natural and cultural landscapes, specific sites, aspects of the built environment, monuments and material in museums and galleries can all trigger and shape individual memories as they are related to personal experiences. However, they also play a powerful role in shaping collective memories in terms of what is selected for preservation and storage, and how these resources are interpreted and presented.

Drawing on examples from museums, galleries and heritage sites in South Africa, this chapter engages with issues relating to the processes of memory shaping and re-shaping within that country. Heritage resources mediate the past, present and future and can be used to shape collective memory into official versions of the past. This process involves choices about what is remembered and what is forgotten; what is collected or preserved and presented, and what is not. When perceived as being authoritative, objective and containing the authentic, heritage institutions are given a power in the memory-making processes to affirm and validate certain cultural expressions and interpretations. Consequently, they are often used in the construction of identities and in nation-building exercises. In the 'new' South Africa, old and new heritage institutions and projects have been drawn into the processes of transformation, whereby they are working towards the re-shaping of public memory and the revision of interpretations of the past. These processes need to recognize the complexities in the construction and reconstruction of identities, the nature of power relationships in the politics of representation, and in the contestation that often accompanies heritage production and communication. The chapter finishes by considering issues relating to all the above in the controversy that arose around the exhibition 'Miscast: Negotiating Khoisan History and Material Culture'.

We must reckon with the artifice no less than the truth of our heritage.

Lowenthal, *The Past is a Foreign Country*

In popular memory, the South African Museum (SAM) in Cape Town, the oldest museum in the subcontinent, is associated with the natural history of 'Bushman, Whale and Dinosaur'.[1] Since the early decades of this century, a series of plaster casts of the indigenous inhabitants of southern Africa has been a consistent visitor attraction. Indeed, surveys suggest they are the most memorable of all the museum's exhibits. Complete in every physical detail and revealing a mastery of technical skill, these casts are quintessential museum specimens, dehumanized objects of scientific inquiry, exhibited for the public gaze. If the casts seem at home in the

contrived realism of a diorama, this is not surprising, since both are constructs of museum practice, representations that mediate the memory of people classified as Bushmen.

Millions of museum visitors have viewed the plaster figures of thirteen /Xam women and men who were living near Prieska in 1912 when they were cast to preserve an exact physical record of a 'nearly extinguished' race. Although by the time they were cast, this group of /Xam no longer wore traditional clothing made from animal skins and had long since been dispossessed of their hunting grounds, their history of resistance and subordination was not presented in the museum. Instead, they were reduced to physical types and exhibited unclothed, except for small aprons and loin-coverings, as examples of a primitive race. The compellingly lifelike casts gave tangible form to stereotypes of KhoiSan physical difference that had been well established during the preceding century in photographs and drawings. They echoed the public display of living 'Bush people' at the shows of London and Europe in the mid-nineteenth century, and recalled the sensation surrounding the earlier exhibition in London and Paris of Saartje Baartman, the 'Hottentot Venus'. For decades, casts of the /Xam and other KhoiSan people were prominently displayed in glass cases inviting contemplation of anatomical features, such as stature, skin colour, and steatopygia. In the 1950s, the thirteen /Xam figures were removed from the display that explicitly emphasized physical attributes and repositioned in an idealized diorama, depicting a nineteenth-century hunter–gatherer encampment in the Karoo. Intended to evoke memories of a past way of life, of bush craft and survival skills, the diorama shows the casts, surrounded by artefacts of everyday use, in a carefully constructed 'natural' environment. But, despite their new setting, the figures inevitably retained the connotations of stereotyped otherness that gave rise to their production in the first place (Davison, 1993). In 1989, a display was mounted adjacent to the diorama to draw attention to the history of the people who were cast, and the ideas that gave rise to the casting project.

The visual rhetoric of the diorama medium evokes associations with the realm of nature – in other galleries fossils, fish, and birds are found similarly displayed. The inclusion of anthropology, but not cultural history, in a museum devoted mainly to natural history affirms this association. The problem is not that human beings are grouped with natural history, but that only ethnographic 'others' are categorized in this way. Such spatially encoded classifications embody theoretical concepts that shape both knowledge and memory. The investigation of classificatory constructs therefore becomes of critical importance in illuminating how museums institutionalize certain forms of knowledge, and perpetuate stereotypes in the name of scientific inquiry.

Pippa Skotnes, artist and curator of the recent exhibition 'Miscast: negotiating KhoiSan history and material culture',[2] set out to interrogate in visual form the historical relationships that gave rise to misconceptions surrounding the people that outsiders had collectively labelled 'Bushmen'. Listening to public responses to the diorama at the SAM had confirmed her view that the Bushmen were indeed 'miscast', fixed in a timeless depiction of an imagined past that occluded the public memory of their dispossession and decimation. Her project was to illuminate the power relations of this history through imagery, artefacts, and ethnographic narrative. The 'Miscast' installation stimulated unprecedented controversy and will remain a landmark in exhibition practice. Later I return to 'Miscast' and consider the conflicting reactions it evoked, but first I reflect briefly on museums as places of memory and outline the changing contours of local museum practice over the last decade.

Museums as mirrors of power

Museums, like memory, mediate the past, present, and future. But unlike personal memory, which is animated by an individual's lived experience, museums give material form to authorized versions of the past, which in time become institutionalized as public memory. In this way, museums anchor official memory. Ironically, the process involves both remembering and forgetting, inclusion and exclusion. In making decisions about collecting policy, museum curators determine criteria of significance, define cultural hierarchies and shape historical consciousness. The institutionalized neglect, until the late 1980s, of African art by national art galleries in South Africa is a case in point, as are the more recent moves to redress this exclusion.

Every preserved artefact is a tangible trace, a crystallized memory, of its manufacture and use, but at the same time attests to conceptual and spatial displacements resulting from acts of acquisition, classification, and conservation. Once assembled, collections are complex and revealing artefacts of museum practice, as well as fragments of former social milieux. Objects held by museums constitute a material archive not only of preserved pasts, but also the concerns that motivated museum practice over time. These concerns can seldom be separated from relations of power and cultural dominance. Museums have often been described as places of collective memory, but selective memory may be a more accurate description.

Although museum presentations are always subjectively shaped, they are widely associated with authenticity and objectivity. Consequently, museums have become privileged institutions that validate certain forms of cultural expression and affirm particular interpretations of the past. In many countries, state-funded national museums have tended to pursue projects that further the national interest, even if this is not openly acknowledged. 'The ordering and reordering of objects and representations in national museums can serve to legitimate or "naturalize" any given configuration of political authority' (Steiner, 1995: 4). Museums are thus used by nation states to represent themselves to themselves, as well as to others. But, as Steiner notes, defining 'themselves' and what constitutes national identity is not uncontested or unchanging- the concept of nationhood, like a sense of community, is a construct of the mind, an imagined reality. In practice, the situation on the ground is more complex – there are always tensions between differing interest groups, overlapping constituencies, and opposing interpretations of events. For political reasons new versions of the past may become the official version and claim authenticity, but former structures and mechanisms remain unchanged.

In practice, despite changing power relations, collections designated as 'national' are assembled by museums and held in trust for future generations. The history of these holdings and their use in exhibitions provide insight into the shaping of national identity and public memory. Moreover, internal museum processes also have specific histories, often taken for granted because they seem self-evident. The conceptual frameworks that order collections and underpin exhibitions also mirror dominant forms of knowledge. Change may occur imperceptibly, but at certain moments, as in contemporary South Africa, it becomes programmatic. Taking its cue from political transformation, the revision of heritage practices has become overt – the re-shaping of public memory is an explicit project.

'In keeping with the spirit of the new South Africa, the South African Cultural History Museum at the top of Adderley Street is rethinking the history of the country it wants to reflect.' This quotation from a press report (*Weekend Argus*, 6–7 January 1996) underlines both the expediency of rethinking the past in the context of a new present, and the selectivity inherent in the process. The version of the past represented in this museum is being reworked to accord with an emerging new orthodoxy. Historical narratives, such as those relating to slavery at the Cape, that

were previously excluded have become politically acceptable, even marketable as part of heritage tourism. The museum is housed in a building that, in much altered form, was the slave lodge of the Dutch East India Company at the Cape from the late seventeenth to early nineteenth centuries. Despite an ever-present spatial echo of slavery, this chapter of Cape history was not, until recently, interpreted at the museum for the visiting public – selective amnesia prevailed. Within the current political climate, however, memory has returned and the museum's slave connection is regarded as an important heritage resource and visitor attraction. A new tourism initiative is seeking to develop a local slave route that would create awareness of the legacy of slavery in the Western Cape, and eventually link up with slave routes elsewhere in the world.[3]

This is but one example of a museum responding to South Africa's new national agenda. State-funded museums have been called upon by the Ministry of Arts, Culture, Science and Technology to redress past inequities as part of the national reconstruction and development programme. Funding is a powerful agent of change, and it has been made clear that financial support will be awarded to those heritage projects that contribute to transforming national consciousness. However, this policy of project-based funding has yet to be implemented. The National Heritage Council that will become the statutory body in control of funding is expected to be constituted during 1997. It is anticipated that appointments to the council will be made following a process of public nomination.

A number of recent exhibition projects have been directly concerned with re-shaping memory. Among the most remarkable are a series of exhibitions undertaken at the Castle of Good Hope, the oldest surviving colonial building in South Africa. The Castle, resonant with complex histories of colonial power, slavery and resistance, has become a venue and symbolic space for challenging the ideologies that supported apartheid, and for reclaiming histories that had been marginalized. The history and culture of the Muslim community was celebrated at the Castle in 1994 as part of the Sheikh Yusuf Tricentenary Commemoration. This was followed by a poignant exhibition of official documents and recorded testimony relating to the racial segregation of the city of Cape Town. Freedom to express views within the confines of the Castle that might formerly have been suppressed in that setting gave the exhibition heightened significance. Also operating within an evocative cultural space, the District Six Museum, founded in 1992, reclaims the social histories of people who were forcibly removed from the area under Group Areas legislation – it is also a memory bank of human resilience in the face of adversity.

My focus is on much older institutions that must confront the burden of their own history in shaping a new future. My central concern is with the SAM and other large state-funded museums. In different ways, these institutions are all striving to embrace transformation and develop strategies for creating new constituencies.[4] However, the process is complex and uneven – the need for structural change may be accepted in principle, but resisted in practice. In considering how museums are responding to political imperatives, I do so as an anthropologist whose personal memories of museum practice go back to the 1970s.

During most of the apartheid years, the SAM and many other state-funded museums tended to assert that they occupied a neutral zone where knowledge was generated and communicated to the public. Museums that emphasized their research role were reluctant to recognize the relationship between knowledge, power, and privilege. Predominantly white museum professionals regarded their work as objective and apolitical. The 1975 entry in the international *Directory of Museums* suggested otherwise:

> The museums of South Africa are the museums of white South Africa. The non-white majority is represented, not in the planning and the organisation of museums, but in

ethnographical collections and exhibits – the European section of the population is, for some reason, not considered suitable material for ethnography … History is invariably presented from the point of view of the white man.

(Hudson and Nicholls, 1975: 385)

Until the 1980s, little criticism of museums emerged from local sources. The Culture and Resistance Symposium held in 1982 in Gaborone, Botswana, although not directly concerned with museums, signalled an increased engagement in cultural practice by the democratic movement. From 1983, when the racially segregated tricameral parliament divided museums into Own Affairs and General Affairs on the basis of presumed 'group' interests, the argument that museums were neutral became untenable. The South African Cultural History Museum (SACHM) was classified as white Own Affairs, despite having large collections that did not fit into this category,[5] while the SAM and the South African National Gallery (SAMG) became General Affairs museums. Criticism was voiced by the Southern African Museums Association (SAMA), but many of its own members accepted the status quo, and did little to counter the prejudices and misconceptions that many museums perpetuated (Webb, 1994).

This complacency was challenged increasingly within the profession.[6] Critical questions were raised regarding whose heritage was preserved in museums and commemorated in monuments, and who had the right to decide what should be preserved. An undeniably Eurocentric bias was shown by the fact that fewer than one per cent of about 4,000 declared national monuments in South Africa related to pre-colonial African heritage (Deacon, 1993). The development since 1990 of a number of new projects reflects a post-apartheid shift in priorities. Notable among these are the site museum at Tswaing, north of Pretoria, designed as an eco-museum that integrates cultural and natural history and serves 'the total South African society, especially hitherto marginalized communities' (Kusel, 1994); the restoration of the stone-walled capital at Thulamela,[7] occupied between about AD 1400 and 1700; and the planning of the Robben Island Museum to commemorate the struggle for human rights in South Africa. Significantly, these projects are striving to set up negotiated decision-making processes that involve local communities in long-term site management. The co-operation between academic archaeologists and Venda chiefs in resolving sensitive issues relating to the excavation and reburial of skeletal remains at Thulamela has been hailed as a model of successful negotiation. Venda people have taken immense pride in the excavations and the restoration project. At the official opening of the site, the importance of Thulamela as a place of public memory was stressed – it affirms the complexity of African culture in southern Africa centuries before the arrival of white settlers and reclaims a significant chapter in Venda history. In this context, ethnic identity has become a positive community resource.

Ironically, because apartheid policy used ethnicity to classify African people and deny them South African citizenship, the mobilization of ethnic consciousness by Africans themselves was, until recently, compromised. Cultural traits had been used too often to perpetuate racial stereotypes, and ethnicity had been used to justify separate 'homelands' for different 'tribes' or 'nations'. In post-apartheid South Africa this has changed and cultural diversity has been embraced within the symbolic construct of nation building. In practice, however, accommodating ethnic difference without resorting to essentialist notions of race and culture remains a challenge.

From the late 1980s, academics who had previously distanced themselves from museum debates became involved in the politics and poetics of museum practice under the banner of 'public history'.[8] At the same time, many museums started rethinking classificatory boundaries within collections and between institutions. In 1990, the formerly separate history and anthro-

pology sections of the SAMA merged to form the humanities group. This symbolic realignment signalled a growing momentum to tell 'hidden histories' that had been suppressed or distorted under apartheid, a new respect for oral histories, and a call to democratize museum practice at all levels. A number of museums targeted new audiences among previously disadvantaged communities and employed black education officers in their outreach programmes. Acquisition policies came under review. Apartheid 'memorabilia', such as 'Whites Only' signs, became sought after by museums. Art galleries were quick to expand their collections to include material of African origin. However, authority to decide what to collect and exhibit did not extend to African people – existing power relations remained unchanged.

New exhibition projects challenged conventional oppositions, such as art/artefact, with varying degrees of success. 'Art and Ambiguity' shown at the Johannesburg Art Gallery in 1991 emphasized the sculptural and aesthetic attributes of works in a collection that could equally well have been presented in an ethnographic or historical context. The Brenthurst Collection of Southern African Art proclaimed itself as 'Art' by definition, location, and visual rhetoric. Although the ambiguities of the collection were largely eclipsed by the mode of presentation, the exhibition succeeded in focusing attention on memories waiting to be recovered. The arresting forms of headrests, staffs, snuff-boxes, and domestic objects, simultaneously aesthetic and functional, also embodied non-verbal histories that had yet to be fully explored. Coinciding with the return of many political exiles, the exhibition seemed to celebrate a heritage regained.

While temporary exhibitions adopted new conceptual approaches, these were less easy to implement in large museums with semi-permanent exhibitions that inhibited rapid change. In theory, the division between cultural history and ethnography had been dissolved, but in practice relatively little changed at the SAM. In 1993, as an interim measure, a series of 'dilemma labels' were installed in the anthropology gallery under the heading 'Out of Touch'. The intention was to highlight problems of interpretation and omission in the ethnographic displays, which had been mounted in the early 1970s. The introduction to 'Out of Touch' reads as follows:

> From looking at these exhibits you might think that all black South Africans lived in rural villages, wore traditional dress and used only hand-made utensils. The objects shown in this hall date from the late nineteenth century through to the mid-twentieth century. During this period, African people were profoundly affected by economic changes, following the discovery of diamonds and gold. Men migrated from rural areas to work in the emerging mining and manufacturing industries. Despite laws preventing black people from living in cities, many settled illegally in areas surrounding major urban centres. This process, however, is not shown in the displays of traditional African life. Instead, African culture is portrayed as trapped in an unchanging past.

A series of contrasting images was superimposed on the existing showcases to create a visual counterpoint to the ahistorical depiction of traditional life. Images of San men in the South African Defence Force were placed over exhibits of hunter–gatherer material culture, the dress of African female executives was contrasted with traditional clothing, western religious ceremonial attire was juxtaposed with the African equivalent. The counter-images deliberately destabilized the narrative of the gallery. Predictably, many visitors found this confusing, while for others it successfully focused attention on critical issues surrounding the interpretation of cultural difference. If public memory is to be more than a dominant mythology, new ways of evoking multiple memories will have to be found.[9] Museums are well placed to take long-term perspectives on complex issues surrounding the shaping of cultural identities. Instead of assuming in advance that

identities are fixed, museums can demonstrate how people shape their identities through cultural strategies (Hamilton, 1994). Culture is a resource that people draw on in relation to ever-changing circumstances and shifting identities. A single individual may embody a range of identities, communicated in dress, language, or any other form of cultural expression. For example, the public attire of Chief Buthelezi, leader of the Inkatha Freedom Party, reflects a masterly mobilization of cultural symbols – ceremonial Zulu regalia on occasions of tribal significance, European suits for business meetings, and African printed shirts for stressing solidarity with the rest of the continent. By posing questions, such as 'What does it mean to be Zulu?', museums could explore complex issues. At a macro level, the same could be done in relation to national identities. In effect, national museums need not simply reflect a constructed national identity, but could show the processes involved, and how national identity shifts over time. A similar approach could be applied to issues of cultural ownership. Who owns Robben Island? Although it is state property and has been declared a national monument, there are competing claims to the heritage of the island. The dominant claim at present is that of political prisoners who were gaoled there under apartheid legislation, but the recently revived Robben Island Historical Society voices other claims to the island's past, as does the Muslim community for whom the island is a site of pilgrimage. The right to interpret the history of the island for the visiting public is not uncontested. '*Esiqithini*: The Robben Island Exhibition', which opened in 1993 at the SAM, set out to raise discussion about the island's future, informed by a presentation of its remote and recent past.

Robben Island at the entrance to Table Bay has been described as the most symbolically charged site in South Africa – historically, a place of exile for political dissidents, and confinement for lepers and the insane; from the 1960s to 1991, a high-security prison and metaphor for the inhumanity of apartheid. Since the release of Nelson Mandela and other political leaders, the island has become a symbol of transcendence over oppression, an icon of hope.

Until 1990, the views of banned ANC leaders were relentlessly censored from the media. For decades it was illegal to publish or display photographs of Nelson Mandela in South Africa. The history of the struggle for human rights was excluded from state-funded museums. State propaganda and school textbooks presented distorted versions of South African history, and ignored the perspectives and interests of the black majority. In museums, African history was usually reduced to static ethnographic descriptions of timeless traditions.

'*Esiqithini*: The Robben Island Exhibition' arose from an unlikely partnership between a long-established national museum and the newly established Mayibuye Centre, committed to recovering the history of the liberation movement. The two institutions had different perspectives on the past, different skills and resources, different constituencies, and different missions. The impact of the exhibition depended in part on these creative tensions. The timing was significant – in 1992 when the exhibition was initiated the ANC was not yet in power, and the ANC-aligned Mayibuye Centre saw itself as engaging critically with the establishment (Odendaal, 1994). From the museum's perspective, this was an opportunity to provide a public forum for debate on the future of Robben Island, informed by its remote and more recent past. It was also an opportunity for the museum to attract new audiences, and to show its willingness to participate actively in an emerging discourse on museum practice in post-apartheid South Africa.

The exhibition evoked memories of prison life on the island mainly through the personal possessions of former political prisoners. Objects and documents were used as mnemonic devices, visual prompts to personal and shared recollection. Former political prisoners were part of the exhibition team, and their memories informed the script and shape of the exhibition. The hardship of prison life was juxtaposed with the commitment of comrades to continuing the struggle behind bars. Recollections also evoked personal memories of wives, mothers, and friends on the

outside. Although female political activists were never imprisoned on Robben Island, the exhibition also recalled their roles in the liberation struggle. The official perspective of the Department of Correctional Services was not excluded. In short, no attempt was made to present a seamless version of the Robben Island story.

Although the post-1960 period was the main focus of the exhibition, an illustrated time-line traced the island's long history from its geological past to the present. At the time of the exhibition, no decision had been taken on the future of Robben Island and viewers were invited to comment on the issue. Responses covered many other issues as well. Some viewers felt that the exhibition was overtly political and biased in favour of the ANC; many applauded the opportunity to learn more about Robben Island. Both positive and negative comments underlined the fact that locating '*Esiqithini*' in the SAM was a significant affirmation of the importance of Robben Island in the social history of South Africa. It was also a symbolic shift to the mainland – the island was no longer 'a place apart'. Four years later, the island has been declared a national monument and, in due course, it will be proposed as a World Heritage Site.

Since the exhibition at the SAM closed, the Robben Island collection has been publicly displayed at the Mayibuye Centre and at an exhibition centre at the Waterfront. Can the artefacts of prison life retain their poignancy after multiple displacements, or will their capacity to move the viewer diminish? The Robben Island Exhibition, which was situated in a Caltex service station complex, showed many of the same objects and documents that were part of '*Esiqithini*' at the SAM, but they conveyed different meanings because of the commercial setting. Context is a crucial cue to meaning, and there is no doubt that the validating context of the SAM evoked respect for the objects – the setting and manner of display added value to the material. This was not the case when the collection was exhibited at the Waterfront. Although regarded by the Mayibuye Centre as a temporary measure, a stepping-stone to a purpose-built museum, it represented a commodification of heritage as visitor attraction.

As a site of memory, Robben Island presents a set of problems for those concerned with its development and management. The physical situation of the island and its history are invaluable heritage resources. Since the early 1990s, the high-security section of the prison has become a place of homage, visited by dignitaries from all parts of the globe. But how will the island's past be packaged for large-scale tourist consumption without irrevocably changing it? This is the implicit paradox of preservation – in the words of Lowenthal (1985:410) – '… preservation itself reveals that permanence is an illusion. The more we save, the more aware we become that such remains are continually altered and reinterpreted … What is preserved, like what is remembered, is neither a true or stable likeness of past reality.' In the early 1990s, when journalists were first allowed into the prison, the cells had been given a new coat of cream paint, a practical cover-up prior to press scrutiny; more recently picturesque murals appeared in some places, seeming to parallel a growing nostalgia among prison officials as their stay on the island drew to a close.[10] The eventual departure of warders and their families at the end of 1996 was marked by tearful reminiscences and sadness at leaving their island home. Signs of tourism development to follow were already present in the local shop: Robben Island T-shirts, souvenir teaspoons and bottles of wine, successfully marketed as Robben Island Red.

In January 1997, Robben Island was designated a museum and regular tours to the island were started by the interim management body responsible for administering the island museum until a formal council had been appointed. The number of tourists wanting to visit the island soon exceeded the official limit of 265 people per day. Inevitably, market forces and private-sector interests put pressure on the authorities to allow greater freedom of access to the island. This was strongly resisted by those in charge, underlining the critical issues of control and moral authority

in planning the future development of the island. The unauthorized use of the name Robben Island in commercial products has also been strenuously opposed. A private venture to market Robben Island memorabilia under the label 'The Original Robben Island Trading Store' provoked an outcry from former prisoners and those involved in the preservation of the island. The swift moves to close this venture reflected the significance of the island in popular memory as a shrine to the liberation struggle (*see Cape Times* editorial, 9 June 1997). The salient issue, however, remains one of control.

Recasting memory

If museums are agents of official memory, individuals and groups continually intervene to contest and re-shape orthodox views. Indeed, public memory emerges from an intersection of official and vernacular versions of the past (Bodnar, 1992). Curatorship, which can be regarded as a process of institutional memory making, is in itself complex and seldom has predictable or stable outcomes. This was demonstrated by reactions to the exhibition 'Miscast: Negotiating Khoisan History and Material Culture' which opened at the SANG in April 1996.

The SANG has energetically embraced the challenges of transformation. At the recent Faultlines Conference, the director declared: 'The process of redress started in 1990, and since then, every function of the national art museum has been reassessed and tested against the needs and requirements of a changing South Africa' (Martin, 1996). The concept of 'Miscast' was in keeping with the overall mission of the gallery to redress past inequalities. The aim of Skotnes' project was to illuminate the colonial practices that had mediated perceptions of people classified as Bushmen and Hottentots, and cast them as objects of scientific study. Using aesthetic and textual tools the exhibition starkly exposed the unequal relationship between observer and observed. Harrowing images and artefacts of human suffering, humiliation, and objectification formed the visual burden of the installation, while transcribed texts from San oral literature, finely crafted objects, and rock art evoked the sense of a heritage lost. No redemption from shame was offered; no affirmation of survival. On the contrary, one gallery was designed so that viewers could not avoid walking on images of KhoiSan people, signifying inescapable complicity with past oppression. But who was Skotnes implicating? What reactions did she anticipate from people of KhoiSan descent? And what of her own position as curator? If unequal power relationships characterized the colonial past, surely this continued to be so in the present. Far from applauding the exhibition, angry KhoiSan descendants contested the authority of the curator to represent their history, and accused the SANG of perpetuating the colonizing practices of the past. Their reactions were summed up in the comment 'To show these things here is just as bad as the people who did these things long ago. It is continuing the bad thing.' Ironically, this was diametrically opposed to the stated mission of the gallery.[11]

As Paul Lane (1996) has noted, KhoiSan responses to 'Miscast' suggest that the ironic intent behind the use of many images was misunderstood. Severed heads, fragmented body parts, and naked torsos were not read metaphorically, but literally, as another form of violence. People claiming KhoiSan descent asserted that the exhibition was aimed at white people; they themselves did not need to be reminded of the humiliations suffered in the past. Controversy surrounding 'Miscast' did not, however, extend to the South African Museum diorama. Skotnes' own response to the diorama had originally motivated the 'miscast' concept, but her indignation was not shared by KhoiSan viewers. On the contrary, the diorama tended to be favourably regarded (Davison, 1991:187–93). Perhaps a reason for this contradiction lies in the fact that, although problematic in other respects, the diorama does not represent San hunter-gatherers as victims. Klopper (1996)

stresses this point in a perceptive assessment of KhoiSan responses to 'Miscast'. She also notes that despite criticism of the installation, the occasion was used strategically by KhoiSan descendants to advance their current claims to land. Survival in the present is the most pressing concern for marginalized people, and it is a remarkable indication of resourcefulness that the exhibition could be used to serve current interests.

A public forum held on the day after the opening, and another before the closing of the exhibition, affirmed that power relations remain at the centre of critical debates on museum practice, but that museums themselves are public spaces that can be used for contesting and negotiating these relations. There is no single authentic voice – exhibitions, like other artefacts, are open to imagination and interpretation. A character from In *the Fog of the Season's End* (1972), by the late African writer Alex La Guma,[12] recalls waiting for a fellow political activist at the South African Museum. In the zoological gallery, he 'had been alone, a stranger in a lost dead world...' but in the anthropology section he had mused: 'These Bushmen had hunted with bows and tiny arrows behind glass; red-yellow dwarfs with peppercorn hair and beady eyes. Beukes had thought sentimentally that they were the first to fight' (cited in Voss, 1990:66).

The tangibility of objects is particularly salient in relation to memory. Museum collections, like monuments and sites, bridge the past and the present and provide cues to recollection. They embody memories of the past and evoke memory in the present. The /Xam casts made in 1912 are material reminders of ideas that were current at the time, but, having been exhibited for over eighty years, they have accrued other meanings over time. Similarly, over a far longer period, Robben Island has accumulated many layers of memory. The significance attached to particular events in the past changes in relation to the politics of the present. But there remains a surplus of meaning waiting to be made and remade. Museums hold and shape memories, but they cannot contain them.

Notes

1 The SAM was founded in 1825. It was originally a general museum including natural history and cultural history, but since 1964 it has covered only natural history and anthropology. 'Bushman, Whale and Dinosaur', is the title of a book on the work of James Drury who was responsible for casting and modelling at the SAM from 1902–42, accurately sums up popular perceptions of the SAM.

2 'Miscast' was presented at the SANG in association with the SAM and the University of Cape Town, from April to September 1996.

3 In July 1996 a workshop on the proposed slave route posed the telling question to the heritage sector, 'What's in it for you?' The control of such projects and who stands to benefit are contested issues.

4 In mid-1996 new councils of trustees for national museums were appointed by the ministry, and the Arts, Culture and Heritage White Paper emphasized redressing past inequities. As Dickson (1991) notes for museum practice in the USA, a convergence of concerns – ethical, political, financial, and social – motivates strategies for bringing the margins into the mainstream.

5 The Bo-Kaap Museum and the Islamic holdings of the SACHM anomalously became part of a white Own Affairs institution.

6 Papers from the controversial 1987 SAMA Conference were published in the *Southern African Museums Association Bulletin* (1987, vol. 17). Papers by Stuckenburg, and Wright and Mazel reflect the critical edge of the meeting. The late John Kinard, director of the Anacostia Museum in Washington, DC, caused a walkout when he urged the profession to confront racial prejudice. In the past five years, many defenders of the status quo have seemingly changed, chameleon like, in line with the shifting balance of power.

7 Thulamela is situated in the northern section of the Kruger Park; archaeologically it relates to the Zimbabwe culture within the southern African Iron Age. It was opened on Heritage Day in 1996 by the Minister for the Environment and Tourism.

8 The Wits History Workshop, 'Myths, Monuments and Museums: New Premises' conference at the University of Witwatersrand, July 1992, exemplifies this trend.
9 The new National Museum of the American Indian in New York City has pioneered this approach, and also revealed the difficulties inherent in post-modern museum practice. See Arieff (1995).
10 Responsibility for Robben Island has been transferred from the Department of Correctional Services to the Department of Arts, Culture, Science and Technology.
11 At the forum held on 7 September 1996, the director of the SANG publicly apologized to individuals and groups who were hurt and angered by 'Miscast'.
12 Alex La Guma, born in 1925, was son of Jimmy La Guma, president of the Coloured People's Congress. As well as being a journalist and novelist, he was a political activist and Communist ideologue. He was accused of treason and banned in South Africa. He died in exile in Cuba. I am grateful to Tony Voss for drawing my attention to this reference.

Bibliography

Arieff, A. (1995) 'A different sort of (p)reservation: some thoughts on the National Museum of the American Indian', *Museum Anthropology*, 19(2).

Bodnar, J. (1991) 'Material culture, context and meaning. a critical investigation of museum practice, with particular reference to the South African Museum', PhD thesis, University of Cape Town.

——— (1993) 'Human subjects as museum objects: a project to make life-casts of "Bushmen" and "Hottentots", 1907–1924'. *Annals of the South African Museum*, 102(5).

Deacon, J. (1993) 'Archaeological sites as national monuments in South Africa: a review of sites declared since 1936', *South African Historical Journal*, 29.

Dickerson, A. (1991) 'Redressing the balance', *Museums Journal*, 91(2).

Hamilton, C. (1994) 'Against the museum as chameleon', *South African Historical Journal*, 31.

Hudson, K. and Nicholls, A. (1975) *The Directory of Museums*, London: Macmillan.

Karp, L. and Lavine, S. (eds) (1991) *Exhibiting Cultures: The Poetics and Politics of Museum Display*, Washington: Smithsonian Institution Press.

Klopper, S. (1996) 'Whose heritage? The politics of cultural ownership in contemporary South Africa', *NKA Journal of Contemporary African Art*, Fall/Winter.

Krafchik, B. (1994) 'Adventurous changes', *Museums Journal*, 94(4).

Küsel, U. (1994) 'No building, no problem', *Museums Journal*, 94(4).

Lane, P. (1996) 'Breaking the mould? Exhibiting Khoisan in Southern African Museums', *Anthropology Today*, 12(5).

Lowenthal, D. (1985) *The Past is a Foreign Country*, Cambridge: Cambridge University Press.

Martin, M. (1996) 'Bringing the past into the present – facing and negotiating history; memory, redress and reconciliation at the South African National Gallery', paper delivered at the Faultlines Conference, UCT Business School, 4–5 July.

Odendaal, A. (1994) 'Let it return!' *Museums Journal*, 94(4).

Steiner, C. (1995) 'Museums and the politics of nationalism', *Museum Anthropology*, 19(2).

Voss, A. (1990) 'Die Bishie is dood: long live the Bushie', *African Studies*, 49(1).

Webb, D. (1994) 'Winds of change', *Museums Journal*, 94(4).

15

Tolerance, trust and the meaning of 'sensation'

Robert R. Macdonald

Heritage sites, museums and galleries are increasingly being viewed as sites for dialogue and exchange. As a result, the last decade or so has witnessed a growing number of exhibitions that have been designed to be provocative and to challenge people's perceptions and accepted ways of engagement. Among these are the exhibitions that have been developed to allow previously unheard voices to be included in the representations and in the interpretations offered for public consumption. Some have used new frameworks, approaches and devices to encourage people to look at, and interpret, material differently. Others have included material deemed to be sensitive. A number of these have stimulated controversy and heated reactions in the public arena – even when they have been curated with sensitivity, responsibility and with a certain amount of consultation. Can, or should, cultural heritage sites and institutions try to avoid controversy?

This chapter charts the controversy and political and cultural contestation surrounding the 'Sensation: Young British Artists from the Saatchi Collection' exhibition, shown in the Brooklyn Museum of Art from 2 October 1999 to 9 January 2000. It is interesting to note the different controversies that surrounded this same exhibition when it was on show at the Royal Academy in London between 18 September and 28 December 1997.

In mid-September, a few weeks before 'Sensation: Young British Artists from the Saatchi Collection' opened at the Brooklyn Museum of Art (BMA), I confidently told a French museum colleague that one of the distinctive qualities of New York City's generous support of the arts was that the almost $80-million annual subsidy came without strings. I described the traditional laissez-faire attitude of the city's officials toward the exhibits and programs of city-funded cultural institutions. So much for tradition! As we now painfully know, New York City was about to experience one of the most emotional cultural controversies in its history. Not since the Astor Place Riot of 1859, when the militia shot and killed 22 mostly young immigrants protesting the performance of a British Shakespearean actor, had New York City seen such an impassioned response to a cultural event.

(Robert R. Macdonald is director, Museum of the City of New York)

'Sensation' closed on 9 January 2000, after a successful three-month run attracting nearly 180,000 visitors. The legal aspects of the controversy were settled in late March when the museum and city dropped their respective lawsuits. However, the extra-legal issues raised by 'Sensation' continue to pose fundamental questions for America's museums.

As New Yorkers rushed to the barricades over issues of artistic freedom and public responsibility raised by Mayor Rudolph Giuliani's plan to withdraw city funding to BMA unless it

canceled the 'Sensation' exhibition, it was clear that Chris Ofili's painting. *The Holy Virgin Mary,* had ignited the controversy. The painting presents a black Madonna, one of whose breasts was fashioned by the artist from elephant dung. Mimicking a halo surrounding the figure are what from a distance look like butterflies. A closer inspection reveals that they are photographs of female genitalia snipped from pornographic magazines. While some observers have praised the painting as an important work of art, most view Ofili's *The Holy Virgin Mary* as undistinguished. One critic noted that if the painting had been titled *My Friend Mildred,* it would have gone largely unnoticed.

By giving the painting the title of an icon sacred to Christians, and particularly to Roman Catholics, Ofili was sure to create a sensation, particularly in a city that had witnessed almost two centuries of struggle by Roman Catholics to overcome anti-Catholic bigotry. Rudolph Giuliani, raised in an Italian-American Catholic family and a product of Catholic schools, was understandably offended by what he perceived to be a profane presentation in a city-supported ($7 million a year) museum. He was not alone. John Cardinal O'Connor, the leader of the 2.3-million-member Catholic Archdiocese of New York expressed his sadness at what he and many others, Catholic and non-Catholic, consider blasphemous. Attempts at compromise between the BMA and the mayor were quickly dashed as the traditional hardball New York politics swung into action.

On one side of the widening gulf were the Brooklyn Museum of Art, its director and trustees, and a majority of the city's cultural community. To these protagonists the issue was defending First Amendment rights against a mayor and his representatives who were perceived as bullies. On the other side were the mayor, Cardinal O'Connor, a variety of Orthodox Jewish organizations, the *New York Post,* and the Catholic League, a group comparable to the Anti-Defamation League.

As in previous battles of the 'culture wars', an air of religious intolerance prevailed and the demons of prejudice lying just beneath the surface of civil society soon awakened. Some of the exhibition's opponents tried to fire up anti-Semitism by claiming that the exhibition's major advocates were Jewish. Some of the exhibition's defenders depicted their antagonists as philistines and racists whose real objection was that Ofili's Madonna was black. In a hurried and sometimes derisory defense, BMA justified the presentation of the painting by noting that the artist himself was Catholic and claimed that the painting's dung accoutrement was an African symbol of renewal. Surprisingly and somewhat comically, both sides promoted vomit as a common metaphor to characterize the exhibition. The Brooklyn Museum of Art advertised and sold posters declaring, 'The contents of this exhibition may cause shock, vomiting, confusion, panic, euphoria, and anxiety. If you suffer from high blood pressure, a nervous disorder, or palpitations, you should consult your doctor before viewing the exhibition.' On opening day, members of the Catholic League gathered in front of the museum to distribute 'vomit bags' to express their disgust. Celebrities from the literary and artistic world mounted their soapboxes, from where they blasted the mayor and others for opposing what they viewed as an important artistic moment in the city's history. It was a moment captured in the following headline in the *New York Times:* 'Seeking a buzz, museum chief hears a roar instead'.

Arnold Lehman's arrival as director of the Brooklyn Museum of Art in 1997 after a distinguished eighteen-year tenure at the Baltimore Museum of Art was a breath of fresh air. Facing the daunting task of increasing the audience for what is universally considered a world-class but attendance-challenged institution, Lehman secured new and popular exhibitions such as 'Impressionists in Winter' and 'Monet and the Mediterranean'. To attract younger audience, he initiated 'First Saturdays' as free monthly events that include refreshments and dancing. The

'Sensation' exhibition was to be the next major project in the director's campaign to raise BMA's profile and increase attendance.

Lehman made the judgment that the works in 'Sensation', all of which are owned by Charles Saatchi, the advertising mogul and wealthy British collector, were worthy of BMA's galleries. The exhibition had previously attracted large crowds at London's Royal Academy, which was one of the reasons Lehman cited for wanting the show in Brooklyn. In court depositions, the director later admitted that he had not seen the exhibition in London before deciding to bring it to Brooklyn. The ownership of the works, the exhibition's underwriters, and the actions and motives of the director soon joined freedom of speech on the controversy's center stage.

One of the more instructive sidebars to the imbroglio was the response of the city's cultural community, specifically institutions funded through the city's Department of Cultural Affairs, collectively known as the Cultural Institutions Group or CIG. The CIG is composed of 33 institutions that include the Metropolitan Museum of Art, the American Museum of Natural History, the Museum of the City of New York, and the Brooklyn Museum of Art. These private institutions occupy city-owned property and receive the bulk of the city's appropriations for culture in the form of annual warrants ranging from several hundred thousand dollars to more than $15 million. A volunteer from one of the member institutions annually chairs the loosely organized CIG. In 1999, that task fell to Alan J. Friedman, director of the New York Hall of Science. When the 'Sensation' crisis escalated with the mayor's threat to end BMA's city subsidy, it became Friedman's job to craft a response agreeable to the CIG members.

Later, Friedman described his efforts to mount a CIG defense of BMA as comparable to 'herding cats'. Through a series of e-mails, later released to the *New York Times,* and faxes, a letter praising the mayor for his support of the arts and criticizing him for his stand on the 'Sensation' exhibition was signed by the majority of the CIG members and several non-city funded institutions. Notably absent from both the CIG's internal discussion and the final letter was a considerate grasp of what had detonated the controversy: a public official's reaction to perceived religious bigotry. The inability of New York's cultural institutions to recognize and appreciate this element in the controversy is possibly one of the more important lessons for the American museum community.

Several signatories of the letter later claimed that the subject of the Ofili painting had not influenced their decision and that they would have signed the letter of protest to the mayor even if the icon in question had been Jewish or Muslim. Those who know New York City ethnic, racial, and religious politics find this assertion implausible. Hilton Kramer, the noted critic and editor of the *New Criterion,* and others proffered that the 'Sensation' *controversy* supported their view that anti-Catholicism had become the accepted prejudice of the contemporary intelligentsia and cultural élite.

Blindness to questions of religious bias raised by the 'Sensation' controversy reveals a tendency among some cultural advocates to become myopic in their defense of First Amendment rights. Lost in this advocacy is the equally important civic and constitutional principle that actually takes precedence over the freedom of expression. That principle, also found in the First Amendment, is the ideal of religious pluralism. This civic value has been severely tested during our national history as Know-Nothings mobs have torched Catholic convents, anti-Semites have sprayed swastikas on temples, and Hollywood has depicted Muslims as bomb-throwing terrorists. Despite these lapses, America and particularly New York City have thrived on religious diversity. One secret to America's success as a nation and New York's as a city has been their citizens' practical habit of respecting one another's beliefs, lifestyles, and values. Unlike some other parts of the world, America's citizens do not normally kill each other because

of their religious differences. Nor do they make a habit of trashing symbols with ethnic, cultural, and religious meaning. When they do and are caught, they usually go to jail. When the alleged offender of this social convention is a publicly supported museum, we can expect a spirited official response and heated public debate.

People of good will can disagree with the allegation that Chris Ofili's *The Holy Virgin Mary* is sacrilegious. One can also debate the quality of the painting, the tactics of Mayor Giuliani, the motives of the Brooklyn Museum of Art, and the role of Charles Saatchi and some of the exhibition's financial supporters. But most concerned observers would agree that something important has occurred with this particular flare-up in the 'culture wars' that requires attention by the museum community.

It seems a safe assumption that one outcome of 'Sensation' has been a decline in the public's trust in museums. Alan Friedman and three other signers of the letter to the mayor defended the Brooklyn Museum of Art against allegations in *the New York Times* of unethical behavior. In a letter to the *Times,* Friedman suggested that BMA's methods in organizing, funding, and promoting the exhibition are common and accepted practices in the museum world. That this view is not widely shared is evident in the moves by the Association of Art Museum Directors and the American Association of Museums to form special committees to address questions raised by BMA's conduct.

It is an American museum axiom that museums have the right and responsibility to exhibit materials that advance an institution's mission even if the exhibited material is considered by some to be offensive. The museum community also takes pride in its tradition of abhorring bigotry of any stripe, intended or not. In the case of 'Sensation', many museum professionals are uncomfortable with the heightened commercialism and gratuitous theatrics that accompanied the Brooklyn Museum of Art's organization and marketing of the exhibition, as well as with Mayor Giuliani's heavy-handed response. They are also uneasy with the role played by Charles Saatchi and the exhibition's sponsors and the techniques the museum used in an apparent frantic effort to attract financial underwriting. Many museum leaders find themselves torn between a desire to defend the principles of intellectual and artistic autonomy and an equally steadfast commitment to professional ethics and religious tolerance. Answers to questions of professional ethics can be found in the traditional role of museums as public trusts in service to society, rather than commercial establishments promoting the interests of individuals. In searching for answers to the balance between free speech and religious tolerance, we might revisit the First Amendment for guidance.

The founders of American democracy were wise in believing that government should not be involved in questions of religion. They felt so strongly about the separation of church and state that they made the first provision of the First Amendment of the Bill of Rights the following: 'Congress shall make no law respecting an establishment of religions, or prohibiting the free exercise thereof'. To the framers of our form of government, this prohibition was more important than the protection against the government abridging freedom of speech, the second provision of the First Amendment. History taught them that the mixture of government and religion was toxic. Inherent in this principle is the prohibition of the use of public funds to support activities that can be seen as anti-religious.

The Brooklyn Museum of Art would deny that the presentation of *The Holy Virgin Mary* was anti-religious. Others would argue that, even if Ofili's painting was anti-Catholic, publicly supported libraries are filled with works that could be considered intolerant. But exhibiting on the walls of a respected museum a painting considered by many as blasphemous is quite different from placing books on library shelves. It is the particular power of museums that their

exhibitions are spectacles, large and small. If museums do their jobs well, audiences will respond to exhibitions visually first, then intellectually and emotionally. It doesn't take a Ph.D. or years of connoisseurship to comprehend how Ofili's work affected many who saw it. Some viewed it as a creative and challenging work of art. Others judged it as a gratuitous sacrilege. Whether art or sacrilege, the failure of the Brooklyn Museum of Art and its supporters to anticipate and appreciate the negative responses to *The Holy Virgin Mary* in a community that takes pride in and relies on tolerance was an error in judgment the consequences of which have yet to be played out.

It is too soon for museums to comprehend all the lessons of the sensation caused by 'Sensation'. But one conclusion is that the appearance of unethical activity and of what some view as an arrogant disregard for the values of their audiences ill serves museums. When they stand their ground, museums need to be confident that they are standing on ethical foundations. It is also essential that museums recognize and appreciate the diverse religious traditions of their audiences. It seems obvious, too, that cultural institutions would do well to realize that when they take the public's money they assume an obligation to be responsive to the public officials who manage this resource. To be unresponsive to the taxpayer's elected representatives implies a cultural autocracy that will not long survive in a democracy. After 225 years of experience, Americans have learned that they can exist with less than total artistic and intellectual freedom, particularly when the issues involve tax-supported institutions and programs. But how long can America's cultural institutions endure without public trust grounded in professional ethics, sensitivity, and tolerance? If it has taught us nothing else, the 'Sensation' exhibition has reminded us that public confidence in the ethical and responsive management of our institutions is an asset easily lost and difficult to recover.

Museums, galleries and heritage
Sites of meaning-making and communication

Rhiannon Mason

It is important for heritage, museums and gallery professionals to be aware of the complexities of communication and interpretation processes. No longer can these processes be viewed in terms of simple and linear transmission models, where fixed messages are produced by an author and transferred to a passive audience. In relation to heritage, museums and galleries, visitors need to be seen as users and consumers who are actively involved in these processes.

This chapter provides a very good overview of how developments in communication and interpretation theories are impacting on how meaning-making is viewed in museums, galleries and at heritage sites. Outlining semiotic and constructivist theories, the chapter goes on to discuss how heritage practitioners and visitors are engaged in the processes of the production and consumption of meaning. It takes into account practical issues of communication encountered by practitioners. These include the interpretive agency of the physical places and spaces where heritage is produced and represented, along with the differing communication styles, strategies, techniques and heritage resources used, and how these can result in the communication of unintended, as well as intended 'messages'. It explores how visitors, as active participants, draw on their own experiences and on the particular contexts that inform their visits. Although there is the potential for each visitor to construct personal and individual meanings, the chapter also engages with notions of shared 'conceptual maps' and 'interpretative communities' to show the possibilities for shaping collective meanings and readings in heritage. The complexities of the processes of consumption are also considered in terms of the concepts of 'selective readings', 'cultural politics' and 'cultural capital'.

Introduction

Every aspect of a museum, gallery, or heritage site communicates. From the architectural style of the building or layout of a site, to the attendants at the entrance, the arrangement of the exhibits or artefacts, the colour of walls, and the positioning and content of labels and text panels; all these things and more are engaged in a communicative process with the visitor. Yet, what is being communicated will depend on many factors; some of this communication will be implicit, some explicit, some intended, some unintended. At the same time, visitors will participate in and contribute to this meaning-making process in many different ways.

In recognition of the complex nature of the communication process, museum studies theorists have developed some conceptual frameworks for its analysis. Less attention has been paid to communication theory within heritage or gallery contexts, although Freeman Tilden (1957) provides a useful introduction to heritage interpretation. However, this chapter will show that the general principles of communication theory can be equally applied to all three fields.

Communication theory and museum studies

In heritage studies 'interpretation' has often been discussed as something that should be done 'for' or 'to' visitors, whereas communication theory developed within museum studies has taken quite a different approach. An introduction to communication theory and its relationship to museums can be found in Eilean Hooper-Greenhill's book, *The Educational Role of the Museum* (1994, 1999). This provides an overview of the development of communication theory and explains how theories and models originally devised for the study of mass communication – radio, television and cinema – have been adapted for museums.

The various models provide an extremely useful entrée into the topic of communication theory, but focus predominantly on museums, permanent displays and material culture at the expense of other historical resources such as oral histories, and intangible heritage. At the same time, some of the models over-simplify the number of variables at work in the communication process. In particular, they do not focus adequately on the importance of the contexts within which acts of communication occur, nor on the diversity of possible audience interactions with museums, galleries and heritage sites. Some also predate many of the critiques of authorship, subjectivity and meaning construction presented by recent thinking in the field of critical and cultural theory, as well as issues of power and cultural politics explored in cultural studies (Milner and Browitt, 2002; Turner, 2003; Jordan and Weedon, 1995). This chapter aims to bring together these different issues and ideas for students of communication theory, and to consider some of the challenges encountered by those wishing to work within museums, galleries and heritage sites.

The passive/active audience paradigm

Irrespective of their differences, the early models have one thing in common. They tend to focus on the process of communication from the point of view of the transmitter (in this case the curator or heritage professional) who sends a one-way message to the recipient who is supposed to receive it. This 'transmission model' – also described as the 'magic bullet or hypodermic needle theory' – sees audiences as supposedly injected with a 'message', which exists complete and external to them (Hooper-Greenhill, 1994:13). This approach puts control of the communication process firmly with the sender and envisages the recipient as an empty vessel waiting to be filled with information or knowledge.

As Hooper-Greenhill notes, as far back as the 1950s there was already a shift in media and communication theory away from understanding audiences as passive receivers of information, and towards seeing them as active participants in the meaning-making process (1994:14). This shift recognized that audiences are much more diverse, selective and therefore active in their responses to all sorts of media. The implications of this thinking were slower to impact upon museums, galleries and heritage studies. However, in recent years there has been increasing acknowledgement in museum theory and practice generally that audiences are anything but blank slates (Karp and Lavine, 1991; Falk and Dierking, 1992, 2000). In line with this shift, Hooper-Greenhill proposed a new 'transactional' communication model for museums which saw both curators and visitors as actively making and exchanging meanings through the medium of the museum (1994:25). Another shift has been to replace the earlier notion of communication as one way and linear with an understanding of the process as more complex, multi-directional and untidy (Hooper-Greenhill, 1999:39–40).

In light of the above reconceptualizations, museums, galleries and heritage sites are now understood to be not so much places of instruction and dissemination, but spaces which facilitate communication, discussion, exchange and interaction (Karp and Lavine, 1991). James Clifford has captured this idea in his description of museums as 'contact zones' (Clifford, 1997). Tony Bennett has similarly described this shift from a 'monologic' museum of modernity to the 'dialogic' museum of postmodernity (Bennett, 1995:103–104). This more participatory approach to museum work is apparent in the way that many cultural organizations, particularly in postcolonial contexts, are endeavouring to engage more with the wishes, values and interests of the aboriginal or indigenous peoples they represent. This is carried out through consultation processes, focus groups, collaboration with communities groups, and visitor evaluation (Peers and Brown, 2003). The inclusion of different perspectives within the exhibition process manifests itself in the increasing use of polyvocality (many voices) within interpretation and labelling. For example, the Denver Art Museum's display of Native American art not only addresses differences between Native American and western European conceptions of 'art', but also contrasts the words of anthropologists, artists and curators with those of various Native American individuals and community members.

Constructivism and semiotics

The move towards rethinking both the role of cultural sector professionals and the nature of visiting, mirrors similar moves in literary criticism, reader-reception theory, media and cultural studies, and hermeneutics. In these fields, attention has turned towards recognizing the active role of the reader or the viewer, and rethinking the role of the 'producer or author'. Educational theory has similarly stressed the active nature of learning and the 'facilitating' or 'enabling role' of teachers (Hooper-Greenhill, 1999). This cross-disciplinary rethinking of the process of meaning-making is due in large part to the influential ideas of constructivism and semiotics which have become mainstream in academic thinking (Hall, 1997). Constructivism is defined by Stuart Hall as an approach which:

> recognises [the] public, social character of language. It acknowledges that neither things in themselves nor the individual users of language can fix meaning in language. Things don't *mean*: we *construct* meaning, using representational systems – concepts and signs.
>
> (Hall, 1997:25)

The semiotic approach, on which constructivism draws, was initially developed in relation to linguistics by Ferdinand de Saussure. Saussure, a Swiss linguist (1857–1913), defined semiotics as 'the science of signs' and set out to understand how communication works (Saussure, 1960). Saussure's ideas, and the subsequent reworking and revision of them by structuralists, poststructuralists, and those interested in deconstruction, are too extensive to discuss here (Weedon, 1987; Hall, 1997; Barker, 2000; Milner and Browitt, 2002). However, it can be said that in recent years the ideas of semiotics and Saussure have been extended far beyond linguistics. Those theories which take Saussure's ideas as their starting point now aim to explain how societies organize themselves, and how communication in the broadest sense is inextricably linked to the creation and operation of value systems that have real effects on the way people live.

Broadly speaking, a post-Saussurean – or semiotic – approach proposes that meaning is not inherent in words, gestures or sounds: *signifiers* to use Saussure's original term. Instead,

meaning is understood to arise from the relationships between signifiers and through their *difference* from each other. In this way, meaning is understood to be a social construct which is acquired as individuals learn language and become schooled in the ways of their respective cultures. The implication of post-Saussurean theory is that meaning is not absolute or fixed, but contingent and variable – that is to say it will change according to different contexts, whether historical, geographical or cultural.

It is important to recognize that for poststructuralists the material – or real – world does not cease to exist but will always be mediated by the signifying system we inhabit. Neither does this argument propose that individuals can simply make things up to suit themselves, because a communication system has to be agreed upon and shared with others for it to work. In the same way, poststructuralist-inspired museologists do not see objects, sites and other historical resources as rendered meaningless, nor do they propose that individuals can simply invent meanings for historical material as they please. The value and meaning of objects, images and sites are both inseparable from the context of their display or interpretation and only intelligible because they are shared and recognized by others in society (Lidchi, 1997).

However, the nature of those 'others' will have a significant impact on the range of meanings recognized and accepted. For example, depending on your point of view, an African mask could be viewed as an ethnographic exhibit, a tribal artefact, a piece of art, evidence of colonial looting, the subject of a repatriation case, or simply a commodity to sell. In each case it is still the same mask, but the understanding and endorsement of a particular interpretation will depend on the location, the mode of display, the choice of interpretation, the legal and ethical ownership (the two are not necessarily the same), who is looking at it, and who has the authority to define and interpret it.

So far, it has been argued that meaning is not fixed within objects, images, historical resources, or cultural sites, but is produced out of the combination of the object/the image/the site itself, the mode of presentation, what is known about its history and production, and visitor interaction. Let us now explore further the *production* side of the process and the way that meanings are constructed within a display, exhibition space or site itself. The communication process will happen here in two ways – intentionally and unintentionally.[1]

Museum, gallery and heritage professionals: producers and consumers of meaning

If we take the issues of intended communication, we can say that the construction of meanings and messages begins with the museum, gallery or heritage professional having an idea for an exhibition, selecting the objects/images/forms of heritage or site to be used, choosing the display methods and the interpretation – the identification of the title, key themes etc. – and then working with others to produce the labelling, text panels, audio guides, publicity, educational programmes, private view cards, marketing, and opening event. In a built heritage context where some of those decisions have, by implication, already been made, the choices might be different, but will still involve issues of presentation, promotion and interpretation. The ways in which the various components are selected and combined will provide different results in terms of what a site or an exhibition will communicate to its visitor (Silverstone, 1989; Bal, 1996; Ferguson, 1996; Greenberg *et al.*, 1996; Lidchi, 1997; Macdonald and Silverstone, 1999).

At this point, it is useful to turn to material on exhibition/site design (Belcher, 1991; Dean, 1996). This has demonstrated, for example, how awareness of the way people will move around a

physical space or the amount of text they can be expected to digest, can be used to draw visitor attention to specific intended messages. Alternatively, in an open-air heritage site, it may be desirable to route visitors a particular way, in order to emphasize a certain idea or to withhold a significant sight until the optimum moment. Conversely, exhibitions can be deliberately multi-routed or random to eschew a single prescribed route. Another issue is that of pacing: high-profile, controversial, or potentially sensitive exhibits need to be positioned carefully in terms of visibility and timing within the overall narrative of an exhibition or site. Sam Ham has argued that the design process should also consider the number of different concepts people are capable of holding and processing at any one time (Ham, 1999).[2] In this respect, exhibits or aspects of a site should be considered not only in terms of what they signify in relation to each other, but what they communicate as an overall experience.

Technologies of communication

In addition to these processes of selection, museum, gallery and heritage professionals will draw upon particular styles and strategies of display in order to put their messages or ideas across. These have been categorized into various exhibition typologies – for example, the aesthetic, the narrative, the emotive, the didactic, the celebratory, the socio-historical, the postmodern and the ironic to name but a few (Kavanagh, 1990:127–39; Hutcheo, 1994).[3] By means of such techniques, museum, gallery and heritage professionals seek to guide visitors towards certain ideas, areas or objects, and thus prioritize the points or narratives they wish to communicate. These issues of design and presentation are intentional communicative acts, but alongside these will be unintended communication. Unintended communication can be understood in two ways. A simple example would be the way that unintended meanings arise from the architecture of the space or its location – circumstances beyond the professional's control. If, for example, a museum has an imposing Victorian façade originally designed to be impressive and awe-inspiring, this will invariably emit a series of signals about the nature of museums. These may well compete with the other messages intended by museum, gallery and heritage professionals.

The very nature of a particular collection or site will also communicate messages about what has been considered important and of value in the past. A heritage example would be those historic houses which in the past tended to focus on the life of the élite residents at the expense of those working classes who managed the great estates. In such instances, it was easier and seem-ingly more obvious to focus on the histories of the masters and the élite, because the property and collections had always been thought of in relation to them and their status as owners. The emphasis of interpretation in some historic houses has changed in recent years because of a burgeoning interest in non-élite, vernacular history since the 1980s (Samuel, 1994). More recently, there has been a growing recognition of the links between historic houses and the lega-cies of empire and the profits of slavery (see for example Harewood House in England; Heywood, 2003). In some cases, this shift of emphasis has required creative thinking and new research – for example, the use of alternative historical resources such as oral history – if the material culture and evidence has not been recorded or preserved.

At the same time, research into the ideological messages present within museums, galleries and heritage sites suggests that professionals who work in them can equally construct messages without intentionally planning to do so (Haraway, 1989; Hutcheon, 1994; Duncan, 1995). An example of this can be found in Helen Coxall's (1996) work on labels in museums. Coxall has analysed the language used in order to explore assumptions contained within particular terms

and grammatical constructions. Elsewhere, Annie Coombes has demonstrated how Victorian ideas about race and the supposed 'primitive nature' of African cultures influenced the way that African artefacts were collected and then interpreted by British museums in the nineteenth century (Coombes, 1994). More recently, Sharon Macdonald's work on the Science Museum, London, demonstrates how the exhibition process takes on a life of its own and can produce results not originally anticipated by curators (Macdonald, 2002).

These examples illuminate the theoretical concepts of discourse and ideology, and the extent to which both individuals and institutions – as products of a given society – will inevitably participate in the values and beliefs circulating within that society. The term 'discourse' refers to French philosopher Michel Foucault's extremely influential proposition, that in every historical moment there will be certain ways of speaking and thinking about topics which rule in certain possibilities while ruling others out (Foucault, 1973, 1990, 1991). The operation of discourse is always linked to systems of power within society, which means that certain groups are able to define and legitimate certain ways of thinking and behaving as 'normal' and 'natural' or alternatively as 'deviant' and 'unnatural'.

In recent years, ideas of discourse, ideology and power have combined with those originating in psychoanalysis and literary theory to focus on the unconscious and to question the nature of individual action – or 'agency' (Barker, 2000). This is not to suggest that individuals should be viewed as powerless puppets who lack all personal autonomy. Individuals will challenge certain beliefs and change values at the same time as they reproduce and endorse others – if they did not, there would never be any change in values and beliefs. Moreover, at any given moment there will be competing discourses and ideologies in operation which may well contradict each other. Coombes' study of the arguments put forward by various Victorian British museum curators about the relative 'primitivism' or, conversely, the 'sophistication' of African artisans demonstrates precisely this kind of discursive conflict (Coombes, 1994).

The key point is that just as visitors draw on their pre-existing knowledge to understand what they see in museums, galleries and heritage sites, so too will museum, gallery and heritage professionals inevitably draw on, and be informed by, the various discourses circulating within society when they produce displays, or interpretation. Wherever possible, professionals should strive to recognize this and critically examine the paradigms and discourses within which they work.

Audiences: consumers and producers of meaning

So far, we have looked at how museum, gallery and heritage professionals communicate – both intentionally and unintentionally – with visitors. It has also been suggested that meanings of objects, images or sites will depend on what visitors bring to them and that this will change according to the personal knowledge and individual experiences of those visitors. The latter part makes up what we might call the visitor's own context. John Falk and Lynne Dierking (1992, 2000) have suggested that visitor 'context' should be sub-divided into the *personal* (what the visitor brings to the experience in terms of prior experience, learning style, interests, motivations etc.), the *sociocultural* (the social, cultural and historical conditions of their visit) and the *physical* (how they interact with space and physical aspects of the museum). For Falk and Dierking, all three spheres overlap, interrelate and are modified as the memory of the visit is revised over time.

From this perspective, the range of possible meanings gained by visitors to museums, galleries and heritage sites appears to be potentially infinite. Research by Fiona McLean and

Steve Cooke (2000, 2002) on the Museum of Scotland shows just how much diversity can exist in visitors' responses to representations of national identity. When asked what they thought the Museum 'was "saying about Scotland" or whether they thought that it presented any particular image of Scotland', McLean and Cooke found that among *Scottish* visitors 'there was no clear agreement on what that image was' (2002:114) [my emphasis].

At the same time, surveying does indicate a degree of consensus and patterning between visitor interpretations; people will often respond similarly to particular artefacts or derive broadly similar meanings from overall exhibitions. McLean and Cooke also showed that visitor perceptions of the Museum of Scotland were clearly affected by whether those visitors identified themselves as Scots, or not. They reported that: '[a]lthough the "producers" of the Museum have distanced themselves from any suggestion that the Museum was attempting to define Scotland or had nationalistic overtones, it is apparent that many of the *non-Scots* whom we interviewed did view the Museum in this way' (2002:115) [my emphasis].

Another example of shared responses can be found in some of the most recent controversial exhibitions. Take, for example, the frequently cited *Into the Heart of Africa* exhibition held at the Royal Ontario Museum, Canada, between 1989 and 1990 (Riegel, 1996; Hutcheon, 1994). This exhibition received negative responses from some visitors, who read the exhibition as racist and colonialist. On the other hand, the curator of this exhibition, anthropologist and Africa specialist Jeanne Cannizzo, stressed that she had intended this exhibition to actively critique colonialist and racist attitudes of the past *not* to reproduce them (Riegel, 1996:91).

These examples present two puzzles. First, how can we say that the range of possible meanings will vary according to each individual and their own personal, social and physical context of their visit and yet also recognize that people's readings of exhibitions are often shared within certain groups? Second, how is it that a visitor can 'misread' a curator's intentions so dramatically? We have already considered some answers to this question both specifically from the point of view of the producer and more broadly in terms of how meanings are constructed within the production process. It is now time to consider the same question in terms of the *consumption* end of the communication process and from the point of view of the visitor.

Hall argues that any communication process necessarily relies on individuals sharing 'conceptual maps' of the world (1997:18). These maps will overlap or fit more closely between members of a similar culture, group, or perhaps those who have shared similar experiences. At the same time, because people's identity is not static (they may move away or adopt a different lifestyle or set of values from their peers etc.), the extent of overlap and affiliation can change through a person's life (Woodward, 1997).

On similar lines, Stanley Fish (1980) has argued that individuals belong to 'interpretative communities' and share 'interpretative strategies'. Fish originally developed his theory of interpretative communities in relation to literary criticism and literary analysis. However, the concept can, and has, been applied to museum, gallery and heritage studies (RCMG, 2001). Although the concept of community does need to be approached critically and cautiously (cf. Witcomb, 2003:79), the concept of interpretative communities could be extended as follows:

1 **Communities defined by shared historical or cultural experiences** For example, a 1998 report into ethnic minority visitors to UK museums found shared frustration at what was perceived to be a colonialist portrayal of history (Desai and Thomas, 1998). See also Appadurai and Breckenridge (1999) on culturally specific ways of viewing and responding to heritage in India and Thomas (2001:307) on ways of looking at Maori *taonga* or 'treasures'.

2 **Communities defined by their specialist knowledge** Visitors who share an advanced or specialist field of knowledge will invariably utilize this knowledge to make sense of what they see and thus will be able to deploy a greater range of interpretative strategies (Bourdieu, 1993; RCMG, 2001; also Newman in this volume).

3 **Communities defined by demographic/socio-economic factors** Demographic categories are the most common way in which audiences have been analysed in the past. It has been well documented that museum, heritage, and in particular, art gallery visitors are more likely to come from the more affluent and highly educated sections of society (MORI, 2002). However, it must be remembered that statistical analyses vary between sets of research and generalizations mask regional differences and variations between different institutions (Hooper-Greenhill, 1997:2).

4 **Communities defined by identities (national, regional, local, or relating to sexuality, disability, age and gender)** For example, those of an older generation looking at an exhibition about the Second World War will draw on different sets of knowledge from their grandchildren, while geographical identification may influence interpretation (McLean and Cooke, 2002); gender difference can be another factor influencing visitor behaviour (Blinde and McCallister, 2003).

5 **Communities defined by their visiting practices** As above, Falk and Dierking (1992, 2000) show how visiting practices and social context shapes visitor experiences.

6 **Communities defined by their exclusion from other communities** Work on social exclusion by Newman and McLean (1998), Newman (2002), Sandell (2002) and Dodd *et al.* (2002) shows how certain sections of society experience exclusion from museums, galleries and heritage sites.

As this list suggests, the concepts of interpretative communities, and shared conceptual maps, are useful in allowing us to differentiate between various responses. At the same time, it is also important to note that recent theory has emphasized the multiple, fluid, hybridized and contradictory nature of postmodern identities (Hall, 1992; Woodward, 1997). Individuals may therefore be members of more than one of these communities or groups simultaneously. The ways in which individuals will respond will depend upon which affiliation is called to the fore at a given moment. A simple analogy is the way that supporters of a local football team will happily switch their support to a national cause in the context of an international competition.

Selective readings

Hall and Fish provide one way of thinking about patterns in visitor responses. Another possibility is to investigate the idea of selective reading. During the 1980s, Hall argued that in one particular study, television viewers could be seen to respond to the intended message of a current affairs programme by producing what he termed either a 'preferred', 'negotiated' or 'oppositional' reading (Hall, 1980:136–8). Hall argued that any signifying practice will foreground or privilege certain meanings above others and these will be presented as the most appropriate or logical set of meanings – the 'preferred reading'. 'Negotiated' readings accept the preferred reading in part, while selectively rejecting elements of it, whereas 'oppositional' readings recognize the preferred reading but reject it entirely.

In a museum, gallery and heritage context, this process of suggesting a preferred reading can be seen in the way that the authoritative voice of the institution – in the form of panels, labels

and guides etc. – offers visitors a particular way of interpreting what they see. In the case of art exhibitions, this process is externally supported by art critics and art reviewers who present and endorse a particular way of interpreting an exhibition to their readers. Of course, visitors may not necessarily accept the preferred reading of either institution or critic. An example of this is Britain's Turner Prize which each year provokes lively controversy about the nature of art and serves to test whether the general public and the press are prepared to confirm the preferred reading of the Tate Gallery; namely, that what is contained within its walls deserves the label of 'art'. However, the Turner Prize and its co-sponsor Channel 4 actively welcomes and encourages controversy and contestation in order to provoke public debate and gain publicity. So, in this example, what looks at first glance to be the oppositional reading turns out to be yet another preferred reading. Where does this leave Hall's argument?

In its time, the concept of preferred, negotiated and oppositional readings was an extremely useful theoretical step towards working out the interaction between producers and consumers of meaning. In Hall's original analysis, the differentiated readings arose from class, employment patterns and power relations. However, recent sociological research into museums, and particularly heritage sites, suggests the reasons why people respond differently are much more varied and less clearly defined along class lines (cf. Dicks, 2000). Gaynor Bagnall (2003) has shown how visitors' responses to the Wigan Pier heritage site and to the Manchester Museum of Science and Industry were determined in part by their own personal experiences of the history being presented, as well as by their emotional responses, and the perceived quality of the living history presented to them by actors and interpreters at the sites on various occasions. This research emphasizes the importance of context, the iterative nature of visiting, the role of spectacle and performance at such sites, and how visitor responses change over time.

Communication and cultural politics

All of the above leads us far away from the initial idea of the basic transmission model with its stable message waiting to be delivered to its recipient. It moves us instead towards thinking about communication as an on-going process of exchange and dialogue dependent on many different factors. It suggests that the meaning-making process cannot be easily divided into production and consumption, because producers are also consumers of meanings and values. Likewise consumers – in the shape of visitors – are equally producers of meanings, because they are active participants in the process. As well as being a cyclical process, the meaning-making process is revealed not as neutral or objective, but as embedded in the realm of cultural politics and having the power to define, legitimize, enforce, negotiate, claim, or oppose certain meanings (Jordan and Weedon, 1995).

The argument that visitors will draw on prior experiences and that cultural participation is linked to structures of inequality and power within society is not a particularly new observation. Pierre Bourdieu and Alain Darbel (1991) discussed precisely this issue in their 1966 study of visitors to French art galleries and the development of the concept of 'cultural capital'. For Bourdieu, 'cultural capital' refers to an individual's accumulated knowledge of, and familiarity with, bourgeois cultural practices – in this case art history – which will enable them to decode and respond 'appropriately' to works of art (1993, 1994). Cultural capital is built up, and internalized, over time through exposure to these codes within society, particularly within the mutually reinforcing environments of the family, and the educational system (both formal and informal). For Bourdieu, cultural capital was inextricably linked to the class system, both in

terms of its acquisition and deployment. First, the individual's opportunity to acquire such cultural capital will be determined by their position within society. Second, because of the public nature of cultural participation, Bourdieu (1994) argued that the display of 'good taste' and artistic knowledge function to identify and reinforce boundaries between the social classes .

Bourdieu developed his concept of cultural capital in relation to French art galleries and in a different context of class relations. It is also important to acknowledge that 'class' itself is now considered a problematic category, given the blurring of traditional boundaries between the various classes which has occurred in Britain since the Second World War and particularly since the Thatcher government of the 1980s (Turner, 2003:198–99). Notwithstanding these caveats, it is debatable how far things have changed. Certainly, a number of British museums have been particularly active and successful in terms of diversifying their range of visitors and broadening their appeal.[4] The MORI poll of 2002 also reported that visitor figures to museums, galleries and heritage sites had increased particularly following the introduction of free entry: 'The overall proportion of adults visiting museums and galleries has gone up since similar research was undertaken two years ago from 31 per cent to 38 per cent.' (MORI, 2002). The shift by museums and heritage sites towards the representation of the lives and histories of 'ordinary people' is another important difference which merits more research (Dicks, 2000). Yet, despite these encouraging signs, MORI also reported that the overall demographics of visitors continue to remain fairly static:

> it seems that at least initially, the increase has been much greater among the wealthy A's (up 18%) than among other social grades ... Looking at museums and galleries separately, the social divide is even clearer, over half of AB's (51%) have visited a museum in the last year, compared with less than one in five DE's (18%). Although, more people overall are visiting galleries (AB's 42%, DE's 9%), the gap between the social classes is the same (33%).
>
> (MORI, 2002)

As Bourdieu would predict, one of the most significant factors differentiating visitors from non-visitors continues to be the level of further education they possess. MORI notes that: 'Among those who have visited museums, 56% have degree/master/PhD while among gallery visitors, 46% have degree/master/PhD.' Moreover, MORI adds that: 'research ... conducted in 1999 showed that cost was only a very small factor in the reason people did not visit museums and galleries' (MORI, 2002).

One of the difficulties is that this process of drawing upon cultural capital is generally invisible to others. Of course, certain types of museums, galleries or heritage sites will require or 'assume' more prior knowledge than others – whether intentionally or not. In science and technology centres, for example, emphasis is on leading visitors along a process of 'discovery' through activities and experiments. However, in other contexts – say a contemporary art gallery – the emphasis is much more on expecting visitors to bring their own ideas and associations to bear upon the experience. Indeed, some in the art world would argue that overly didactic 'interpretation' runs the risk of 'closing down' the range of possible meanings and thought processes that an artwork might provoke in a visitor; it could be accused of suggesting that there is one 'correct' reading. In one respect, this argument could be seen as positively – although not necessarily intentionally – embracing the constructivist museum idea that visitors are active participants in the meaning-making process (Hein, 1999:76–77). Proponents of this line of thinking suggest that the diversity, subjectivity and originality of individual responses

should be celebrated, respected and encouraged rather than contained and pre-determined by staff. Similarly, Tate Modern's director, Nicholas Serota, has written about how redisplays of art along thematic lines can allow the gallery to facilitate and produce multiple responses (Serota, 1996; see Whitehead in this volume). There is also the argument that over-reliance on textual interpretation misses the point of an artwork, because if its meanings could be satisfactorily translated into words, there would have been no need to use visual means. However, this argument is based on the misapprehension that interpretation is about somehow 'summing up' the meaning of the object, image or site. On the contrary, interpretation can be used more imaginatively as a means of opening up a way of thinking about the object, image or site.

While it is important to engage with these arguments, research into visitor responses shows that interpretation or meaning-making does not occur within a vacuum. It is never simply a matter of individuals freely choosing between various meanings. Instead, as has been argued above, the meaning-making process occurs in relation to a number of structural factors within society, such as the socio-economic, educational, familial and cultural background of individuals, to name a few. The combination of these factors will affect an individual's opportunity to acquire certain forms of cultural capital and, moreover, to feel inclined to want to access cultural institutions.[5]

Significantly, in some contexts visitors may interpret their inability to 'decode' what they encounter as a personal failing or a result of their lack of education. This sense of personal inadequacy and embarrassment may go some way towards explaining the hostility and dismissal sometimes expressed towards work of art, especially contemporary art. The alternative response is often to find the fault within the artwork because of a failure to recognize the intellectual codes in operation – 'it's meaningless and therefore it isn't art' might be a typical reaction. Bourdieu describes the individual who is unable to decode an artwork as being:

> in a position identical with that of ethnologists who find themselves in a foreign society and present, for instance, at a ritual to which they do not hold the key ... Since the information presented by the works exhibited exceeds the deciphering capabilities of the beholder, he perceives them as *devoid of signification* – or, to be more precise, of structuration and organization – because he cannot 'decode' them, i.e. reduce them to an intelligible form.
>
> (1993:217–18; my emphasis)

The fault here does not necessarily lie with either the artist, the artwork, or the individual beholder, but in the breakdown of the communication process between them. As this suggests, the politics of cultural capital and the process of interpretation continue to be serious issues for all those who care about museums, heritage and especially art galleries. Not least because as long as there is a perception, right or wrong, that these institutions are exclusive and elitist it will continue to be difficult to persuade funding councils to support such venues with public money.

Implications for practice

Recognition of such issues presents prospective museum, heritage and gallery professionals with a number of challenges. Museum workers, for example, need to be able to attract specialist interest groups with high 'cultural capital', while simultaneously offering a 'way-in' for those who have little prior knowledge of a subject. Art curators need to find a way of reconciling the pressures from the education team who may like an exhibition on contemporary art to provide something for visitors from the age of five years upwards, with the wishes of the artist, who may

not want the visual impact of his/her artwork changed by the inclusion of large text panels. Heritage professionals face similar dilemmas. For some visitors, the inclusion of extensive interpretation panels at heritage sites can be intrusive and detract from the beauty of the landscape. On a practical level, signage may also concentrate visitors in one particular area, causing problems such as ground erosion or overcrowding. Yet, if visitors come to a heritage site and leave knowing little more than when they arrived, this has surely been a missed opportunity. Moreover, those who reject the need for heritage interpretation may only do so because they already possess the cultural capital to feel equipped to make sense of what they encounter; as argued above, this will not necessarily be true for other visitors.

There is no one single response to these issues which will suit every scenario. The needs, opportunities and challenges of each site and organization need to be taken into consideration, and individual strategies of communication and interpretation need to be developed with all the relevant players in mind. These might include experts, landowners, collectors, funding bodies and practitioners, as well as various audiences, different identity groups, tourists, local residents, and groups with specific needs or interests. The task is by no means insignificant but, as indicated throughout this article, a body of research and practice has developed which can offer guidance on many of the issues mentioned. In addition, prospective museum, gallery and heritage professionals should familiarize themselves with their potential audiences (both visitors *and* non-visitors) and think as creatively as possible about how they can bring them together with their subjects and their organizations.

For those who research museums, galleries or heritage sites, this article has suggested some ways of identifying the various players and factors involved in the communication process, and has emphasized the need to delineate between the respective interests, agendas and effects of those players and factors – intentional and otherwise.[6] Museum, gallery and heritage studies constitute an extremely challenging area of current research because they are so multifaceted and, in some respects, still relatively new. At the same time, this novelty means that much interesting work remains to be done.

In conclusion, it should be recognized that communication within museums, galleries and heritage sites will inevitably be a complex and often unpredictable process, because it depends upon so many variables. However, it is precisely this same variety and unpredictability which makes museums, galleries and heritage organizations such endlessly fascinating places within which to work, visit and study.

Notes

1 The issues of authorial intention have been much criticized and problematized in recent cultural studies, media and literary theory – see Hall (1997:25–7), Hooper-Greenhill (1991) and Lawrence (1991). However, museum, gallery and heritage professionals do indeed intend and aim to convey certain messages, despite the fact that they themselves, their actions and their 'intentions' are always discursively situated. See Barker (2000) on the discursive construction of personal agency, including Giddens on structuration theory (2000:179).

2 See, for example, the Holocaust Exhibition in London's Imperial War Museum, which uses a combination of documentary-style displays, personal testimony of survivors through the use of oral history and televised interviews, and immersive environments such as a life-size recreation of a wagon used to transport Jews to the camps.

3 The typologies of display adopted by museums, galleries and heritage sites overlap considerably. The National Gallery, for example, is arguably closer in terms of its mode of display and its style of interpretation to a National Trust property than to a contemporary 'art factory' like the Baltic Centre for Contemporary Art, Gateshead.

4 See, for example, work by Tyne and Wear Museums.
5 See Barker (2000:183) on the constructed nature of choice itself.
6 A useful model of analysis is the 'circuit of culture' (du Gay *et al.,* 1997; McLean, 1998).

References

Appadurai, A. and Breckenridge, C. (1999) 'Museums are good to think: heritage on view in India', in Boswell, D. and Evans, J. (eds), *Representing the Nation, A Reader: Histories, Heritage and Museums*, London: Routledge.

Bagnall, G. (2003) 'Performance and performativity at heritage sites', *Museum and Society*, 1(2), 87–103.

Bal, M. (1996) 'The discourse of the museum', in Greenberg, R., Ferguson, B. and Nairne, S. (eds), *Thinking About Exhibitions*, London: Routledge.

Barker, C. (2000) *Cultural Studies: Theory and Practice*, London: Sage.

Belcher, M. (1991) *Exhibitions in Museums*, Washington: Leicester University Press/Smithsonian Institution Press.

Bennett, T. (1995) *The Birth of the Museum: History, Theory, Politics*, London: Routledge.

Blinde, E.M. and McCallister, S.G. (2003) 'Observations in the National Baseball Hall of Fame and Museum: doing gender in Cooperstown', *Research Quarterly for Exercise and Sport*, 74(3), 301–12.

Bourdieu, P. (1993) *The Field of Cultural Production: Essays on Art and Literature*, Cambridge: Polity.

—— (1994) 'Distinction and the aristocracy of culture', in Storey, J. (ed.), *Cultural Theory and Popular Culture: A Reader*, Hemel Hempstead: Harvester.

—— and Darbel, A. (1991) *The Love of Art: European Art Museums and Their Public*, Cambridge: Polity.

Clifford, J. (1997) *Routes: Travel and Translation in the Late Twentieth Century*, Cambridge, MA: Harvard University Press.

Coombes, A.E. (1994) *Reinventing Africa: Museums, Material Culture and Popular Imagination in Late Victorian and Edwardian England*, New Haven: Yale University Press.

Coxall, H. (1996) 'Resistant readings: it is what you say and the way you say it', *Journal of Social History Curators' Group*, 22, 5–9.

Dean, D. (1996) *Museum Exhibition*, London: Routledge.

Desai, P. and Thomas, A. (1998) *Cultural Diversity: Attitudes of Ethnic Minority Populations Towards Museums and Galleries*, report prepared for Museums and Galleries Commission by BRMB International.

Dicks, B. (2000) 'Encoding and decoding the people: circuits of communication at a local heritage museum', *European Journal of Communication*, 15(1), 61–78.

Dodd, J., Hooper-Greenhill, E., O'Riain, H. and Sandell, R. (2002) *A Catalyst for Change: The Social Impact of the Open Museum*, Leicester: RCMG.

Du Gay, P., Hall, S., Janes, L. *et al.* (eds) (1997) *Doing Cultural Studies: The Story of the Sony Walkman*, London: Sage.

Duncan, C. (1995) *Civilising Rituals: Inside Public Art Museums*, London: Routledge.

Falk, J. and Dierking, L. (1992) *The Museum Experience*, Washington: Whalesback.

—— (2000) *Learning From Museums: Visitor Experiences and the Making of Meaning*, Walnut Creek: AltaMira.

Ferguson, B.W. (1996) 'Exhibition rhetorics: material speech and utter sense', in Greenberg, R. Ferguson, B. and Nairne, S. (eds), *Thinking About Exhibitions*, London: Routledge.

Fish, S. (1980) *Is There a Text in This Class?: The Authority of Interpretitive Communities*, Cambridge, MA: Harvard University Press.

Foucault, M. (1973) *The Order of Things*, New York: Vintage.

—— (1990) *The History of Sexuality: Vol 1, An Introduction*, London: Penguin.

—— (1991) *Discipline and Punish*, London: Penguin.

Greenberg, R., Ferguson, B. and Nairne, S. (eds) (1996) *Thinking About Exhibitions*, London: Routledge.

Hall, S. (1980) 'Encoding/decoding', *Centre for Contemporary Studies: Culture, Media, Language: Working Papers in Cultural Studies, 1972–79*, 128–38.

—— (1992) 'The question of cultural identity', in Hall, S., Held, D. and McGrew, T. (eds), *Modernity and its Futures*, Cambridge: Polity.

—— (ed.) (1997) *Representation: Cultural Representations and Signifying Practices*, London: Sage.

Ham, S. (1999) 'Cognitive psychology and interpretation: synthesis and application', in Hooper-Greenhill, E. (ed.), op. cit.

Haraway, D. (1989) *Primate Visions: Gender, Race and Nature in the World of Modern Science*, New York: Routledge.

Hein, G. (1999) 'The constructivist museum', in Hooper-Greenhill, E. (ed.), *The Educational Role of the Museum*, London: Routledge.

Heywood, F. (2003) 'Bittersweet legacy', *Museums Journal*, Oct., 28–31.

Hooper-Greenhill, E. (1991) 'A new communication model for museums', in Kavanagh, G. (ed.), *Museum Languages: Objects and Texts*, Leicester: Leicester University Press.

Hooper-Greenhill, E. (ed.) (1997) *Cultural Diversity: Developing Museum Audiences in Britain*. London and Washington: Leicester University Press.

—— (ed.) (1999) *The Educational Role of the Museum*, London: Routledge.

Hutcheon, L. (1994) 'The post always rings twice: the postmodern and the postcolonial', *Textual Practice*, 8, 205–38.

Jordan, G. and Weedon, C. (1995) *Cultural Politics: Class, Gender, Race and the Postmodern World*, Oxford: Blackwell.

Karp, I. and Lavine, S. (eds) (1991) *Exhibiting Cultures: The Poetics and Politics of Museum Display*, Washington: Smithsonian Institution.

Kavanagh, G. (1990) *History Curatorship*, London: Leicester University Press.

Lawrence, G. (1991) 'Rats, street gangs and culture: evaluation in museums', in Kavanagh, G. (ed.), *Museum Languages: Objects and Texts*, Leicester: Leicester University Press.

Lidchi, H. (1997) 'The poetics and politics of exhibiting other cultures', in Hall, S. (ed.), *Representation: Cultural Representations and Signifying Practices*, London: Sage.

Macdonald, S. (2002) *Behind the Scenes at the Science Museum*, Oxford: Berg.

—— and Silverstone, R. (1999) 'Rewriting the museums' fictions: taxonomies, stories and readers', in Boswell, D. and Evans, J. (eds), *Representing the Nation: A Reader: Histories, Heritage and Museums*, London: Routledge.

McLean, F. (1998) 'Museums and the construction of national identity: a review', *International Journal of Heritage Studies*, 3(4), 244–52.

—— (2002) 'Our common inheritance? Narratives of self and other in the Museum of Scotland', in Harvey, D.C. (ed.), *Celtic Geographies: Old Culture, New Times*, London: Routledge.

—— and Cooke, S. (2000) 'Communicating identity: perceptions of the Museum of Scotland', in Fladmark, J.M. (ed.), *Heritage and Museums: Shaping National Identity*, Oxford: Alden.

213

Milner, A. and Browitt, J. (2002) *Contemporary Cultural Theory: An Introduction*, London: Routledge.

MORI (2002) 'Attractions, museums, and galleries research', available online at www.mori.com/digest/2002/c020426.shtml

Newman, A. (2002) 'Feelgood factor', *Museums Journal*, March, 29–31.

—— and McLean, F. (1998) 'Heritage builds communities: the application of heritage resources to the problems of social exclusion', *International Journal of Heritage Studies*, 4(3/4), 143–53.

Peers, L. and Brown, A. (2003) *Museums and Source Communities: A Routledge Reader*, London: Routledge.

RCMG (2001) 'Making meaning in art museums, 1: Visitors' interpretitive strategies at Wolverhampton Art Gallery', available online at www.le.ac.uk/museumstudies/bookshop (accessed 12 September 2003).

Riegel, H. (1996) 'Into the heart of irony: ethnographic exhibitions and the politics of difference', in Macdonald, S. and Fyfe, G. (eds), *Theorizing Museums: Identity and Difference in a Changing World*, Oxford: Blackwell.

Sandell, R. (ed.) (2002) *Museums, Society, Inequality,* London: Routledge.

Samuel, R. (1994) *Theatres of Memory: Past and Present in Contemporary Culture*, London: Verso.

de Saussure, F., (1960) *Course in General Linguistics*, London: Peter Owen.

Serota, N. (1996) *Experience or Interpretation: The Dilemma of Museums of Modern Art*, London: Thames & Hudson.

Silverstone, R. (1989) 'Heritage as media: some implications for research', in Uzzell, D. (ed.), *Heritage Interpretation 2: The Visitor Experience*, London: Frances Pinter.

Thomas, N. (2001) 'Indigenous presences and national narratives in Australasian museums', in Bennett, T. and Carter, D. (eds), *Culture in Australia*, Cambridge: Cambridge University Press.

Tilden, F. (1957) *Interpreting Our Heritage* (3rd edn), Chapel Hill: University of North Carolina Press.

Turner, G. (2003) *British Cultural Studies: An Introduction*, New York and London: Routledge.

Tyne and Wear Museums (2000) *Annual Report*, available online at www.twmuseums.org.uk/about/images/annreport.pdf (accessed 24 March 2003).

Weedon, C. (1987) *Feminist Practice and Postructuralist Theory*, Oxford: Blackwell.

Witcomb, A. (2003) *Re-imagining the Museum: Beyond the Mausoleum*, London and New York: Routledge.

Woodward, K. (ed.) (1997) *Identity and Difference*, London: Open University/Sage.

17

Presenting the past
A framework for discussion

Peter Stone

Heritage resources have the potential of being vital and dynamic educational assets. An understanding of the ways in which heritage resources are interpreted by academic archaeologists and indigenous peoples can only but enhance presentations of the past. It could broaden presentations of the past as they are framed in formal school education, and also expand those presentations that provide opportunities for informal learning and which are found in museums and at heritage sites, or associated with the built environment and with urban and rural cultural landscapes. The range of heritage resources includes the movable and immovable tangibles, as well as all the expressions of culture now included under what has been termed the 'intangible cultural heritage'. Unfortunately, in a Western-dominated world that has tended to focus on the written and printed word as the primary source of evidence about the past, these other heritage resources and how they have been interpreted have not always been utilized to their full educational potential. Although the situation is improving with, for example, television documentaries, many of the theories and interpretations of academic archaeologists have not been made readily available for public consumption. Likewise, the interpretations of heritage resources by indigenous peoples have for varying reasons been ignored, or, at times, even suppressed. More needs to be made of these elements of the often 'excluded past' in formal and informal education, especially where they expand history by including interpretations of 'prehistory' and the perspectives of indigenous peoples.

Drawing from authors and examples from different parts of the world, this chapter explores issues, tensions and potentials associated with four key aspects (and the possible points of intersection between them) as they relate to public learning about the past. The four aspects are recent thinking and approaches in theoretical archaeology; the potential benefits of extending school history curricula to include the elements of the previously 'excluded past'; the presentation of history in heritage institutions and at heritage sites; and indigenous views concerning the past.

Introduction

This chapter is about the confluence of four approaches to the interpretation and presentation of the past: academic or theoretical archaeology; indigenous views of the past; school history; and the past as presented to the general public in museums and at 'historic sites'. All four approaches have their own priorities and agendas but, although they frequently draw on different sets of data, they have as their common thread the interpretation of past human activity. Central to all of the chapters in Stone and Molyneaux (1994) is a belief that the presentation of the past, in

school curricula and in museum and site interpretations, will benefit from a greater understanding of how the past is interpreted by archaeologists and/or indigenous peoples.

Within academic archaeology during the past twenty or so years there has been an increase in the number of archaeologists who have argued for the extension of teaching about archaeology to an audience wider than their own students. The reasons have varied at different times and from person to person, and have included the desire to extend the understanding of the development and progress of the human species (for example, Alcock, 1975:2); the belief that the study of archaeology can be used as a tool to extend the 'judgement and critical power' of students of all ages (for example, Evans, 1975:6); and as preparation for the study of archaeology at university (for example, Dimbleby, 1977:9–10).

This interest in more extensive teaching about archaeology can also be seen as part of the much wider debate that has discussed the role and value of the past as an element of public 'heritage' (see, for example, Wright, 1985; Lowenthal, 1985; Hewison, 1987; Cleere, 1989; Layton, 1989, 1990; Ucko, 1994). While many (?most) museums and historic sites seem to be concerned with the presentation of a frequently static, well-understood past that reflects the achievements of a specific period – and frequently a particular section of society – as part of a national inheritance (Hewison, 1987), modern archaeology is more concerned with questioning the validity of any interpretations or presentations of the past (see, for example, Hodder, 1986; Shanks and Tilley, 1987), arguing, for example, that 'interpretation owes as much to the interests and prejudices of the interpreter as to the inherent properties of the data' (Renfrew, 1982:2).

At the same time, the study of the past in schools is predominantly the study of the past as documented by written records and, as such, is universally referred to in curricula as 'history'. This emphasis on the documentary past not only excludes much of prehistory from school curricula, but has also tended to exclude the interpretation of the past through archaeological study and through indigenous (and usually oral) views of the past as well (Stone and MacKenzie, 1990). Given this school view of 'the past', the contemporary archaeological suggestion that the past is 'constructed' – and is therefore open to constant reinterpretation and coexisting different interpretations – is one that does not easily equate with the way that history is taught in school curricula (see Stone and MacKenzie, 1990).

This chapter looks at attempts to link together some or all of these four aspects of teaching about the past. All of the projects described in the following chapters have particular local or specific aims and objectives – for example, the introduction of 'archaeofiction' in classrooms in France (Masson and Guillot, 1994) or the introduction of indigenous values into local education policy (Jamieson, 1994) – they all also share a common belief that an extension of the way(s) in which the past is studied and understood by students and/or members of the general public would be a 'good thing' and, if it is achieved, will enhance contemporary, and future, society as a whole. This is a belief that is frequently left largely unsubstantiated by its adherents – partly, at least, because it is almost impossible to quantify. There is, for example, no empirical evidence to prove that a greater understanding, on the part of the general public, of what can be gained from the archaeological study of a given site will ensure any greater level of protection for that site, or for any other site. However, the association between greater understanding and better protection has been accepted by many as a worthy aim to pursue (Seeden, 1994; Gregory, 1986; Cleere, 1989:8–9) and there is certainly no evidence to refute the suggested association. Equally, the argument that students have better judgement and critical awareness because they have studied the past through archaeology, as opposed to the more usual document-based study of the past, has, to my knowledge, never been systematically tested until the recent work in India reported here (Dahiya, 1994). Dahiya's work certainly suggests that those students who studied the past

through an archaeological rather than a document-based approach did learn and retain more information and, at the same time, appeared to enjoy the work more. Dahiya's work introduces a specifically educational element to the debate: from an educational point of view, the success of one methodological approach over another (effectively 'hands-on', as opposed to didactic) is just as important as the fact that one group of children now has more information about the past than another, as the successful methodology may be transferable to other subjects. Until recently, archaeologists have, perfectly legitimately, taught about the past in order to increase the amount of information assimilated and understood by their students about a particular period or culture. More recently, as archaeologists have seen their subject used – and abused – for political and social advantage (Layton, 1989, 1990; Ucko, 1994), many of them have accepted a wider role for archaeology. This wider role is also based on the acceptance that archaeology has an educational role, in that it is a subject that requires students to work critically and carefully, without accepting any single 'true' version of the past.

This educational role of archaeology – illustrated in one instance by the methodological work of Dahiya – has yet to be accepted by those in control of teaching about the past. Also ignored is the educational role of indigenous views of the past (see, for example, Blancke and Slow Turtle, 1994; Jamieson, 1994) and any educational benefit of teaching specifically about prehistory (and see Corbishley and Stone, 1994).

Formal curricula

The acceptance by archaeologists of the educational importance of the wider teaching of the past – much of which has been defined as 'the excluded past' (MacKenzie and Stone, 1990) – has its roots in a relatively few practical initiatives that go back little further than the mid-1970s (Stone and MacKenzie, 1990; McManamon, 1994; Podgorny, 1994; Corbishley and Stone, 1994). Unfortunately, there has been little or no comparable acceptance of the value of teaching about the excluded past within the world of formal education (Corbishley and Stone, 1994; and see Stone and MacKenzie, 1990). Extolling the virtues of an 'excluded past' as an essential part of a curriculum is not the same as making it part of that curriculum. The following chapters show evidence of the gulf between the need for inclusion expressed by archaeologists, other academics and indigenous and minority groups, and the general failure to accept this need by those with power within the educational establishment (see, for example, López and Reyes, 1994; Mbunwe-Samba *et al.*, 1994; McManamon, 1994; Wandibba, 1994; Witz and Hamilton, 1994). Even where part of the excluded past is recognized – for example the existence of the past of a particular indigenous group – other significant minority groups may be overlooked (Wade, 1994) or dealt with unsympathetically (Podgorny, 1994).

It is an important point that, if the 'excluded past' is to be accepted within the curricula of formal education, its value must be couched in *educational terms,* as defined above. Zimmerman *et al.* (1994) (and see Davis, 1989) suggest that most archaeologists want to teach archaeological skills and ideas in the classroom, whereas educationalists look for the means to stimulate the educational, rather than archaeological, development of children. Zimmerman *et al.* (1994) caution that continued attempts to teach archaeology in schools, without reference to the priorities of educationalists, will merely confirm the view of the latter that archaeology has no role within school curricula.

The excluded past is not always simply ignored as irrelevant, however (MacKenzie and Stone, 1990:3–4). It may be kept out of the curriculum because education authority finance is controlled by those who, for political reasons, explicitly oppose its presence, as Jamieson (1994)

describes in his attempts to introduce indigenous culture in a school curriculum in northern Canada. Occasionally, a pragmatic need is identified that results in the exclusion of specific archaeological information, where its inclusion would destroy a consensus fundamental to the acceptance of using archaeological information in the curriculum: Devine (1994) describes such an occurrence, where the good working relationship between educators, archaeologists and Native people was threatened by a disagreement over the interpretation of some specific information. The problem was avoided by the omission of certain parts of the archaeological interpretation, which itself raised the question of control and ownership of the interpretation of the past (and see Ucko, 1994). In other instances, the study of archaeology and prehistory may be the victim of attitudes about their economic potential and so is denied resources. This problem is especially clear in Third World countries, as development programmes ignore the teaching of the 'excluded past' in the belief that it has little or no immediate economic value (for example, Kiyaga-Mulindwa and Segobye, 1994; Mbunwe-Samba *et al.*, 1994, although see Ucko, 1994; Addyman, 1991; and Collett, 1992, for discussion of an alternative view of the economic value of the archaeological heritage). Other developing countries regard it as a vocational subject and therefore do not include it in employment planning (Wandibba, 1994).

Despite these practical problems, the work that archaeologists and others are now putting into producing new educational materials and courses, as described in many of the following chapters, is not only encouraging, but also critical to the future of heritage education. However, convincing the educational establishment that these efforts are not merely attempts to ensure the existence of archaeological jobs is not easy, and requires co-operation among government departments, educational authorities and teachers (see, for example, Devine, 1994; Jamieson, 1994). The nurturing of such an acceptance also requires those fighting for the extension of the study of the past to develop a theoretical and educational basis for their arguments. It is, and has always been, insufficient to argue that the 'excluded past' should be taught 'because it is important' – such statements have almost certainly contributed to the exclusion of the prehistoric, archaeological and indigenous pasts from school curricula around the world. Some of the following chapters outline the history (if any) of such arguments (Corbishley and Stone, 1994; Podgorny, 1994; Zimmerman *et al.*, 1994) and some (Dahiya, 1994) set out methodological arguments for teaching about the past with the help of archaeological information. A few (Blancke and Slow Turtle, 1994; Devine, 1994; Planel, 1994; White and Williams, 1994) actually begin to address why and how the way the past is taught should be extended.

Informal learning

The co-operation between archaeologists and those involved in the planning and organization of formal curricula is, however, only one aspect of teaching about the past. Although success in this area may go some way towards guaranteeing that future societies will be more aware of the reasons for the preservation, study and interpretation of the historic environment, there is a pressing need to educate contemporary society, if the fragile database is not to be lost before any such enlightened future societies take on responsibility for its preservation. A number of authors refer to the continuing destruction of the historic environment and the associated illicit trade in antiquities (see, for example, McManamon, 1994; Pwiti, 1994; Ramirez, 1994; Seeden, 1994; Zimmerman *et al.*, 1994).

The issues and events referred to by these writers emphasize that education concerning the protection and preservation of the material past must consist of more than merely claiming that

it has intrinsic value. Archaeologists need to know and, equally important, must be able to explain why such tangible evidence is vital – if they are to stop the theft of artefacts and the careless or intentional destruction of sites. If archaeologists do not explain why the physical heritage is important, they cannot blame those who, having no archaeological training or education, consciously or unconsciously destroy, or sell, parts of that heritage (see, for example, with relation to damage caused by metal detectors in the UK; Gregory, 1986). Such explanations will vary from archaeologist to archaeologist and from situation to situation, but will always include the statement that archaeological evidence (as well as indigenous views of the past) can, and will, be used as a means of interpreting the past, in addition to documentary sources.

This use of archaeological evidence can enrich an individual's – or a society's – understanding of the past and, used in this way, can be regarded as beneficial. However, if access to the evidence of archaeology is not available to all, through its inclusion in formal and informal education programmes, then society runs the risk of the interpretation of archaeological evidence being biased – as it was, for example, in Germany in the 1920s and 1930s (Podgorny, 1994; MacKenzie and Stone, 1990). If such a message is put across well enough, and is convincing enough, then there may be some justification in the belief that contemporary society will protect the historic environment for future generations. Time is of the essence here, as the failure to include archaeological interpretation in curricula can be argued to have contributed to the lack of understanding on the part of the general public, with regard to the archaeological-cum-educational-cum-political importance of sites. This can lead to a situation such as that found in Colombia, where so-called (by the archaeological community) 'looters' see nothing wrong in digging into burial sites – even attempting to legitimize their activities by applying to form their own trade union (Ereira, 1990:21). Similarly, in Lebanon, the public appear to be content to sit back and watch the wholesale destruction of archaeological sites (Seeden, 1994).

It follows that archaeologists, and others who control the data of the past or who regard themselves as having a custodial role with regard to the historic environment, must use every means available to them – including film, television, radio, newspapers and popular publications – to reach the general public (see, for example, Frost, 1983; Hoare, 1983; Bender and Wilkinson, 1992; Groneman, 1992; Borman, 1994; Seeden, 1994; Momin and Pratap, 1994). There are, of course, dangers associated with this approach: media communications is an industry in its own right and responds first to business imperatives, rather than cultural or academic ones, thus creating a constant risk of distortion or sensationalizing archaeological material (Momin and Pratap, 1994; Witz and Hamilton, 1994). Indeed, as Seeden points out (1994), publicity can actually *increase* the likelihood of the destruction of archaeological sites by attracting people to them in search of 'buried treasure'. However, the potential benefits in informing society at large must surely outweigh such concerns (Andah, 1990; Burger, 1990: 148–9; Ekechukwu, 1990:125; McManamon, 1994). It is essential that those already involved in this work begin to co-operate and share their successes and failures, if the present rate of destruction is to be stemmed. In addition, those archaeologists who take on this responsibility must not be penalized in their careers, as they seem to be in some parts of the world, including the USA, by an out-of-date peer assessment process that sees such work as less important than other aspects of an archaeological career (Bender and Wilkinson, 1992). Nor must archaeologists continue to ignore the value and importance of teaching about communication within archaeology undergraduate courses. A number of universities offering archaeology degrees now have optional courses in heritage management, and some of these include a lecture on heritage education. Such courses, together with the study of archaeological tourism, should be included

as necessary components of all archaeology degree programmes throughout the world, and should incorporate both academic and practical training (see Ekechukwu, 1990).

Museum display

The traditional method of communicating with the general public has been through museum display. However, despite huge advances in the methods and technology of display, museums still reach only a tiny proportion of the population (Hooper-Greenhill, 1991a). A number of contributors argue that museums are generally regarded as places for specialists or particular (usually élite) groups within society (for example, Nzewunwa, 1994; Wandibba, 1994). This point is supported by Andah (1990) in his assertion that African museums were created for the colonial population *about* the indigenous population. Andah's argument is all the more depressing when he suggests that little has changed in museum displays since the independence of African states – a point supported by Mazel and Ritchie (1994) in their discussion of Botswana and Zimbabwe and also discussed by Ucko (1994) in his analysis of the present plans for the development of the National Museums and Monuments of Zimbabwe. Further north in Africa, it is interesting (even shocking?) to note that less than five per cent of the visitors to the Cairo museum are Egyptians (Boylan, 1991:10). Andah (1990) argues strongly that museum and cultural tourism must be aimed first and foremost at the local population, since anything else simply maintains the colonial dependency of, in his case, Africa, on the western world. Ekechukwu (1990) develops the point by emphasizing that local tourism is an essential element of the creation of a national identity, and the creation of a national museum for the national population has been identified as one of the four most vital symbols of independent nationhood perceived by newly independent governments (Boylan, 1991:9). Andah (1990:152) looks forward to a time when 'The museum can begin to be transformed from a reservoir of folklore for tourists thirsting for exotics, to a living image of the past, a source of culture, a crossroad for ethnic culture, a symbol of national unity'. And, in much the same way as Ucko (1994) supports the ideal of culture houses in Zimbabwe, he sees such museum centres as being designed to

> serve the function of the market place in the African past – namely an open air school; a forum for healthy debate, formal and informal on any problems of life – an institution available to all with its greenery, its gardens, local flora and fauna, aquariums and ponds, special exhibition halls (featuring both permanent and temporary exhibitions) recreational (theatre) areas, hair dressing salons, restaurants serving local dishes, craftsmen at work, craft and technology experimentation units etc.
>
> (Andah, 1990:152)

The important point is that this is not a museum in the conventional western sense, but rather it is an attempt to create an institution that emerges from traditional African society and custom.

Western museum structures and contents may, as Devine (1994) argues, actually alienate Native peoples by presenting stereotypes of their culture – and so make such peoples museum pieces themselves (see also Hall, 1991). This often unconscious stereotyping has not only adversely affected the relationship between two groups (archaeologists and Native peoples) who could be working together in the presentation of the past, but has also helped to reinforce a negative image of Native peoples among the rest of society. The insensitivity to the beliefs of

Native peoples in the museum environment is testified to by Momin and Pratap (1994), who describe a scene in which some 'ethnic groups' visiting museums bow down and leave religious offerings in front of images of gods and goddesses, and are understandably upset that their sacred objects are regarded by those in authority as museum artefacts (and see Andah, 1990:149; Carmichael *et al.*, 1994). It seems obvious that Native peoples and other minority or oppressed groups should be consulted on the display and interpretation of objects related to their pasts. Indeed, such consultation should also extend to the content of formal education syllabuses referring to Native cultures (see Devine, 1994; Jamieson, 1994; Riley, 1992). Unfortunately, this creative – and appropriate – approach to curriculum development does not appear to be commonplace (see Andah, 1990; Momin and Pratap, 1994; Ucko, 1994).

The International Code of Professional Ethics adopted by the International Council of Museums (ICOM) in 1986 'insists that the development of the educational and community role of the museum must be seen as a fundamental ethical responsibility' (Boylan, 1991:10). In order to meet this ideal – in effect to be successful in attracting people to visit museums and heritage sites and to help them to leave happy, fulfilled and somewhat the wiser – museum staff need to agree on the function of their institutions and their presentational role (Lowenthal, 1993). They need to ask not only 'who are we serving?' but, more important, 'who are we not serving?' (Hall, 1991:14).

Hall (1991:11) lists a set of fundamental questions asked of southern African museums at the start of such a review. They have relevance everywhere:

- Why do museums educate?
- Who are our audiences?
- How should we educate?
- When and how often should we present programmes?
- Where should we present programmes?
- By whom should the programme be carried out?
- What are the main subjects we ought to teach?

A number of authors offer similar tentative checklists to be discussed when setting up new exhibitions (for example, Borman, 1994; Delgado Ceron and Mz-Recaman, 1994; Giraldo, 1994; Nzewunwa, 1994). Borman (1994) argues that for too long European museums have been concentrating on how archaeologists know about the past rather than what information they have about it. He accepts that archaeological remains tend to be fragmentary records of a past culture removed from their original context that will never present a 'true' picture of what life was like in the past, but he argues that even such relatively mysterious objects can be used as an 'entrance' to the past, where visitors, having been given an introduction to the evidence by an exhibition, can be challenged to make their own personal conclusions about what life may have been like (also see Delgado Ceron and Mz-Recaman, 1994; Mikolajczyk, 1994; Stone, 1994). In this way, visitors may begin to relate to museum displays in a way that was impossible when one 'correct' story was disseminated through a didactic exhibition.

These developments are a very long way from the opinion expressed in 1968 by an English professor of history (and quoted in Olofsson, 1979) when he argued:

Let me say at once that I hate the idea of museums being used primarily as teaching aids of any sort. Their first job is to house valuable objects safely and display them attractively … The second responsibility is to those who are already educated, to the student, the collector,

the informed amateur … A third responsibility to put above anything specifically educational is, in the case of certain museums, a loyalty to their own personalities.

Olofsson rejects this opinion and the chapters in her book reflect the recently more common view of museums as educational tools. However, just as there is at present a lack of communication between archaeologists and educationalists over the teaching of the past, so Olofsson identified 'insufficient contacts' between museum staff and the school system, the main recipient of their services' as being the major obstacle to the developed use of museums in education (Olofsson, 1979:11).

While some of this lack of communication has now been resolved, at least in western museums – especially through the hard work of many museum-based education officers (see, for example, Hooper-Greenhill 1989) – there are still many practical obstacles and problems to overcome before the two worlds work in harmony. For example, in the Cameroon *et al.* (1994) note that most secondary-level history teachers never take their students to museums nor, in fact, have many of the teachers actually been to the museums themselves. Similarly, a recent survey in India shows only one per cent of history teachers using museums as part of their normal teaching (Raina, 1992; see also Dahiya, 1994). In a recent study in England, only two out of ten museums had any liaison with the local education authorities (HMI, 1990). Only when such links are made between curriculum planners and museums can the 'abysmal gap' (Delgado Ceron and Mz-Recaman, 1994) between museums and formal curricula be closed. And if this gap is not closed, museums are 'in danger of becoming irrelevant, expensive luxuries' (Hall, 1991:13).

We seem to be now faced with a three- (sometimes four-)way failure of communication (archaeologist (indigenous expert)/educator/museum curator) that must be solved before museums will be able to take a major role in the teaching of the past within formal education.

Archaeologists and, where they exist, museum education staff, who work on the fringes of formal education, have helped to develop teaching programmes that extend the database that children can use to study the past. A number of contributors describe attempts to develop museums as active rather than passive partners in teaching children about the past (see, for example, Dahiya, 1994; Delgado Ceron and Mz-Recaman, 1994; Giraldo, 1994; Mbunwe-Samba *et al.*, 1994; Nzewunwa, 1994). The unifying factor in all of these projects is the use of authentic historic artefacts as stimuli for creative work that encourages children to begin to understand the reasons why archaeologists and others value the past, rather than simply to learn dates and 'facts' and visit 'treasures' behind glass cases.

Previous studies of the advantages of teaching within such a creative 'hands-on' experimental framework have in the main failed to make a direct comparison between their success and a more didactic approach (Olofsson, 1979). Dahiya (1994) confronts this failure head-on and provides powerful testimony by doing so. Unfortunately, she faces enormous practical problems in convincing teachers in India to move towards a more 'hands-on' approach to teaching about the past, as over 86 per cent of Indian history teachers rely almost entirely on a 'lecture/narration method' of teaching (Raina, 1992:24). According to Raina, the purpose of teaching about the past in Indian schools seems to be to pass exams and 'it is a myth to think of teaching history to either "develop the skills of a historian" or to develop a proper attitude and interest in the subject' (Raina, 1992:26).

Such developments in how museums communicate and display their historic collections require the retraining of museum staff (see Adande and Zevounou, 1994; Mbunwe-Samba *et al.*, 1994; Pwiti, 1994; Reeve, 1989; Stone, 1993) and the introduction of, at least, discussion of the

role of museums within undergraduate archaeology, history and education courses (Andah, 1990:155; Kiyaga-Mulindwa and Segobye, 1994). On a more practical level, in Zimbabwe, for example, plans are presently being developed for the introduction of a Certificate in Heritage Education (Stone, 1994). While this course was initially conceived as part of an internal staff development programme, other countries have expressed interest in using it as a basis for similar courses. In Kenya, annual seminars organized by the National Museum aim to reduce the gulf between museum educators and their counterparts within formal education [Karanja (personal communication), and see Uzzell (1989) for a number of case studies of the training of interpreters]. Such retraining must become commonplace before museums can take on their leading role in the extension of the database used in the teaching of the past.

The role of native people in curriculum development and museum display

As part of this extension of teaching about the past, both archaeologists and educationalists must accept that there are indigenous specialists in the past who are outside the western academic and pedagogical traditions, but who nevertheless should have a central role to play in the development of teaching about their own pasts (Ahler, 1994; Belgarde, 1994; Blancke and Slow Turtle, 1994; Devine, 1994; Jamieson, 1994). Archaeologists have consistently offended the sensibilities of Native peoples by excavating burial sites and removing sacred objects and other significant cultural materials as a matter of routine, as have museums and academic institutions by studying and displaying such objects for educational and entertainment value (see Hubert, 1989, 1991). Although such insensitivity is declining (at least in some areas), encouraged by legislation that often compels archaeologists and museums, among other things, to consult with Native groups and their specialists (see McManamon, 1994), archaeologists and museum curators still have considerable problems in interpreting and displaying the results of archaeological research to Native people – especially where, so often, the different interpretations conflict with one another (and see Carmichael *et al.*, 1994). However, if these professionals cannot work with and appreciate the beliefs and feelings of those that they often most directly affect, then what hope is there of changing the common charge that archaeology is simply a self-indulgent pastime?

Similarly, the idea of a common curriculum across countries that contain culturally diverse groups has led to educational systems which are often insensitive to the different intellectual and social traditions of the students they are trying to reach (Belgarde, 1994). This is not a particularly new observation and was, for example, at the heart of Kenyatta's dislike of European education:

> We have therefore to ask ourselves whether a system of [indigenous pre-Colonial] education which proves so successful in realising its particular objectives may not have some valuable suggestion to offer or advice to give to the European whose assumed task it is in these days to provide Western education for the African.
>
> (Kenyatta, 1938:120)

The failure of western-style education even to take note of indigenous methods of education has resulted, in many instances, in the alienation of the majority of Native students (Belgarde, 1994; Blancke and Slow Turtle, 1994; Devine, 1994). Several authors advocate new approaches to curriculum, which make use of the educational insights of traditional Native teachers, rather than simply relying on western-oriented and educated curriculum theorists (Ahler, 1994;

Devine, 1994; Jamieson, 1994). Others go even further, arguing for an integration of 'universal' and Native approaches (Blancke and Slow Turtle 1994) or placing Native students in tertiary education in their own schools (Belgarde, 1994; also see Burger, 1990:146–7). Of fundamental importance here is that most 'indigenous' systems of education have a strong foundation in the traditional beliefs of their particular group. By imposing western-style curricula on indigenous peoples' educationalists have – often as a conscious decision – removed them from their own cultural heritage (see, for example, Barlow, 1990; Kehoe, 1990; Watson, 1990).

The future

There are eight specific ways in which those committed to the teaching of the past, which includes the evidence of archaeology, and the viewpoints of indigenous groups, can help to bring about such an extension of school history and public presentation and interpretation. Wherever possible they should:

- develop professional courses in collaboration with education authorities in the presentation of archaeological evidence and indigenous viewpoints;
- stress the importance of communicating about their work in archaeology undergraduate programmes;
- educate student and practising teachers about the 'excluded past';
- publish their research in language accessible to teachers and students;
- develop contacts with the media – through television, radio, newspapers and popular publications;
- develop stronger links between traditional museum display and good educational practice;
- train museum staff in the educational value of their displays and collections;
- accept that those involved in education have their own agendas and priorities as to the role of the past in teaching.

These eight steps are not a panacea that will, overnight, change the way the past is interpreted, taught and presented. However, they do combine to form the first steps of a programme that should begin to change the way the past is taught.

References

Adandé, A.B.A. and Zevounou, F. (1994) 'Education and heritage: an example of new work in the schools of Benin', in Stone, P. and Molyneaux, B. (eds), op. cit.

Addyman, P. (1991) *Tourism and the Presentation of Monuments in Zimbabwe*, Harare: UNDP/ Unesco.

Ahler, J.G. (1994) 'The benefits of multicultural education for American Indian schools: an anthropological perspective', in Stone, P. and Molyneaux, B. (eds), op. cit.

Alcock, L. (1975) *The Discipline of Archaeology*, Glasgow: College Courant.

Andah, B.W. (1990) *Cultural Resource Management: An African Dimension*, Ibadan: Wisdom.

Barlow, A. (1990) 'Still civilizing? Aborigines in Australian education', in Stone, P. and MacKenzie, R. (eds), op. cit.

Belgarde, M.J. (1994) 'The transfer of American Indian and other minority community college students', in Stone, P. and Molyneaux, B. (eds), op. cit.

Bender, S. and Wilkinson, R. (1992) 'Public education and the academy', *Archaeology and Public Education*, 3, 1–3.

Blancke, S. and Slow Turtle, C.J.P. (1994) 'Traditional American India education as a palliative to western education', in Stone, P. and Molyneaux, B. (eds), op. cit.

Borman, R. (1994) '"The fascinating world of Stonehenge": an exhibition and its aftermath', in Stone, P. and Molyneaux, B. (eds), op. cit.

Boylan, P.J. (1991) 'Museums and cultural identity', *Museum Visitor*, 9–11.

Burger, J. (1990) *The Gaia Atlas of First Peoples*, London: Robertson McCarta.

Carmichael, D., Hubert, J., Reeves, B. and Schanche, A. (eds) (1994) *Sacred Sites, Sacred Places*, London: Routledge.

Corbishley, M. and Stone, P.G. (1994) 'The teaching of the past in formal school curricula in England', in Stone, P. and Molyneaux, B. (eds), op. cit.

Cleere, H.F. (ed.) (1984) *Approaches to the Archaeological Heritage*, Cambridge: Cambridge University Press.

—— (ed.) (1989) *Archaeological Heritage Management in the Modern World*, London: Unwin Hyman.

Collett, D.P. (1992) *The Archaeological Heritage of Zimbabwe: A Masterplan for Resource Conservation and Development*, Harare: UNDP/Unesco.

Dahiya, N. (1994) 'A case for archaeology in formal school curricula in India', in Stone, P. and Molyneaux, B. (eds), op. cit.

Davis, H. (1989) 'Is an archaeological site important to science or to the public, and is there a difference?' in Uzzell, D. (ed.), op. cit.

Delgado Cerón, I and Mz-Recaman, C.I. (1994) 'The museum comes to school in Colombia: teaching packages as a method of learning', in Stone, P. and Molyneaux, B. (eds), op. cit.

Devine, H. (1994) 'Archaeology, prehistory and the Native Learning Resources Project: Alberta, Canada', in Stone, P. and Molyneaux, B. (eds), op. cit.

Dimbleby, G. (1977) 'Training the environmental archaeologist', *Bulletin of the Institute of Archaeology*, 14, 1–12.

Ekechukwu, L.C. (1990) 'Encouraging national development through the promotion of tourism: the place of archaeology', in Andah, B.W. (ed.), op. cit.

de Giraldo, E.M. (1994) 'The Colegio Nueve Granada Archaeological Museum, Colombia: a proposal for the development of educational museums in schools', in Stone, P. and Molyneaux, B. (eds), op. cit.

Ereira, A. (1990) *The Heart of the World*, London: Jonathan Cape.

Evans, J. (1975) *Archaeology as Education and Profession*, London: Institute of Archaeology.

Frost, J. (1983) *Archaeology and the Media*, unpublished BA dissertation, Department of Roman Studies, Institute of Archaeology, London.

Gathercole, P. and Lowenthal, D. (eds) (1990) *The Politics of the Past*, London: Unwin Hyman.

Gregory, T. (1986) 'Whose fault is treasure-hunting?' in Dobinson, C. and Gilchrist, R. (eds), *Archaeology, Politics and the Public*, York: York University Publications.

Groneman, B. (1992) 'A response to Blanchard', *Archaeology and Public Education*, 3, 9–10.

Hall, J. (1991) 'Museum education: adapting to a changing South Africa', *Journal of Education in Museums*, 12, 10–14.

Her Majesty's Inspectorate (1990) *A Survey of Local Education Authorities' and Schools' Liaison with Museum Services*, London: HMSO.

Hewison, R. (1987) *The Heritage Industry*, London: Methuen.

Hoare, R. (1983) *Archaeology, The Public and the Media*, unpublished MA dissertation, Department of Archaeology, University of Edinburgh.

Hodder, I. (1986) *Reading the Past*, Cambridge: Cambridge University Press.

Hooper-Greenhill, E. (1991a) *Museum and Gallery Education*, Leicester: Leicester University Press.

——— (1991b) *Writing a Museum Education Policy*, Leicester: Department of Museum Studies.

——— (ed.) (1989) *Initiatives in Museum Education*, Leicester: Department of Museum Studies.

Hubert, J. (1989) 'A proper place for the dead: a critical review of the "reburial issue"', in Layton, R. (ed.), op. cit.

——— (1991) 'After the Vermillion Accord: developments in the "reburial issue"', *World Archaeological Bulletin*, 5, 113–18.

Jamieson, J. (1994) 'One view of Native education in the Northwest Territories, Canada', in Stone, P. and Molyneaux, B. (eds), op. cit.

Kehoe, A. (1990) '"In 1492 Columbus sailed …": the primacy of the national myth in American schools', in Stone, P. and MacKenzie, R. (eds), op. cit.

Kenyatta, J. (1938) *Facing Mount Kenya*, Nairobi: Secker & Warburg.

Kiyaga-Mulindwa, D. and Segobye. A.K. (1994) 'Archaeology and education in Botswana', in Stone, P. and Molyneaux, B. (eds), op. cit.

López, C.E. and Reyes, M. (1994) 'The role of archaeology in marginalized areas of social conflict: research in the Middle Magdalena region, Colombia', in Stone, P. and Molyneaux, B. (eds), op. cit.

Layton, R. (ed.) (1989) *Who Needs the Past?* London: Unwin Hyman.

——— (ed.) (1990) *Conflict in the Archaeology of Living Traditions*, London: Unwin Hyman.

Lowenthal, D. (1985) *The Past is a Foreign Country*, Cambridge: Cambridge University Press.

——— (1993) 'Remembering to forget', *Museums Journal*, June, 20–2.

MacKenzie, R. and Stone, P. (1990) 'Introduction', in Stone, P. and MacKenzie, R. (eds), op. cit.

Masson, P and Guillot, H. (1994) 'Archaeofiction with upper primary-school children 1988–1989', in Stone, P. and Molyneaux, B. (eds), op. cit.

Mazel, A. and Ritchie, G. (1994) 'Museums and their messages: the display of the pre- and early colonial past in the museums of South Africa, Botswana and Zimbabwe', in Stone, P. and Molyneaux, B. (eds), op. cit.

Mbunwe-Samba, P., Niba, M.L. and Akenji, N.I. (1994) 'Archaeology in the schools and museums of Cameroon', in Stone, P. and Molyneaux, B. (eds), op. cit.

McManamon, F.P. (1994) 'Presenting archaeology to the public in the USA', in Stone, P. and Molyneaux, B. (eds), op. cit.

Mikolajczyk, A. (1994) 'What is the public's perception of museum visiting in Poland?', in Stone, P. and Molyneaux, B. (eds), op. cit.

Momin, K.N. and Pratap, A. (1994) 'Indian museums and the public', in Stone, P. and Molyneaux, B. (eds), op. cit.

Nzewunwa, N. (1994) 'The Nigerian teacher and museum culture', in Stone, P. and Molyneaux, B. (eds), op. cit.

Olofsson, U.K. (ed.) (1979) *Museums and Children*, Paris: Unesco.

Planel, P.G. (1994) 'Privacy and community through medieval material culture', in Stone, P. and Molyneaux, B. (eds), op. cit.

Podgorny, I. (1994) 'Choosing ancestors: the primary education syllabuses in Buenos Aires, Argentina, between 1975 and 1990', in Stone, P. and Molyneaux, B. (eds), op. cit.

Pwiti, G. (1994) 'Prehistory, archaeology and education in Zimbabwe', in Stone, P. and Molyneaux, B. (eds), op. cit.

Raina, V.K. (1992) 'Instructional strategies used by Indian history teachers', *Teaching History*, April, 24–7.

Ramírez, R.R. (1994) 'Creative workshops: a teaching method in Colombian museums', in Stone, P. and Molyneaux, B. (eds), op. cit.

Reeve, J. (1989) 'Training of all museum staff for educational awareness', in Hooper-Greenhill, E. (ed.), op. cit.

Renfrew, C. (1982) *Towards an Archaeology of Mind*, Cambridge: Cambridge University Press.

Richardson, W. (ed.) (1988) 'Papers from Archaeology Meets Education conference', *CBA Educational Bulletin*, 6.

Riley, T.J. (1992) 'The roots of Illinois: a teacher institute', *Archaeology and Public Education*, 3, 6–7.

Seedon, H. (1994) 'Archaeology and the public in Lebanon: developments since 1986', in Stone, P. and Molyneaux, B. (eds), op. cit.

Shanks, M. and Tilley, C. (1987) *Re-constructing Archaeology*, Cambridge: Cambridge University Press.

Stone, P. (1992) 'The Magnificent Seven: reasons for teaching about prehistory', *Teaching History*, October, 13–18.

—— (1994a) 'The re-display of the Alexander Keiller Museum, Avebury and the National Curriculum in England', in Stone, P. and Molyneaux, B. (eds), op. cit.

—— (1994b) *Report on the Development of the Education Service of the National Museums and Monuments of Zimbabwe*, London: English Heritage.

—— and MacKenzie, R. (eds) (1990) *The Excluded Past: Archaeology in Education*, London: Unwin Hyman.

—— and Molyneaux, B. (eds) (1994) *The Presented Past: Heritage, Museums and Education*, London and New York: Routledge.

Ucko, P.J. (1994) 'Museums and sites: cultures of the past within education – Zimbabwe, some ten years on', in Stone, P. and Molyneaux, B. (eds), op. cit.

Uzzell, D. (1989) *Heritage Interpretation: The Natural and Built Environment*, London: Belhaven.

Watson, L. (1990) 'The affirmation of indigenous values in a colonial education system', in Stone, P. and MacKenzie, R. (eds), op. cit.

Wright, P. (1985) *On Living in an Old Country*, Thetford: Thetford Press.

Wade, P. (1994) 'Blacks, Indians and the state in Colombia', in Stone, P. and Molyneaux, B. (eds), op. cit.

Wandibba, S. (1994) 'Archaeology and education in Kenya: the present and the future', in Stone, P. and Molyneaux, B. (eds), op. cit.

White, N.M. and Williams, J.R. (1994) 'Public education and archaeology in Florida, USA: an overview and case study', in Stone, P. and Molyneaux, B. (eds), op. cit.

Witz, L. and Hamilto, C. (1994) 'Reaping the whirlwind: the *Reader's Digest Illustrated History of South Africa* and changing popular perceptions of history', in Stone, P. and Molyneaux, B. (eds), op. cit.

Zimmerman, L.J., Dasovich, S., Engstrom, M. and Bradley, L.E. (1994) 'Listening to the teachers: warnings about the use of archaeological agendas in classrooms in the United States', in Stone, P. and Molyneaux, B. (eds), op. cit.

Understanding the social impact of museums, galleries and heritage through the concept of capital

Andrew Newman

Drawing from the work of Bourdieu, literature in museum and heritage studies often makes reference to the notion of 'cultural capital': a form of capital that people are perceived to need to fully benefit from museum and gallery visiting. This form of capital can be acquired and accumulated, although it is always more easily done by those from culturally dominant groups. However, when considering the social impacts and benefits that people can acquire through visiting museums, galleries and heritage sites, it may be useful to consider other forms of capital.

In this chapter the notions of 'human', 'social' and 'identity' capital are considered and used to describe a wider range of benefits that may be accrued when people visit and engage with museums, galleries and heritage. The acquisition of these other forms of capital, in addition to cultural capital, can benefit individuals and society as new skills, abilities and values are acquired and accumulated. These forms of capital are important for determining the value and impact of museums, galleries and heritage.

Introduction

The aim of this chapter is to present an analysis of the social impact of museums, galleries and heritage. This will be viewed in terms of the acquisition of various forms of capital. It will attempt to determine the ability of such an analysis to effectively describe the museum, gallery and heritage experience.

Published research into the social impact of museums, galleries or heritage is wide ranging. For example, material culture (Pearce, 2000) and learning theory (Hein, 1998; Falk and Dierking, 1992, 2000) seek to explain this process. Authors such as Dicks (2000) have presented a range of sociological perspectives, such as a return to the past, nostalgia, reminiscence, identity in terms of place, nationalism, memorialism and politics, heritage as a communication medium including the encoding and decoding of messages and imagined communities.[1] Consideration of the physical processes influencing social impact includes the study of memory (Kavanagh, 2000; Crane, 2000) and emotion, physicality and performativity[2] (Bagnall, 1996). However, despite the above, there is still much uncertainty about the ways that people interact with museums, galleries or heritage.

Apart from academic interest, understanding this process has considerable importance to museum, gallery and heritage policy construction and practice. For example, the UK Labour

Party Administration, elected in 1997, attempted to use all aspects of government, including museums, galleries and heritage, as agents of social policy to resolve problems of social exclusion[3] (Social Exclusion Unit, 1998, 2001). This resulted in a series of policy guidance publications which presented strategies that were designed to assist museums, galleries and heritage organizations in this objective (Department for Culture, Media and Sport, 2000, 2002). Organizations such as English Heritage[4] and the National Trust[5] were being expected to have a clear social benefit and to see their role as going beyond the preservation of the built environment to become more focused upon the needs of users. However, the success of such an approach was dependent upon having a clear understanding of the impact of museums, galleries and heritage. Without this, it is extremely difficult for policy, which aims to achieve certain defined outputs, to be successful. An understanding of the processes involved is also important for practitioners who view their ability to effectively communicate with audiences as extremely important. For example, if an organization sees its aim as primarily educational, it is essential to know how people interact with the museum gallery or heritage site and so how learning occurs if that aim is to be achieved.

This chapter uses the concept of capital, as in its various forms it has been used to describe the benefits that might be accrued by an individual by developing certain knowledge, skills and abilities. This makes it useful in an attempt to understand what the public gains from engagement with museums, galleries and heritage. This has already been used in a cultural context by Bourdieu (1984) in terms of 'cultural capital' but will, here, be extended to include 'human', 'social' and 'identity' capital, as described by Cote (1996). Human and 'social capital' are seen as resources that can support sustainable economic and social development (Healy *et al.*, 2001). 'Cultural capital' (Bourdieu, 1984) helps to explain the accessibility of museums and galleries and 'identity capital' (Cote, 1996) was proposed to replace 'human', 'social' and 'cultural capital' as more relevant in modern society.

This chapter will define 'human', 'social', 'cultural' and 'identity capital' and then make links with the perceived functions of museums, galleries and heritage. It will then draw conclusions as to the ways that capital can provide a way of understanding the impact of museums, galleries and heritage.

Human capital

Cote (2001) stated that the term 'human capital' was first used in the early 1960s by economists such as Schultz (1961), who considered the idea of viewing human beings as a form of capital who are invested in and invest in themselves. He stated that 'human capital' was increasing at a much greater rate than non 'human capital' and this was responsible for a significant proportion of post-war economic progress. 'Human capital' has been defined as: 'the knowledge, skills, competencies and attributes embodied in individuals that facilitate the creation of personal, social and economic well being' (Healy *et al.*, 2001:18).

Becker (1993) used the economic returns of educational attainment as a way of measuring 'human capital'. He identified that the average income of those with a college education was higher than those who do not have one. However, Cote (2001) criticized such an approach, as it ignores the complex nature of human learning which will occur over a lifetime. Much research has focused on the economic benefits of the acquisition of knowledge and skills, but other research has demonstrated its wider social benefits (Behrman and Stacey, 1997). The acquisition of 'human capital' appears to have a beneficial impact upon health, reduces crime and increases civic participation.

Although museum, gallery and heritage literature does not refer to 'human capital', the acquisition of knowledge and skills is fundamental to the ways that they are perceived to function. This is demonstrated by the definition of museums and galleries adopted by the International Council of Museums[6] (ICOM) in 1989 (amended in 2001, based on a definition adopted in 1974).

> A museum is a non-profit making, permanent institution in the service of society and of its development, and open to the public, which acquires, conserves, researches, communicates and exhibits, for purposes of study, education and enjoyment, material evidence of people and their environment.[7]

The purposes of museums and galleries, according to this definition, of study, education and enjoyment, are in close agreement to the personal and social well-being elements of the definition of 'human capital' given above.

Hooper-Greenhill (1991) traced the development of museum and gallery education and stated that museums and galleries started out at the beginning of the nineteenth century primarily as educational establishments and in recent years have refocused upon that objective. The importance of the educational function is illustrated in a report to the Department of National Heritage[8] (Anderson, 1997), where museums were encouraged to develop as learning organizations with education central to their purpose. The care and display of collections was no longer seen as sufficient justification for their existence.

The most significant educational contribution of museums, galleries and heritage is in informal learning. This has been described by Falk and Dierking (2000) as free-choice learning that is context driven. This does not focus upon what things have been learnt from a particular experience, but in the ways that those things contribute to or interact with what the learner already knows. Learning then is influenced by the context that the learner exists within. The contexts given are personal, physical and sociocultural; these are considered to be interrelated and of fundamental importance to the ways that people learn. While this model was written from the point of view of museums and galleries, the principles are equally applicable to all free-choice learning environments, including heritage sites and the wider historic and natural environment.

There is also a tradition of community development projects based in museums, galleries and heritage organizations which aim to provide participants with useful skills. These mainly focus upon social and personal development, but also might provide participants with skills that may facilitate individuals obtaining employment. An example is the Living Museum of the West in Melbourne, Australia (Sandell, 1998:143), that provided training for the local community with the aim of enabling people to gain employment after the lifetime of the project. Further accounts of the impact of learning in terms of skills are given in *Renaissance in the Regions – a New Vision for England's Museums* (Resource, 2001:36–42) and *People and Places Social Inclusion Policy for the Built and Historic Environment* (Department for Culture, Media and Sport, 2002:14).

There are limited examples in the literature of 'human capital' being developed by cultural activities being used consciously to encourage large-scale economic development. While a number of studies have considered the economic impact of museums or the arts (Brand *et al.*, 2000; Myerscough, 1988), they do not separately consider the impact of 'human capital'. However, in a report, by the *Economic Review Subcommittee on Enhancing Human Capital* of the Government of Singapore (2002), it was argued that there was a direct relationship between the creativity of the workforce and economic development. The involvement of people in the arts, culture, sports and recreation would facilitate the change from an economy based upon manufacturing to one based upon knowledge and innovation.

The above demonstrates that members of the public use heritage, museum and gallery resources to aid the development of 'human capital'. The term itself is not in common usage, but the concept is firmly established.

Social capital

'Social capital' is based upon the relationships between people and the concept has called attention to the importance of civic traditions (Cote, 2001). Trust is considered an important outcome of investment in this sort of capital and it is seen as essential to many aspects of society. Three types are identified: 'bonding' that relates to links with members of families or ethnic groups; 'bridging' that refers to links with distant friends, associates and colleagues and, finally, 'linking' that refers to relations between different social strata, or between the powerful and less powerful. It is viewed (Healy *et al.*, 2001:39) as relational, not being the property of a single individual and produced by investments that are not as direct as investment in physical capital. A further source of 'social capital' is seen as civil society, the development of associations and voluntary organizations. The greater the investment in 'social capital' amongst a group, the greater the social cohesion of that group will be. The definition of bonding social capital might also include links with imagined communities (Anderson, 1983; Calhoun, 1991; Phillips, 2002), which are tied together by facets of perceived identity rather than interpersonal contact.

An influential study on 'social capital' has been written by Putnam (2001), who charts the decline in political and community participation seen in American society. Using considerable supporting evidence the author presents possible reasons for this, such as pressures of time and money, mobility and sprawl, technology and the mass media. Evidence is presented linking 'social capital' with health and happiness, democracy, and safe and productive neighbourhoods. Finally, a series of recommendations are made to reinvigorate American communities. Further research linking 'social capital' with health was given by Veenstra (2001), who suggested that societies with excessive income inequality are those with low social cohesion and so low 'social capital', and this results in poor health. Glaeser (2001) provided an overview of the formation of 'social capital', proposing that the process starts with individual decisions. It is postulated that a greater investment in 'social capital' is made if an individual has decided to live in a particular community for a length of time.

The view that museums and galleries have a part to play in their communities has a long history, but the form it takes now dates to what has been described as the 'second museum revolution' in the mid-1960s (Van Mench, 1995). This saw museums and galleries as social institutions with political agendas becoming much more concerned with people than they had been previously. An important element of this social responsibility was the fact that museums and galleries were seen as civic organizations and part of the community that they served. An example of this is the American Association of Museum's *Museums and Community Initiative,* which was established in 1998 to 'explore the potential for renewed, dynamic engagement between museums and communities'.[9] The research phase included six community dialogues, one of which took place at Bellingham, Washington in 2001.[10] The sessions focused upon 'finding creative solutions that build 'social capital' and support healthy communities'. The emphasis was on exploring museums' civic role in a way that facilitated social cohesion. It was suggested that museums can assist in the development of 'social capital' because they are comfortable, accessible, enjoyable and trusted places. Support for the view that museums have a role to play is given in the results of a report of an initiative that was designed to measure the social impact of museums, libraries and archives (Bryson and Usherwood, 2002:7). It was stated

that, 'respondents clearly perceived the cultural organisations examined in this study as providing resources for building 'social capital'. Possible mechanisms for the development of 'social capital' are involvement through volunteering, and community development projects.

The importance of heritage in terms of the built and historic environment, in providing the setting through which communities can be strengthened and so 'social capital' may be developed, is emphasized in *People and Places, Social Inclusion Policy for the Built and Historic Environment* (Department for Culture, Media and Sport, 2002:3). Tessa Jowell[11] stated in the foreword that:

> physical structures are vital in defining a community, with a high quality well managed built environment essential for community cohesion. But in many of our poorest neighbourhoods, poor quality buildings and public space have contributed to decline.

The report goes on to say that:

> getting involved with improving the local built environment can lead to positive social and educational outcomes including raising skills, raising aspirations for a neighbourhood, and building a sense of community.

The built environment provides the potential to facilitate 'social capital' through allowing people to feel connected with their culture, so contributing to active citizenship.[12] The report encourages the development of strategies that involve communities in the planning process.

From the above, it can be demonstrated that while the roles and functions of museums, galleries and heritage sites can be mapped onto the definitions of 'human' and 'social capital' there is much overlap. A museum, gallery or heritage site might provide evidence of both elements. The literature provides support for this view; for example, Coleman (1988), quoted in Healy *et al.* (2001:13) stated that 'the role of strong communities and trust among parents, educators and pupils in fostering learning' and 'education and learning can support habits, skills and values conducive to social participation'.

'Cultural capital' and 'identity capital' have grown out of research on the nature of society. They are distinct from 'human' and 'social capital' in that they are more abstract and have fewer direct links to social policy.

Cultural capital

Bourdieu (1997) described 'cultural capital' as existing in three forms: in an embodied state; an objectified state in the form of cultural goods; and in an institutionalized state that confers original properties on 'cultural capital' that it is presumed to guarantee, for example, educational qualifications. Gershuny (2002:8–9) defines it as, 'knowledge related to the participation in, and enjoyment of the various forms of consumption in society. Specific knowledge about consumption contributes to an individual's satisfaction with their consumption'. 'Cultural capital' is used by Bourdieu and Darbel (1997:37) to explain the ways that visitors behave in museums and galleries. They stated that, 'it is indisputable that our society offers to all the pure possibility of taking advantage of works (of art) on display in museums, it remains the case that only some have the real possibility of doing so'. They go on to say that the time a visitor takes to view a work of art is directly in proportion to the ability of the viewer to decipher the range of meanings that are available to them. Works of art, when considered as symbolic goods, only can be fully understood by those who have sufficient 'cultural capital' to interpret the coded meanings held within them and

this may be correlated with educational attainment. The greater the educational attainment, the longer a visitor spends viewing the work of art. This process is further explored by Bourdieu (1993:215).

It is possible to suggest that this situation can be equally applied to the museum or gallery itself as an institution and that different collection types such as social history, or for example a heritage site, might be decodeable (Hall, 1980) by people with a different sort of 'cultural capital' to that needed to help the decoding of works of art. Bourdieu's work has been criticized for its overemphasis on class, for example in Bourdieu (1984), where a hierarchy of taste is constructed, and for not recognizing the role of viewer or participant sufficiently in constructing meanings (Du Gay *et al.*, 1997:98).

While the principles described above have been established within an art gallery, they are equally applicable to heritage sites and the built environment. In order to understand the messages being conveyed at, for example, a country house, interpreted archaeological site or preserved townscape, the viewer needs to be able to decode the messages that have been encoded. In order to do this, they will need sufficient 'cultural capital'; if this is not the case, the individual will not be able to make sense out of what they encounter.

The idea of 'cultural capital' has been adopted by museums, galleries and heritage sites through the emphasis given to access in current policies guiding their management, but in an inverse manner. The approach followed is that exhibitions and activities should be designed so that those without specialized forms of capital can access the messages that are available. This means that as far as possible, technical or specialist terms, for example, are not used in interpretation and links are made to the lives of visitors. Judgements are being made about the forms of 'cultural capital' held by visitors and interpretation is being designed accordingly. Such an approach has been criticized for not sufficiently challenging visitors and not enabling them to widen the scope of their 'cultural capital' (Appleton, 1997:21).

Identity capital

Cote (1996) developed the concept of 'identity capital' as a replacement for 'human' and 'cultural capital' as being the most appropriate to modern life. He suggested that in different types of society the acquisition of particular forms of capital would become the basis of strategies that would allow an individual to effectively negotiate the difficulties that they encounter. Three forms of society are described: pre-modern, where identity is ascribed; early modern, where identity is achieved; and late modern, where identity is image orientated and managed. It is proposed that in pre-modern society 'human capital' might be the most appropriate form to invest in, in early-modern society, 'cultural capital' and in late-modern society, 'identity capital'. An individual invests in a certain identity or identities and then engages in a series of exchanges with others. The process of construction is described, 'to do this in a complex, shifting social milieu requires certain cognitive skills and personality attributes that are not imparted by 'human' or 'cultural capital', and are certainly not imparted by mass/public education systems'. 'Identity capital' is described as being tangible, elements that are socially visible, such as memberships, speech patterns and dress and also intangible, such as critical thinking abilities that give individuals the capacity to understand and negotiate various life obstacles.

The possible role played by museums, galleries and heritage in the construction of 'identity capital' might be described as being both tangible and intangible. An example of the tangible variety might be provided by visiting museums, galleries and heritage sites. This generates a visible exclusive membership, particularly seen in some galleries of modern art. In this instance,

particular forms of dress, speech and behaviour are often adopted, representing investments in a particular identity that will hopefully assist in achieving desired social outcomes. Museum, gallery and heritage site visiting may provide tangible 'identity capital' through an association with cultural property that has been imbued with value. It might be seen as an investment in the self in a similar way that, for example, the collection of paintings is an investment in an individual's identity as much as a financial investment. An example of the intangible variety might be seen in community development programmes. These are often designed to develop social skills amongst participants so they are more able to successfully manage their lives. Silverman (2002) described the *Museums as Therapeutic Agents* group that was established in Bloomington, Indiana, USA in 1997. This consisted of representatives from museums, the local university and local social service programmes. One of the aims was to provide people with the skills to lead independent lives. Those who benefited from this initiative may have not decided, in a conscious strategic way, to invest in themselves, but will have benefited from investment in 'identity capital' made on their behalf.

The descriptions of the four different types of capital given above and the attempt to map them onto the functions of museums, galleries and heritage has resulted in an analysis that represents a series of different ways of understanding their impact upon individuals and society. It is clear that it is difficult to draw boundaries around each of these approaches and in some cases overlap occurs. However, it is believed that the concepts are sufficiently different to make them useful analytical tools.

Conclusion

The four different forms of capital described above assist in understanding the impact of museums, galleries and heritage upon the public. Together they present a complex picture that illustrates and to some extent explains that impact and adds to an understanding of their consumption. They also help to provide a basis for an understanding of their contribution to social policy by presenting possible ways through which museums and galleries can contribute to society.

'Human capital' as a concept is a useful way of understanding aspects of social impact, but needs to be seen in terms of free choice constructivist learning (Falk and Dierking, 2000). Museums, galleries and heritage sites have long claimed that this was central to their function (Anderson, 1997; Hooper-Greenhill, 1991) and it remains important to practitioners.

'Social capital' appears to be an important way of describing a significant form of impact of museums, galleries and heritage sites upon visitors. It is suggested that they might be used as part of a strategy to address some of the decline in political and civic participation identified by Putnam (2001). Of the three sorts of 'social capital' identified, 'bonding', that is links between family or social groups as well as links to imagined communities, would probably dominate in museums, galleries and heritage sites, although research is needed to confirm or refute this.

The presence or absence of different forms of 'cultural capital' (Bourdieu, 1997) is a useful way of explaining the accessibility or otherwise of museums, galleries and heritage sites. It determines the ability of people to decode the messages that have been encoded and so fundamentally influences their ability to make meaning out of the resources that are available to them.

'Identity capital' is also a useful concept to analyse the impact of museums, galleries and heritage upon members of the public. The resources that they provide might be used as part of a strategy that enables people to negotiate difficulties that they encounter (Cote, 1996). Apart

from this, it might be suggested that the acquisition of 'identity capital' would provide individuals with a better understanding of the world.

It could be argued that 'human' and 'social capital' are the product of many civic organizations or where groups of people come together for various purposes, but when they are blended with 'cultural' and 'identity capital', they combine to produce a much more complex picture. Conceptualizing social impact in terms of capital embeds that impact within broader theories of society and so provides a clearer vision of the consumption of museums, galleries or heritage. The concept of capital needs to be used as the basis for the analysis of empirical research into the social impact of museums, galleries and heritage to provide evidence to support or refute the arguments presented above.

Notes

1 Imagined communities are defined as 'large collectives linked mainly by common identities but minimally by networks of directly interpersonal relationships' (Calhoun, 1991:95–6 quoted in Phillips, 2002:597).
2 Performativity is the process through which individual consumers stimulate memories using resources provided by museums and galleries.
3 The term was first used in France in the 1960s where the poorest sections of society had begun to be referred to as 'the excluded' (Silver, 1995). Rene Lenoir was the first to use the term 'social exclusion' itself in 1974, when describing different categories of people who were not covered by social insurance. The understanding of 'social exclusion' broadened in the 1980s to include the consequences of technological change and economic restructuring, known as the 'new poverty' (Gore, 1995).
4 English Heritage aims to make sure that the historic environment of England is properly maintained and cared for. The organization's social inclusion goals may be found online at www.english-heritage.org.uk (accessed 1 July 2003).
5 The National Trust, www.nationaltrust.org.uk/main/ (accessed 1 July 2003), was founded in 1895 by three Victorian philanthropists – Octavia Hill, Sir Robert Hunter and Canon Hardwicke Rawnsley. Concerned about the impact of uncontrolled development and industrialization in England, they set up the Trust to act as a guardian for the nation in the acquisition and protection of threatened coastline, countryside and buildings. A report by Hunt (2001) showed the challenges that faced that National Trust by social inclusion.
6 www.icom.museum/ (accessed 1 July 2003).
7 www.icom.museum/definition.html (accessed 1 July 2003).
8 This became the Department for Culture, Media and Sport in 1997 with the election of the Labour Party administration.
9 www.aam-us.org/initiatives/m&c/index.cfm (accessed 1 July 2003).
10 www.aam-us.org/initiatives/m&c/dialogues/bellingham.cfm (accessed 1 July 2003).
11 At the time this chapter was written, Tessa Jowell was Secretary of State for Culture, Media and Sport, a post she had held since 1998.
12 Burchell (1995:540) provided an overview of the active and passive traditions of citizenship. These are viewed as being organized as a series of oppositions, 'between a citizenship focused upon the public sphere and one focused upon the private, between liberal-individualist and communitarian impulses, between an emphasis on duties and one on rights'. The active citizen is viewed as being essentially self-created and the passive citizen the product of the social discipline associated with the activities of government.

References

Anderson, B. (1983) *Imagined Communities: Reflections on the Origin and Spread of Nationalism*, London: Verso.

Anderson, D. (1997) *A Common Wealth, Museums and Learning in the United Kingdom*, London: Department of National Heritage.

Appleton, J. (2001) *Museums for 'The People'? Conversations in Print*, London: Institute of Ideas.

Bagnall, G. (1996) 'Consuming the past', in Edgell, S., Hetherington, K. and Warde, A. (eds), *Consumption Matters*, Oxford: Blackwell.

Becker, G.S. (1993) *Human Capital: A Theoretical and Empirical Analysis, with Special Reference to Education*, Chicago: University of Chicago Press.

Behrman, J.R. and Stacey, N. (eds) (1997) *The Social Benefits of Education*, Michigan: University of Michigan Press.

Bourdieu, P. (1984) *Distinction: A Social Critique of the Judgement of Taste*, London: Routledge and Kegan Paul.

—— (1993) *The Field of Cultural Production: Essays on Art and Literature*, Oxford: Polity.

—— (1997) 'Forms of capital', in Halsey, A.H., Lauder, H., Brown, P. and Wells, A.S. (eds), *Education, Culture, Economy and Society*, Oxford and New York: Oxford University Press.

——, Schnapper, D. and Darbel A. (1997) *The Love of Art: European Art Museums and Their Public*, Oxford: Polity.

Brand, S., Gripaios, P and McVittie, E. (2000) The *Economic Contribution of Museums in the South West*, Taunton: South West Museums Council.

Bryson, J. and Usherwood, B. (2002) *South West Museums Archives and Libraries Social Impact Audit*, Tauton: South West Museum Service.

Calhoun, C. (1991) 'Indirect relationships and imagined communities', in Bourdieu, P. and Coleman, J.S. (eds), *Social Theory for a Changing Society*, Boulder: Westview.

Coleman, J. (1988) 'Social capital in the creation of human capital', *American Journal of Sociology*, 94, 95–120.

Cote, J.E. (1996) 'Sociological perspectives on identity formation: the culture-identity link and identity capital', *Journal of Adolescence*, 19, 417–28.

Cote, S. (2001) 'The contribution of human and social capital', *Canadian Journal of Policy Research*, 2(1), 29–36.

Crane, A.A. (2000) *Museums and Memory*, Stanford: Stanford University Press.

Department for Culture, Media and Sport (2000) *Centres for Social Change: Museums, Galleries and Archives for All*, London: HMSO.

—— (2002) *People and Places: Social Inclusion Policy for the Built and Historic Environment*, London: HMSO.

Dicks, B. (2000) *Heritage, Place and Community*, Cardiff: University of Wales Press.

Du Gay, P., Hall, S., Janes, L., Mackay, H. and Negus, K. (1997) *Doing Cultural Studies: The Story of the Sony Walkman*, London: Sage.

Falk, J.H. and Dierking, L.D. (1992) *The Museum Experience*, Washington: Whalesback.

—— (2000) *Learning from Museums: Visitor Experiences and the Making of Meaning*, Walnut Creek: AltaMira.

Gershuny, J. (2002) 'A new measure of social position: social mobility and human capital in Britain', *Working Papers of the Institute for Social and Economic Research*, Colchester: University of Essex.

Glaeser, E.L. (2001) 'The formation of social capital', *Canadian Journal of Policy Research*, 2(1), 34–40.

Gore, C. (1995) 'Introduction: markets, citizenship and social exclusion', in Rodgers, G., Gore, C. and Figueirdo, J.B. (eds), *Social Exclusion: Rhetoric, Reality, Responses*, Geneva: International Institute for Labour Studies.

Government of Singapore (2002) *Enhancing our Human Capital for the New Economy, Through Arts, Sports, Culture and Recreation*, Singapore: Government of Singapore.

Hall, S. (1980) 'Encoding/decoding', in Hall, S., Hobson, D., Lowe, A. and Willis, P. (eds), *Culture, Media, Language*, London: Hutchison.

Healy, T., Cote, S., Helliwell, J. and Held, S. (2001) *The Well-being of Nations, The role of Human and Social Capital*, Paris: OECD.

Hein, G.E. (1998) *Learning in the Museum*, London: Routledge

Hooper-Greenhill, E. (1991) *Museums and Gallery Education*, Leicester: Leicester University Press.

Hunt, G. (2001) *Social Exclusion and its Challenge to the National Trust*, London: National Trust.

Kavanagh, G. (2000) *Dream Spaces: Memory and the Museum*, Leicester: Leicester University Press.

Myerscough, J. (1988) *The Economic Importance of the Arts in Great Britain.* London: Policy Studies Institute.

Pearce, S. (ed.) (2000) *Researching Material Culture*, Leicester: Leicester University Press.

Phillips, T. (2002) 'Imagined communities and self-identity: an exploratory quantitative analysis', *Sociology*, 36(3), 597–617.

Putnam, R. D. (2001) *Bowling Alone: The Collapse and Revival of American Community*, London: Simon & Schuster.

Resource (2001) *Renaissance in The Regions: A New Vision for England's Museums*, London: Resource.

Sandell, R. (1998) 'Museums as agents of social inclusion', *Museum Management and Curatorship*, 17(4), 401–18.

Schultz, T.W. (1961) 'Investment in human capital', *The American Economic Review*, 51(1), 1–17.

Silver, H. (1995) 'Reconceptualizing social disadvantage: three paradigms of "social exclusion"', in Rodgers, G., Gore, C. and Figueirdo, J.B. (eds), *Social Exclusion: Rhetoric, Reality, Responses*, Geneva: International Institute for Labour Studies.

Silverman, L.H. (2002) 'The therapeutic potential of museums as pathways to inclusion', in Sandell, R. (ed.), *Museums, Society, Inequality*, London: Routledge.

Social Exclusion Unit (1998) *Bringing Britain Together: A National Strategy for Neighbourhood Renewal*, London: Social Exclusion Unit.

—— (2001) *Preventing Social Exclusion*, London: Social Exclusion Unit.

Van Mensch, P.J.A. (1995) 'Magpies on Mount Helicon', in Scharer, M. (ed.), *Museums and Community*, Paris: ICOM.

Veenstra, G. (2001) 'Social capital and health' *Canadian Journal of Policy Research*, 2(1), 72–81.

Suggested further reading for Part 2

American Association of Museums (2001) *Museum Policy and Procedure for Holocaust Era Issues: Resource Report*, Washington: AAM.

Ames, M.M. (1992) *Cannibal Tours and Glass Boxes: The Anthropology of Museums*, Vancouver: University of British Columbia Press.

Barkan, E. and Bush, R. (2003) *Claiming the Stones/Naming the Bones: Cultural Property and the Negotiation of National and Ethnic Identity*, California: Getty Research Institute.

Barringer, T. and Flynn, T. (eds) (1998) *Colonialism and the Object: Empire, Material Culture and the Museum*, London: Routledge.

Brodie, N., Doole, J. and Watson, P. (2000) *Stealing History: The Illicit Trade in Cultural Materials*, Cambridge: McDonald Institute for Archaeological Research.

Brodie, N. and Walker Tubb, E. (2001) *Illicit Antiquities: The Theft of Culture and the Extinction of Archaeology*, London: Routledge.

Butler, R.S. (1998) *Contested Representations*, Amsterdam: Gordon & Breach.

Carmichael, D.L., Hubert, J., Reeves, B. and Schanche, A. (eds) (1994) *Sacred Sites, Sacred Places*, London: Routledge.

Clavir, M. (2001) *Preserving What is Valued: Museums and First Nations*, Vancouver: University of British Columbia Press.

Cleere, H.F. (ed.) (1989) *Archaeological Heritage Management in the Modern World*, London: Unwin Hyman.

Commonwealth Association of Museums and University of Victoria (1996) *Curatorship: Indigenous Perspectives in Post-colonial Societies*, Hull: Canadian Museum of Civilisation/Commonwealth Association of Museums/University of Victoria.

Coombes, A.E. (1994) *Reinventing Africa: Museums, Material Culture and Popular Imagination in Later Victorian and Edwardian England*, London: Yale University Press.

Crooke, E. (2000) *Politics, Archaeology and the Creation of a National Museum of Ireland*, London: Irish Academic Press.

Dubin, S.C. (1999) *Displays of Power: Memory and Amnesia in the American Museum*, London: New York University Press.

Falk, H.F. and Dierking, L.D. (1992) *The Museum Experience*, Washington: Whalesback.

—— (2000) *Learning from Museums: Visitor Experiences and the Making of Meaning*, Washington DC: Walnut Creek: AltaMira.

Fforde, C., Hubert, J. and Turnbull, P. (2002) *The Dead and their Possessions: Repatriation in Principle, Policy and Practice*, London: Routledge.

Fladmark, J.M. (ed.) (1999) *Heritage and Museums: Shaping National Identity*, Shaftesbury: Donhead.

—— (2002) *Heritage and Identity: Shaping the Nations of the North*, Shaftsbury: Donhead.

Force, R.W. (1999) *Politics and the Museum of the American Indian: The Heye and the Mighty*, Honolulu: Mechas Press.

Gathercole, P. and Lowenthal, D. (1994) *The Politics of the Past*, London: Routledge.

Greenfield, J. (1996) *The Return of Cultural Treasures* (2nd edn), Cambridge: Cambridge University Press.

Hallam, E. (2000) *Cultural Encounters: Representing Otherness*, London: Routledge.

Handler, R. and Gable, E. (1997) *The New History in an Old Museum*, Durham: Duke University Press.

Hein, G.E. (1998a) *Learning in the Museum*, London: Routledge.

—— (1998b) *Museums: Places of Learning*, Washington: AAM.

Henderson, A. and Kaepler, A. (eds) (1997) *Exhibiting Dilemmas: Issues of Representation at the Smithsonian,* Washington, Smithsonian Institution.

Henson, D., Stone, P. and Corbishley, M. (eds) (2004) *Education and the Historic Environment*, London: English Heritage/Routledge.

Hooper-Greenhill, E. (1992) *Museums and the Shaping of Knowledge*, London: Routledge.

—— (1999) The *Educational Role of the Museum* (2nd edn), London: Routledge.

—— (ed.) (1995) *Museum, Media, Message*, London: Routledge.

—— (ed.) (1996) *Cultural Diversity: Developing Museum Audiences in Britain,* London: Leicester University Press.

ICOM (1995) *Illicit Traffic of Cultural Property in Africa*, Paris: ICOM.

—— (1996) *Illicit Traffic of Cultural Property in Latin America*, Paris: ICOM.

Kaplan, F.E.S. (ed.) (1994) *Museums and the Making of 'Ourselves': The Role of Objects in National Identity,* London: Leicester University Press.

Karp, I. and Lavine, S.D. (eds) (1990) *Exhibiting Culture: The Poetics and Politics of Museum Display*, Washington: Smithsonian Institution.

Kawasaki, A. (ed.) (2000) *The Changing Presentation of the American Indian: Museums and Native Cultures*, Washington: Smithsonian Institution.

Kowalski, W.W. and Schadla-Hall, R.T. (ed.) (1998) *Art Treasures and War: A Study on the Restitution of Looted Cultural Property, Pursuant to Public International Law,* London: Institute of Art and Law.

Kreps, C.F. (2003) *Liberating Culture: Cross-Cultural Perspectives on Museums, Curation and Heritage Preservation*, London: Routledge.

Layton, R. (ed.) (1989) *Conflicts in the Archaeology of Living Traditions*, London: Unwin Hyman.

——, Stone, P. and Thomas, J. (eds) (2001) *Destruction and Conservation of Cultural Property*, London: Routledge.

Leggett, J. (2000) *Restitution and Repatriation: Guidelines for Good Practice*, London: Museums and Galleries Commission.

Lidchi, H. (1997) 'The poetics and politics of exhibiting other cultures', in Hall, S. (ed.), *Representation: Cultural Representations and Signifying Practices*, London: Sage/Open University.

Linenthal, E. (2001) *Preserving Memory: The Struggle to Create America's Holocaust Museum*, Columbia: Columbia University Press.

Luke, T.W. (2002) *Museum Politics: Power Plays at the Exhibition*, Minneapolis: University of Minnesota Press.

Macdonald, S. (ed.) (1998) *The Politics of Display: Museums, Science and Culture*, London: Routledge.

McManamon, F.P. and Hatton, A. (2000) *Cultural Resource Management in Contemporary Society: Perspectives on Managing and Presenting the Past*, London: Routledge.

McManus, P.M. (ed.) (1996) *Archaeological Displays and the Public: Museology and Interpretation*, London: Institute of Archaeology.

Meister, B. (ed.) (1996) *Mending the Circle: A Native American Repatriation Guide*, New York: The American Indian Ritual Object Repatriation Foundation.

Messenger, P.M. (ed.) *The Ethics of Collecting Cultural Property: Whose Culture? Whose Property?* Albuquerque: University of New Mexico Press.

O'Keefe, P.J. (1997) *Trade in Antiquities: Reducing Destruction and Theft*, London: Archetype Publications/Paris: UNESCO.

Palmer, M. (2000) *Museums and the Holocaust*, Washington: AAM.

Pearson, M. and Sullivan, S. (1995) *Looking after Heritage Places: The Basics of Heritage Planning for Managers, Landowners and Administrators*, Victoria: Melbourne University Press.

Peers, L. and Brown, A.K. (2003) *Museums and Source Communities*, London: Routledge.

Renfrew, C (2000) *Loot, Legitimacy and Ownership*, London: Duckworth.

Shackley, M. (2001) *Managing Sacred Sites: Service Provision and Visitor Experience*, London: Continuum.

Sherman, D. and Rogoff. I. (eds) (1994) *Museum Culture: Histories, Discourses, Spectacles*, London: Routledge.

Simpson, M. (1997) *Museums and Repatriation: An Account of Contested Items in Museum Collections in the UK, with Comparative Material from Other Countries*, London: Museums Association.

—— (2001) *Making Representations: Museums in a Post-Colonial Era* (2nd edn), London: Routledge.

Stone, P. and MacKenzie, R. (eds) (1990) *The Excluded Past: Archaeology in Education*, London: Routledge.

Stone, P. and Molyneaux, B. (eds) (1994) *The Presented Past: Heritage, Museums and Education*, London: Routledge.

Stone, P. and Planel, P. (eds) (1999) *The Constructed Past: Experimental Archaeology, Education and the Public*, London: Routledge.

Tunbridge, J.E. and Ashworth, G.J. (eds) (1996) *Dissonant Heritage: The Management of the Past as a Resource in Conflict*, London: Wiley.

Wallace, M. (1996) *Mickey Mouse History, and Other Essays on American Memory*, Philadelphia: Temple University Press.

Walsh, K. (1992) *The Representation of the Past: Museums and Heritage in the Post-Modern World*, London: Routledge.

Weil, S. (1985) *Beauty and the Beasts: On Museums, Art, the Law, and the Market*, Washington: Smithsonian Institution.

West, R. *et al.* (2000) *The Changing Presentation of the American Indian: Museums and Native Cultures*. Washington: Smithsonian Institution.

Heritage and cultural tourism

19

Heritage
A key sector in the 'new' tourism

Richard Prentice

A key change has taken place within the tourism industry since the 1980s. This change has been the increasing fragmentation and specialization of tourism products and destinations for a growing number of new niche markets within the overall tourism mass market. Within this 'new' tourism, heritage tourism has taken its place as a significant sector. Indeed, heritage tourism has become big business.

This chapter is important for showing how heritage tourism, although not necessarily new, has become a key sector in the 'new' tourism. The segmentation and diversification within contemporary tourism is reflected in heritage tourism itself, and the piece is useful in terms of showing the diversity of heritage attractions within a general typology, with twenty-three broad divisions, each with its own supplementary subdivisions. The danger in viewing this variety of heritage attractions as a single 'industry' is expressed. The distinctiveness of each attraction means that it is currently impossible to develop universal characteristics that can be attributed across the board, or to formulate generalizations. More surveys and research needs to be done before any real comparisons can be made or basic patterns established. The chapter continues by drawing attention to issues relating to the sustainability of, and competition between, the multiplying numbers of heritage attractions. It then goes on to introduce issues concerning the demand for heritage products in terms of visitor profiles, visitor motivations and benefits sought during visits, before finally considering the implications this has for the future developments of interpretative strategies and the use of different media at heritage attractions.

The significance of heritage tourism

Heritage tourism needs to be seen as one element of supply and demand within the wider 'new' tourism industry. Poon (1989) described this 'new' industry as characterized by flexibility, segmentation and diagonal integration, in contrast to the mass, standardized and rigidly packaged 'old' tourism of the three decades preceding the 1980s. Important to the understanding of contemporary tourism is that the mass market is splitting apart and that products are being developed to meet this diverse market. 'Heritage' as a tourism product is one such development. Even potentially negative images can be positively sold under the heritage theme; for example, redundant coal-mining infrastructure and waterfronts are now offered as part of a heritage product. The selling of Cape Breton Island in Nova Scotia as a tourist destination is a seminal example of the power of heritage imagery. Cape Breton Island has its own tartan, evoking both Scottish and landscape heritage, with the colours of this tartan, which is essentially green in colour, poetically described to tourists as:

> Black for the wealth of our coal mines,
> Grey for our Cape Breton steel,
> Green for our lofty mountains;
> Our valleys and our fields;
>
> Gold for the golden sunsets
> Shining bright on the lakes of Bras d'Or,
> To show us God's hand has lingered
> To bless Cape Breton's shores.

In this way, even the island's heavy industrial past is evoked as a *positive* part of the tourism place-image of Cape Breton Island. The presumed power of heritage imagery can be seen likewise in the case of England and Wales, which are becoming a land of 'tourism centres' (Figure 19.1), largely dominated by reference to historic and literary figures or landscape features; associations with historic persons and landscape features also recur as secondary promotional themes across England (Figure 19.2). Associations of this kind are not peculiar to Britain; for example, in 1992 Oklahoma was promoted as *Native America,* exploiting its Indian heritage for tourism. England and Wales now have both *heritage coasts* and *heritage landscapes*, the former an official and the latter an unofficial labelling (Countryside Commission, 1988, 1989). References and labels of this kind unambiguously confirm that for promotional as well as protective purposes heritage associations have become a central element of the 'new' tourism: however, the promotional value of heritage associations does not end with tourism, and as such tourism needs to be seen as part of a wider usage. For example, one British clearing bank offers a National Trust credit card, making payments to the Trust as the card is used; 'So, the more you use your card, the more you help to keep our country beautiful'.[1] Among other uses, Stonehenge has been used to promote the image of reliability and chunkiness for biscuits, the permanency of double glazing and perfection in surveying competence (Crouch and Colin, 1992).

'Heritage' is in the literal sense something that is inherited: 'The word "heritage" means an inheritance or a legacy; things of value which have been passed from one generation to the next' (Parks Canada, undated, p. 7). In this sense, cultural heritage is cultural *property*, and in extreme cases may be fought over or otherwise physically appropriated (Eirinberg, 1992). However, this is only loosely how the term 'heritage' has in the past fifteen years come to be used in tourism. Essentially in tourism the term has come to mean not only landscapes, natural history, buildings, artefacts, cultural traditions and the like, which are either literally or metaphorically passed on from one generation to the other, but those among these things which can be portrayed for promotion as tourism products. As a term, 'heritage' came to the fore in the 1970s in Europe, and throughout the 1980s expanded increasingly to encompass other aspects and to be used increasingly for commercial purposes. In the developing world, 'ecotourism' has been a growing mass tourism sector with markets in the developed world; a form of heritage tourism based on the natural ecological attractions of developing countries, with tourist activities ranging from snorkelling off coral reefs to game viewing in savannah grasslands (Cater, 1992).

If a benchmark for the start of heritage consumption as a mass demand in Europe is desired, however imperfect this benchmark might be, European Architectural Heritage Year of 1975 is probably the best claimant for this, for not only was building conservation promoted, but 'heritage centres' were frequently founded on the North American model to 'tell the story' of an

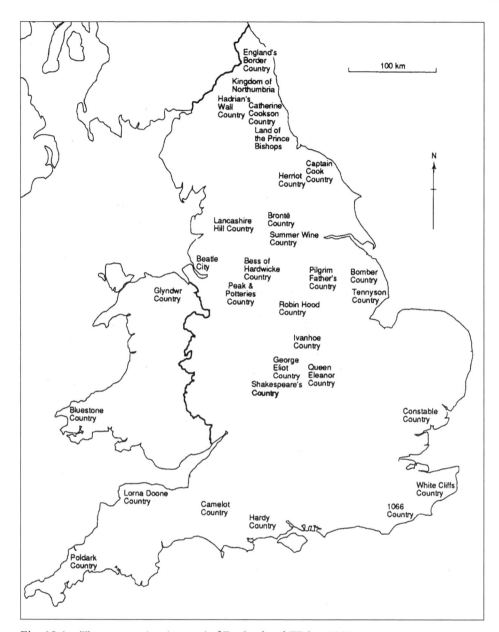

Fig. 19.1 The new tourism 'centres' of England and Wales, 1992

historic town (Dower, 1978). However, cathedrals and castles have for several generations been popular places for tourist visits and popular demands for access to upland landscape in Britain predate 1975 by four decades or more. Indeed, by the 1880s the working class of Lancashire and Durham were making day-trips by train to the English Lake District to gaze on the beauty of the landscape, as the middle classes had begun in volume to do as tourists fifty years previously (Marshall and Walton, 1981). Victorian souvenirs included needle-work embroidery packs of place-images and site-images, vases and other items made out of local stone, 'geological' jewel-

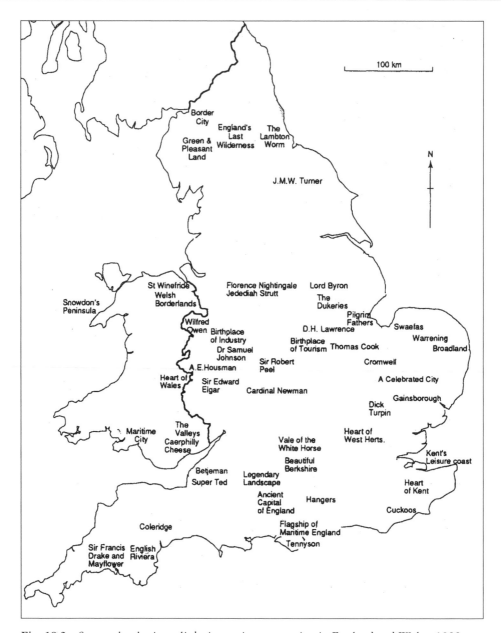

Fig. 19.2 Some other heritage links in tourism promotion in England and Wales, 1992

lery of semi-precious stones and brooches and rings characterizing particular places, such as Luckenbooth brooches from Scotland and Claddagh rings from Ireland (Garrad, 1976): souvenirs intended to fix the associations of place in the minds of visitors long after their return home. As such, we should be careful in interpreting contemporary demands for the consumption of heritage as distinctly novel, at least in quality if not in quantity. Heritage may be said, therefore, to have had some place in the 'old' tourism and its evolution.

Heritage tourism and leisure is undoubtedly now big business. For example, the number of visits recorded at historic buildings, gardens and museums and galleries in the UK in 1990 gives some indication of the scale of demand for heritage. Visitor figures do not distinguish between tourist and leisure visitors, and as such it would be wrong to equate visitor figures with tourist demand alone. However, in 1990, some fifty-seven historic buildings in the UK were each visited by in excess of 200,000 visitors, and likewise thirteen gardens and sixty-three museums and galleries (English Tourist Board *et al.*, 1991a).

Within Scotland, fifteen out of the twenty most visited attractions in 1989 where admission had to be paid could be described as heritage attractions, including six castles (Scottish Tourist Board, 1990). However, although such figures give some indication of the scale of demand for heritage within the UK, they give no indication of the proportion of tourists expressing their desire to visit sites of the kind described. Some indication of background demand for heritage in Europe can be gained from surveys of people's participation in types of activities. For example, for 1986, it was estimated that on average each adult in Great Britain was involved in walking (including rambling and hiking) over two miles as an outdoor activity on twenty days of the year, visiting historic buildings or like sites on 3.7 days and visiting museums and art galleries on 0.8 days (Office of Population Censuses and Surveys, 1989). These background attributes of demand can in some cases be made more specific to tourists. For example, between 1973 and 1982, four out of ten Swiss adults are estimated to have made at least one holiday involving circular tours or 'discovery trips', just under a quarter had taken a holiday in this period to visit a city, one in eight to visit the countryside other than mountains, and one in ten for cultural or study purposes (Schmidhauser, 1989). Similarly, for 1990 alone, it is estimated that seven per cent of holiday trips in the UK involved as their main purpose hiking, hill walking, rambling or orienteering, and that four per cent of trips involved as their main purpose visits to museums, galleries and heritage centres (English Tourist Board *et al.*, 1991b). Of Canadian tourists, one in twelve has been classified through their activities as a heritage tourist and a further one in twelve as a city culture tourist (Taylor, 1986). Moreover, it would be wrong to think that heritage demands are solely a European and North American phenomenon. Of tourists from Hong Kong, it is estimated that upwards of three-quarters visit places of historical significance when on holiday, and almost all of those tourists who can be classified as sightseers (Hsieh *et al.*, 1992). Visits to commemorative places have also been established as frequent among tourists from Hong Kong, and especially so for the sightseers among them.

A heterogeneity of supply

Walsh-Heron and Stevens have commented that 'Attractions come in all shapes and sizes, catering to a wide variety of tastes and leisure requirements' (Walsh-Heron and Stevens, 1990:2). Much the same comment has been made about heritage attractions, which have been described as 'a bewildering variety' (Light, 1989:130), the unique selling point of each being the attraction's individuality (Millar, 1989). In response to this heterogeneity, a preliminary typology of attractions has been presented (Prentice, 1993). Such a typology has of necessity to reflect the range of attractions which are visited by tourists and other visitors; as such, it has to include some attractions for which this very term may seem inappropriate, and the inclusion of some types of site may be distasteful to some. Foremost among such sites are those commemorating genocide. The typology proposed as a basis for the emergent research agenda into heritage issues is shown in Table 19.1.

Table 19.1 A typology of heritage attractions

Natural history attractions, including nature reserves, nature trails, aquatic life displays, rare breeds centres, wildlife parks, zoos, butterfly parks, waterfowl parks; geomorphological and geological sites, including caves, gorges, cliffs, waterfalls.

Science-based attractions, including science museums, technology centres, 'hands-on' science centres, 'alternative' technology centres.

Attractions concerned with primary production, including agricultural attractions, farms, dairies, farming museums, vineyards, fishing, mining, quarrying, water impounding reservoirs.

Craft centres and craft workshops, attractions concerned with hand-made products and processes, including water and windmills, sculptors, potters, woodcarvers, hand-worked metals, glass makers, silk working, lace making, handloom weaving, craft 'villages'.

Attractions concerned with manufacturing industry, involving the mass production of goods, including pottery and porcelain factories, breweries, cider factories, distilleries, economic history museums.

Transport attractions, including transport museums, tourist and preserved railways, canals, civil shipping, civil aviation, motor vehicles.

Socio-cultural attractions, prehistoric and historic sites and displays, including domestic houses, social history museums, costume museums, regalia exhibitions, furnishings museums, museums of childhood, toy museums.

Attractions associated with historic persons, including sites and areas associated with writers and painters.

Performing arts attractions, including theatres, street-based performing arts, performing arts workshops, circuses.

Pleasure gardens, including ornamental gardens, period gardens, arboreta, model villages.

Theme parks, including nostalgia parks, 'historic' adventure parks, fairytale parks for children (but excluding amusement parks, where the principal attractions are exciting rides and the like).

Galleries, principally art galleries.

Festivals and pageants, including historic fairs, festivals, 'recreating' past ages, countryside festivals of 'rural' activities.

Fieldsports, traditional activities, including fishing, hunting, shooting, stalking.

Stately and ancestral homes, including palaces, country houses, manor houses.

Religious attractions, including cathedrals, churches, abbeys, priories, mosques, shrines, wells, springs.

Military attractions, including castles, battlefields, military airfields, naval dockyards, prisoner of war camps, military museums.

Genocide monuments, sites associated with the extermination of other races or other mass killings of populations.

Towns and townscape, principally historic townscape, groups of buildings in an urban setting.

Villages and hamlets, principally 'rural' settlements, usually of pre-twentieth century architecture.

Countryside and treasured landscapes, including national parks, other countryside amenity designations, 'rural' landscapes, which may not be officially designated, but are enjoyed by visitors.

Seaside resorts and 'seascapes', principally seaside towns of past eras and marine 'landscapes'.

Regions, including *pays*, *landes*, counties, or other historic or geographical areas identified as distinctive by their residents or visitors.

The twenty-three types of heritage attraction shown in Table 19.1, and their potential subdivisions, clearly illustrate the diversity of the heritage 'product', giving further confirmation of Poon's stance. However, this diversity has been masked by the prevalence of the term 'heritage industry', to describe heritage attractions. The categorization of this diverse group of attractions as one 'industry', the heritage industry (Hewison 1987), groups together attractions of varying compatibility in terms of size, theme, management objectives and funding. Categorization of all attractions as one industry can easily lead to the limitations of some attractions being universally attributed to all, and implicitly denies the diversity inherent in the 'new' tourism. The heterogeneity of heritage attractions also has implications for our ability to make generalizations about their markets. As yet, insufficient survey evidence exists from which generalizations can safely be made. Our knowledge-base favours certain types of attraction and, in consequence, present generalizations may be attributing market characteristics falsely to those unresearched attraction types.

Of further concern is whether or not the past rapid rate of expansion in heritage attraction numbers can be sustained. An increasingly discerning market (Cossons, 1989) cannot indefinitely demand widespread upgrading of attractions without large investment. However, concern is wider than commercial viability alone. Tourists can degrade the attractions they visit. Not only may physical degradation counter development (Darvill, 1987; Cater, 1992; Pillmann and Predl, 1992), but the loss of integrity and authenticity may do so as well (Jenkins, 1992). A scarcity of material to interpret and a shortage of both trained staff and conservation facilities can counter integrity and authenticity in presentation, particularly where several minor attractions compete in a locality to present the same theme. For example, the slate-quarrying industry of North Wales and the coal-mining industry of South Wales are arguably already over-supplied with heritage attraction developments, each competing to present the same regional industrial and social past. Nor may attractions be welcome if they contravene the heritage values of minority populations, as for example in conflicts over developments between Australians of Aboriginal and European descent (e.g. Davis and Weiler, 1992).

Demand for heritage products

A recurrent feature of surveys and visitors to heritage attractions is their disproportionately middle-class profile, although, as noted above, the deficiencies in our present knowledge-base need to be acknowledged. In this sense, in terms of expressed demand, heritage is frequently a middle-class product. Heritage tourism is no exception; equally, it would be incorrect to equate heritage consumption with middle-class tourists, for the market bias found does not mean that other sections of the population are totally excluded. The social class bias in visits to heritage attractions has been a recurrent feature of surveys undertaken over the past fifteen years, and is remarkably consistent across the types of attractions surveyed.

A survey of visitor surveys at heritage attractions (Prentice, 1989a) confirms the view that holiday tourists visiting heritage sites are likely to be of a socially unrepresentative social class profile, with a substantial bias to non-manual worker social groups. Further support for such an inference is provided by other studies not summarized in this composite source. For example, only a quarter of tourists visiting Dylan Thomas's boathouse at Laugharne in Dyfed were found by a 1983 survey to be from manual-worker households (Wales Tourist Board, 1984a); in contrast, a third of all tourists surveyed at the attraction were from professional or senior managerial households. Even at the primary production industrial heritage attraction of Big Pit, in South Wales, manual workers were not disproportionately more prevalent than non-manuals

among visitors in the 1980s. A survey undertaken in 1985 reported twenty-six per cent of this attraction's visitors to be *Daily Telegraph* readers, compared to sixteen per cent generally at the nine attractions surveyed throughout Wales (Public Attitudes Surveys Research, 1986): as the *Daily Telegraph* is predominantly a newspaper read by non-manual households, this industrial attraction would appear to have disproportionately attracted non-manual visitors, and not manual visitors as might have been expected. A survey of the same attraction on the first year of its operation confirms this. This survey found that three out of ten of its tourist visitors were from professional or senior managerial households, and a further third were from other non-manual households (Wales Tourist Board, 1984b). The socially unrepresentative profile of heritage consumption is also confirmed for holiday-maker tourists visiting heritage attractions on the Isle of Man. Upwards of six out of ten holiday tourists visiting Manx attractions were found to be from non-manual households, despite the social profile of tourists to be found on the island (Prentice, 1993).

Despite the impression given by many conservators of historic sites, a recurrent characteristic of visitors to historic sites is their general interest in what they are gazing at, rather than a historical interest. English Heritage addressed this imprecise motivation in their archaeological management review:

> the past means different things to different people, and many consider the presence of the past as somehow improving the quality of life. Beneath this general concept, however, there is a rather more fundamental trait of human nature which attracts people to ancient monuments.
> Understanding, exploring, and conquering the mystery of the past, and seeking answers to the questions posed by ancient monuments ... is something inbuilt in human nature. For many people, the remains of the past provide a sense of security and continuity in an uncertain world, a thread of timelessness running through a rapidly changing environment.
> (Darvill, 1987:167)

Millar has made a similar point: 'Broadly defined, heritage is about a special sense of belonging and of continuity' (Millar, 1989:13). For visitors to attractions less 'authentic' than archaeological or historical sites, motives other than historical interest are even more likely. For example, concerning heritage events which celebrate or display some theme, Getz (1989) has identified five benefits, only one of which is authenticity, the others being belonging, spectacle, ritual and games. Joy, celebration and excess may dominate at such events, rather than learning. For natural heritage visits, studying wildlife is only one benefit, among others such as hunting, viewing wildlife or natural features of the landscape, perceived as varyingly beneficial or non-beneficial in meeting expectations as diverse as to be in a natural setting, to have fun, or to take chances (Kuentzel and Heberlein, 1992; Kuentzel and McDonald, 1992). For the wider tourist market, a wide range of benefits may be postulated for casual heritage consumption; for example, tourists visiting North Carolina have been segmented on the basis of twenty-six benefits perceived from holidaying (Gitelson and Kerstetter, 1990). As well as intellectual needs to be met when on holiday, those of competence mastery, social interaction or stimulus avoidance compete for prominence among this wider market of potentially casual visitors to heritage attractions among holiday-makers (Lounsbury and Polik, 1992).

As an example of visitor motivation at 'authentic' heritage attractions (castles and the like), surveys in Wales have shown that tourists visit heritage attractions out of general, rather than specific, interests or to enjoy sightseeing, with an interest in archaeology, architecture, culture

or other specific interest in a site as only secondary reasons (Thomas, 1989). In these respects, tourists were found to be similar to visitors generally at Welsh heritage attractions. Achmatowicz-Otok and Goggins (1990) report much the same for visitors to a mansion in Ohio. Similarly, at the primary production, coal-mining, attraction of Big Put, only around a quarter of visitors surveyed in 1983 gave educational reasons for their visit and even fewer, about one in seven, gave an interest in industrial archaeology as a reason; in contrast, three-quarters of all visitors gave 'to see how coal is mined' as a reason (Wales Tourist Board, 1984b). The dominance of sightseeing and a *general* interest has also been found among tourists' reasons for visiting attractions on the Isle of Man (Prentice, 1993). A *particular* interest in castles or historic places and the visit as one part of a day out were secondary reasons given for visiting. In contrast, a particular interest in Manx culture and history formed only a third-order reason for visiting the Manx attractions. Taken together, these studies raise the question of the appropriateness of categorizing, implicitly or otherwise, all tourists visiting heritage attractions as heritage specialists or enthusiasts. Equally of importance, among so-called specialists most would seem to be members of heritage rather than historical or archaeological societies, even when interviewed at castles or museums (Prentice, 1993).

Future use and role of heritage in tourism

Conceptualizing tourists' consumption of heritage 'products' as a 'gaze' (Urry, 1990) usefully summarizes how many tourists regard what they view or otherwise experience of heritage attractions, at least as currently presented. Quite how far this results from the predominantly *passive* presentation of attractions, in contrast to their *active* presentation, presents one pertinent research question for the 1990s. For many tourists, a general wish to see sights or to become aware of a destination area's heritage is a sufficient motivation for their visit to a heritage attraction, and sets the context for attraction managers in supplying 'products' to benefit their customers. However, other than in terms of the authenticity debate, the dimensions of how tourists seek to benefit from visiting attractions are as yet insufficiently researched for different types of attraction, and it is the fuller understanding of the types of benefits sought by tourists through visiting heritage attractions which forms a major research challenge.

The primacy of a general interest in heritage attractions by many of their visitors has important implications for how such attractions should be presented to these visitors, not least in that prior information about an attraction cannot be assumed, nor a demand for detailed information at the attraction. The importance of the leisure context of tourist visits to attractions may be seen from a study in Wales, which included a case assessment of the effectiveness of site interpretative media for higher educational visitors – in this case, undergraduates on a field visit (Prentice, 1991). A general conclusion from this case study of particular pertinence to the present discussion was that even when given a learning task, many students through lack of thorough attention to the media around the castle failed to recall correctly, or at all, much of the information presented. The predominantly leisure context of tourist visits to heritage attractions sets an even greater challenge for the designers of presentational media, for a learning objective can not be assumed to be to the fore, as it would be in the case of a university field excursion.

The social bias in the profile of tourists visiting heritage attractions also has important implications for the development of heritage 'products' in the 'new' tourism. First among these is the question of how members of the working class appropriate their heritage and gaze on that of others. Are the heritage products on offer uninviting, presenting middle-class views of social

and economic affairs, or do members of working-class households choose other leisure pursuits or appropriate their heritage in other ways, such as attending a football match, for example? What is known is that the prices generally charged for heritage attraction admission do not seem to discriminate socially in terms of their deterrence, at least to potential visitors at their gates (Prentice, 1989b).

The second implication for heritage 'product' development of the social bias among the visitors to heritage attractions is the disproportionate bias towards a market with formal educational qualifications. However, this relationship should not be exaggerated, for it can depend upon the tourist profile of a destination area and on the range of competing attractions. However, for those tourists with formal educational qualifications, a different site presentation may be desirable than for those visitors without such backgrounds.

These conditions have important implications for providing the beneficial experiences sought by those visiting heritage attractions. Principal among the benefits offered to visitors by the managers of heritage attractions is that of information, an 'informed visitor experience', as it is often termed. The prevalence of the tourist's generally unspecific and often uninformed interest in particular sets a pertinent context in which information is to be presented. Information needs to be provided in a manner compatible with the leisure context in which it is generally to be consumed if it is to be of benefit in helping visitors to understand, however superficially and transiently, what they are gazing upon. The means of providing this benefit has been known as *interpretation*, and such means have become increasingly diverse and multimedia as heritage tourism has become big business (Alderson and Low, 1986; Uzzell, 1989; Jenkins, 1992). The study of the information benefits provided at many attractions is not without ethical considerations as to which benefits *ought* to be presented. In particular, the benefit of authenticity has been a recurrent concern of historians and museum curators alike, who have found the subject matter of their discipline and conservation increasingly becoming a recreational resource. Jenkins is far from alone in the standpoint evident in the following:

> One reason why Big Put, Blaenafon, one of South Wales's principal tourist attractions, falls short of expectations is that it consists merely of a pit-head gear with associated colliery buildings around it, stuck in the middle of a reclaimed, featureless industrial desert ... Equipped with safety helmets and cap lamps, visitors get a taste of life underground; yet because they can walk comfortably upright along well-lit corridors the reality of coal mining can hardly be presented to them. Most of the pits of South Wales were damp and low ceilinged with noise, coal-dust laden air and little light. If the visitor relies on impressions of the coal industry gathered from a visit to Big Put, then he or she will hardly understand why coal miners throughout history fought employer and government over the wretched conditions of work in the mines.
>
> (Jenkins, 1992:83)

Concerns such as these reflect the traditional view of heritage as providing educational benefits to its consumers. That such benefits may not be uppermost in the minds of many visitors to attractions, with many as, outlined above, preferring instead to gaze on constructed images or to have fun, sets a challenge for the providers of attractions who seek to present authentic experiences.

For the future development of heritage attractions, an understanding of the comparative effectiveness of different interpretative media is also important. Such assessments are beginning to be made. Techniques for investigating the effectiveness of presentational media include studies of non-verbal communication as a means of feedback from visitor to guides providing

verbal information (Risk, 1989), the unobtrusive recording and subsequent analysis of visitors' conversations at attractions (McManus, 1989), time-lapse photography (Vander Stoep, 1989), the reports made by visitors on the media seen (Herbert, 1989), and unobtrusively tracking visitors and recording their behaviour (Russell, 1989). However, the basic point to be made is that studies of the effectiveness of different types of media at attractions have until recently been few and far between.

Recent studies provide some guidance as to how beneficial visitors to attractions find the variety of media used in the presentation of attractions, and give some guidance as to future development. These findings would concur with the stance that media are quite different in their effectiveness. For example, a survey of visitors to state monuments in Wales showed that visitors to these attractions were strongly in favour of the provision of exhibitions of crafts, costumes and armour, but also favoured the partial reconstruction of ruined sties, re-roofing of rooms, and 'events' to portray images of past happenings (Herbert, 1989). Research in Ireland has found that visitors tend to find literature informative and, only secondarily, interesting; exhibitions and exhibits interesting, and only secondarily, informative or well presented; but audiovisual media to be both informative and interesting (Tourism Development International, 1992). Work on the Isle of Man has emphasized the importance of a multimedia presentation at attractions, stimulating a range of senses (Prentice, 1993), and has provided guidance as to those media most frequently attended to carefully by tourists. These media include furnished rooms, other displayed items, models including costumed figures, an introductory film or video, directional signs, live animals and craft demonstrations. The Manx findings also confirm that several types of media recur in terms of positive tourist reaction, namely in terms of catching the attention of tourists, holding that attention and being thought of as important by tourists. These are models (including costumed figures), an introductory film or video, furnished rooms, directional signs and live animals.

Although customer satisfaction is of great importance to heritage enterprises, other benefits are also offered to their visitors, in particular the messages provided by the presentational media used to interpret the attractions. How far heritage attractions meet a desire to increase personal understanding as a recreational experience has been largely unknown, other than in the presumptive and possibly erroneous sense that as visitor numbers have increased at attractions, visitors must at least think that they are having this need met. The informational benefits derived from visiting attractions are of particular pertinence to those seeking to provide educational experiences to the tourist market. Such evidence as we yet have on tourist understanding of what they have visited suggests that the benefits of visiting heritage attractions managed by the same agency can vary substantially in terms of the information tourists possess when leaving attractions (Prentice, 1993). The determinants of these differing information levels pose important research questions for our further understanding of heritage attractions as part of the 'new' tourism.

Conclusions

Heritage attractions are part of Poon's 'new' tourism, especially in terms of their supply. Particularly in the 1980s, their popularity became an established feature of tourism demand and promotion. Countries are now in effect being relabelled for tourism purposes, to invoke an integrative heritage theme for their localities. The emphasis on heritage products has become a phenomenon across the developed world. A heterogeneity of attraction types has also developed, further emphasizing the diversity inherent in the 'new' tourism era.

However, it would be wrong to assert that heritage tourism was a universal phenomenon across all social classes, for it is unquestionably disproportionately a middle-class interest for those types of heritage attraction for which we have data. This social bias in consumption has important implications both for how the heritage 'product' is presented, and for the content of the heritage presented. The pervasive leisure context of heritage attraction visits also has important implications for attraction development. Taking the social class and leisure contexts for product development together, it seems that the commercial fortunes of the heritage part of the tourism sector will be dependent upon the leisure budgets and preferences of the middle classes of the developed world. Equally, the current social bias in consumption sets a challenge for finding product-types which may appeal to other social classes. Product development strategies will increasingly need to be based upon an understanding of the benefits sought by tourists when visiting attractions, otherwise as competition increases through the development of new attractions, business failures will increase among those enterprises providing less-wanted 'products'. Our understanding of these benefits is as yet under-developed, and frequently still constrained for built heritage by the doubly presumptive view that tourists are seeking the twin benefits of an authentic and learning experience, and that if they are not, they ought to be. The research agenda for heritage tourism in the 1990s needs properly to address the benefits perceived by heritage tourists, within the wider context of benefits perceived generally from tourism.

The recognition that informal leisure benefits form a substantive part of consumer expectations has itself an important implication for the production of what may be termed 'official' heritage. To date, many state monuments have been presented by state agencies, combining the designational and presentational roles, on the implicit justification that preservation is the dominant consumer demand. That informal leisure may be the major demand changes this emphasis from designation to presentation; effectively from one rooted in preservation to one rooted in marketing. The latter skills have traditionally been found in the private sector, and the former in the public sector. A changed emphasis in perceptions of the role of heritage has implications therefore as regards which sector may best provide heritage products. As such, the recognition of a consumer orientation to the production of heritage fits in with contemporary 'privatist' ideologies for the delivery of public services, separating the facilitation of services (in this case designation and preservation) from their delivery (in this case marketing and presentation). Current debates in Britain about the possible privatization of state monuments are likely to be increasingly fuelled in part by an emergent recognition of the changing role that official heritage is being called upon to provide in the 'new' tourism era.

Note

1 *Geographical Magazine,* 1992, 64(12), 9.

References

Achmatowicz-Otok, A., and Goggins, L. (1990) 'Stan Hywet Hall as a cultural memorial in American perception', in Otok, S. (ed.), *Environment in Policy of the State*, Warsaw: University of Warsaw Press.

Alderson, W.T., and Low, S.P. (1986) *Interpretation of Historic Sites* (2nd edn), Nashville: American Association for State and Local History.

Cater, E. (1992) 'Profits from paradise', *Geographical Magazine*, 64(3), 16–21.

Cossons, N. (1989) 'Heritage tourism – trends and tribulations', *Tourism Management*, 10(2), 192–4.

Countryside Commission (1988) *Heritage Landscapes Management Plans*, Cheltenham: Countryside Commission.

—— (1989) *Heritage Coasts in England and Wales*, Cheltenham: Countryside Commission.

Crouch, D. and Colin, A. (1992) 'Rocks, rights and rituals', *Geographical Magazine*, 64(6), 14–19.

Darvill, T. (1987) *Ancient Monuments in the Countryside*, London: English Heritage.

Davis, D. and Weiler, B. (1992) 'Kakadu National Park – conflicts in a World Heritage Area', *Tourism Management,* 13(4), 313–20.

Dower, M. (1978) *The Tourist and the Historic Heritage*, Dublin: European Travel Commission.

English Tourist Board, Northern Ireland Tourist Board, Scottish Tourist Board and Wales Tourist Board (1991a) *Sightseeing in the UK 1990*, London: English Tourist Board.

—— (1991b) *The UK Tourist Statistics 1990*, London: English Tourist Board.

Eirinberg, K. (1992) 'Culture under fire', *Geographical Magazine,* 64(12), 24–8.

Garrad, L.S. (1976) *A Present From ...* , Newton Abbot: David & Charles.

Getz, D. (1989) 'Special events: defining the product', *Tourism Management,* 10(2), 125–37.

Gitelson, R.J. and Kerstetter, D.L. (1990) 'The relationship between socio-demographic variables, benefits sought and subsequent vacation behaviour', *Journal of Travel Research*, 28(3), 24–9.

Herbert, D.T. (1989) 'Does interpretation help?', in Herbert, D.T., Prentice, R.C. and Thomas, C.J. (eds), *Heritage Sites: Strategies for Marketing and Development*, Aldershot: Avebury.

Hewison, R. (1987) *The Heritage Industry: Britain in a Climate of Decline*, London: Methuen.

Hsieh, S., O'Leary, J.T. and Morrison, A.M. (1992) 'Segmenting the international travel market by activity', *Tourism Management*, 13(3), 209–23.

Jenkins, J.G. (1992) *Getting Yesterday Right: Interpreting the Heritage of Wales*, Cardiff: University of Wales Press.

Kuentzel, W.F. and Heberlein, T.A. (1992) 'Does specialisation affect behavioural choices and quality judgments among hunters?', *Leisure Sciences*, 14, 211–26.

Kuentzel, W.F. and McDonald, C.D. (1992) 'Differential effects of past experience, commitment, and lifestyle dimensions on river use specialization', *Journal of Leisure Research,* 24, 269–87.

Light, D. (1989) 'The contribution of the geographer to the study of heritage', *Cambria*, 15, 127–36.

Lounsbury, J.W. and Polik, J.R. (1992) 'Leisure needs and vacation satisfaction', *Leisure Sciences*, 14, 105–19.

Marshall, J.D. and Walton, J.K. (1981) *The Lake Countries from 1830 to the Mid-Twentieth Century*, Manchester: Manchester University Press.

McManus, P. (1989) 'What people say and how they think in a science museum', in Uzzell, D. (ed.), *Heritage Interpretation 2*, London: Belhaven.

Millar, S. (1989) 'Heritage management for heritage tourism', *Tourism Management*, 10(1), 9–14.

Office of Population Censuses and Surveys (1989) *General Household Survey 1986*, London, HMSO.

Parks Canada (n.d.) *Parks Canada Policy*, Ottawa: Parks Canada.

Pillmann, W. and Predl, S. (eds) (1992) *Strategies for Reducing the Environmental Impact of Tourism*, Vienna: International Society for Environmental Protection.

Poon, A. (1989) 'Competitive strategies for a "new tourism"', in Cooper, C. (ed.), *Progress in Tourism, Recreation and Hospitality Management 1*, London: Belhaven.

Prentice, R.C. (1989a) 'Visitors to heritage sites', in Herbert, D.T., Prentice, R.C. and Thomas, C.J. (eds), *Heritage Sites: Strategies for Marketing and Development*, Aldershot: Avebury.

—— (1989b) 'Pricing policy at heritage sites', in Herbet, D.T., Prentice, R.C. and Thomas, C.J. (eds), *Heritage Sites: Strategies for Marketing and Development*, Aldershot: Avebury.

—— (1991) 'Measuring the educational effectiveness of on-site interpretation designed for tourists', *Area*, 23, 297–308.

—— (1993) *Tourism and Heritage Attractions*, London: Routledge.

Public Attitudes Surveys Research (1986) *Visitors to Attractions in Wales*, Cardiff: Wales Tourist Board.

Risk, P. (1989) 'On-site real-time observational techniques and responses to visitor needs', in Uzzell, D. (ed.), *Heritage Interpretation 2*, London: Belhaven.

Russell, T. (1989) 'The formative evaluation of interactive science and technology centres', in Uzzell, D. (ed.), *Heritage Interpretation 2*, London: Belhaven.

Schmidhauser, H. (1989) 'Tourist needs and motivations', in Witt, S.F. and Moutinho, L. (eds), *Tourism Marketing and Management Handbook*, Hemel Hempstead: Prentice Hall.

Scottish Tourist Board (1990) *Visitor Attractions Survey 1989,* Edinburgh: Scottish Tourist Board.

Taylor, G.D. (1986) 'Multi-dimensional segmentation of the Canadian pleasure travel market', *Tourism Management,* 7(2), 146–53.

Thomas, C.J. (1989) 'The roles of historic sites and reasons for visiting', in Herbert, D.T., Prentice, R.C. and Thomas, C.J. (eds), *Heritage Sites: Strategies for Marketing and Development*, Aldershot: Avebury.

Tourism Development International (1992) *Visitors to Tourist Attractions in Ireland in 1991*, Dublin: Bord Fáilte.

Urry, J. (1990) *The Tourist Gaze*, London: Sage.

Uzzell, D. (ed.) (1989) *Heritage Interpretation* (2 volumes), London: Belhaven.

Vander Stoep, T. (1989) 'Time-lapse photography', in Uzzell, D. (ed.), *Heritage Interpretation 2*, London: Belhaven.

Wales Tourist Board (1984a) *Survey of Visitors to Dylan Thomas' Boathouse, Laugharne*, Cardiff: Wales Tourist Board.

—— (1984b) *Survey of Visitors to Big Pit Mining Museum, Blaenafon*, Cardiff: Wales Tourist Board.

Walsh-Heron, J. and Stevens, T. (1990) *The Management of Visitor Attractions and Events*, Englewood Cliffs: Prentice Hall.

The politics of heritage tourism development
Emerging issues for the new millennium
Linda K. Richter

As with any other form of tourism, certain more general aspects linked to motivations and expectations of the different stakeholder groups, including producers and consumers, need to be taken into account in the development of heritage tourism. Economic growth, job creation, distribution of resources, division of incoming returns and the meeting of market demands need to be considered. However, issues relating to the complexities of the political and power dynamics associated with heritage tourism development are probably more pronounced in this form of tourism than in any other. Heritage tourism is open to controversy and contestation because of its ability to be used as a source for the construction and affirmation of identities and the communication of political messages.

This chapter considers four key sets of interconnected issues regarding the political dimensions of heritage tourism development. The first of these sets of issues revolves around shifts in previous power relationships. The second set relates to the increasing number of people who not only want to be included in the story, but also want a say in how it is shaped and told. The third centres on issues regarding the struggle for authenticity and competing interpretations. Finally, the chapter includes a section on 'dark tourism' that is linked to the increasing recognition and commemoration of tragic events and actions that were politically motivated, with many societies now more willing to confront the shameful legacies that these have left.

'How much remembering is the right amount?'
(Horn, 1997:60)

Introduction

Heritage tourism has become a rather elastic term applied by some to almost anything about the past that can be visited. Such tourism may involve museums, historic districts, re-enactments of historical events, statues, monuments and shrines.

Perhaps because the word 'heritage' sounds lofty and important, there may be a general assumption that such tourism is by definition good and its development uncontroversial. That would be wrong. All the motivations, expectations, problems and negotiations that surround any form of tourism development must be factored into the development of heritage sites. The desire for economic growth, jobs, tax revenues, civic pride and private benefits are all a part of

the struggle for heritage development. As such, heritage tourism is in no way immune from the battle over power and resources. Establishing a heritage district in some cities in the world is scarcely easier than creating a red-light district!

However, there are political issues and challenges that are more central to heritage tourism development than other forms of tourism. Heritage tourism would appear to be a potentially important form of development, for example, as a source of national identity, political communication and socialization; but there has been little empirical research done on this topic. This chapter suggests where such research is needed. It also illustrates how this expanding form of tourism has become a growing arena for political conflict.

The issues of heritage development are central to what Harold Lasswell called *Politics: Who Gets What, When and How?* (Lasswell, 1936). Heritage tourism also goes to the core of what constitutes our collective political memory, our national identity. As Garry Wills observes:

> If any culture is to be understood, historians must read it by judging what it chose to honour. The ancient Greeks did not praise warriors alone. They honoured philosophers. Medieval statues were of saints. The Renaissance brought classical gods back down to earth. Though we Americans do not think of ourselves as militaristic, the outdoor statues in Washington are overwhelmingly of generals. Is that an unwitting self-revelation, a kind of 'Freudian slip' in stone?

> (Wills, 1997:21)

Benign, militaristic, jingoistic, or 'Disneyfied', the heritage tourist experience may also help form attitudes and values that shape individual orientations toward groups, institutions and issues. Even the very substance of a heritage is a political construction of what is remembered – different for many groups in a society.

Ordinarily social scientists do not think of tourism as political socialization and communication because it takes place largely outside the familiar institutions of politics: the home, church, school, media and government. Heritage destinations may convey particular political messages – intended and unintended – that have been only rarely studied.

Because groups and communities are increasingly aware of the symbolic importance of being represented in heritage sites, interest group activity has concentrated on issues of what gets saved, destroyed, interpreted. Public policy has also revolved around decisions to commemorate political and historical legacies. In this chapter, four emerging and interrelated political issues associated with heritage tourism will be examined. The first section looks at the changing balance of power in the preservation, development and presentation of heritage tourism. The second section details the growing number of claimants to political representation at heritage sites, while the third discusses the increased competition over issues of authenticity and interpretation. The fourth section explores the emerging popularity of commemorating tragic political events. At each juncture, research gaps will be noted.

The changing balance of power

The struggle over heritage tourism reflects its growth and success. Everyone wants a piece of the action. To understand why the struggle has intensified, one needs only to look at the magnitude of tourism involved.

Tourism is one of the world's largest industries. Solely in terms of international tourism, there were 613 million tourist arrivals in 1997 and international tourism receipts amounted to

US$448 billion (WTO, 1998). Heritage tourism's growth, while trickier to measure, is also substantial. For example, the number of registered historical sites in the USA went from 1,200 in 1968 to 37,000 by 1987. A new museum is opening every week. Currently, the USA has over 8,000 museums with over one billion visitors a year (Horn, 1997:54). In the UK, the number of heritage sites has grown to 500,000 historic buildings, 5,500 conservation areas and 12,000 museums (Dann, 1994:55).

Why the growth? Several explanations have been offered. Dean MacCannell attributes it to the alienation many feel from their stressed and busy lives (Graburn, 1995:167). John Urry adds it is 'clearly part of a process by which the past has become much more highly valued in comparison with the present and the future' (Dann, 1994:60–1). Maybe, but does that explain holocaust, internment and slavery museums? More likely from this writer's perspective, the museums offer a multifaceted look at a past neither known nor understood. The humanities are increasingly neglected in our schools and colleges at the very time tourists are seeking out heritage sites.

A fourth factor that may be involved is community pressure to expand the number of attractions and destinations to accommodate the huge numbers of tourists. Many sites are at capacity most of the year. Controlling growth in one place while promoting alternative cultural sites is becoming crucial for many governments. Like the most popular national parks, the premier cultural sites are being 'loved to death'.

Fifth, demographics also favour the growth of heritage tourism. The 'greying' of the tourist trade augers well for heritage sites. There is the expectation that older tourists may seek out such sites in disproportionate numbers (Dann, 1994:60).

Given the reasons advanced for the continued increases in heritage tourism, how has the balance of power shifted during this process? To answer that it is important to look at the overall context in which heritage tourism exists. Tourism has long been noted for its asymmetries in impact. Some of these disparities have been discussed in centre-periphery terms (Hoivik and Heiberg 1980), where some nations are tourist-generating nations and others primarily destinations. Tourism has also reflected imbalances in racial and gender hiring practices, with minorities and women comprising a disproportionate share of the tourism jobs, but largely those at the base of the career ladder (Fredericks, 1992:12; Edgell, 1993:18; Richter, 1994).

Heritage tourism is no different. Historically these sites have reflected dominant establishment views of what is important to remember and commemorate. That power is to be expected in the process of what gets saved has been ably illustrated by Donald Horne. In his splendid study, *The Great Museum*, he examines how certain figures often of equal importance in the history of several countries may be revered in one nation with many statues and museums and ignored in another (Horne 1984). What gets destroyed is often a deliberate political act as well. Often one of the first acts of revolution is destruction of the artefacts of the past (Ashworth and Tunbridge, 1990:255).

Conservative critics of the proliferation of new museums and/or the more controversial interpretations attached to museum narratives may cry 'political correctness' (Leo 1994:21), but *revisionist* history is a time-honoured tradition as power shifts. Heritage tourism is not a stranger to class struggle! The current period following the Cold War has launched an unusual amount of revisionist history, joined as it is to democratization and anti-socialist processes world-wide. What conservatives overlook is that it is the political left, Lenin and Marx, that are being 'downsized' or forgotten and new figures are emerging centre stage even in the museums and monuments. It was not very long ago, however, that museums were repositories for the glory and loot of the empire. In fact, the creation of some British museums was explicitly designed to instil working class awe of 'their betters'.

Friedrich Nietzsche would probably have approved of such didactic heritage tourism: 'How could history serve life better than by tying even less favoured generations and populations to their homeland and its customs.' On the other hand, he would have sympathized with policymakers on tight budgets faced with demands for funds to preserve something dear to the heart of their constituency. 'The fact that something has become old now gives rise to the demand that it be immortal' (Nietzsche, 1988:20–1).

If the process of revisionist heritage tourism is not new, what is new is first the number of attractions designed to remember the *marginalized groups* in society. Many of the new monuments and museums reflect groups that even today get only passing attention in mainstream history books.

Second, decisions may increasingly be divorced from the individuals who will be affected by the site. As heritage tourism is taken more seriously, the number of political actors who function as veto groups or facilitators of projects has proliferated. Political leadership and indeed national and international organizations as well as foundations and associations are becoming seriously involved in the issues of funding, design and interpretation of historic sites. UNESCO's involvement in the restoration of Borabadur Temple in Indonesia and the historic city of Dubrovnik in Croatia, the Pacific Area Travel Association's heritage awards, and the US Congressional concerns over the Vietnam Wall, the Enola Gay, and the Franklin Roosevelt memorial suggest the variety of issues involved. Specific decision-making roles attached to this commitment by outside groups, and their consequences for those who are affected by their involvement have not been studied.

A third factor in the changing balance of power is the global fascination with downsizing the public sphere, while increasing privatization of goods and services (Richter and Richter, 1995). Heritage tourism has also reflected this trend, becoming more entrepreneurial and entertainment-oriented in an effort to compete with theme parks, even as the latter try to look more educational (Graburn, 1995:167). Research needs to explore how the change in funding is impacting what gets remembered and how. Will we someday see the Coca Cola wing of the British Museum or the Toyota Deer Park in Nara?

Fourth, along with the broadening of museum or heritage tourism subjects and changes in funding, there has also been a democratization of the process by which tourists absorb the experience. 'Museums ... are now no longer viewed simply as showcases containing trophies of a bygone era. They are to be entered and possessed' (Dann, 1994:66). Thus, when one tours the Holocaust Museum in Washington DC one has the option of taking a card with the name and description of a holocaust victim. More information is added at intervals in the tour until the details of the person's death are noted. The intent is obviously to build empathy and infuse reality into the museum's horrific story.

Moreover, the museums and sites are themselves being transformed by the tourist. Beyond the comments section of the guest books, a new expectation of participation is being forged between the tourist and the heritage site, with either able to initiate the communication.

How did this happen? No one has a definitive answer, but some speculate that it was influenced in the USA by the powerful emotions evoked by the AIDS quilt and the Vietnam Memorial:

> The most dramatic transformations in museums is their inclusion of voices once disqualified as too lowly, unscientific, and naive. The AIDS quilt like the teddy bears and poems left by visitors at the Vietnam Veterans Memorial ... demonstrated how ordinary people could help shape the places that preserve the nation's memories.
>
> (Horn, 1997:60)

these new museums have remade themselves into true public forums, places for communal experience and exchange, for sorting out group and national identity. The histories they tell are no longer authored by expert curators alone. They incorporate testimony from ordinary people, witnesses, participants even visitors to the museum.

(ibid.:54)

In some museums, tourists are invited to add information they may have about individuals featured in the museum. Not all information and advice is enthusiastically received. It was public pressure in April 1997 by disabled people, for example, that led to the FDR memorial being altered to reflect the former American president's disability.

Most museums are increasingly interactive in format. At the Museum of Tolerance in Los Angeles, it is possible at several points to determine how much or how little explanation is desired. Most unnerving to this writer was one computer terminal that allowed one to punch in one's state and city. Flashed onto the screen are the names and numbers of hate groups in that area!

To generations accustomed to television and the computer, the new museums offer an accessibility not based exclusively on lecture and printed captions. Moreover, with the Internet, one can redefine what it means to be a tourist, visiting and interacting with sites transported by modem to another era and another world.

Finally, there may be a changing balance of power that has not been acknowledged. Is the modern museum a Big Brother where an Orwellian level of control is created? Light, sound, music, even smells and temperature can be manipulated to affect the emotional intensity of the experience. People are often moved through the museum at a controlled pace, sitting, standing and listening according to a carefully choreographed scripting of the visit.

Would it not be an ironic twist of fate if the techniques that allowed tourists to maximize their appreciation of these heritage sites were the same techniques that controlled and manipulated the visitor as never before?

New claimants to political representation

'Of course, who gets to tell the story is the battle of the day.'

(Horn, 1997:60)

The new claimants to political representation in our memorialized past have at least two objectives: (1) to be in the story and (2) to have a say in how the larger story is told. Ten years ago, it would have been relatively easy to identify all the sites remembering minorities' and women's contributions to US history. That is no longer true. The civil rights movements of the 1960s and 1970s may have stalled, but their effect has been to recover much of the history neglected by the mainstream historians. Now that history is being put on display in scores of museums and statues, exhibits, and special events.

One of the most impressive examples is not strictly a political heritage museum, but an art museum exclusively featuring the work of women. In the process of acquainting visitors with the unfamiliar names and pieces, like puzzle pieces the captions reveal the neglect of women artists. 'The history of all times, and of today especially teaches that ... women will be forgotten if they forget to think about themselves' (Louise Otto-Peters, 1849). This quotation hangs as a cautionary tale in the National Museum for Women in the Arts in Washington DC. Her advice

was taken when in 1987 this museum became the first in the world dedicated to the work of women artists. Many of those featured are acknowledged by their peers to be superior to the male artists – often brothers, sons and husbands – now famous in major world galleries. Some, like the women of the cloister who worked on the Bayeaux Tapestry in the eleventh century, remain unknown.

This museum is an example of how private resources were needed to address the fact that public galleries routinely overlooked women artists. In fact, some of the individuals who were renowned in their own time had been lost to the modern era until this museum opened. As the court painter to Marie Antoinette wrote in 1835 about the women painters and sculptors: 'It is difficult to convey an idea of the urbanity, the graceful ease, in a word the affability of manners which made their charm of Parisian society forty years ago. The women reigned then: the Revolution dethroned them' (Personal tour, 1993). In 1994, the museum featured an exhibit of art by Arab women which broke through the stereotypes of what these women are like and their artistic range ('Lifting the Veil', 1994). How will such art affect attitudes toward women and the Arab world? This is a question worth investigating.

The Buffalo Soldiers monument, dedicated in 1992, is an example of a recent effort to commemorate black soldiers who have fought in every American war, but have seldom been recognized. The buffalo soldiers were men drawn into cavalry regiments and infantry units in 1866 from among the ranks of the US Coloured Troops. These men had served or were serving as volunteers after the Civil War.

Other commemorative places are being developed that will tell the often unsavoury history of race relations in the USA. In Savannah, Georgia, for example, it is now possible to take tours centred around important sites in black history. Museums and markers detail the life of black abolitionist Harriet Tubman and the Underground Railroad by which she smuggled slaves to the North.

That this can happen in the American South reflects real changes in black power, even as some state capitols still insist on flying the flag of the Confederacy! How secure are these new attractions? Who visits these sites? Do the races differ in what they take from these landmarks? Are the major tours or school field trips visiting these sites? We should find out.

The increasing struggle over authenticity and interpretation

The politics of heritage tourism development seems fairly straightforward when planners seek to restore a historical site, build a monument, or combine entertainment with a celebration of cultural richness. The process is seldom so uncomplicated. The political climate has expanded the number of groups and interests that want to determine how that story is told. That poses problems, because revisionist history may or may not be more accurate (Bruner, 1993). At the very least, it adds new intellectual uncertainties to what were once portrayed as unquestioned truths.

The Arizona Memorial in Pearl Harbor is a case in point. It has been interesting to see the transformation of this museum over thirty years, in part, because of the changing political and economic realities of Hawaiian tourism. The facts on which the Memorial is based are not in dispute, but the interpretation has become more delicately nuanced. The 'sneak Jap attack' of 7 December 1941, which President Franklin Roosevelt told the nation was 'a day that would live in infamy' is now recalled at Pearl Harbour as the tragic site in which the national interests of two great world powers collided. The films that describe that fateful day have gradually become less indignant and hostile as Japanese tourists to Hawaii have increased. It would be easy

to claim there has been a whitewash. But it may be, on balance, a more accurate telling of events than the earlier accounts. It is important to consider how the racial and gendered organization of our memories affects both tourism and our political impressions of what we see.

Has there been a similar change in the Hiroshima Museum in Japan? Far fewer American tourists visit Hiroshima than Japanese visit Hawaii.

> That may change, however, if city planners get their way. There is an effort to redesign the city space, not simply in order to erase its dark brooding memory in the interests of prosperity but to enclose or isolate it. The effect, however, is to 'celebrate peace in its weightlessness' without the anger and pain and inevitably to transform Hiroshima's historical meaning.
>
> (Duara, 1997:142)

Meanwhile, the American Congress recently showed a decided unwillingness to reconsider the decision to drop the atom bomb on Hiroshima. The planned Smithsonian exhibit of *Enola Gay*, the airplane that dropped the bomb, occasioned harsh attacks because part of a larger battle over funding for the Smithsonian leading to the resignation of one curator and the *Enola Gay* being shown without any explanation (Holloway, 1995:32–3; Washburn, 1995:40–9). Once more, there is irony in the fact that conservative politicians were more than ready to criticize 'socialist realism' in its control of the arts in the former Soviet Union, but apparently saw no parallel in their own efforts to censor and control.

The Australian War Museum also furnishes an example of the political subjectivity of exhibits. No curator by 1987 had been able to decide on a representation of Australia's involvement in Vietnam that could garner public support. Was it a noble effort to defeat communism and assist an ally, or a bloody blunder? (personal interview, March 1987).

Perhaps it is as well the USA made no such effort, but simply acknowledged its terrible cost by building the Vietnam Wall. Given the immense popularity of the wall today, it is easy to forget that this memorial was the subject of harsh attack from those who wanted a more celebratory memorial (Wagner-Pacifici and Schwartz, 1991:376–420). The fact that the design was done by a young Asian female only compounded the fear that it was a subversive propaganda statement ('Maya Lin: A strong, clear vision', 1996). What actually happened was that individuals focused on the people who sacrificed instead of the disputed issues of what was at stake.

Popular as the wall is, additional sculptures have been added as groups fought for recognition of their role in this divisive struggle. The Vietnam Women's Memorial was added on Memorial Day in 1993. But before that, it went on a travelling exhibit. One would not think a bronze memorial on a flatbed truck in a mall parking lot in Wichita, Kansas, could occasion strong emotions. However, having seen it, this writer can testify to the depth of emotions that ran through the crowd of several hundred. Vietnam veterans kissed and hugged some two dozen Vietnam nurses, gave them flowers, reminisced about the women who had nursed them through long nights. Everyone there appeared to realize that whatever side they had been on during the war, it was a beautiful and overdue recognition to see that the nurses – eleven of whom had died serving – at long last were remembered. How long did those intense feelings last? What did it mean to male and female veterans? What was learned? What was remembered?

Indeed, the whole process by which heritage tourism has begun to include more and more groups is barely examined. For example, many mainstream museums are getting more attentive to the inclusion of women and minorities in their exhibits. Why is this so? Several explanations are possible. First, the increased clout of blacks, women, even gays, has helped these groups to

negotiate their convention and tourism decisions with increased attention from convention planners and tourism officials. For instance, the African-American convention business is growing rapidly. Increasingly, black convention planners have told cities their destination decisions will be based in part on the way black heritage is presented, the degree of black political representation in the community, and the political reception their members receive. One third of all corporate convention planners, in general, would boycott certain cities because of social issues (Eisenstodt, 1995:15).

Second, there appears to be more acceptance of the notion that the mainstream story has been too narrowly focused. A third possible explanation is related to the first, to broaden the clientele for the attraction. As minorities become more powerful and affluent, they become not only subjects, but consumers of heritage tourism.

The answer may differ from setting to setting, but it is clear that the formula of merely adding or stirring in new groups in the mainstream story will not suffice if the group has much clout. For example, Colonial Williamsburg, faulted for 'sanitizing history' by glossing over slaveholding, fared no better when it added a mock slave auction. The black civil rights group, the NAACP, was furious, claiming that the auction trivialized the real suffering slaves had known. Nor were black employees of the Library of Congress impressed with the exhibit on slavery the Library had developed (Horn, 1997:56). In some cases, it may be more infuriating to be included if one finds the interpretation unacceptable.

Still, not everyone is enamoured with the interpretations minorities have placed on heritage sites within their control. Complaints surfaced that the National Museum of the American Indian was giving too much attention to settlers' brutality and far too little to Indian violence. The Museum of African American History in Detroit has been criticized for referring to the 'rebellions of 1968', which to the mainstream media had always been known as 'race riots' (Horn, 1997:56–60). A 'rebellion' implies considerably more political legitimacy than a 'riot', but few who fought to restore order were likely to see the events in the same category as the Boston Tea Party!

The US National Park Service has tried to balance the interpretation at its historical sites. That is often difficult to do. Complex, ambiguous stories are less easy to tell or to remember. In some cases, there is even rivalry within a marginalized group for recognition of their history. The National Park Service, for example, was encouraged to balance its explanation of the Crow victory at Little Big Horn, known as Custer's Last Stand, with attention to Sioux and Cheyenne involvement (Horn, 1997:56).

Another controversy that illustrates that no good deed goes unpunished was the belated Congressional decision in 1997 to bring a large suffragette sculpture out of the basement of the Capitol where it had languished seventy-five years. Supporters in Congress who had fought to have the sculpture moved to the Rotunda were stunned when black civil rights groups found the sculpture unacceptable because it featured three white women – Susan B. Anthony, Elizabeth Cady Stanton and Lucretia Mott – but had overlooked the eloquent black women's rights crusader of the same period, Sojourner Truth. There were even suggestions that her likeness be chiselled on the sculpture. In this instance, the sculpture was moved unaltered into the Rotunda, but in the future there will be greater Congressional caution, if not sensitivity, to the politics of heritage. Given the possibilities for conflict, some museums and national parks opt to present exhibits with several interpretations attached.

Most nations, however, are quick to commemorate the legacy of those in power. Since 1989 in Eastern Europe and the former Soviet Union, heritage sites are in fundamental transition as

the legacy of Marxism is erased. Busts of Lenin and even the embalmed leader himself appear to be on the way out. The Museum of the Revolution in Cuba still exists (Seaton, 1996:242).

Probably the museums most susceptible to politicization are the Presidential Libraries and Museums. First, the person for whom the museum is named is often still alive when it is built. Second, those giving to the museum are generally those who are enthusiastic about the president being immortalized. One only has to tour the Nixon Library, to get the impression that most of Nixon's two terms were devoted to foreign policy before he was forced to resign because a third-rate burglary sabotaged his presidency. More telling details of the issues leading to possible impeachment are downplayed.

Yet, it is the presidential libraries that often provide for a more accurate assessment of a presidential administration than that available from news accounts of the period. As the repository of classified information, they provide additional details which, once declassified, have altered the historical standing of such presidents as Truman and Eisenhower. Still, presidential museums and libraries perhaps say more about Americans than they do about the presidents. For all their ridicule of 'cults of personality', Americans may be unique in so honouring modern chief executives with their very own tourist attractions!

Authenticity issues

Authenticity is also an issue in the politics of heritage tourism. Is authenticity essential? And if so, in what form, from what period and by whose standards? Some tourist sites are more interesting as ruins than they would be if everything were rebuilt. Consider Pompeii, Byblos, Mohenjodaro or even some contemporary abandoned towns. Local residents may not like having their community called a 'ghost town', but it may be a more successful 'ghost town' than a nondescript unincorporated cluster of renovated houses.

> Restoration also raises issues of authenticity. Tastes change. Would we admire the Parthenon if it still had a roof, and no longer appealed to the modern stereotype taste ... If we repainted it in its original red, blue and gold and if we reinstalled the huge, gaudy cult figure of Athena, festooned in bracelets, rings and necklaces, we could not avoid the question that threatens our whole concept of the classical: did the Greeks have bad taste?
>
> (Horne, 1984:29)

The Polynesian Cultural Centre, the most popular tourist attraction in Hawaii, builds its exhibits around various cultural groups of the South Pacific and their traditional dwellings, dances and crafts. There is some attention to accuracy in terms of the cultures presented, but the performers — college students from the Mormon College at Laie — may or may not be from the group they are depicting. Fijians and Tongans may be doing Samoan dances. The individuals are merely acting (Brameld, 1977). Does it matter? In this instance, this writer would argue 'staged authenticity' (MacCannell, 1979) may be preferable to making people's actual lives a tourist attraction.

The more interesting question is 'who gets what' from this centre? Are the performers properly paid for their labour? Who controls what is presented? Do the cultures presented accurately portray current life in the South Pacific, or do they contribute to what Dann refers to as 'museumization, the freezing of a heritage and the selling of the frozen product' (Dann, 1994:59). Do the visitors get an appreciation of South Pacific cultures or a sense of superiority over these societies? We do not know.

Some groups are adept at seizing the tourism initiative by creating an affordable, tourist-friendly heritage. The Ute of Southwestern Colorado is one group that has taken control of its evolving heritage and its tourist future in ways scarcely traditional. Up until modern times, the Utes were well-known for their beadwork, but contemporary Utes found beadwork tedious and unrewarding. What to do? They decided to learn pottery from a non-Indian, determine a few designs and colours that would define Ute pottery and went to work. In 1986, when this writer visited their factory-cum-tourist shop, they had just begun. Today one finds 'traditional Ute pottery' featured in speciality catalogues. It is authentic, but the tradition is only twelve years old.

The Toraja of Indonesia are another group that have absorbed those useful components of their tourist image and made them their own. That has engendered some conflict among those neighbour groups who wish to share the economic windfall from tourism (Adams, 1995:143–53).

The political power of various groups may well control not only whose interpretation and definition of authenticity prevails, but also what will be saved or remembered at all.

Misery loves company

> 'a painful past is good box office'.
> (Horn, 1997:54)

There is no question that heritage tourism today in many societies is much more willing to confront the shameful legacies of the past and the inability of government policies to live up to the ideals immortalized in more traditional heritage sites. What is more problematic is whether the messages are primarily motivated by greed, 'milking the macabre' as Dann puts it (1994), or the need to re-examine the tragedies so tourists can learn from them how not to behave. Equally hard to gauge has been the message received by the tourists. The labels 'dark tourism' or 'thanatourism' have been put on such tourism, but there have been relatively few sites assessed for their impact (Seaton, 1996, 1997).

One that has is Dachau Concentration Camp with its shrine and museum. From 1965 to 1988, more than thirteen million visited the scene of the extermination of millions of Jews, gypsies, and others the Nazis deemed undesirable. Sixty per cent of the visitors were international visitors; many of the others were German school children. No one surveyed their motivation in coming, their impressions of the camp, nor did any follow up of the impact of these visits. Their motives have been assumed to be (1) personal, perhaps seeking the names of relatives; (2) political, since political parties persecuted by the Nazis often hold meetings there; (3) historical and educational, as in the case of the many school children brought there and (4) humanitarian, as it is the site of Jewish–Christian groups and youth camps.

What *is* known about Dachau's impact is that the residents of the city are becoming increasingly unhappy with being associated with genocide. Yet, thirteen million visitors do generate impressive economic benefits. In an effort to keep the tourists coming, but to blur the message, there have been specific efforts made to put more emphasis on the local resistance to Nazism and the activities of the anti-fascists from 1918 to 1945 (Hartmann, 1989:41–7).

The Gestapo Prison Museum in Berlin, the Japanese Prisoner of War Museum in Singapore, Auschwitz in Poland, the Inquisition Museum in Lima, the KGB museum in Moscow and even the Tower of London are other examples of this type of heritage tourism.

In this regard, two other museums need to be mentioned which opened in the 1990s: the Holocaust Museum in Washington DC and the Beit Hashoah Museum of Tolerance in Los

Angeles. Both are designed to leave a lasting impression of the evil of bigotry by the various ways in which they encourage visitors to identify with the victims of persecution. Reactions differ as to the probable lessons such museums convey (Rosenthal, 1993:4–5A). Horne, who studied similar museums in Europe, is not so sanguine about their impact:

> In monuments to the victims of fascism, what is novel are reminders of the concentration camps. Museums display ... photographs of incinerators, of patient queues obligingly waiting to be hanged, shot or gassed, and the piles of the dead ... With a clear eye one can see the concentration camp museums not as monuments to the heroic, but to the sufferings of passivity: a record of the triumph in power of one of the possible forms of a modern industrial state. To the tourists on a horror pilgrimage, however, this can seem exceptional – something that ended with the Nazis.
>
> (Horne, 1984:244)

The Museum of Tolerance avoids Horne's critique by stressing the point philosopher Hannah Arendt made about the 'banality of evil'. It includes the Holocaust in Germany, but also similar bloodbaths in Cambodia, Rwanda and elsewhere. The very unexceptional quality of hate groups throughout the world attempts to send home the message that intolerance is a virus to which no society is immune.

Professor Mary Philips' reaction illustrates a quite different opinion from Horne's about the messages received from such museums, and both impressions seem to beg for more empirical research. Philips writes (1994:43) that as she left the Museum of Tolerance:

> I saw a sign whose message I hope is burned in my memory. It said, 'As long as we remember, there is hope ...'. There is not only the danger that some will forget what happened. There is another danger that some people, for whatever reason, never truly understood what was happening all around them ... It is essential that educational experiences such as this ... be provided for future generations, for those who weren't connected to the times in which we lived.

Clearly, Philips got the message being sent. Authorities are also using the Museum of Tolerance as a place to send juveniles involved in hate crimes. The director of the Museum felt that the visit had a positive, but sobering, impact on the individuals sent (personal interview, March 1994).

In Kuala Lumpur, Malaysia, at least one new museum, the Pudu prison, is being used to instruct children about the evils of drugs and the discomforts of prison life. Mock executions and real videos of canings drive home the message (personal tour, 1997).

Groups need to know if such places have the intended impact before they proliferate further, sometimes with public funding. In a violence-satiated environment of horror films and television carnage, one could argue that it is the very generation the museums are trying to reach most that may be least susceptible to its values. The line between what is real and what is not is increasingly blurred to a generation attuned to a diet of mayhem and virtual reality.

Nor need we assume that only youths will be attracted for the wrong reasons to such grim tourism. While the phenomenon of tragedy tourism has accelerated recently, in its tackier forms it has been around for some time: 'In Paris at the turn of the century, sightseers were given tours of the sewers, the morgue, a slaughterhouse ...' (MacCannell, 1979:57).

Political will to make such heritage attractions accessible to the public may vary from society to society and according to who are cast as the villains in the story. Given the penchant for

privatization around the globe, we may expect more and more heritage sites to reflect private aspirations rather than national or other public considerations. Is this consistent with diversity or the balkanization of national identity? One may take encouragement from the Mashantucket Pequot Tribe in Connecticut who seized the initiative and raised the money for a $135 million museum to commemorate the 1637 massacre of tribe members (Horn, 1997:56). Would we be as sanguine with various anti-government militias running museums extolling white supremacy, secessionist and conspiracy agendas? Perhaps they already are.

While it may be more politically palatable if the horrible events remembered are the work of other countries or groups, public institutions are belatedly acknowledging painful episodes in their own history. *'Mea culpa'* tourism as it might be called, is perhaps cathartic for the dominant group and some solace to others. The US National Park Service has recently added the Manzanar National Historic Site to the park system. It commemorates the thousands of Japanese-Americans who during the Second World War were uprooted from their homes, farms and businesses solely on the basis of their Japanese ancestry and interned for years in guarded camps. The Wounded Knee Battlefield is also an American historical site acknowledging the US cavalry's slaughter of 300 Sioux. Similarly, the Trail of Tears stretching from Tennessee to Oklahoma marks the uprooting of 15,000 Cherokee, many of whom died en route.

Conclusions: heritage tourism and the politics of power

Several broad issues have been explored in this chapter. First, not only is the balance of power shifting somewhat from dominant groups to the formerly marginalized, but other changes form an increasingly decentralized, privatized, and yet often globalized policymaking environment. As the heritage sites have changed, so have the opportunities for two opposing tourist experiences. The visitors now have an unprecedented opportunity to interact with and make an impact on the sites at many heritage destinations. But at the same time, the place itself has an increased ability to control and manipulate the tourist's visit.

Second, there has been a virtual explosion in the number of heritage sites that commemorate the powerless and the overlooked. Some of these places remember tragic episodes, others the striking achievements of groups long ignored. Third, as the number of groups represented in heritage sites has grown, there has been an intense struggle over the content of that representation. It has revolved around issues of accuracy, emphasis, authenticity and political message.

Fourth, the final trend examined is the growing popularity of tourism focused on sad or tragic experiences. Interpreting such sites as vehicles for increasing understanding and reducing racism and bigotry is a comforting but neglected hypothesis that needs to be pursued. Such places could be powerful, just as television and movies have been charged, in producing 'copycat crimes' and entertaining with tales of the lurid and grotesque.

Each issue raised can be examined according to disciplinary emphasis, but several central political questions lead back to 'Who Gets What, When and How?' (Lasswell, 1936).

> Though a declared aim of all of them [all kinds of museums] was educational, one of the unintended functions of these museums was to put most people in their place. A much quoted survey carried out in France in 1966, suggested that eight out of ten working people who visited an art museum associated it with a church; two-thirds could not remember the name of a single work.
>
> (Horne, 1984:16)

In the case of some exhibits, forgetting might be the best one might hope for. The Smithsonian Museum of American History had a provocative exhibit in the late 1980s on World Fairs. At one such fair shortly after the American conquest of the Philippines in 1898, tribal people were brought to the USA as an exhibit. Used to the tropics, several died of exposure. Grotesque as such an exhibit might seem today, the 'zooification' of indigenous peoples goes on around the globe. Such exhibits are thought by many to justify imperial designs and pacification campaigns or simply make the tourist feel prosperous by comparison:

> The world's fairs of this era preached that white men's manliness fueled the civilizing imperial mission and in turn, that pursuing the imperial mission revitalized the nation's masculinity. White women were meant to come away from the fairs feeling grateful … without the Samoan, Filipino and other colonized women, neither male nor female fair-goers would have been able to feel so confident about their own places.
>
> (Enloe, 1989:27)

Today's museums, it might be argued, attempt more thematic exhibits, but since museums and exhibits increasingly appear to be more ideological in content, it would be worth studying what the tourist receives from the experience. When Philippine President Corazon Aquino made a museum of Malacanang Palace where her corrupt predecessor, Ferdinand Marcos, had lived, the expectation was that the impoverished public would be outraged at the lavish excesses and her own seizure of power legitimized. Some got the intended message, but many others were simply dazzled by the fantasy life of the dictator. The palace tours ceased (Richter, 1989).

Nor does the current era seem overcome with a consideration for the very different memories of fellow citizens. The 500th anniversary of Columbus' 'Discovery of America' was seen by the US government as a great tourism promotion opportunity. What was neglected was the fact that many African-Americans, and most Native Americans and many in the Caribbean regret and mourn the so-called 'discovery'. The aboriginals of Australia also did not celebrate the bicentennial of the first ships arriving with the white British prisoners who would colonize that country (Altman, 1989:456–76).

Case studies are needed to probe who gains and loses from heritage tourism. There are a lot of assumptions about it with very little empirical data. We do know that a double standard still persists in what is legitimate to investigate and make into attractions. Excavations and tourist attractions based on burial or sacred indigenous sites are common. Exhuming pioneers and pilgrims for tourist sites would be unthinkable!

Ultimately, the most important political issue surrounding heritage tourism is whether even an extensive exposure to it leads to a better informed or perhaps more tolerant individual. If so, schools could better make the case for excursions and parents might be more ready to include some heritage sites in their travel. Public and private funds for such places might have more support. Studies have shown again and again that education followed by income are the best predictors of tolerance toward others. In our increasingly diverse societies, does heritage tourism have a role to play in providing that education? Can episodic, out-of-context, historical exhibits yet create a foundation to inspire future learning? Those who can say what impact such tourism has will be needed to inform public policy and private development decisions for the future of heritage tourism.

References

Adams, M. (1995) 'Making up the Toraja? The appropriation of tourism, anthropology, and museums for politics in Upland Sulawesi, Indonesia', *Ethnology*, 34(2), 143–53.

Altman, J. (1989) 'Tourism dilemmas for aboriginal Australians', *Annals of Tourism Research*, 16(4), 456–76.

Ashworth, G.J. and Tunbridge, J.E. (1990) *The Tourist-Historic City,* London: Belhaven.

Boyer, M. (1992) 'Cities for sale', in Sorking, M. (ed.), *Variations on a Theme Park,* New York: Hill and Wang.

Brameld, T.B. (1977) *Tourism as Cultural Learning,* Washington: University Press of America.

Bruner, E. (1993) 'Lincoln's New Salem as a contested site', *Museum Anthropology*, 17(3), 14–25.

Dann, M.S. (1994) 'Tourism: the nostalgia industry of the future', in Theobald, W.F. (ed.), *Global Tourism: The Next Decade,* London: Butterworth-Heinemann.

Duara, P. (1997) Review of Jonathan Boyarin (ed.), *Remapping Memory: The Politics of Timespace*, *Journal of Asian Studies*, 56, 141–2.

Edgell, D. Sr (1993) *World Tourism at the Millennium*, Washington: Department of Commerce.

Eisentodt, J. (1995) 'Should planners have a social conscience?', *Meeting News*, 24 April, 15.

Enloe, C. (1989) *Bananas, Beaches, and Bases*, Berkeley: University of California Press.

Fredericks, A. (1992) 'Thinking about women in travel', *Travel Weekly*, 2 July, 12.

Garnet, S. (1994) 'Buffalo soldiers: rugged men of the west', *Dollars and Sense*, Jan., 56–63.

Graburn, H.H. (1995) 'Tourism, modernity and nostalgia', in Ahmed, A. and Shire, C. (eds), *The Futures of Anthropology*, London: Athlone.

Hartmann, R. (1989) 'Dachau revisited: tourism to the memorial site and museum of the former concentration camp', *Tourism, Recreation, Research*, 14(1), 41–7.

Hoivik, T. and Heiberg, T. (1980) 'Centre-periphery tourism and self-reliance', *International Social Science Journal*, 1, 69–98.

Holloway, N. (1995) 'Museum peace', *Far Eastern Economic Review*, 2 Feb., 32–3.

Horn, R. (1997) 'Through a glass darkly', *US News and World Report*, 122(20), 54–60.

Horne, D. (1984) *The Great Museum: The Re-presentation of History*, London: Pluto.

Ireland, M. (1993) 'Gender and class relations in tourism employment', *Annals of Tourism Research*, 20 (4), 666–84.

Lasswell, H. (1936) *Politics: Who Gets What, When and How,* New York: Whittlesby House/ McGraw Hill

'Left at the wall' (1992) *The Economist*, 31 October.

Leo, J. (1994) 'The national museum of PC', *US News and World Report*, 10 October, 21.

'Lifting the veil on Arab women artists' (1994) *Women in the Arts,* 11(4), 1–4.

MacCannell, D. (1979) 'Staged authenticity: arrangements of social space in tourist settings', *American Journal of Sociology*, 79, 589–603.

'Maya Lin: A strong clear vision' (1996) Public Broadcasting System, 26 November.

Murphy, P.E. (1992) 'Urban tourism and visitor behavior', *American Behavioral Scientist*, 36(2), 200–11.

'Never again' (1993) *The Economist*, 1 May.

Nietzsche, F. (1988) *On the Advantage and Disadvantage of History for Life*, Indiana: Hackett.

Norkunas, M.K. (1993) *The Politics of Public Memory: Tourism, History and Ethnicity in Monterey, California*, New York: State University of New York.

Philips, M. (1994) 'The Beit Hashoah museum of tolerance', *National Forum*, 74(1), 31–3.

Richter, L.K. (1989) *The Politics of Tourism in Asia*, Honolulu: University Press of Hawaii.

—— (1994) 'Exploring political roles of gender in tourism research', in Theobald, W. (ed.), *Global Tourism: The Next Decade*, New York: Butterworth.

—— and Richter, L. (1995) 'Reinventing government abroad', paper presented at the American Society for Public Administration meeting in San Antonio, Texas.

Rosenthal, F. (1993) 'New holocaust museum offers tour through hell', *Wichita Eagle*, 19 April, 4–5.

Seaton, A.V. (1996) 'Guided by the dark: from thanatopsis to thanatourism', *International Journal of Heritage Studies*, 2(4): 234–44.

—— (1997) 'War and tourism: the paradigm colussus of Waterloo 1815–1914', paper presented at the War, Terrorism and Tourism Conference in Dubrovnik, 27 September.

Wagner-Pacifici, R. and B. Schwartz (1991) 'The Vietnam veteran's war memorial: commemorating a difficult past', *American Journal of Sociology*, 97(2), 376–420.

Washburn, W.E. (1995) 'The Smithsonian and the Enola Gay', *The National Interest*, Summer, 40–9.

Wills, G. (1997) 'Carved in stone', *Washington Post National Weekly Edition*, 5 May, 21.

WTO (1998) 'Tourism growth slows due to Asian financial crisis', *WTO News*, Mar.–Apr., 1–2.

Urry, J. (1992) 'The tourist gaze "revisited"', *American Behavioral Science*, 36(2), 172–86.

Other sources

Personal interviews in Canberra, Australia and in Manila, Philippines (1987 and 1992) and Los Angeles, USA (1994).

Personal tours of Pudu Prison (Kuala Lumpur), Museum of Tolerance (Los Angeles), Australian War Museum (Canberra), Malacanang Palace (Manila), Smithsonian Museum of American History, Holocaust Museum, and National Museum for Women and the Arts (Washington DC).

A people's story
Heritage, identity and authenticity
Sharon Macdonald

Heritage tourism is often thought about and analysed in terms of the 'commodification' of culture and the objectification of local people for the 'tourist gaze'. This raises questions linked to issues of authenticity and the shaping of identities. Who is involved in the appropriation of heritage for the construction of identities, what are their reasons and what stories to they formulate and tell? What are the complexities in the processes behind the presentations and consumption of identities, histories and stories, as they are articulated in heritage tourism products? These questions are of particular interest when one looks at heritage centres, which, although now conforming to a fairly standard heritage model worldwide, are employed in relation to the specifics of individual localities. When analysing heritage centres, it is important to take account of their unique contexts.

This chapter provides insight into a number of issues that can be considered in terms of these complexities by using the heritage centre, Aros: The Skye Story, as a case study. The centre, established on the Isle of Skye in the Scottish Hebrides in 1993, does indeed provide a useful example for engaging with the intellectual frameworks most commonly employed in analysing heritage as presented for tourism. The chapter begins with a reflection on the frameworks which often emphasize the problems of artificiality and inauthenticity – or at least 'staged authenticity' – in heritage representations. With the commodification of culture, the value of a heritage resource can be altered from an original 'use value' to an 'exchange value', where heritage becomes a form of currency. In this altered state, ethnic and local difference can become accentuated and implicit meanings made more explicit, thereby leading to a certain amount of alienation between the people and their cultural heritage. However, with its assessment of the chosen case study, the chapter shows that the processes involved can be more sophisticated than the heritage model and the general frameworks for analysis suggest. The context of the creation of Aros, the aims of the creators, and their understanding and deployment of 'history' and 'story' are outlined. The identities constructed and interpretations presented, along with the authenticating devises used, are then discussed. This leads to an analysis of the range of display strategies and technologies employed and how they can be read. Finally, the chapter returns to question heritage and culture as a commodity and to suggest other analytical considerations relating to heritage as an 'inalienable possession'.

Introduction

There is a story which I have heard, in various versions, many times in Skye. It goes like this:

> There was an old woman [or man] living in township X. One day a couple of tourists come by and start asking her questions. 'Have you ever been outside this village?' they ask. 'Well, yes. I was at my sister's in [neighbouring township] not so long ago.' 'But you've never been off the island?' 'Well, I have, though not often I suppose.' 'So, you've been to the mainland?' She nods. 'So you found Inverness a big city then?' 'Well, not so big as Paris, New York or Sydney, of course …' she explains, going on to reveal that she has travelled to numerous parts of the globe.

This is one of a large repertoire of jokes which highlight local people's awareness of touristic images of themselves, their ability to play along with those images, and their enjoyment of subtly disposing of them. It also highlights the conceit of tourists who assign local people only the role of object of the tourist 'gaze' (Urry, 1990).

An abiding concern in tourism research has been with the implications of being an object of the tourist gaze, and, in particular, its implications for identity and authenticity. This chapter takes up this concern by exploring a heritage centre – Aros: The Skye Story – which opened on the Isle of Skye, in the Scottish Hebrides, in 1993. Through an analysis of Aros – especially its exhibition – and its makers' claims about it, my aim is to examine how far the centre can be seen to involve a commodification of culture and history. My information is drawn primarily from interviews with various individuals involved in tourism and heritage on Skye, and unless otherwise specified, all quotations are taken from interviews in October 1994 with Donald, one of the centre's creators. I also draw on documentary sources, observations of the centre, and my earlier and ongoing ethnographic research on identity in Skye (Macdonald, 1997).

A heritage centre is, I suggest, a useful site in which to explore questions about local identity and the performance of culture for tourism. It is a purpose-built representation of what is considered an appropriate depiction of the past and the locality; and as such it constitutes what John Dorst has called an 'auto-ethnography' (1987:4) – a text that culture has produced about itself (1987:2). It is a formalized and self-conscious cultural account, though one which inevitably bears the imprint of more than its creators' conscious intentions. While Dorst limits his analysis to the finished representation, here I look, too, at its makers, their relationship to the locality, and their claims. The makers are, after all, themselves thoroughly and professionally engaged in questions of identity, locality and authenticity (cf. Bruner, 1994:398); and their authorial intentions are worth examining in their own right. Moreover, attention to the producers highlights the specific position from which they speak and signals that they may be well aware that the history and identity which their representations attempt to articulate are by no means uncontroversial or uncontested.

Heritage representations, like performances of culture and history for tourists more generally, are regarded in a good deal of tourism research as inherently 'artificial' or 'inauthentic'. MacCannell's (1989) notion of 'staged authenticity', for example, highlights the ersatz nature of that which the tourist is offered; and Hewison's characterization of heritage as 'bogus history' (Hewison, 1987:144) likewise emphasizes fraudulence. Not only is it tourists who are duped, according to these analyses, but also those who perform for them. According to Davydd Greenwood, for example, local people risk losing the 'authentic meanings' of their culture and debasing it to mere 'local color' by performing for outsiders (Greenwood, 1989). In similar vein, MacCannell argues that highlighting ethnic difference ('a kind of going native for tourism';

MacCannell, 1992:159) puts its performers in danger of 'a distinctive modern form of alien-ation, a kind of loss of soul' (MacCannell, 1992:168). For Greenwood, the debasement is a result of making explicit meanings which were previously implicit; and of 'the commodification of culture' – turning culture into something which can be bought and sold. The alienation which MacCannell describes also stems from commodification, a process in which phenomena such as ethnicity or authenticity cease simply to 'be' – to have *use-value* – but come to have *exchange value* in a cultural system which peddles numerous formulae for translating between, or exchanging, things and categories which would be thought incommensurable in other 'modalities'. The market, and market-values, subsume everything, according to MacCannell, 'to the exclusion of all other values' (1992:169). Nothing is valued in itself, but only as currency.

A heritage representation like Aros certainly involves some of the processes which Greenwood and MacCannell implicate in the 'inauthenticating' of culture. First, it clearly involves a kind of 'making explicit'. Indeed, a heritage representation is, intentionally, a cultural explicating device. Moreover, the heritage format as used at Aros, with its staged sets and mannequins, and its claims to be 'The Skye Story' [cf. The Oxford Story, The Queenstown Story (Cobh, Ireland), The Story of Hull, The People's Story (Edinburgh) etc.], has become rather a standardized model for proclaiming and establishing 'place myths' (Shields, 1991:6). It is in itself a generalized sign of 'being' or 'having' a culture (cf. Handler, 1985, 1988). In MacCannell's terms, this standardiza-tion (a touristic technology for going native?) is itself evidence of inauthenticity and alienation. Aros is also in the business of making a profit, and it does so through the sale of its depiction of local culture and history. Clearly, it could be argued that it treats culture and history as commodi-ties. Moreover, as we shall see, Aros's representation of culture and history involves a good deal of translating of the local into categories with more global *semantic reach*. Again, this is part of a process – here, the translation of categories with local use-value into wider systems of exchange – which MacCannell regards as an alienating reconstruction of the local. It is a process in which, he suggests, the local is 'subsumed' to the global.

My argument here, however, is that the matter is not so unequivocal. Although Aros uses what has become a standardized and indeed transnational format ('the heritage model') – and one which relies mainly upon display technologies which have been associated with inauthenticity (reconstruc-tions) – its creators are very concerned with authenticity and with presenting a sense of local distinc-tiveness. However, both their understandings of authenticity and their notions of local identity and culture, in relation to the wider system which impinges upon it, are a good deal more sophisticated than many of the models for interpreting heritage and touristic performance would allow.

This chapter proceeds as follows. I first provide some background to the creation of Aros and to its creators. I then discuss their notions of 'history' and 'story', before going on to describe and locate the kind of identity which the exhibition constructs and the authenticating devices which it uses. This is followed by a discussion of some of the particular features of heritage representations – their suitability and unsuitability for certain kinds of stories and identities; and possible variations in ways in which they may be read. In conclusion, I return to the question of the models which we use to analyse heritage and tourism, and, from the basis of my attempt to understand some of the local conceptions of these matters, suggest some alternative analytical possibilities.

Making heritage

The island of Skye has been a highly romanticized tourist location since the mid-nineteenth century, when its wild landscape and exotic history and culture began to appeal to wealthy, cultured tourists from the South (Cooper, 1979). Over the past century, Skye's tourist appeal has

become much broader and many new tourist facilities have developed to try to tap what is one of the major sources of income and employment on the island. Aros – which is advertised in the tourist brochures and which provides its commentary in French, German, Italian, Spanish and Japanese, as well as Gaelic and English – is clearly intended to attract tourists. And the heritage format which it uses to do so – professionally produced period sets, Walkmans with commentary and sound-effects, a gift shop and restaurant – has become a familiar genre in tourist development projects. Indeed, what sparked off the idea of creating a heritage centre on Skye was a visit to the Jorvik Viking Centre by one of the centre's founders. Later on, in formulating their proposals, the makers of Aros visited other heritage sites and museums too. In this 'pirating' of the 'heritage model', Aros's makers were also able to draw on an established 'technical means' for putting the model into operation (cf. Anderson, 1983:30, 66). This technical means included the Edinburgh-based heritage companies, which provided the mannequins, period dress, graphic panels and audio-visual technologies, and which gave advice on matters such as how to write an engaging story, how best to display artefacts, and how to entice visitors into the exhibition and gift shop. National, and indeed transnational, notions and technologies of heritage, then, thoroughly played their part in the creation of the Skye heritage centre.

Aros is a purpose-built heritage centre containing an exhibition (The Skye Story), and a restaurant and gift shop which together cover a much larger area than does the exhibition itself. It is situated on the main road into Portree (Skye's capital) from the mainland. Its large car park contains a notice welcoming coach parties, though in late 1994, when I carried out my research, Aros had not yet succeeded in establishing itself on the agenda of any of the numerous Highland coach tours which drive past. The centre cost around £800,000 to set up; and this was financed by a combination of private share capital (about 25 per cent), state funding in the form of grants from the Highlands and Islands Development Board (now Highlands and Islands Enterprise) and the Local Enterprise Council, and bank loans. It was intended to be both a money spinner (to repay the loans and generate dividends for share-holders) and a significant local employer in what is an area of high unemployment. In 1993–94 it employed seventeen full-time staff during the summer and twelve in winter, which was relatively high by comparison with many similar operations and by no means trivial in the local jobs market. The exhibition has received rather fewer visitors than was hoped; though the financial consequences of this have been compensated by the fact that the centre has made considerably more from its gift shop and restaurant than was anticipated. Although detailed figures have not been kept, it seems that this pattern is largely accounted for by local people, who visit the shop and restaurant far more than they do the exhibition. Among my contacts, local people seemed to be more forthcoming on its restaurant, praising its 'good plain fare', than on the exhibition itself. Nevertheless, in economic terms, the centre seems so far to be more successful than many such ventures; though, ironically, its success may be founded less on its attempt to present a 'quality' vision of local heritage than on a semi-internationalized style of fast food.

The heritage makers

The idea of setting up a heritage centre on Skye was devised and put in motion by two local Gaelic speakers, Donald and Calein, both of whom, then in their thirties, had been involved in a number of Gaelic revival projects on the island. The 'Gaelic revival' or 'Gaelic renaissance' is a movement to maintain and increase the amount of Gaelic spoken in Scotland which, particularly since the mid–1980s, has spawned numerous Gaelic developments, including Gaelic play groups, Gaelic medium primary schooling, community history projects, community coopera-

tives, Gaelic festivals, and enormous increases in the number of hours of Gaelic television broadcasting throughout Scotland. In the late 1980s, Donald and Calein were both 'looking around for something new', a future source of employment and income, when Calein's visit to the Jorvik Viking Centre inspired them to investigate the possibility of a similar kind of heritage representation on Skye. They were later joined by two of their Gaelic-speaking peers who had complementary skills; and invited the historian, James Hunter, to help them formulate the ideas for the exhibition.

Donald and Calein are representative of a younger generation of Gaelic speaker who, were it not for the Gaelic revival and the jobs (mostly in the cultural industries) which it has created, would almost certainly have had to leave the island to find work elsewhere. In using their 'Gaelicness' to stay on the island and also 'attain a certain standard [of living]', as Donald puts it, this 'revival generation' has to ally Gaelic with ideas of commercial enterprise. When Donald talks of Aros, and his own experience in the revival more generally, he repeatedly assimilates Gaelic to enterprise. He refers to 'the revival or business or whatever you call it', taking them as apparently synonymous; he accounts for his own participation in the revival in terms of the life experience that turned him into an enterprising person; and he tells me that the name of the centre, 'Aros', was chosen both because it means 'dwelling' or 'home' in Gaelic and the exhibition was to be 'the home of The Skye Story' and because 'from the marketing point of view it starts with an A, so it's important to be top of the list and that sort of thing'.

This linkage of Gaelic and commercial enterprise is antithetical to the romanticism which has long been a principal lens for viewing the Scottish Highlands. Within romantic discourse, Gaelic culture seems to act as a repository for many of the qualities which the urban, industrialized and rational world to the south lacks (Chapman, 1982:129; see also Chapman, 1978); so making the association of Gaelic culture with those 'Southern' qualities feel like category errors (or jokes). For many older Gaelic speakers too, though for different reasons, Gaelic and enterprise are often seen as opposed. In this case, it is a view of Gaelic as a 'waste of public money', and suspicions over the use of Gaelic for social mobility, that inform their distrust of the association. Revivalists are well aware of older Gaels' alternative view, but they contest it. As one involved in the island's heritage strategy said to me: 'Gaelic is not just about the old folks. If it is to have a future it has to be about us too. That's what we've got to change. We've got to say it's not about a dying way of life'. Accommodating Gaelic with commercialism, then, is seen by revivalists as a way of giving new strength to the language and culture. In the revivalists' vision, the market and tourism are appropriated and put to the service of Gaelic culture. In some ways, we could argue that this is seen by them, not so much as the commodification of culture, as the Gaelicization of commerce; though it is probably more accurate to argue that the two exist alongside one another and are not seen as mutually exclusive. In some ways, this articulation of enterprise with Gaelic is like that between enterprise and heritage more broadly. As Corner and Harvey have argued, although these might appear to be 'self-evidently in opposition', both involve a 'powerful articulation of past, present and future' and can act in a mutually supportive way (Corner and Harvey, 1991b:46). What is more, they suggest that, although enterprise and heritage have been particularly used to support one another in the discourse of 'the Right', they also 'connect with alternative visions of society' (Corner and Harvey, 1991b:75). In other words, they and their linkage contain the potential for articulating with other kinds of politics (cf. Urry, 1990:110; McCrone *et al.*, 1995:23f.). This certainly seems to be the case with Aros.

Donald, who is the manager of the centre, describes what he and his colleagues have been trying to do as 'cultural tourism'. He argues that this is distinct from much of Skye's tourism in that it is 'for the people', i.e. the people who live in Skye, rather than primarily 'for the tourist'.

In making this argument he refers me to various documents that have been issued by Highlands and Islands Enterprise (a government-funded organization which oversees development in the Scottish Highlands) and Commun na Gàidhlig (an organization concerned mainly with the support of Gaelic), which explain and make a case for the promotion of 'cultural tourism' in the Highlands. They do so by casting 'Gaelic heritage' as 'an under-utilised resource', which can be used as a 'development tool' to attract tourists (Pedersen and Shaw, 1993:1). Although on the one hand this might be seen as a model in which Gaelic culture becomes a commodity, it is important to note that this model of tourism does not presuppose that 'Gaelic culture' can, therefore, be 'bought' and exchanged by whoever should wish to do so. Gaelic culture is a 'resource', not so much in the sense of being something available to be transformed and used, though there is something of that involved, but in the sense of being Gaels' own repository of 'inner reserves' on which they can draw. This is a conception of 'resource' as potentially active, as a transformative tool, which can play a part in 'enhanc[ing] ... the development of Gaelic culture and society' (Pedersen and Shaw, 1993:1). Rather than as material to be acted upon, Gaelic culture is perceived as an agent which can shape the course of development. And 'development' here is not accepted as meaning conversion into an industrial, urban archetype, but as strengthening and extending the local and traditional. This is a process which McKean, in his discussion of Balinese tourism, has described, after Geertz (1963), as 'cultural involution' (McKean, 1989:126). Instead of development being conceptualized as distinct from local culture, in a dualistic model which assumes that 'change' is imposed from the outside, it is fully incorporated within it, and, as such, carried out on local terms and potentially used to strengthen local pride and interest in traditional culture. In this way, cultural involution can lead to the conservation and elaboration of the traditional. Where conventional tourism might lead to cultural 'dilution', 'cultural tourism' aims to produce its intensification.

The makers of Aros, then, are local Gaelic speakers who have a vested interest in local heritage and Gaelic culture, and this is both for employment and as a source of their identities. As young, upwardly-mobile individuals whose self-definition is also formed partly in opposition to that of many older Gaels, their interest and engagement is also just as much with the future as with the past, and with change as with tradition. It is their specific vision, and in particular their attempt to forge a new Gaelic identity, which informs and indeed is part of the motive force for the story that the exhibition tells.

Myths, histories and stories

The makers of Aros are emphatic that the centre is not just intended for tourists. On the practical front, they point to the jobs it provides and say that, as the majority of these are held by young Gaelic speakers, the centre helps to curb some of the outmigration that Highland areas typically suffer. Just as significantly, however, Aros is also seen as a resource for local people in 'understanding their history'. The exhibition is aimed primarily, Donald argues:

> [at] the people. It's for the people. It's for the ordinary person who lives on a croft, really. That's who it's done for. It's aimed at a lot of people, you know, whoever's interested in their history and in their culture who wants to get a wee bit extra from what they would get in most of the story books.

Telling local people of their history, and going beyond 'the story books', is particularly important, according to Donald, because:

we find that a lot of them are not well versed in their history in this part of the world. There's an awful lot of myths told about their history. So we feel that … somebody had to deal with them.

The tourist industry is a particularly powerful player in the perpetration of these myths; so what Aros does is to use the technical means of this industry, the heritage display, to tell what is intended to be 'quite a radical story'. This telling is not, however, openly confrontational. Rather than refer outright to the accounts told by Skye's other main tellers of Skye heritage, namely the clan centres (the Clan Donald centre at Armadale Castle, ancestral home of the MacDonalds, and Dunvegan Castle, ancestral home of the MacLeods), Aros provides an alternative account:

> The story we tell is very different from what is told elsewhere in Skye, especially Dunvegan Castle and Clan Donald. I'm not criticising what they are doing at all but it is a very different story, told from a different point of view. But we were also very careful not to step on their toes.

The clan centres deal mainly with history surrounding the clan system, which is generally said to have ended with the Battle of Culloden in 1746. Aros deals mainly with more recent history. The clan centres focus on the history of the lairds, whereas Aros deals primarily with 'the people', that is, the crofters. However, there are areas of overlap, especially in dealing with Bonnie Prince Charlie. What is more, Aros incorporates a good deal of implicit intertextual reference to more romantic historical accounts and it also very pointedly depicts some aspects of the activities of clan chiefs which are certainly not mentioned in the clan centres (for example, the 'slavery' episode, discussed later in the chapter).

By Donald's own account, many visitors seem readily to perceive Aros's difference from the histories that they have previously encountered:

> One of the things we find … if a bus comes in here and they go through the exhibition, so many of them come out and say 'That's totally different from what the courier told me.' The courier loves to tell the romantic side of things, Bonnie Prince Charlie as being, you know, this wonderful character who, you know, ran up the hills and sort of slept in caves and … invented Drambuie and all this sort of nonsense. And that's not how it was. So we do open a few people's eyes.

Using heritage to counter alternative heritage accounts is, then, one feature of Aros. This is no simple matter, however, for why should visitors believe the account at Aros rather than that at the other sites? Donald himself repeatedly refers to Aros as a 'story' – 'we tried to tell a story which … ', 'we tell the story and let them make up their own minds', and indeed the exhibition's title is The Skye Story. In using the term 'story', Donald signals awareness of the fact that the exhibition, as with historical accounts in books, is a particular *version* of history, told from a particular 'point of view'. It is also only a very small part of what might potentially be told ('we could only go into so much'); and is significantly different from many other accounts of Skye history ('it's a very different story from that told elsewhere'). Donald clearly leaves space then for alternative accounts of history. This vision of history as having alternatives, and as only ever being partially represented and from particular perspectives, is very different from the crude opposition of 'true history' versus 'bogus history' which is used by Hewison in his critique of the

heritage industry (1987). Perhaps, as Angela Morris (1991) has suggested, this vision of history as having alternative versions is more easily accepted in Scotland, where there has long been an awareness that Scottish history is not the same as English history, or even that which passes as British.

Yet, despite the careful characterization of history as story, Donald and the other creators of Aros are certainly not licensing a view that all accounts are equally correct or that veracity is unimportant:

> It was very important to us that we were factually correct. We did a lot of research. And we were very careful. If we were in doubt about anything we didn't use it.

A central aim of the exhibition, Donald says, is 'to uncover the myths' that are told about Skye history. Myths in this context are not simply accounts told from different vantage points (as are stories), but are factually incorrect and get in the way of a version of history both more authentic and more meaningful to local people. Myths are based on lies which should be revealed.

Moreover, although the exhibition uses technologies of display which have been associated by various cultural theorists with the decline of authenticity, and in particular with what Benjamin calls 'the withering of aura' (1973:215), it by no means abandons authenticating devices and ploys. As we shall see below, although the exhibition consists almost entirely of reproductions rather than 'real' old artefacts, it finds plenty of non-auratic means to attempt to enlist visitors to its account. So, although Aros admits to being a story, we should observe that it also claims to be the Skye story, the story of Skye, and the story *from* the Skye point of view.

Aros is not, however, only an account of the past. Nor can its version of the past be described as 'nostalgic', as has been the accusation levelled at many heritage centres. Far from attempting to 'draw ... a screen between ourselves and our true past', as Hewison (1987:10) argues is characteristic of the heritage industry, Aros is very directly concerned with making links between past and present. Rather than being a 'denial of the future' (Hewison, 1987:46), it is an assertion of it.

The Skye story

While the clan centres concentrate particularly upon an aristocratic history of clan chiefs, Aros focuses upon the history of 'the people', a term used in the Highlands to refer to 'crofters' as opposed to 'lairds', and which also has wider socialist connotations (Macdonald, 1997; Bennett, 1988). Aros is also much more consciously politicized than Skye's various folklife museums, which nostalgically depict a way of life that has largely passed. Aros's story is very different from that at the clan centres, principally in that it depicts the clan chiefs as largely responsible for the historical hardships which Skye people have suffered. It tells a story of atrocities endured and of the way in which the people resisted and are now enjoying a renaissance of their culture and language. As such, Aros attempts to point out the political causes for the depopulation of the Highlands and the decline of Gaelic culture and language; and to attribute agency for overcoming these problems to the people themselves. The exhibition seeks, in various ways, to tie the idea of the people and resistance together with the Gaelic language and culture, so making contemporary efforts to revitalize Gaelic (the 'Gaelic Revival') the outcome of a long-standing popular battle against oppression. In so doing, it selects a particular set of events and figures to create its story, a process inevitably involving inclusion and exclusion.

The opening vignette at Aros, a woman sitting at a fire with a kettle, is the beginning point of establishing this linkage. Although she looks like the stereotypical old woman from the past that can be seen at so many heritage centres and folklife museums (and was no doubt from the same cast and intended perhaps to remind us of the folklife model), she is intended here to be a specific person, Mary MacPherson or Màiri Mhór nan Oran (Big Mary of the Songs). She was a nineteenth-century Skye poetess who is a heroine of the Crofters' Wars (or Land Wars) when local people demonstrated against their removal from the land to make way for sheep. Although the exhibition does not mention it, Màiri also made flattering references in her poems to MacDonald of Sleat, one of Skye's worst landlords (Mac Gill-eain, 1985).

The linkage of the Gaelic language and popular resistance is also made in a reconstruction of a Napier Commission hearing. The Napier Commission, established in the 1880s by the government as a way of trying to assess the crofters' grievances that had been demonstrated in the Land Wars, toured the Highlands taking evidence from crofter representatives; and the Commission's report led to considerably improved legislation for crofters, giving them security of tenure and distributing back to them land that had been taken from crofters. At the hearing shown at Aros, the crofter representative, Angus Stewart from Braes, stated that he preferred to give testimony in Gaelic rather than English. Quite why he did so is not clear. Perhaps he was more confident of his fluency in Gaelic, perhaps he thought his account would be less likely to get back to his landlord, or perhaps it was indeed a political statement as it is interpreted at Aros, where Stewart is commended for standing up for his people and his language.

The Gaelic language is more specifically commented on in various other sections of the exhibition. Its status as 'high culture' is established through reproductions from the Book of the Deer and the Book of Kells, which are intended to illustrate that Gaeldom was 'a beacon of civilisation when the surrounding countries were heathen and illiterate' (as the exhibition states). Although the books are reproductions, they are placed under glass casing, using a museum representational technique to confirm their auratic and international value. This is one of a number of ways in which Gaelic's significance is extended out from the local. Through referring to Gaelic as 'The Lion's Tongue', the exhibition defines Gaelic as the language of Scotland, not merely of the Highlands (see MacKinnon, 1974).

Yet in fact Gaelic has never been spoken by all the population within what is now Scotland; and the idea that the Gaelic language should be seen as 'Scotland's language' today is controversial (Withers, 1984). The exhibition tells no direct lies here, it simply heads the section on Gaelic with what is a well-known slogan, but it makes implications which are questionable. Gaelic is also defined as a Celtic, a European and a minority language. A map of Europe shows 'minority languages', visually establishing their minority ethnic kinship (McDonald, 1986), and notes that they have been driven from their previous strongholds. No explanation of the processes involved or of their variations is given, but an agency is implied that the rest of the exhibition can fill in for the Gaelic case. Again, the condensed means of exhibition presentation creates a less equivocal picture than a more discursive account might convey.

Gaelic language and culture today are also specifically commented upon in a section near the end of the exhibition, entitled 'Contemporary Skye'. This includes a collage depicting various indicators of Gaelic revivalism: Gaelic road signs; Gaelic cartoon figures (Angus Og, apparently modelled on a man from North Skye; and Postman Pat in his Gaelic incarnation as Padraig Post); and bagpipes and posters for Runrig (a successful rock group from Skye who sing in both Gaelic and English and blend mainstream rock with Gaelic traditional song). Here we are shown a thriving and modern Gaelic culture, and one which merges seamlessly with the past.

Aros also deals with the favourite Skye romantic subject: Bonnie Prince Charlie. However, it does not present the heroic tale that is favoured in many popular histories. The Jacobite rebellion which the Prince led in 1745, and the Battle of Culloden (1746) at which the cause was lost, are not related as a near triumph of Scotland over England, but as something of a disaster for Highland people (see Pittock, 1991). The romantic construction of the episode seems to be commented upon through the display styles, where Culloden is portrayed in a (specially commissioned) painting, which seems to parody depictions of heroic battle scenes, rather than attempt to be realistic. Aesthetic intertextualism continues with gilt-framed reproductions of famous paintings of the Prince and Flora MacDonald. These are hung above the words of two carefully juxtaposed songs: the Skye Boat Song ('Fly bonnie boat like a bird on the wing ... '), which is described as being one of the sources of romantic versions of the episode; and a Gaelic song of the period which laments loved ones lost in battle.

A walk-in reconstruction depicts what Donald tells me is one of the few well-evidenced aspects of the Young Pretender's stay on Skye. It is a scene from MacNab's Inn in Portree, where the Prince stayed briefly. However, rather than showing him as a Highland hero, the reconstruction illustrates that he was an aristocratic outsider who did not know or understand the codes of the place. He is shown, and described on the taped commentary, as not wanting to share a drinking cup (as was Highland practice), and tipping the inn keeper lavishly, so leading MacNab to suspect his true identity.

The account of the Prince also addresses the lack of support he received from Skye's main clan chiefs, MacDonald of Sleat and MacLeod of Dunvegan. Many histories account for this in terms of the chiefs' reluctance to participate in an ill-planned and under-resourced campaign by the headstrong Young Pretender. The Skye Story, however, argues that the chiefs were in effect bribed into inaction because their roles in a 'slave trade' from Skye had been rumbled. Skye people were being rounded up and sent out to America to work as slaves. In the most dramatic set of the exhibition, there is a large reconstruction of part of the slave ship – referred to as 'The Ship of the People' (*Soitheach nan Daoine*). In most histories of the Highlands this fairly brief episode is given much less weight than the Clearances, which were a considerably more extensive and drawn-out process of people being either induced or forced to emigrate or otherwise moved off their land. By focusing on an event referred to as 'slavery', however, the exhibition deploys a more widely recognized, and indeed transnational, category. By doing so, the local is translated into terms which have greater semantic reach. This also sidesteps continuing and rancorous debate among historians over the extent to which the clan chief landlords were to blame for the Clearances, or whether they were themselves victims of wider economic forces (Hunter, 1976; Richards, 1982). Slavery, however, being universally regarded as morally disgraceful, provides an unequivocal symbolic statement countering the image of the clan chief as paternalistic benefactor.

Again, this is not simply a matter of the past, of 'dead heritage'. The role of landlords, many of whom are still clan chiefs, is also a contemporary issue, a longstanding source of dispute being over landlords' responsibility for the well-being of their tenants versus their aim to make profit from their estates. The historian James Hunter, who wrote the storyline of the exhibition in collaboration with Donald and Calein, has taken public issue with historians who he feels absolve the landlords of blame, and has made clear that he sees this as a contemporary as well as a historical matter. He has also been actively involved in contemporary crofting politics, particularly through having played a key role in the establishment of the Crofters Union, which works for crofters' rights today (Hunter, 1991). His vision, and that of the others involved in creating The Skye Story, is one in which history is a matter of highly politicised contemporary signifi-

cance. This is not to say that the exhibition is a polemic. On the contrary, the past–present linkages are mostly implicit, constructed through the linkage of sets, and the recurrence of the theme of the oppression of Gaels and their resistance to oppression. The creators of The Skye Story are well aware that to present too ostensibly political an account risks alienating visitors and thereby reducing the exhibition's power to compel its audience. Although Donald tells me that the aim of the exhibition is to 'let visitors make up their own minds', we have already seen that it contains a carefully orchestrated narrative and that the exhibition-makers have certainly not relinquished either the notion of 'fact' or a sense of the importance of the past. If visitors are being allowed to 'make up their own minds', they are not being allowed to make them up in conditions of their own choosing. The display technologies of Aros, to which we now turn, are directed towards leading visitors in particular, chosen, directions.

Authenticity at Aros

Aros's attempt to be *the* Skye story inevitably, if indirectly, brings it into competition with Skye's other heritage sites and other versions of history. Lacking most of the features which stamp these sites as authentic, Aros nevertheless is concerned to present itself as an important and true account.

 The island's clan history is the basis for its most commercially successful heritage sites, Dunvegan Castle and the Clan Donald Centre. Both make their claims to authenticity through place or *siting* and through genealogy, a putative connection through blood over time. In both cases, though, we might note that the present castles were largely created in the nineteenth century (the fashion for towers and castellation being inspired partly by Sir Walter Scott), although as they partly incorporated former buildings they can claim to be older and are widely assumed to be so. In addition to their own fairly aristocratic histories, both sites also lay claims upon what is perhaps the most famous aspect of Skye's myth-history, Bonnie Prince Charlie's attempt for the throne in the mid-eighteenth century, and in particular the assistance he received from 'Skye lass', Flora MacDonald. This is partly established through artefacts: Dunvegan has a lock of the Prince's hair and Flora's stays, and Clan Donald has some shoe buckles of the Prince and a wine glass out of which he is said to have drunk. Any such object is 'auratic' in Benjamin's terms; it has an authenticity which 'is the essence of all that is transmissible from its beginning, ranging from its substantive duration to its testimony to the history which it has experienced' (Benjamin, 1973:215). Its unique existence is based in its 'historical testimony' (1973:214). It is imbued with the magic of having 'been there'.

 It is through the auratic modalities of age, site and artefact that Skye's many other castles, ruins, historic houses and folklife museums are authenticated. This is the case for the history of crofters, as well as of the clan chiefs. The Skye Museum of Island Life at Kilmuir, for example, consists of 'black houses', nineteenth-century thatched cottages which have been either restored or moved to the site and are mostly filled with artefacts of the period (and some Flora MacDonald items). When talking with the creator and manager of this museum, he repeatedly uses the phrase 'old things … I would not have anything artificial, no'. The idea of the museum as an amassing of old things is what predominates. Although these aged artefacts are arranged into different houses (such as the Smithy, the Weaver's house, the Ceilidh house), and although there is an attempt in some of them to reconstruct room settings, this is secondary to the collection principle. What is more, the reconstructions do not aim for the historical accuracy of a kind of photo-snapshot of a particular time and place in the past ('token-isomorphism' as Handler and Saxton term it; 1988:423). For example, the dresser of the main room of the Croft house is

crammed with diverse objects, egg-cups, books, butter-shapers, a photograph of the museum's opening, all probably dating from between the mid-nineteenth century right up to the 1960s and 1970s. In the Smithy, there are numerous rusting iron tools, many more surely than in a Smithy at that time; and whose dilapidated surfaces spell long-standing disuse. Rather than being true to their moment of use, these objects have a patina of age that 'serves as a kind of visual proof of status' (McCracken, 1988:32). It is age *per se* and the aura conveyed by having been part of a now-past way of life that legitimes these sites and their contents (Macdonald, 2002).

Aros, by contrast, does not for the most part contain original historical artefacts. Certainly, the reconstructions contain various apparently old objects, an iron kettle, creels, a butter churn, but we are not told whether they are reproductions or originals. When I ask about where they have come from, Donald tells me that he found most of them himself at home. Their material status, their *provenance*, does not particularly matter: what matters is that they convey the right kind of picture, for at Aros authenticity lies not in the aura of artefacts, but in the 'story' which gets told.

So how is this story, which competes with alternative, more established stories, made compelling and authoritative? There are a number of strategies at work here. One is the presentation of 'facts'. In much of the written text and in the audio narrative, 'the story' is related in terms of 'such and such happened'. It is told as given. This, of course, is the *modus operandi* of heritage presentations: they do not normally discuss sources or alternatives; and their physical, material form itself connotes 'fact'. The exhibition is also a relatively closed or coercive one. A narrator, a male Highland voice, ties it all together into a seamless account; and unless visitors forgo the commentary altogether, they must traverse this exhibition at a fixed speed and in a particular direction. The use of headsets also makes it very difficult to talk with other visitors, so making the visitor experience very much an individual, and rather concentrated, one; again, shutting out some of the possible sources of unplanned and alternative readings.

An exhibition such as The Skye Story contains only a small amount of carefully selected material: as Donald says: 'We were very careful not to overload it'. This means, however, that details which do not neatly fit the story have been eliminated. There is none of the messiness that can generate alternative accounts, which is not to say that people may not come out with alternative interpretations, but Aros does its best to prevent this. Its makers may recognize that Aros is only one story, only one interpretation, but they are nevertheless keen to make it as compelling as possible for those who visit.

However, the exhibition does not wholly abandon sourcing. In one section, about famine and hardship, the visitor is presented (in large, stark white print on a black background) with eye-witness evidence in the form of dated quotations from observers of the Highlands, Dr Johnson, Lady MacAskill and Sir Archibald Geikie. That even well-to-do English and Lowland outsiders should have been in no doubt about the dreadfulness of the situation is undoubtedly rhetorically persuasive, if ironic, in establishing such a picture as objectively the case.

The exhibition also makes selective use of realism in the form of three-dimensional natural-istic sets built to scale and often accompanied by appropriate sound effects (such as the lapping of waves). Here, the visitor enters into a bounded world which conceals, albeit momentarily and incompletely, the limits which give lie to its constructedness. Such realist representations are used for the most part to depict events which the exhibition-makers wish to foreground as central to understanding the people's experience: especially, the slave ship and the Napier Commission hearing, powerful symbols respectively of the oppression of the people and their resistance. The Bonnie Prince Charlie myth is also countered with a rather mundane, realistic scene, the Prince in MacNab's Inn. Its ordinariness serves as a metaphorical deflation of the romance which more usually characterizes representations of the Prince.

As Haraway has argued, realism is both an epistemological and an aesthetic stance – the two are mutually supportive – whose:

> power … [lies] in its magical effects: what is so painfully constructed appears effortlessly, spontaneously, found, discovered, simply there if one will only look. Realism does not appear to be a point of view.
>
> (Haraway, 1991:38)

Realism is a powerful strategy for presenting an event in as incontrovertible a manner as possible. It makes it *look* real, 'and therefore it is real; in any case the fact that it seems real is real even if, like Alice in Wonderland, it never existed' (Eco, 1986:16). Such an emphasis on the visual, increasingly supplemented by other sensory modes, has been argued to be supplanting auratic, or what Eco calls 'historical', modes of authenticating (Eco, 1986:16). While this is surely not the case to the extent implied by both Benjamin and Eco (see Lumley, 1988:15), Aros clearly makes much use of an established, and perhaps increasingly widespread, means of authenticating its account.

The exhibition is not realist throughout, however, and indeed in some places, especially the depiction of Culloden, non-realist styles are used ironically to signal the constructed nature of the representations which have come down to us. The exhibition plays with different styles and juxtapositions; and sometimes it uses these to authorize its own selections (as when a piece of Skye rock, or reproductions of famous Celtic books, are put in glass casing), and at others to hint at the contrivance of accepted images (the gilt-framed portraits of the Prince and Flora). If the audience is assumed to be 'not well-versed in their history', their intertextual interpretative skills, by contrast, are expected, it seems, to be rather sophisticated. Although it has been suggested that visitors are increasingly well-capable of recognizing and enjoying irony, and indeed this is a characteristic of 'post-tourists' (Feifer, 1985; Urry, 1990:100), there is always a danger in such representations that this sophistication is overestimated (Riegel, 1996). Perhaps partly in recognition of this, the taped commentary in The Skye Story is more direct and less ironic than are the visual exhibits. Throughout the exhibition, however, irony and intertextualism are only used to make particular points: there is no play with styles for their own sake. The story the exhibition tells, a story of Gaelic identity, past, present and future, is too important to the exhibition's makers for that.

If The Skye Story uses many technologies of display that have been associated with the proliferation of, and even revelling in, inauthenticity, and more generally with a post-modern emphasis on style and surface, rather than depth and processes of production (see, for example, Harvey, 1989; Jameson, 1991), it does not do so in order to dispense with questions of authenticity, authority, narrative and origins. Nevertheless, display strategies are not all equally compelling, nor all equally suited to telling certain kinds of stories. While the emphasis on reproductions and 'mechanically produced' visual realism, rather than on original artefacts with their 'unique historical testimony' (Benjamin, 1973:215), has sometimes been associated with a politics of the Right; in The Skye Story, the very malleability of reproductions (including reproductions without originals), the fact that 'the story' can predominate, seems to afford a popular or radical potential. Such reproductions can be used to tell stories where artefacts are typically mute: stories of hardship, of linguistic oppression, of power relations. Moreover, they seem particularly well-suited to creating the kind of past-present linkages and the vision of a dynamic and changing culture and identity that is attempted at Aros.

Appropriate though the representational technologies of Aros may be for articulating a changing rather than a static identity, they have by no means ousted either alternative modes of

authenticating or alternative visions of 'Skye' or 'Gaelic' identity. Sites such as the castles and the folklife museums, not to mention Skye's dramatic physical landscape, have a hold on what are undoubtedly very powerful auratic forms of authenticity. These show no signs of 'withering', and, if visitor numbers are anything to go by, clearly exceed those of Aros. Perhaps Aros's techniques, the techniques of the heritage model, will not be able effectively to compete. Why go to look at a set of reconstructions when the island abounds with what appears to be 'the real thing'?

Just as Aros's modes of authenticating must compete with those of other heritage sites, so too must its (and its makers') constructions of culture and identity. One of the key questions here is how far the account presented in The Skye Story will be perceived as 'the people's history' by local people – will it be seen as theirs, and as an account to visit and revisit.

I have not conducted systematic research upon this topic but, on the basis of comments made to me by local people, the following might be noted. The 'demythifying' intention of Aros does seem to strike a chord with some. As one woman said of other accounts: 'they've kept so much from us', implying that Aros uncovers a conspiracy of silence. For others, however, the exhibition was regarded as having been intended for tourists. In only one case was this related to the content of the exhibition. In this case, an elderly man told me that it was clearly not directed at local people as, in his view, the history it presents would already be well known to them. 'It's very thin', he said, comparing it unfavourably with a local folk museum where you could find pictures and names of people or relatives that you knew and where 'you could spend a month reading and not be done'. The relatively coercive directed technologies of Aros and the heritage model do not offer themselves up for the alternative readings and openness to independent historical research that this particular visitor preferred. For those others who viewed the exhibition as being directed more at tourists than themselves, it was the classification of Aros within a broader range of enterprises which were all assumed to be intended for outsiders. Its commercial dimensions almost always figured in this, with the exhibition's admission cost (£3 per adult) often given as a reason not to visit more than once. One man made the generality very clear: 'It's a commercial venture – they're all commercial ventures. They're for tourists, not for the likes of us'. He went on to disparage the general attempt to link Gaelic with business and to argue that the Gaelic revival was based upon a set of 'gimmicks' – to be inauthentic in his terms. An older Gaelic speaker, his view was part of an alternative cultural view that the younger revivalists hope to conquer.

Inalienable heritage

Heritage has been seen by various commentators, especially Hewison (1987) and Wright (1985), as particularly bound up with conservative politics. What we see at Aros, however, is heritage put to more radical use; a potential which Samuel (1994) argues has long been thoroughly part of the heritage movement (see also Urry, 1990:110, 1996; McCrone *et al.*, 1995; Rojek and Urry, 1997).

The Skye Story has been constructed by a particular group of local people, young, fairly successful Gaelic speakers who are making a living from their 'Gaelicness'. It is a story they tell themselves about themselves (Geertz, 1985:448). This is a story of a distinctive local historical experience; a story of continued Gaelic resilience in the face of outside threat. It is a story which, I have suggested, the heritage format (which does not rely upon originals) may be well-suited to telling, though it is certainly neither uncontested nor without its problems (in particular, the danger that it may be misread or dismissed). But what of the charge that this kind of representation entails a commodification of culture and history?

How do the makers of Aros see the matter? As we have discussed, while they intend the centre to make money, they reject the opposition between Gaelic culture and commercial enterprise. Such an opposition would be to condemn their way of life to marginality and spell the end of their language; and it is an opposition which itself is imposed, at least in part, from outside. However, this is not to say that they see themselves as in any sense selling their heritage, for heritage is not conceptualized as a commodity.

In Gaelic, Aros is subtitled *Dualchas an Eilein*, which might be translated as 'the heritage of the Island' (*an Eilein*, the Island, being colloquially used to refer to Skye). However, *dualchas* means heritage in rather a specific sense. Rather than referring to the property, or material, that is inherited from generation to generation, for which the term *oighreachd* would be used (and which most dictionaries give as the standard translation of heritage), *dualchas* refers to more intangible matters of nature, character and duty. The following glosses are given in Gaelic's most comprehensive dictionary (which also notes the difficulty of translating the term literally):

> 1. Hereditary disposition or right. 2. Imitation of the ways of one's ancestors. 3. Bias of character. 4. Nature, temper. 5. Native place. 6. Hire, wages, dues. 6. [sic.] Duty.
>
> (Dwelly, 1977:367)

Dualchas is a kind of imperative, something to which one is obviously and undeniably connected. It might manifest itself in various ways (a child is not identical to its parents), and might be put to various uses, but at root it is inalienable, it is kept even while it is passed on (such as from one generation to the next).

This idea of the inalienable, and its embodiment in material form, as Weiner has argued, is a very different kind of relationship to objects than that of commodity-relations (Weiner, 1992:6). In commodity-exchange, ownership is transmitted from seller to buyer. 'Inalienable possessions', by contrast, involve what Weiner calls 'the paradox of keeping-while-giving': even while they enter into systems of exchange and social relations, they are 'kept' and 'imbued with the intrinsic and ineffable identities of their owners' (Weiner, 1992:6). This paradoxical quality of inalienable possessions means that they are also well-suited to mediating the paradox of continuity (or identity) through change. says:

> In one sense, an inalienable possession acts as a stabilizing force against change because its presence authenticates cosmological origins, kinship, and political histories.
>
> (Weiner, 1992:9)

And yet precisely because of its role in cosmological authentication, an inalienable possession is likely to be a focus of struggles for change. Heritage is just such an inalienable possession (McCrone *et al.*, 1995:197). Outsiders may come to look, to learn and to admire, and they may take away souvenirs, knowledge and images, but this does not lead to a diminishment in what is 'kept' by the people. *Dualchas* is thus not a commodity; and nor does it have 'commodity candidacy' (Appadurai, 1986a:13), that is, the likelihood of becoming a commodity.

However, in using what has become a standardized model for proclaiming their heritage as distinctive, do Aros's makers reduce the local to a familiar, and ultimately undistinctive, transnational archetype? Is it the case, as MacCannell (1992:170) argues for the Amish, Black, Chicano, Dervish, Eskimo and Guyanan, that Gaels will find themselves subsumed in a wider system in which 'They can never *be* the body, they can only be incorporated, contained, "assimilated", taken into the body, eaten up'? Again, it is important to consider how they see the matter.

The story that Aros tells is not of a pristine, untouched culture. On the contrary, much of the story concerns contact and relations with outsiders. However, as 'heritage' is not conceptualized as a bounded body of material, these interactions often highlight the manifestation of *dualchas* (particularly resilience) rather than its corruption; and in the story which is told, it is Gaelic culture which incorporates and appropriates material and practices from outside. The Skye Story has no problem with showing Gaels making use of outside agencies (such as the Napier Commission) or of defining that which has been appropriated as Gaelic (Postman Pat). The primary origins of things and practices are not what matters. What matters, and this meshes with the view of history being told from alternative vantage points, is the perspective from which they are now seen. Heritage is, in part, a strategy of appropriation.

To some extent, what is also involved here is a strong sense of the inalienability of *dualchas*. As Weiner has argued for inalienable possessions, this alters the character of exchange:

> Because each inalienable possession is subjectively unique ... exchange does not produce a homogeneous totality, but rather is an arena where heterogeneity is determined ... The possession not only authenticates the authority of its owner, but affects all other transactions even if it is not being exchanged.
>
> (Weiner, 1992:10)

Not only does this imply that heritage can be an arena for determining identity; it also suggests that the commodity relations which also surround heritage might be seen as distinct from ordinary commodity relations. Not so much a commodification of history and culture, what might be involved here (as Miller has argued for Christmas) is a 'sacralisation' of consumption (Miller, 1994:106).

Conclusion

These local understandings can be used to alert us to some of our own analytical presuppositions. On culture and the tourist encounter, they show that we need not conceptualize culture as 'an original pure state ... like the ethnographic present, before contact ... as if history begins with tourism, which then pollutes the world' (Bruner, 1994:408; see Chapter 1). Alternative, more dynamic, notions of culture are available – notions which allow for local, as well as global, appropriation (Gewertz and Errington, 1991). Moreover, they highlight some of the dangers of a proprietorial discourse of 'origins'. Categories such as cultural identity and heritage are part of 'an international political model that people all over the globe use to construct images of others and themselves' (Handler and Linnekin, 1984:287). They act as a transnational symbolic resource for self-definition, though they may also be given their own local inflections (Appadurai and Breckenridge, 1992). While there undoubtedly are differentials in the global flow of images and meanings (see Lash and Urry, 1994; Hannerz, 1992), the reflexive layerings and multiple borrowings have, by now, surely become so complex that we cannot easily assign ownership. Wherever we live, we do so to some extent in categories which have been defined elsewhere. As Eco wrote of the 'global village': 'all are in it, and all are outside it: Power is elusive, and there is no telling where the "plan" comes from' (Eco, 1986:149).

To see local people as merely the passive recipients of an external world which impinges upon them is rather like the conceit of tourists who assign local people only the role of object of the tourist gaze. As we have seen here, not only may they be well aware of external images of themselves, they may also attempt actively to counter those images and to construct alternative

visions of their history and culture. Using a transnational and commodified format to do this does not necessarily mean abandoning local notions of heritage and identity, and may, moreover, help establish the significance of local experience. The heritage centre, and cultural tourism more generally, *can* be a way of telling the people's story, and of helping to make sure that it will be heard.

Acknowledgements

I offer grateful thanks to all those in Skye who helped me with this research, especially Donald MacDonald, Jonathan Macdonald and Sine Gillespie. The following made many helpful comments on earlier versions of this chapter: Mike Beaney, Kevin Hetherington, John Urry, and participants at Sussex University and St Andrews Social Anthropology seminars.

References

Anderson, B. (1983) *Imagined Communities*, London: rso.

Appadurai, A. (1986) 'Introduction: commodities d the politics of value', in Appadurai, A. (ed.), *The Social Life of Things: Commodities in ultural Perspective*, New York: Cambridge University Press.

—— and Breckenbridge, C. (1992) 'Museums good to think: heritage on view in India', in Karp, I., Kreamer, C. and Lavine, S. (e , *Museums and Communities*, Washington and London: Smithsonian Institution.

Benjamin, W. (1973) *Illuminations*, Glasgc Fontana.

Bennett, T. (1988) 'Museums and "the Pe e"', in Lumley, R. (ed.), *The Museum Time-Machine*, London: Routledge.

Bruner, E. (1994) 'Abraham Lincoln a uthentic reproduction: a critique of postmodernism', *American Anthropologist*, 96, 397–4 .

Chapman, M. (1978) *The Gaelic Visi in Scottish Culture*, London: Croom Helm.

—— (1982) '"Semantics" and the elt"', in Parkin, D. (ed.), *Semantic Anthropology*, London: Academic Press.

Cooper, D. (1979) *Road to the Isl Travellers in the Hebrides, 1770–1914*, London: Routledge.

Corner, J. and Harvey, S. (199 'Mediating tradition and modernity: the heritage/enterprise couplet', in *Enterprise and F ritage: Crosscurrents of National Culture*, London: Routledge.

Dorst, J. (1987) *The Written uburb: An American Site; An Ethnographic Dilemma*, Philadelphia: University of Pennsylvania Press.

Dwelly, E. (1977) *Faclair Gaidhlig gu Beurla le Dealbhan (Dwelly's Illustrated Gaelic to English Dictionary)*, Glasgow: Gairm.

Eco, U. (1986) *Travels in Hyper-Reality*, London: Picador.

Feifer, M. (1985) *Going Places*, London: Macmillan.

Geertz, C. (1963) *Agricultural Involution*, Berkeley: University of California Press.

—— (1985) 'Deep play: notes on the Balinese cockfight', in Geertz, C. (ed.), *The Interpretation of Cultures*, New York: Basic Books.

Gewertz, D. and Errington, F. (1991) *Twisted Histories, Altered Contexts: Representing the Chambri in a World System*, Cambridge: Cambridge University Press.

Greenwood, D. (1989) 'Culture by the pound: an anthropological perspective on tourism as cultural commoditization', in Smith, V. (ed.), *Hosts and Guests*, Philadelphia: University of Pennsylvania Press.

Handler. R. (1985) 'On having a culture: nationalism and the preservation of Quebec's Patrimony', in Stocking, G. (ed.), *Objects and Others: Essays on Museums and Material Culture*, Wisconsin: Wisconsin University Press.

Handler. R. (1988) *Nationalism and the Politics of Culture in Quebec*, Wisconsin: Wisconsin University Press.

—— and Linnekin, J. (1984) 'Tradition, genuine or spurious?', *Journal of American Folklore*, 97, 273–90.

—— and Saxton, W. (1988) 'Living history: dissimulation, reflexivity and narrative', *Cultural Anthropology*, 3, 242–60.

Hannerz, U. (1992) *Cultural Complexity: Studies in the Social Organization of Meaning*, New York: University of Colombia Press.

Haraway, D. (1991) *Simians, Cyborgs, and Women. The Reinvention of Nature*, New York: Routledge.

Harvey, D. (1989) *The Condition of Postmodernity*, Oxford: Blackwell.

Hewison, R. (1987) *The Heritage Industry*, London: Methuen.

Hunter, J. (1976) *The Making of the Crofting Community*, Edinburgh: James Donald.

—— (1991) *The Claim of Crofting: The Scottish Highlands and Islands 1930–1990*, Edinburgh: Mainstream.

Jameson, F. (1991) *Postmodernism, or the Cultural Logic of Late Capitalism*, London: Verso.

Lash, S. and Urry, J. (1994) *Economies of Signs and Spaces*, London: Sage.

Lumley, R. (1988) 'Introduction', in *The Museum Time-Machine*, London: Routledge.

MacCannell, D. (1989) *The Tourist* (2nd edn), London: Macmillan.

—— (1992) *Empty Meeting Grounds: The Tourist Papers*, London: Routledge.

McCracken. G. (1988) *Culture and Consumption*, Bloomington and Indianapolis: Indiana University Press.

McCrone, D., Morris, A. and Kiely, R. (1995) *Scotland: The Brand*, Edinburgh: Edinburgh University Press.

McDonald, M. (1986) 'Celtic ethnic kinship and the problem of being English', *Current Anthropology*, 1, 333–47.

Macdonald, S. (1997) *Reimagining Culture. Histories, Identities and the Gaelic Renaissance*, Oxford: Berg.

—— (2002) 'On "old things": the fetishization of past everyday life', in Rapport, N. (ed.), *British Subjects. An Anthropology of Britain*, Oxford: Berg.

Mac Gill-eain, S. (1985) 'Màiri Mór nan Oran', in *Ris a' Bhruthaich*, Stornoway: Acair.

McKean, P. (1989) Towards a theoretical analysis of tourism: economic dualism and cultural involution in Bali', in Smith, V. (ed.), *Hosts and Guests*, Philadelphia: University of Pennsylvania Press.

MacKinnon, K. (1974) *The Lion's Tongue*, Inverness: Club Leabhar.

Miller, D. (1994) *Modernity, An Ethnographic Approach: Dualism and Mass Consumption in Trinidad*, Oxford and Providence: Berg.

Morris, A. (1991) 'Popping the cork: history, heritage and the stately home in the Scottish borders', in Day, G. and Rees, G. (eds), *Regions, Nations and European Integration: Remaking the Celtic Fringe*, Cardiff: University of Wales.

Pedersen, R. and Shaw, J. (1993) *Gaelic Tourism Concepts*, Inverness: Highlands and Islands Enterprise.

Pittock, M. (1991) *The Invention of Scotland: The Stuart Myth and the Scottish Identity, 1638 to the Present*, London: Routledge.

Richards, E. (1982) *A History of Highland Clearances*, London: Croom Helm.

Riegel, H.(1996) 'Into the heart of irony', in Macdonald, S. and Fyfe, G. (eds), *Theorising Museums*, Oxford: Blackwell.

Rojek, C. and Urry, J. (1997) 'Transformation of travel and theory', in Rojek, C. and Urry, J. (eds), *Touring Cultures: Transformations of Travel and Theory*, London and New York: Routledge.

Samuel, R. (1994) *Theatre of Memory*, London: Verso.

Shields, R. (1991) *Places on the Margin: Alternative Geographies of Modernity*, London: Routledge.

Urry, J. (1990) *The Tourist Gaze*, London: Sage.

—— (1996) 'How do societies remember the past?', in Fyfe, G. and Macdonald, S. (eds), *Theorising Museums: Representing Identity in a Changing World*, Oxford: Blackwell.

Withers, C. (1984) *Gaelic in Scotland, 1698–1981: The Geographical History of a Language*, Edinburgh: John Donald.

Weiner, A. (1992) *Inalienable Possessions: The Paradox of Keeping-while-Giving*, Berkeley: University of California Press.

Wright, P. (1985) *On Living in an Old Country*, London: Verso.

The South-east Asian 'living museum' and its antecedents

Michael Hitchcock, Nick Stanley and Siu, King Chung

Ethnographic cultural village museums that bring together tangible and intangible cultural heritage can now be found throughout many Asia-Pacific countries. Although influences in their development may be traced back to the open-air folk museum movements in Europe and North America, these cultural village museums often have differing underlying principles to their Western counterparts, with national politics playing a leading role. In South-east Asia, two significant examples of this form of museum are located in China and in Indonesia, respectively. The China Folk Culture Villages project was established in 1991 at Shenzhen in the Gaundong Province of China, within the Special Economic Zone created to stimulate development. In Indonesia, the Tamin Mini museum was initiated in the early 1970s by Mrs Tien Suharto, the wife of the second president. Common to both of these museums has been the recognition of cultural diversity within a unifying nationalist framework. However, if decisions about what is to be presented and how it is to be displayed are state-driven, who is in control of, and who is allowed to participate in, the process?

Focusing mainly on these two museums, both in relation to their place within the broader context of living museums as well as their specific political, social, economic and cultural environments, this chapter considers issues relating to each. For example, a major part of the chapter is given over to discussions of the key issues relating to the Shenzhen project in China, which is aimed at affirming cultural pluralism and the respect of minority traditions within a nationalist rhetoric and identity. These issues include those regarding architectural representation, use of costume, and the integration of performance and traditional cultural expressions. Some relate to the training and management of the human resources, whilst others are associated with the actual selection of the minority nationalities that are included. Finally, there are those linked to visitor profiles, the expectations of these visitors and how they interact with the displays.

Post-colonial consciousness has made anthropological representation a vexed issue in Europe and North America. In South-east Asia, however, it has found a new home and rationale, particularly in cultural village museums. Modelled on earlier European folk village museums, these Asian ethnographic displays provide space for tangible and symbolic expressions of modernization. Elements of the past are portrayed as an integral part of the future in a rapidly changing socio-political climate. Visited by both foreign and domestic tourists, these museums provide venues for national constructions of identity derived from an exemplary past.

Open-air museums dedicated to the popular anthropological topics can be visited in many Asia-Pacific countries. Some of these museums deal with the lives of ordinary people, whereas

others concentrate on high cultural traditions. such as Asian court culture. Most follow the cultural village format, and these museums usually comprise a collection of traditional buildings. The buildings are often used to display arts and crafts and serve as venues for music and dance performances. Many employ actors to help re-create old traditions in a living environment. Two of the most impressive of these open-air museums are located in Indonesia (Taman Mini) and South China (Shenzhen).

China Folk Culture Villages

In Shenzhen, in Guandong Province in China, a tourist development complex has sprung up on the shores of Shenzhen Bay, just over the border from Hong Kong. It is located in the Special Economic Zone, which is financed with Hong Kong capital. Beside the Shenzhen Bay Hotel are three separate but interrelated displays. The first, Splendid China, opened in October 1989, as the 'world's largest miniature scenic spot' of over thirty hectares. It offers the visitor China's scenic attractions, historical sites and folk customs and dwellings all in a single visit. The second display, China Folk Culture Villages opened next door in October 1991. In the Folk Culture Villages there are twenty-four life-size 'villages' (usually comprising two or more buildings large enough to accommodate at least a dozen performers and a continually moving audience of 100 or more), providing a setting for twenty-one selected minority nationalities. To complete the complex, The World's Windows is under construction. It is designed to work in the same way as the Folk Culture Villages, but brings the rest of the world to China in the form of roughly fifty of the world's great natural and man-made wonders, including the Eiffel Tower (already completed), Mount Fuji and the Pyramids.

In January 1992, Deng Xiaoping visited Shenzhen, emphasizing official support for the economic experiment that not only created the Shenzhen stock exchange, but laid the plans for greyhound racing and other tourist facilities. The most significant and widely reported aspect of Deng's visit to Shenzhen was his tour of the Folk Culture Villages, where he was photographed in a US-made Cushman courtesy carriage. As can be seen from the following extract from one Westerner's comments, the folk culture displays are sometimes seen simply as a theme park: 'Here are ... replicas of non-Chinese "minority villages" to be compulsively photographed and at night a stunning show of stilt walkers, acrobats with kids on their shoulders and a wedding procession with gongs and other attractions'. The journalist continues: 'The show ends in an approved Western theme park spectacular style with multicoloured lasers playing rhythmically on the pulsating waters of a computer-controlled fountain' (Gittins, 1992). Whilst this description is accurate enough as far as it goes (except that non-Han minorities are definitely not seen as non-Chinese), it fails to grasp two fundamentally important aspects of the Folk Culture Villages, which distinguish them radically from the normal Western theme park.

The Folk Culture Villages project is designed to fulfil a number of functions: 'to carry forward Chinese culture in a more vigorous way, to let the world have a better understanding of China, to help boost Chinese tourism and to promote friendship between the Chinese people and people of other nations' (Chinese Folk Cultural Villages official brochure). Only one of its central purposes is then to represent China; yet the programme evolved may at first appear somewhat paradoxical. By explicit design, the Han majority scarcely receives a mention. Instead, as the international publicity announces:

In the Folk Culture Villages there are 24 sets of buildings including mountain villages, residential compounds, streets and markets. Each of them has its characteristic feature

forming a relatively independent 'small community'. Among the 86 building units are 65 civilian residencies and 21 supplementary structures, occupying an area of 21,000 square metres. In addition there are 8 fairly large open-air singing and dancing grounds. Performances of folk songs and dances of different nationalities are to be given in 16 villages.

(China Travel Services, 1992:18).

Through the construction of a museum, the exemplary display provides a kaleidoscope of pluralism held together with the cement of nationalist rhetoric.

It is tempting to see the Folk Culture Villages as merely the window-dressing of a centralized state displaying a liberality in ethnological matters. The Folk Culture Villages cannot be dismissed merely as a Disneyland of fables drawn from a mythical past dressed up as an advertiser's confection. It bears marked similarities with another thirty-year-old ethnic tourist display, the Polynesian Cultural Centre in Hawaii (Webb, 1994:59–86). The display at Shenzhen is not stripped of historical or cultural references, but responds to and reflects aspects of the history of China's policy for minority peoples. The exhibition attempts some revisionist readings and implicitly claims that, if proper care is taken, all cultures and their artistic products can be accorded equal respect and attention. The significance in the Shenzhen Folk Culture Villages lies in the strategies adopted to interpret and evaluate this range of material and symbolic worlds.

What Gittins' report on Shenzhen fails to note are these two features: first, the museum display provides a new arena for the development of a more complex nationalism, which no longer stresses an evolutionary model of cultural development from primitive to modern (i.e. industrialized and urban). Second, Gittins' attention to the more obvious technical and marketing innovations prevents him from recognizing some highly traditional features that persist in the midst of novelty. Both of these aspects are considered here.

The Folk Culture Villages are built on the site of a former amusement park in Shenzhen Bay. The contents of the amusement park were sold on to an operation in Sichuan for HK\$30,000,000. A most ambitious programme has been realized with Hong Kong finance and local planning and construction in a remarkably short time. The twenty-four life-size 'villages' are set in a V-shaped site on the shore of Shenzhen Bay. The two-kilometre-long lake of Cuihu provides a central focus, stretching up the middle of both arms of the display. This watercourse provides the Folk Culture Villages with the opportunity to create some twelve different bridges in stone, hardwood and bamboo. The bridges also echo architectural features in the village buildings. These buildings have had a great amount of attention paid to correct architectural representation and construction techniques. But, increasingly, they also offer evidence of 'reform of practice' philosophy, a feature of China's government minorities policy. For example, the Bouyi, Dai and Zhuang houses follow reformed design principles, separating humans from livestock in the *ganlan* structure, rather than, as tradition would dictate, with animals on the ground floor and humans on the first floor above the animal pen.

The Folk Culture Villages can be seen as an example of a more general movement, and in Kunming, Yunnan Province, a similar project has been mounted:

Covering an area of 2.7 hectares the village has, in addition to the White Pagoda, five residential houses, two Dai-style buildings and other constructions including a Burmese-style temple and a so-called Wind and Rain Bridge. The first residents were fifty Dai people. Next to the Dai village, a 6.7 hectare Bai village has begun to take shape ... local officials say that Yunnan Province has 26 ethnic groups and each has its own colourful customs and

practices. Thus 26 different ethnic villages will be built beside Lake Dianchi to form a unique cultural scenic group.

The same process also operates at a more local level. Xijiang village in Guizhou, for example, has been developed as a 'natural museum of traditional Miao [Hmong] lifestyle'. The Folk Culture Villages should also be seen as part of a contemporary architectural trend in China, the 'Old Town' idiom, widely employed to provide a conscious copy of antique building in the design of streets and neighbours. But 'antique-modern' schemes offer the most significant opportunity to preserve antiquities:

> Many of the 'traditional' Dong structures remained in disrepair and locals could not afford to put on extravagant rituals which the tourists could observe. They had not the wealth, in other words, to reconstruct a tradition for tourist consumption. Far from threatening a traditional landscape, modernization was awaited as the impetus for rebuilding what outsiders expected to be there.
>
> (Oates, 1992:11).

The Folk Culture Villages do not only display physical evidence of a more widespread official tourist strategy. Much of the concept builds upon the work of the State Nationalities Affairs Commission, particularly with reference to culture, language, education and economic development. The themes of the Folk Culture Villages echo directly elements of the minorities policy. 'Habits and customs', a term employed in the policy to express the essential rights of minority peoples, provides the theme under which all the exhibits are organized. These rights concern both religious and special cultural requirements. For example, the policies on national minorities lay emphasis upon respecting the religious sensibilities of Muslim nationalities: these are partially satisfied with special dietary arrangements.

The policies also stress minority rights with regard to special forms of dress and costume. Indeed, so important is the issue of dress that one of the fifteen departments of the Folk Culture Villages is devoted entirely to costume. Costume designers modify original designs to create new ones appropriate for performers. The department also commissions ethnic costume manufacturers in regions like Yunnan, Mongolia and Xinjiang to complete large orders. Costumes provide the emblematic marker and identifier throughout the Villages. Costumes are like uniforms in terms of their narrowness in design variation. The constant reiterating of a common design solution – each nationality is provided with both male and female costumes – creates some special challenges for the costume department. In common with many minority peoples worldwide, the same tendency for males to forsake ethnic dress earlier than females is encountered in China. The Bai men's costume worn in the Bai Village offers a male version of the female garb, rather than a contemporary model, which would be the standard form of trousers worn elsewhere in China. This is only one of many issues that the Villages have had to face in making decisions over what 'reality' to present. There is an added irony, no doubt familiar to all performers and viewers in the Folk Culture Villages, that from the Cultural Revolution until 1978 the wearing of ethnic dress was problematic and often discouraged, though, as the official record states 'some areas did infringe the above policy' (Information China, 1989:1283). The renewed promotion of ethnic dress can either be viewed as a proper restoration of previous practices and official policies on minority nationalities, or, alternatively, it can be judged more as a cynical marketing of exotic non-Han designs and costumes worn indifferently by the performers

and guides. Of course, both views may be held simultaneously. In this case, the significance of costume may be unstable, and likely to shift according to context.

Context in the Folk Culture Villages is provided initially through architecture, a rather diffi-cult medium in which to give actions significant meaning. Although the villages are designed to offer a form of authenticity (the Zhuang bedroom, for example, has a hand-crafted bed and chest of drawers, as well as a set of 'ethnic' clothes hung on the wall and a bright new electric fan), they remain exhibits, and suggest little, if any, sense of being lived in. There are few marks of personal investment. This highlights, perhaps, Graburn's contention that the content of tourist arts 'consists of signs rather than symbols' (Graburn, 1976:17), signs that point but do not provide context. The only areas that provide any sense of communication are the small sales areas in some of the villages (like the Bai). The way that architecture and costume are brought together is through the festival. In line with the official minorities policy, the Folk Culture Villages celebrate minority nationality festivals and holidays. The official programme lists twelve such festivals throughout the year. Interestingly, five of these are specifically Han (the lantern festival, the dragon boat, the birthday of the goddess of the sea, the mid-autumn and the kite festival). No doubt this arrangement reflects the pattern of holidays for visitors as much as for performers. Festivals are further broken down into performances of elements of festivals. For this purpose, a song and dance routine has been arranged by the Folk Culture Villages' depart-ment of performance management. Such performances usually take place either in the environ-ment of the village during the day or in the central theatre for the 'evening party' or show. There are nine folk and dance performances per hour during the day by the respective nationalities, as well as lunch-time and evening performances at the central theatre. The visitor is therefore bound to see at least three or four performances during her or his visit. This certainly is further increased by many of the performances turning into processions along the lake. The department of ethnological arts researches minority arts and customs and makes proposals to the ethnic affairs committee for execution. Thus the aspects of festival that permeate the display serve to unite architecture, folk customs, dress and performance into a single entity. The Folk Culture Villages have also incorporated the food and drink associated with festivals into many of the displays, which have associated food counters.

The Villages plan was conceptualized under two headings: the 'hardware' consists of the phys-ical construction and layout of the site, the physical environment. The software is the human element – the seven thousand employees working in the Folk Culture Villages. The personnel undergo a fairly rigorous programme of training that lays considerable stress on the political context in terms of the Communist Party and official policy, as well as the particular circum-stances of the Shenzhen Special Economic Zone. The 1991 training programmes were created to:

> make clear the principle of 'training for the practical'; the training programme should aim at the uniqueness of the minority performers and their craftsmen, and to pay special atten-tion to the trainees' actual cultural disposition as well as their abilities in order to raise the average level of performance as a whole. Through a short training programme the trainee's psychological (political) readiness will be reinforced for the various performances in the Folk Culture Villages.[1]

Whilst the programme may be 'short-term' it is certainly not short. In the original plan there is a total of 294 training hours, devoted to ten areas of learning and training. The list is instruc-tive. The first three elements provide a short context: item one covers the Party's basic direction and the initial stages of socialism (eight hours); item two, the party open-door reforms and the

development and construction of the Special Economic Zone (four hours); item three, the development of the Overseas Chinese Town and its legal regulations (four hours). The next two units introduce the Folk Culture Villages Philosophy. Item four deals with basic knowledge of tourist culture (four hours), whilst five provides an introduction to a theory of public relations (twelve hours). The sixth element deals with basic knowledge of folklore and ethnology (twenty-two hours). Language acquisition (item seven) is accorded a large segment of the training programme (ninety-six hours for Mandarin, Cantonese and English). The remaining three items receive equal weighting (forty-eight hours each). These cover basic principles of music (score reading, music theory and audio-visual practice), training in personal presentation, and finally, performance training.

This programme was later slimmed down to 161 hours, but still remains a substantial undertaking. The objectives of the training programme are threefold: first, to adapt to these changing working conditions of the reformed environment in the Special Economic Zone and to become attuned to the changed working conditions and lifestyles. Second, the training is designed to 'understand the value and importance of Chinese ethnicities and their arts, custom and cultures' and to develop a knowledge of and pride in the Folk Culture Villages.

The third objective is to increase levels of aesthetic awareness and to develop personal skills in performance, language, presentation and interpersonal skills in the context of the tourist industry.

The training programme in the summer of 1992 was augmented by a six-week formal programme at Guangzhou Chinese Tutorial Institute of 160 hours. The ten courses offered cover much the same territory as the earlier programme. The only significant changes were in the reduction of the language component, the withdrawal of performance training (probably because the facilities were not available in Guangzhou) and the introduction of a new item 'developing spiritual civilisation and general knowledge in legal matters'.

A discernible shift in management style has occurred at the end of the first two-year cycle. Some performers have stayed on (most of the Yi, for example). Performers from other venues are now recruited on six-month contracts to engender a new competitive attitude amongst the performance groups. With the increasing popularity of the ethnic village market in China, there is now an ever-expanding pool of potential performers for the management of the Folk Culture Villages to draw upon.

The training programme has to take into account the special circumstances concerning recruitment, namely that the performers have come directly from their home territories into the Special Economic Zone, without stopping, so to speak, in the more ordinary conditions in the rest of China. It is this fact, of course, that provides a major incentive for the performers to volunteer to work in the Folk Culture Villages in the first place. Not only are they able to earn money that they are able to remit home for the purchase of durables like electrical appliances, but they are also located in the most advanced economic sector of China.[2] The minority nationality performers thus leapfrog from some of the least developed regions of China directly into the most economically advanced. This achievement is only possible, however, through the paradox of displaying elements of traditional culture in a new way in a highly innovative and rapidly changing world.

These special circumstances inevitably produce the possibility of stress and conflict. As the Folk Culture Village March 1991 training programme notes:

> In dealing with minority trainees, it is necessary to put in more emotional investment, to promote understanding and constant communication; building on such premises the following four relations should be dealt with appropriately:
> 1 the relation between modern civilization and the minorities' life style,

2 the relation between the minority religions and corresponding policies,

3 the positive relations among different minority groups,

4 the equal and respectful relations between the Han nationality and the other minorities.

As the Director of the Folk Culture Villages noted at the time:

> The group of minority employees is composed of teenagers aged between 17 and 20. Most of them are naive and have not left home long. Especially as they have to receive long training and adapt to different living habits they could become homesick and run away. This could occur at any time. Therefore I propose that a high-standing policy officer with considerable patience, a middle-aged female, should be appointed as a political counsellor to look after the extra-curricular arrangements and the trainees' behaviour.

Evidently, the Folk Culture Villages provide potential for social and managerial headaches. In our interview with the Director of the Villages, Mr Ma explained that in the work contract, intimate relations between different minorities were not encouraged, 'otherwise the people working in the Folk Culture Villages would be Hannised themselves'. On the other hand, working together provided individuals with the opportunity to interact and learn from each other. Similarly, Village employees might be tempted to marry local people to obtain residency in either Shenzhen or Hong Kong. To prevent this, a 'Beyond the Eight Hours of Work Consultation Committee' has been established.

There is in the very concept of the Folk Culture Villages a tension that inevitably affects the representatives of minority cultures. The performers are caught, as it were, in a contradiction between the apparently stable environment of their home minority region and the impetus that attracts them to the Villages, offering a modern and plural environment open to international influences.

Performing in the Folk Culture Villages must create tension between the two polar alternatives: on the one side, homesickness and the desire to return, and on the other, the unfolding vision of another world with markedly different career perspectives. This would argue for a rapid turnover of personnel in the Villages, which would underscore the importance of a continually evolving training programme. Inevitably, this raises in turn the question of the selection of cultures deemed appropriate for incorporation and malleable to the Folk Culture Villages' philosophy and management ethos.

The selection of cultures

The name 'China Folk Culture Villages' (Zhongguo Minsu Wenhua Cun) specifically avoids employing the term 'ethnic minorities' (*shao shu minzu*) in favour of a homophonic neologism 'people's customs' (*minsu*). This new term was chosen by the experts 'after long deliberation, to show the harmony of the races'. A decision was made to bypass the sensitive argument about the basis of selection, and more significantly, for exclusion. The Folk Culture Villages only represented a choice of 'people's customs', not necessarily total 'ethnic nationalities'. The display attempted to incorporate as many nationalities as possible within the limitations of space. If a nationality was not represented directly in its own village, aspects of the culture might yet be offered, for example, in the song and dance of the theatrical display. The brochure for the Folk Culture Village neatly avoids the issue:

For a faithful reflection of the folk customs and practices, hundreds of artists and service workers belonging to 21 nationalities have been recruited for performances and service work in the villages from urban and rural areas in ten provinces and autonomous regions where most national minorities are living. Carnivals of national arts, song and dance performances by professional artists and folk festive celebrations have been organised and an exhibition hall of folk customs has been built, all ready to welcome visitors who wish to have a taste of the colourful cultures of China's 56 nationalities.

Nevertheless, some fairly hard decisions have had to be taken. Twenty-one nationalities are represented in the Folk Culture Villages. This means, of course, that thirty-three are not. The selection is not a representative sample based on the demographic or geographic distribution of China's ethnic minority populations. Indeed, the contrast is instructive. All the nationalities having a population of over a million are represented, even if, sometimes, as in the case of the Hui, their presence is restricted to representation only in the performances. The basis of selection for the smaller ethnic groups is harder to establish. The formal principle 'originating from real life but rising above it, and discarding dross and selecting the essential' is evoked in the official brochure, which also reminds the reader that the Folk Culture Villages are not an exact reproduction of real life. The argument appears to be that there is a kind of distillation of ideal characteristics that the creators of the Villages were looking for. The Mosou people, part of the Naxi ethnic group of Yunnan, is represented simply because it is a matrilineal society. As such, this people is, in Chinese terms, unique in its social structure. On the other hand, despite a population in excess of seven million, the Hui are not represented because, it is suggested, their culture is so similar to that of the Uygur from Xinjiang. They are therefore eliminated on the grounds of duplication. Another reason for disqualification is smallness of population. If there are only a few hundred people in an ethnic group, then it is not deemed necessary to include them. Nevertheless, the smallest 'nationality', the Gaoshan (1,500) from Fujian are well represented – possibly because these people also live in Taiwan, from where many visitors are expected to come. Taiwan has its own 'cultural parks' for minority peoples, which are also popular tourist attractions.

Other considerations of a more display-oriented nature enter into the selection criteria. The Mosou are selected, not only for cultural reasons, but also because their architecture is unique. Gender ratios are also considered important. The policy is to hire a ratio of seven women to three men. The Director of the Folk Culture Villages explained that beautiful female performers are more attractive to visitors, especially to male visitors from Hong Kong. This decision is further justified on the basis of display. In traditional Chinese society, the Director maintains, more women are engaged in handicrafts than men. It is also impossible within the confines of the Folk Culture Village environment to show men engaged in typical occupations like farming or hunting. Men, however, have their uses. In the Hani display – a society where smoking is very widespread – men are employed to smoke all day, rather than women, as such a spectacle involving women would be unacceptable to the visitors.

There is, nevertheless, a cultural agenda discernible in the architecture of the Folk Culture Villages. At first sight, the prominence of the Tibetan exhibits is puzzling. Not only is there a large Tibetan stone watch-tower, peopled with a good complement of performers, but also a large, separate building on a small hill constructed as a Tibetan Lamasery. The interior of this latter building has large frescos that advance a political message: the scene represents 'the marriage ceremony of King Zongzan Ganbu of Tibet and Princess Wencheng, the adopted daughter of the Tang Emperor Li Shiming'.[3] The Chinese government continues to validate its disputed claim to Tibet with reference to this dynastic marriage. The grandeur of the Lamasery and the detailing of

the site and interior give it and the watch-tower a pre-eminence out of proportion to the population's size. Perhaps the status of Tibetan culture in the Folk Culture Villages reflects the attention that the nationality has received in Chinese academic study of late. The 1990/1 *People's Republic of China Yearbook* emphasized how much research work on Tibetan studies had taken place in the previous two years, particularly the 'King Gesar' international academic seminar held in Chengdu.

If the Tibetan exhibits underscore the significance of that culture, the mosque provides a contrary puzzle. The exhibition is significantly named 'Moslem architecture'. This approach – purely architectural – contrasts very markedly with all the other displays. In this display there are none of the normal Skansen-like 'living pictures': there are no interiors, no culture or performances. Most significantly, there are no nationalities mentioned. Yet ten of the fifty-five minority nationalities are Muslim, and four of them, Hui, Uygur, Kazak and Dong, are represented in the Villages. Yet none of these displays makes significant reference to Islamic social or religious features. What there is in the newly opened mosque is merely a bazaar for the sale of Uygur products; textiles, carpets and a wall of highly variegated paintings. The display suggests that Islam has to be seen to be addressed – perhaps for architectural purposes, as there are Buddhist and Taoist structures represented in the Villages. But the practice of Islam seems quite unassimilable to the general design of the set; no bridge is offered to link the religion to its adherents.

Visitors to the Folk Culture Villages

The organization of the Folk Culture Villages is, as some of the observations on selection criteria above suggest, market-oriented. There are three quite different audiences that are catered for in the display. Each of these is constantly present, and to some extent interactive with the other two. The declared objective is to bring in an audience from outside China. In the first instanc,e Hong Kong provides both a channel for an international audience and also a conduit for Hong Kong residents. Twenty per cent of the visitors come from Macao, Taiwan, Hong Kong and elsewhere. This audience represents a significant proportion of the total. Another small but highly significant section are officials from China, for whom the Folk Culture Villages represent an element of the modern Shenzhen experience alongside the other elements of the new economic policy. Most of the nation's leaders, such as Li Peng, Yang Shang Kun, Jiang Zemin and Wan Li, have visited the Villages and, like Deng Xiaoping, have been publicly photographed for the press there. Such official interest at the highest level no doubt prompts others less exalted to undertake reconnaissance visits for themselves.

Finally, nearly eighty per cent of the visitors are members of the Chinese public, mainly from Guangdong and neighbouring provinces. These come as part of their new 'developmental experience', and as part of a new phenomenon, Chinese tourists, intent on combining an exploration of this internationally-oriented display with a feature which should not be overlooked, pure enjoyment. Whilst the Villages offer astonishing features sch as the artificial waterfall 'like white ribbons fluttering in mid-air and pearls rebounding in all directions', they still retain aspects of the traditional fair – such as entertainers with performing monkeys. Indeed the visitors to the Villages are provided with photo opportunities, such as sitting in the Tibetan house at a table, toasting the camera with the Tibetan beakers conveniently provided. The Lahu big wheel similarly provides an ethnically inflected fair-ground attraction. It would be wrong, however, to overemphasize this aspect of the Villages.

The ethnographic and educational mission of the enterprise remains constantly visible. Indeed, the third audience for the Folk Culture Villages is the minority national visitor. As the director of the Villages remarks:

they are concerned about their ethnic dignity. They are curious as to how they are being represented in terms of their architecture, dance, handicraft and food. They come to see whether they are accurately represented. Even minority leaders come to visit their performances. Officials from Tibet, Xinjiang, Mongolia and Korean nationalities have seen the Folk Culture Villages and found it well done and very satisfying.

The Director argued that these leaders felt that the Folk Culture Villages provided a channel to let the rest of the world understand their cultures. Indeed, the Chairman of the State Nationalities Affairs Commission in Beijing, Ismael Asmat, was reported to have spoken very highly of the Villages.

All three audiences have ample opportunity not only to see the exhibits, but to observe each other. The throughput of visitors is very high. In the first six months of existence, three million visitors had been entertained. The highest record for a day stands at 40,000. This puts Shenzhen in the major league of tourist attractions, and on par with such spectacles as Disney World.

Taman Mini

It remains unclear precisely when the cultural village concept was introduced to South-east Asia; though the modern open-air museums owe much to local inspiration, they did not develop in isolation. The idea for these seems to have taken root in the early decades of the twentieth century in the countries that were under colonial rule, and their development may be linked to the growth in tourism.

The Dutch, for example, introduced tourism in Bali shortly after the pacification of the island between 1906 and 1908. This was not only an economic measure, since it was also designed to restore the Netherlands' international image, which had been tarnished by the bloody campaigns needed to subdue the island. To the colonial authorities, tourism appeared to be an effective means of restoring respectability to a regime blighted by turmoil. The authorities decided to revive what they perceived to be the 'real' way of life of the islanders and turn Bali into a 'living museum'. The Balinese were deemed to be the custodians of a Hindu culture that had flourished before the collapse of the kingdom of Majapahit and the triumph of Islam in Java (Picard, 1993:74).

One of the first museums in Asia to make use of traditional buildings and open-air display areas was the Bali Museum in Denpasar in the Netherlands East Indies (now Indonesia). The museum, which had serious educational objectives, was developed in conjunction with the rise in tourism in Bali in the inter-war years. Western painters, musicologists and anthropologists witnessed the rejuvenation of Balinese arts and performances, which arose partly in response to tourism in the 1920s. This development continued in the 1930s, despite the worldwide recession (Boon, 1977). Walter Spies, the German–Russian painter, became the curator of the Bali Museum, a museum that combined the two principal architectural edifices in Bali, the temple and the palace. In his capacity as curator, Spies was responsible for organizing the cultural programme for the visit of the Viceroy of the Netherlands East Indies. Spies had the task of welcoming the distinguished visitor and showing him the Balinese treasures that he had collected and therefore saved from the souvenir hunters (Rhodius and Darling, 1980:41). It was museums such as the Bali Museum that later served as local models for the development of cultural village museums in the post-war era in South-east Asia. There is, however, some evidence that the developers of the major open-air museums looked further afield, especially to Europe and North America, when designing cultural village-type museums.

The Dutch were responsible for introducing the museum concept to what was to become Indonesia; but it was not until well after the formation of Suharto's 'New Order' government that museum building on a monumental scale began in earnest. The first major development, *Taman Mini*, commenced at the behest of the second president's wife, Mrs Tien Suharto, at an estimated cost of US$26 million (May, 1978:277). In late August, 1971, Mrs Suharto attributed her decision to build the complex to a sudden inspiration that occurred during a recent visit to Disneyland:

> I was inspired to build a Project of that sort in Indonesia, only more complete [lengkap] and more perfect, adapted to fit the situation and developments in Indonesia, both 'materially' [materiil] and 'spiritually' [spirituil]
>
> (Pemberton, 1989:215).

Mrs Suharto announced the scheme in November 1971 amid polite protests and small student demonstrations, though it was widely condemned in private as a waste of national resources.

The plan was to build an open-air museum devoted to Indonesian architecture, arts and crafts on a site measuring approximately 1,350 by 580 metres near Jakarta. In a lavish brochure, Mrs Suharto placed emphasis on her desire to 'develop and deepen the love of the Indonesian people for their fatherland', though the first promotional point mentioned was the attraction of tourists (May, 1978:277).

The museum was to be called *Taman Mini Indonesia Indah* (*taman*, 'garden'; *mini*, 'miniature'; *indah*, 'beautiful') and was designed to display the enormous diversity of Indonesia's population. The centre-piece was to be a miniature version of the Indonesian Archipelago, set in a lake, which included a 'tall and dignified monument' to reflect the national philosophy of *pancasila* (five principles put forward by the state for political and social rule) (May, 1978:277). The museum was created to celebrate the national motto of *bhinneka tunggal ika* 'unity in diversity', and to draw attention to Indonesia's exemplary traditional culture.

In order to appreciate why *Taman Mini* should serve as a showpiece for Indonesian identity, it is necessary to consider briefly how the nation came into being. It is important to note that Indonesia's political space was created as a result of many centuries of Dutch colonial interference. Dutch expansion in South-east Asia came to a halt during the first two decades of the twentieth century, thus laying down the borders of what was to become the Indonesian motherland (Hubinger, 1992:14). The inhabitants of this vast region, regardless of their ethnic or religious affiliation, shared Dutch overlordship, and this introduced a kind of negatively defined consciousness of an entity known as 'Indonesia'. According to Hubinger, Indonesian nationalism is a created reality, which is derived from the Herderian brand of nationalism, in which the nation's founders are its people, the 'folk' (1992:4).

In 1975 a 174–hectare site was cleared near Jakarta, and twenty-seven pavilions were erected, representing the provinces of Indonesia. The 300 families whose houses and gardens were razed to make way for the site complained that the compensation, fixed by the sponsors at 100 Rupiahs per square metre, was insufficient (May, 1978:278). Adnan Bujung Nasution's legal aid/public defence institute became involved in defending the householders, but did not pursue the matter. At the height of the dispute, powerless though the home-owners were, Mrs Suharto claimed that she would go on fighting for her project as long as she lived (May, 1978:278).

It is possible that the expenditure of $26 million on a tourist project at a time when Indonesia badly needed other kinds of investment (industrial infrastructure, schools, etc.) was justified in the long run. Critics have, however, noted that the land was purchased and the plans

made public in advance of any sound evaluation of the scheme. Despite reassurances from the government that the museum would be examined in terms of profitability, and its benefits compared to those of other forms of development, the project went ahead. By 1990, when tourism in Indonesia had moved into fourth place as an earner of foreign exchange, outstripping rubber and coffee, these objections had largely been forgotten.

The Skansen movement

Museums such as the Bali Museum, though devoted to Asian ethnography, belong to the wider tradition of European open-air museums. The forerunner of the cultural village museum made its appearance at the turn of the century, though there is some dispute regarding its origins. Skansen near Stockholm is widely regarded as the first of its kind, though this is disputed by the Norwegians. What is significant as far as this chapter is concerned is that a strong sense of nationalism, particularly ethnonationalism, can be detected in the work of the founder of Skansen, Arthur Hazelius.

When Hazelius travelled in Sweden's rural hinterland in the 1850s and 1860s, he noticed that the traditional forms of village life were disappearing as a result of the growth of industries and modern communications. Hazelius was convinced that if future generations were to be able to understand what Sweden had been like, then collections had to be formed before the material disappeared. The museum was to provide a vital link between the ancient and the modern. Hazelius started acquiring objects in the 1870s, and eventually mounted a small exhibition in Stockholm. In 1878, Hazelius broke new ground by displaying scenes from country life using models dressed in Swedish costume set against reconstructions of peasant rooms; he called them 'living pictures'. Hazelius was motivated not just by social science, but by nationalism, and wanted, among other things, to purify the Swedish language of foreign loanwords (Hudson, 1987:120).

Hazelius arranged for the purchase of the site known as Skansen in 1891, the original displays comprising two wooden and stone cottages, as well as a Saami camp and two charcoal burners' huts. Development continued with the purchase and re-erection of buildings from all over Sweden. Houses, farms, workshops and mills were reassembled at Skansen, and in 1911 an open-air theatre was added. Folk dancing was also introduced, and a special area was set aside for performances in the 1930s. The world's first cultural village museum was undoubtedly popular, and by 1938 was attracting two million visitors per annum (Hudson, 1987:122).

From the outset, the museum aimed to provide relaxation as well as education. The first café opened in 1892; in 1952 a restaurant was added, with seating for 800 people inside, and an additional 1,000 outside on the terraces in summer (Hudson, 1987:122). By the time that he died in 1901, Hazelius had the satisfaction of knowing that his concept of an open-air museum was not only being copied elsewhere, but was also extremely popular.

Hazelius' approach was undoubtedly highly original, but he was not working in an academic vacuum. Hazelius' approach was in keeping with the intellectual climate of the time. For example, at the same time that Hazelius was formulating his ideas, the German scholar, Ferdinand Tönnies, was working on his book *Gemeinschaft und Gesellschaft* (1887). Tönnies was born into a North German rural family and had an abiding interest in the development of rural life. Like Hazelius, Tönnies was interested in describing the way of life of ordinary people in North Germany and the changes that were taking place in response to increasing urbanization and industrialiszation.

In retrospect, Hazelius' ideas seem somewhat romantic, if not a little naive, and there is a certain 'folksiness' about Skansen that has more to do with European ethno-nationalism than serious Swedish ethnography. To a certain extent, Skansen reflects how Hazelius and his nationalist-oriented folklorist movement wanted us to see Sweden, though one cannot dismiss the quality of some of the underlying ethnographic research. Hazelius' concept spread rapidly, and the early twentieth century saw the introduction of Skansen-type museums across the length and breadth of Europe. Open-air museums dedicated to the lives of ordinary people were, for example, opened in the Netherlands (Arnhem) in 1911; in Wales (St Fagans) in 1949 and in Ulster (Cultra) in 1958 (Hudson, 1987:125–7). Open-air museums inspired by the example of Skansen, but not necessarily the folklife principles advocated by Hazelius, were also set up in North America. Perhaps the most striking similarities between Skansen and one of its descendants are encountered in Romania.

The opening of the Village Museum in Bucharest in 1936 represented the culmination of ten years of research under the leadership of Professor Dimitrie Gusti. Mixed-disciplinary teams of sociologists, ethnographers and students recorded the customs and culture, and particularly the material culture, of the inhabitants of forty Romanian villages, under the supervision of Victor Ion Popa and H. H. Stahl. Traditional houses were taken down and reassembled in the museum by craftsmen from their villages of origin, and the research teams also made collections in each of the villages, supported by careful documentation and photography. The researchers set themselves the task of recording Romanian popular culture by showing the daily activities of a '… householder's family from each village' (Negota, 1986:21). Like Skansen, the Village Museum was built beside a lake near a major urban conurbation that had a poor, rural hinterland. The parallels with Shenzhen and Taman Mini are striking.

Despite their success, the village museums were not without their critics. Hudson, for example, asks whether or not dancing and farm animals can really bring to life the world of nineteenth-century Sweden. The cultural context of Skansen has changed, and the society that visitors see in the museum today is more remote from their experience than it was from the first urban tourists who went there. Modern Skansen is more exotic than it was at the time of its foundation, and a greater effort is required on the part of the visitor to imagine what life must have been like in reality (Hudson, 1987:124). As G. B. Thompson has noted, there are two in-built weaknesses in folk village movements. First, the transfer of materials to the museum may romanticize them, especially when they are restored and kept in good repair. When the buildings are cleaned up, many of the unpleasant associations that they had for the people who once lived in them are removed. Second, only a special kind of society is represented – rural society. Hazelius felt that it was the rural way of life that was disappearing, and townspeople tended not to be represented. There were also practical considerations, since it was usually only rural buildings that could be transported, because they were wooden (Hudson, 1987:125). In practice, attention is devoted to the material culture of the pre-industrial age, and what we are left with is a collection of attractive buildings.

The Asia-Pacific cultural village

In the case of Taman Mini and Shenzhen, what is interesting is that they both portray nations that are simultaneously ethnically diverse, but unified. In the case of Shenzhen, it is the non-Han minority cultures that are represented, whereas Taman Mini promotes the national philosophy of 'Unity in Diversity' and, in theory, embraces all the nation's ethnic groups. For Indonesians, the creation of a united nation-state involved either shedding 'ethnic' identities (seen as

symbols of backwardness within the process of modernization) or reconceptualizing them as part of the nation's past, its 'folk culture' and hitherto 'living traditions'. In the development of Taman Mini these traditions were to be displayed and admired by both the local and international public. This represents a continuation of the earlier European practice of celebrating the nation's brilliant present and admirable past through exhibitions (Hubinger, 1992:7). Both Taman Mini and Shenzhen present varying aspects of nationhood and, through their exemplary displays, show a kaleidoscope of peoples held together by nationalistic rhetoric. Although the outward appearance of these museums closely resembles that of their European prototypes, their underlying philosophies differ greatly.

Museums have been set up in the Asia-Pacific region with the development of national culture very much in mind. The ethnographic exhibition has become a popular medium in Asia, where the tourist's curiosity has been harnessed to the needs of nationalist politics. Audiences, as yet, seem to be unconcerned with issues such as ethnographic accuracy and authenticity, and the displays are often quite eclectic. Genuine ethnographic artefacts may be combined with objects devised by on-site design departments, and folk dance displays may be dreamed up by trained choreographers. The buildings displayed in the museum may be more elaborate and even larger than the originals on which they are based, and, therefore, convey an idealized view of culture.

The rising wealth of Asian populations and new opportunities to travel have provided political leaders with opportunities to promote their views in ways that could never before have been contemplated. The cultural village museums are designed to fulfil a number of functions, ranging from the need to promote international friendship through an understanding of culture to the desire to boost both domestic and foreign tourism. It would be tempting to dismiss these museums as Disney-like theme parks that rely on a mythological past dreamed up by advertisers; but there are good reasons for considering alternative explanatory frameworks. The museums clearly draw on the ethnographic traditions devised by Hazelius, and are not devoid of serious cultural and historical references. Taman Mini tries to make sense of a heterogeneous nation that was brought together by colonial intervention; Shenzhen reflects China's attitudes to its minority peoples. The essential elements of tradition persist in combination with other elements that are changing. Tradition, an essential element of identity, is constantly being created and recreated in response to new needs.

When considering the relationship between museums and national culture, one also needs to bear in mind the use made of tourism by governments seeking to reinforce their legitimacy. According to Picard, tourism was seized on as one of the means of restoring Indonesia's troubled image after the bloodbath of the 1965 alleged coup and counter-coup. The spectacle of thousands of holiday-makers queuing to visit Indonesia, especially Bali, enabled the 'New Order' to claim that it had earned the confidence and respect of the rest of the world. To a certain extent, the regime's methods were not unlike those of the Dutch earlier in the century; in both cases tourism was seen as an effective means of restoring respectability in regions blighted by strife. In Suharto's Indonesia, the culture of Bali has become a resource, one of the 'cultural peaks' in the emerging national identity, whose function is to facilitate the growth of tourism and foster national pride (Picard, 1993). Especially significant within this context appear to have been the ideas of Dewantara, who actively promoted the development of many regional cultures that would subsequently contribute to the emerging national culture. Together these cultural peaks, *puncak-puncak dan sari-sari kebudayaan*, would lay the rich foundations of a unique national culture (Nugroho-Heins, 1995:16–17). The rough edges that characterized real social relations between the different ethnic groups had to be smoothed over so as not to obscure the objectives of national unity. The individual cultures of Indonesia were re-evaluated, especially those being

marketed as tourist destinations. Diversity in this new set of orderings had to be expressed aesthetically: hence the importance accorded to expressions of identity in an artistic manner. 'Balinese culture', like the other 'high cultures', is perceived as holding a similar position with regard to both tourism and Indonesian identity; its culture serves the needs of international tourism in Indonesia and the development of Indonesian national culture (Picard, 1993:94). Bali has been remoulded so that it conforms to the national philosophy of 'unity in diversity', and can therefore take its place in the national cultural village.

Tourism and display theory

The Folk Culture Villages exhibition draws on two strengths for its marketing success. Firstly, it continues a long tradition of representing folk culture in China, most notably in the genre of peasant painting. Joan Lebold Cohen describes this tradition as working in two basic styles (Cohen, 1987:145). The first is for propaganda, portraying local heroes and deep space. Some of the publicity for the Folk Culture Villages works in this way. This can be seen, for example, in the official catalogue, where a Naxi youth is depicted as 'a bright and brave ethnic youth'. The other style is 'decorative with strong geometric organisation and repeated patterns. These scenes are populated with happy peasants at work. The designs were inspired by textiles, embroidery, paper cut-outs and cartoons.' Such representations have not been confined to art publications, but were to be seen in the 1980s in such public places as Beijing International Airport, where Yuan Yunsheng's 'Water Festival, Song of Life' mural was drawn directly from the Dai Water Festival. Subsequently, other public commissions have employed specific minority references to emphasize a visual pluralism in contemporary art as a determined policy to incorporate non-Han culture. The incorporation always remains, however, either at an abstract, symbolic or, alternatively, at a resolutely practical level. The relationship between different groups or, perhaps more importantly, with majority Han culture never finds expression in the Folk Culture Village displays. The symbolic unity is portrayed as deriving from the physical proximity of different cultures on a single site. The real significance of the display is not to be found in the historical and political rhetoric. It draws from a quite new and a very different source.

Following the great success of its topographical predecessor and neighbour the 'Splendid China' exhibition, the Folk Culture Villages exhibition was designed to offer a kind of 'integration between tourism and cultures to suit the tourists' psychological needs'. If 'Splendid China' permits the visitor to see all the sights of China in one visit, then the Folk Culture Villages let one meet 'all of the people' in a similar whirlwind tour. People are psychologically curious, the Director of the Villages maintains, to see exotic things. This psychological propensity provides the basis for 'Chinese-Style Tourism', which actively seeks to reduce the trend towards Westernization, particularly prevalent among the youth in contemporary China. The exhibition provides a focus for diffused nationalist sentiment with a determinedly non-Han focus. As the official catalogue concludes, the purpose of the display is to attempt a reflection of China's culture, as well as fostering its tourism, with distinctive national features.

Nevertheless, certain features of the Folk Culture Villages cannot be explained entirely by recourse to ideas of nationalist sentiment. The laser folk music fountain that plays a significant part in the evening entertainment provides pure tourist spectacle. The justification offered for its incorporation is somewhat unconvincing – that it signifies the advance of Chinese culture in a technological sense, and shows that Chinese civilization is not a stagnant entity and that it can keep pace with the modern world. Furthermore, it is argued, all music played is genuine folk music, in line with the policy of 'Chinese-style tourism', which stipulates that every element in

the display should consistently exclude foreign and non-folk influences (no foreign handicrafts, no MacDonald's hamburgers). The laser fountain, however, does not seem to obey the directive to avoid 'borrowing from others the idea of those mechanical amusements to try and attract foreign visitors'. We argue that the visitors to Shenzhen in general, and the Folk Culture Village in particular, approach the experience specifically as tourists. Obviously, the overseas and Hong Kong visitors fit the category. The other eighty per cent buy into this mode of experiencing as travellers partaking of the modern-style tourist attractions. The Villages provide a new kind of fusion between the tradition of the spectacle of the fairground, with its stress on exoticism and novelty, and the opportunity for visitors to become 'ethnographic subjects' – self-conscious consumers and evaluators of the spectacle and ethnic evidence before them. Visitors can still expect to be served by the performers (taking sedan-chair rides or making detailed interrogations of performers on aspects of the village life displayed), but they can also 'disappear' by hiring ethnic costume or joining in the dance performances. Telling a visitor from the authentic requires a good eye for shoes and hairstyles.

The Folk Culture Villages are advertised both within China and extensively through the China Travel Service (Hong Kong) in the rest of the world. Other promotional activities, including overseas visits and performances, take the Villages out into the international tourist market. It is further reported that the personnel from the Folk Culture Villages are involved in consultancy exercises with thirty or more other countries to help establish similar Chinese folk villages in these countries. There is, so the Director of the Villages maintains, a vogue for building cultural villages. Two are planned in Japan and others elsewhere. The Hong Kong Institute for the Promotion of Chinese Culture is launching a series of programmes with Hong Kong schools to visit the Villages. The Institute is also forming a research committee and hoping to provide a means of integrating education on nationality into the Hong Kong civic curriculum.

The import–export potential of the Folk Culture Villages in Shenzhen is considerable. As Kirshenblatt-Gimblett notes, 'events staged specifically for visitors are well suited for export because they have already been designed for foreign audiences on tight schedules'. The Folk Culture Villages provide a highly visible index of political and cultural vision. At one level, it could be argued by those unconvinced by the spectacle, the Villages offer but a surface appearance not consistent with the texture of life within these minority communities. The performances and paraphernalia of costume are driven by the exigencies of the tourist show. They provide what Kirshenblatt-Gimblett calls 'the illusion of cultural transparency in the face of undeciphered complexity and the image of a society always on holiday'. Yet, at another level, it could be argued that the display represents an attempt – either in terms of domestic consumption or of a cultural export potential – to show China working through elements of a policy on multi-ethnic cohabitation, which, as the promoters are quick to point out, contrasts markedly with reality in other parts of the world. Whilst some of the display and philosophy may appear relatively unsophisticated to the world-travelled tourist, nevertheless, the Shenzhen Folk Culture Villages provide a site both physical and metaphorical for the pursuit of modernization while at the same time aiming to preserve elements of tradition. It can be claimed with some confidence that the modernizing element is well advanced in the development of the Folk Culture Villages. What remains to be seen, in the short and medium term, rather than the long, is whether the liveliness of the youthful minority displays can be sustained over time and under the pressure of mass tourism. Inevitably, political considerations will play a not insignificant part in the development of the Villages. The danger that they must face is that the actors cease to represent a credible present and become merely mechanical performers of a nationally prescribed culture.

Acknowledgements

We gratefully acknowledge the assistance received in preparing this chapter from Mr Ma Chi Man, Director of the Chinese Folk Culture Villages, Shenzhen, and Mr Van Lau, Chairman of the Hong Kong Institute for Promoting Chinese Culture, as well as to our colleagues in Hong Kong Polytechnic who have contributed both in interviews and discussion of ideas, Lydia Ngai, Matthew Turner and Phoebe Wong. We are also grateful for the researches of Kenichi Ohashi of Fukushima Women's College, Japan. Our thanks are also due to the British Academy, the Economic and Social Research Council and the Indonesian Institute of Sciences (LIPI). Earlier versions of this chapter were published as two separate papers in the *Journal of Museum Ethnography*. We would also like to thank Stella Rhind and the Centre for South-East Asian Studies, University of Hull, for their generous help.

Notes

1 Internal documents on the preparation of the Folk Culture Villages' Employees Training Programme, March 1991.
2 Wang, Zhe, Chuang Shijie De Minzu cun Ziaojie. *Shenzhen Qing Niang*, October 1992:14–16.
3 Chinese Folk Culture Villages Official Catalogue (1991). Shenzhen:27.

References

Boon, J.A. (1977) *The Anthropological Romance of Bali, 1597–1972: Dynamic Perspectives in Marriage and Caste, Politics and Religion*, Cambridge: Cambridge University Press.

China Travel Services (Hong Kong) Ltd (1992) *Enjoyable Trip to China* (travel brochure).

Cohen, J.L. (1987) *The New Chinese Painting 1949–1986*, New York: Abrams.

Gittins, J. (1992) 'Mudpaths paved with gold', *Weekend Guardian*, 1 August.

Graburn, N. (1976) *Ethnic and Tourist Arts: Cultural Expressions from the Fourth World*, Cambridge: Cambridge University Press.

Hubinger, V. (1992) 'The creation of Indonesian national identity', *Prague Occasional Papers in Ethnology*, 1, 1–35.

Hudson, K. (1987) *Museums of Influence*, Cambridge: Cambridge University Press.

May, B. (1978) *The Indonesian Tragedy*, London: Routledge and Kegan Paul.

Negota, J. (1986) *The Village and Folk Art Museum: Bucharest, Romania*, Bucharest.

Nugroho-Heins, M.I. (1995) 'Regional culture and national identity: Javanese influence on the development of a national Indonesian culture', EUROSEAS conference paper, Leiden.

Oates, T.S. (1992) 'Cultural geography and Chinese ethnic tourism', *Journal of Cultural Geography*, 12, 2.

Pemberton, J. (1989) 'An appearance of order: a politics of culture in colonial and postcolonial Java', PhD thesis, Cornell University.

Picard, M. (1993) '"Cultural tourism" in Bali: national integration and regional differentiation', in Hitchcock, M., King, V.T. and Parnwell, M.J.G. (eds), *Tourism in South-East Asia*, London: Routledge.

Rhodius, H. and Darling, J. (1980) *Walter Spies and Balinese Art*, Amsterdam: Zutphen.

Webb, T.D. (1994) 'Highly structured tourist art – form and meaning of the Polynesian cultural centre', *Contemporary Pacific*, (6)1, 59–86.

Repackaging the past for South African tourism

Leslie Witz, Ciraj Rassool and Gary Minkley

In South Africa, with its particular colonial and apartheid histories, there are a number of issues associated with heritage and cultural tourism that are very pronounced in terms of the legacies of the unequal power relations between different peoples. Chief amongst these are issues relating to who held the economic power and other means to develop and maintain the tourism industry. Private enterprise played a key role in controlling processes in the appropriation, commodification and packaging of culture and heritage for the tourist market. Although there were mechanisms in place for regulation, it was the tourism entrepreneurs and private companies who held the balance of power. In the past, the majority of key players in these processes came from the dominant white class. Although the profile of this group may have changed in the 'new' South Africa and attempts have been made to involve previously marginalized and disadvantaged groups, the tourism issues associated with imbalances in power are still evident. Masked by promises of economic development and job creation, the distribution of income generated by tourism is still uneven.

This chapter engages with issues relating to the packaging of images by the South African tourism industry through three products, which each attempt to market an 'African experience' and to promote South Africa as an 'African' cultural destination. The three products discussed are the 'cultural village', the 'township tour' and Ratanga Junction: The Wildest Place in Africa theme park. With the first, there are issues related to authenticity (and what is marketed as being the 'real' experience), synchronic representations of culture, stereotyping, re-imagining of rural traditions and the construction of identities. By comparison, the township tours focus on 'living culture', sites of political resistance and the adaptation of rural traditions for urban life. Issues here relate to the objectification of people, the commodification of deprivation and voyeurism. Finally, regarding the theme park, where images of Africa are translocated into a place of fantasy, there are real issues relating to the establishment of the venue itself.

Tourism to South Africa is not merely a business. It is also about the packaging of images that represent the society and its past. In the 1990s, the tourist industry consolidated an image of South Africa as a 'world in one country'.[1] With the ANC in power, the industry continued to invite visitors to 'discover our new world' – and also gaze on the 'ancient rituals' of 'Olde' Africa, exploring a 'culture as fascinating as it is diverse'.[2] While in post-apartheid South Africa museums, monuments, and textbooks were scrutinized for their depictions of society and its past, tourism continued to provide a 'safe haven' for a 'troubled history that glorifies colonial adventure and a repudiated anthropology of primitivism'.[3]

In the late 1990s, South African policymakers recast themselves as the leading proponents of an African Renaissance. They wished to repudiate stereotypes of backwardness and primitiveness. President Thabo Mbeki, writing in South Africa's top-selling travel and tourist magazine, *Getaway*, called for a departure 'from a centuries-old past which sought to perpetuate the notion of an Africa slowly condemned to remain a curiosity slowly grinding to a halt on the periphery of the world'. Mbeki stressed, instead, Africa's monumental structures ('the Egyptian sphinx and pyramids'; 'Great Zimbabwe'), artistic creations ('the Benin bronzes of Nigeria'), places of learning ('Timbuktu of Mali'; 'the ancient universities of Alexandria of Egypt, Fez of Morocco'), and its heroic armies ('Omduruman in the Sudan').[4] These images of Africa stood in stark contrast to the images elsewhere in the magazine, which promoted 'wilderness experiences' in the 'nouveau bundu'.[5]

This essay focuses on three sites that attempt to promote South Africa as an 'African' cultural destination: cultural villages, township tours, and the African theme park Ratanga Junction in Cape Town. The cultural village is fast consolidating itself as a new genre of cultural museum, incorporating previously marginalized people into the tourist route. The township tour turns curiosity about the country's recent past into voyeurism. Meanwhile, at Ratanga Junction, where local revelers partake of tourism's African images, an African past is depicted through the desires and fantasies of colonialism.

Markets of authenticity: cultural villages

The world of the wild has long beckoned foreigners to visit South Africa; so has the promise of seeing 'natives in tribal setting'.[6] But in recent years, a vast new industry has been developed in all corners of the country, as urban and rural communities have sought to present a heritage that has until now been 'hidden from view'. Unveiling 'old traditions' and 'historic sites' for the tourist gaze, these new destinations present a grand celebration of a South Africa at last freed from bondage.[7]

Encounters with living cultures are arranged in a congested marketplace of sites and routes, jostling with each other to take their place as the authentic representation of the past. The tourist in quest of the 'real Africa' is able to select from a range of options. Across the countryside, shops, markets, and roadside stalls sell curios and crafts, sometimes made by workers in local communities. In urban centers, the visitor may savor 'local cultural traditions' in a momentary encounter.[8] Or striking into the interior, taking 'the road that the tour guide uses to take visitors deeper into the valleys', the explorer can visit a 'native village'. The tourist thus steps into the imagined archaeological tracks of 'early explorers' and 'white pioneers' in a well-rehearsed colonial encounter.[9]

These villages offer the tourist portable, snapshot histories – culture at your fingertips – that give the illusion of knowing the whole. In KwaZulu-Natal, cultural villages have a long genealogy. The 'first authentic Zulu village', KwaBhekithunga, was set up in the late 1960s on a farm between Eshowe and Empangeni. In a 'guarantee of authenticity', Zulu families here invite tourists to 'share their home'. KwaBhekithunga has since been joined by Thandanani Craft Village, Simunye Cultural Village, Phezulu Safari Park, and Dumazulu Traditional Village. The latter, located near Hluhluwe Game Reserve, is devoted not only to presentations of 'Zuluness', but also portrays separate Ndebele, Swazi, and Xhosa abodes 'in order to maintain individual identities'.

But the most popular of all Zulu resorts is unquestionably Shakaland, developed between 1986 and 1988 on a film set from the television series *Shaka Zulu*. Visitors are immersed in a tourist anthropology of Zulu identity, from the moment of being greeted on arrival by a

warrior-gatekeeper to the Zulu cultural lessons given inside of the 'Great Hut' by a 'cultural advisor', who explains the 'Zulu way of doing things'.[10] By the beginning of the twenty-first century, KwaZulu-Natal had become a veritable 'Zululand Zig Zag' of cultural sites, as the region was re-imaged as the 'Kingdom of the Zulu' and a 'Province of Colour'.[11]

The displays of culture in KwaZulu-Natal are replicated in ethnic representations in other parts of the country. 'Authentic Sotho lifestyles' in the form of traditional beer 'from a calabash', Sotho dishes, and the 'marabaraba rural rhythms' can be encountered in a visit to the Basotho Cultural Village in Phutaditshaba.[12] In Mpumalanga, at a cost of R2 million, a pair of financial executives, working together with a local community leader, have created a Shangaan village where 'ethnic damsels show tourists their traditional African dancing skills'.[13]

The crowning accomplishment of 'South Africa's New Tourism' is Lesedi cultural village. Not only is Lesedi in easy reach of Johannesburg, but, like Dumazulu, it offers a range of ethnic experiences. At Lesedi you are offered the choice of moving in with a 'real Xhosa, Sotho, Pedi, or Zulu family'. It is this unique combination of the Western and the multiplicity of the traditional that Lesedi presents as its prime appeal, simultaneously offering the tourist the facade of the 'traditional homestead', but with a 'distinctly Western modern interior', where the polished cow dung floors do not smell.[14]

In this dazzling array of cultural villages, culture and history are brought together in a timeless zone as a kaleidoscope of frozen ethnic stereotypes that correspond with dominant tourist images of Africa. The essence of the cultural productions in all these 'theatres of memory',[15] where identities and histories are scripted, rehearsed, and performed, is to reproduce dominant media images of Africa as composed of distinct tribal entities. Each village reproduces a specific ethnic stereotype that has its genealogy in colonial encounters, the creation of administrative tribal units, and displays in imperial exhibitions across Europe in the nineteenth and early twentieth centuries. The Zulu thus appear as a distinct 'warrior nation', the Xhosa as 'proud', and the Pedi as 'warm-hearted'.[16] Visitors are allowed to witness distinctive tribal ceremonies and to participate en masse in daily programs of secret, ancient rituals. Yet for all these ethnic characterizations, there is a common imagery of rhythmic music and dance that, without exception, the villages offer as the highlight of the tourist encounter. It is the correspondence between the nineteenth-century images of pulsating tribes and the performance of 'ethnographic spectacle'[17] that produces notions of authenticity and enables tourists to enthuse that the tribal village is the closest they can get to 'the real Africa'.[18]

But the re-imagining and repackaging of traditions are also being directed at South Africans. Before 1994, the idea of tourism was foreign to most black people in South Africa. The notion of a journey was usually associated with migrant labor. It was ridden with 'mental and emotional trauma', a 'series of anxieties to be endured' without the time and space of 'pleasure of movement'.[19] Despite the growth in international tourism, domestic leisure tourism is the major source of tourist revenue. While reliable and current statistics on tourism are difficult to obtain, a government-commissioned report indicated that of the more than forty million arrivals in 1996, more than seventy-seven per cent were South African.[20] Beyond these statistics, domestic tourism is encouraged as part of the process of nation-making.

Visits to different cultural villages are presented as a way to know oneself, to learn about the 'other', and to become a nation. While he was president of the Free State, Mosiuoa Lekota visited the Basotho Cultural Village to find out about 'authentic Sotho lifestyles'; Zoliswa Sihlwayi, from Soweto, went to Shakaland to become 'aware of his own culture'; the performers at Shangana were 'proud to be able to share their culture'; and Xhosa-speaking schoolchildren were invited to go to Xhosaville to 'learn their culture as part of community development'.[21]

Tourist images of an African past have protruded into the real world of land restitution. Group identities have formed the basis of land claims launched by the government's land reform program set in place by the Restitution of Land Rights Act 22 of 1994. 'Communities' were entitled to claim land if they could show that their rights to it were 'derived from shared rules determining access to land held in common'.[22] In addition, successful land claimants, assisted by their lawyers and an array of non-governmental organizations and consultants, have quickly turned to tourism as the basis of reconstituting communities on restored land. Tourist routes, curio outlets, game lodges, and living museums have all been suggested as the passport to community development.

In March of 1999, in a ceremony presided over by Mbeki, 50,000 hectares of land within the Kalahari Gemsbok National Park were handed over to the 'southern Kalahari San' after a land claim had been launched in 1995. When the claim was lodged, many of the 'southern Kalahari San' were performing as indigenous bushmen in the setting of a private game park, Kagga Kamma. At Kagga Kamma, the tourist could 'fly in' on an 'overnight Safari', in a 'Jurassic Park' adventure, to the 'timeless world' of the bushmen.[23] Through listening to 'Khoisan history … condensed into a five-minute account', witnessing their nakedness, and fondling their children, the visitor is led to believe that he or she is contributing to the survival of the bushmen.[24] The terms of this performative 'bushman' identity were based on the patronage afforded by the owners of Kagga Kamma, without which the 'bushmen' would simply have been part of the marginalized rural poor of the northern Cape. These relations of patronage had been in place since at least 1936, when Khoisan people were displayed as 'living fossils' at the Empire Exhibition in Johannesburg. In 1995, the southern Kalahari land claim based itself indirectly on the ethnological and anthropometric research conducted in 1936 by a team of University of the Witwatersrand anthropologists and linguists in preparation for the Empire Exhibition.[25] The successful claim for land in the southern Kalahari emphasized continuities with an aboriginal past, closeness to nature, and a racialized identity of a people 'frozen in an artificial time',[26] first performed in Johannesburg in 1936 and later transferred to Kagga Kamma.

The successful land settlement regarding Pafuri, the far northern region of the Kruger National Park, won by the Makuleke community in the Northern Province, was also based on a group claim. After being forcibly removed in 1969 under apartheid's Bantu Authorities Act, the Makuleke, a 'community' under the Land Restitution Act, were given back the title to Pafuri. Under the terms of the settlement, the Makuleke agreed not to occupy the land, enabling it to remain a conservation area of 'preserved wildland', with the proviso that the Makuleke benefit from new tourism development.[27] A key component of this proposed economic encounter with the tourist trade is to develop a 'living museum'.

Since its emergence at Skansen in Sweden in the 1890s, the 'living museum' has sought to present a nation in microcosm through live performances in an open-air setting.[28] In the 1990s, the Skansen model was brought to Africa through the Swedish–African Museum Program (SAMP), when the open-air museum in Dar es Salaam embarked upon a series of 'Ethnic Days'. The building of dwellings, preparation of dishes and drinks, discussions of history and culture, and performances of 'traditional dances' were all part of separate ethnic days for different groups.[29] In spite of an awareness of the dangers of emphasizing ethnic separateness, as well as the possibility that these ethnicities were created under colonialism as administrative units, the events of these ethnic days lend themselves to tribal understandings of national heritage, where the 'traditional way of life of … particular ethnic group[s]' is displayed.[30] In the Northern Province, the Makuleke and their consultants are equally aware of the dangers of stereotyping and conforming to outsider views of Africa. In spite of this awareness, it is the models of Shakaland,

Dumazulu, and Simunye as stimuli of job creation and bearers of development that are referred to, with 'other projects' filling in the 'heritage … gaps'.[31] In a significant departure from the conventional model, however, the Makuleke proposals call for the creation of an 'interpretive centre,'[32] thus creating the possibility for notions of static cultures and ethnicities to be contradicted and challenged, rather than memorialized and fixed in a cultural village.

Routes of culture and struggle: township tours

If the cultural village depicts rural snapshots of culture, where ethnicity evokes the bucolic and timeless, then the townships, created by apartheid on the margins of its cities, are presented as sites of 'living culture', 'political resistance', and 'modern life'.[33] For tourists in search of more than an ethnic performance, the tour through these dormitory locations may offer the 'experience … of a true African township'. A 'safe guided walk' through the 'whole township', with an excursion through 'an original historic hostel', presents the opportunity to 'learn more about the migrant labor system (1958–94)'.[34] The township is not portrayed in a sanitized fashion in a 'postcard panorama'. Instead, here tourists might see moments 'where butchers shoo flies away from sheep's heads, starving dogs sprawl listlessly in the road and children dig in piles of trash'.[35] In urban South Africa, there seems to be no apparent need for the staging of reality, when township life seems to offer unmediated scenes of continued harshness and deprivation.

Nevertheless, the urban edges of South Africa are traversed by routes and pathways in which life is put on show and scripted into a special genre of the township tour. As in the cultural village setting, these tours are configured as journeys across the African frontier, to go 'where no man has gone before'. These tours open up 'the other side of the color line', enabling the post-apartheid adventurer to enter areas 'previously inaccessible to whites'.[36] These sightseeing jaunts, striving to reflect the experiences of the majority of South Africans, promise a 'first-hand experience of the township', where the tourist could 'interact with the people'.[37] What might have started off as a means for foreign visitors to experience 'the other side' has also turned into a field of cultural encounter among South Africans, where townships are presented for 'the eyes of the whites'. White South Africans now feel able to experience the 'real' Africa at home, previously thought of as 'possible only in countries north of South Africa'.[38] In a profound case of irony, South Africa's arms manufacturer, Denel, began sending its executives on tours of the very townships whose popular uprisings its ammunition and military hardware once sought to crush.[39]

Township tours offer sensory samples of ethnic diversity, visual traces of apartheid's deprivations, and memorials to resistance. These three elements invariably form part of each township tour in a variety of permutations and with differing emphases.

Soweto is the location of what is perhaps the crowning achievement of all township tours. Most townships appear nondescript and anonymous to the tourist. But Soweto is presented not only through its relentless rows of regimented housing, but also as the place where the struggle against apartheid was reignited in the 1970s. A tour of Soweto offers visitors a glimpse of 'crammed rooms and makeshift beds, clothes hung on coat hangers above the sleeping space, and roofs with the lacy pattern of rust and zigzagged with illegal electrical connections'.[40] From this repetitive urban sprawl, tourists – approximately one thousand per day – are directed to sites that confirm Soweto's media-created resistance pedigree. Capitalizing on these prior memories, tourists are bussed on a 'March to Freedom', from the Hector Petersen Memorial Square to Vilakazi Street, where the homes of Mandela and Tutu stand. Included on this heritage trail are Morris Isaacson School, where the uprisings of 1976 broke out, and Kliptown, site of the Freedom Charter's adoption. Onto this legacy of repression and resistance, Soweto

tourism has grafted a sense of cultural Africanness. At a variety of restaurants and shebeens, tourists can sample African 'traditional fare': 'dumpling, tripe, pap, spinach, vetkoek, samp and beans'.[41] Just below the Mandela house in Orlando West, the Ubuntu Kraal, a 'popular tourist spot', offers a shebeen, crafts for sale, and a variety of cultural events including 'traditional dancing'.[42] These tastes, rhythms and mementos of tradition bring the tourist back to the essence of Africa, providing relief from the specter of history.

Almost invariably on the township tour, the 'Struggle Route' gives way to the 'Shebeen Route'. In order to attract tourists seeking the African spectacle, the township is presented as an extension of the rural village in an expression of timeless ethnicity. The aim of one township tour based in KTC, an informal settlement in Cape Town, for instance, is 'to present the Xhosa-speaking people's culture, customs, beliefs, traditions and daily activities, and to show the way they have adapted from rural to urban life'.[43] The voyage of discovery into the township incorporates essentialized African alternatives to the well-worn tourist paths of mountains, sea, and scenic beauty. Tourists 'spoilt' with 'African warmth' go across the threshold of a 'typical township home', imbibe 'traditional African beer (*umqombothi*)' at a shebeen, partake of 'African cuisine', and gaze upon 'hawkers at work' and 'a performance by a traditional Healer/Sangoma'.[44] In a bizarre cultural switch in which the modern is cast as ancestral, tourists are able to participate in a 'traditional 'Xhosa picnic'' – held outdoors when the weather is fine – where 'alfresco meals' are cooked over open fires.[45]

Once tourists have eaten and drunk their fill of Africa, they make their way to the nearby craft center to purchase memories of an African experience. In an aesthetic genre constructed by older trade circuits in ceremonial African art and artefacts, as well as by ideas of functionality, decorativeness, and domesticity long unchanged, the township tour meets tourists' expectations of African crafts. To authenticate their products as traditional, the craft center has to ensure that the producers appear as local and indigenous and that the items produced appear handmade using local knowledge and skills.[46] If the producers are seen in situ, they appear in traditional costume, ready to demonstrate the function of the object. Craft objects created to meet European expectations come to stand for ethnicity, meeting the visitor's desire for real things that mark African life. In Grahamstown, tourist demand for crafts resulted in a search for tradition among township residents. Empowerment projects, which had begun the manufacture of recycled objects out of plastic garbage, soon switched to 'traditional beadwork',[47] finding a ready market in local and overseas tourist outlets. Beads, which entered Africa through trade, are now sold back to European tourists as exotic, symbolizing an 'encounter with a romanticized vision of traditional, pristine Africa'.[48]

In the urban setting of Cape Town, there was one genre of community tour that deliberately set itself apart from mainstream cultural tourism: the tour initiated by Western Cape Action Tours to sites of political struggle against apartheid. These are tours conducted by ex-combatants in the ANC's military wing, uMkhonto we Sizwe, who take tourists on a route described as 'an appreciation of a long history of social engineering, of political, social, and economic oppression'. In addition, the tour attempts to uncover the 'good' that occurred 'alongside this oppression'.[49] The guides present themselves as embarking along with the tourist on a journey filled with emotion, knowledge, and lived experience. Tourists are taken to colored and African townships and shown how buffers were created between them. In these townships, they meet members of the community spearheading development projects, are given an escorted field trip to sites where young guerillas fought heroic battles against the apartheid state, and are shown where black people were confined to single-sex barracks in dormitory townships.

There is the ever-present danger that these may be only embellishments upon what is essentially a township tour with all its traditional dressings. Visitors are introduced to 'traditional medicine' at a 'traditional herb store', are given the opportunity to 'taste local culture' by sipping *umqombothi* (a 'traditional brew'), and pay a visit to 'bead bedecked sangomas' in the KTC informal settlement.[50] It might be that on the edges of the tourist gaze, the sites of resistance and remembrance slide almost uneasily into the world of cultural difference. Yet the tour is styled as an 'appreciation tour' and demands respect, not voyeurism, from the visitors. Indeed, the tour resists being framed as a 'township tour'. This tour has the potential to construct a new cultural map of the city, focusing on the traces of urban resistance. Premised on a notion of prior unity between African and colored people, the tour poses questions about successive attempts at racial division and social engineering.

The wildest place in Africa: Ratanga Junction

While the cultural village and the township tour are presented in the tourist universe as the regions of authenticity, the theme park belongs to the space of fantasy. South Africa's first major theme park opened its doors in December of 1998. Taking the off-ramp to Century City, one leaves the western zone of Table Mountain and the Cape Peninsula, with its 'foreign patina'[51] and an overwhelming impression of a European heritage, and ventures into a themed environment, Ratanga Junction, which markets itself as the wildest place in Africa. As in the cultural villages and township tours, impressions of Africa constitute the driving theme of the Ratanga experience, creating a memory of having visited an African place.

In order to journey across the imperial bridge into Ratanga Junction, and to be permitted to pass beyond the guardhouse – where all of one's 'film requirements' are available for purchase – one has to buy a visa. This allows one to enter Ratanga Town, located on an island in the center of the complex and 'restored to its original splendor'. Here the Ratanga Officers Club offers one a drink in the members' bar, the Casa Sophia is a 'splendid café' in the ruins of the Italian embassy, and in the Old Market Place, the Moosa family of Ratanga allows one to 'relax and enjoy the passing spectacle' while partaking of their spicy samosas, flying fish, and other 'secret treats and eats'. On the island, one can also discover the secrets of the Walled City with its river pirates, smugglers, and Kashmiri spices. Passing the 'Marrakesh style bustling market' of Salim Pasha's Souk takes one to the Ratanga River Cargo Services. Here, in the vicinity of Skeleton Bay, one has the option of catching the boat or joining the East African convoy and taking the road train for a '"perilous" drive into uncharted territory' to one of the many rides that Ratanga Junction offers. At Crocodile Gorge the visitor can 'shoot the rapids through the valley of fear'; Monkey Falls invites one to take a 'death-defying plunge into the abyss'; and, at the most notorious ride, the Cobra, one can travel at '100 kilometers per hour at four times the force of gravity … absolute terror never felt so good'. Across the bridge on the Congo River, amidst a carefully arranged set of skulls, is the site of the wreckage of the airplane that crashed in the jungle, the survivors establishing Ratanga Junction. Adjacent to the crash site is the ride that evokes one of the 'real' founders of Ratanga Junction, Monastery Mining and Exploration: on the Diamond Devil Run one is 'out of control on a runaway train' in a dilapidated mine.[52]

In this wild world of spectacle at Ratanga Junction, there seem to be arbitrary, somewhat haphazard notions of reality and society operating. There is a relative lack of narrative continuity between the different sites in Ratanga Junction. In addition, there seems to be an absence of explicit, authentic markers and signifiers, located in real time and space, such as museums, or any association with known individuals or events. The experience of Ratanga thus places the

emphasis on consumption, giving the impression that its depictions are purely marketing ploys that have little or no association with the real world.[53]

However, Ratanga Junction reflects a very real world. In the first place, the theme park, seemingly outside the city's ambit, grew out of a series of land deals and financial transactions. Second, Ratanga Junction represents a translocation of imagined pasts of Africa into a real space, which one can see, partake of, and domesticate. Finally, the theme park presents itself as more than mere fantasy. It seeks to place these images of Africa into a world of science and education, where schools have been offered the opportunity of an 'Edu-Venture'.[54]

Ratanga Junction is owned and operated by Monex, a company that started its life in the mid–1980s as Monastery Mining and Exploration, a diamond mining operation in the Free State. In 1992, Monex started looking into the possibility of building a theme park. The opportunity to go ahead with the project arose in 1995 when it joined forces with the property developer ILCO Homes.[55] ILCO Homes was deeply in debt at the time in spite of a R4.9 million out-of-court settlement paid to it by the state because of land in District Six that had been expropriated. This land, from which people had been removed under apartheid, had been purchased by ILCO Homes in 1989. The chair of the District Six Civic Association, Anwah Nagia, slammed the deal as 'immoral',[56] a flagrant case of 'profiteering from apartheid'. At almost the same time, ILCO was compensated for the land, the company was taken over by Boland Bank, which then transferred the shares it acquired to a nominee company, Pro-Mark Network. Keith Watkins and Martin Wragge, who were Monex shareholders, later procured this company.[57] ILCO became part of Monex, and Martin Wragge became the majority shareholder and managing director.[58] By September of 1995, plans for the re-zoning of land bordering on the N1 motorway were approved, enabling Monex to build a complex called Century City. Newspapers reported that Cape Town was on track for its 'own Disneyland'.[59] Despite a R2.1 million operating loss between June and December of 1995, toward the end of 1996 Monex was showing strong signs of recovery 'due to restructuring and opportunities presented by Century City'.[60]

These opportunities at Century City were primarily centered on the development of a theme park. On the basis of quite narrowly defined economic criteria, the theme park was projected to turn a profit, despite costing some R350 million.[61] According to Wragge, consumer studies had shown that 'entertainment centres like Disneyland flourish when times are tough and get even better when they improve'.[62] In South Africa, a weak currency meant that many families could not afford to travel abroad to experience European and US theme parks.[63] More broadly, the construction of a theme park set Monex firmly in what it called the 'experience' or 'fourth' economy (the first three were termed 'agrarian', 'industrial' and 'service'), 'where consumers in increasing numbers will spend increasing amounts of their disposable income in pursuit of "immersive" experiences which they can make their own'. Through places like Ratanga Junction, Monex aimed to 'create, design, package and deliver these "immersive" experiences ... in a world without boundaries'. From designing cartoon strips to creating laser shows in the Libyan desert for Muammar Gaddafi's birthday, staging pop concerts, and building a theme park of Africa in Africa, Monex sees itself at the cutting edge of this new economy.[64]

In this new immersive economy, where 'fantasy has no fixed geographic location',[65] Ratanga Junction is a tightly bound localized enclosure that is both within and set apart from the metropolitan surrounds. Displaced from the urban setting, it presents precolonial Africa as the place of the exotic, the oriental, the secretive, and the uncharted. There is a history of 'the Orient': 'a taste of the East' on Spice Island and an encounter with the 'Raj' at the Ratanga Officers' Club 'overlooking the jungles of Lake Ratanga'. In this precolonial past, people of Africa hardly exist. It is a time of the ancients, tradition, and primal fear.

315

Moving into the colonial past at Ratanga Junction, the images of Africa created by colonial modernity reign supreme. Explorers can take a swinging-boat ride on the Congo Queen, a ship adorned with 'gigantic African masks' that 'overshadows its surroundings'.[66] The Congo evokes an 'uncivilized' zone meant to 'epitomise the binary distinction between the civilised West and its primitive Other'.[67] Likewise, the walled and birded images that adorn the architecture and walkways of Ratanga Junction draw on a familiar colonial trope, the epic of the lost city, a legendary place of prior nonindigenous settlement, characterized by wealth, glory, and powerful rulers. As the African Renaissance attempts to reappropriate archaic and exotic images into a postcolonial iconography, their continued representation at the wildest place in Africa recalls the genealogy in the real world of the colonial imaginary.

While Monex would be the first to admit that they have 'not perfected the formula for Ratanga Junction',[68] they have pioneered the field of the themed environment in South Africa after apartheid. Theme parks in general have been places of 'safe and nonthreatening' holidays, offering 'sharp contrasts with the constraints, regimentation, and normative burdens of … everyday existence'.[69] In South Africa, Ratanga Junction has necessarily taken on an added responsibility. It provides a holiday from apartheid's continuing legacies and the stresses and strains of a society in transition. This is not a place that encourages contemplation. Visitors are invited to 'just do it, accept it and have fun'.[70] The themed images of Africa are naturalized into the funfair atmosphere and visitors are expected to imbibe them without question.

The African holiday backdrop provides the setting for a South Africa whose African images are still rooted in the colonial paradigm and the early South African intonations of the African Renaissance. While these two tendencies seem to be diametrically opposed, at Ratanga Junction they are merged.

Memories of Africa in the time of the renaissance

Postcolonial tourist ventures drew upon familiar fantasies of 'nativist authenticity', in which the basis of indigenous life continues to be the tribal unit, designed as traditional.[71] The tourist theming of South African society continues in the age of exploration and discovery, primarily through the cultural village and the township tour. The irony of South Africa's modernity is that the country is still mapped and memorialized for international and domestic tourists as a sequence of routes from tribe to tribe in rural and urban settings. While Ratanga Junction might not be an obviously ethnographic theme park, its image economy is rooted in the same idea of primitiveness and the discovery of a 'Dark Continent left behind by progress'.[72]

Notwithstanding the perspectives offered by the Makuleke and Western Cape Action Tours, it might seem there is no escape from the tourist gaze for local initiatives seeking to benefit from the spreading effects of international tourism. Often they remain peripheralized.

Yet, ironically, we have been given a hint that perhaps the tourist gaze can be subverted. An advertisement for the South African Electricity Supply Commission (Eskom) appeared on SABC television in 1998. Aboard a luxury bus driving through a seemingly deserted countryside is a group of American tourists. Suddenly they spot a hut with painted murals that signify it as Ndebele. The bus screeches to a halt, allowing the tourists to disembark and acquire their piece of much-valued Ndebele culture. After negotiating the price of the pots, the tourists extol the traditional authentic virtues of their purchases. They board their bus well satisfied that they have acquired a piece of Africa, unmistakably authentic, at a bargain price. The Ndebele women, who had made the sales to the tourists in a seemingly unsophisticated manner, then disappear into the hut. There, inside the hut, is an electrically powered industrialized assembly

line, operated by knowing workers. The workers together with the vendor laugh gleefully at the accomplishment of their success in manufacturing and selling tradition. After a short run, this advertisement disappeared from South Africa's television screens. Was this merely routine? Was it because of cultural stereotyping of the tourist dollar, rather than 'the native'? Or was it that the level of perception shown in the advertisement about the processes of ethnic creation and cultural objectification made it subversive enough to be suppressed? We suggest the latter.

Acknowledgements

This essay is based upon research conducted for the National Research Foundation (NRF)-funded Project on Public Pasts, based in the history department at the University of the Western Cape. The financial support of the NRF for this research is hereby acknowledged.

Notes

1 For an extensive account of the development of this imagery see Ciraj Rassool and Leslie Witz (1996) "South Africa: a world in one country': moments in international tourist encounters with wildlife, the primitive and the modern', *Cahiers d'Etudes Africaines*, 143, xxxvi–3.
2 Connex Travel (1994) *South Africa: Discover our New World in One Country*.
3 Barbara Kirshenblatt-Gimblett (1998) *Destination Culture: Tourism, Museums and Heritage*, Berkeley: University of California Press, 136.
4 Thabo Mbeki (2000) 'The African renaissance', *Getaway*, 12(1), 45. *Getaway* has average monthly sales of 98,914. It contains features on tourist destinations throughout Africa, offers of organized trips to specific locations, reviews of travel books and equipment, a readers' forum, several competitions, columns by regular and guest writers, and an extensive 'shop window' where tourism providers can advertise their products (which comprises almost half the space of a 270-odd-page magazine).
5 *Getaway* op. cit., 89, 134, 97.
6 For a fuller account of the history of the development of 'native villages' and the tourist gaze on South Africa see Rassool and Witz, op. cit.
7 SATOUR (1996) *Explore South Africa: A Promotion by the South African Tourism Board*.
8 Tourism KwaZulu-Natal (2000) *Province of Colour: A Feast of Local Cultures, Arts and Crafts, Accommodation and Entertainment Delights*, 5.
9 Chris Chapman (ed.) (2000) *KwaZulu-Natal South Coast*, Durban: Ugu Tourism Marketing Association/Artworks, 11.
10 Coast to Coast Tourism Bureau (1994) *Routes for all Seasons*, 18–19; E. Badenhorst (1994) 'The southern hemisphere's largest authentic Zulu village', *Flying Springbok*, May, 10; C.A. Hamilton (1993) 'Authoring Shaka: models, metaphors and historiography', unpublished PhD dissertation, Johns Hopkins University, 540–2.
11 Tourism KwaZulu-Natal, op. cit. cover page.
12 *Open Africa* (supplement to *Mail and Guardian*), 19 June 1996.
13 Amanda Vermeulen (1999) 'Taking SA tourism into a rich ethnic playground', *Business Times* (supplement to *Sunday Times*), 22 August.
14 D.G. McNeil Jr. (1996) 'My hut is your hut: South Africa's new tourism', *New York Times International*, 17 May; S. Crowe (1996) 'Village life', *Flying Springbok*, 76, 209.
15 The term is Raphael Samuel's (*Theatres of Memory*, London, Verso, 1994).
16 Lesedi Cultural Village (2000) *Lesedi Cultural Village: 'Place of Light'*.
17 This is a term used by Nick Stanley throughout his book, *Being Ourselves for You: The Global Display of Cultures* (London: Middlesex University Press, 1998).
18 Vermeulen, op. cit.
19 N. Ndebele (1996) 'A home for intimacy', *Mail and Guardian,* 26 Apr.–2 May.
20 This statistical research may be found online at www.environment.gov.za/tourism/factsheet99

21 Eddie Koch (1996) 'Spitting a cud to the winds in QwaQwa', *Open Africa* (supplement to *Mail and Guardian*), 20, 5; Vermeulen, op. cit.; 'Experience tribal life in Xhosaville', *The Argus*, 18 December 1995; Crowe (1996) 'Village life', *Flying Springbok*, June, 76.

22 See the Restitution of Land Rights Act 22 of 1994, section 1; for a discussion of the provisions of the act see Bertus de Villiers (1999) *Land Claims and National Parks*, Pretoria: HSRC.

23 Kagga Kamma (1992) *Safaris to Kagga Kamma: Place of the Bushmen*.

24 Crowe, op. cit., 70.

25 Hylton White (1995) *In the Tradition of the Forefathers: Bushman Traditionality at Kagga Kamma*, Cape Town: University of Cape Town Press; for a discussion of patronage and the genealogy of 'bushman' cultural performance, see Ciraj Rassool (1998) 'Cultural performance and fictions of identity: the case of the Khoisan of the Southern Kalahari, 1936–1937', in Yvonne Dladla (ed.) *Voices, Values and Identities Symposium*, Pretoria: South African National Parks.

26 Crowe, op. cit., 72–3.

27 David Bunn and Mark Auslander, 'Owning the Kruger Park', in *1999 Guide to South African Arts, Culture and Heritage* (available online at www.artsdiary.org.za); see also Eddie Koch (1999) 'Cultural tourism in the Makuleke region of the Kruger National Park: a preliminary assessment of the possibilities and problems', Nelspruit: Makuleke Communal Property Association.

28 See Stanley, op. cit., 28–30, and Tony Bennett (1995) *The Birth of the Museum*, London: Routledge, 115.

29 Paul Msemwa (1996) 'Ethnic days at the village museum', paper presented at the Swedish–African Museum Programme Conference on African Open Air Museums, Dar es Salaam, October 1996.

30 Gaudence Mpangala, (1996) 'Benefits and dangers of presenting different ethnic cultures at museums', paper presented at the Swedish–African Museum Programme Conference on African Open Air Museums, Dar es Salaam, October 1996.

31 Koch, op. cit.; see also Lamson Maluleke (1999) 'Culture, heritage and tourism: proposals for a living museums project in the Makuleke region of the Kruger National Park, South Africa', *Proceedings of the Constituent Assembly of the International Council of African Museums – Africom*, Lusaka: Africom, 3–9 October 1999, 101–5.

32 Maluleke, op. cit., 105.

33 Richard Kurin (1997) *Reflections of a Cultural Broker: A View from the Smithsonian*, Washington: Smithsonian Institution, 273.

34 Lwandle Migrant Labour Museum (2000) *Lwandle Migrant Labour Museum and Arts and Crafts Centre*.

35 Kathleen Chapman (1999) 'Township tours: exploitation or opportunity?' *Cape Times*, 8 July.

36 Grassroute Tours (1999), *Grassroute Tours Invites You to Have a Look Beyond the Rainbow Curtain*.

37 One City Tours (1994) *Township Educa-tour*.

38 Grassroute Tours, op. cit.; Don Makatile (2000) 'The Alex all-white tour', *Drum*, 25 May.

39 Chapman, op. cit.

40 Charlene Smith (1998) 'Shebeen route is a tourist magnet', *Independent Online*, available online at www.archive.iol.co.za/Archives/1998/9803/24/satstar0703news29.html

41 MelanieAnn Feris (1998) 'Soweto a growing magnet for overseas visitors', *Independent Online*, available online at www.archive.iol.co.za/Archives/1998/9807/24/tour2.html

42 Smith, op. cit.

43 *Info Africa: Travel, Leisure and Sports Guide*, Pretoria: Mel Cunningham, June 1996, 26.

44 Comair (1996) *Air Tales*, 3(3), July, 70.

45 The Masithandane Association (1998a) *The Masithandane Association*; The Masithandane Association (1998b) *Masithandane: A Brief History*.

46 For an illuminating discussion of craft and tourism in Zimbabwe see Patrick W. Mamimine (1997) 'The social construction of authenticity in ethnic tourism: a case study of Chapungu Cultural Centre', *Vrijetijdstudies*, 15(2), 26–39.

47 *Masithandane: A Brief History*, op. cit.

48 Christopher Steiner (1994) *African Art in Transit*, Cambridge: Cambridge University Press, 128.

49 Y. Fakier (1998) 'Tour of the past is a journey into the future', *Cape Times*, 20 October.

50 Ibid.

51 Anthony Holiday (1994) 'Desire to shake off colonial trappings', *Cape Times*, 4 July.

52 This description of Ratanga Junction is based upon visits there in May and August of 1999, the map and information brochure distributed to visitors, and the winter promotional offer 'It's Snowing at Ratanga Junction'.

53 This is the point that Alan Bryman makes in reference to the World Showcases pavilion at Disneyworld, but which we think can be usefully applied to Ratanga Junction in general. See Alan Bryman (1995) *Disney and His Worlds*, London: Routledge, 52.

54 'Cape Argus/Ratanga Junction Edu-Venture', supplement to *Cape Argus*, 3 May 2000.

55 Johan Coetzee (1998) 'City's roller-coaster ride', *Finance Week*, 11 December.

56 Edward West (1995) 'Land deal angers Western Cape ANC', *Business Day*, 26 September; Glynnis Underhill (1995) 'District Six payout slammed as "apartheid deal"', *The Star*, 23 September.

57 Maggie Rowley (1995) 'Monex, Boland deny collusion in project', *Business Report*, 21 September; Coetzee, op. cit.

58 Coetzee, op. cit.; 'Ilco Homes Kry'n Nuwe Gedaante', *Beeld*, 22 September 1995.

59 Gerhard Cloete (1995) 'Kaap se eie Disneyland vinning goedkeur', *Finansies & Tegniek*, 8 September.

60 Robyn Charmers (1996) 'Monex makes recovery after restructuring', *Business Day*, 21 October. Monex also had a loss of some R1.75 million when it, together with Tsogo Sun, staged the musical *Les Misérables* at the Nico Malan Theater in Cape Town. The intention had been to test whether it would be viable to build a theater at Century City. Although ninety-eight per cent of the tickets for the show were sold, the fact that the run was not extended meant that the production ran at a loss. See J.M. Wragge (1996) 'Monex Limited, interim report for six months ended 30 September 1996', *Business Day*, 13 December.

61 'Monex verwag verdere styging in verdienste', *Beeld*, 22 September 1998; J.M. Wragge (1998) 'Monex Limited, interim report for six months ended 30 September 1998', *Business Day*, 10 November.

62 Gerald Hirshon (1998) 'Not Mickey Mouse but a project on Disney scale', *Financial Mail*, 31 July.

63 Audrey D'Angelo, 'Monex Turns to Leisure for Expansion,' *Business Report*, 1 September 1998.

64 'Chairman's review for year ended March 31, 1999', *Monex Limited Annual Report*, 1999, 7.

65 Barbara Kirshenblatt-Gimblett, op. cit., 147.

66 Ratanga Junction (2000) *It's Not a Day, It's a Holiday*.

67 Nicholas Mirzoeff (1999) *An Introduction to Visual Culture*, London: Routledge, 133–4.

68 *Monex Limited Annual Report*, 1999, 13, 12.

69 Mark Gottdiener (1997) *Dreams, Visions, and Commercial Spaces*, Boulder: Westview, 114.

70 Jennifer Stern (1999) 'Wacky, wet fun at Ratanga', *Cape Times*, 18 June.

71 Rebecca Luna Stein (1998) 'Israeli tourism and Palestinian cultural production', *Social Text*, 56(3), 117. In this article Stein identifies and analyzes the imaging of Palestinian identities within changing tourist relations in ways that bear a remarkable resemblance to South African tourist depictions of indigenous communities.

72 Mirzoeff, op. cit., 133.

Suggested further reading for Part 3

Abraham, S., Waldren, J. and MacLeod, D.V.L. (eds) (1997) *Tourists and Tourism: Identifying with People and Places*, Oxford and New York: Berg.

Ashworth, G.J. and Larkham, P.S. (eds) (1994) *Building a New Heritage: Tourism, Culture and Identity in the New Europe*, London: Routledge.

Boniface, P. (1995) *Managing Quality Cultural Tourism*, London: Routledge.

—— and Fowler, P.J. (1996) *Heritage and Tourism in the 'Global Village'*, London: Routledge.

Burns, P.M. (1999) *An Introduction to Tourism and Anthropology*, London: Routledge.

Butler, R. and Hinch, T. (eds) (1996) *Tourism and Indigenous Peoples*, London: Thomson.

Crouch, D. and Lubbren, N. (eds) (2003) *Visual Culture and Tourism*, Oxford: Berg.

Dicks, B. (2003) *Culture on Display: The Production of Contemporary Visitability*, Buckingham: Open University Press.

Fladmark, J.M. (ed.) (1994) *Cultural Tourism*, Shaftesbury: Donhead.

Ghimire, K.B. (ed.) (2001) *The Native Tourist: Mass Tourism within Developing Countries*, London: Earthscan.

Greenspan, A. (2002) *Creating Colonial Williamsburg*, Washington: Smithsonian Institute.

Herbert. D.T. (1995) *Heritage, Tourism and Society*, London: Mansell.

Jacobs, J.M. and Gale, F. (1994) *Tourism and the Protection of Aboriginal Cultural Sites*, Canberra: Australian Government Publishing Service.

ICOM (2000) *Museums, Heritage and Cultural Tourism*, Paris: ICOM.

ICOMOS (1993) *Tourism at World Heritage Cultural Sites: The Site Manager's Handbook*. ICOMOS International Specialised Committee on Cultural Tourism. International Scientific Committee 10th General Assembly.

Kirshenblatt-Gimblett, B. (1998) *Destination Culture: Tourism, Museums, and Heritage*, Berkeley: University of California Press.

Nash, D. (1996) *Anthropology of Tourism*, Oxford: Pergamon.

Orbasli, A (2000) *Tourists in Historic Towns: Urban Conservation and Heritage Management*, London: Spon.

Prentice, R. (1993) *Tourism and Heritage Attractions*, London: Routledge.

Robinson, M., Evans, N. and Callaghan, P. (eds) (1996a) *Culture as the Tourist Product*, Sunderland: Centre for Travel and Tourism/Business Education Publishers.

—— (1996b) *Tourism and Cultural Change*, Sunderland: Centre for Travel and Tourism/Business Education Publishers.

Robinson, M., and Boniface, P. (eds) (1998) *Tourism and Cultural Conflicts*, Wallingford: CAB International.

Rojek, C. and Urry, J. (eds) (1997) *Touring Cultures: Transformations of Travel and Theory*, London: Routledge.

Runyard, S. (1993) *Museums and Tourism: Mutual Benefit*, London: Museums and Galleries Commission.

Stanley, N. (1998) *Being Ourselves for You: The Global Display of Cultures,* London: Middlesex University Press.

Urry, J. (1990) *The Tourist Gaze*, London: Sage.

—— (1995) *Consuming Places*, London: Routledge.

PART 4

Democratizing museums
and heritage

24

'Social exclusion zone' and 'The feelgood factor'

Andrew Newman

Problems associated with 'social exclusion' became an issue for museums, galleries and heritage in the UK in the late 1990s. Since then, there has been increased discussion about the role that museums, galleries and heritage can play in combating social exclusion. Although the potential role of the heritage and cultural sector did not receive much attention in the early government reports, the notion of social inclusion has increasingly found its way on to the agendas of the Department for Culture, Media and Sport, The Council for Museums, Archives and Libraries (previously Resource) and individual institutions and organizations.

This chapter outlines the initial problems associated with a lack of clarity in how notions of social exclusion were understood and the disjointed perceptions concerning the possible role that museums, galleries and heritage could play in combating it. It considers the difficulties faced when attempts are made to try to measure the impact the sector has made upon people's lives. Success cannot be measured in terms of the range of people who have taken part in public programmes. Rather, they have to be measured in terms of how programmes influence and help change the lives and circumstances of individuals. This chapter argues that more critical and careful evaluation of programmes needs to be done, before the real impact of the sector can be gauged.

Social exclusion zone

The problems of social exclusion in the UK were first identified in a report published by the Social Exclusion Unit in September 1998, Bringing Britain Together: a National Strategy for Neighbourhood Renewal. Policies were formulated from the responses of eighteen Policy Action Teams (PATs) based around a number of themes. The Department for Culture, Media and Sport (DCMS) set up PAT 10. This body considered a range of topics, including the possible role of museums and galleries. An action plan was developed by the Social Exclusion Unit and published in January 2001 – A New Commitment to Neighbourhood Renewal: National Strategy Action Plan.

Government views of museums

The idea that museums and galleries have an important social role appears to be accepted by the different elements of government to a varying degree. It is possible to understand what these views are by analysing documents and interviewing influential people. But these results are indicative and it is often hard to identify official policy or a consistent view.

Our analysis of documents, as well as an interview with two members of staff at Resource, indicates that the museums, libraries and archives council strongly supports the view that

museums and galleries have an important role to play in ameliorating social problems. Resource is funding a number of research projects to provide evidence that supports this view, in accordance with its advocacy role. These include an investigation of the role of museums, libraries and archives in neighbourhood renewal by the University of Northumbria and research by the University of Leicester into the role of small museums.

But apply the same approach to the DCMS and the picture is less clear. A number of DCMS policy documents have emphasized the role of museums and galleries in dealing with the problems of social exclusion (Libraries, Museums, Galleries and Archives for All: Co-operating Across the Sectors to Tackle Social Exclusion, which was published in 2001). It has even been suggested that museums and galleries could be agents for social change. This attitude was supported by an interview with a key DCMS staff member by one of our researchers.

But other DCMS documents provide a different view. PAT 10 largely left museums and galleries out of its initial publications. More recent PAT 10 documents envisage a limited role in social exclusion polices for museums and galleries, particularly Building on PAT 10, which was published this year. The department is also reluctant to fund initiatives in this area even though Resource is lobbying for this. These different positions are not easily reconcilable. One possibility is that the department is responding to lobbying by the profession, while not really believing that museums and galleries have an important role to play.

Recent reports produced by the Social Exclusion Unit, which has considerable influence over national social exclusion policy, do not include museums and galleries to any extent – most notably in Preventing Social Exclusion: Report by the Social Exclusion Unit (2001).

A key member of the unit also proved to be unaware of the work that has been going on in museums and galleries and had not seen many of the policy documents produced by the DCMS. The interviewee viewed social exclusion in terms of the unit's own definition and would only be convinced by hard evidence demonstrating an impact on unemployment, poor skills, low incomes, poor housing, high crime environments, bad health and family breakdown.

Demonstrating a significant impact by museums and galleries in terms of these indicators has not proved possible so far. A response to this problem has been to view the contribution of museums and galleries as adding to a person's quality of life. It will be interesting to see the results of a study on the social auditing of museums and galleries recently commissioned by the South West Museum Service to be carried out by the University of Sheffield and funded by Resource. Whether soft indices, such as confidence building, will ever be accepted as a justification for the claims that museums and galleries can be a significant force in society remains to be seen. It seems unlikely.

The (then) Scottish Executive's policies, reflected by the Scottish Museums Council, focused on what was described as social justice rather than social exclusion. This philosophy was based on an individual's rights and related to a broader view of citizenship. But both terms were used in the same way. It is worth noting that the Scottish Executive did not include museums and galleries in its main strategies to promote social justice. But the social value of culture was recognized in Scotland's National Culture Strategy, published in 1999.

Understanding social exclusion

The way the profession views social exclusion has determined the way it tries to demonstrate social relevance. Without understanding the nature of deprivation and people's needs, it is very difficult to plan initiatives or programmes. This research project, as well as others, has shown there is very little clarity about what the profession sees as social exclusion.

Many curators said they had been doing this work for years and felt it was similar to access and audience development. Some said social inclusion was something that happened naturally when people came into museums. But there was little discussion of the concept in wider terms and how this process might occur. The professed relationship between access, audience development and social inclusion is emphasized in Centres for Social Change: Museums, Galleries and Archives for All (DCMS, 2000).

When considered logically, broadening the audience lets the museum act on a greater range of the population, but tells very little about the impact it is having on those visitors. It will indicate whether the institution is inclusive in terms of the ethnic or socio-economic nature of audiences, but this is not a measure of success in terms of having an impact on social exclusion. Audience development is a means to an end and should not be considered an end in itself. If the aim of a museum-based activity is to improve people's lives, measuring success in terms of the range of people who have taken part is inappropriate. Success can only be judged by the impact that has been made on participants. Becoming involved in a museum-based initiative will not automatically mean a person moves from exclusion to inclusion.

This lack of understanding of social exclusion is problematic because it inevitably means strategies are planned without clear objectives. The Social Exclusion Unit's definition is the one that is frequently quoted in the literature published by museums (these are problems such as unemployment, poor skills, low incomes, poor housing, high-crime environments, bad health and family breakdown). It is important to emphasize that these issues are linked and that social exclusion is a process. This means a combination of circumstances may make a person excluded. An individual might experience periods of exclusion or it may go on for years. Various factors may combine and be the start of a downward spiral. A number of interviewees were clearly excluded in some ways, not being able to work because of a disability or having to care for young children, but they often had an effective social support system. It is important to emphasize that there is not a linear progression from inclusion to exclusion, as is often thought.

An example is a participant in one of the initiatives we studied. He is a 35-year-old man who lives with his parents on the fringes of Tyne and Wear. He has learning difficulties and because of this does not work and has had little opportunity to do so in the past. He is excluded from many aspects of life that most take for granted and may never live independently. But he is a positive, happy individual with a very active social life. He is currently involved in teaching social workers how to deal with people with learning difficulties. It was difficult to find a gap in his diary so he could be interviewed. He does not fit the widely accepted view of what a socially excluded person should be.

People suffering from social exclusion are not an easily identifiable homogeneous group that can be targeted by a particular initiative. Those who are excluded have complex interlinked problems and that complexity needs to be addressed and recognized. It is important to understand the unique nature of an individual's experience of social exclusion if they are to be helped.

Museums and galleries

The response of museums and galleries to the need to become a force for inclusion has varied. Some bodies, such as Tyne and Wear Museums, have placed it at the centre of their philosophy. Tyne and Wear Museums has included the subject in its mission statement. The aim has been to 'position' the organization for inclusion by changing attitudes and established practices.

The most common response has been to plan a strategy that includes initiatives to engage with individuals or community groups in the museum or within communities. Problems with

such an approach are that those suffering from extreme forms of exclusion are difficult to iden-
tify, are unlikely to belong to any group and are therefore hard to make contact with. Those
who belong to community groups tend to be those whose experience of exclusion might be
limited, or perhaps is being addressed in a way that is appropriate to their needs.

Sustainability is clearly a difficult issue to resolve, as the majority of projects are funded for
limited periods. One interviewee said providing an activity that was helping people and then
removing it was potentially damaging to the vulnerable. Such activities are also an expensive
way of engaging with very small numbers of people and any evaluation is often fragmentary
and inadequate. These issues were all identified in interviews with those implementing
programmes and were well understood.

The impact on participants of such programmes is difficult to measure. The study has
allowed us to explore this in a new way.

We interviewed a twenty-five-year-old single mother living in a deprived part of Tyne and
Wear who was participating in a project. She is unemployed and lives in a housing association
flat that is too small and in a poor state of repair. Her main difficulties are a lack of childcare
facilities and too little money to bring up her son as she would wish. She has an active social
life and support from family and friends.

She enjoyed taking part in the initiative, although it had very little impact on her everyday
life. New skills were not learned and she was already a very confident person. But she learned a
great deal about herself during the project. This impact was complex and difficult to resolve. It
seemed to relate to how she saw herself and was very important for her well-being. There was no
demonstrable impact in terms of the indices of social exclusion accepted by the Social Exclusion
Unit.

The sense of well-being that initiatives engender might mean they work by helping people
to develop a stronger and more positive sense of self. To make the claim that particular initia-
tives enable museums to change society is overstating the case.

It appears the sections of government closest to the development of social exclusion policy
do not feel museums and galleries have a central role to play. They are viewed as peripheral in
comparison with other sectors, such as housing and health. The ability of museums and
galleries to socially engineer society, while an attractive idea to many, cannot at present be
demonstrated. An effort to dovetail the limited measurable outputs of initiatives with indices
of inclusion largely fails and the Social Exclusion Unit understands this. A policy encouraging
museums and galleries to focus on such indices of inclusion appears misguided.

But so far, our research indicates that initiatives do have an impact. This might be related
to the way people develop a sense of who they are. The profession and the various elements of
government appear to misunderstand the importance of this. It could be a first step to inclu-
sion for many people.

The next part of this chapter will look at this process in more detail and propose a mecha-
nism by which museums and galleries influence the way people make sense of who they are
and their place in the world. There is a need to articulate a confident vision of a future for
museums and galleries based on what they can achieve and how they influence society.

The feelgood factor

Museum and gallery staff need to understand the social roles of museums and galleries if they
are to achieve the goals that we now expect of them. But at the moment, museum practice in
this area is not based on sound foundations. Either it stems from the collective memory of

curators that has been passed from generation to generation, without being questioned, or it is based on an unrealistic idea of what museums and galleries can achieve – reflecting the aspirations of curators and educators, rather than things they can deliver.

The research that this part of the chapter is based on consisted of a series of in-depth interviews with museum and gallery policy makers as well as practitioners. The views of visitors to the Great City exhibition in Newcastle's Discovery Museum were explored through focus groups, interviews and questionnaires. Two other initiatives were also examined. The first, Making History, was an innovative contemporary collecting project based in the Discovery Museum. About 200 people from Tyne and Wear were asked to donate five items that represented themselves. An effort was made to involve as wide a range of people as possible, many of whom would not normally visit museums. The second initiative was the Greater Pollok Kist project, part of Glasgow Museums and Galleries' Open Museum. This project aims to develop sustainable community access to Glasgow museums, to strengthen the links between the Burrell Collection and the local community and to test a model that could be applied elsewhere in the city.

The policy maker and practitioner interviews revealed a number of themes. Both groups thought museums and galleries have an important social impact on individuals and the broader society. Interviewees felt that museums and galleries were able to help foster personal and community development. They could, for example, help an individual's self-confidence, and were capable of empowering communities and encouraging self-respect. Other functions were seen as facilitating education, as well as representing and celebrating identities. Interestingly, these functions were mainly, though not exclusively, seen as being the product of initiatives rather than exhibitions.

The ideas are consistent with recent museum publications on the subject, such as *Including Museums: Perspectives on Museums, Galleries and Social Exclusion*, and the *Group for Large Local Authority Museums report, Museums and Social Inclusion*. These views are also implicit in *Renaissance in the Regions: a New Vision for England's Museums* published by Resource. In terms of an impact on a broader society, the view that these functions allow museums and galleries to be agents for change was accepted by many of the interviewees. This was articulated in *Agents for Social Change: Museums, Galleries and Archives for All*, published in May 2000.

But despite this consensus, there was little discussion about the ways these effects on individuals and communities may occur. One curator said: 'The trouble is we have never really been evaluated … we think it works, and if it was tested, it probably does work. But to what level it works, who knows?'

The lack of evaluation of initiatives and exhibitions appears to be common across the profession and the concern it caused was reflected in a number of policy maker and practitioner interviews. As a result, it is hard to determine how the broad consensus about what museums and galleries can achieve has been arrived at.

When projects are evaluated, two significant flaws emerge. First, the reason for the evaluation is often advocacy, to support further funding applications, not to understand the processes involved. Second, the methodology is often flawed as it depends on direct questioning. Asking a participant if a particular initiative increased their personal development is very likely to elicit a positive answer. A more appropriate way of determining the effect of exhibitions or museum and gallery initiatives is to record interviews with participants and analyse the resulting narrative. This method is time consuming and the results are difficult to interpret. But this approach is more likely to give a realistic picture. The need for more effective evaluation was acknowledged by the regional representative of the Department for

Culture, Media and Sport in north east England, who recognized the difficulties associated with evaluation and felt that studies should be instigated over longer periods of time.

Our evidence, as presented in transcripts of interviews, focus groups and questionnaires, gives clues as to the effects of initiatives and exhibitions on individuals and so the wider community. To get a more complete picture, further research is needed, especially on the impact of exhibitions. Nevertheless, the research results were analysed to test whether the social functions of museums and galleries, as understood by the profession, were reflected in the lives of participants.

The first person interviewed about the impact of Making History was a twenty-eight-year-old man who lives in Tyne and Wear with his parents and sister. He became blind after suffering from a brain tumour at the age of sixteen. He has an active social life and is a member of many clubs and societies. A lack of confidence is an issue for him, but despite this he does enjoy the challenge of new experiences. He likes visiting museums and galleries and had been involved in a previous project at the Laing Art Gallery in Newcastle upon Tyne. He said the main benefit of the project to him was that it allowed him to tell others about his life and what was important to him. He was also interested in what it taught him about other people. His involvement did give him a sense of pride in himself and what he had achieved, but it did not teach him new skills or increase his confidence. Initially he was uncertain about what to donate and said that: 'At first I didn't want to donate items in case someone thought I was weird and the stuff I was to donate was weird too.'

The second participant was a thirty-five-year-old man with learning difficulties who lives with his parents in Tyne and Wear. He has an active social life and considerable support from parents and friends. His involvement with a theatre group for people with learning difficulties is very important to him. He enjoys visiting museums and galleries and particularly likes archaeology. It was difficult to get him to discuss his feelings about the project, but he did say that one of his motivations for being involved was meeting people. It did appear to give him a sense of pride and he said that involvement made him feel better about himself, although the reasons for this were not clear.

The third interviewee was a twenty-five-year-old single mother living in Tyne and Wear. She is involved in a series of voluntary organizations such as the Children's Society. She has an interest in museums and galleries and had been involved in an oral history project at South Shields Museum. She spent a long time deciding what to donate and this made her realize that she had done some important things in her life. Although she did not learn new skills or meet new people, the project enhanced her self-esteem and even changed her view of herself. It had struck her that different ethnic groups had all chosen similar items and had spoken in the same way about them.

The Greater Pollok Kist project focus group consisted of a group of eight people, who were self-selecting, suffered from minor forms of exclusion and shared an interest in the history of the area. They were recruited mainly through leafleting and tended to be older or retired people who could remember a time when the community was much stronger than it is at present. There are now few opportunities for young people and the group felt that the area had lost its identity. They felt that the project would help local people to get back a sense of their own history. Once this had been achieved, it was felt that morale would improve. There was also a strong sense that the project was about people. One of the participants said: 'As you get older you realise that history is about you.'

The impression gained from the interviews with policy makers and practitioners was that the greatest contribution museums and galleries can make is through initiatives. But it was

felt that it was also necessary to examine, within the constraints of the project, the impact of exhibitions on visitors. The Great City exhibition was initially examined by recording an interview with a first-time visitor. She enjoyed the visit a great deal and was able to relate strongly to it on a personal level. Her most powerful responses related to artefacts that invoked memories about events or places that were important to her. She said: 'It seems that there is a memory in every case. 'It was important to her that events that had happened in her own lifetime were represented. It appeared that the display was saying positive things about her and her family's experiences.

This exhibition was also examined by using questionnaires that attempted to understand the reactions of a series of visitors. The parts of the exhibition that they reacted to most seemed to be those that represented particularly formative periods of their lives. The displays were provoking memories, mainly positive but not exclusively so. Sections of the display on wartime provoked sadness in one particular individual.

Two very different groups visited the Museum of Transport in Glasgow before sharing their observations in a focus group: one was a group of pensioners from Glasgow's West End and a men's group from Easterhouse. They responded strongly to the representation of their own experiences and that of their families. They said it was important to teach children about their own background and identity. One participant said: 'You definitely need roots – you need to remember where you came from.'

Both the initiatives and the exhibitions, had an effect on those who took part or visited. As might be expected, some of those involved reacted strongly and others less so. This impact seems to be most powerfully related to sense of self or identity. The process of choosing objects for the Making History project made participants think about themselves and gave value to their identity. The Greater Pollok Kist project was seen by participants as a way of helping to give a community back its distinctiveness. People visiting the exhibitions also responded most strongly to elements that related to their own family or community identity.

The evidence seems to suggest that the contribution of museums and galleries to an individual and to the broader community is identity based. A stronger sense of self might foster personal or community development and could be a precursor to inclusion, although more research is needed. This contribution appears to go beyond simple validation of identity and plays a role in its construction. How this occurs is a complex process that may be related to memory. It was evident that objects and other interpretative media used in exhibitions and museum-based projects were acting as memory cues.

Current thinking on identity sees it as something that is not constant, but continually being reconstructed depending on the needs of the present. Identity is based on gender, religion, regional affinity, race and many more factors. Particular elements of identity may come to the fore at any one time. A football fan might feel more English when watching the national team beat rivals Germany, for example.

An individual who stands in front of a display case, or takes part in an initiative based on cultural property, has memories invoked that are used to help that person understand themselves and their relationship to others. This process enables them to construct their identity by selecting and using memories in particular ways. But this process is dependent on ways of thinking that are common within society, which are known as 'discourses'. How these form and subsequently change over time is contested, but must be partially influenced by the process of forming individual and collective identities. Cultural property appears to play an integral part in the process of identity construction and in the formation of 'discourses' for people and their communities.

If these ideas are correct, it is difficult to accept that museums and galleries can change behaviour in predictable ways. Individuals use museums and galleries in ways that respond to their own and their group's needs. The stories that curators want to tell might not be those that the visitor or participant in a project takes away. Further research into the ways museums and galleries act on people and communities is critical if their role in society is to be clarified and practice is to be improved.

Acknowledgements

The research, the Contribution of Museums and Galleries to the Inclusive Community: an Exploratory Study, was conducted by: Andrew Newman, International Centre for Cultural and Heritage Studies, the University of Newcastle upon Tyne; Fiona McLean and Gordon Urquhart, Department of Marketing, the University of Stirling; Emily Gilbert, the National Group on Homeworking, Leeds.

25

Learning community
Lessons in co-creating the civic museum
David Thelen

Museums, galleries and heritage organizations all over the world are having to re-consider their purposes and practices in terms of being part of civic society. During 2000 and 2001, the American Association of Museum's 'Museums and Community Initiative' held meetings across the country with a wide range of community associa-tion representatives and activists, educators, social services professionals, elected officials, business people and museum professionals. These meetings revolved around fundamental questions regarding the nature of the museum and its civic role. Can the museum take a place at the heart of its communities? Can communi-ties be at the heart of the museum's mission and its daily operations? What does it mean to be 'civically engaged'? This chapter offers insightful comments regarding the promise and potential problems of creating – or rather co-creating – the civic museum.

We are living at a time when museums and other meaning-making institutions of popular education and culture are re-considering their civic missions and practices, the places they seek, the ways they engage new partners and audiences, and, therefore, their priorities. Many believe that the health of these institutions depends on becoming more civically engaged with a range of communities. Coming at a time when museums have become more visible, popular, and trusted institutions even as their resources are torn between competing missions, this attempt to define and engage 'community' can be seen as a very significant and timely development. It has great potential to help museums recognize and take advantage of possibilities for building part-nerships with community-based organizations and to identify both external and internal chal-lenges that accompany these partnerships. In addition to educating museums, the initiative might help community-based organizations recognize museums as potential partners.

The issue of community and the roles of museums therein will serve to introduce museums to the debates being conducted by other civic institutions addressing many similar issues, in which managers, funders, scholars, and activists are exploring and discussing theory and practice. These debates are about civic empowerment and they center on issues of how and where citizens seek and engage each other, about their senses of power, trust, and agency. These debates are fundamentally about the terrain that can be imagined, constructed, fought over, and learned from when museums encounter community-based organizations and their constituents. From these debates, museums not only can learn what comparable institutions are learning from similar initiatives but, perhaps more importantly, they can gain more clarity about the priorities and civic implications involved. The immediate need is not to take sides in such debates, but simply to use the process of discussion to help widen the lens, to see more alternatives, possibili-ties, and implications.

Let me illustrate and be blunt. Author and Harvard professor Robert Putnam (*Bowling Alone: The Collapse and Revival of American Community,* Simon and Schuster, 2000) promotes civics as the building of 'social capital'. His metaphor for our basic civic problem is that we are 'bowling alone'. That, along with the larger 'civil society' perspective that his model fits, is a very controversial approach to the theory and practice of civic empowerment. Even among those who evoke 'social capital' and 'civil society' frameworks, some draw conservative and others draw populist implications. Museums have important stakes in assessing where (or indeed whether) they want to fit in these controversies. Museums may be able to better historicize possibilities in the present and thus better recognize expectations and languages that others, particularly (as demonstrated in the Museums and Community Initiative's Los Angeles dialogue) community-based organizations, will bring to partnerships, as well as the choices its members must make. Since museums may very well have a sense that they are striking out into unfamiliar and risky territory in this process, there is a great need to try to understand where the present moment fits in history and thus what directions and choices are likely to lie before us.

I want to consider why at this point debating these issues, as opposed to adopting a single specific position on them, should inform a museum's civic initiative. Critics of Putnam's 'social capital' theory suggest that people are doing more things more actively together than in the past and that a good civics, rather than lamenting the loss of older collective forms (whose character may well be romanticized and whose racism and sexism are minimized in 'social capital' theory), would begin with the vast range of new ways that citizens are acting together and collectively addressing social problems. They point to new participatory patterns in twelve-step programs after the familiar model of Alcoholics Anonymous and similar programs, constructed around active collective participation. They also point to the rise of horizontal and interactive evangelical religious, women's, and environmental organizations, and internships and experiential learning initiatives that make students more active shapers of their learning than a generation ago. They note that the complaint that technology and commerce have disconnected people from each other and from reality may reflect real changes, but such a complaint also echoes a tradition of cultural criticism that reaches back to Emerson and Thoreau and Ruskin in the nineteenth century. Contemporary critics like Garry Wills claim that our basic civic problems – income disparity, inadequate health care, poor schooling, proliferation of guns, relinquishing of real control to multinational corporations, a political system shaped by wealthy contributors – and the fact that other countries have solved these problems better than the USA suggest that the very distrust of government that Putnam and others promote may well retard a more progressive civics.[1]

This point is likely to be very important to many of the community-based organizations museums will encounter. We may indeed have lost the mid-twentieth-century faith that government can solve all problems – and depressions, win wars, or overcome poverty and racism – but I think it would be an intellectual and political mistake to join critics such as Christopher T. Gates, president of the Denver-based National Civic League, in seeing government more as a problem than as a solution (see *Forum,* 'Democracy and the Civic Museum', p. 47). Indeed, Harry Boyte, author, activist, and professor at the University of Minnesota, has suggested that by turning the spotlight away from the corporate holders of real power and trying to dismiss government as a means for popular control, Putnam and his followers have relegated citizens to 'the playground of civil society' where they can't do any harm to powerful institutions, thus freeing such institutions from popular constraints. The civic issue is power, not trust. 'Feeling helpless, we desire agency, power; we are offered, instead, [by social capital theorists] collaboration if we will do/volunteer more', writes Elizabeth Minnich in what she calls a new version of 'blame the victim'.[2]

From these critics' perspective, the watchword of civic partnerships becomes co-creation, not dialogue. Participants bring and share skills and resources that they contribute to making and sustaining powerful agents for solving everyday problems – for example, the re-entry of prisoners into their communities, or daycare, or crime, or inadequate transportation, or insensitive bureaucrats' plans for school curricula, or highways to intersect a neighborhood. Participants develop what Boyte calls 'civic muscle' as they construct powerful alternatives.

And this exists not only in the realm of theory. There are real-world examples. In Tampa a science and industry museum commits permanent space to a Headstart program. In southern California, a sheriff is looking to museums to help his huge staff imagine how museums can help them reintroduce parolees to community life. A southern California museum employs street gang members as docents, despite curators' fear that they will destroy collections. But here is raised an important question for our institutions: Are museums ready to commit people and resources to this vision of civic activism?

Critics of the 'social capital' perspective have proposed a different path for how institutions like libraries, colleges, and museums might approach their civic missions. They suggest that instead of beginning in outward-looking artificial dialogues and volunteering – everyone is already too busy to join vague civic dialogues – people in these institutions should begin by trying to identify the civic dimensions of their existing work. They then should use those as means to do two things: first to reach inward in hopes of turning their own workplaces into civically driven institutions, and then to look outward to other institutions and groups. The challenge to museums would be for their curators, marketers, docents, educators, boards, and managers to try to identify actual and potential civic dimensions in their work. The exercise of beginning by considering public and civic dimensions of existing work, Elizabeth Minnich and Harry Boyte[3] argue, will 'free the [civically-oriented] powers locked within' individuals in the work they do. When they do this, professionals will be likely to conclude that the overwhelming trend toward marketing and professionalizing that their institutions and professions have taken in recent years has submerged or frustrated civic motives or agendas that attracted them to their careers in the first place. The deeper, personal motivation that so many museum professionals cite as key to their job satisfaction may well have been devalued in their institutions' increasing pursuit of earned income and other, more commercial concerns. Such internal exercises and discoveries, in turn, could provide fertile soil for developing serious discussion within a museum about what it means to build an institution on civic or public dimensions of work.

After listening to conversations in Tampa and Los Angeles, I was struck by the difficulties museums face when they begin to reach outward to new partnerships if they haven't first looked inward, examined public or civic elements in all aspects within the museum, and defined how and why they are seeking partners to help them develop public and civic aspects of what they already do or want to be doing – in short, without making civic engagement the mission of the whole institution. And I would suggest that this issue be placed on the agenda of all museums that wish to pursue a course of deeper community engagement. Participants in the first three Museums and Community dialogues referred to this challenge. Representatives from several institutions said that outreach or community partnerships were simply pieces of their museums' work, assigned to education or community programs departments, but low priorities for the institution as a whole. Other participants claimed that their museums were not deeply committed to partnerships, that community programs were 'window dressing'. One senior professional explained that 'many museums have trouble seriously coming to grips with community and having community involvement as part of their mission', noting that unless top administrators, not education directors, took part in such dialogues, community engagement

would continue to be a low priority. Of course, the opposite could also be true: a museum might be led by an advocate of civic engagement, but be staffed by people whose experiences and values were shaped by other considerations.

The University of Minnesota has provided a model for universities by launching an exercise in which all employees – administrators, faculty, technicians, librarians, secretaries – identify civic dimensions in their work. The university then provided funds to encourage employees to develop further civic implications in their work. In his recent charge to University of Minnesota staff, the provost may have provided a model for museums when he asked whether civic engagement should be 'another category' of activity or whether it should suffuse everything. 'What makes a university a civic institution?' he asked. He answered: 'The university does not do civic engagement; it is civically engaged. It begins by asking how civic engagement makes a difference in every other activity, how professional work is or should be different in a civically-engaged institution from one that is not civically engaged.[4]

Partnerships with community groups become crucial means for museums to discover civic potential within the museum. I heard two reasons for this in the dialogues. First, community-based organizations simply have more practice in participatory civics. And second, as a human relations official observed in Los Angeles, pressure from community groups forces museums to pay attention to the sources of that pressure. He observed that community groups were listened to more respectfully during the protests of the 1960s than they are now, because pressure has subsided and institutions such as museums can get by with the appearances, but not the substance, of sharing authority in such areas as defining what should constitute a collection or ownership of a collection. In Los Angeles, community-based (often ethnic) and problem-oriented (often around problems of youth and law enforcement) groups provided a spectacular display of how to make partnerships work. I was stunned by how quickly and naturally they moved beyond the language funders use to define collaboration – 'buy-ins', 'stake-holders', 'net-working' – to critique how inadequate these words are in describing a reality where partners can genuinely co-create or confidently and fully share authority and resources. At one table, a community organizer asked: 'Are we trying to impress funders or to be serious?' about a partnership that group was contemplating. To him it was an important distinction. The director of a history museum expressed the fear that 'social capital' would become the latest jargon he'd have to learn in order to satisfy funders, rather than be a viable perspective that could help him improve his museum's civic practice. At Providence, Tampa, and Los Angeles museum, participants expressed the desire to listen to community-based organizations reflect on what they sought and learned from their partnership experiences.

On several occasions, the experience and observation of participants at Los Angeles, sometimes expressed in asides, raised basic questions: how to present controversial subjects, how to collaborate with community groups, and even how to imagine future museums.

What is needed to deepen community and museum collaboration is a format that can encourage both community and museum people to reflect about the strengths and weaknesses, the surprising discoveries that accompany their attempts to move beyond networking and 'buy-ins' to build sustained collaborations, to co-create, to empower each other, even to envision how such collaborations provide glimpses of a greater civic purpose within a museum. Museum directors or other officials would need to report candidly the challenges and problems they had encountered and perhaps failed to solve.

Many people have already discovered that sharing authority and resources is terribly scary, unfamiliar, and hard. And what's worse, it's likely to bring museums up against what the profession itself has called 'best practices', up against the whole professionalizing thrust that by

definition aims to distance professionals from amateurs, to give professionals the skills and confidence to assert expertise and control, to view visitors as customers or students or amateurs, not as citizens or equals or partners.

In Los Angeles, an organizer for the St. Vincent de Paul Society told Robert Archibald, president of the Missouri Historical Society, that he didn't know what museums could offer his group and thus what kind of partnership to imagine. I think Archibald's answer to the St. Vincent organizer is significant. Archibald asked him whether he would be able to identify resources and skills his organization could use if he were provided with a description of the resources and skills the museum had to offer. The organizer enthusiastically said he could. Perhaps ways can be devised to provide community groups with some inventory of skills and resources that our museums have to offer – perhaps examples of partnerships already in motion. Community groups could then be invited to talk about how they might use certain resources and skills toward co-creating new partnerships. This exercise might encourage museums to see more clearly what they have to bring to civic partnerships, perhaps unexplored civic dimensions they had not fully appreciated. Can ways be found for community groups to express what they look for and need – as well as what they fear – from museums when they consider a partnership?

Because the word 'trust' occurs frequently in discussions about museums and community, I want to comment on a study commissioned in July 2000 by the exhibition design group Ueland Junker McCauley and Nicholson. A copy of the study was distributed to participants at Tampa. I fear that, if interpreted literally, this study may actually make it harder for museums to build partnerships with community groups. In our book, *The Presence of the Past: Popular Uses of History in American Life* (Columbia University Press, 1998), Roy Rosenzweig and I found the same basic conclusion as their study: Americans trust museums more than other institutions in our culture. But the Ueland study said the basis for this trust was that museums are seen as more 'objective' than other sources. From our 1,500 half-hour interviews we do not believe that Americans are mainly looking for 'objectivity' when they seek information about the past or that 'objectivity' is what they trust in museums. We found that people trust museums because they connect people to original objects, and invite visitors to form and test their own conclusions based on their own experiences, which are often formed with family and friends under terms shaped by the visitors (unlike history classes, say). We found Americans to be tremendously suspicious of mediation, including mediation by 'experts', seeking, instead, direct first-hand engagement on their own terms. This is what museums and historic sites offer. If museums conclude from the Ueland study that they are trusted because they are 'objective', which the dictionary defines as 'impersonal', they will have a hard time carrying on dialogues, let alone exploring civic dimensions within themselves and co-creating partnerships outside their walls with the kind of community- and problem-based groups I observed in Los Angeles.

It will not be easy for museums to identify the best process to follow in crafting an approach to community involvement. Will candid accounts of successes and failures – perhaps separately by both museums and their community partners – provide tools for other museums to learn from, to use and adapt for their own use? Rather than being 'best practices', could these stories be 'learning opportunities' in which the emphasis would be on learning and 'unlearning' in motion in practice?

There is a concern: what will participants of future dialogues carry away with them and how will they build on the conversations? The interests of local museums and community groups may be so diffuse that first-hand, individual accounts of actual partnerships might be more valuable than trying to find common denominators in such a complex initiative, where individuals and their institutions and communities bring such varied agendas.

In its Museums and Community initiative, AAM has taken a creative and open-ended step that most of the institutions I know best – colleges and universities – have barely contemplated. The idea of listening to people from museums and community-based organizations in different communities talk about their experiences and try to imagine new collaborations strikes me as a great place to begin. Both at Tampa and Los Angeles, participants brought hopes and fears into the open and showed themselves willing, sometimes eager, listeners to each other, participants in exploring common ground. The best thing about the project is that it taps into debates and experiences of diverse people in different places.

The significance of this initiative is so immense, the challenges in this area so diverse, that the watchwords for such dialogues must be 'experimentation' and 'adaptability'. Museums will need to listen to whether, as well as how, members of community-based organizations wish to engage museums on issues of partnership and the building of a civic society. Of equal importance, museum professionals must reflect among themselves about the internal challenges they face in recognizing, connecting to, and mobilizing civic dimensions in their activities as they contemplate or explore making civic engagement and partnership core missions of their institutions.

Notes

1 From *Campus Compact Reader*, 1, 2 (Fall 2000), pp. 13–15.
2 Elizabeth Minnich, 'Whats wrong with civic life: remembering well-springs of US Democratic action'. *The Good Society*, 9, 2 (1999), pp. 7–14.
3 These debates are being carried on and alternatives generated in other institutions. Since participants at LA identified public libraries as models for museums to explore, AAM might explore Libraries for the Future (www.lff.org), a group that is spearheading the movement among libraries to become civic centers and interactive sites. The Project for Public Spaces (www.pps.org) grows out of participatory management movements. Publicwork.org, the web site of the Center for Democracy and Citizenship, carries on this debate.
4 See 'Off the playground of civil society', pp. 1–7 and 'Reconstructing democracy', pp. 32–6, *The Good Society*, 9, 2 (1999).

Building a community-based identity at Anacostia Museum

Portia James

The 'neighborhood museum' ideal was first expressed in the Anacostia Museum, founded in the late 1960s as a conduit for the Smithsonian Institution to work with one of the poorest areas in the District of Columbia. Soon after its establishment, the museum was highlighted as a potential model for community access and involvement, and the principles behind it fed into the discourse of 'new museology' that focus on the democratization of museum action. By following the history of the museum, it is possible to learn important lessons about the application of the principles of community museology and some of the tensions and challenges this involves.

In this chapter, a historian who has worked in the museum explores the construction of Anacostia Museum's identity from the 1960s to the present by examining the history of its exhibitions. Direct community accessibility was part of the museum's founding mission, but Smithsonian administration, museum staff and community residents all seemed to have different ideas about the meaning of the 'neighborhood museum' concept. Designed a 'Smithsonian outpost', and intended to draw African-American visitors to the Smithsonian museums on the Mall, the new museum's mission was instead shaped by community advisory groups to focus broadly on African-American history and culture. Staff efforts to 'professionalize' and upgrade museum operations later threatened community access to the exhibition-development process, and most community/museum interaction was relegated to the program and outreach activities of the education department. The 1994 'Black Mosaic' exhibition provided an opportunity to devise new ways of integrating the perspectives of a changed community into the exhibition-development process.

Introduction

Since its founding in 1967, the museum in Anacostia has received a good share of attention from museum professionals and its public audience – first, as a neighborhood museum sited in one of the District of Columbia's least affluent areas; then as a museum producing African-American exhibitions and educational materials for a national audience; and currently as a museum seeking to build networks of similar institutions offering models of community-based research and exhibition development. These identities have not been serially adopted, but integrated each within the other – even as internal structural and external social changes posed different challenges. Integrating these identities has often caused observers to question and challenge the museum's constancy and direction. But as with other museums, the construction of institutional identity has not been a linear development. Instead, it has been an accumulative process, bringing together disparate groups and attitudes.

The exhibitions at Anacostia Neighborhood Museum (now Anacostia Museum) have served as a form of discourse with its audiences – a dialogue as much about the museum itself and its particular way of seeing the world as about the ostensible subject of the exhibitions. The full discourse includes not just the completed installation but the development process itself. (Not included are the 'traveling' exhibitions produced elsewhere and installed temporarily at the museum.) In part, the construction of the museum's identity has centered on this ongoing discourse.

In the late 1980s, the staff initiated an exhibition project that came to be called *Black Mosaic: Community, Race, and Ethnicity Among Black Immigrants in Washington, D.C.* It came at a critical time for the museum and developed over a number of years. The museum's founding director, John Kinard, died in 1989 and a period of increased concern about the museum's direction ensued.

There were additional pressures. The Smithsonian began seeking means to create a national African-American museum on the Mall in the 1980s, and this required the museum administration to clarify and define the institutional mission in ways that it had not previously had to do. The ensuing statement defined its community geographically – as if that were the essential aspect of the institution's identity – but gave no clues as to its vision of community-based museology.

Developing *Black Mosaic* allowed staff to focus once again on how they define the museum's 'community', who comprises it, how the museum interprets contemporary black community life, and how community perspectives may be integrated into the exhibition process.

The early years – building with the community

In many ways, the stature, formidable personality, and strong views of the museum's first director, John Kinard, a minister and neighborhood organizer, served as foundation for the museum's initial search for an identity (Martin-Felton and Lowe, 1993). His ideas and his vision were reflected in the way the staff was recruited and organized, the kind of work that was done, and the community-based focus that drove the museum's work. This community-centered core of identity remained – with later incoming professional and curatorial staff having in large part to accommodate their goals and their work to this identity.

Origin of the store-front neighborhood-museum concept

The institution's origin can be traced back to an idea for a 'drop-in' or 'storefront' museum sponsored by S. Dillon Ripley, then secretary of the Smithsonian Institution (Ripley, 1969:106). His idea was to situate the museum in a low-income neighborhood somewhere within the district's inner city, where it would showcase artefacts and material from the Smithsonian museums downtown. Undoubtedly, one source of inspiration had been the all-too-apparent underrepresentation of inner-city residents among the visitors to the museums on the Mall. This posed a challenge to the federally-funded Smithsonian Institution. He argued (Ripley, 1969:105):

> To a large extent, people from rundown neighborhoods tend to stay there. They tend not to be mobile, or to move much out of their district, except in a transient sense from slum to slum. Such people, referred to again by slogan phrases like 'disadvantaged', are likely never to go into any museum at all. Here I agree wholeheartedly with the sociologists. Indeed such people may feel awkward going out of their district, badly dressed or ill at ease. They may easily feel lost as they wend their way along an unfamiliar sidewalk toward a vast monumental marble palace. They may even feel hostile. If the above is true, then the only

solution is to bring the museum to them. For of all our people, these are the ones who most deserve to have the fun of seeing, of being in a museum.

Despite the patrician language, Ripley's goal was to re-examine the role of museums and how they interacted with urban – and particularly African-American – audiences (Ripley, 1969:106):

> the bookmobile concept won't do. Involvement is what is wanted, and a bookmobile museum in a slum implies something for nothing from rich folks somewhere else, a kind of charity, a handout, largesse in white gloves. Involvement can only be created if it is *their* museum. It must be on the spot, participated in by the people who live there. This was our principle in 1966 when we in the Smithsonian started looking about for a neighborhood which might want a neighborhood museum. We looked for a site, perhaps an abandoned movie theatre or a grocery store, given up because some new chain store had taken over the district. Our one guideline was that the area must have stability, not be too full of transients or migratory unemployed. Preferably we wanted a block that contained a laundromat, that symbol of daytime neighborhood involvement, rather than too many bars.

The Anacostia Neighborhood Museum, 1968: neighborhood doubts

After considerable lobbying by community activists, Smithsonian officials chose their neighborhood for the site of the proposed Anacostia Neighborhood Museum (ANM). Although other areas had been considered, the organized groups and community activists in the neighborhood eventually won over Smithsonian authorities. But compare contrasting perspectives on how the new institution was viewed.

From Secretary Ripley: 'Consultations with the Southeast Neighborhood House in Anacostia revealed an instant enthusiasm on the part of the local residents' (Ripley, 1969:106).

From John Kinard, the first director: 'While there was great joy and the anticipation of better things to come for Anacostia when the museum opened, there was also fear and uncertainty ... It was felt that a museum was just not the kind of institution the neighborhood needed, that it would prove to be not only irrelevant to the issues of concern to the community but totally alien, and judging from what was known about museums, it might be so highbrow as to be an embarrassment or downright insult' (ANM: Fifth Anniv., 1972:1–2).

From an early staff member: 'The question [is] why the Smithsonian chose Anacostia for the site ... Studies had shown that there were other equally deprived areas in Washington. It has been generally agreed that the deciding factor was the interest expressed on the part of the community leaders and their active response to what they felt would be good for the community ... it was the neighborhood residents' trust in their community leaders which overcame their doubts and led to their acceptance of the Smithsonian's offer' (ANM: Fifth Anniv., 1972:3–5).

An auspicious beginning for ANM

The site, the Carver Theater, an old, abandoned 'colored' theater, was renovated by teams of young people in conjunction with professional Smithsonian staff: 'Neighborhood teenagers, including a group called the Trail Blazers, directed by the DC Department of Recreation and Parks, as well as adults and museum staff, worked side by side with Smithsonian technicians, designers, curators, illustrators, exhibits specialists, painters, carpenters, and electricians' (Martin-Felton and Lowe, 1993:19).

There were meetings: an informal advisory committee held open meetings each week to plan the museum's exhibits and programs. 'Every agency and organization in the community was represented – Southeast House, Frederick Douglass United Community Center, the churches, the schools, the civic groups, and business associations. It was a good cross-section of the community. There was but one restriction to membership – that the majority of the members should be residents of Anacostia. No formal notices were sent out; the message spread by word of mouth. Most of the time, from thirty-five to fifty people met every week to plan for a museum that would be the first of its kind in the world' (ANM: Fifth Anniv., 1972:5). This group of community advisors and volunteers joined their efforts to those of professional Smithsonian staff to lay the foundation of the new museum. As one staff member observed: 'The august Smithsonian had come across the river to serve the Anacostia community' (ANM: Fifth Anniv., 1972:5).

The inaugural exhibition

In coming across the Anacostia River, which separates a substantial portion of largely African-American Southeast Washington from the rest of the city, the Smithsonian launched an evolving and sometimes contentious effort to explore community-cenetred museology. In keeping with its founding goal – to be a community outpost of Smithsonian resources – the inaugural exhibition (never named) showcased disparate and eclectic objects from the Smithsonian collections. The secretary described it in detail (Ripley, 1969:107):

> The [exhibition] resulted from a vast number of suggestions, primarily from the advisory council, but also from the Smithsonian staff curators. A complete general store, just as existed in Anacostia in the 1890s, occupies one corner. In it is a post office (which we hope to get a license to operate), old metal toys, a butter churn, an ice-cream maker, a coffee grinder and a water pump, all of which can work, and any number of objects of the period from kerosene lamps and flatirons to posters and advertisements. There is ... a do-it-yourself area for plastic art, with, at present, volunteer class instruction. There are skeletons of various kinds, some of which can be put together, some disassembled. There is space for temporary art shows. There is a TV monitor system on the stage. Occupying one of the modules is a live zoo with green monkeys, a parrot and a miscellany of animals on loan from the National Zoological Park. A great success was a shoebox museum in an A-frame structure, full of wooden shoeboxes containing bird skins (in celluloid tubes), mammal skins, shells, fossil specimens, pictures and slide projectors for intensive handling and study. A behind-the-scenes museum exhibit of leaf-making, silk-screen techniques, casting, and modeling gives an additional outlet for instruction.

Initial staff

All but one of the original staff of eight (ANM: Fifth Anniv., 1972:6), were temporary, their salaries coming from private and foundation money. They were 'an assistant director in charge of programs; a public relations man, an exhibit design and art specialist, another exhibit specialist, a museum aide, an administrative secretary, two custodians, and a part-time typist' (Kinard and Nighbert, 1968:193). Aside from administrative duties, they were assigned to community outreach and exhibition production. There were no curatorial or research personnel and, initially, no departments.

An initial identity crisis

In their original vision, Smithsonian planners saw the ANM as a 'conduit', an emissary institution that would bring the larger world of the Smithsonian to neighborhood-bound, non-museum-going, 'isolated', inner-city African-American residents. Ripley expressed it forthrightly:

> I wanted to keep the Neighborhood Museum rather individual, just itself, different from the rest of the Smithsonian. It is their Museum in a real sense, not ours. However, after a while I had wanted to have a small, discreet sign put up, saying in effect, 'If you want more of this, take the such-and-such bus line over to central Washington and go to Constitution Avenue Northwest between Fifth and Fourteenth Streets and you can see more of it, on the Mall' … How to get people who never went anywhere to go to a museum where somehow change and evolution in their own lives might be set in train? Surely, if museums of the future are to be valid, they must be of use, must communicate to the very people who need them most.

He continued:

> One day I took Harold Howe II, then United States Commissioner of Education, to see the Anacostia Museum and then to have a sandwich in the little noisy restaurant next door. We entered the vestibule of the old theatre … Inside John Kinard was standing with a group of several men. Suddenly one of them … turned to me and said: 'You know, Mr. Ripley, I've lived my whole life right here. I drive a truck, see, and I go everywhere. I been up and down that old Constitution Avenue all my life. I've never been in those big buildings. I'd be scared to. But now – you, you're getting me cultured before I know it.' And so I heard what I had come to hear.
>
> (Ripley, 1969:110–111; also see Advisory report on ANM, 1979:5).

The inversion of the Smithsonian Mission

Community advisors and neighborhood residents turned the initial mission on its head. They did indeed see ANM as an outpost and an emissary – but to share *their* insights, *their* perspectives, and *their* history with the Smithsonian and its public audiences. This was an *inversion* of the museum's original mission and it represented the opening of a discourse that would shape the museum's future. It also dictated a course of institutional growth that often threatened to overshadow the museum's community-based identity.

Significantly, exhibitions – even the earliest ones – did not limit their focus to the neighborhood, but also dealt with broad subjects (ANM: Fifth Anniv., 1972:5). Though neighborhood residents had the controlling voices on the advisory boards, by the museum's second year, exhibition themes were exclusively concerned with black history and culture. And by 1972, ANM's assistant director would say:

> No longer an experiment, the Anacostia Neighborhood Museum is now a viable, forceful institution with strong community ties and a growing expertise in black history and culture and urban problems (ANM: Fifth Anniv., 1972:9).

This should have been expected, given the dearth of African-American cultural resources in the metropolitan area, the Smithsonian's language about community control of the museum,

and the fact that ANM was situated in an almost entirely black neighborhood in a largely black city. A founding employee, James Mayo, noted that before ANM's opening, 'the Smithsonian had never produced anything [a major exhibition] on African-American history and culture ... There were no black curators in the Smithsonian' (Martin-Felton and Lowe, 1993:22). Surprisingly enough, this aspect of the museum's identity, the African-American focus of its exhibition calendar, was the cause of some later concern from Smithsonian officials (Advisory Report on ANM, 1979:4–5).

Community participation, staff, and exhibitions

Community participation during the formative period seemed to impose a kind of dynamism on the museum's activities. Active decision making by advisory boards in the day-to-day administration was possible, given the simplicity of the internal structure. Programs and other activities suggested by residents were accommodated as much as possible by the education department. Exhibition concepts were derived from diverse sources, as the exhibition-development process had not yet been formalized and separated from other activities. Education, design, and production staff members, as well as advisory groups fulfilled some curatorial functions. The fluidity and informality of the museum's internal structure encouraged this kind of direct access to the exhibition development process.

In the museum's first five years, exhibitions had diverse subject matters – children's art from Brazil, black artists' work, a Jamaican cultural 'festival', African sculpture, black literature, black trailblazers in the West, an overview of Africa, an exhibition developed by inmates at Lorton Reformatory – all reinforcing the general themes of recovering and validating black history; examining contemporary community life and popular culture from an insider's perspective; and reinforcing the growing interest (particularly on the part of middle-class blacks) in the history and cultures of the African diaspora (ANM: Fifth Anniv., 1972:19–24).

Exhibitions also reflected the concerns of a constituency focused on the issues of urban and contemporary community life (Martin, 1971:168–71). *The Rat: Man's Invited Affliction* (1970) was an intense exploration of the local environment. A first of its kind, its featured live rats captured from the alleyways around the museum. When some image-conscious residents questioned how that exhibition would reflect on the neighborhood, Kinard responded: 'The [museum] has dedicated itself to focusing on those things that are relevant to life in this community. The blight [rat infestation] that afflicts Anacostia afflicts every city throughout America ... The Neighborhood Advisory Committee ... has decided that we cannot afford to present exhibits that deal only with life in the past. Such exhibits must have some relevance to present-day problems that affect the quality of life here and now in Anacostia' (Martin, 1970:12).

The Rat, one of the museum's most popular installations, resulted from an education department initiative in conjunction with the ANM Youth Advisory Committee. 'In 1970 the education staff sent a memo to the director expressing concern about the rat problem ... The memo contained a suggested outline for an exhibition on the Norway rat. Following approval came six months of research involving the education staff with active participation by children, teenagers, and adults in the neighborhood' (ANM: Fifth Anniv., 1972:19–24).

The Evolution of a Community, Part I and Part II both opened in 1972 and were based on oral histories collected from neighborhood residents. The concept came from the interview subjects themselves, as well as from a 'survey of community residents'. The survey was undertaken with funding from a grant from the Carnegie Corporation of New York, which established a 'Center for Anacostia Studies' (ANM: Fifth Anniv., 1972:24, 41).

Other exhibitions relied significantly on museum supporters and advisory groups. *This Is Africa* (1968) came from a suggestion box; the concept and the title for *This Thing Called Jazz* (1968) stemmed from the Youth Advisory Committee; *Lorton Reformatory: Beyond Time* (1970), an exhibition on life behind bars, was conceptualized and put together with inmates of that institution, who also developed a slide show for the installation. *Toward Freedom* (1971), an exhibition looking at the civil rights movement, was negotiated with (and substantively changed by) the Neighborhood Advisory Committee (ANM: Fifth Anniv., 1972:20–3).

Exhibition staff

His biographers note that 'Kinard often referred to the early panel displays as "pasteboard exhibits"'. An early staff member 'vividly remembers typing labels on an IBM Selectric typewriter, using the Orator (an 'all-caps' font) element, and then attaching the labels to panels with double-sided tape'. She goes on to say rather wistfully: 'That's when we were at our best ... The level of spirit was so good, and the kids and the neighborhood were always there' (Martin-Felton and Lowe, 1993:27).

James Mayo also recalls the initial five-year period: 'Since inception of the idea for a neighborhood museum, many Anacostians have given generously of their time and skills to assist in whatever exhibit was in process. One well-known incident is that of the man (name unknown) who walked in at three a.m. one morning before an opening, picked up a paint brush, and worked about an hour and a half, then thanked everyone and went on his way. This type of participation has occurred on many occasions' (ANM: Fifth Anniv., 1972:35).

Museum staff expanded, and exhibition facilities were upgraded. In 1968, the museum added a staff photographer and an in-house photography lab (ANM: Fifth Anniv., 1972:7). By 1972, it could boast of ten full-time, permanent (Smithsonian) employees, and ten additional employees on grants. It was not a small staff, but they were divided into only three departments. Aside from the director's office, there was an education staff, and one other department that combined the functions of research, design and exhibition production.

As the complexity of exhibition goals increased, however, the museum's relationship with its local community grew more challenging, and the kind of informal, active intervention by community people that characterized the museum's early years gave way to more formal, more structured ways of integrating community voices into exhibitions.

Impact of professionalism on community ties

This phase in the life of the museum saw many changes, all of which affected the construction of the institution's identity – lessened participation by community members, increased socio-economic problems, more sophisticated and costly exhibitions, a change in the museum's name (deleting the word 'neighborhood'). In 1973, the museum's original Neighborhood Advisory Committee of 90 was incorporated as a Board of Directors and was subsequently reduced to a more manageable number (twenty-one members in 1982). Broad, inclusive interaction with community residents began to be confined to the museum's education department (where, despite taking on more formalist dimensions, it remained a significant force), and to the still considerable community activities of John Kinard himself. Most of the museum's diverse community advisory boards also slowly dissipated. (In stark contrast to the many museum advisory groups described in the museum's fifth anniversary booklet, by 1982 the only museum-

connected group mentioned in the museum's fifteenth anniversary publication is the 'Anacostia Historical Society' and the 'Fifteenth Anniversary Committee' itself.) This seemed due to social and political changes in the community as much as to internal museum decisions.

Two major exhibitions and their context

Louise Hutchinson, the museum's first historian, had arrived in 1971. In 1976, separate and distinct research and exhibit production departments emerged, signaling a continuing specialization within the staff. The early efforts of the re-organized research department resulted in two major exhibitions. *The Anacostia Story: 1608–1930* (1977) presented a historical examination of the neighborhood. *Anna J. Cooper: A Voice From the South* (1981) brought public and scholarly attention to a little-known nineteenth-century African-American scholar residing in Washington.

Part of the context surrounding the development of *Anacostia and Anna Cooper* was the museum's struggle with its critics (including many in the Smithsonian) who challenged its standing because it lacked the quintessential museum property – a permanent collection. Early on, Kinard had argued that 'the Anacostia museum … defines its mission from an under-standing of the history, the everyday events, the problems, and the life-style of the residents of the area' (ANM: Fifth Anniv., 1972:2). There was no mention of a permanent collection as the source – or even as an essential component – of the museum's mission and identity. (The museum did not receive the authority to collect or develop a permanent collection until 1993.)

But the absence of a collection was crucial in shaping the museum's identity. The success of exhibitions depended upon staff's identifying, locating, and ultimately persuading those holding materials to lend them for installation, which meant developing and maintaining an active network in the community.

By the time of these last two exhibitions, more and more artefacts were being borrowed, and exhibitions took on an increasingly three-dimensional appearance – with the vitrines and roped-off areas that accompany such installations. And extensive research catalogues, published by the Smithsonian Institution Press, also marked the transition to a more formal emphasis on historical research and traditional exhibition development

But there were tradeoffs for the institutional advances. Former staff members observed: 'The exhibition of valuable artifacts and expensive works of art dictated the use of guards, early closings, and … a diminished accessibility to the museum by community groups. Additionally, staff stopped using the museum floor for large programs … as nonmovable 'installations' replaced the panels that had easily glided up against walls … ' (Martin-Felton and Lowe, 1993:33).

Smithsonian perspectives on the museum's goals

The museum's scholarship also came under scrutiny, and the staff's lack of advanced academic degrees and research publications left museum administration feeling vulnerable to such perceived criticism. Kinard was still struggling to convince critics and Smithsonian officials that ANM could be a community-based institution, reflecting its community's concerns and perspectives *and* a fully functioning museum utilizing the scholarly and material resources that mainstream institutions employed. But he and his staff failed to effectively assert a mission that incorporated both of these elements in the face of Smithsonian notions of what the mission should be.

In 1979, the panel of museum professionals convened by S. Dillon Ripley to evaluate the museum was still using outdated concepts to measure the museum's achievements and determine its future. The panel began by defining a 'neighborhood museum' as 'a museum whose

focus is the history and culture of a particular neighborhood; it would not have comprehensive collection'. This neighborhood, the report goes on to imply, would exist without any perspectives or insights of its own to share, helpless in its ignorance of the broader world around it. Excerpts from the panel's report are (ANM Report, 1979):

> The fundamental objective of this type of facility is to be a 'window to a larger world'. While it would not ignore the local community as a subject of exhibition or other programs, its primary focus would be on subjects and themes largely unknown to the community which may be 'isolated' by virtue of its location, income level or racial composition.

> The Anacostia Neighborhood Museum is a product of the extraordinary social ferment of the late 1960s. It has necessarily borne the stigmata of its origins which can be distinguished from its more promising possibilities in a more stable and reflective period. The Anacostia Neighborhood Museum should be continued as a *community* museum with innovative exhibition and other programs that are designed to achieve three goals – (a) development of greater knowledge about the history and culture of Anacostia as a local community; (b) provision of greater educational opportunity for awareness of the broad and variegated areas of knowledge represented by the unparalleled collections of the Museums of the Smithsonian; and (c) encouragement of persons who, for a variety of reasons, have been isolated previously from the Mall museums to visit them and participate in the full spectrum of their activities.

It is hard to escape the implication here that the museum, in confining its exhibits to the geographical parameters of neighborhood boundaries, would serve primarily to bolster African-American visitation to other Smithsonian museums. This notwithstanding the dearth of African-American materials, exhibitions, and programs to be found there. Other sections of the report actually decry ANM's efforts to focus on African-American subject matter (ANM Report, 1979).

The changing Anacostia scene

The militant activism and direct interventionism characterizing much of African-American community politics in the late 1960s (for example, the volatility in Anacostia that presaged the museum's arrival (Martin-Felton and Lowe, 1993:18) gave way to a more formalist, electorally-focused politics in the late 1970s and early 1980s. As the numbers of black elected officials increased – including the election of Walter Washington, an African American, as the city's mayor – the challenge of new neighborhood and ward-based political structures and service providers began taking up some of the energies of local and neighborhood activists.

Other changes were sweeping through the neighborhood, reflective of the declining situation of inner-city communities across the country. Lack of viable employment, economic recession, proliferation of drugs, and the resulting increase in crime; all began to take a toll on museum visitation – and on participation in museum activities. More and more, museum supporters were refusing to cross the stretch of urban decay surrounding the museum. By 1982, internal museum literature was referring to the museum's inner-city location as a handicap (AM Management Review, 1988:2; Martin-Felton and Lowe, 1993:30). The regulars, the winos, the derelicts, the old men who regularly hung out on either side of the museum, who stood on the corner and served as unofficial watchdogs for the museum, were replaced by a younger, harder, more anonymous group (Martin-Felton and Lowe, 1993:28–30). Often involved in illegal drug

activity, this group imposed an intimidating gauntlet that visitors had to negotiate to get to the museum. Staff members recall: 'As the 'corner' began to develop a reputation as one of the largest outdoor drug marts in the city, some people began to avoid the museum' (Martin-Felton and Lowe, 1993:30). Complaints began to appear frequently in the suggestion box, and Kinard began his long campaign to move the museum into a larger and permanent space in Anacostia.

Change of place and name

As a first effort in this campaign, the museum vacated its original home in the Carver Theater, and moved to a facility located about a mile distant in 1987. Although the museum was still in the immediate neighborhood, it had relocated to a site in the middle of a landscaped public park. No longer surrounded by drug activity, its new site did not, however, allow for casual walk-in visitors. Most visitors had to drive or catch public transport to get there. At this time, Kinard also changed the name from the Anacostia Neighborhood Museum to the Anacostia Museum (AM). Almost lost in the hubbub surrounding these two important changes was the change in the museum's sense of mission, a subtle shift in identity that was not publicly acknowledged or noted.

Upgraded standards

A long way from the inaugural exhibition

The Renaissance: Black Arts of the Twenties (1985) was the last exhibition installed in the old Carver Theater building. A historian with a doctoral degree was engaged as curator, and *Renaissance* had a substantially higher budget than earlier museum shows. The exhibition included historical artefacts and art objects (insured at great cost) borrowed from lenders across the country and award-winning videos produced by the museum specifically for the installation. Security measures were increased and great care taken with the protection of the materials on display. Things had come a long way from the inaugural exhibition.

Climbing Jacob's Ladder: The Rise of African American Churches Along the Eastern Seaboard (1987) and *The Real McCoy: African American Invention and Innovation* (1989) were the first exhibitions to take place in the museum's new building (to which the staff had relocated by 1982). Their look reflected their installation in a modern gallery constructed specifically for the purpose; it allowed such design approaches as more sophisticated lighting, reconstructed environments and a more sophisticated integration of audiovisual media into the installation (Reinckens interview, 1995). New curatorial staff were brought in, and by 1985 the museum's research department had three historians. By the time of development activities for these exhibits, participation of community groups in the conceptualization and development of exhibitions was virtually nonexistent. Nor did any outside community advisory bodies work with the projects. Despite the loss of specific structures within the museum to integrate community perspectives into exhibition processes, in many ways, public support for the museum seemed to broaden. Demand for Anacostia's historical exhibitions meant a successful national traveling circuit, brisk sales for research catalogues, and increasing visitation rates at the museum itself.

Neighborhood, community-based, or mainstream?

With the apparent upgrading of exhibition standards, museum administration and staff found themselves caught upon the horns of a dilemma. On the one hand, the museum was criticized

for abandoning its early level of community involvement, but on the other, it was denied additional resources and prohibited from developing a permanent collection precisely because of its designation as a 'community' museum (Advisory Report on ANM, 1979; AM Management Review, 1988). Kinard's efforts to 'mainstream' the museum and formalize the exhibition process should be seen in this context. Critics challenged Kinard to define the essential core of the museum's identity: What was it anyway, an African-American museum, or a community-based museum that happened to be located in a black community? Efforts to separate these two philosophical strands of the museum's identity, however, were less than successful. Kinard's ploy to emphasize the museum's African-American focus to the detriment of its community-based roots only confused the issue further, and Smithsonian officials' efforts to negate the museum's African-American foundation were less than convincing. (See Advisory Report on ANM, 1979, for an example of Smithsonian efforts; and AM Management Review, 1988, and Martin-Felton and Lowe, 1993:37, for an example of Kinard's efforts.)

From the very beginning, there had been a lack of consensus on the part of the different parties involved in the museum's conception. For Smithsonian officials it was one thing, for neighborhood and city residents it meant an institution that would 'recover' African-American history and culture; and for Kinard and staff it became a way of doing things, an approach to the work of the museum and a key to its self-perceived identity as a community-based institution, rather than an indication of the geographical parameters of the museum's audiences or an indication of the limits of its scope of inquiry.

Kinard himself contributed to the persistent confusion. Was the museum ever a neighborhood museum in the sense that it focused exclusively on the neighborhood or that its audiences came primarily from that neighborhood? As late as 1982, he asserted that 'this institution, with the intimate involvement of the community, has as its mandate the celebration of neighborhood history and the pinpointing of neighborhood issues which affect the quality of life of the people of Anacostia' (ANM: Fifteenth Anniv., 1982:3). But by that date, the calendar of exhibitions had only included nine or ten out of a total of thirty-four that even alluded to neighborhood subject matter. And most of them took place in the early years. Five years later, in an effort to remove perceived constraints and attract more resources, he would delete 'neighborhood' from the name of the museum. (Also see Martin-Felton and Lowe, 1993:37, for a 1978 memo asserting the museum's *national* focus.)

These warring interpretations were never reconciled, and perhaps any attempt to do so would have left an artificial construct with little real meaning or vitality. The challenge for the museum seemed not so much to disentangle the separate strands of its community-based mission from that of its African-American focus, but to effectively unite these two elements and to develop means for experimenting with emerging methods of community/museum interaction in an explicitly African-American and urban context.

Kinard's achievements

After the early 1970s, the museum also became more actively engaged with other institutions around the country; and Kinard himself was instrumental in a number of achievements. Denied permission to build a permanent collection at the Anacostia Museum, he encouraged the incorporation of African-American materials into other Smithsonian museum collections, pushing the acquisition of the Duke Ellington collection, and directly acquiring important African-American works of art that ended up in the collections of the National Museum of American

Art. He also helped establish the African-American Museum Association, and began working closely with a number of African and Caribbean museums.

It was also during this period that Anacostia Museum exhibitions began to circulate under the auspices of the Smithsonian Institution Traveling Exhibition Service (SITES), providing the first major African-American exhibitions for that Smithsonian bureau. The number of professional staff at the museum was at its highest, its most recent exhibitions were traveling to national audiences, its educational programs were sought after as models by other museums, a series of successful publications had been launched, and new national and international constituencies had been engaged – all measures of success according to traditional indices. But what had become of the museum's notion of the 'community-based institution'?

Black Mosaic: refocusing on the community

At the time of Kinard's death, he was engaged in a public struggle to expand existing facilities into a larger museum complex in Anacostia (*The Washington Post,* 1989). Subsequently, the museum's acting co-directors held a series of discussions with museum staff, Smithsonian staff people, neighborhood residents, and other individuals. They were convened to look at the museum's past history, the work that had been done, the museum's mission, and its community engagement. The challenge emerging from these discussions was to transform the museum's history of involvement with communities from the personal mandate of a founding director and individually committed staff members to a mission statement that would articulate and institutionalize such goals (AM Roundtable Discussions, 1990).

It is in this context that the preparations for building the *Black Mosaic* project began at Anacostia Museum in the late 1980s. *Black Mosaic: Community, Race, and Ethnicity Among Black Immigrants in Washington, D.C.* (1994) examines the history and experience of selected black immigrant communities in metropolitan Washington DC. This project represented a continuation of past efforts and a more ambitious effort to explore the parameters of community-based research. At the same time, the new museum director, Steven Newsome, was engaged in an effort to redefine and clarify the mission statement.

Immigration: an appropriate subject?

The focus on black *immigrant* communities was experimentation with subject matter that had already been touched upon in earlier exhibits. The African 'diaspora' had been discussed in installations that presented early West African history, Brazilian art, Jamaican art, and several other themes. But this new focus on black immigrant communities in Washington raised concerns among some staff and some of the museum's traditional constituents. Newsome faced challenges about the long-term implications of the exhibition – did it not represent an abandonment of the museum's mandate as an African-American institution? Given the zero-sum rhetoric that surrounds much of the politics of cultural representation and the dearth of African-American-directed cultural resources, this seemed a reasonable concern. From the museum's inception, there had been questions about which groups were being included in the museum's community. *Black Mosaic* further underscored such questions. Although encountered every day, black immigrants form an invisible community existing within the very core of Washington's African-American community life and social history and yet still exist on the margins of the city's public history. In engaging this population and integrating them into its community, the museum seemed to be crossing yet another river (Newsome interview, 1995).

Provocative questions

These concerns about the exhibition also raised a number of questions:

- Is the museum's concept of community expansive or confining?
- Should inquiry be limited to events within the traditional confines of African-American public history, or can African-American perspectives on broader issues and historical events – immigration and economic globalization, for example – be offered?
- To what extent should the museum focus on the contextual social, cultural, and economic history of African Americans?
- Should a black museum exclusively feature black faces?
- And most importantly, how to recapture the dynamism of the museum's earlier work with the community and effectively integrate that energy with its new scholarly and curatorial resources?

These were not issues that could be resolved in a series of meetings, but could only be worked out through ongoing exchanges between the director, members of the exhibit team, the museum staff, scholars, and members of the museum's public audience.

For Newsome also, the project presented an opportunity for the museum to re-state the institutional (and his) commitment to examining contemporary community life:

> *Black Mosaic* indeed provides us with a unique opportunity. It allows us to tell the compelling and strong stories of immigration and community development. It allows us to link Washington to several places in the Western Hemisphere, to be more inclusive in our definition of the black community. But from my perspective, its most important contribution was the opportunity to share contemporary social and cultural history within a museum. I am still amazed at the powerful sight of watching people at the opening gaze upon images of themselves or family members. That dynamic is what I had hoped for. The Anacostia Museum had long ago proven the worthiness of providing historical imagery which was reflective of the black community. *Black Mosaic* proves that museums are not relegated to solely the things and people of the past, but can indeed analyze and interpret contemporary issues.
>
> (Newsome interview, 1995)

Some Black Mosaic *answers*

At the outset, the following objectives for *Black Mosaic* were defined: First, the content would be shaped as much as possible by the people whose stories it presented. This would allow the museum to experiment with integrating community voices and perspectives into the exhibition process. Second, the exhibit would reflect the complexity and dynamism of the heterogeneous communities whose histories it sought to interpret by bringing to bear the full range of Smithsonian resources. Ideally, the final installation would be one in which scholarly and community voices were combined to present an insiders' interpretation of community life girded by (or counterposed by) historical context. And finally, the process of building the exhibit should be one that contributed in a significant way to the strengthening of existing cultural-resource networks within the communities with which the exhibition team was working (*Black Mosaic* Advisory Board, 1991–93).

Project staff began by focusing on the most prominent black populations in the metropolitan area: those with the greatest public presence as measured in size of population, number of institutions, and presence in mainstream and African-American media and popular culture. The

local Haitian, Brazilian, Rastafari, Jamaican and Afro-Latino communities were identified. Initial exhibit development efforts focused on bringing these specific communities into the interpretation process. Names of long-time residents were solicited; and people with information networks – community activists, service providers, school teachers, church activists, and others – assisted with the conceptualization of the content. These individuals also served as a resource base for the broader project. A widely-based project advisory board was pulled together from scholars and community people.

The exhibition team began a series of community-specific meetings in which residents and representatives of social clubs and national organizations were asked to discuss their views, concerns, and visions of the project. The degree of institutional development within each community largely determined how successful it would be in shaping the exhibition. Representatives of organizations were much more effective in maintaining a presence at meetings, maintaining continuity in their concerns, turning out community people, and ultimately in getting their points of view across.

The most notable obstacle to effective collaboration between the museum and community advisors seemed to be the lack of general knowledge about the exhibition process and what it is that museums do. The lack of information (and misinformation) about the kind of work done in museums, how they work with material culture, and how exhibits are put together meant that people often felt disempowered from contributing to decision making. It also reduced their effectiveness as resource people: for example, there was a tendency to withhold artefacts unless they were deemed of sufficient 'museum quality'. There was even a reluctance to be interviewed unless one could present the level of material wealth and social status that deemed one suitable – or again, of sufficient 'museum quality' – for public presentation. These problems constantly threatened to turn community representatives into passive consumers of the museum's ideas (*Black Mosaic* Community meetings, 1991–93).

Enlisting the community

The next step in the exhibition-development procedure was to bring on the team members who would be on the actual front lines of the inquiry process: the 'community scholars'. They were individuals from each community who were primarily responsible for identifying the people, institution, and traditions that would be featured, conducting the oral history interviews, and gathering the artefacts and materials for the exhibition. They would also serve as overall liaisons for the museum. The effective integration of their work with the archival and secondary research done by the curatorial staff would largely determine the success of the project.

The exhibition team began documenting events in the selected communities and quickly developed sizeable photo archives of religious ceremonies, political demonstrations, cultural performances, holiday celebrations, grocery stores, restaurants, and other images of everyday life. These were developed into a traveling exhibition that circulated locally to raise additional interest in the larger exhibition.

Working with educational and cultural organizations, the team also initiated public programs: lectures, performances and commemorations of cultural and national holidays, etc. In this way, the project accumulated a base of people (new museum constituents) whose activities had been documented, whose programs had been supported or augmented, and who in turn had an investment in shaping the development of the project and in the museum itself.

Working with these new community advisory boards and seeking the active intervention of people in interpreting contemporary community life meant re-entering the playing field of

community politics. At times, the different perspectives offered were virtually oppositional. Differences surrounding some discussions – the causes of political exile, the politics of immigration, and racial identity – were inappropriate to 'resolve'. For such discussions, the exhibition offered multiple perspectives that suggested the complexity of the subject, while offering insight into the reasoning behind each viewpoint.

Interviews were collected from over forty families. Also collected were 5,000 slides and photographs, and several hours of videotaped footage (Reinckens, 1995). After most of the interviews were completed, community scholars identified artefacts and documents in family and community settings. These, along with the audiotaped interviews and family photographs were used to construct the personal histories that made up a large part of the exhibition. They were also used to construct the topical discussions – immigrating to this country, race and ethnicity in Washington, building new communities – that were featured.

Much of the audiotaped material pointed to the drama and complexity of the individual lives and issues under discussion, but the photographs and artefacts that were typically offered did not always support the discussions. Often, family and personal photographs had been formally staged and aimed to present safe, almost bland, images. People from low-income families did not want photos, for example, that suggested materially-impoverished backgrounds. Additionally, some immigrants did not bring artefacts or family photos from home (particularly the case with political refugees) or lost them in the move.

Despite some concerns, the exhibition team decided to include all materials that could possibly inform the discussion, including fuzzy home Polaroids (Reinckens, 1995). Artefacts of everyday life, such as street posters, worn suitcases, a bulletin board from a local Jamaican restaurant covered with notices and other Jamaican community news, were used to suggest the dynamism of the communities. Some of this material arrived dusty and disheveled – a learning experience for staff grown used to prime-condition artefacts. Some spectacular 'museum quality' pieces – artwork, traditional dress, historical artefacts and photos, and most notably, the remains of a Cuban refugee boat recovered from a Florida beach – were also incorporated. Altogether, the selection of materials reflected the museum's effort to construct representation across class and other boundaries.

Concerns about representation and inclusion, about addressing both community 'insider' as well as 'outsider' audiences were driving forces behind the exhibit design and presentation. The final installation was a multilayered presentation of multiple perspectives in varying formats. The audio interviews and first-person narrative histories offered insightful and intimate views of subjects that would have been difficult for curators to elicit – tensions between different cultural communities, personal experiences with racial discrimination, the impact of immigration on family life and relationships, and anti-immigrant attitudes. Curators' text panels and archival photographs and documents provided historical contexts for selected topics.

A culmination and a beginning

Opening day saw a heterogenous mix of people: African Americans, many of them repeat visitors not seen since the museum's early years; people from the Caribbean and other black immigrant communities; and others – scholars, neighborhood people; and individuals interested in the immigrant experience. Though originally viewed as the culmination of the *Black Mosaic* project by staff, the exhibition actually served to further engage community activists, leaders of community-based organizations, cultural workers, teachers, and others from the featured communities. Additional initiatives and proposals began to come from these new constituencies.

By the project's end, staff had developed structures that allowed the exchange of ideas and resources with community groups and individuals. Each department – design, education, research, public programs – developed its own network of contacts, advisors and resource people.

Integrating community goals into this process from the beginning gave the exhibition team additional insights during the conceptualization phase, allowed for planning work with specific goals and timetables, and allowed community interests to be realized in a way that had the most direct impact on the public audiences. The project also encouraged staff and audiences to think about 'community' in the broadest sense: the telescoping of international and local issues and perspectives that black immigrants face, the Caribbean and African immigrant origins of many local residents, and the acknowledgement of a growing Hispanic community in the neighborhood – all pointed to ways in which community perspectives serve as a prism for interpreting the larger world.

Looking back and looking ahead

Created as a neighborhood outpost by Smithsonian officials to attract neighborhood residents to museums on the Mall, Anacostia Museum was re-created by organized community groups, activists, neighborhood residents, and museum administration and staff into a cultural resource to serve the shifting needs and goals of a community whose parameters have been constantly changing. But the pressure on Anacostia Museum (as with other African-American cultural institutions) to meet wide-ranging needs left it constantly struggling to meet ambitious goals and objectives with inadequate resources. Part of the founding director's response to this situation was to 'mainstream' museum exhibitions. This effort weakened the museum's structural ties to the communities it served, however, by confining significant community/museum interaction to its education department and to the individual activities of the museum director. This distancing from its claimed communities threatened to fracture institutional identity by divorcing the museum's exhibition-related processes from its other, more community-focused activities, such as outreach and educational programs.

The director's challenges, then and now

The arrival of Steven Newsome as director in 1991 resulted in the development of a formal collection policy, the inauguration of a permanent collection, and the development of an extended mission statement that discussed the community-based nature of the museum's work (AM Collections Policy, 1992; AM Mission, 1992). It remained, however, for staff to develop structures that could integrate community expectations with program goals. This involved challenges for Newsome slightly different from those Kinard had faced. Kinard was charged with developing programs and exhibitions around a dynamic core of community advisory boards; his initial task was to build a museum that focused on such community initiatives. The task facing Newsome, on the other hand, was to integrate community perspectives into existing museum structures.

Future exhibitions and ongoing outreach

Anacostia Museum will continue to explore community-based research and exhibition projects. Future exhibitions promise to examine: African-American communities of faith and traditions of worship, undertaken in conjunction with local churches and religious bodies; the history of the all-black township of North Brentwood, Maryland, a project conceived and directed by a

local historical society; the African-American rural experience in the South in partnerships with rural community groups and cultural institutions; the neighborhood of Anacostia, in conjunction with the community groups, service providers, and families in the area. The museum will return to its roots, with new resources and goals and a renewed agenda, to work in its own neighborhood, that place across the river.

There remains the ongoing task of marshaling the broader museum community to continue the examination of the future of community-based museum work and to support other institutions doing such work. Newsome argues that much of this will involve building networks between funders, museums, and other cultural institutions: 'Whether community-based institutions openly acknowledge it or not, funding institutions also remain an influential part of the museum/community dialogue – in the sense that they play a significant role in shaping institutional goals. One of the museum's primary tasks will be to work with the funding community to familiarize programme officers with community-based museological initiatives and to legitimize and increase the presence of such projects among funders. Means for evaluating the effectiveness and long-term impact of such programs must also be developed. Funders can play a conservative role in discouraging community-based initiatives or can encourage the dissemination of effective models of museum/community interaction' (Newsome interview, 1995).

Identity: an elusive goal

The history of Anacostia Museum illustrates that the very notion of institutional identity is challenged by the situation of the African-American museum. Often, for small, underfunded, personality-dominated institutions, continuity of mission – and therefore identity – over long periods of time is sometimes problematic. The appointment of a new director, the incorporation of additional professional staff, the inauguration of a permanent collection – such accomplishments can compromise previous commitments and send the institution careening off in new directions. Institutional identity in this sense implies a cohesiveness and sense of continuity that often does not exist, other than that found in the most generic notion of exhibiting African-American history and culture.

Finally, perhaps much of the problem is philosophical: museum administrations (and curatorial staff) are a product of their environment. Their success is measured by the size of their accomplishments – facilities and staff expansion, blockbuster public events and blockbuster exhibitions, and the accumulation of a treasure house of African-American artefacts. And African-American communities, our public audiences, all too often remain unaware of the full potential of museum/community partnerships. They are too often just pleased to see reasonably well-conceived and executed exhibitions, no matter how distant and removed the process. The future lies not so much in bigger buildings and facilities, program auditoriums, exhibition spaces, and larger artefact repositories, but in the uncharted waters of relationships. There must be stronger bridges between the museum – as both an intellectual and a public institution – and its claimed communities.

References

Anacostia Museum (1988) *Roundtable: Anacostia Museum Management Committee Program Review. Director's Report* (June 24), AM Archives.
—— (1990) *Roundtable Discussions: Exhibits and Programs, Executive Summary* (June 16), AM Archives.

—— (1992) *Anacostia Museum Collections Management Policy*, AM Archives.

Anacostia Museum of African-American History and Culture (1992) *Statement of Mission and Philosophy*, AM Archives.

Anacostia Neighborhood Museum (1972) *Anacostia Neighborhood Museum, Fifth Anniversary*. Washington: Anacostia Neighborhood Museum/Smithsonian Institution.

—— (1979) *Report of the Advisory Panel on the Anacostia Neighborhood Museum*, AM Archives.

—— (1982). *Anacostia Neighborhood Museum, Fifteenth Anniversary*, Washington: Anacostia Museum/Smithsonian Institution.

Black Mosaic Advisory Board (1991–93) *Black Mosaic Advisory Board Meetings*, tape recordings: 3 December 1991; 28 July 1992; 15 December 1992; 2 February 1993.

Black Mosaic Community Groups (1991–93) *Group Meetings*, tape recordings: Brazilian Community, 15 May 1991; Rastafari Community, 12 September 1991; Ghanaian Community, 10 November 1993; Jamaican Community, 12 November 1993.

Hutchinson, L.D. (1977) *The Anacostia Story: 1608–1930*, Washington: Smithsonian Institution Press.

—— (1981) *Anna J. Cooper: A Voice From the South*, Washington: Smithsonian Institution Press.

Kinard, J.R., and Nighbert, E. (1968) 'The Smithsonian's Anacostia Neighborhood Museum', *Curator*, 11(3), 190–205.

Martin, Z.B. (1970) 'Anatomy of an inner city museum', *Alma Mater*, Bethlehem, PA: Moravian College.

—— (1971), 'Urban ecology and the inner city museum', in *Museums and the Environment: A Handbook for Education*, Washington: American Association of Museums.

Martin-Felton, Z., and Lowe, G. (1993) *A Different Drummer: John Kinard and the Anacostia Museum, 1967–1989*, Washington: Anacostia Museum/Smithsonian Institution.

Newsome, S. (1995) Interview with the Director of the Anacostia Museum, April 1995.

Reinckens, S. (1995) Interview with the Deputy Director of the Anacostia Museum, April 1995.

Ripley, S.D. (1969) *The Sacred Grove: Essays on Museums*, New York: Simon & Schuster.

The Washington Post (1989) 'Lion of the Anacostia Museum', 19 July, D1, 10–11.

Community museums
The Australian experience

Phillip Gordon

Although there may be a number of shared principles within the notion of community-based museology and heritage management, the primary one is that museum action and heritage management should be driven by the 'community' itself and undertaken to meet its own expressed needs. This means that museology and heritage management that is community-based will be approached differently in different contexts, as each community works in partnerships with museum and heritage professionals in responding to its own situational and cultural needs and objectives. This process requires careful balancing and negotiation. Museum professionals can provide useful input, facilitation, training and resources; however, they need to be led by the communities that they are working with, who need to feel a shared sense of ownership, with space to raise issues and suggest appropriate ways forward.

This chapter discusses the particular experience of the Australian Museum in its programmes in New South Wales that have been developed to assist Aboriginal people to establish, and/or maintain, 'keeping places', cultural centres, site management programmes, networks and recommendations to help them meet their own cultural needs. It outlines the practical steps taken and the resource provision in these programmes.

I am Phil Gordon, the manager of the Aboriginal Heritage Unit at the Australian Museum, Sydney, Australia. My role within this institution is to be the interface between the Aboriginal community and the museum, and in this role I have responsibility for the development of policy and public programme development.

In this chapter I will discuss the Australian experience in the development of community museums. I shall begin with a discussion of the history and the philosophical framework associated with this movement in Australia. I will then move on to some of the more technical aspects of my museum's response to this movement. I will also discuss various examples of museums that Aboriginal people have used to fulfill their cultural objectives. I will then outline the Australian Museum's response to this movement. This response is a multifaceted one and is brought together in the programme that I manage called the 'outreach programme'.

To help you to understand what I am talking about today, I will need to take a historical and philosophical look at what the museum was in the past, and how and why this has changed over time.

The Australian Museum is one of the world's oldest natural history museums. It had its origins in the early 1830s. The role of the museum at the earliest stage was to collect and preserve the flora and fauna and other specimen of the natural world and, of course, cultural material from the indigenous peoples of the region. Thus, we started our life as a classic museum in the European sense, as a treasure house of the rare, curious and exotic material from the colony.

In the area of Aboriginal cultural material, the museum pursued a policy of collecting and preserving the material manifestations of the 'dead and dying' indigenous peoples of Australia before they became extinct (of course the extinction never come about). Thus, the museum had its philosophical base as a collector of the rare and curious of the Empire in a classic museum sense. The objects themselves became the major reason for the museum's existence. There was no, or little, attempt to place the collections within any context and certainly there was no contact with Aboriginal people at all.

This situation persisted until the late 1970s, when there were a number of changes happening not only in Australia but also in the rest of the world. These changes were leading institutions to take into account the wishes of their clients. In the case of museums in Australia, the pressure was on for us to take into account the wishes of Aboriginal peoples. One of the main manifestations of and catalysts of change during this period was the Regional Seminar held by UNESCO in Adelaide in 1978, entitled 'Previous Indigenous Cultures: New Role for Museums'.

For many people working within the museum world, this was the first time that they had actually dealt with Aboriginal people. One of the outcomes of the seminar was the realization within the museum field that Aboriginal people had a legitimate right to participate at all levels in the curation and usage and presentation of the material held within the museum; this had dramatic implications for the way museums did business.

Therefore, museums decided that one of the first steps towards this 'new world' was through the employment of Aboriginal people within museums. This had many other implications in a whole range of museum activities, including such areas as education, display, and public programmes. One of the major benefits in the employment of Aboriginal people is that it is the building block upon which the idea of partnership can be developed between the museum world and indigenous peoples.

Other significant events that have helped to set the scene for the development of museums in this area of relationships with Aboriginal people and their cultural objectives is the policy document entitled 'Previous Possessions: New Obligations'. This was a policy document endorsed by all major museums and for the first time it attempted to outline a whole range of policy issues that museums need to address to meet the growing demands of Aboriginal people to be an equal partner in the preservation and interpretation of their cultural material.

These policies cover the whole range of museum activities such as:

1 Self-determination
2 Management and collections
3 Access to collections and information
4 Assistance to Aboriginal and Torres Strait Islander Communities
5 Employment and training
6 Policy formulation
7 Repatriation.

In this new world, museums became vibrant places working in partnership with Aboriginal people or, as Dr Chris Anderson (Director, South Australian Museum), puts it:

> The only other possibility is that museum activities reflect the nature of people's rights in the objects themselves. To do this is not necessarily to renege on normal museum responsibilities; it is really just a change of emphasis. It means letting Aboriginal people know what is in the collections; it means opening these up for research and use. It means joint ventures

in almost every sphere. Most of the criticisms made of museums by indigenous peoples stem from museology's basic premise of the sanctity and primacy of the object (something deep in Western culture). There has to be a shift of focus to the human relationships that cultural objects have always represented.

Thus the scene has dramatically changed from the traditional view of museums as warehouses of the natural world and of dead and dying peoples and their culture. We now view ourselves as something totally different; 'custodianship' and 'partnership' are important words reflecting this. I think this is best shown with three quotes from the Australian Museum's statement of philosophy:

1 Our research activities will concentrate on Australia and nearby regions. Collections and associated information are managed for the purposes of research and communication to the public and are being preserved for the benefit of future generations.

2 The future of our natural environment and cultural heritage is of central concern: we intend to join in public debate and give advice to government, the community and business where we have special knowledge.

3 We will respect the rights and wishes of the peoples whose knowledge and material culture form the basis of our human studies programs. We will consciously abide by legislation and conventions protecting the natural environment, wildlife and cultural heritage.

This new relationship is an evolving one that has changed dramatically over the last ten years and will continue to change. It is not an easy one to develop and, as I have already mentioned, it does take quite a significant rethinking of the philosophical basis of museums and what they are and what they need to be in the twenty-first century, if they are to remain relevant.

As you may be aware, Australia is a federation made up of six state governments and two territories. Each state has a major museum. The Aboriginal population in each state varies greatly in its composition and lifestyle. From Aboriginal people living a semi traditional lifestyle on traditional lands in the northern parts of the country; through to urban Aboriginal people living in Southeastern Australia. This presents a whole range of variation in the responses that are required by museums in assisting Aboriginal people in the pursuit of their heritage objectives.

At this stage, I need to discuss what we in Australia define as a community museum. In Australia we tend to use the term 'keeping place'. This term covers a whole range of community-inspired activities that fall outside of the classic museum's models. By this, I mean a large building built to professional standards. The examples of this approach are the large-scale tourist-oriented developments such as the museums in Cairns and Tweed Heads. In contrast, you find small complexes that are community-oriented and definitely not in a classic museum model, such as those in Brewarrina and Wallaga Lake, right through to small display cases in community offices that are there to encourage cultural issues.

Each development is a unique response to community wishes and needs and as such these facilities are more likely to be useful to their community, and thus to be successful, as opposed to museums that have been developed without a clear community mandate, which tend to stagnate and fail.

It is this diversity in community needs that is the most exciting part of the whole movement towards Aboriginal people becoming partners in the management of their material culture and which requires us to be flexible and responsive in all that we do.

The Australian museum basically deals with Aboriginal people in the state of New South Wales (NSW) and thus our outreach programme has been designed to deal with different cultural issues in NSW. The various programmes have grown, as our expertise in dealing with these issues has grown and as Aboriginal people have come to understand how museums can assist them in their needs.

History of the outreach programme

Over the past ten years, the Australian Museum has assisted Aboriginal communities within NSW in identifying and achieving their specific cultural objectives. For most of these communities, the objective that was identified as being most important was the establishment of a cultural centre or keeping place within their community. This desire was supported by the recommendations put forward at the 1978 UNESCO seminar on the role of museums, preserving indigenous cultures where:

1 community museums are set up at the request of indigenous people;
2 indigenous people are trained in the areas of museum management.

Following these recommendations, the Australian Museum instigated their Aboriginal outreach programme.

Community museum training programme

This programme endeavoured to give Aboriginal people from various communities throughout NSW adequate training in museum-based skills, so that they would be able to develop and run a cultural centre or keeping place within their own communities. This training was planned to be accomplished within the Australian Museum.

With the training programme, the Australian Museum achieved its desired role to become a major resource for NSW Aboriginal communities in their museum-related activities.

Outcomes of the training programme

The training programme was deemed to be an overall success in a number of aspects. These included giving the participants a chance to develop their own skills in relevant areas associated with museum work, as well as identifying the specific needs in the development of a cultural centre in the communities they were associated with.

Aboriginal outreach programme

In February 1994, the Australian Museum was granted $47,500 by the Aboriginal and Torres Strait Islander Commission (ATSIC) for an extension to its outreach programme for the next five months. This extension was seen to have the potential to have a substantial effect on the ability of local Aboriginal communities not only to operate their own local museums, but also to provide an opportunity to assess for themselves whether a museum-like building or organization is the most appropriate way of achieving their own cultural objectives.

The programme has been undertaken in a number of stages. The objectives of these stages were to offer Aboriginal communities of NSW a broad base to gain specific skills in, and knowledge of, the successful development and running of a cultural centre or keeping place.

As a component of the outreach programme, the Australian Museum will continue to fulfill these objectives until every Aboriginal community within NSW has been approached to participate in the programme. There are about 150 such communities in NSW.

Stage one: community meetings

Stage one incorporated a number of areas that gave a basic introduction to issues involved in the development and maintenance of a small museum. The first area involved separate meetings with different Aboriginal communities throughout NSW, where the community was assisted in defining what their specific needs were and how best these could be met. This was achieved in part by using the experience of Australian Museum staff in these areas, as well as investigating the various types of small museum and keeping place models that are in use both in Australia and overseas.

The second area of this stage incorporated a number of community workshops held in specific communities. These workshops aimed at building up the skill base within the community in the various needs that were previously identified. The workshops were convened by Australian Museum staff and covered areas such as the consideration of conservation issues in the planning of the museum building, conservation of artefacts, basic curation for collections, display design, and the identification of areas of community research.

Stage two: training of staff

The second stage of the programme aimed at providing a higher level of training specifically targeted at people who were at the management level of cultural centres and keeping places. This training entailed more comprehensive training in the areas of curation, design and conservation, as well as focusing on such areas as corporate planning, merchandising and corporate sponsorship. The training was conducted at the Australian Museum in Sydney.

Stage three: production of catalogues

Stage three of the programme involved the production of various manuals and catalogues. The manuals covered three key areas of museum techniques and procedures that were identified as being imperative to the successful maintenance of a cultural centre or keeping place: the registration and conservation of Aboriginal material culture, and the design techniques used in the production of basic displays.

In conjunction with both the registration and conservation manuals, respective kits were produced to be dispersed with the manuals. These kits included a wide range of supplies that are used in the areas of registration and conservation, as well as a list of suppliers that could be contacted.

A number of regional catalogues were also produced, with the first two covering the Northern Tablelands and the Singleton region of NSW distributed to the relevant Aboriginal communities. These catalogues were produced to enable Aboriginal cultural centres and keeping places to identify what cultural material was held at the Australian Museum from their areas.

The catalogues identified both ethnographic and archaeological material that derived from the area, as well as covering such other important aspects as procedures for the collation of information concerning skeletal remains and secret and sacred materials, and a list of other institutions to be contacted for heritage-related information.

It is planned for the future that the whole of NSW will be covered in this regional catalogue format.

Two reference catalogues were also produced under the outreach programme. These included the 'Guide to the Australian Museums Archaeological collection' and the 'Guide to the NSW Aboriginal Ethnographic collection'. These two catalogues would also enable Aboriginal communities to identify cultural material from their region held at the Australian Museum.

Stage four: community workshop

The last stage of the programme was a two-day workshop for all communities on the various issues that are faced when the communities undertake the development and running of a cultural centre or keeping place.

The Aboriginal community workshop was held as a part of the Australian Museum's outreach programme. The objective of the workshop was to address two important key areas in the support of Aboriginal communities within NSW achieving their own cultural objectives. First, the workshop attempted to identify important issues that were relevant to Aboriginal communities who expressed an interest in the development and maintenance of Aboriginal cultural centres and keeping places. The workshop was also deemed to be a place where these issues could be discussed within a structure that could achieve positive outcomes. Second, the workshop was seen to be an important catalyst in the development of a NSW network for Aboriginal persons interested in achieving their own cultural objectives within cultural centres and keeping places.

The format for the two days consisted of the coverage of these four key areas:

1 the dispersion of information to participants in the workshop relating to Aboriginal cultural heritage matters;
2 the identification and discussion of the above-mentioned issues;
3 the development of a NSW network;
4 the future of the Aboriginal outreach programme.

The involvement of participants in the different areas of the workshop occurred in an informal manner. Each participant was encouraged to express his/her views on all issues raised at any time.

The identification of key issues

The following issues were identified as being important to the development and maintenance of Aboriginal cultural centres and keeping places by the participants of the workshop. It was intended that these issues were to be discussed, but this was not possible due to time constraints. It was therefore decided that these issues will be the subject of a separate workshop at a future date and also that the issues would be used as the basis for the terms of reference of the NSW network. As can be seen by the diversity of issues raised, these activities can be seen as a focal point for a range of cultural initiatives that no other organizations can carry out.

These were as follows:

- Formation of a NSW network.
- Training in areas such as conservation and other museum practices, as well as the ongoing support for specific needs.
- A community-based analysis of training needs, such as loans processing, funding applications, conservation, and problems associated with building maintenance.
- The raising of funds for acquiring artefacts.

- The establishment of an Aboriginal State advisory board (it was expressed that this board would have the function of advising state bodies that deal with Aboriginal cultural issues).
- The assessment of Aboriginal cultural items in local history museums.
- Access to information on the Aboriginal collections held by all museums in Australia.
- Sustainability of resources for cultural centres and keeping places.
- The launching of a newsletter.
- The promotion and acceptance of Aboriginal cultural centres within the broader society.
- An ongoing national network.
- A report to the House of Representatives' Standing Committee on Aboriginal and Torres Strait Islander Affairs on the establishment of the newly formed NSW network and what the network perceives as its role in Aboriginal cultural heritage matters.
- Institutions to redirect the acquisition of collections to cultural centres.
- Media promotion of both the newly formed network and Aboriginal cultural centres and keeping places throughout NSW.
- A plan to lobby the National Parks and Wildlife Service, NPWS, for the change of legislation concerning Aboriginal sites and the protection of those sites.
- Training in Aboriginal site management.
- A recommendation to both the State and Federal Offices of Aboriginal Affairs to consult with cultural centres.
- The identification of all funding resources and the production of a calendar listing these funding sources and the due dates for submissions.
- Clarification of copyright issues.
- Consultation with Councils of Elders.

Registration and conservation kits

Registration and conservation kits were distributed at the community workshop at Armidale to all existing cultural centres. These kits comprised samples of materials commonly used in both registration and conservation that would be needed in maintaining a collection of objects. These kits would form the basis of supplies that the cultural centre or organization could add to.

It is envisaged that kits will be supplied to cultural centres and other organizations as they set up their collections.

An ongoing commitment that falls into both the functions of the outreach programme, as well as a service provided by anthropologists, is the loan of Aboriginal objects to Aboriginal communities. In these instances, we not only supply Aboriginal material for loan for exhibition, but also where material has been traced to a particular area, we offer such materials for an indefinite loan period. In the latter case, loans of this type have been supplied to Armidale, Gunnedah and Wallaga Lake.

Small grants

Some communities that have participated in the outreach programme have received modest financial assistance for small-scale activities that has allowed them to achieve some of their objectives. This money has been used for a number of projects such as display cases, artefacts to be used in education programmes, and photographic film. We have found this an efficient way of responding on a small scale to communities' needs.

The dissemination of information

One of the achievements of the outreach programme is that it has lead to a significant increase in the numbers of Aboriginal people who can now participate in discussions of the role that museum-like organizations can play in the development of communities' own cultural objectives.

Conclusion

There is a variety of reasons for communities to want to have a community museum. These range from a desire to protect one's culture from the dominant culture that prevails in the society, to the use of the museum and associated enterprises as a way of promoting local employment. There are a number of ways these desires can be met. All these desires and responses are legitimate and require museum professionals to work them out with the community, to come to a solution that meets the community's wishes. This is not always an easy task.

As a major museum, the Australia Museum has on obligation to listen and assist these communities in the search for appropriate structures to meet their needs.

It is also important that we provide comprehensive services for the ongoing support of the community's cultural initiatives and that this support is tailored to the individual community's needs and that we provide these services on an ongoing basis.

I see the growing development of community museums as being a very positive movement. It will reinforce the role of major museums as the providers of comprehensive services to this growing market and thus make it a relevant player in the future.

References

Edwards, R. and Stewart, J. (eds) (1980) *Preserving Indigenous Culture: A New Role for Museums*, Canberra: GAPS.

Griffin, D. (ed.) (1993) *Previous Possessions, New Obligations*, Canberra: Museums Australia.

Anderson, C. (1990) 'Australian aborigines and museums – a new relationship', *Curator*, 33(3), 165–79.

Places, 'cultural touchstones' and the ecomuseum

Peter Davis

During the early development of the ecomuseum, theorists advocated a number of key principles that, when applied, could make museum action and heritage the management of museums and heritage sites far more democratic than the more traditional models. These principles include public participation in all the processes, from decision making through to the management of heritage resources and how they are used to construct and reflect identities. Rather than relying solely on outside 'experts', the ecomuseum concept has encouraged the empowerment of local communities to identify and take control of their own heritage resources. In addition, the concept values the significance of all forms of heritage resource, including immovable and movable tangible heritage, and intangible cultural heritage, as they relate to the network of interactions between people and their particular physical, economic, social, cultural and political environments. Instead of alienating these resources from their communities as traditional museums and heritage management approaches have done, the ecomuseums concept has recommended that the management and interpretation of these resources take place where possible, *in situ*, in the contexts of their original locations and settings. In many ways, the principles of the ecomuseums ideal are more holistic than traditional museum and heritage management approaches. Where implemented together, these principles come close to following the overall process suggested in the introduction to this volume.

This chapter considers the value of using ecomuseum principles at a local level, where people have strong connections to place, and shared 'cultural touchstones', and a collective sense of identity. It outlines the origins of the term 'ecomuseum' and briefly shows how the concept has spread internationally. It then goes on to discuss definitions and to introduce certain ecomuseum models that represent the key principles. With the fluidity that comes from full public participation in the ecomuseums concept, no two ecomuseums will be the same. Although there may be agreement on the key principles, they will not all be employed to the same degree, or in the same combination. However, the one characteristic that appears to be shared by all manifestations of the concept is a sense of pride in place.

Introduction

The growth of interest in the environment, and the emergence of environmentalism as a phenomenon in the 1960s was pivotal to the development of the ecomuseum philosophy, with the early experiments being conducted in newly created protected rural areas in France, the Regional Natural Parks. However, for ecomuseological purposes, it is important to recognize that the term 'environment' has special meaning. It is not an ecological or biological definition

which is used in an ecomuseum context, but a much broader concept, where the term 'environment' includes not only geological features and plant and animal communities of a geographical area, but also the people that live there, the landscapes that they have modified, their traditions, material culture and ways of life. When considering the ecomuseum concept, it is easier to explore the idea of 'environment' through the much simpler term of 'place'. There are certain features of places, tangible and intangible, that make them meaningful to people, and it might be argued that there are certain aspects of place that are so important that they are given special significance. Such features have been referred to as 'cultural touchstones' by Common Ground (1996). The ecomuseum – so little understood by many museum professionals in the English-speaking world, yet a concept that has led to an amazing diversity of protected sites and museums (Davis, 1999) – is one way in which the significance of place can be conserved, enjoyed and promoted to a wider public. This link between places, special sites and the ecomuseum phenomenon is explored here.

Places and local distinctiveness

Despite its complexities, there appear to be some certainties about place. First, although it is ultimately culturally defined, there is normally a sense of location or position. Second, place has a physical form, a landscape composed of a complex interplay between the natural and built environment; appearance is an important feature of all places. Third, places change, albeit in some cases very slowly, and the fact that they do can serve to re-enforce our attachment to them. By observing change, we document the history of places for ourselves; changes in the physical nature of places does not necessarily mean that they lose their personality. Fourth, places are defined by the people that live in them, the shifting composition of their communities influences their meaning. Fifth, each individual has their own personal places that are the focus of their life and existence, and each person will apply their own criteria when identifying those places, influenced by their personal histories and lifestyles.

Every individual appreciates a place in their own way, in the same way that each visitor to a museum brings their own values and knowledge to the experience of visiting. So tourists visiting the Mediterranean island of Crete might be delighted by its snow-capped mountains, deep steep-sided gorges, vultures circling on thermals, cobbled donkey trails, and tiny white churches in accessible places. Venetian houses, Roman wells, Turkish inscriptions the sound of goat bells, Minoan palaces, retsina, blue seas, colourful fishing boats, welcoming tavernas, and friendly Cretans add to the experience. These are the features that make it special to tourists, and each visitor will react to and remember the Cretan environment in a different way. However, if a Cretan were to compile a list of what makes his/her place special, it would probably be very different. In particular, it would reflect a much tighter geographical notion of place – perhaps their home village – and the list of what was 'special' about it would be much more 'people centred' and have far greater emphasis on the intangible nature of place – collective memory, local stories and folklore, music and community history. Place is a very individual thing, yet it also has a community expression; it is a chameleon concept, changing colour through individual perception, and changing pattern through time.

Every locality possesses physical attributes, each with associated (and often historical) meanings that are important to the local community. Just *how* important those physical features are, even how prevalent they are, is a function of the community itself. Physically small and self-contained places, those (often rural) places on the margins geographically and economically, can often demonstrate rich local character. It is here that the connection between people and place

may be greatest. Where people work in their immediate surroundings, their activities and creativity shape the character of the place, features that over time result in the accumulated detail of the landscape that gives it local distinctiveness. However, it is important to recognize that 'local distinctiveness' as a concept does not apply only to small rural settlements, it can equally be identified in an industrial town or the suburbs of a major city. Every place has special features that can be recognized, protected and celebrated.

The UK-based organization Common Ground has done much to draw attention to local distinctiveness, the phenomenon that Clifford and King (1993) refer to as 'that elusive particularity, ... the richness we take for granted'. They suggest that it is 'as much about the commonplace as about the rare, about the everyday as much as the endangered, and about the ordinary as much as the spectacular'; those features of the cultural landscape that are often paid scant regard. And yet human beings recognize and appreciate subtle distinctions and detail, the difference and richness of places. 'Every place is its own living museum, dynamic and filled with sensibilities to its own small richnesses ... symbolism and significance cling to seemingly ordinary buildings, trees, artefacts ... Places are different from each other' (ibid.). As yet, few mechanisms have evolved to protect the smaller, but no less significant features of the cultural landscape: 'Apples, bricks, sheep and gates, all of which have had generations of careful guided evolution creating qualities related to conditions of locality and need, no longer show the differentiation that whispers ... where you are' (ibid.).

Scale is important in terms of local distinctiveness, and small scale is the most appropriate. So it is the scale of the neighbourhood, the parish, the village, the suburb, the street, a place that is identified from within, with a cultural and natural base that individuals and communities relate to. Small scale does not necessarily mean simplicity in terms of local distinctiveness, it remains a many faceted concept that demands an appreciation of detail, of authenticity and a patina created by time. As elements of place become indicators of continuity (such as landscapes, festivals, oral traditions) and time (fragments of the past such as old woodlands, archaeological sites or former industrial complexes) so they may become increasingly valued.

Common Ground has demonstrated that certain attributes of place can be listed or quantified, and has done this by encouraging communities in the UK to create 'illustrated alphabets' of their locality, an idea that has been further enhanced by the production of Parish Maps (Clifford and King 1996; Leslie, 2001). Thousands of these illustrated representations of place have been created b,y local people in England, important records of elements of the past and present that are valued by their communities. However, the concept that is variously named 'sense of place' or 'spirit of place' still remains elusive. Relph (1976) noted that 'Obviously the spirit of place involves topography and appearance, economic functions and social activities, and particular significance deriving from past events and present situations – but it differs from the simple summation of these ... The spirit of place ... is not easily analysed in formal and conceptual terms. Yet at the same time it is naively obvious in our experience of places for it constitutes the very individuality and uniqueness of places.'

Individuals and communities attach deep significance to places, and every community in every country has a feeling of attachment to particular sites within their territory; places that might be identified as 'cultural touchstones'. Humankind has created various mechanisms to conserve the sites or objects that possess special significance, at every level from the World Heritage Site to the Tree Preservation Order. It is interesting to note that these processes have, by and large, been carried out by large organizations (governmental or voluntary) that have assumed responsibility for assessing, documenting and caring for aspects of the environment. In England, typical examples are English Nature, The Countryside Agency, English Heritage and

367

the National Trust, all of which have a national remit. Their activities in preservation and interpretation have helped to proclaim the significance of sites, adding labels, signposts or other markers in a process that has witnessed the musealization of the environment. 'Experts' who attach their own meanings to sites or objects have largely carried out these processes, not the people who experience them. There is a paradox here, in that these organizations declare what is important at a national scale, but only rarely take local needs or interests into consideration. This can mean that those features of the immediate environment that local people value, if they are not deemed to be of national or even regional significance, may not be protected. If a community values its local distinctiveness, then community empowerment is necessary to protect it. It might also be argued that local people are best placed to interpret the significance of sites, should they wish to add interpretation to their conservation role.

When recognizing the complexity of place and what it represents to individuals and communities, it is evident that the 'traditional' museum can never capture its elusive qualities. It is impossible for the curator to acquire place, carefully label it and store it in an acid-free container. Museums can acquire fragments of place, and exhibit them together to re-create their version of place, but that is all. The essence of place lies beyond the museum, in the environment itself, and is defined by the individuals and the communities that live there. If museums are going to play a major role in conserving places, in protecting the environment, then a new kind of museum is required, with two important attributes. The first of these, the realization that the museum extends beyond the physical barrier of its walls, has been largely accepted by museums. The second attribute, community empowerment, is gradually beginning to be appreciated. It is important because it is communities that shape and define the significance of the local environment. In effect, a new philosophy is needed that leads to the empowerment of local communities, providing them not only with a mechanism for rescuing an artefact, a habitat, or a way of life from loss or destruction, but also a means of expressing a deep conviction to preserve and deepen a sense of place. One new philosophical approach that recognizes these needs – and one that echoes the views of Common Ground – is the ecomuseum.

Local distinctiveness and the ecomuseum

Common Ground (Clifford and King, 1993) suggest that empowerment – local responsibility for local heritage – encourages people to change places for the better, retains local identity and local character, and preserves the fingerprint of the cultural landscape. It encourages local dialect, celebrates time, place and the seasons through festivals and feasts, fights for authenticity, and values the commonplace. Similarly, empowerment and democratization became a feature of the ecomuseum as it emerged in the late 1960s and early 1970s. Ecomuseums would serve the present and future needs of their communities, and value the special nature of places. Its two main proponents, Hugues de Varine and Georges Henri Rivière (1897–1985) were central to the development of new ideas about communities and heritage. Rivière, steeped in the traditions of French ethnography, was anxious to interpret human history, and the objects and artefacts associated with that history, in an environmental context (Hudson, 1992; Rivière, 1973). Varine, deeply committed to the democratization of museums, wished to promote the community role of museums within an economic and political framework. The first experiments with ecomuseums occurred in French rural areas in the late 1960s, closely linked to the establishment of a regional natural park system from 1969. The Parc Naturel Régional d'Armorique in Finistère (Brittany) is a landscape of diverse habitats that extend from the littoral to mountains of 387m (Gestin, 1995), an area of varied agricultural practices in which

are located significant archaeological sites and industrial buildings such as windmills, watermills, tanneries and potteries. There, with the guidance and enthusiasm of Georges Henri Rivière, two ecomuseums were established (the Ecomusée des Monts d'Arrée and the Ecomusée de l'Ile de Ouessant), which reflect two very different landscapes, one coastal, one in the mountainous interior. On the Isle of Ouessant, three houses and a windmill were eventually designated as an ecomuseum, but the 'Maison des techniques et traditions ouessantines' and its associated 'circuit muséographique', opened in July 1968, is regarded by Desvallées (1983) as the world's first ecomuseum, even though the word had not then been coined. Exhibitions about the past traditions and environment of the area were displayed here, with special emphasis on farming, fishing and ornithology.

Further experimental museums were created in Gascony (1969), the Camargue (from 1974) and most famously at Le Creusot-Montceau in Burgundy (1974) (see Davis, 1999:66–7). The latter established not only political, social and regeneration ideals, but cemented the concept of the 'fragmented museum', which encouraged the visitor to explore the local area by visiting several 'cultural touchstones'. This split-site approach has since become the most common feature of ecomuseums worldwide. The ecomuseum had taken the notion of place, expressed as 'territoire' (territory) – as a cornerstone of its philosophy. The ecomuseum mission is to conserve the very special nature of places – a territory, with its landscapes, wildlife, historic artefacts, peoples, customs and folklore that is managed by local people – with emphasis on special 'touchstones' that are valued and exhibited to local people and visitors. In ecomuseum jargon these are known as 'antennae'.

The word 'ecomusée' was devised in September 1971 by the museologist Hugues de Varine for the French Minister for the Environment, Robert Poujade, when he was seeking a new word to express these new museological approaches to community–environment interaction occurring in France. According to Hubert (1989), Poujade, as a modern politician with responsibilities for environmental issues, had an aversion to the fusty term 'museum' – '... très réticent à l'utilisation du mot musée, qui était porteur d'une image de marque négative C'est ainsi que, jouant sur les mots, Hugues de Varine forgea après quelques tentatives, le mot écomusée'. Poujade first used the term at an international museums meeting in Dijon on 3 September 1971, and a year later, in September 1972, took the opportunity to use the term once more, this time at the ICOM conference (*Musées et Environnement*) held at Lourmarin, Istres et Bordeaux (Varine, 1992; Wasserman, 1989).

The ecomuseum was created at a time when environmentalism was achieving great prominence, and is symptomatic of the impact of the green movement throughout society. However, it is also clear that it was chosen as a term of convenience, driven by political expediency. Poujade evidently thought that the ecomuseum would boost his image, but not everyone agreed with the term. Varine (1992) recalls the strong views expressed in the Dijon journal *Les Dépêches*, which damned the creation of a 'regrettable and useless neologism that will only increase intellectual jargon'. But, as Varine notes, 'Trop tard, l'écomusée était né'.

The ecomuseum is now firmly established in France, making the country a 'virtual laboratory for the study of contemporary questions of cultural heritage and museological change' (Poulot, 1994). The ecomuseum occupies an important place in relation not only to museum culture, but also in relation to rural life and economic development. Other countries, especially those with close links to France, rapidly adopted the philosophy of the ecomuseum. Canada, and especially francophone Quebec, was in the forefront. In Scandinavia, the idea of the ecomuseum was adopted from the mid-1980s and has evolved to promote the interpretation and enjoyment of the cultural heritage of extensive geographical areas. The philosophy and practice is now found in most Euro-

pean countries, and is rapidly gaining favour in South America and the Far East. A survey of ecomuseums carried out in 1998 (Davis, 1999) indicated that there were some 166 ecomuseums in twenty-five countries. The number is now much greater, for example in 1998 Italy could boast fifteen ecomuseums; in 2003 there were sixty-four (www.ecomusei.net); the same web site lists 150 ecomuseums in Europe alone. Japan had a few emerging ideas in 1998, it now has eight sites using the term and many other ecomuseological initiatives (Kazuoki Ohara, personal communication, May 2003).

Ecomuseum definitions and models

Georges Henri Rivière reworked and refined his definition of the ecomuseum as his experimental work continued. The three major variations of the definition (giving dates and places of minor changes for each) are given in Rivière (1992), and provide a fascinating view of the evolution of a concept that was moulded by his experiences. The early definitions (1973) have a bias towards ecology and the environment, whilst those of 1978, though stressing the experimental nature of the ecomuseum and its evolution within the regional natural parks, makes the case for the role of the local community. The final version[1] of 22 January 1980, and published in *Museum* in 1985, is the one usually cited and includes many of the key concepts – local identity, territory, landscape, a sense of history and continuity – that are important in creating a sense of belonging. Perhaps the most important features of Rivière's definition are the repetition of the word 'population' (the emphasis on community) and the idea of the ecomuseum having 'limitless diversity', a suggestion that the ecomuseum can be anything local people and museum professionals want it to be, that it is a malleable concept.

One of the most interesting features of Rivière's lengthy definition is the comment that 'it is an interpretation of space – of special places in which to stop and stroll'. Here is the link then to place – the ecomuseum is not limited to a building or even a museum site, but it encompasses everything within the region it refers to as its 'territoire'. Here key sites – cultural touchstones – have special meaning and are integrated into the museum. Rivière's definition says little about the traditional museum activity of collecting, other than 'it helps to preserve and develop the natural and cultural heritage of the population'. Heritage is not defined either, but we must assume that it is more than just material culture, encompassing memories, folklore, music and song. At the extreme, the ecomuseum includes everything within its territory. Intangible local skills, behaviour patterns, social structure and traditions are as much a part of the ecomuseum as the tangible evidence of landscapes, underlying geology, wildlife, buildings and objects, people and their domestic animals. As Van Mensch (1993) shrewdly observed, 'it has become increasingly difficult to discern where the museum stops and the real world begins'.

There have been many other attempts to state succinctly what an ecomuseum is and how it might be distinguished from the 'traditional' museum. Pierre Mayrand (1982, quoted in Rivard, 1988) suggests that 'The ecomuseum … is a collective, a workshop extending over a territory that a population has taken as its own … [it] is not an end to itself, it is defined as an objective to be met.' Sheila Stephenson (1982, quoted in Rivard, 1988) considers that 'The ecomuseum is concerned with collections management – the collection being everything in the designated area … flora, fauna, topography, weather, buildings, land use practices, songs, attitudes, tools etc.' Although he does not suggest that it is a definition, Desvallées (1987), in his exploration of the meaning of the term, suggests that if we accept Rivière's definition, then the ecomuseum must be a museum of identity (the notions of time, space and the mirror) and a museum of territory.

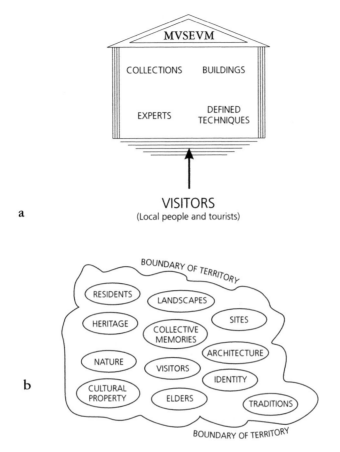

Fig. 28.1 Graphic representations of the (a) traditional museum versus the (b) ecomuseum

René Rivard (1988) has provided the most useful definition by comparing the traditional museum (=building + collections + experts + public) to the ecomuseum (= territory + heritage + memory + population). The graphical representations of this became the first and often repeated 'model' for the ecomuseum (Figure 28.1). Rivard also makes a distinction between traditional 'museums of ecology' (= natural history museums), ecological museums (= field centres, interpretive sites, natural parks and nature reserves) and ecomuseums. He suggests that the latter look especially at the interactions between humans and the natural environment, and involve the community in creating and 'improving' the environment by helping to conserve traditional habitats and ecosystems. Hugues de Varine refuted (in 1978) the notion that the ecomuseum was 'a special gadget, a miracle product, the *nec plus ultra* of the new museology'. Realistically he suggested that the label 'ecomuseum' was nothing more than an opportunity to run with new ideas, to be imaginative, to initiate new ways of working, even to be audacious (Varine, 1992). It is interesting to note that in his retrospective assessment of the ecomuseum, Varine (1988a,b) reduces the objectives of the ecomuseum to the four key areas of: community database; an observatory of change; a focal point and showcase for the community.

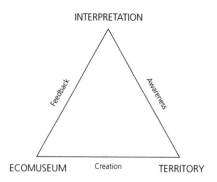

Fig. 28.2 The ecomuseum creativity triangle

The Canadian museologist, Pierre Mayrand, when setting up the Ecomuseum of Haute Beauce in Quebec, expressed the process in the form of a 'creativity triangle', which shows the ecomuseum developing as a result of interpretive activities within its geographical area (Figure 28.2). An interpretation centre lies at the apex, which increases public awareness of the geographical area or territory, through its activities, which would include the creation of antennae. As the territory (and its natural and cultural heritage) becomes better known, there is a demand for the creation of an ecomuseum and the involvement of the local community. Once the ecomuseum is established, there is feedback from local people and professionals to the interpretive process. Mayrand (1994, 1998) has subsequently refined his 'creativity triangle' and placed it within a theoretical 'three year cycle'; the implication is that within three years it is possible to move from idea to foundation, from apathy to empathy, and to move through various transitional stages of museology. Mayrand's last two stages of ecomuseum development demand the emergence of the social role as the dominant force (the museum curator as social worker), and a 'utopian' stage where individuals within the community no longer need the social services of museums.

The simple Venn diagrams proposed by Davis (1999) are another graphic representation for the ecomuseum. The degree of overlap between the circles representing museum, environment and community provide some measure of the degree to which the ideology has been adopted and how far the traditional museum has changed (Figure 28.3). However, perhaps a better model for the true ecomuseum is one that shows it embedded within the community, which is in turn placed within the environment; the outer circumference then marks the geographical boundary of the territory (Figure 28.4).

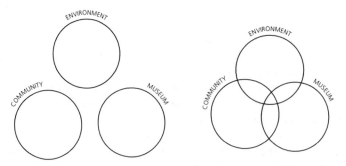

Fig. 28.3 The relationship between museum, environment and community

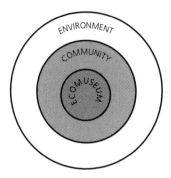

Fig. 28.4 An ecomuseum must be located within its community and the local environment

If ecomuseums seek to capture the sense of place – and it would appear that this is what makes them special – then how might this best be expressed? The models described above fail to capture this concept adequately, and neither do they take into account recent diversification and the growing significance of the adoption of the split-site model, that Hamrin (1996) felt should be termed the 'Scandinavian Ecomuseums Model' because of its prevalence in the Nordic countries. It might be argued that the ecomuseum is best thought of as a mechanism, a means whereby the museum could grow to encompass wider heritage concerns. The term 'ecomuseum' has now come to represent a tangible phenomenon. After thirty years of development, the ecomuseum is now thought of as, for example, an industrial site, a collection of buildings or a geographically dispersed network of interpretive facilities. However, it originated as a very special way of working, a mechanism that would enable the conservation of cultural and natural heritage and the maintenance of local cultural identity, the democratization of the museum and the empowerment of local people. The ecomuseum can still be thought of as an enabling mechanism, a process that ties together the varied elements that make up the special nature of places.

Flaubert's observation that 'Les perles ne font pas le collier, c'est le fil' (it is not the pearls that make the necklace, it is the thread), provides a useful metaphor for the ecomuseum (Figure 28.5). If the ecomuseum is thought of as a thread, it can then be perceived as the mechanism that holds together the varied elements (the pearls, or special sites) that make individual places special. In the 'Scandinavian Ecomuseum Model' the thread of the ecomuseum will string together the various sites in its territory. Thus the thread of Ekomuseum Bergslagen links together the fifty or so cultural sites in its territory. Alternatively, we can think of the ecomuseum thread beyond the sites themselves, and regard it as a means of holding together the various elements (collective memories, architecture, natural sites, etc.) in Rivard's (1984) model. Here, the pearls are the elements of landscape, nature, sites, song, traditions and so on. This 'necklace' model of the ecomuseum helps us to understand that by combining the attributes of regions – their cultural sites and their associated histories and themes, vernacular architecture, traditions, dialect, memories – the ecomuseum brings together those elements that make places special. A subtle yet vital addition to the necklace model of the ecomuseum is the clasp – in effect as vital a part of the mechanism as the thread. Ecomuseums are based in their communities, and the clasp could represent local people, but in reality it probably represents the activists who manage and direct the organization, the people who hold the ecomuseum together and make it work.

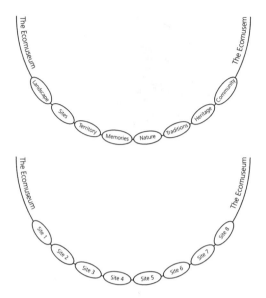

Fig. 28.5 The 'necklace' model for the ecomuseum

Conclusion

Have ecomuseums, with their holistic approach and community focus proved to be a new Utopia? Do ecomuseums demonstrate the authenticity of place, a foundation for collective understanding and involvement? Heron (1991) in his exploration of the ecomuseum concept, whilst recognizing their diversity, suggests that the three principal features of ecomuseums are their 'strong sense of local pride in traditions, customs, and vernacular architecture', a link with economic regeneration and their attempts to save a threatened culture. Davis (1999) suggests that the one characteristic that appears to be common to all ecomuseums is their pride in the place that they represent. This is true whatever the nature of the ecomuseum, whether it be a farm settlement, an abandoned factory, a water mill, a large country house or a national park. This pride is expressed in a variety of ways. Sometimes it can be seen in the careful restoration of machinery and objects, in professional standards of exhibition and interpretation, and this is usually the case in those establishments that are well funded. However, many ecomuseums are not 'professional' establishments, and it has to be said that buildings and collections are not always well conserved – indeed larger objects frequently appear abandoned – and hand-written labels are commonplace. This gives many ecomuseums a charm of their own, a welcome contrast to a museum world dominated by slick presentation and marketing gloss. Ecomuseums are often simple and accessible, and especially effective when interpreted through third-person interpretation by local people.

The ecomuseum, whether we think of it as a building, or a musealized landscape, or simply as a mechanism for change, has had a significant impact on theoretical museology and museography. However, there are several myths that surround ecomuseums, the most widely believed being the notion that all ecomuseums conform to the same pattern and follow a prescribed ideology laid down by George Henri Rivière. They do not, revealing immense variation in every aspect of their organization. Other mythical features include the ideas that ecomuseums are concerned with the natural environment, that they all interpret a number of

sites in their territory, and that they are all open-air museums. None of these statements are entirely true, nor entirely false either. The philosophy of the ecomuseum has been stretched and distorted, leading to a situation where the boundaries between ecomuseums and other heritage organizations are confusing at best. Indeed, many museums now exhibit ecomuseum characteristics. There can be little doubt that some community museums, small village museums, fragmented site museums, industrial museums, and museums run and maintained by volunteers have been influenced by and absorbed the changes that were heralded and promoted by ecomuseums, adopting practices that enable them to seek and maintain that elusive 'sense of place'.

Note

1 'an instrument conceived, fashioned, and operated jointly by a public authority, and its local population. The public authority's involvement is through the experts, facilities and resources it provides; the local population's involvement depends on its aspirations, knowledge and individual approach. It is a mirror in which the local population views itself to discover its own image, in which it seeks an explanation of the territory to which it is attached and of the populations which have preceded it, seen either as circumscribed in time or in terms of the continuity of generations. It is a mirror that the local population holds up to its visitors so that it may be better understood and so that its industry, customs and identity may command respect. It is an expression of man and nature. It situates man in his natural environment. It portrays nature in its wilderness, but also as adapted by traditional and industrial society in their own image. It is an expression of time, when the explanations it offers reach back before the appearance of man, ascend the course of the prehistoric and historical times in which he lived and arrive finally at man's present. It also offers a vista of the future, while having no pretensions to decision-making, its function being rather to inform and critically analyse. It is an interpretation of space – of special places in which to stop and stroll. It is a laboratory, insofar as it contributes to the study of the past and present of the population concerned and of its total environment and promotes the training of specialists in these fields, in cooperation with outside research bodies. It is a conservation centre, insofar as it helps to preserve and develop the natural and cultural heritage of the population. It is a school, insofar as it involves the population in its work of study and protection and encourages it to have a clearer grasp of its own future. This laboratory, conservation centre and school are based on common principles. The culture is the name of which they exist is to be understood in its broadest sense, and they are concerned to foster awareness of its dignity and artistic manifestations, from whatever stratum of the population they derive. Its diversity is limitless, so greatly do its elements vary from one specimen to another. This triad is not self-enclosed; it gives and it receives' (Rivière, 1985).

References

Clifford, S. and King, A. (1993) 'Losing your place', in Clifford, S. and King, A. (eds), *Local Distinctiveness: Place, Particularity and Identity*, London: Common Ground.
—— (eds) (1996) *From Place to PLACE: Maps and Parish Maps,* London: Common Ground.
Common Ground (1996) Common Ground promotional leaflet, London: Common Ground.
Davis, P. (1999) *Ecomuseums: A Sense of Place*, London and New York: Leicester University Press/ Continuum.
Desvallées, A. (1983) 'Les écomusées', *Universalia*, 80, 421–2 (reproduced *in ICOFOM Study Series*, 2, 15–16).
—— (1987) 'L'esprit et la lettre de l'écomusée', in *Écomusées en France*, conference proceedings of the *Premières rencontres nationales des écomusées*, L'Isle d'Abeau, 13–14 November 1986, Agence Régional d'Ethnologie Rhône-Alpes/Écomusée Nord-Dauphiné, 51–5.

Gestin, J.-P. (1995) 'Le parc naturel régional d'Armorique', in *Patrimoine culturel, patrimoine naturel*, conference proceedings, 12–13 December 1994, Paris: École Nationale de Patrimoine.

Hamrin, G. (1996) 'Ekomuseum Bergslagen: fran ide till verklighet', *Nordisk Museologi*, 2, 27–34.

Heron, P. (1991) 'Ecomuseums – a new museology?', *Alberta Museums Review*, 17(2), 8–11.

Hubert, F. (1989) 'Historique des écomusées', in *La muséologie selon Georges Henri Rivière*, Paris: Dunod/Bordas.

Hudson, K. (1992) 'The dream and the reality', *Museums Journal*, 92(4), 27.

Leslie, K. (2001) *Mapping the Millennium: The West Sussex Millennium Parish Maps Project*, Chichester: Selsey Press.

Mayrand, P. (1994) 'La reconciliation possible de deux langages', *Les cahiers de développement local* (conférence des CADC du Quebec), 3(2), 3–5.

—— (1998) *L'exposition à l'heure juste du développement local: cycle théoretique de trois ans*, unpublished manuscript, Reinwardt Academy, Amsterdam.

Poulot, D. (1994) 'Identity as self-discovery; the ecomuseum in France', in Sherman, D.J. and Rogoff, I. (eds), *Museum Culture: Histories, Discourses, Spectacles*, London: Routledge.

Relph, E.E. (1976) *Place and Placelessness*, London: Pion.

Rivard, R. (1984) *Opening up the Museum*, typescript held at the Direction des musées de France, Paris.

—— (1988) 'Museums and ecomuseums – questions and answers, in Gjestrum, J.A. and Maure, M. (eds), *Okomuseumsboka – Identitet, Okologi, Deltakelse*, Tromsø: ICOM.

Rivière, G.H. (1973) 'Role of museums of art and of human and social sciences', *Museum*, 25(1/2), 26–44.

—— (1985) 'The ecomuseum – an evolutive definition', *Museum*, 37(4), 182–3.

—— (1992) 'L'écomusée, un modèle évolutif', in Desvallées, A. (ed.), *Vagues – une anthologie de la nouvelle muséologie*, Lusigny sur Ouche: Editions W. Macon.

Van Mensch, P. (1993) 'Museology and the management of the natural and cultural heritage', in De Jong, R. (ed.), *Museums and the Environment*, Pretoria: Southern Africa Museums Association.

Varine, H. de (1988a) 'New museology and the renewal of the museum institution', in Gjestrum, J.A. and Maure, M. (eds), *Okomuseumsboka – Identitet, Okologi, Deltakelse*, Tromsø: ICOM.

—— (1988b) 'Rethinking the museum concept', in Gjestrum, J.A. and Maure, M. (eds), *Okomuseumsboka – Identitet, Okologi, Deltakelse*, Tromsø: ICOM.

—— (1992) 'L'écomusée', in Desvallées, A. (ed.), *Vagues – une anthologie de la nouvelle muséologie*, Lusigny sur Ouche: Editions W. Macon [originally published in *La gazette* (Association des Musées Canadiens) 1978, 11].

Wasserman, F. (1989) 'Les écomusées, ou comment une population reconnait, protège, met en valeur les richesses naturelles et culturelles de son territoire', *Musées et collections publiques de France*, 182(3), 53–5.

Suggested further reading for Part 4

American Association of Museums (2002a) *A Museum and Community Toolkit*, Washington: AAM.

—— (2002b) *Mastering Civic Engagement: A Challenge to Museums*, Washington: AAM.

Archibald, R. (1999) *A Place to Remember: Using History to Build Community*, Walnut Creek: AltaMira.

Davis, P. (1999) *Ecomuseums: A Sense of Place*, London and New York: Leicester University Press Continuum.

DCMS (2001) *Libraries, Museums, Galleries and Archives for All: Co-operating Across the Sectors to Tackle Social Exclusion*, London: DCMS.

—— (2002) *People and Places: Social Inclusion Policy for the Built and Historic Environment*, London: DCMS.

Hall, C.M. and McArthur, S. (1998) *Integrated Heritage Management: Principles and Practice*, London: HMSO.

Karp, I. *et al.* (1992) *Museums and Communities: The Politics of Public Culture*, Washington: Smithsonian Institution Press.

Newman, A. and McLean, F. (1998) 'Heritage builds communities: the application of heritage resources to the problems of social exclusion', *International Journal of Heritage Studies,* 4(3/4), 143–53.

Sandell, R. (ed.) (2002) *Museums, Society, Inequality*, London: Routledge.

Smithsonian Institution (1995) *Culture Builds Communities: A Guide to Partnership Building and Putting Culture to Work on Social Issues,* Washington: Smithsonian Institution Press.

—— (1997) *Museums for the New Millennium: A Symposium for the Museum Community*, Washington: Smithsonian Institution/AAM.

Index

Page numbers in italics indicate illustrations, tables and figures.